Rembrandt: th

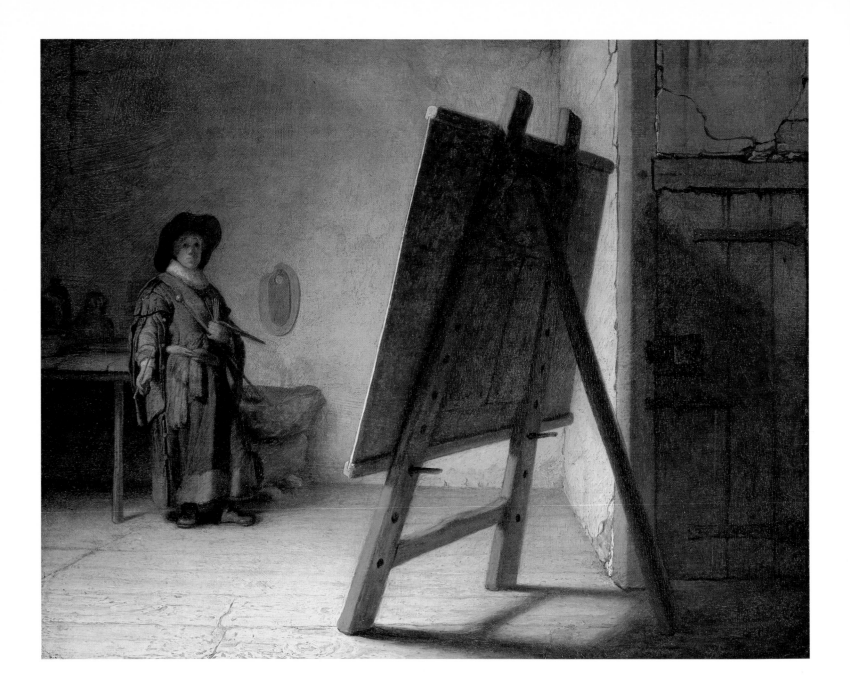

Christopher Brown, Jan Kelch & Pieter van Thiel

Rembrandt: the Master & his Workshop

Paintings

Yale University Press, New Haven and London
in association with
National Gallery Publications, London

Exhibition dates:

Gemäldegalerie SMPK at the Altes Museum, Berlin: 12 September 1991–10 November 1991
Rijksmuseum, Amsterdam: 4 December 1991–1 March 1992
The National Gallery, London: 26 March 1992–24 May 1992

Exhibition Organiser: Uwe Wieczorek

Edited by Sally Salvesen

Designed by Derek Birdsall RDI

Translators: Elizabeth Clegg, Michael Hoyle, Paul Vincent.

Typeset in Monophoto Van Dijck by Servis Filmsetting Ltd, Manchester
Printed in Italy by Amilcare Pizzi, s.p.a., Milan, on Gardamatt 135 gsm

Library of Congress Catalog Card Number 91–65959

British Library Cataloguing-in-Publication Data

Brown, Christopher
 Rembrandt: the master & his workshop: paintings.
 I. Title II. Kelch, Jan III . Van Thiel, Pieter
 759. 9492

ISBN: 0–300–05149–2
ISBN: 0–300–05150–6 (paperback)

Frontispiece: Rembrandt,
The Artist in his Studio
Boston, Museum of Fine Arts

Cover illustration: Rembrandt,
The Standard-Bearer (detail)
Private Collection

Contents

Patrons

Her Majesty Queen Elizabeth II

Her Majesty The Queen of the Netherlands

His Excellency Dr Richard von Weizsäcker
President of the Federal Republic of Germany

Directors' Foreword

Rembrandt has changed in the last twenty years. A steady flow of documentary research has combined with unprecedented stylistic and technical examination, carried out for the most part by the Rembrandt Research Project, to give us a view of the artist and his work materially different from that presented by the Rembrandt exhibition in Amsterdam in 1969. Many works long loved and admired are now believed to have been painted by other artists. Berlin's *Man with the Golden Helmet*, the Frick Collection's *Polish Rider* and the Chicago *Girl at the Door*, along with many other paintings previously attributed to him in museums around the world, are now questioned as the work of Rembrandt, or, by many scholars, rejected outright.

If we exclude these pictures, some previously revered as the summits of his achievement, we have to ask what sort of Rembrandt we are now left with. Who, in short, is Rembrandt in the 1990s? And, no less important, who are the other artists that we have been unwittingly admiring for so long? If Dou, Drost and Hoogstraten are the true creators of paintings that have for years delighted and inspired us, it is clearly time that we took another look at them as well. Rembrandt remains a giant, even if not quite the one we thought we knew; but he is a giant surrounded no longer by pygmies, but by artists of real stature, whom we ought to know better.

The investigation of this new Rembrandt and of his contemporaries are the two main purposes of this exhibition. There is, however, a third. We wanted to show the public how decisions about attribution are made. Paintings, drawings and prints we believe to be definitely by Rembrandt are therefore shown with works definitely by other artists. With them are exhibited paintings once given to Rembrandt, now attributed to one of those others. Visitors to the exhibition will therefore be in a position to examine the pictures, weigh the evidence and decide for themselves whether the conclusions drawn in this catalogue are sound.

The Gemäldegalerie, the Rijksmuseum and the National Gallery are all fortunate in having rich Rembrandt holdings. The curators who look after them, all distinguished Rembrandt scholars, have between them written most of this catalogue. Other distinguished scholars of Rembrandt and of Dutch art and society in the seventeenth century have contributed essays and catalogue entries. Yet we could not have thought of organising an exhibition like this one, an exhibition able to address these very particular questions, without the support of lenders, both private and institutional, throughout the world. And no less could we have embarked on so ambitious a venture, had not American Express Foundation supported us financially with generosity and encouraged us throughout with its enthusiasm for the project.

We hope that both sponsors and lenders will find their generosity of spirit repaid not only by our thanks, but by the enjoyment of hundreds of thousands of visitors.

We are particularly indebted to Simon Levie, former General Director of the Rijksmuseum, who was a driving force behind the exhibition in its early stages.

Henning Bock
Director
Gemäldegalerie
Berlin

Henk van Os
General Director
Rijksmuseum
Amsterdam

Neil MacGregor
Director
National Gallery
London

Lenders

Her Majesty Queen Elizabeth II, 27, 35, 58
Private collections, 26, 53, 56, 57, 62, 65, 70, 73

Amsterdam, Rijksmuseum, 1, 8, 30, 31, 44, 48, 61, 63, 76
Anholt, Museum Wasserburg Anholt, 16
Berlin, Staatliche Museen Preußischer Kulturbesitz, 2, 20, 33, 37, 45, 46, 60, 82
Boston, Museum of Fine Arts, 3
Brussels, Koninklijk Museum van Schone Kunsten, 34, 78
Chatsworth, The Trustees of the Chatsworth Settlement, 28
Chicago, The Art Institute, 72
Dresden, Staatliche Kunstsammlungen Dredsen, 24
Dublin, The National Gallery of Ireland, 38, 59, 71
Düsseldorf, Kunstmuseum Düsseldorf, 68
Edinburgh, National Galleries of Scotland, 36
Glasgow, City Art Galleries and Museums, 43
The Hague, Koninklijk Kabinet van Schilderijen, Mauritshuis, 4, 25, 51, 79
Hamburg, Hamburger Kunsthalle, 11
Innsbruck, Tiroler Landesmuseum Ferdinandeum, 7
Jerusalem, The Israel Museum, 69
Kassel, Staatliche Kunstsammlungen Kassel, 29, 77
Kedleston Hall, The National Trust, 66
Leiden, Stedelijk Museum 'De Lakenhal', 54
Leningrad, State Hermitage Museum, 21, 64, 67, 74
London, The Iveagh Bequest, Kenwood (English Heritage), 49
London, The Governors of Dulwich Picture Gallery, 12
London, The National Gallery, 15, 19, 22, 23, 32, 40, 55
Melbourne, The National Gallery of Victoria, 50
Munich, Bayerische Staatsgemäldesammlungen, 13, 14
New York, Metropolitan Museum of Art, 9, 41
Nuremberg, Germanisches Nationalmuseum, 5
Oxford, The Ashmolean Museum, 83
Paris, Musée du Louvre, 39, 47
Raleigh, North Carolina Museum of Art, 52
Rotterdam, Museum Boymans-van Beuningen, 42, 80
Salzburg, Residenzgalerie Salzburg, 6
San Francisco, The Fine Art Museums, 81
Toronto, Art Gallery of Ontario, 75
Vienna, Akademie der bildenden Künste, 10

Introduction

The selection of paintings in this exhibition has been made by a committee composed of Christopher Brown, Chief Curator of the National Gallery, London; Jan Kelch, Senior Curator of the Gemäldegalerie, Berlin and Pieter van Thiel, Director of the Department of Paintings at the Rijksmuseum, Amsterdam. The exhibition is divided into two sections and we feel it would be useful to both visitors and readers to be aware of the principles on which the selection has been made. The first section comprises paintings which we believe can be securely attributed to Rembrandt. They have been chosen to represent every period of his long working career, from 1626 to 1669, and the different types of subject-matter he treated, including portraits and history paintings as well as a still-life and a landscape.

We have been assisted by Volker Manuth of the Free University of Berlin and Bernhard Schnackenburg, head of the Gemäldegalerie Alte Meister, Kassel, in the selection and cataloguing of the second section of the exhibition. This takes into account the recent debate about Rembrandt attributions, much of which has been generated by the work of the Rembrandt Research Project. We have chosen twelve paintings which until recently have been considered to be by Rembrandt, but which are here attributed to a pupil or follower. To hang with each of these paintings we have selected one or two pictures by the same pupil or follower, at least one of which is signed or documented, in order to make the visual argument for the attribution.

Requesting paintings from museums and private collectors, which until recently were considered to be by Rembrandt, in order to display them as the work of a pupil or follower of Rembrandt is inevitably a difficult and controversial matter. We are conscious of an immense debt of gratitude to those owners who have been willing to allow their paintings to be included. All these attributions have been made in the hope of making a useful contribution to a fascinating and continuing debate. In some cases we have indicated in the texts of the catalogue entries that we are less certain than in others. We have represented almost all of the most important of Rembrandt's pupils: the only substantial omission, whose absence we regret very much, is Rembrandt's brilliant late pupil, Aert de Gelder.

In making the selection, we have received much valuable help from Josua Bruyn, Werner Sumowski and Ernst van de Wetering.

Christopher Brown
Jan Kelch
Pieter van Thiel

Chronology

1568–1648	Revolt of the Netherlands against Spain.
1573–74	Leiden besieged by the Spaniards. The town is relieved by rebel forces on 3 October 1574.
1575	Foundation of the University of Leiden.
1584	Prince William of Orange (1533–1584) assassinated in Delft on 10 July. Succession of his son, Prince Maurits (1567–1625).
1589	Rembrandt's parents, Harmen Gerritszn. van Rijn and Neeltgen Willemsdr. van Zuytbrouck, are married in the reformed Pieterskerk in Leiden on 8 October.
1602	The United Dutch East India Company founded.
1606	Rembrandt born in Leiden on 15 July.
1609–1621	The conclusion of the Twelve-Year Truce brings a temporary cessation of hostilities. During the truce religious disputes erupt between Remonstrants and Counter-Remonstrants.
1618–1619	Rembrandt attends the Latin School.
1613	Prince Maurits takes the side of the Counter-Remonstrants and purges town councils of Remonstrant members.
1618–1619	At the Synod of Dordt the Remonstrants are expelled from the Calvinist church. A Bible translation is commissioned.
1620	Rembrandt is enrolled at the University on 20 May, but never studies there.
1621	End of the Twelve-Year Truce. Foundation of the Dutch West India Company.
1621–1623	At about this time Rembrandt is a pupil of the Leiden history painter Jacob van Swanenburgh.
1624	For six months Rembrandt studies with the history painter Pieter Lastman in Amsterdam.
1625	Prince Maurits dies on 23 April and is succeeded by his brother Prince Frederik Hendrik (1584–1647), well-known for his Remonstrant sympathies. Rembrandt sets up as an independent painter in Leiden.
1628–1631	Gerrit Dou and Isaac Jouderville work with Rembrandt as his pupils.
1629	Rembrandt paints *The repentant Judas returning the thirty pieces of silver to the High Priest*, a work which is highly praised by Constantijn Huygens on a visit to Rembrandt's studio.
1630	Rembrandt's father dies in April.
1631	The painter and art dealer Hendrick Uylenburgh borrows 1,000 guilders from Rembrandt on 20 June. Rembrandt paints his earliest known portrait of an Amsterdammer, Nicolaes Ruts.
1632	Rembrandt carries out portrait commissions in Amsterdam—including *The Anatomy Lesson of Dr Nicolaes Tulp*—and in The Hague. In June he is mentioned as lodging with Hendrick Uylenburgh in Amsterdam.
1633	Rembrandt's residence in Amsterdam becomes more permanent. In April the Remonstrant preacher Johannes

Wtenbogaert comes to Amsterdam to be painted by Rembrandt in Uylenburgh's studio. At about this time Govert Flinck starts work in Uylenburgh's studio.

1634 On 22 June Rembrandt marries Saskia Uylenburgh in Sint Annaparochie in Friesland. He becomes an Amsterdam citizen and joins the local St Luke's Guild. The couple move in temporarily with Hendrick Uylenburgh.

1635 Rembrandt rents a house of his own in the Nieuwe Doelenstraat, where their first son, Rombertus, who survives only two months, is born in December.

1637 Rembrandt moves to the 'Sugar Refinery' (*Suyckerbackerij*) on the Binnen-Amstel, where Ferdinand Bol and Leendert van Beijeren are his pupils.

1638 Birth of a daughter, Cornelia, in July. The child lives less than a month.
The dowager queen of France, Maria de Medicis (1573–1642) is given a state reception in Amsterdam. The Amsterdam militias are at their peak.

1639 On 1 May Rembrandt moves to the Sint-Anthonisbreestraat, to what is now the Rembrandt House in the Jodenbreestraat.

1640 A second daughter, also named Cornelia, is born in July, but lives only a few weeks.
Rembrandt's mother dies in September.

1641 In September a son, Titus, is born and survives.
Rembrandt works on *The Nightwatch* (completed in 1642) and the *Double Portrait of the Mennonite teacher Cornelis Claeszn Anslo and his wife Aeltje Gerritsdr Schouten*.

1642 Saskia Uylenburgh dies on 14 June and is buried in a family grave in the Oude Kerk.
Geertje Dircks is employed as a nanny for Titus and begins a liaison with Rembrandt.

1647 Prince Frederik Hendrik dies on 14 March and is succeeded by his son Prince Willem II (1626–1650).
At about this time Hendrickje Stoffels joins Rembrandt's household as a maidservant.

1648 Peace with Spain. Work starts on a new town hall on the Dam in Amsterdam.

1649 Problems between the painter and Geertje Dircks lead to a court action against Rembrandt for breach of promise, as result of which Rembrandt is sentenced to pay a yearly maintenance allowance of 200 guilders.

1650 In the summer Prince Willem lays siege to Amsterdam. The prince dies on 6 November.
Rembrandt has Geertje Dircks detained at his own expense in the women's house of correction in Gouda.

1650–1672 First Stadholderless Period.

1652–1654 First Anglo-Dutch War.

1653 Renovation of the house next to Rembrandt's, which causes him great inconvenience. He paints his *Aristotle*.
The owner of Rembrandt's house wishes to finalise the transfer of the property and arrange for payment in full by the painter.

1654 In October an illegitimate daughter, Cornelia, is born to Rembrandt and Hendrickje Stoffels.
On 10 December Rembrandt becomes the owner of the house in the Sint-Anthonisbreestraat, having taken out a mortgage.
Rembrandt paints the *Portrait of Jan Six*.

1655 The new Town Hall is officially inaugurated on 29 July. Rembrandt paints a second anatomy lesson, given by Dr Joan Deyman.

1656 In the summer Rembrandt appears before the Chamber of Insolvent Estates. An inventory of his property is drawn up.

1657–1658 Liquidation sales of Rembrandt's paintings, drawings, prints, art collections, household effects and house.

1658 Rembrandt leaves the Sint-Anthonisbreestraat before 1 May and moves to the Rozengracht in the Jordaan district.

1660 On 15 December Rembrandt enters into a contract with his son Titus and Hendrickje Stoffels setting up an art dealership.

1662 Rembrandt paints the *Syndics* and the *Conspiracy of Claudius Civilis* for the Town Hall. The latter painting is removed a few months later.

1663 Hendrickje Stoffels dies in July and is buried in a rented grave in the Westerkerk.

1665–1667 Second Anglo-Dutch War.

1667 Cosimo de Medicis visits Rembrandt on 29 December.

1668 Titus van Rijn, having married Magdalena van Loo on 28 February, dies and is buried in the Westerkerk on 7 September.

1669 On 22 March Rembrandt's grand-daughter Titia is baptised in the Nieuwezijds Chapel, with Rembrandt acting as godfather.
Rembrandt dies on 4 October and is buried four days later in an unknown rented grave in the Westerkerk.

Rembrandt's Manner:
Technique in the Service of Illusion

Ernst van de Wetering

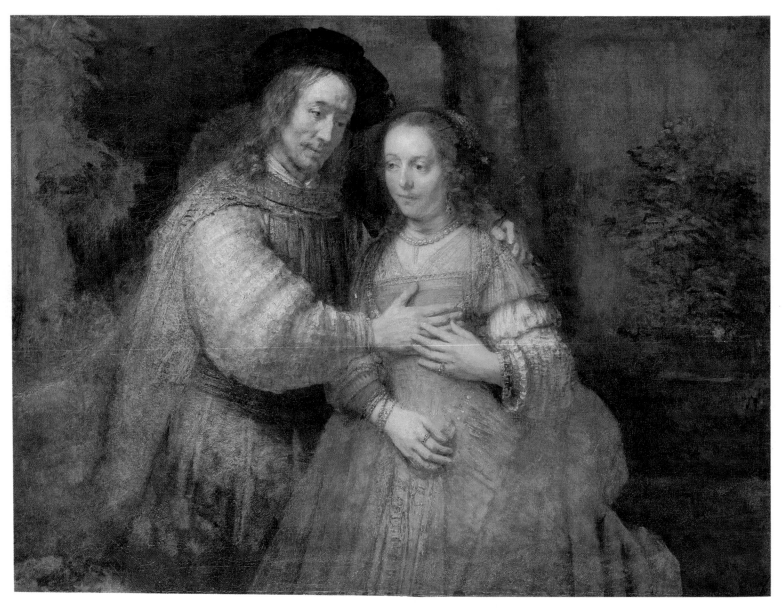

1: Rembrandt, *The Jewish Bride*, c. 1665.
Amsterdam, Rijksmuseum.

In the autumn of 1885 Vincent van Gogh and his friend Anton Kerssemakers visited the newly opened Rijksmuseum in Amsterdam. When they reached Rembrandt's *Jewish Bride* (Fig. 1) Vincent stopped while Kerssemakers walked on. When he returned a good while later he found Van Gogh still in front of the picture. Kerssemakers later wrote that as they were about to move on Vincent said: 'Would you believe it—and I honestly mean what I say—I should be happy to give ten years of my life if I could go on sitting here in front of this picture for a fortnight, with only a crust of dry bread for food?'.[1]

This fascination with work from Rembrandt's late period has been shared by many other people, both before and since Van Gogh. In part it is undoubtedly due to the utterly intriguing process whereby these works were created—to Rembrandt's technique. With many artists the act of painting can easily be followed from brushstroke to brushstroke, but in Rembrandt's late work it appears to be the result of unfathomable processes. An older, Paris-based contemporary of Van Gogh's, the German Eduard Kolloff, wrote: 'Very meticulous connoisseurs and amateurs of art who study everything through magnifying glasses are disconcerted by his manner of painting and find themselves at a loss: unable to discover how his pictures are made, they can do no better than declare that the hermetically sealed facture of his paintings is sorcery, and that even the painter had no clear understanding of how it was done'.[2] It seems a strange idea that a painter should not know how he created his work. It recalls the controversial remark by the Dutch Expressionist Karel Appel, who said of his method in an interview in 1955: 'I just mess about'.[3]

I would not quote this banal and provocative statement if it did not irresistibly remind one of the words of the painter Gerard de Lairesse (Fig. 2), a contemporary and personal acquaintance of Rembrandt's who must have seen him at work. After maintaining that an artist should paint 'with a bold hand', he added the caveat: 'but not like Rembrandt or Lievens, whose colours run down the piece like mud'. The fact that he mentions Rembrandt and his former friend Jan Lievens in the same breath will prove important, as we shall see in Part II of this essay. De Lairesse clarified this statement by saying that an artist should work 'evenly and lushly' ('gelijk en mals'), by which he meant that the brushwork should be full but uniform over the whole painting, so that 'your subjects appear rounded and raised by Art alone, and not by daubing'.[4]

As will become clear in the course of this essay, the term 'Art' as used by De Lairesse stands for the controlled and skilled use of elements like contour, colour, light and shadow, to depict subjects which are convincing in their plasticity and spatial effect, even when the brushwork is smooth.

If one carefully examines the painting that prompted these thoughts, *The Jewish Bride* (Figs. 1, 3–14), it becomes clear what De Lairesse may have meant by 'daubing'.

Leaving aside the subject (to quote Vincent van Gogh again: 'What an intimate, what an infinitely sympathetic picture'),[5] the first thing one notices is the unbelievably rich and varied handling of paint—a differentiation which could only have been achieved by consummate control over the paint. And yet, one gets the impression that it was not the artist who painted but the painting that painted itself, that it appears to be the outcome of a geological process rather than paint applied by a human hand, that in some elusive way chance plays an important part in this manner of painting.

One of the most spectacular passages is the man's sleeve (Figs. 3, 4), where the paint rises from the surface in clots and flakes, reflecting the light. It is a mystery how such a surface structure was achieved, to imagine what implement was used, for it is impossible to distinguish any clear brushstrokes, nor are there are any obvious traces of the use of a palette knife. The woman's shoulder (Figs. 5, 6), which is covered with transparent fabrics and upon which the man's hand emerges from the shadows, is equally amazing in its execution. Lying on a seemingly chaotically brushed-on and smudged under-layer are drippings of paint which, despite the apparently haphazard way they have landed in their positions, enhance the effect that these are costly fabrics interwoven with metal thread. In the woman's red skirt (Figs. 7, 8) a relief of light-coloured lumps of paint lying beneath the surface rises up out of a sea of pink and translucent red veils of paint.

And what about the way Rembrandt rendered the famous tender hands on the woman's breast (Figs. 9, 10)? Part of the back of the man's hand has a rough surface, giving the skin an almost tangible texture. Towards the knuckles a veil of pinkish and greyish tones rests on a smooth under-layer, and over it lies the woman's finger painted with a plasticity in which the dragging hairs of the brush have drawn furrows that catch the light. Spatially, and as regards lighting, this separates the finger from its dusky foundation. The man's grey-green cloak (Figs. 11, 12) takes its atmospheric nature from brown paint rubbed

2: Rembrandt, *Portrait of Gerard de Lairesse* (detail), 1665. New York, The Metropolitan Museum of Art, The Lehman Collection. The strange deformation of De Lairesse's face has been ascribed, probably wrongly, to the effects of syphilis. He was 24 when this portrait was painted. He wrote that in his early years he had been an admirer of Rembrandt, but he later rejected his art on theoretical grounds.

3: Detail of *The Jewish Bride* (Fig. 1). 4: Detail of Fig. 3.

5: Detail of *The Jewish Bride* (Fig. 1). 6: Detail of Fig. 5.

7: Detail of *The Jewish Bride* (Fig. 1). 8: Detail of Fig. 7.

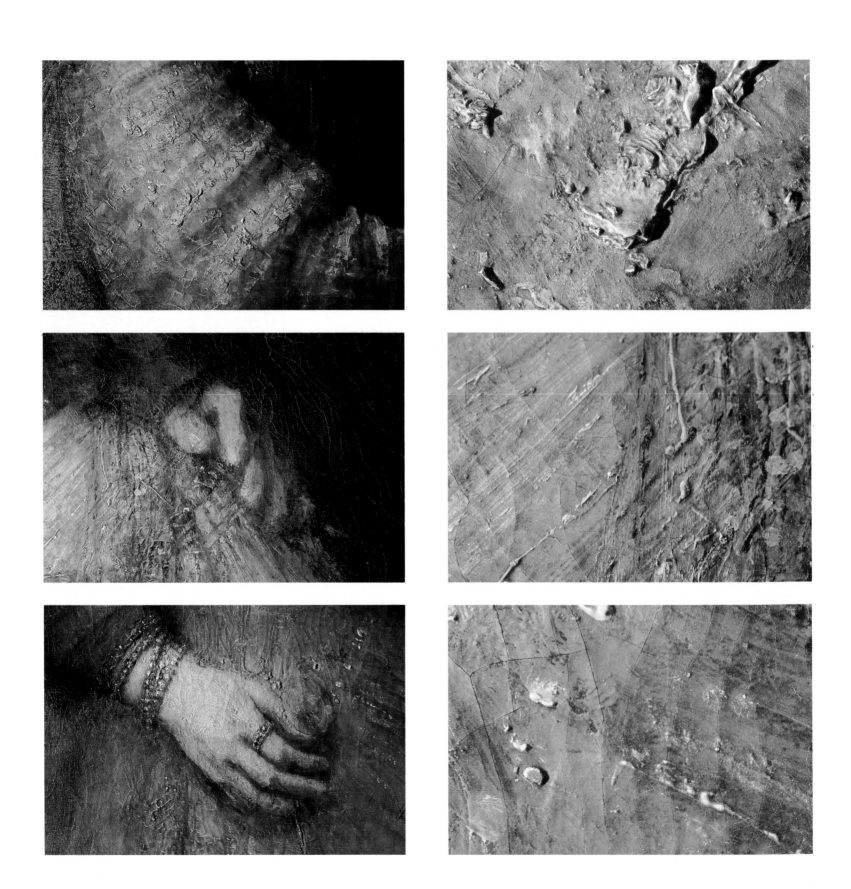

9: Detail of *The Jewish Bride* (Fig. 1).

10: Detail of Fig. 9 (the tip of the woman's middle finger).

11: Detail of *The Jewish Bride* (Fig. 1) (the man's cloak).

12: Detail of Fig. 11.

13: Detail of *The Jewish Bride* (Fig. 1).

14: Detail of Fig. 13.

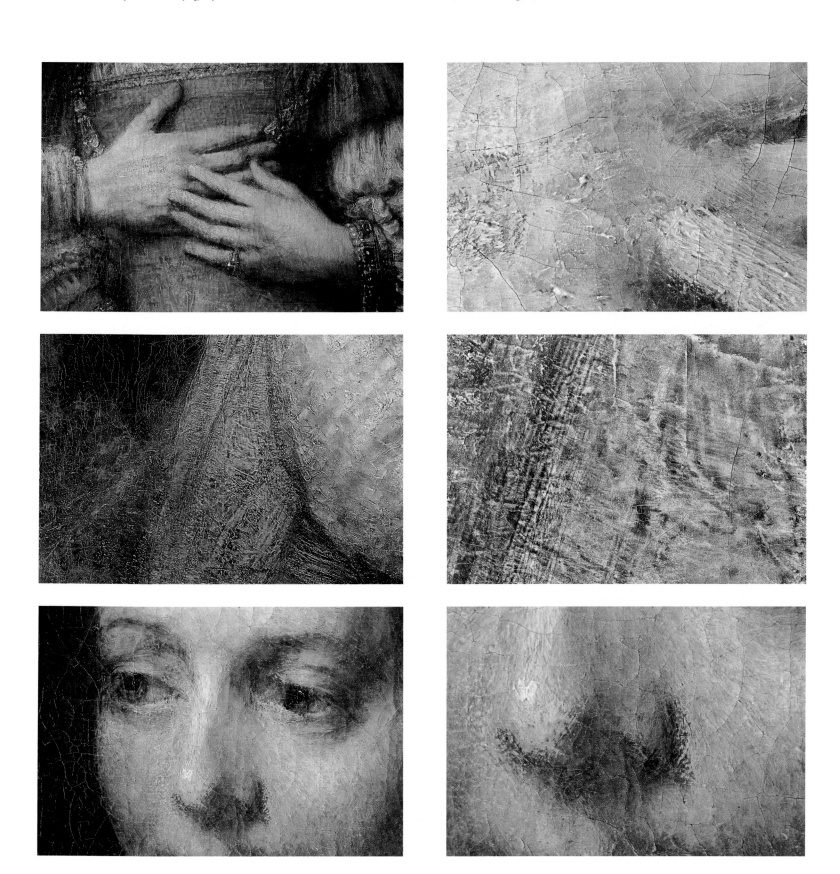

15: Rembrandt, *Self-Portrait*, 1629 (detail). The Hague, Mauritshuis. See Cat. No. 4.

16: Rembrandt, *Self-Portrait*, 1661 (detail). London, Kenwood House. See Cat. No. 49.

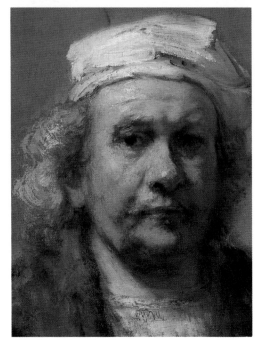

into a scratched under-layer that has a stony appearance, like ink wiped onto an etching plate. The brown paint has collected in the scratches and shallow dents in the surface, but in such a way that the eye only searches briefly for form and structure before wandering on to less indistinct passages. The transitions from light to shadow near the woman's nose (Figs. 13, 14) are not smooth, but more the result of dragging an almost dry brush over the surface.

One could carry on in the same vein, exploring the many mysterious effects to be found in this picture. An attempt will be made in this essay to uncover the roots of this manner of painting. In the process it will, I hope, become clear that the course followed by Rembrandt in his remarkable development can to a large extent be traced to ideas current in his day. By examining them in their context we may perhaps be able to 'hear Rembrandt thinking' about his way of painting.

I: *The 'rough' Manner: Rembrandt and Titian*

It is hard to believe that the painter of the *Jewish Bride* was also the founding father of the school of Leiden *Feinmaler*, the painters who, with invisible brushstrokes and 'the patience of saints and the industry of ants', took the illusionistic depiction of objects to its furthest extremes.[6] Rembrandt began with a fine technique (Fig. 15) but ended up painting in the 'rough manner', as it was called in the seventeenth century (Fig. 16). Until well into the present century this evolution was regarded as a highly personal development, and one that was supposedly a spontaneous process of organic growth, culminating in an '*Alterstil*', an *ultima maniera*—that magical apotheosis which typifies some artists' biographies. However, there are also grounds for speculating that the process may have been guided by conscious decisions based on current ideas on 'the smooth and rough manners' which were part of the seventeenth-century workshop culture. When I discuss these opinions in the following sections and see how far they apply to Rembrandt, I am not suggesting that those factors alone governed the course of his breathtaking career as a painter. In the final two sections and the conclusion I shall set out to show that very different concepts must also have played a part.

The discussion on the smooth and rough manners has been going on for some time now, particularly in the case of Rembrandt. Jan Emmens was the first to demonstrate that the two modes were above all determined by art theory, in other words that they involved a deliberate choice on the part of the artist.[7] A literary quotation taken at random serves to illustrate the feelings that the visible brushstroke evoked in the first half of the twentieth century (and still does today): 'One must see the swathes left by the brush; they are the twistings, the cries of the soul'.[8] Such a response to the visible brushstroke was clearly prompted to a large extent by an Expressionist attitude towards works of art. A contemporary view comes from a treatise of around 1630 containing hints to those planning to visit an artist in his studio. One was advised to compliment the artist with remarks like: 'Is it possible that the pencil can have given such softness by such rough touches, and that such apparent carelessness should be so attractive?'[9] This admiration for the fact that a convincing depiction of reality could also be achieved with a rough *peinture* shows that the paramount criterion was illusionism.

The second half of that quotation mentions the attractiveness of apparent carelessness, and it is this aspect of the rough manner that has attracted particular attention in recent years. It was sparked off by a remark by Eddy de Jongh about Rembrandt's *Portrait of Jan Six*, that brilliant masterpiece still in the possession of the Six family (Figs. 17, 60). De Jongh referred to the concept of *sprezzatura*, which had already been the subject of some discussion in the literature on art.[10] Baldassare Castiglione had elucidated this concept in 1528 in his *Il libro del cortegiano* by drawing a parallel between the demeanour of the courtier and the loose, seemingly careless touches which the artist applied with his brush. In Rembrandt's day *sprezzatura* was translated as 'looseness' ('*lossigheydt*'), and in the case of the courtier and the nobleman (or gentleman) this was interpreted, in line with Castiglione, as an effortless nonchalance of pose and behaviour. The first Dutch edition of *Il libro del cortegiano* appeared in 1652 and was dedicated to the same Jan Six, the Amsterdam patrician and 'gentleman-virtuoso' whose portrait Rembrandt painted in 1654. As was to be expected, not only was Jan Six's casual pose associated with Castiglione's *sprezzatura*, but likewise, given the latter's reference to the painter's loose touch, the remarkably free manner which Rembrandt employed for this particular portrait.[11]

Yet the concept of *sprezzatura* does not provide an entirely satisfactory explanation for Rembrandt's conversion to the rough manner. 'Looseness' is not the most typical aspect of his late style. There is another sixteenth-century author who is of a far greater importance for understanding Rembrandt's rough manner, and that is Vasari in his life of Titian (1488 or 1490–1576), which was included in the second, 1568 edition of

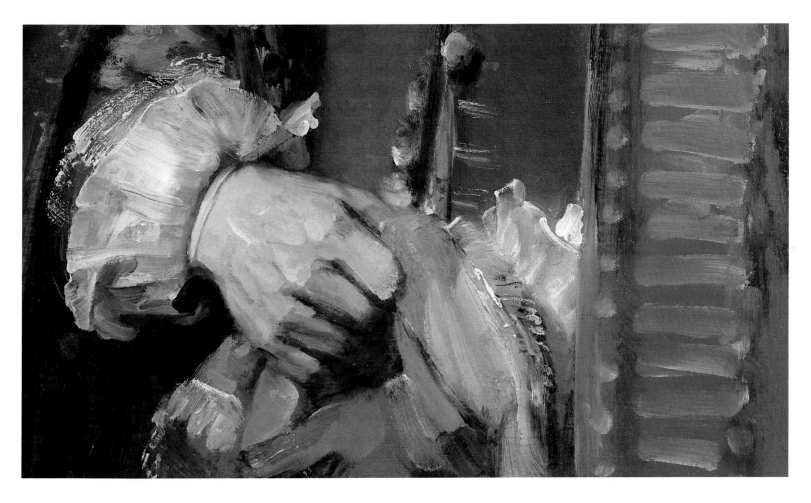

the *Vite*,[12] and was translated almost word for word by Karel van Mander in his *Schilder-boeck* of 1604.[13] Although Titian could be classed as a '*cortegiano*', the roots of his late, rough manner do not derive primarily from the concept of *sprezzatura*.

Although he died only thirty years before Rembrandt was born, Titian had long been a legendary figure, not just to artists but to all cultivated Europeans. He was the painter who had consorted with princes on an almost equal footing, but what made him almost as intriguing was that his style changed so radically in the course of his long life. After beginning with a fine technique he later adopted a manner which Vasari called 'pittura di macchia', or 'painting with splotches' (Fig. 19). Vasari put this down to Titian's great age, leading Samuel van Hoogstraten to conclude that it was actually due to failing eyesight.[14] It makes more sense, though, to regard Titian's technique as a consequence of his method, described by Vasari, of painting directly, without first making preparatory drawings.[15] In this procedure, tonal and colour values take precedence over form. The revolutionary nature of this approach becomes apparent when one compares a painting by Raphael, say, with a late Titian (Figs. 18, 19). It is no exaggeration to say that Titian's late style brought about a fundamental change in the course of the history of painting.

In this essay I will be discussing a number of ideas which Vasari and other writers associated with Titian's 'splotchy' technique. There is not the slightest doubt that they were passed on more directly and with greater force by word of mouth in the contacts within and between workshops than they were through Vasari's *Vite* or Van Mander's *Levens*. In order to appreciate how ideas circulating among the Italian studios could have reached Rembrandt, one only has to recall that his two teachers, Jacob Isaacsz. van Swanenburgh and Pieter Lastman, had worked for much of their lives in Italy.

One of the aspects which was discussed in connection with the rough manner was the fact that paintings executed in this way had to be viewed from a distance. From close up one saw only blotches, but from further off they fused into a representation of reality that could be more convincing than that found in a finely brushed work. It seems, then, that in the seventeenth century it was felt that pictures of this kind *had* to be seen from a distance. One of the very few pronouncements on art that we have straight from Rembrandt's mouth occurs in a letter to Constantijn Huygens of 27 January 1639, which tells us that he himself considered that one of his

18: Raphael, *Madonna and Child with the infant Baptist* (detail). London, National Gallery.

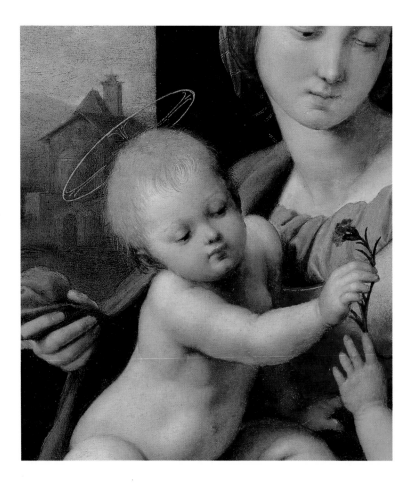

paintings, a large canvas from his early Amsterdam period, should be hung in such a way 'that it can be viewed from a distance'.[16] These words appear to confirm the story that Rembrandt 'tugged people away who peered too closely at his pictures when visiting his studio, saying: "The smell of the paint would bother you"'.[17] Arnold Houbraken only published this anecdote in 1718, but we can assume that he had it directly from a Rembrandt pupil whom he knew, possibly his own teacher, Samuel van Hoogstraten, or his friend Aert de Gelder.[18] Nowadays it is a matter of course to inspect roughly textured paintings from close range as well as from a distance. Max Doerner, the influential German writer on painting technique, obviously speaks of what he observes at close range, given the nature of his interest. Repeatedly, though, he says what a 'great delight' it is to look at a Rembrandt from close to.[19]

The fact that Rembrandt stated so explicitly that his paintings should be seen from a distance is certainly remarkably close to Vasari's observation on Titian's late work, namely that 'they cannot be looked at from close quarters, but from a distance they appear perfect'.[20]

The idea that one has to stand well back from certain works of art in order to do them justice is also mentioned on several occasions in classical literature, which was regarded in the seventeenth-century as the source which legitimised all kinds of opinions. Horace's sentence beginning with the famous words: 'Ut pictura poesis' is devoted to this very subject: 'A poem is like a picture: one strikes your fancy more, the nearer you stand; another, the farther away'.[21]

Another fact which must have featured prominently in the debate about Titian is that many of his late works are in a state which could only have been regarded as unfinished by the standards of the contemporary painting practice (Fig. 19). The same applies to Rembrandt's later works (Figs. 20–22), and here too there was an antique source which endorsed a positive attitude to the unfinished. It is Pliny, who remarks that for various reasons the last unfinished works of famous Greek painters were more admired than their finished ones.[22] A story that Boschini had directly from one of Titian's last pupils, Jacopo Palma Giovane (1544–1628), undoubtedly did the rounds of the seventeenth-century Dutch workshops, namely how 'the most discerning connoisseurs' bought unfinished pictures which Titian had stacked face to the wall with the intention of continuing to work on them later.[23] According to Houbraken, Rembrandt was deliberately non-committal about whether a picture

19: Titian, *The Child with the Dogs*, c. 1570–76 (detail). Rotterdam, Museum Boymans-van Beuningen.

20: Rembrandt, *Family Group*, c. 1665 (detail). Braunschweig, Herzog Anton Ulrich-Museum.

21: Rembrandt, *Woman bathing in a Stream*, 1654
(detail). London, National Gallery.
See Cat. No. 40.

22: Rembrandt, *Jacob blessing the Sons of Joseph*
(detail), 1656. Kassel, Schloss Wilhelmshöhe.

was finished or not, and allowed no one else to decide when a painting was ready. Houbraken relates that he had seen paintings by Rembrandt 'in which some parts were worked up in great detail, while the remainder was smeared as if by a coarse tar-brush, without consideration for the drawing'. Moreover, Houbraken continues, now apparently quoting his informants, 'he was not to be dissuaded from this practice, saying in justification that a work is finished when the master has achieved his intention in it.'[24] This story is corroborated by many of the late pictures, which bear a signature indicating that Rembrandt considered them finished (Figs. 21, 22).

One of the most noteworthy statements in Vasari's life of Titian, and possibly the most important one for an understanding of Rembrandt's career, is the remark that behind the apparently effortless 'pittura della macchia' (painting with splotches) lay a vast store of knowledge and experience. Vasari accordingly warned young artists not to attempt this technique, stressing (in a passage which Van Mander again translated almost literally)[25] that an artist should begin with a painstaking and fine technique and only adopt the rough manner later in life.[26] Surveying Rembrandt's career, it is as if he took this advice very much to heart (Figs. 15, 16).

The idea that an artist of Rembrandt's stature modelled his artistic biography, so to speak, on Titian's seems highly suspect, not to say blasphemous. The possibility of entertaining such a notion was suggested to me by the brilliant essay by Gridley McKim-Smith on the relationship between painting technique and art theory in the Spain of Velázquez.[27] Working from a series of contemporary Spanish texts she demonstrates how compellingly the example of Venetian painting, and of Titian in particular, influenced the theory and practice of art in Spain. Seventeenth-century Spanish writings on art are possibly even richer in content than the Dutch, although both have more or less the same tenor. Since the sixteenth century, Dutch and Spanish artists and writers had come into contact, either directly or indirectly, with the antique sources and Italian art theory and workshop culture. Italy was the self-evident touchstone for every European painter and connoisseur.[28]

McKim-Smith highlights a phenomenon which may have made Titian normative for painters like Velázquez and, it seems to me, for Rembrandt as well, and that is his liberal use of the *repentir*, or alteration made while painting. Nowadays we tend to regard the *repentir* as the record of a highly individual process, by which the artist revises and improves as he searches for the perfect form, as if

regretting his earlier solution. The terms *repentir* and *pentimento* are in fact derived from words meaning 'repentance', and in Germany they even spoke of the *Reuezug* or 'stroke of repentance'. There are at least a few *pentimenti* in any painter's œuvre. Titian, though, made countless modifications to his work, and evidently did so without feeling the slightest bit contrite, for traces of the rejected passages are often still visible, and in many cases must have been so in his own day as well. It is odd to think that such an individual aspect of the painting process should have acquired a certain normative status. The *pentimento* is an almost inevitable side-effect of a method whereby Titian tried 'to imitate life and nature . . . as closely as possible by variegating cool and warm tones just as one sees them in real life, . . . because he was firmly convinced that the proper and best procedure was to work with paint alone, without making any drawn studies on paper'. This approach, as we know, was directly at variance with the equally normative Florentine and Roman view that the drawing and the preparatory study, the *disegno*, were central to the art of painting. In the binary mode of thought that applied in the Renaissance, that is to say a system governed by polarities, the opposite of the fundamental principle of *disegno* was *colorito*, of which Titian was the first and most important exponent. In this he was later followed by painters like Rubens in Flanders and Rembrandt in the northern Netherlands.[29]

Rembrandt, too, rarely prepared his paintings with the aid of drawings. The few sheets that can be directly associated with finished pictures quite often turn out on closer inspection to have been executed during the painting process, when he was contemplating a radical change to a composition.[30] As a rule he began by working with paint and brush directly on the panel or canvas (see also the essay 'The invisible Rembrandt: the results of technical and scientific Examination', pp. 90–105). Karel van Mander explains in *Den grondt der edel vry schilder-const* that one consequence of this procedure is that many improvements are made while working, and concludes (significantly, in this context): 'So [those] who are fertile in invention do as the bold do, improving a fault here and there'.[31] Van Mander's treatment of revision and improvement as part of the painting process is a sign that the *pentimento* had already become a theoretical concept by the sixteenth century.[32] The fact that he said that only daring painters could permit themselves such licence with *pentimenti* must have encouraged an ambitious artist like Rembrandt to 'improve' uninhibitedly while he was 'inventing', and even

to allow traces of his revisions to remain visible, as Titian and Velázquez did.

In a sense the *pentimento* was a manifestation of the artist's freedom and power over his own creations. This is illustrated by Houbraken's statement that Rembrandt was self-willed, and that he took his right of sole decision to such lengths that 'he is said to have tanned over [overpainted with a brown pigment] a beautiful Cleopatra in order to give full effect to a single pearl'.[33] Such an apparently exaggerated statement is borne out time and again by x-ray investigation of the 'hidden Rembrandt'. In his very last self-portrait, for example, executed in 1669 and now in London, a comparison of the picture with its x-radiograph (Figs. 23, 24) reveals just what must have happened to Cleopatra: more and more of the elements that would catch the lights and draw the eye were painted out, toned down or altered in order to bring out the 'force' of just one part of the painting—in this case the face with the steady gaze. Once again one seems to detect an echo of Vasari on Titian, who 'constantly returned to a picture and went over it again so often that the meticulousness became apparent: an extremely judicious, fine and astonishing manner, which makes his paintings look very lifelike, being executed with great artistry, while the effort that has been expended on them remains hidden'.[34]

Rembrandt's special interest in Titian is evidenced by the fact that in his large collection of prints after earlier masters he had a 'very large book with almost all the works of Titian', which undoubtedly means prints by and after the Italian master. Naturally, Rembrandt had also seen paintings by Titian, and had borrowed motifs from them,[35] but as I have argued above (persuasively, I hope), it could well have been the Titian legend that had the strongest impact on him.

This was an age when people were far more open in modelling themselves on great predecessors, whom they took as their yardsticks. *Aemulatio* was the key-word. Rivalry, though, is only possible when one is armed with the same weapons, and there was the rub: how to outshine an artist whom one considered perfect? The problem of finding a way around that dilemma must have exercised many a mind, and McKim-Smith cites an early example of a text describing one way around the problem. It is a letter to Philip II of Spain in which Titian is quoted as saying that even if he succeeded in approaching the art of Michelangelo, Raphael, Correggio and Parmigianino 'I would be considered less than they, or considered their imitator,' and that he

had therefore adopted a style of 'broad brush-strokes, almost like careless splotches'.[36] Houbraken says that Rembrandt took the same way out of this dilemma, and also gives the classical source which provided the prototype for this attitude and stratagem. Tacitus tells us that Tiberius had supposedly said 'that he avoided anything that would give the people cause to compare him with Augustus, whose memory, he saw, was pleasing to all'. Houbraken thus concludes that Rembrandt chose his 'approach to art' with the object of avoiding comparison with the work of 'famous Italians and others of high repute'.[37]

Leaving aside the question of whether Houbraken was right to apply this commonplace to Rembrandt, it is important to note the existence of this dilemma concerning *aemulatio*, and to realise that Rembrandt too could have needed to find a way out of it. If there is one aspect of his painted œuvre in which he differs radically from all other painters, Titian included, it is what was described at the beginning of this essay in connection with *The Jewish Bride*—the manner characterised by Gerard de Lairesse as 'daubing', in other words the remarkable differentiation in the handling of paint (Figs. 18–20). The background to this aspect of his technique will be examined in the following two sections.

23: Rembrandt, *Self-Portrait*, 1669.
London, National Gallery.

24: X-radiograph of the 1669 *Self-Portrait*
(Fig. 23).

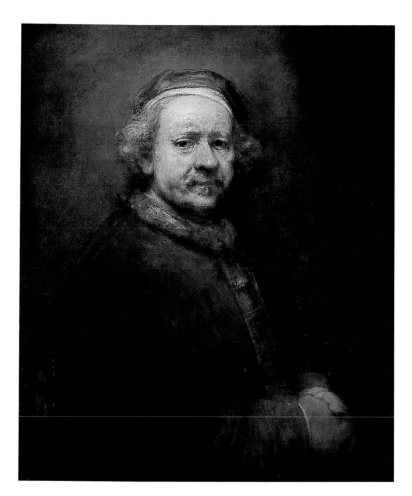

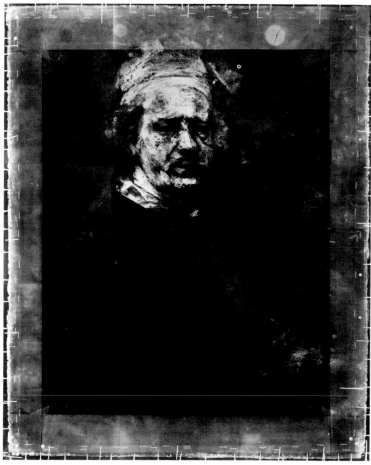

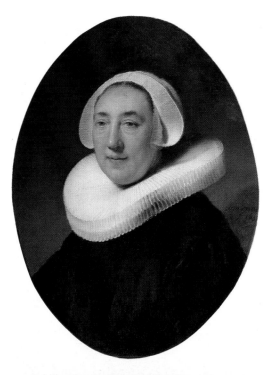

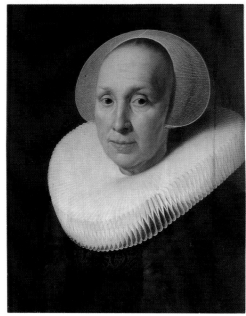

II: *Traditional formulae and experimental developments*

By definition, illusionism in painting conceals the means used to create the illusion. For a successful illusion focuses one's attention first and foremost on the objects or materials depicted, on the suggested spatial or atmospheric setting. It is only after close and painstaking study of the paint surface that one gains an understanding of the pictorial means used to achieve this form of visual deception: the painting. To date there has been no really searching study of such pictorial elements, apart from the investigation of perspective methods. One has to agree with Gombrich, and say that the historiography of art has barely made a start on this essential question—perhaps the most important one as regards workshop practice of the period.[38]

In part this may be due to the fact that illusionism is now out of favour with both artists and critics. Today one would only hear an innocent child say that a picture looked 'absolutely real', whereas that was precisely the sort of compliment the seventeenth-century connoisseur was advised to pay an artist.[39] Another possible reason why the historiography of illusionism is only in its infancy is that it is implicitly assumed that each convincing representation of reality is a newly minted, autonomous effort by the artist, or as Gombrich puts it, perhaps art historians have 'overrated the explanatory force of a phrase such as "the meticulous observation of nature."'[40] Nor does the saying: 'With the patience of a saint and the industry of an ant', referring to the meticulous work involved in creating the illusion, tell us anything about how it was actually done.

In the teeming confusion of the everyday world artists have had to search for hundreds of years for those particular elements that contribute most to a convincing illusion of reality. When one relates the history of that process one is in fact describing a series of discoveries that have been prised from the medium of painting and from reality itself. Gombrich has given a valuable impetus to this form of historiography, not only in *Art and Illusion* but also in his essay 'Light, Form and Texture in fifteenth-century Painting'.[41]

The news of every discovery, small or large, which could lead to an even more convincing representation of reality would have spread swiftly, with the result that this kind of innovation rapidly became part of the repertoire of painterly tricks that every artist had to have at his fingertips. That applied to every aspect of reality, including the face of a person of whom a faithful portrait had to be made. Even such an apparently unique task had first to be reduced to the complex of constituent elements involved in creating an illusion of reality. It was only then that the features specific to an individual could be 'projected' into this programme. 'Making comes before matching' is the condensed formula devised by Gombrich for this process.[42]

When he painted his portraits Rembrandt also had at his disposal this stock-in-trade of codified discoveries made by his predecessors, as did every other artist, in Amsterdam or anywhere in Europe. One only begins to understand just how rich this repertoire was when a particular formula is detected in a series of comparable paintings and is then analysed as to its function in contributing to the illusion. This can be demonstrated by confronting a portrait taken at random from Rembrandt's early period (Figs. 25, 27–29) with one by a contemporary (Figs. 26, 30–32; attributed to Nicolaes Eliasz. Pickenoy). Comparing the two pictures detail by detail one realises, for example, how important it must have been to discover that a lit form can throw reflected light into the shaded zone of another form. In these two paintings a white ruff casts its light onto the shadowed cheek and the underside of the nose, and that reflection in turn makes the colour of the skin in the lower half of the face cooler in tone than that in the upper half. It is also clear that both artists knew that an illuminated eyelid reflects light into the dark part of the eye socket beside the root of the nose (Figs. 27, 30), and that it is not only the eyeball that has a catchlight but the fluid rimming the lower eyelid and the moist, pink inner corner of the eye as well (Figs. 28, 31). Other effects which both artists had in their armoury include the appearance of a diffuse shadow cast by the eyeball, overlain by the upper eyelid with its barely discernible lashes, onto the skin beside it; the cast shadow under the nose beginning with a sharp outline and ending blurred; the use of a little red at the nostril on the side of the nose turned to the light, so as to suggest the translucency of the nostril; and light paint on the upper lip brushed in the direction of the light (Figs. 29, 32). Such formulae are rarely found in the written sources, so usually they can only be extrapolated from the pictures after intensive comparison.

The confrontation of the two paintings illustrated here also, of course, offers the opportunity of identifying the specific features that characterise Rembrandt's style. Where Pickenoy pays close attention to each detail, modelling clearly and sharply (and at first sight far more convincingly), Rembrandt uses the brush more loosely and fleetingly, and avoids sharpness in his contours and inner drawing. One only has to look

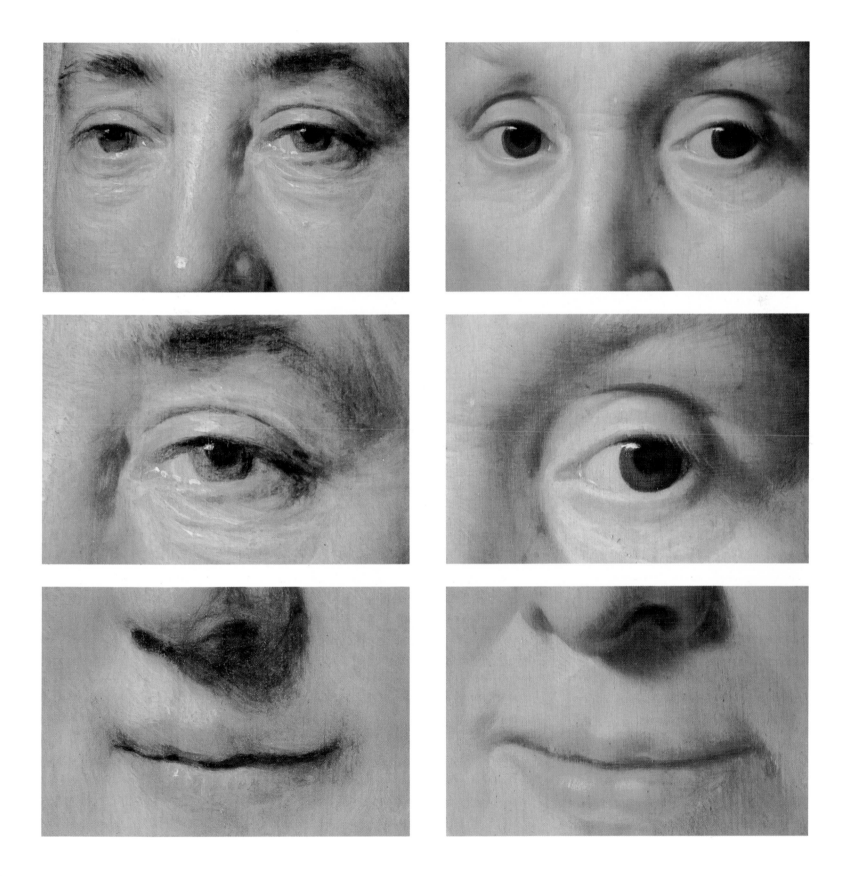

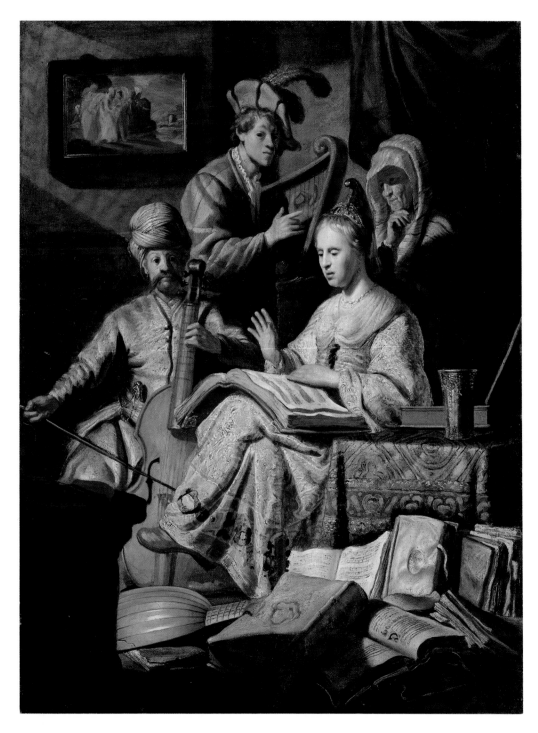

33: Rembrandt, *Musical Company*, 1626.
Amsterdam, Rijksmuseum.

at the catchlights in the eye and the errant gleams on the slightly greasy skin under the eye and on the lower lip to see how, notwithstanding the formulaic use of illusionistic devices, the emphasis in his work is on the casualness, the almost chance nature of such effects. Alongside the monumentally moulded, frozen forms of Pickenoy, Rembrandt's figure appears to live. It is as if she is on the very point of changing her expression or blinking. Conveying such a lifelike image, however, could only be done on the basis of that extremely detailed programme of illusionistic tricks.

There was a similar body of knowledge for the depiction of other objects and materials. For instance, an artist had to know that when painting velvet the highest light had to be placed near the contour of the material if it was to really look like velvet, or that pewter had to be painted slightly bluer than silver, or that the reflection of a dark shape in water should not be as dark as the shape itself, and so on.[43]

In order to assess the experiments conducted by Jan Lievens and Rembrandt in this sphere in their proper context it is important to remember that in the late middle ages certain textural effects were achieved by imitating the structure of the surface of the material to be depicted. For brocade, for instance, a relief pressed into tinfoil (the so-called *Pressbrokat*) was glued to the picture, or to a sculpture to be polychromed, and then painted. In his famous manual the fifteenth-century Florentine artist Cennino Cennini advises anyone who wanted to suggest a woollen material to roughen up the surface of the support at that point before painting it.[44] This sort of expedient was abandoned after the major innovations in the rendering of materials that began to be introduced in the southern Netherlands in the fifteenth century. From then on artists were expected to depict materials convincingly by means of an apt replication and gradation of colour, and of light and dark, thus suggesting light and shadow, gleam and reflection, but without modifying the consistency of the paint. This method is what De Lairesse called 'the Art' ('de Konst').

When one examines Rembrandt's paintings it immediately becomes clear that the surface structure has regained its importance as a means of suggesting textures. It is my belief that the young artists, Lievens and Rembrandt, experimented with these effects, and that the surface relief of Rembrandt's late works is to be comprehended not only in terms of the rough manner discussed in the previous section, but that there is also a connection with these early experiments in the imitation of texture.

A picture displaying a wealth of such surface effects is the *Musical Company* of 1626 in the Rijksmuseum in Amsterdam (Figs. 33–35). To realise just how carefully the actual substance of the paint was manipulated to enhance textures one only has to compare the gleaming leather of the red shoe—suggested by wiping thin, whitish paint into a transparent red which was not quite dry—with the gold brocade hem of the skirt lying over the shoe, which is executed with ridges of yellow and white paint on a impastoed yellow under-layer (Fig. 34); or the silkily brushed gleam on the very smoothly painted lute with the grooved surface of the paint applied in a single stroke to indicate the individual edges of the pages of the book it is lying on (Fig. 35).

The initiative for this enrichment of the stock of devices available for textural representation may very well have come from Jan Lievens (Fig. 36). In the diary kept by Constantijn Huygens (the secretary of the Stadtholder, Prince Frederik Hendrik), who got to know the two young painters in 1628, the 'beardless youths' emerge as two extremely ambitious adolescents convinced of their own self-importance.[45] This was particularly true of Jan Lievens, who, as we learn from the life of him written by his fellow-townsman Jan Orlers, was already being fêted as a prodigy at the age of 12.[46]

That the two young men deliberately set out to be innovators becomes clear when one compares their early work with that of their teacher, Pieter Lastman (Figs. 37, 38). Despite all the stylistic similarities to his work, the most striking contrast is the degree of differentiation in the consistency of the paint used for rendering materials and lighting. Lastman applied his paint far more uniformly than did his two pupils from Leiden.

As regards reinforcing the effect of light, it must have been discovered some time earlier that this is done by applying light-coloured paint thickly and with an uneven relief. Paintings are generally hung and viewed in such a way that the paint surface does not shine, in other words that the light impinging on them does not bounce back into the viewer's eyes. On the sloping 'walls' of the relief of an impasto passage, however, the light always reflects into the eye to a certain extent, considerably enhancing the brilliance of that passage. This effect is found, for example, in the depiction of the glowing end of a burning torch in paintings by Gerrit van Honthorst. Lievens had undoubtedly seen paintings of this kind, as shown by his own very early pictures of boys with torches and glowing coals, and it seems that he and Rembrandt developed this idea.

34 and 35: Details of Fig. 33.

36: Jan Lievens, *Esther and Ahasuerus*, c. 1625 (detail). Raleigh, North Carolina Museum of Art. See Cat. No. 52.

37: Pieter Lastman, *Balaam and the Ass* (detail).
New York, with Richard Feigen.

38: Rembrandt, *Balaam and the Ass*.
Paris, Musée Cognacq Jay.

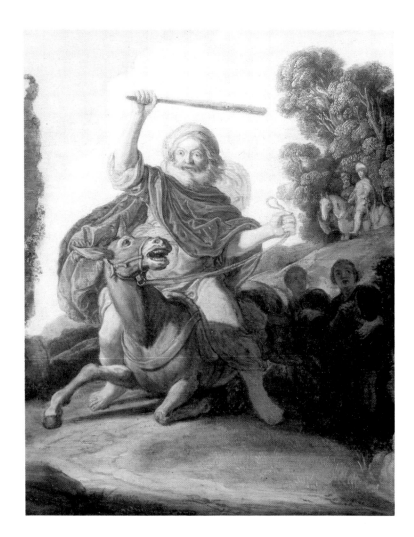

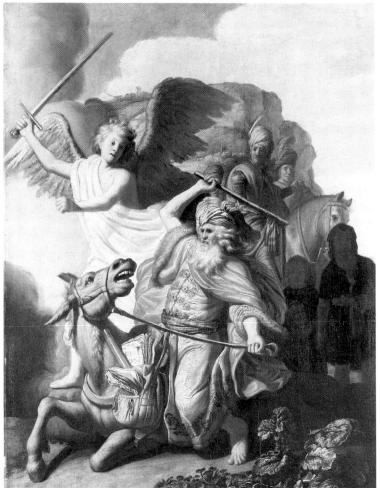

That it was probably Lievens who took the lead in this adventurous journey of discovery can be deduced not only from the fact that he was evidently the more precocious of the two, having set up as an independent master earlier than Rembrandt, despite being a year younger, but there is also a seventeenth-century source which can perhaps be read in this light. It is a statement in the *Inleyding tot de hooge schoole der schilderkonst* by Samuel van Hoogstraten, who could have come by this piece of information while he was a pupil in Rembrandt's studio: 'Jan Lievens was expert in seeking wonders in the mixed ["*aengesmeerde*"] pigments, varnishes and oils'.[47] It seems, then, that Lievens took a particular interest in experimenting with binding media—the drying oils with which the dry pigment powder is ground to form a malleable paste. An interesting indication that Hoogstraten may have been recording a historical fact is provided by a studio scene drawn by Rembrandt around 1630 (Fig. 39) in which the artist clearly has Lievens's features.[48] What makes this workshop so remarkable is the large grinding-stone right beside the easel, which suggests that the artist ground his own colours while he was working. Could this be taken to mean that Lievens gave particular attention to the preparation of his paints? One gets the impression from the many seventeenth-century scenes of artist's studios that the paint was usually ground by apprentices or journeymen. Of course, one has to be careful of interpreting studio scenes, even when they are drawings, as literal snapshots of reality; they are always syntheses of a number of meaningful elements. But that is precisely what makes the position of the huge, hollowed-out grinding-stone beside Lievens's easel so interesting. The fact that a similar stone is given a prominent place in Rembrandt's earliest studio scene, now in Boston (Fig. 40; Cat. No. 3), with several bottles on a table to the left of it, could also be a pointer to a special interest in the preparation of paints in the circle around Rembrandt and Lievens. This concern is further documented by Joachim Sandrart, the German artist and biographer, who states that Gerard Dou, whose studio he visited around 1640 and who had been a Rembrandt pupil for some years from 1628, ground his own colours,[49] implying that it was unusual for a master to do so. Dou's intention, according to Sandrart, was to get the purest colours possible, but Rembrandt and Lievens must have manipulated the consistency and malleability of their paint on their grinding-stones in order to give the various passages in their pictures a *peinture* and surface structure that matched the nature of the material depicted.

39: Rembrandt, *Jan Lievens in the Workshop*, c. 1630, pen and brown ink. Malibu, The J.P. Getty Museum.

40: Rembrandt, *The Artist in his Studio*, 1629 See Cat. No. 3.

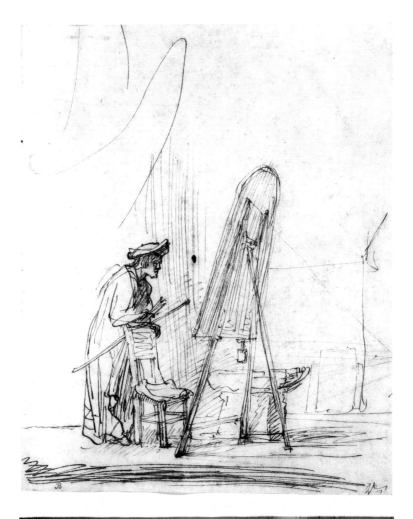

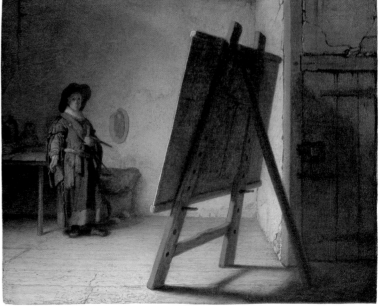

41: Rembrandt, *St Paul at his Writing-Desk*,
1629–30 (detail). See Cat. No. 4

42: Jan Lievens, *Job* 1632 (detail).
Ottawa, National Gallery.

It was not long, though, before they graduated from this rather naive manner. Around 1629, when their palettes began taking on a more monochrome cast, they employed the paint relief less descriptively, although it is still highly differentiated (Figs. 41, 42). Its main purpose now was to help 'trap' the light on the paint surface, as it were, and this, as I shall argue below, heightened the spatial and atmospheric effect. In many respects the pictures from that year recall the way the paint is applied in such late works as *The Jewish Bride* and the Braunschweig *Family Group*, for example (Figs. 1, 20). However, a comparison of details from the *Jeremiah* of 1630 (Cat. No. 8; Figs. 48, 49) and the *Staalmeesters* of 1661 (Cat. No. 48; Figs. 50–53) shows that even after 1629 Rembrandt continued using this differentiated handling of paint to produce textural effects. The fundamental difference between this and other approaches to painting can best be illustrated by taking another detail from the *Staalmeesters* and contrasting it with a similar motif from a picture of the same period by Ferdinand Bol, a pupil of Rembrandt who had by then completely shaken off his master's influence (Figs. 54, 55).

Whereas even Jan Lievens, the probable instigator of this innovation by the two young Leiden artists, also changed course in later years and largely abandoned paint plasticity for surface effects, Rembrandt never did. On the contrary, he used it with a versatility unparalleled in seventeenth-century painting.

Leaving aside Hoogstraten's remark about Lievens, the idea that this manner required specially prepared paints did not re-emerge until the nineteenth century. Baldinucci, in 1686, suggested that the reason why Rembrandt's paint surface had such an unusual relief was that he worked very slowly and went over certain passages time and again, making them thicker and thicker. Houbraken, on the other hand, put it down to Rembrandt's supposedly rapid way of working, slapping his paint on with a trowel.[50] It was only later that people began wondering whether the paint might not have been mixed with additives which affected its composition, such as resin, wax and albuminous substances.[51] These suspicions could only be put to the test by imitating Rembrandtesque effects and experimenting with different additives. Max Doerner, who was particularly influential in Germany, also based his findings on reconstruction experiments. His ideas on Rembrandt's supposed use of resinous media in transparent glazes have since been proved incorrect by tests carried out in the Scientific Department of the National Gallery in

London.[52] It is only now that analytical techniques have become so sophisticated that the problem of Rembrandt's binding medium can be tackled scientifically rather than empirically. The London researchers focused primarily on the organic constituents of the medium, the oils that could have been used, and possible organic additives like resins, waxes or albuminous materials. Not one of the admixtures proposed in earlier hypotheses was found, and the only organic materials detected were linseed oil, and occasionally walnut oil. These are extremely important findings, although they do not completely resolve the question of Rembrandt's paint medium, for leaving aside the organic materials it is possible that inorganic compounds could have been added to modify the consistency of the paint. These substances are more difficult to detect, since most of the pigments with which the medium is very intimately mixed are composed of inorganic matter, and since the latter is not pure it is possible to isolate numerous inorganic substances in paint samples which are not necessarily directly associated with the preparation of the medium. Nevertheless, advances are also being made on this front. Agents which must have been added primarily to speed the drying process, such as lead compounds and ground glass, have now been found.[53] The scientific examination of the factors affecting the differentiation in the consistency of Rembrandt's paint is still in its infancy. Time will tell whether, in a chemical sense, there are 'wonders' to be found in Rembrandt's 'mixed pigments, varnishes and oils', but optically that is certainly the case.

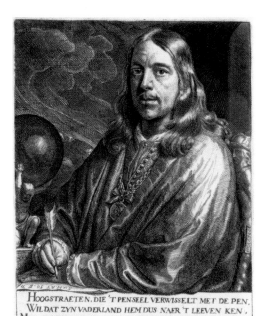

43: Samuel van Hoogstraten, *Self-Portrait*, etching from his book, *Inleyding tot de hooge schoole der schilderkonst* (1678).

HOOGSTRAETEN, DIE 'T PENSEEL VERWISSELT MET DE PEN.
WIL DAT ZYN VADERLAND HEM DUS NAER 'T LEEVEN KEN,
MIN IN ZYN BEELD, DAN KONST OP LOUTRE REEDENS GRONDEN,
GEROEMT IN CESARS-HOF TE ROOME, EN BINNEN LONDEN.
J. Oudaan.

III: *Paint Surface and the Evocation of Space*

We have not yet exhausted the avenues for examining Rembrandt's ideas on a painting technique that produced such an unusual paint surface. A roundabout attempt had to be made in the preceding sections to reconstruct some of the concepts which might have formed the basis for this method of painting, but it turns out that there is one source, and a remarkably explicit one at that, which introduces several important new factors into the discussion. They are found in the book by Rembrandt's pupil Samuel van Hoogstraten, the *Inleyding tot de hooge schoole der schilderkonst*, which was published in 1678, some thirty years after he had left Rembrandt's studio.[54]

It is strange that seventeenth-century theories on perception have been neglected in Rembrandt research to date, despite the fact that Hoogstraten lays such emphasis on them in the passages discussed below. In fact, he even provides a key to a new way of looking at certain features of a picture like the *Nightwatch* (Fig. 58).

Hoogstraten has always been regarded with suspicion as a possible source of information on Rembrandt's ideas about painting, for he was one of the pupils who in a sense 'betrayed' his master by abandoning the manner he had learned in his studio, embracing instead the smooth, idealising style which dominated Dutch art in the latter half of the seventeenth century. To make matters worse, Hoogstraten had committed the unforgivable sin of criticising Rembrandt. Moreover, it had struck scholars of seventeenth-century texts that he relied heavily on previous authors, among them Karel van Mander and Franciscus Junius.[55] From the latter he borrowed the uninterrupted stream of references to painters and writers of classical antiquity which makes his book such hard going (and, at first sight, incompatible with Rembrandt's approach to art). He does, however, put forward a number of ideas on the theory and practice of painting which shed a light on some of the views which Rembrandt must have held and which are only fragmentarily reflected in the Rembrandt literature.

Samuel van Hoogstraten (Fig. 43) trained with Rembrandt in the early 1640s, when the *Nightwatch* was being completed. That picture is referred to several times in Hoogstraten's chapter on composition, and since the nineteenth century this has served as an important (albeit partly misunderstood) document on the contemporary reaction to Rembrandt's largest group portrait.[56]

The reason why Hoogstraten's remarks on human perception as it relates to painting have been ignored in the art-historical literature is probably because they incorporate ideas which hold not the slightest appeal within the conceptual framework we have constructed around the phenomenon of 'style'. The categories in which style has been viewed since the rise of stylistics mainly relate to the polarities set out by Heinrich Wölfflin in his *Principles of Art History:* the linear and the painterly, plan and recession, the closed and the open form, multiplicity and unity, and absolute and relative clarity.[57] These features, which Wölfflin discusses as abstract pictorial categories, can be appreciated without reference to any depiction of reality.[58]

There is no such stylistic vocabulary to be found in the seventeenth-century sources. To take an example which is relevant in this context, when dealing with the concepts of 'plane and recession' Wölfflin swiftly passes over the pictorial devices which contribute to a convincing illusion of space in favour of categories like 'planes', 'masses', 'directions', 'contrasts', 'diagonals', 'parallels' and so on. These are abstract representational constructs which differ fundamentally from the means of achieving spatial illusion discussed by Hoogstraten in his chapter 'On advancing, withdrawing and shortening'.[59]

Hoogstraten based his reflections on the notion current in his day (and indeed since antiquity) that light passages in a picture tend to advance towards the viewer while darker tones recede. Gombrich gives a lucid account of the discovery of this phenomenon in his essay 'The Heritage of Apelles',[60] and according to him it is likely that the legendary Greek artist Apelles was the first to apply it in painting. Now what is so striking about Hoogstraten's text is that he denies the validity of this principle. The arguments he uses, and their pictorial consequences, will be dealt with later.

According to him there is another element which is far more important for the effect of three-dimensionality, and in discussing it he employs the concept of 'perceptibility' ('*kenlijkheyt*'), which he refers to in connection with a coarse surface. He illustrates this by pointing out that if one goes outdoors and renders a blue sky with clouds on a piece of blue paper one never loses the impression that the paper is very close to the eye, whereas the blue sky itself is infinitely distant. He explains this phenomenon by observing that 'your piece of paper, however smooth it may appear, nevertheless has a certain perceptible roughness, into which the eye can stare, wheresoever you choose, which is not possible in the even blue of the heavens'. What Hoogstraten presumably means is that the coarse surface of the paper gives the eye something to fasten on to and on

which it can focus, making it appear substantial, perceptible, and thus close at hand, whereas the blue sky lacks this optical 'anchorage'. This piece of information provides the key to the following statement, which is crucial for an understanding of Rembrandt's technique. 'I therefore maintain that *perceptibility* ["*kenlijkheyt*"] alone makes objects appear close at hand, and conversely that *smoothness* makes them withdraw, and I therefore desire that that which is to appear in the foreground be painted roughly and briskly, and that that which is to recede be painted the more neatly and purely the further back it lies. Neither any one colour or another will make your work seem to advance or recede, but the *perceptibility* or *imperceptibility* of the parts alone.' Interestingly, Hoogstraten did not apply this proposition, which he advances with great emphasis, in his own paintings from the period when he wrote these words; they are smoothly executed, in both foreground and background. His master Rembrandt, however, supplies the most consistent demonstration of this manner of suggesting space, particularly in the *Nightwatch*—the picture that Hoogstraten knew so well. The emphatically rough brushwork in the foreground (not just in Ruytenburgh's dress [Figs. 44, 45, 46] but also in the drum on the right and in Banning Cocq's collar and hand), and the gradual levelling of the paint towards the background, form the clearest possible illustration of this method of spatial suggestion.

That Hoogstraten did not follow his own advice in his own later work is because by then he must have been subject to the norms of what De Lairesse called 'Art', and by those lights 'daubing', or the use of different thicknesses of paint, was outmoded. It is not surprising, then, that at the very end of his discourse Hoogstraten comes up with quite another view of spatial suggestion. He notes that plasticity and spatiality ('*ronding*' and '*uitheffing*', literally: rounding and raising) have to be achieved 'by a careful observation of lights and shadows' in pictures which are 'evenly and smoothly' executed, and in such a way that even artists are deceived and cannot believe that it is mere paint 'until touch assures them that it is so'. Illusionism, in other words (Hoogstraten, the *trompe l'oeil* painter calls it 'deception'), in which the consistency of the paint must be absolutely smooth, never rough, with the precise representation of lights and shadows alone serving to create the illusion of three-dimensionality. And this brings us back to the broad waters of illusionism using the 'even' brushstroke that began with the revolution of Jan van Eyck.

At this point it is worth returning to Hoogstraten's reflections on the 'heritage of Apelles'. Here too we shall see that his ideas are most clearly demonstrated in Rembrandt's paintings, and in the *Nightwatch* in particular. Once again his apprenticeship with Rembrandt seems to have left its traces in his treatise. He calls it a 'blindness [which] has been profound to this day' that painters worked on the principle that light passages advance and dark recede.

He begins by describing what sounds like an experiment in perception theory, namely the effect produced by adjoining strokes of black and white paint on a flat panel. Although they lie in the same plane, Hoogstraten writes, 'the white will nevertheless appear closer and the black further off'. It is for this reason that 'the deep hollow of [. . .] a pit [. . .] or a channel' should be painted with dark colours. Quoting from Franciscus Junius's *De pictura veterum*, which appeared in a Dutch translation in 1641, he continues that 'a girl's breasts or an outstretched hand' are usually given 'a distinct shadow' on either side in order to make them stand out.

Having said this, Hoogstraten then begins putting forward arguments from which it emerges that the opposite is also possible. He argues that the sun, although bright, is not experienced as being near at hand, and points out that a hollow looks even deeper when it 'receives some light in its actual depth'. He goes on to maintain that darker forms can also advance by referring to the phenomenon, noted back in classical times by Philostratus,[61] that dark fish which are closer to the surface of a transparent body of water appear darker than those swimming nearer the bottom. No matter how far-fetched the arguments may appear at first sight, this represented a direct challenge to traditional ideas on pictorial three-dimensionality. Hoogstraten naturally grants that many artists inserted 'heavily shaded figures in the foremost corners' of their paintings, 'flooding the middle-ground with a light'. The sense of space conjured up by a dark repoussoir, generally in the form of a shadowed coulisse ('in the foremost corners'), had been discovered back in the sixteenth century, but it is as if Hoogstraten wants to go further in contesting traditional thinking on the behaviour of light and shadowed passages in painting. It is not just the shaded repoussoir that is an exception to this rule.

If one looks at the *Nightwatch* in this light (Fig. 58), it does indeed appear to be a practical demonstration of Hoogstraten's theories, and such a literal one as to prompt the thought that it was Rembrandt himself who challenged the correctness of the 'heritage of Apelles', and that

Hoogstraten is merely echoing his master's ideas. For the fully illuminated Banning Cocq wears a jet-black costume and is a dark element in the composition, yet he does not 'yield ground' to the radiant figure of Ruytenburgh. The equally luminous yellow girl, on the other hand, does 'withdraw' into the hollow between the guards-men. Banning Cocq's outstretched hand is not flanked by darker tones, but on the contrary by his brightly lit, white cuff. Likewise, the dark tip of Ruytenburgh's partisan, which is in a fully illuminated zone and was felt by Rembrandt's contemporaries to be startlingly three-dimensional, is surrounded by the much lighter shade of Ruytenburgh's trousers.

There is another important observation on the rendering of depth which Hoogstraten discusses in considerable detail, and in a sense it combines the two previous ideas. It concerns what Hoogstraten calls 'the thickness of the air' ('de dikte der lucht'), namely the presence of air between the viewer's eye and the objects beheld, which affects their appearance. It had long been known that a landscape takes on an increasingly lighter hue the further it recedes into the distance. This phenomenon, known as aerial perspective, was a firmly established artistic tenet by the fifteenth century. Leonardo's well-known *sfumato*, or slight blurring of contours, was associated with this realisation that air has a mellowing effect comparable to that of vapour or smoke (*fumo* in Italian, hence *sfumato*).

In speaking of the 'thickness of air' Hoogstraten dwells at length on the fact that more distant shadows are lighter in tone than those nearby (one recalls the example of the fish near the surface and the ones further down, which initially seemed rather far-fetched). Once one's attention has been drawn to this phenomenon one realises that Rembrandt used it as a way of enhancing the suggestion of distance between, say, the yellow Ruytenburgh and the little girl in the yellow dress in the *Nightwatch*; the shadows in the girl are definitely lighter (Fig. 58). What is particularly interesting, though, is Hoogstraten's remark that 'it appears that the light forms a body even over a short distance, and clothes itself in the colour of the heavens'. In other words, aerial perspective even produces tonal differences when the viewer is close to an object, separated only by shallow layers of air-filled space. The young Rembrandt had already applied this insight with great subtlety in his depiction of the heads of the group of surgeons in the *Anatomy Lesson of Dr Nicolaes Tulp* (Figs. 56, 57). It is only when one consciously notices these extremely refined modulations of light and tone that it becomes

44: Rembrandt, *The Nightwatch*, 1642 (detail).
Amsterdam, Rijksmuseum. See Fig. 58.

46: Rembrandt, *The Nightwatch*, 1642 (detail).
See Fig. 58.

48: Rembrandt, *Jeremiah lamenting the Destruction of
Jerusalem* (detail). Amsterdam, Rijksmuseum.
See Cat. No. 8.

45: Detail of Fig. 44.

47: Detail of Fig. 46.

49: Detail of Fig. 48.

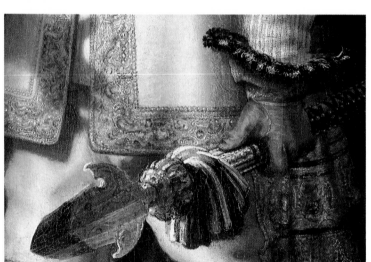

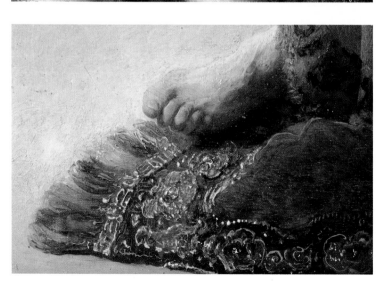

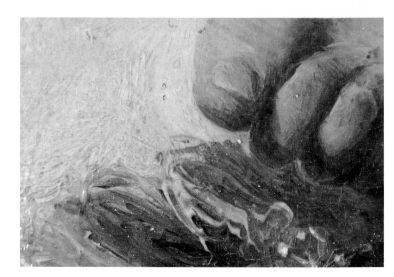

50: Rembrandt, *The Staalmeesters* (detail).
Amsterdam, Rijksmuseum. See Cat. No. 48.

51: Detail of Fig. 50.

52: Rembrandt, *The Staalmeesters* (detail).
Amsterdam, Rijksmuseum. See Cat. No. 48.

53: Detail of Fig. 52.

54: Detail of the rug on the table in
The Staalmeesters (Cat. No. 48).

55: Detail of the rug on the table in Ferdinand
Bol, *Six Regents and the Beadle of the Nieuwe Zijds
Institute for the Outdoor Relief of the Poor*, 1657.
Amsterdam, Rijksmuseum.

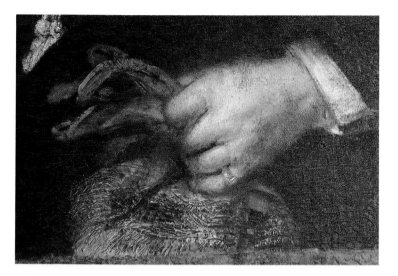

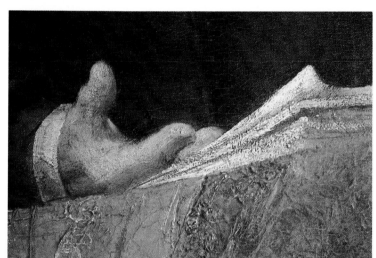

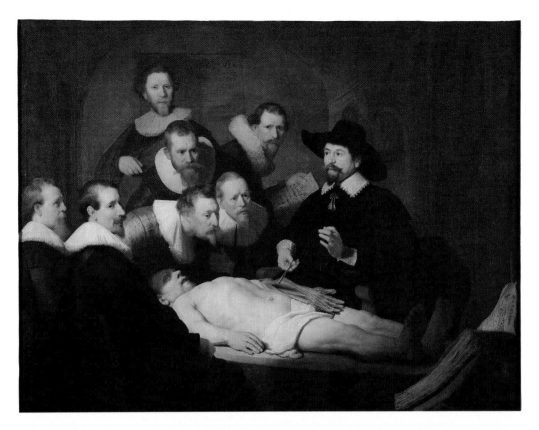

56: Rembrandt, *The anatomy Lesson of Dr Nicolaes Tulp*, 1632. The Hague, Mauritshuis.

57: Detail of Fig. 56.

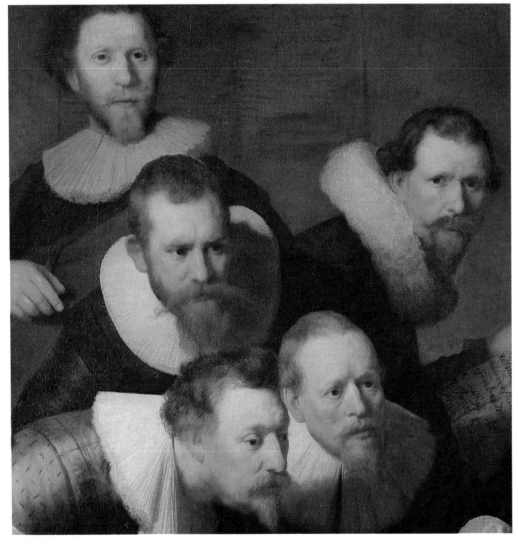

clear that this is one of the main reasons for the strikingly atmospheric effect of Rembrandt's paintings. One spectacular instance of his deployment of the fact that light also 'forms a body' over a short distance is the tassel on Ruytenburgh's partisan (the spear-like weapon in his left hand), for he starts using a lighter blue beyond the point where the blue-and-white fringe of cords is bound together (Figs. 46, 47). It is also clearly noticeable that over this distance of a few centimetres the paint surface is already starting to become smoother. So this passage in the *Nightwatch*, which according to Baldinucci struck the citizens of Amsterdam with the utmost amazement and admiration, brings together three of the aspects of spatial representation discussed above: the use of a variable roughness of the paint surface, aerial perspective operating over a short distance, and the possibility of darker passages advancing further than lighter ones.

There is another aspect to the representation of space, and it is associated with the previous ones. It concerns the handling of contours, which are conspicuously coarse in Rembrandt's later work. As for the blurring of contours, he must have been faced with something of a dilemma. With Leonardo's *sfumato* method the paint could be 'dispersed' due to its relatively slow drying time, that is to say it could be blended wet-in-wet with the adjacent passage. De Lairesse speaks in this connection of 'a suitable and moist ground behind the figures, such that the outermost contour can disappear into it'.[62] However, this implies that the paint becomes smooth at that point, that it takes on the 'evenness' which, as Hoogstraten may have heard from Rembrandt's own lips, 'make objects recede'. It was for this reason that Rembrandt evolved that peculiar, rough *sfumato* which is done by dragging a brush loaded with stiff paint over the surface to produce a rough ('perceptible') but still evocative contour or tonal transition which plays an essential part in the spatial and atmospheric effect of the picture (Figs. 13, 14, 52, 53).

This later device, and much of what has been adduced in the previous two sections to explain Rembrandt's handling of paint, has a distinct overtone of 'effect' or 'trick' to our twentieth-century sensibilities. That impression would be correct if Rembrandt had used these methods calculatedly as a painter's sleight-of-hand. However, his work is also characterised by that 'boldness' mentioned at the beginning, that attitude which Vasari calls 'spirit, [allied to] a charming and vivacious style' when he quotes Michelangelo on Titian.[63] A place had been found for artists of this kind in the theory of art current throughout Europe in the seventeenth century, as is clear from the words of Gian Lorenzo Bernini, the most famous architect and sculptor of his day. During his stay in Paris in 1665 (at approximately the time when Rembrandt must have been working on the *Jewish Bride*) his conversations were noted down by his French host, Paul Fréart de Chantelou. Speaking of the Venetian followers of Titian—Tintoretto and Veronese—Bernini said that they 'and some other modern artists have succumbed to a free or wild manner of painting'.[64] Rembrandt can clearly be classed in this category, but as I trust I have shown above, 'freedom or wildness' does not automatically mean 'messing about' so that 'the colours run down the piece like mud'.

The object of this essay has been to penetrate the terminology and thinking of the seventeenth-century painter in an attempt to shed light on Rembrandt's theoretical concepts. It will have become apparent that it is very difficult to distinguish between new ideas attributable to Rembrandt himself and ideas for which the ground had been prepared, partly or wholly, in earlier times, often as far back as classical antiquity. What is needed is a sort of genealogy of all these ideas which would enable us to trace them back to their roots.

When, at the beginning of this essay, I likened the surface appearance of the *Jewish Bride* to the result of a geological process, I did so in an almost helpless attempt to record my impression of a structure which, however well planned, could only have been achieved with a strong element of chance. A passage in the discourse on art delivered by Sir Joshua Reynolds on 10 December 1784 may perhaps shed a surprising light on this aspect of Rembrandt's manner. It is of course of far too late a date to be directly applicable to this investigation, but who knows, perhaps this is another text with much older roots, as is so often the case with Reynolds. Here he deals with the role of chance in painting (and in direct connection with Rembrandt, at that), and ends with the words: 'Work produced in an accidental manner, will have the same free unrestrained air as the works of nature, whose particular combinations seem to depend upon accident'.[65] Perhaps here we have a last theoretical means of access to the peculiarities of Rembrandt's late manner.

Summary

Rembrandt's 'daubing', his richly differentiated use of paint, has been approached from three different angles in this essay. The first was in the context of the debate on the 'rough and smooth manners', which must have been a considerable

talking-point in seventeenth-century workshops. Factors that played a role here were viewing distance, degree of finish, apparent casualness, and the use of the *pentimento* as a side-effect of 'painterly painting'. Such notions can be associated with a blotchy or rough manner of painting, which was introduced by the immensely influential Titian. However, they fail to provide a satisfactory explanation for Rembrandt's use of surface relief and for the differentiation in the consistency of his paint. It turned out that there were two avenues for deducing the reasoning behind this aspect of his method: the young Rembrandt and his friend Jan Lievens abandoned the method of rendering textures which they had learned from their teacher, Pieter Lastman, and in effect went back to medieval procedures, manipulating the surface of the picture to produce a mimetic representation of the materials depicted. In Rembrandt's œuvre one finds traces of this approach persisting right up until the end of his career. In addition, though, the rough paint structure also played an important part in creating spatial effects, and this also accounts for the rough contour—Rembrandt's own variant of Leonardo's *sfumato*.

The phenomena discussed here have always been seen as highly individual aspects of Rembrandt's art, the fruits of his own pictorial temperament. Their rationalisation, as done in this essay, is a little sobering. By connecting Rembrandt's manner with certain seventeenth-century ideas, however, at most our angle of view is shifted a little. This does not need to affect our admiration for his work, but in this way it may be brought more into line with Rembrandt's own artistic intentions.

This essay was written with the support of the Netherlands Organisation for Scientific Research (NWO), and is part of the work being carried out by the Rembrandt Research Project, which is financed by NWO. I am particularly grateful to Karin van Nes for her secretarial assistance, and to Ernst Klusman and René Gerritsen, who took the detail photographs. My thanks also go to Rudolf Evenhuis and the students in my seminar group on the rendering of texture in seventeenth-century painting at the Art History Institute of the University of Amsterdam. I drew great inspiration from the work of Gridley McKim-Smith (see note 27) and Ernst Gombrich (notes 21, 38, 40). I am indebted to the following for their valuable comments and suggestions during the writing of this essay: J. Bruyn, B. Haak, P.J.J. van Thiel, M. Franken, P. Broekhoff, H. Miedema, K. Reichenfeld, and translators M. Müller-Haas and Michael Hoyle. The encouragement and gracious patience of the editor, Sally Salvesen, have been of inestimable importance.

1. Anton Kerssemakers in *De Amsterdammer, Weekblad voor Nederland*, 14 April 1912, p. 6; see *The complete Letters of Vincent van Gogh*, 3 Vols., Greenwich (Conn.) & London 1958, Vol. II, p. 446.

2. Eduard Kolloff, 'Rembrandt's Leben und Werke nach neuen Actenstücken und Gesichtspunkten geschildert', in *Historisches Taschenbuch*, ed. Friedrich Raumer, 3rd series, Vol. V, Leipzig 1854, quoted from the facsimile reprint edited by Christian Tümpel and published by the Deutsches Bibel-Archiv, Hamburg 1971, pp. 401–582, esp. p. 539: 'Sehr genaue Kenner und Liebhaber, die Alles mit dem Vergrösserungsglase untersuchen, werden durch seine Malerei aus dem Concepte gebracht und in Verlegenheit gesetzt; sie können nicht angeben, wie es gemacht ist, und wissen sich nicht anders zu helfen als mit der Erklärung, das hermetisch versiegelte Machwerk seiner Bilder sei eine Zauberei und der Maler selbst habe keine klare Erkenntniss davon gehabt.'

3. L. Gans, 'De mythe van Karel Appel's "Anrotzooien"', in *Album Discipulorum J.G. van Gelder*, Utrecht 1963, p. 179 ff., esp. p. 182.

4. Gerard de Lairesse, *Het groot schilderboek*, Amsterdam 1707, Bk. V, p. 324: 'met kloeke hand' [. . .] 'evenwel niet op zyn Rembrands of Lievensz., dat het sap gelyk drek langs het Stuk neêr loope. [. . .] 'maar gelijk en mals [zodat] uwe voorwerpen alleen door de Konst rond en verheeven schynen en niet door kladdery'.

5. Letter 426 of 10 or 11 October 1885; see *Complete Letters*, cit. (note 1), Vol. II, p. 417.

6. Two recent works on the Leiden *fijnschilders* are Eric J. Sluijter *et al.*, exhib. cat. *Leidse fijnschilders; van Gerrit Dou tot Frans van Mieris de Jonge 1630–1760*, Leiden (Stedelijk Museum de Lakenhal) 1988, and Peter Hecht, exhib. cat. *De Hollandse fijnschilders; van Gerard Dou tot Adriaen van der Werff*, Amsterdam (Rijksmuseum) 1989.

7. J.A. Emmens, 'Natuur, onderwijzing en oefening' in *Album Discipulorum J.G. van Gelder*, Utrecht 1963, pp. 125–36; idem, *Rembrandt en de regels van de kunst*, Utrecht 1964 (diss.).

8. Felix Timmermans, *Pieter Bruegel; Zo heb ik u uit uwe werken geroken*, Amsterdam 1927, quoted from the fourth impression, Amsterdam n.d., p. 189: 'Ge moet de borstelvegen zien: dat zijn de kronkelingen, de kreten van de ziel'.

9. Pierre Le Brun, 'Recueuil des Essaies des Merveilles de la Peinture', 1635, manuscript published in *Original Treatises On the Arts of Painting*, ed. Mary P. Merrifield, Vol. II, New York 1967 (ed. princ. London 1849), pp. 766–848, esp. pp. 824–25: '3. Comme est il possible

que le pinceau ait couché tant de douceurs sous ces traits si rudes, sous des couleurs si rudes, et que parmy tant de nonchalance, on ait couché tant d'attraits'.

10. E. de Jongh, review of B. Haak, *Hollandse schilders in de Gouden Eeuw, Simiolus* 15 (1985), p. 67.

11. Baldassare Castiglione, *Il Libro del Cortegiano*, Venice 1528, p. 18, The Dutch translation by Lambert van de Bos, *De volmaeckte Hovelinck, van de graaf Baldassare de Castiglione*, was published in Amsterdam in 1652. See also David R. Smith, '"I Janus": Privacy and the gentlemanly Ideal in Rembrandt's Portraits of Jan Six', *Art History* 2 (1988), pp. 42–63.

12. Giorgio Vasari, *Le Vite dé più eccellenti pittori scultori ed architettori [. . .]*, ed. Paola Barocchi, Florence 1987 (ed. princ. Florence 1568), Vol. VI, pp. 154–74.

13. Van Mander 1604, Fols. 174v–77v, see also idem, *Den grondt der edel vry schilder-const*, ed. Hessel Miedema, Utrecht 1973, Cap. XII, lines 22–26, pp. 258–61.

14. Hoogstraten 1678, p. 234.

15. Vasari, op. cit. (note 12), p. 155, lines 24–38, p. 156, lines 1–6.

16. Rembrandt in his fifth letter to Constantijn Huygens, 27–1–1639; see Strauss and van der Meulen 1979, 1639/4, p. 167: '[. . .] dat men daer wijt ken afstaen'.

17. Houbraken 1718–21; I have used the second edition of 1753, Vol. I, p. 269: '[. . .] de menschen, als zy op zyn schilderkamer kwamen, en zyn werk van digteby wilden bekyken, te rug trok, zeggende: de reuk van de verf zou U verveelen'.

18. In his life of Aert de Gelder, Houbraken discusses the fact that the choice between the rough and the smooth manner was subject to fashion (Vol. III, p. 206).

19. Max Doerner, *Malmaterial und seine Verwendung im Bilde*, Stuttgart 1960 (ed. princ. Munich 1922), pp. 332–38.

20. Vasari, op. cit. (note 12), p. 166, lines 30–31: '[. . .] di maniera che da presso non si possono vedere e di lontano appariscono perfette'.

21. Horatius, *Ars Poetica*, lines 361–62 'Ut pictura poesis: eritquae, si propius stes, te capiat magis, et quaedam, si longius abstes'. The English translation is from Horace, *Satires, Epistles and Ars Poetica*, trans. H. Rushton Fairclough, London & Cambridge (Mass.) 1947, p. 481. See also Ernst H. Gombrich, *Art and Illusion*, Oxford 1990 ed., pp. 161–69.

22. Pliny, *Natural History*, ed. H. Rackham, vol. 9, London & Cambridge (Mass.) 1968, Bk. XXXV, xl, lines 143–46, pp. 365–67.

23. Marco Boschini, 'Le minere della pittura', *Compendiosa informazione di Marco Boschini, non solo delle pitture pubbliche di Venezia, ma delle isole ancora circonvicine*, Venice 1664, p. 119–20.

24. Houbraken, op. cit. (note 17), p. 259: '[. . .] daar dingen ten uitersten in uitgevoert waren, en de rest als met een ruwe teerkwast zonder agt op tekenen te geven was aangesmeert. En in zulke doen was hy niet te verzetten, nemende tot verantwoording dat een stuk voldaan is als de meester zyn voornemen daar in bereikt heeft'.

25. Van Mander, op. cit. (note 13), Fols. 176v, 177; idem, *Den Grondt*, cit. (note 13), Cap. XII, line 23.

26. Vasari, op. cit. (note 12), p. 166, lines 32–36.

27. Gridley McKim-Smith 'Writing and Painting in the Age of Velazquez', in Gridley McKim-Smith *et al.*, *Examining Velazquez*. New Haven & London 1988, pp. 1–33.

28. Joseph Gantner, *Rembrandt und die Verwandlung klassischer. Formen*, Bern & Munich 1964; Kenneth Clark, *Rembrandt and the Italian Renaissance*, London 1966.

29. Vasari, op. cit. (note 12), p. 155, lines 17–24

'. . . cominciò a dare alle sue opere più morbidezza e maggiore rilievo con bella maniera, usando nondimeno di cacciar sì avanti le cose vive e naturali, e di contrafarle quanto sapeva il meglio con i colori, e macchiarle con le tinte crude e dolce, secondo che il vivo mostrava, senza fa disegno, tenendo per fermo che il dipignere solo con i colori stessi, senz'altro studio di disegnare in carta, fusse il vero e miglior modo di fare et il vero disegno'. On the question of *disegno* and *colorito* see, for instance, David Rosand, *Painting in cinquecento Venice: Titian, Veronese, Tintoretto*, New Haven & London 1982, pp. 15–25.

30. See E. van de Wetering, 'Painting Materials and working Methods' in Bruyn *et al.* 1982–, Vol. I, pp. 11–33, esp. p. 42.

31. Van Mander *Den Grondt*, op. cit. (note 13), Cap. XII, line 5: '. . . dus [zij] die overvloedich in 't inventeren zijn, doen als de stoute en verbeteren hier en daer een foute'.

32. McKim-Smith, op. cit. (note 27), p. 13; see also David Rosand, 'Titian and the critical Tradition', in idem (ed.), *Titian, his World and his Legacy*, New York 1982, pp. 1–39.

33. Houbraken, op. cit. (note 17), p. 259: '[. . .] om ene enkele parel kracht te doen hebben, een schone Cleopatra zou hebben overtaant'.

34. Vasari, op. cit. (note 12), p. 166, lines 33–38: '[. . .] e ciò adiviene perché, se bene a molti pare che elle siano fatte senza fatica, non è così il vero e s'ingannano, perché si conosce che sono rifatte, e che si è ritornato loro addosso con i colori tante volte che la fatica vi si vede. E questo modo sì fatto è giudizioso, bello e stupendo, perché fa parere vive le pitture e fatte con grande arte, nascondendo le fatiche'.

35. Strauss and van der Meulen 1979, 1656/12, No. 216, p. 371: 'Een seer groot boek met meest alle de wercken van Titian'. See the chapter 'Rembrandt and the Venetians' in Clark, op. cit. (note 28), pp. 101–45; and Broos 1977, p. 138 (Titian).

36. McKim-Smith, op. cit. (note 27), p. 24, and note 116 on pp. 137–38: '. . . de golpes de pincel groseros, casi como borrones al descuido . . . respondió el Ticiano: Señor, yo desconfié de llegar a la delicadeza y primor del pincel de Micael Angelo, Urbino, Coreggio y Parmesano y que cuando bien llegase, sería estimado tras ellos, o tenido por imitador dellos'.

37. Houbraken, op. cit. (note 17), p. 273.

38. Ernst H. Gombrich in 'Michael Podro in Conservation with Sir Ernst Gombrich' *Apollo*, December 1989, pp. 373–78, esp. p. 374.

39. Le Brun, op. cit. (note 9), pp. 824–27.

40. 'Light, Form and Texture in Fifteenth-Century Painting North and South of the Alps' in Ernst H. Gombrich, *The Heritage of Apelles*, pp. 19–35, esp. p. 32.

41. Gombrich, op. cit. (note 21); idem, op. cit. (note 40).

42. Gombrich, op. cit. (note 21), p. 99.

43. Systematic discussions of the rendering of different materials were mainly to be found in manuals on watercolour painting written for amateurs, such as Gerard ter Brugghen, *Verlichtery Kunst-Boeck*, Amsterdam 1616, and W. Beurs, *De Groote Waereld in 't kleen geschildert*, Amsterdam 1692, who also gives instructions for the painter in oils. In other sources, too, such as the De Mayerne manuscript and Gerard de Lairesse's *Groot Schilderboek*, one finds incidental hints on the representation of various materials.

44. Cennino Cennini, *Il libro dell'Arte* ca.1390, Ch. CXL; see *The Craftsman's Handbook*, trans. Daniel V. Thompson, New Haven 1933, Dover reprint p. 90.

45. Constantijn Huygens, autobiographical fragment (in Latin), 1629–1631, Koninklijke Bibliotheek, The Hague; translated by C.L. Heesakkers as *Mijn Jeugd*, Amsterdam 1987, pp. 84–90.

46. Jan Jansz. Orlers, *Beschrijvinge der stadt Leyden*, Leiden 1641. Cf. exhib. cat. *Jan Lievens, ein Maler im Schatten Rembrandts*, Braunschweig (Herzog Anton Ulrich-Museum) 1979, p. 35.

47. Van Hoogstraeten 1678, p. 238: 'In d' aengesmeerde verwen, vernissen en olyen wonderen te zoeken, was *Jan Lievens* dapper t'huis'.

48. H.L.M. Defoer, 'Rembrandt van Rijn, De Doop van de Kamerling', *Oud Holland* 91 (1977), pp. 2–26, esp. p. 18; Van de Wetering 1976–77, pp. 21–31, esp. p. 29.

49. Joachim von Sandrart, *Teutsche Academie der Bau-Bild- und Mahlerey Künste*, ed. A. Peltzer, Munich 1925, p. 196.

50. Filippo Baldinucci, *Cominciamento, e progresso dell'arte dell'intagliare in rame, colle vite di molti de'più eccellenti Maestri della Professione*, Florence 1686, p. 79; see also Slive 1953, p. 110, note 2.

51. See, for instance, G.P. Manzart, *Le Peintre amateur et curieux*, Brussels 1763, p. 142; Sir Charles Lock Eastlake, *Methods and Materials of Painting of the great Schools and Masters*, Vol. II (1847), Dover reprint 1960, p. 346; J. Maroger, *The secret Formulas and Techniques of the Masters*, New York 1979, pp. 121–22.

52. Max Doerner, op. cit. (note 19), pp. 332–38, Raymond White, 'Rembrandt's paint Medium', in London 1989, pp. 26–29.

53. Maryan Wynn Ainsworth *et al.*, *Art and Autoradiography: Insights into the Genesis of Paintings by Rembrandt, Van Dyck and Vermeer*, New York (The Metropolitan Museum of Art) 1982, p. 102.

54. Van Hoogstraeten 1678.

55. Van Mander, op. cit. (note 13); Junius, *De pictura veterum*, Amsterdam 1637, the Dutch translation of which was published in Middelburg in 1641 (*De schilder-konst der oude begrepen in drie boeken*), three years after Junius's own English translation, *The Painting of the Ancients*, London 1638.

56. Van Hoogstraeten 1678, p. 176.

57. Heinrich Wölfflin, *Kunstgeschichtliche Grundbegriffe*, Munich 1915.; English edition: *Principles of Art History*, trans. M.D. Hottinger, New York 1932.

58. A similar approach to art, based in part on the theories of the nineteenth-century German painter Hans von Marées and of the philosopher Konrad Fiedler, who was influenced by Von Marées, also spread throughout the English-speaking world, chiefly through the works of Herbert Read.

59. Van Hoogstraten 1678, pp. 306–09: 'Van voorkoming, wegwijking en verkorting'. The original Dutch of the quotations in the following paragraphs is as follows: '[. . .] dat uw papier, hoe effen gy 't ook oordeelt, een zekere kenbaere rulheyt heeft, waer in het oog staeren kan, ter plaetse, daer gy wilt, 't welk gy in 't gladde blaeuw des Hemels niet doen en kunt'; 'Ik zeg dan, dat alleen de *kenlijkheyt* de dingen naby doet schijnen te zijn, en daer en tegen de *egaelheyt* de dingen doet wechwijken: daerom wil ik, dat men 'tgeen voorkomt rul en wakker aensmeere, en 'tgeen weg zal wijken, hoe verder en verder, netter en zuiverder handele. Noch deeze noch geene verwe zal uw werk doen voorkomen of wechwijken maar alleen de *kenlijkheyt* of *onkenlijkheyt* der deelen'; '[. . .] blindheyd [die] tot deze tijden noch zoo groot [is] geweest'; '[. . .] nochthans het witte altijt naerder, en het zwarte verder af te schijnen te zijn [. . .] dat de verdiepte holligheyd van [. . .] een put [. . .] of een gracht'; and 'Het schijnt dat de locht zelf in een kleine wijtte een lichaem maekt, en zich met Hemel verwe bekleed'.

60. Gombrich, op. cit. (note 40), pp. 3–18.

61. Philostratus, *Imagines*, London & Cambridge (Mass.) 1979, Bk. I, Ch. 13, p. 57.

62. Lairesse, op. cit. (note 4), p. 14: '[. . .] een bekwame en vogtige grond achter de Beelden om den uiterste omtrek daarin te doen verdwynen'.

63. Vasari, op. cit. (note 12), p. 164, line 24 '[. . .] avendo egli bellissimo spirito et una molto vaga e vivace maniera'.

64. 'Journal du Voyage du Cavalier Bernin en France par M. de Chantelou', manuscrit inédit publié et annoté par M. Ludovic Lalanne, *Gazette des Beaux Arts* 15 (1877)—32 (1885), esp. 26, 2e période (1882), p. 534: '2 octobre 1665. [. . .] qu'au contraire les practiciens comme Tintoret, Paul Véronèse et quelques modernes s'étaient abandonnés a une franchise ou furie de peindre'.

65. Joshua Reynolds, *Discourses on Art, 1769–1790*, ed. Robert R. Wark, New Haven & London p. 223.

Rembrandt and his age:
The life of an Amsterdam burgher

A. Th. van Deursen

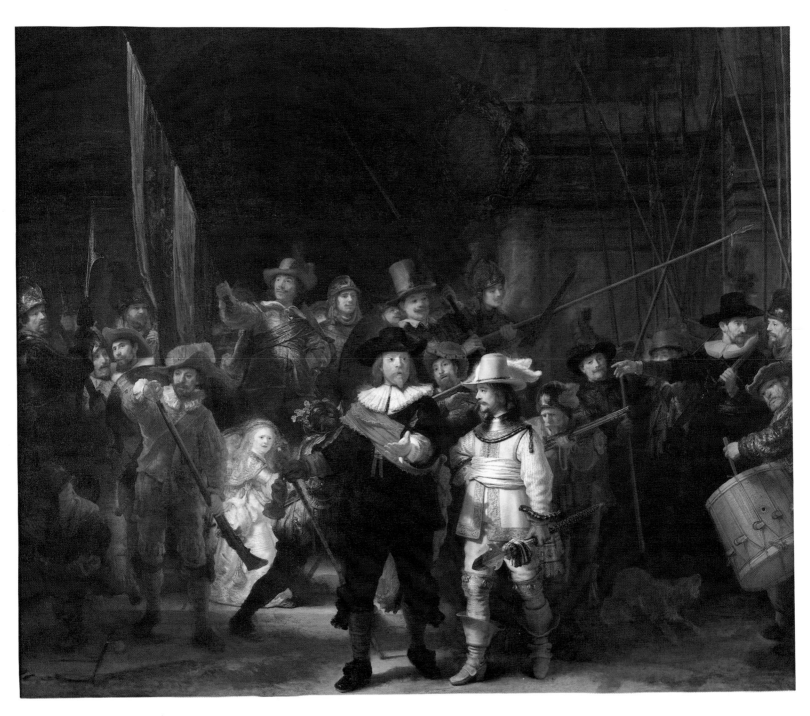

58: Rembrandt, *The Nightwatch*. 1642.
Amsterdam, Rijksmuseum.

'Rembrant van Rijn, merchant, of Amsterdam',[1] is how Holland's most famous painter is described in a notarial deed drawn up in Edam on 1 November 1642. The term tells us nothing about status, wealth or social position. A merchant might hawk his wares from door to door on his back, but equally he might send his ships across the seven seas. He might be engaged in trade full time, or just chance a modest venture on the local market every so often. 'Merchant' is a vague description, about as revealing as 'blonde' in a passport or 'pretty' describing a girl of eighteen. However, as a designation it does tell us something about the time when it was entered on the document. It was applicable to hundreds, perhaps thousands of Amsterdammers in those days, and involved no risk, since no one would be offended at finding himself regarded as a merchant. This is how the Edam notary may well have sized up Rembrandt: a perfectly ordinary Amsterdam burgher—let's call him a merchant.

This essay will deal with Rembrandt the burgher. In it we are looking not for the particular, but specifically for the general. Therefore things are deliberately viewed the wrong way round. Rembrandt owes his place in history to the particular, and nothing else: he is not a great painter because he lived in the Breestraat in Amsterdam and was the son of a Leiden miller. However, it is impossible to focus clearly on what was unique about him if we do not understand what Rembrandt had in common with his time, in the way in which he shaped his life and in everything beyond his control that happened to him. In what follows we shall direct our attention to the seventeenth-century burgher known as Rembrandt Harmensz. van Rijn.

Rembrandt's father, Harmen Gerritsz. van Rijn, was a malt-miller by trade. Malt was the principal raw material in beer-brewing, and in the seventeenth century beer was the staple beverage of the common people. Leiden was never in the position of Delft or Gouda, where beer was an important export commodity. In consequence Leiden brewers did not dominate the economic life of their town, but neither were they dependent on the regional beer trade with its violent battles over even the smallest of markets. Leiden beer was drunk almost exclusively in Leiden, a town with a fast-growing population, so that brewers and malt-millers could be expected to prosper. The evidence of the life of Harmen Gerritsz. van Rijn confirms that expectation: the wills which list his possessions[2] give an impression of reasonable prosperity, enough to maintain a respectable, bourgeois standard of living.

The family was certainly a large one, even by seventeenth-century standards. At least ten children were born to Harmen Gerritsz. van Rijn and the baker's daughter Neeltgen Willemsdr.,[3] of whom Rembrandt, born in 1606 after his parents had been married for seventeen years, was the ninth. This points to a fairly high birth rate— the usual interval between children at the time was probably a little over two years—and to marriage at a young age, for there was at least one more child after Rembrandt. On her marriage in 1589, Neeltgen Willemsdr. cannot have been much more than twenty. Probably Harmen Gerritsz. could afford to marry young, so that the family must have been fairly well-off. The mill provided solid financial foundations.

An official record of 1622 gives us a fuller picture. In that year it was necessary to count and register the population of Leiden for tax purposes, and hence we know that the miller and his wife still had five children living at home then.[4] One son had become a shoemaker, and had already begun a family of his own, another was apprenticed to a baker. A third, as we know, was learning the trade of painter, but was still living at home and the other four, two sons and two daughters, were obviously employed in the mill and in the house. From another tax census of 1581[5] it appears that the then miller and his wife, that is Rembrandt's grandmother and step-grandfather, had two servants and a maid in the house, besides their two children. At that time then there was work for six or seven people, and in 1622 the situation had not changed. For a traditional business around 1600 that was a very reasonable size, and if it was maintained for forty years, then life certainly cannot have been too hard at the mill.

The documents are clear on this point. Those wishing to make any further statements about Rembrandt's parental home will have to rely largely on their own boldness and imagination. This applies, for example, to the area of church and faith. Harmen Gerritsz. and Neeltgen Willemsdr. were married in the Pieterskerk in Leiden. Hence their union must have been blessed in a Calvinist service, and their children were also baptised, because the Calvinist church refused to marry anyone not baptised, and Rembrandt's marriage was consecrated in church. This makes it perfectly possible that the miller and his wife were members of that church, but it is very far from conclusive proof. Plenty of people made use of church facilities for baptism, marriage and burial, and perhaps even attended Sunday sermons fairly regularly, but never actually registered as members. It will probably

never be known whether Harmen Gerritsz. and his wife were members, or whether they had that rather looser association with the church, which their contemporaries called 'adherents of the reformed religion'; not unbelievers, not alienated from church and religion, but not true confessors, so totally committed to the church of their choice that they were ready to submit to church discipline.

Of course those eager to exploit even the most tenuous clues try to capitalise on Rembrandt's short school career. We know that Rembrandt's parents sent him to the Latin school, in the hope that he 'might serve the town and the common good with his learning'.[6] What kind of learning they had in mind the sources do not reveal. The theological faculty had without doubt the most students at the time, and the pulpit was the closest of the academic professions to the conceptual world of a bourgeois family. If that were the case Rembrandt's parents would have been Calvinists, but the foundation of that theory is as unsound as the attempts to make them out-and-out Remonstrants.[7] We simply do not know, and we shall have to resign ourselves to the fact.

How much Rembrandt learnt at the Latin school remains a mystery. There were no formal graduation examinations. Anyone who considered himself qualified could go on to university on his own initiative. Enrolling as a student was often more a sign of naive over-confidence than hard-won maturity. The fact that Rembrandt's name was included in the album of Leiden University in May 1620, does not therefore prove that he was ready to pursue academic studies. It is conceivable that he retained almost nothing from his schooldays, since the human capacity to forget what has been learnt is virtually boundless. However, in view of the curriculum of the Latin school at the time,[8] two things must have been drummed into him daily: Latin grammar and Christian doctrine. Young Rembrandt must have once been able to recite whole sections of the Heidelberg Catechism from memory, perhaps even in Latin.

However, he chose a different path from the academic one. Like his brothers he preferred to learn a trade, and that of course cost money. Rembrandt himself charged his pupils one hundred guilders a year in 1630,[9] which is probably about the same as his parents paid. It was not an insurmountable obstacle, and it was for a limited period: professional training seldom lasted longer than four years in the uncomplicated seventeenth century. By about 1625 Rembrandt had made sufficient progress to earn his own living.

An aspiring painter must first secure a place in the market, and establish his own circle of customers and patrons. Prudence forced him to be sparing with time and money. Thrift may not have been the virtue in which Rembrandt most excelled, but on his entry into the adult world he proceeded with exemplary caution. He remained living with his parents and probably shared a studio with his young Leiden colleague Jan Lievens. They had talent and ambition in common. After a few years Leiden had grown too small for them. Shortly after Rembrandt's father's death in April 1630, his youngest son decided to move to Amsterdam.

Seventeenth-century Leiden was certainly no provincial backwater (Fig. 59). The Leiden textile industry was renowned throughout Europe, and Leiden University was fast becoming so. In terms of population, Leiden ranked as the second town in Holland, just ahead of Haarlem, and far above Enkhuizen or Rotterdam. But still Amsterdam was in a different class. It was not only a bustling commercial or industrial centre; it was a metropolis. Whatever characteristic we choose: number of inhabitants, volume of trade, political power, richness of culture, Amsterdam would be superior in every respect to all other towns in the Dutch Republic, and even beyond the borders of the Low Countries it had few worthy rivals. This was the town where Rembrandt spent the greater part of his life. What did it have to offer him?

The French philosopher Descartes summed up his positive judgment of Amsterdam in three points: you can buy anything you want, you are free, and you are safe.[10] The last observation was frequently heard at the time. Caspar Barlaeus also praised the Amsterdammers for their respect for the law, their sense of public order and their obedience.[11] It may have been because of the large number of foreigners that Amsterdam was so law-abiding, for there were thousands of Flemish and German immigrants at this time, and probably the danger to one's life or property was fairly minimal. Not a single source mentions Rembrandt as having been mugged in the street. His cellar was once broken into, but it had been let to a tobacco merchant at the time.[12] Those with enough money to buy what Amsterdam had to offer, and hence able to enjoy its freedom in style, were not prevented from doing so by others. Amsterdam was not constrained in its endeavour to become a city of culture and wealth.

The story of Amsterdam's rise is familiar enough. In the sixteenth century its trade and shipping were focused on the Baltic, so that Amsterdam became the storehouse for two products which the whole of Europe needed: wood and grain. Wood was used for house construction and especially shipbuilding, in the century during which European trade developed into worldwide commerce. A people short of wood could not sail the seas, and were bound to be left behind when others went in search of profit and booty. All countries depended on corn from Poland and Prussia whenever their own grain harvest was insufficient to cover national or local needs—a very common occurrence! Only Amsterdam invariably had abundant supplies of grain and wood, and could provide them for others in need. Its captains sailed to Spain and brought back salt. They called in at French ports and loaded up with French wines. The same happened in every country they visited. Amsterdam had plenty of ships because wood and grain required ample cargo space, and for the same reason there were a host of warehouses on the quaysides. And so Amsterdam developed into the town where in Descartes's words the purchaser never sought a product in vain.

Those who can satisfy all their material wants are reluctant to have bounds imposed on them in the non-material sphere. Culture must be as well supplied as the goods market. Amsterdam was able to meet these expectations too. Every Sunday there were church services for Calvinists, Remonstrants, Lutherans, Mennonites and Catholics. There were sermons in Dutch, but also in German, French and English, while Mass was sung in Latin, and on Saturday the synagogues opened their doors to High German and Portuguese Jews. There were books for sale to the more experienced cultural consumers, newspapers and pamphlets for readers in a hurry, eager for fast information. For lovers of the stage there was the theatre, for the learned the Athenaeum, for the musically inclined organ-playing in church. The wealth of the cultural programme equalled the range of other commodities.

A free, open market and a wide spectrum of intellectual life existed, where every material and spiritual need could be satisfied. But it was all paid for from a single purse. At the inauguration of the Amsterdam Athenaeum Caspar Barlaeus spoke on the theme of the wise merchant, the *mercator sapiens*. This was the model and example of Amsterdam society, and not the poet with business sense or the preacher in trade. There were such people in the city, and it was not wholly insignificant that Rembrandt too should have been called a merchant in the notarial deed mentioned above. However, the tone was set by the Amsterdam élite, who controlled the world of trade and navigation and also had a secure hold on the government of the city.

We know these Amsterdam regents from Rembrandt's work: Frans Banning Cocq, Nicolaes Tulp, and above all Jan Six (Fig. 60), whose portrait corresponded almost feature by feature with Barlaeus's ideal of the *mercator sapiens*. What these three had in common with each other and with all their fellows in the first place was their eminent birth. A regent had to be of good family. This did not strike the people of the seventeenth century as odd: they had no difficulty in accepting that birth was a precondition for the holding of high office. They saw around them day by day how the baker, the schoolmaster and the surgeon trained their sons to follow the same profession. Why shouldn't the sons of regents be able to learn their trade from their fathers? Families with a tradition of public service ought to know best how to bring up their children for the same purpose. They knew the criteria a regent must meet and passed the requirements on to their sons.

Of course they also left their fortunes to their sons. The second characteristic of the regent class was that a regent had to be rich. It is difficult to say which counted for more: background or money and there is scarcely any point in asking such a question, because usually it is their combination that is important. If that was threatened, an attempt was made to redress the balance by means of an appropriate strategy. In the case of imminent financial embarrassment the solution was marriage to a rich girl, if necessary of a slightly lower class; in the case of origins which were too humble[13] a genealogist who was not too scrupulous was called in. Wealth as a prerequisite for a share in power was entirely consistent with seventeenth-century thought. Around 1630 the wealthiest Dutchmen lived not in Amsterdam but in The Hague.[14] They were not merchants, but civil servants. Consequently many people saw the holding of public office as a better means of becoming rich than any trade or shopkeeping. It was preferable for the community if those in office came from the wealthiest circles. They would be least exposed to the temptation to enrich themselves through the exercise of power. It was not a cast-iron guarantee, but there was nothing better,[15] because regents were not monitored by anyone outside their own circle.

The third characteristic is the hardest to express, and it was not found equally in all public officers. In some it was almost entirely absent, but without it one cannot paint a collective portrait of the regent class: they partook of the same culture. They had learned Latin and had usually spent

59: Pieter Bast, *Street Map of Leiden* (detail). 1660. Leiden, Gemeentearchief. Rembrandt's birthplace is marked with an arrow.

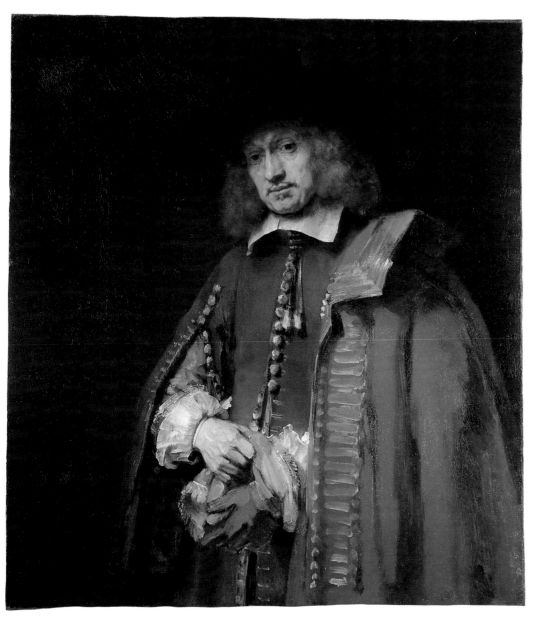

60: Rembrandt, *Jan Six*. 1654.
Amsterdam, Six Collection.

several years at a university. They spoke reasonable French, some of them also spoke Spanish or Italian. They knew the history of Rome, but also knew something about the Dutch past, albeit principally about the history of the county of Holland in the Middle Ages. They liked to surround themselves with beautiful objects, books as well as paintings. They knew how to appreciate beauty and were not averse to using their money to help an artist.

Their taste was not always the same as that of posterity. Jan Vos's bloody drama *Aran and Titus* (1641), in which only two of the fourteen actors survive to the end of the last act, was the box-office hit of the century, and enchanted even superior minds. Caspar Barlaeus saw it seven times. His friend Hooft saw it only once, but was deeply impressed,[16] although in our eyes Hooft's own dramatic work is far superior to that of Vos. At a slighter lower level of refinement, culture was even then equated with leisure and amusement. 'The difference between poor people and those who are fairly well-off,' wrote an Amsterdam lady to her grown-up daughter, 'is solely a matter of the kind of work and leisure which the latter can enjoy much more than the former. So use what God has given you properly and let yourself serve and take your leisure and enjoyment decorously'.[17] Life was certainly nothing grand or exalted, but very pleasurable for those fortunate enough to belong to the regent class.

These were the people with power in Amsterdam. Their authority was not based on a popular mandate. That would not have strengthened their position in seventeenth-century eyes, since power came not from below but from above. Kings ruled not by virtue of the will of the people, but by the grace of God. Regents never claimed that for themselves. However, they shared with monarchs of their time an aversion to the humility intended by this formulation, even if they lived in very sober style. To the extent that ruling by the grace of God stresses independence of other human beings, this definition of authority awakened a response in their hearts. Within the city walls the regents exercised virtually unrestricted power.[18]

Very occasionally unpopular measures encountered popular resistance, and consequently the magistrates were sometimes forced to admit defeat. But for there to be effective monitoring there must be organs which can translate criticism of government into action, and such organs were more-or-less non-existent. The militia attempted to fulfil this rôle—we shall return to this subject shortly—but did not succeed. The only body that occasionally performed the func-

tion was the Calvinist church council. In Rembrandt's day it enjoyed little success. The aldermen of Amsterdam were not generally men who in the words of the militant preacher Adriaen Jorisz. Smout, sought council from the mouth of the Lord.[19] Most regents belonged to the Calvinist church, and their sense of law and order was too highly developed for them to deviate stubbornly from the well-trodden path in their choice of church. But their sympathies were often on the side of the Remonstrants, the small group which had left the national church in the conflict over doctrine in 1618, though there were few real Remonstrants among the ruling class.[20]

Such was the Amsterdam where Rembrandt lived and worked. The work falls outside the scope of this essay. What concerns us here is the financial result which enabled him to live the life of a well-to-do burgher. The best measure of his increasing prosperity in the 1630s is the quality of his accommodation. Initially the bachelor found lodgings with Hendrik Uylenburgh, an art dealer in the Breestraat. In 1635, as a married man, he set up house in the Nieuwe Doelenstraat, and in 1639 he undertook the purchase of a house of his own in the Breestraat, for the not insignificant sum of 13,000 guilders.

He did not pay for the house immediately, but that does not prove that the purchase was beyond his means. In the seventeenth century there was usually a long gap between delivery and payment. Individuals paid their baker and beer-merchant once a year and with major purchases of property and possessions the last instalment might be still further delayed. The government was an even slower payer: their suppliers could count themselves lucky if their bills were settled only three years after the event. A reminder or two in the meantime could do no harm, as we see Rembrandt doing when he was kept waiting for payment for paintings delivered to Frederik Hendrik.[21] This, far from being proof of straitened financial circumstances,[22] is more an expression of an all too justified and long suppressed impatience. On the other hand, it must be admitted that Rembrandt was extremely slow in paying for his new house, even by the standards of his time.

It is not easy to determine what a seventeenth-century businessman is worth at a given moment. Besides the investment portion of their assets there is always a floating portion consisting of recoverables and debts. Money was often lent and borrowed among private individuals. Even though Amsterdam had its Exchange Bank, banking was still in its infancy, and those needing

capital in the short or long term were more likely to seek it among their circle of friends and acquaintances. For example, in 1646 Rembrandt's brother Adriaen borrowed five hundred guilders from a farmer in Gouda, with his sister Elisabeth providing collateral. This by no means indicates that he was in financial difficulties.[23] If he had been, that Gouda farmer would not have given him credit. Perhaps Adriaen saw a good opportunity of expanding his business and believed he had found a favourable investment opportunity which required more cash that he had available. So he borrowed a little more to help him go further than his own resources would allow.

Many people did the same, especially if they wanted to invest in shipping, because ships' shares were owned by great and small, and there was a lively trade in them. We know that Joost van den Vondel was very active in this market.[24] It was a risky business, because if the ship went down or was captured by pirates, the whole stake was lost. For that reason rich Amsterdammers preferred to invest the greater part of their capital in land,[25] and play the game of ships' share poker with only hundreds rather than thousands at stake. The risks proved too great for Vondel's modest resources. In his case there is conclusive proof. In Rembrandt's case the documents do admittedly also speak of 'losses at sea' (*verliesen bij der zee*),[26] but that was a standard formula at the time and need not be taken literally, though the possibility is not of course excluded. A successful sea voyage could yield profits of 25 per cent or more, and someone living under the shadow of the threat of bankruptcy might easily be tempted to try to set things magnificently to rights with one substantial investment.

However, in the 1630s there were no such clouds on the horizon, and Rembrandt's life was free from financial worries. There is no reason to doubt the assurance he gave in 1638 that through the grace of God he was richly provided with goods.[27] It is however, quite possible that he paid too little attention to the solidity of his financial basis. Let us look at the estate of his mother, Neeltgen Willemsdr.: its total value on her death in 1640 amounted to 9,960 guilders.[28] By far the largest portion was invested in houses and other property, and 595 guilders in loans to individuals. That was less than 6 per cent of the total, and she had no ships' shares at all. She had then opted principally for security. It is of course conceivable that Rembrandt also owned land, but the evidence has not yet come to light. It can be safely assumed that he did not invest in property, since house-ownership is generally so well documented

that such transactions would not have gone undetected. So it looks more likely that Rembrandt the merchant was wont to put his capital in tradable commodities. That certainly did not preclude reasonable wealth, as is clear as late as 1642 when Rembrandt was still able to advance 1200 guilders to help ransom Dutch sailors in Barbary.[29] But it was not a safe existence.

Nevertheless his marriage in 1634 indicates that at that time Rembrandt was still well-to-do. It cannot have been such an everyday occurrence for a miller's son to marry a real mayor's daughter, albeit one from the less important provinces. It is likely that Saskia van Uylenburgh brought a considerable dowry with her,[30] and that her family had greater status than her husband's is evidenced by the choice of witnesses at the birth of Rembrandt's children: it is invariably relations of his wife's who are present at the christening.[31] This happened four times and in three cases a funeral quickly followed. Only his youngest son Titus reached adulthood, though he was not to survive his father. Saskia too died young, when she was not quite thirty. Biographers have always been fascinated by the figure of Saskia, as she represents the romantic side of Rembrandt's existence. This woman is the fairy-tale motif in Rembrandt's life: young, beautiful and distinguished, for a simple burgher almost as fabulous a prize as that gained by that other miller's son, the marquess of Carabas. Who does not delight in looking at Saskia's portraits? But that is more or less all we can do. One cannot flesh out the life of Saskia van Uylenburgh any further with the help of the dry documents.

She died in 1642, a year with special significance in Rembrandt's life for another reason, because it was then that he completed his most famous painting. We are not concerned with the painter here, and hence not with *The Nightwatch* as a painting. But this canvas portrays the militia company of Frans Banning Cocq (Fig. 58). The captain was eventually to become mayor of Amsterdam, and so belonged to the top echelon of the governing elite. Most of those depicted, however, never rose to the top posts. They were by no means poor. It is known that on average they paid the painter a hundred guilders for the privilege of being able to point out their own faces in the tumult of officers and men to their family and admirers. We no longer know which face belongs to which individual, but thanks to Haverkamp-Begemann,[32] who based his study on the detective work of Dudok van Heel, the brief biographies of all of them are known to us. In this way one group of Amsterdam militiamen have been brought to life.

61: Nicolaes Eliasz. Pickenoy, *The Company of
Captain Jan Claesz. Vlooswijck*. 1642.
Amsterdam, Rijksmuseum.

61: Nicolaes Eliasz. Pickenoy, *The Company of
Captain Jan Claesz. Vlooswijck*. 1642.
Amsterdam, Rijksmuseum.

It is a company of merchants that we see before us, especially concerned with the textile trade. They belong to the prosperous bourgeoisie, contribute to the wealth of the city, serve as regents of charitable institutions or as deacons on the church council, but remain excluded from influence and power. Amsterdam politics pass them by, but it is their task to maintain public order when this is threatened by controversial political decisions. This ambivalent position of the militia was not unique to Amsterdam. It was their duty to support a policy which was framed without consulting them. They were the strong arm of the regents, the symbol and expression of municipal power and local self-confidence. The militia effectively protected freedom and prosperity. But freedom for what purpose, in what area and for whose benefit were questions which were decided exclusively by the regents.

This could lead to tensions, as had become apparent shortly before Rembrandt's arrival in Amsterdam. In the days of Oldenbarnevelt Amsterdam had been a bulwark of orthodox Calvinism. In 1622, however, the city council changed direction, and began favouring the Remonstrants as far as possible. From 1625 Remonstrant services were again permitted, and they received official protection against hostile mobs which attempted to disrupt the gatherings. The militia was the obvious instrument for that protection, but consisted mainly of orthodox Calvinists, who did not feel any great enthusiasm for maintaining public order for the benefit of Remonstrant dissenters. The authorities tried to strengthen their hold on the militia by appointing politically reliable officers. In 1628 Jan Claesz. van Vlooswijck was made captain precisely because of his Remonstrant sympathies. Eight years previously he had been dismissed as a lieutenant in the militia for exactly the same reason. This provocation was too much for many people. Most members of his company refused to obey an officer who in their view was an enemy of religion. They were supported by the Calvinist church and even the theological faculty in Leiden believed that in these circumstances the militiamen would be well advised to refuse to swear the oath of allegiance.[33]

It was now up to the burgomasters to assert their authority. No sterner test could be imagined. The two institutions capable of mounting organised resistance were ranged against them. The town council called in the help of Prince Frederik Hendrik, who sent six companies of foot-soldiers, thus restoring order to the town. Five opposition leaders were banished from Amsterdam, the other objectors gave in. Henceforth Captain Vlooswijck was able to enjoy his office undisturbed, as Nicolaes Pickenoy's militia painting (Fig. 61) proves to this day to all visitors to the Rijksmuseum. The rebellious citizens had been tamed.

This restored order for years. It had been made clear in Amsterdam that while militias defended privileges and laws, they did so under the sole authority of the corporation, not as an independent bourgeois force. But just as in the France of Louis XIV the nobility was compensated for the loss of real power by participation in a splendid court ritual, the symbolic function of the Amsterdam militiamen was given even greater emphasis. For their officers, like Banning Cocq, the symbol was also a reality: the militia companies did indeed embody municipal power, now that it had been established that the militia would always act in the spirit of their town council. Rembrandt's *Nightwatch* underlines these relationships. The difference between the two commanding officers and the other men in the company is plain for all to see. It is a well-ordered society in which everyone knows their place.

Happy the person who is assured of a good place in such a society. Around 1642 Rembrandt had such status, and may perhaps have himself been a member of a militia. But his way of life was not the kind that guaranteed that he would keep that place. True, he was still well-off, and he had control over Saskia's whole inheritance. But that benefit would be denied him the moment he entered into a second marriage. This stipulation was neither unusual nor unreasonable; there was no reason why Rembrandt's possible second wife should share in the assets which the first wife had left to her own child, and which were being administered by the father solely as a guardian. However, it attached material consequences to a second marriage, which otherwise would have seemed virtually inevitable for a thirty-six year-old widower. Rembrandt tried to avoid those consequences and in so doing incurred other problems.

His son Titus was still only one year old. Therefore the first thing that Rembrandt needed was a nanny, which is how Geertje Dircks entered his life. Geertje was a young woman from the area of Holland north of Amsterdam. A farm girl from Ransdorp, as Rembrandt's biographer Houbraken was later to call her,[34] though she was born in Edam, and never worked on a farm in her life. A farmer's daughter from North Holland would not normally lead a very adventurous existence. She was almost sure to find work as a milkmaid and cheese-maker on her parents' farm. Geertje, however, had to look for a position away from home and this she found in the Moryaenshooft inn in Hoorn. It was not the most prudent choice a young woman could make. No Calvinist church council would have advised her to start work in such a place where drink flowed freely. Nor did she stay there very long. In 1634 she married the ship's trumpeter Abraham Claesz. However, like so many seamen's wives she soon became a widow, and again had to fend for herself. This time she became housekeeper to a wood merchant in Edam, another choice of profession not calculated to protect a young woman from any whiff of scandal. Why, in her will of 1648, should she have left her portrait to one of the daughters of this wood merchant? A few years later she went to live with her brother Pieter in Ransdorp, from where she was later to move to Amsterdam as a dry nurse for Titus and housekeeper to his father.[35]

This career is in no way extraordinary. There were countless others like Geertje: women left to support themselves, who, without finally overstepping the bounds of decency, tried to earn their living on the fringes of public morality. In the life of the Edam wood merchant Pieter Lambertsz. Beets she was no more than a passing episode, and the same might well have happened with Rembrandt. But Rembrandt was less careful than the Edam merchant; Geertje and he separated on bad terms. By that time she must have been approaching forty. She would soon be an old woman, the most unenviable position conceivable in the seventeenth-century Netherlands. However, she still had one powerful card to play: in 1649 she sued Rembrandt for breach of promise.

According to the law of the time such a promise of marriage, once given, could not be unilaterally revoked. Someone who had plighted his troth in the presence of witnesses, could not terminate the relationship without the consent of the other party. In all probability Rembrandt actually made such a promise. At any rate Geertje was able to produce a ring in evidence, and her case was upheld by the Amsterdam court. Though Rembrandt was not obliged to marry her—the courts were very cautious on this point,[36] particularly if the plaintiff was not pregnant—he was ordered to pay Geertje an annual allowance of 160 guilders.[37] He was therefore made wholly responsible for her welfare as though she were his wife, for a woman could just about eke out a meagre existence on 160 guilders. That should have been the end of the matter.

There was, however, a sequel. Geertje was confined in the house of correction in Gouda.

62: Rembrandt, *The Oath of the Batavians under Claudius Civilis*. 1661.
Stockholm, Nationalmuseum.

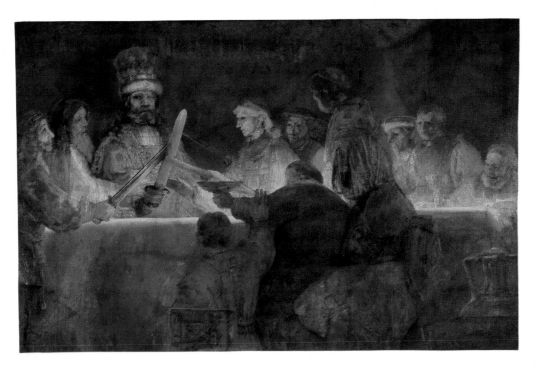

Why in Gouda? What can have been the reason that a woman from Edam, living in Amsterdam, and wanting to go to Ransdorp,[38] was locked up in Gouda of all places? It cannot have been because of a conviction, because in that case room would have been found for her in the Amsterdam women's prison, the 'spinning house'. This was undoubtedly a case of so-called detention on request. In such cases the initiative lay with the family, which for the sake of its own honour and reputation wished to exclude from society a blood relative branded as socially disruptive.[39] Proceedings were most probably begun by Geertje's family, even though Rembrandt must have been partly responsible. If the court consented the family could then reach an agreement with an institution which took in such persons. Gouda had a 'very large and well-appointed house of correction'.[40] There was more room than could be filled by local criminals. For that reason the regents of the prison reduced the running costs by admitting those imprisoned on request, for whom the family paid board and lodging.[41] This does not prove that Geertje led a dissolute life, even though the literature does occasionally imply that this is the case.[42] The social position of the applicants and their relation to the local authori-

ties played a not insignificant part in such cases. On the other hand, this need not point to a diabolical conspiracy between Rembrandt and Geertje's family.[43] No one could be incarcerated on the authority of a brother or sister without adequate grounds. Probably there was some justice on both sides. Geertje was released a little over five years later. This may also have been connected with Rembrandt's financial state. His maintenance obligations did not end with her incarceration and subsequently served to pay for her board and lodging. If payments were not made the regents of the prison would undoubtedly have expelled her. For she was not in prison as a punishment, but at the family's request. If payments ceased, the detainee was released.

Geertje did not come back into Rembrandt's life. She had been replaced by the much younger Hendrickje Stoffels, who was probably born in 1626. In 1649 she was already living with Rembrandt, and she remained there until her death in 1663. For at least fourteen years she was the woman at Rembrandt's side, longer than either Geertje or Saskia. She was also the mother of his youngest daughter Cornelia, but not his lawful wedded wife. Hendrickje accepted the situation, though she was certainly put under

pressure. In 1654, as is well known, she was summoned before the Calvinist church council, and denied communion on the grounds of unwedded cohabitation.[44] The church council took no steps against Rembrandt. This does not indicate a double standard. Church discipline was imposed only on Calvinist members. If the church council concerned itself with Hendrickje and not with Rembrandt, that is sure proof that she belonged the Calvinists and he did not. He may well have been a churchgoer, and according to the various inventories of his property there was always a Bible in his house, but he was not a church member.

If more proof were needed, it may be found in Rembrandt's bankruptcy. There is no mention anywhere in the minutes of the church council of a penalty being imposed, but church discipline was unrelenting precisely with this sin as one would expect in seventeenth-century Holland.[45] Everyone was prepared to give credit, and to supply goods for months without reminders of money owing. But in return they must be assured that at the appropriate time settlement would be made promptly. Those not paying their debts were letting down not only their creditors but the whole of society. They had asked for credit and shown themselves unworthy of it. If their example could be followed with impunity then the boom in trade and shipping would soon be sabotaged. Economic life is unlikely to flourish where payment is only possible in cash.

It is no longer possible to reconstruct precisely how and why things went wrong with Rembrandt's finances. The explanation, though, will probably have to be sought less in falling income than in his careless handling of money. There may very well have been overspending, as the Uylenburgh family believed they detected even while Saskia was alive.[46] The inventory of his possessions supports this in details such as the quality of the chairs, which usually have upholstered seats,[47] making them just a little more than simple utilitarian objects. In all probability, however, the main reason was Rembrandt's penchant for risky investments. Such systematic tempting of fate could undermine the greatest fortune, and would certainly be fatal for the moderate bourgeois wealth which was the highest point of Rembrandt's prosperity.

The further course of events was the normal one for the time. It differs very little from the present one, since the seventeenth-century rulers of Amsterdam were familiar enough with the nature and seriousness of these maladies to be able to prescribe the best remedy.[48] The Chamber of Insolvent Estates appointed a receiver, made an

inventory, and impounded the accounts and papers. An attempt was always made to reach an accommodation, and only when that proved impossible were the goods auctioned off, as Rembrandt's were.

His financial downfall brought about a number of important changes in his everyday life. With his housekeeper and children, Rembrandt moved into another house on the Rozengracht. He would have to support this family, but he had far from satisfied all his creditors completely, so that the latter had first claim on the fruits of his labours. For this reason a scheme was devised, whereby Hendrickje set up a painting business together with Rembrandt's son Titus and Rembrandt was employed by the company, with no other salary than board and lodging.[49] Legally there was no objection to this transparent ruse. Its morality is debatable, but there is no evidence that it brought Rembrandt into disrepute. Had he been considered a man without honour, the corporation would not have commissioned him to contribute to the decoration of the new Town Hall (Fig. 62). Amsterdam had no shortage of painters, and the Syndics of the cloth merchants' guild could easily have turned to someone other than the man who twenty years before had immortalised so many of their guild-members in *The Nightwatch*.

Rembrandt died on 4th October 1669, just after his sixty-third birthday. He acquired no further wealth or property in the last years of his life, and left nothing but his clothes and painting equipment.[50] As a merchant Rembrandt had failed. The joint will that he had drawn up with Saskia, was completely worthless, given the absence of worldly goods. Only the set formulae commending their souls into God's hands and their bodies to Christian burial were valid.[51]

1. 'Rembrant van Rijn, koopman te Amsterdam.' See Walter L. Strauss and Marion van der Meulen, with the assistance of S.A.C. Dudok van Heel and P.J.M. de Baar, *The Rembrandt Documents*, New York, 1979, p. 230. Hereafter cited as *Documents*.
2. *Documents*, pp. 37, 51 and 66.
3. *Documents*, p. 35.
4. *Documents*, p. 53.
5. *Documents*, p. 33.
6. '. . . de stadt ende tgemeene besten met zijn wetenschap zoude mogen dienen' (*Documents*, p. 216).
7. This conviction is very prominent in Gary Schwartz, *Rembrandt. Zijn leven, zijn schilderijen*, Maarssen, 1984.
8. R.B. Evenhuis, *Ook dat was Amsterdam, II. De kerk der hervorming in de gouden eeuw*, Amsterdam, 1967, p. 260.
9. *Documents*, p. 66.
10. H. Brugmans, *Geschiedenis van Amsterdam, III. Bloeitijd 1621/1697*, Utrecht, 1973, p. 131.
11. B. Haak, *Rembrandt. Zijn leven, zijn werk, zijn tijd*, The Hague, n.d., p. 77.
12. S.A.C Dudok van Heel, 'In de Kelder van Rembrandt', *Kroniek van het Rembrandthuis*, 90 (1990), p. 3.
13. S.A.C. Dudok van Heel, 'Amsterdamse burgemeesters zonder stamboom. De dichter Vondel en de schilder Colijn vervalsen geschiedenis', *De zeventiende eeuw*, V (1990), p. 144–51.
14. A.Th. van Deursen, *Het kopergeld van de gouden eeuw*, III, Assen, 1979, p. 11.
15. D.J. Roorda, *Partij en Factie*, Groningen, 1961, p. 44.
16. Evenhuis, II, p. 291.
17. 'Het onderschijt van arreme menschen en van taemelijck gegoede is alleen in de dinst en verquicking die de laetst gezegde meer als de eerste kenne geniete. Bedint u dan op ordentlijke wijse van hetgeen God uw gegeven heeft en dout uw dienen en neemt behoorlijk uw gemak en vermaak.' (Gemeentearchief Amsterdam, archief Backer 87.)
19. A.Th. van Deursen, *Bavianen en slijkgeuzen. Kerk en kerkvolk ten tijde van Maurits en Oldenbarnevelt*, Assen, 1974, p. 219.
20. Evenhuis, II, p. 181.
21. *Documents*, p. 173.
22. As one sometimes finds in the literature on Rembrandt. Cf., for example, M.Muller, *Zo leefde Rembrandt in de gouden eeuw*, Baarn, 1968, p. 195.
23. *Documents*, p. 248.
24. A.Th. van Deursen, *Het kopergeld van de gouden eeuw, I. Het dagelijks brood*, Assen, 1978, p. 105.
25. Brugmans, p. 262.
26. *Documents*, p. 345.
27. *Documents*, p. 152.
28. *Documents*, p. 191.
29. *Documents*, p. 230.
30. Schwartz, p. 187.
31. Schwartz, p. 185.
32. E. Haverkamp-Begemann, *Rembrandt: the Nightwatch*, Princeton, 1982.
33. On the Amsterdam militia riot, see P. Knevel, 'Onrust onder de schutters. De politieke invloed van de Hollandse schutterijen in de eerste helft van de zeventiende eeuw', in *Holland*, 20, 1988, pp. 158–74.
34. Arnold Houbraken, *De groote schouburgh der Nederlantsche konstschilders en schilderessen*, Maastricht, 1943, I, p. 214.
35. *Documents*, p. 112.
36. Donald Haks, *Huwelijk en gezin in Holland in de 17de en 18de eeuw*, Assen, 1982, p. 124.
37. *Documents*, pp. 270 and 276.
38. *Documents*, p. 280.

39. P. Spierenburg, 'Opsluiting op verzoek', in *Spiegel Historiael*, 16 (1981), pp. 459–64.
40. '. . . een seer groot en bequaam tuchthuis . . .', A. Hallema, 'Rekeningen van het tuchthuis te Gouda 1611/13', in *Bijdragen en mededeelingen van het Historisch Genootschap*, 63 (1942), pp. 291–346. The comment quoted here is on p. 292.
41. Hallema, p. 299.
42. See, for example, Horst Gerson, *Rembrandt*, Wiesbaden, 1968, p. 84.
43. Schwartz, p. 242.
44. H.W. Roodenburg, *Onder censuur. De kerkelijke tucht in de gereformeerde gemeente van Amsterdam 1578–1700*, Hilversum, 1990, pp. 230–33.
45. Roodenburg, pp. 377–81.
46. *Documents*, p. 152.
47. *Documents*, pp. 351, 357 and 381.
48. W.F.H. Oldewelt, 'Twee eeuwen Amsterdamse faillissementen en het verloop van de conjunctuur (1636–1838)', in *Tijdschrift voor Geschiedenis*, 75 (1962), pp. 421–35.
49. *Documents*, p. 462.
50. C. Hofstede de Groot, *Die Urkunden über Rembrandt (1575–1721)*, The Hague, 1906, p. 371.
51. *Documents*, p. 120.

Rembrandt van Rijn (1606–1669): A Changing Portrait of the Artist

S.A.C. Dudok van Heel

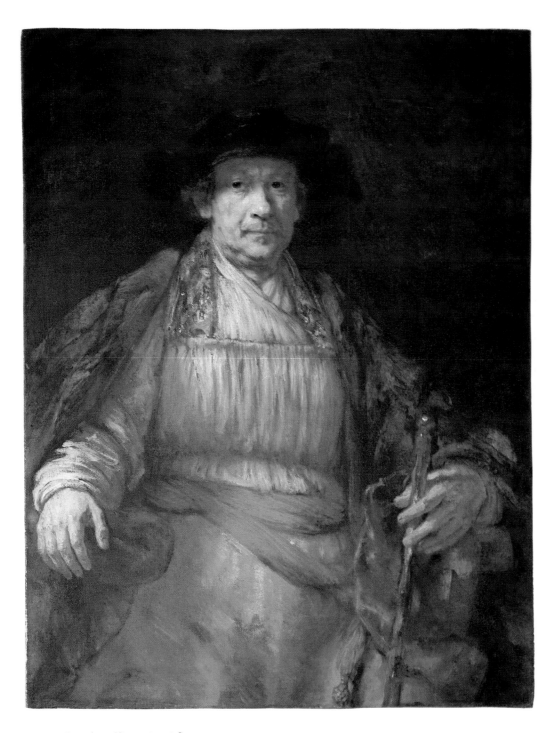

63: Rembrandt, *Self-portrait*. 1658.
New York, The Frick Collection.

'With the threefold skills of draughtsman, etcher and painter Rembrandt created three separate worlds, each self-contained and autonomous. Each contains a commentary on the others, each is governed by an inner imperative, and each reveals the master almost in his entirety—almost, because without one of these constituent fields, which are like interlocking circles, an essential element would be missing from the image of the artist.'

These are the opening words of F. Schmidt-Degener's essay on 'Rembrandt's Threefold Talent' in the catalogue of the 1932 Rembrandt exhibition at the Rijksmuseum. His article was fifteen pages long, while the 'Short Life of Rembrandt' occupied a mere two pages. The 'Life' concludes with the following observation on the crucial year 1642 in Rembrandt's life:
'Until 1642 he had worked in the Baroque manner. After that date there was a stylistic renewal and he began to move increasingly in the opposite direction. Outward appearances became less important to him than the inner being. The public was alienated and no longer understood him.'

Both these quotations illustrate the fact that in 1932 Rembrandt was not treated as a historical figure. What mattered was the essence of his art. That situation had still not changed when A. van Schendel published his compelling article 'The First Heretic in Painting' in the catalogue of the 1956 Rembrandt exhibition. He has the following to say about the same year of 1642:
'While he was concentrating all his powers on the completion of the monumental militia piece for the Kloveniersdoelen, Saskia succumbed to illness and left him with a son of less than a year. Did these harrowing experiences, which must have deeply affected his sensitive nature, bring about a spiritual transformation? It is not immediately apparent from the work, but gradually he seems to be less attracted by virtuoso display and eloquent gesture. He paints Holy Families in the intimacy of Dutch interiors, which seem like silent reflections on the warmth of domestic bliss.'

Rembrandt the artist and Rembrandt the man were at that time approached almost exclusively in aesthetic terms on the basis of his many-faceted and extensive œuvre. The object of investigation was the painter's psyche, his state of mind at the time his work was created. That the historical figure might also be of help to us in this search was still not universally accepted. Even before 1932 C. Hofstede de Groot and A. Bredius had contributed a book and some scores of articles documenting the life of Rembrandt, but only

scant use was made of these. There is not a single painter from the Northern Netherlands about whom so much documentary evidence survives. Why was it not used?

It was the commemorative exhibition of 1956 that was the occasion for Dr I.H. van Eeghen to link some of the paintings on display with archival material. Hitherto anonymous sitters acquired names and backgrounds, others changed names. Thanks to her ingenious publications subsequent editions of the catalogue required revision. This research was pursued further during the later commemorative exhibition of 1969. Some of us at the opening strained to decipher the text of the letter in the *Shipbuilder*. We were unable to reach agreement at that time, because of the changes made during successive restorations, but Miss van Eeghen found the solution. Her investigations contributed significantly to an increased understanding of the painter and the world he lived in.

The presence of a *femme fatale* in Rembrandt's life had been known since 1899, but was kept discreetly hidden from the public at large. Even after the extensive publications on her in the 1960s, all that was revealed in the 1969 Rembrandt catalogue was that she had lived with Rembrandt from about 1643 until 1649. Could she perhaps have been connected with the radical changes in Rembrandt's life after 1642?

This is one of various questions that can be posed concerning the historical figure of Rembrandt. How does he fit in, as a simple miller's son, with the typically urban culture of painting? Was he a craftsman or was he on a par with merchants and regents? Can he be compared as an erudite connoisseur and artist with the painter-diplomat Rubens? Was Rembrandt, after the completion of *The Nightwatch* (the previously-mentioned large painting commissioned for the Kloveniersdoelen), a neglected artist? On the basis of this type of question an attempt will be made here to place Rembrandt socially and culturally in the context of his age.

In seventeenth-century Holland there were eighteen towns—six large and twelve small—entitled to send representatives to the Provincial States of Holland. Rembrandt was to spend his life painting in the two largest centres, Leiden and Amsterdam. At the beginning of the sixteenth century both towns were estimated to be of the same size, with 18,000 inhabitants each. The Spanish siege of Leiden caused the population to fall to 12,000 in about 1580, but by 1622 there were 45,000 inhabitants. In the same period Amsterdam underwent an even more spectacular

growth from approximately 30,000 to 106,000, an expansion which was largely due to immigration from the Southern Netherlands. Leiden had attracted large numbers of textile workers and Amsterdam particularly rich merchants and specialised craftsmen. In consequence a marked disparity in wealth between the two towns established itself in the same short space of time.

Rembrandt's ambition was to be a history painter, the highest pinnacle of attainment in painting. Most history painters in his day came from the prosperous urban élite. The family of Rembrandt's first teacher, Jacob van Swanenburgh (1571–1638), was involved in the government of Leiden. Van Swanenburgh himself was a Catholic.[1] His second teacher, Pieter Lastman (1583–1633), was the son of a town official dismissed from his post in 1578 because of his adherence to the Catholic church.[2] Among other precursors of Rembrandt, the brothers Jan Pynas (1581/82–1631) and Jacob Pynas (1592/93– after 1643) came from a line of Alkmaar regents,[3] while Claes Moyaert (1591–1655) was a scion of one of the leading Amsterdam regent families.[4] The remarkable thing is that they were all Catholics. Like Moyaert, Rembrandt's family connections with the ruling families were on his mother's side.[5] In his case too many relations had remained Catholics.[6] Rembrandt's parents themselves were protestants. All these artistic descendants of the old patriciate had declined somewhat in social status, but most of them still had influential relations.

On his father's side Rembrandt came from a family of corn millers. They owned the first mill on the north bank of the Old Rhine outside the town gates. Rembrandt's father (Fig. 64), Harmen Gerritsz. (1568–1630), was a fourth-generation miller and two more generations were to follow him. Millers functioned as a link between town and country. When the Spaniards laid siege to Leiden during the Eighty Years' War, they succeeded in setting fire to the mill outside the town walls. Immediately after the relief of Leiden Rembrandt's grandmother, Lijsbeth Harmensdr. (1538–1599), obtained permission to rebuild the mill on the inner moats within the town walls, thus integrating the family into the town. Because Rembrandt's father's mill was situated close to the water, it was named 'de Rijn' after the river and at the beginning of the seventeenth century he also came to be known as Harmen Gerritsz. van (de) Rijn. In those days millers generally belonged to the prosperous middle class. Englishmen from the retinue of the Earl of Leicester observed with some irony that Holland was ruled by 'millers and cheesemen'.[7] In 1658

64: Rembrandt, *The Artist's Father*. Drawing.
Oxford, The Ashmolean Museum.

65: Rembrandt, *The Artist's Mother*. Etching.
Amsterdam, Rijksprentenkabinet.

descendants of the owner of the first mill outside the Reguliers Gate in Amsterdam were even raised into the nobility by the Holy Roman Emperor with the family name of Heereman van Zuydtwijck.[8] Rembrandt's parents had been well-off and on her death Rembrandt's mother (Fig. 65), Neeltgen Willemsdr. van Zuytbrouck (1568–1640), left an estate worth almost 10,000 guilders.[9]

As the youngest son of at least ten children Rembrandt was not in the first instance destined to carry on his father's business as a miller or a baker. His parents were prosperous enough not to have to arrange a trade apprenticeship for him and instead enroled him in the Latin School. In 1641 his first biographer wrote:[10]

'Rembrandt van Rijn, the son of Harmen Gerritsz. and Neeltgen Willemsdr. van Zuytbrouck, was born in Leiden on 15 July 1606. His parents had sent him to school to learn Latin and later to have him enrol at the Academy of Leiden, so that as a grown man he might serve the town and the country with his learning. He had no enthusiasm for this, since his natural inclination was more towards painting. Therefore they were obliged to remove their son from school and to apprentice him, as was his wish, to a painter who was to teach him the basic principles. In accordance with this decision they took him to the competent painter Jacob Isaacsz. van Swanenburgh for instruction. He stayed there for about three years, and because he made good progress during that time, which amazed connoisseurs and convinced them that he would in time grow into an excellent painter, his father gave his permission for him to be apprenticed to the renowned painter Pieter Lastman, so as to learn more and receive still better instruction. After spending approximately six months with him he decided to practise painting independently and to become his own master. In this he was so successful that he has become one of the most renowned painters of our time. Because his style and works found great favour with Amsterdammers and he was regularly asked to paint portraits and other pieces there, he moved from Leiden in about 1630 and settled in Amsterdam, where he is still living today.'

This account is substantiated only scantily by archival documents, so that the text is given quite widely differing interpretations. On 16 May 1620—two months before his fourteenth birthday—Rembrandt was enroled at Leiden University by his parents. It was a local custom in Leiden for pupils at the Latin School who were destined for the Academy to be enroled in advance,[11] after which they could receive intensive preparation

for university study. Given his parents' expectations one is bound to wonder what course of study they had in mind for their son. It is very unlikely that Rembrandt was seen as a potential student of law, a subject generally studied by regents' sons with prospects of a career in local or national politics and administration. That left medicine and theology. Medicine was usually associated with a strong family tradition in the field,[12] which was lacking among Rembrandt's relations. Given the social position of the family, theology was the most obvious course of study. Quite a number of student scholarships were available for this purpose, of which the middle classes made grateful use. However, at the moment Rembrandt was about to go to the University the climate had been soured by the dispute between Remonstrants and Counter-Remonstrants. Neither Rembrandt nor his family belonged to the strict Calvinist or pious party, which had been dominant since 1618. The turbulent situation may have been one reason why Rembrandt's parents gave way to Rembrandt's wishes and did not finally send him to University. This was the period when Remonstrant sympathisers turned their backs on the church and the theological faculty in Leiden.

His apprenticeship with Jacob van Swanenburgh may have left no visible trace in Rembrandt's later work, but the fact that Van Swanenburgh was a history painter, who had spent twenty five years in Italy must have had a lasting impact on Rembrandt. His period in 1624 in the Sint-Anthonisbreestraat in Amsterdam with Pieter Lastman, who had also studied in Italy, was demonstrably more influential. On his return from Amsterdam Rembrandt, now eighteen, probably went back to his parents' home. One can fairly confidently expect his first studio to have been there in the Weddesteeg. There was no division between residence and workplace in those days. Rembrandt's teacher Pieter Lastman also lived with his mother and paid her rent.

Around 1628 Rembrandt (Fig. 66) attracted the attention of the secretary to the Prince of Orange, Constantijn Huygens (1596–1687), who was very enthusiastic about his work and that of his fellow-townsman Jan Lievens (1607–1674). However, amid all the praise he added a word of criticism of the two painters, whom he found somewhat complacent and provincial:[13]

'In one respect, however, I am critical of these celebrated young men, about whom I can hardly stop talking. As I have already observed in criticism of Lievens, they are rather full of themselves and have not yet deemed it necessary to devote a few months to a study visit to Italy.

This is of course the touch of irrationality found in otherwise brilliant minds. If someone could dissuade these youngsters from such notions he would really provide the sole missing element necessary for the perfection of their artistic powers. How I would love them to become acquainted with the likes of Raphael and Michelangelo and to make the effort to draw inspiration from the creations of so many towering geniuses! How quickly they would surpass them in all areas and give the Italians reason to visit their native Holland. If only these two, born to raise art to sublime heights, knew themselves better!'

At that moment Rembrandt and Lievens had scarcely turned twenty. A trip to Italy would have been a perfectly natural conclusion of their training, but this was never to be. Huygens had previously remarked 'that Rembrandt is superior to Lievens in sureness of touch and vividness of emotions. Conversely, Lievens surpasses him in grandeur of invention and boldness in his choice of subjects and forms':

'I quote as an example the painting of the repentant Judas returning the thirty pieces of silver, the price of his betrayal of our innocent Lord, to the High Priest. It holds its own with anything produced in Italy, indeed with any masterpiece that has survived from remotest antiquity. Just look at the gesture of the despairing Judas (to say nothing of the other impressive figures in this one painting), of the distraught Judas crying aloud, begging for forgiveness, but not expecting any, from whose features all traces of hope have vanished; his crazed expression, his hair torn out, clothes ripped, arms twisted, hands clenched till they bleed; in a blind impulse he has fallen to his knees, his whole body contorted in pitiful loathsomeness. This I would place on a par with whatever beauty has been created throughout the ages. I should like to bring this to the attention of all those shallow minds, who are wont to maintain . . . that nothing more can be created or expressed in words that has not previously been expressed or created by antiquity. I maintain that no one, be he Protogenes, Apelles or Parrhasius, ever conceived or—were they to return to earth—ever could conceive what has been gathered in a single human figure and expressed in its totality by a beardless boy, a Dutchman, a miller's son. I say this in pure amazement. Rembrandt, I salute you! Transporting Troy, or even the whole of Asia to Italy is less of an achievement than capturing the highest accolade that Greece and Italy have to offer for the Dutch, and this is the work of a Dutchman who has scarcely ventured beyond the confines of his native town.'

66: Rembrandt, *Self-portrait*. c.1628. Panel. Amsterdam, Rijksmuseum.

67: Rembrandt, *Lijsbeth Harmensdr. van Rijn*. Panel. Whereabouts unknown.

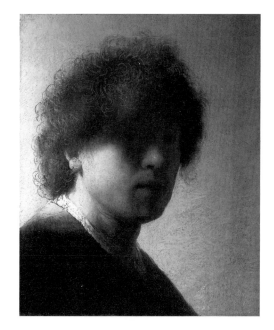

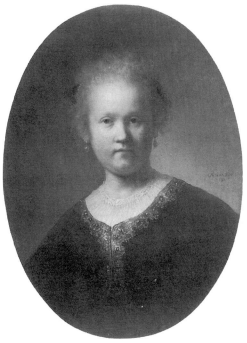

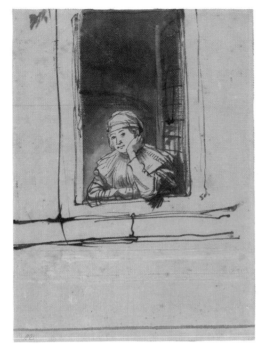

68: Rembrandt, *Saskia at an open window*. Drawing. Rotterdam, Museum Boymans-van Beuningen.

Interest in both painters had been aroused in The Hague and so their first works found their way to the stadholder's court.

In February 1628 Rembrandt took on his first pupil, Gerrit Dou (1613–1675) and before November 1628 the latter was joined by Isaac Jouderville (1612–1645/48).[14] These two pupils lived virtually around the corner from Rembrandt's parents' house. It is apparent from their paintings that Jan Lievens must have been in fairly close contact with Rembrandt at this time. The question, however, is where. If one accepts that the old lady in the work of Rembrandt, Dou and Lievens is Rembrandt's mother, the most obvious choice would be Rembrandt's studio in the Weddesteeg.[15] Dou stayed with Rembrandt until the spring of 1631 and the last receipt for Jouderville's tuition fees, amounting to one hundred guilders a year, was signed in November 1631. Rembrandt was at that point still living in Leiden.

Up to that time Rembrandt had not painted any portrait commissions, but between 1631 and 1635 he produced an impressive series. In Amsterdam, as early as December 1631, he painted Nicolaes Ruts (1573–1638), Marten Looten (1586-1649)—dated 17 January 1632—

and the *Anatomy Lesson of Dr Nicolaes Tulp* (1593–1674) of 31 January 1632. In addition there were portrait commissions in The Hague in 1632 for the heavily pregnant Amalia of Solms (1602–1675),[16] Maurits Huygens (1595–1642), Jacques de Gheyn III (1596–1641) and Joris de Caulery (c.1600– after 1661). In 1633 Maria van Bilderbeecq of Leiden (c.1606–1653) sat for him and in 1634 he painted the brewer Dirck Pesser (1587–1651) with his wife Haesje van Cleijburg (1583–1641) in Rotterdam, where the artist was staying in July of that year.[17] These are the few names that can be attached to the earliest surviving authenticated Rembrandt portraits. To begin with Rembrandt probably travelled from Leiden to his clients, just as Jan Lievens went twice from Leiden to the Hague in 1627 to paint Constantijn Huygens[18], and Isaac Jouderville commuted from Leiden to Amsterdam.[19]

At present it is assumed on good grounds that Rembrandt received his portrait commissions through the agency of the art dealer Hendrick Uylenburgh (1587–1661), portraiture being one of the latter's specialities.[20] The whole series of portraits falls within the period of Rembrandt's collaboration with Uylenburgh. Rembrandt was doing business with Uylenburgh as early as 1631 and during his stays of varying length in Amsterdam was able to lodge with him in the Sint-Anthonisbreestraat, where there was studio space available for him.[21] The year 1632 was the last one in which Rembrandt signed himself R(embrandt) H(armensz.) L(eijdensis) van Rijn,[22] stressing his Leiden origins as he had since 1629. It seems that in his last year at Leiden his sister Lijsbeth Harmensdr. van Rijn (c.1608–1655) modelled for him (Fig. 67).[23] As the youngest daughter, she probably kept house for her mother and brothers still living at home, so that she remained in the Weddesteeg and did not marry.

By 1633 Rembrandt must have realised that his future lay in Amsterdam. The previous year he had spent so much time away from Leiden that a notary had made inquiries after his whereabouts in Amsterdam. The only time we hear of a sitter coming to Amsterdam is the Remonstrant preacher Johannes Wtenbogaert (1557–1646), who in April 1633 travelled from The Hague to the city to have his portrait painted by Rembrandt for the benefit of an admirer.[24] Here on the Amstel he produced impressive life-size portraits of Amsterdam notables: the shipbuilder Jan Rijcksen (1560–1637) with his wife in a double portrait of 1633; the English preacher Johannes Elison (1581–1639) and his wife; and the wealthy young Maerten Soolmans (1613–1641) and his

wife, Oopjen Coppit (1611–1689), in 1634. At this time he changed his signature to 'Rembrandt'—possibly at the instigation of Hendrick Uylenburgh—following the example of such celebrities as Raphael, Leonardo and Michelangelo. On top of all this, in June 1633, came his engagement to Saskia Uylenburgh (1612–1642), the art dealer's niece (Fig. 68). Not until his marriage did Rembrandt buy the citizenship of Amsterdam and join the guild of St Luke.[25] The couple initially stayed with Hendrick Uylenburgh.[26]

Rembrandt had made a good match and appears to have been happy. His father-in-law, Dr Rombertus Uylenburgh (c.1554–1624), was a former pensionary of the Court of Friesland and mayor of Leeuwarden.[27] The marriage provided Rembrandt with a large number of influential contacts in the north, but did not alter his position in Amsterdam. One should not overestimate the dowry Saskia (Fig. 69) brought to the marriage, since she was the youngest of eight children to survive to adulthood. The Uylenburghs could not be regarded as rich.

It was typical of seventeenth-century society that painters like Rembrandt, though in fact tradesmen, were easily accepted into patrician circles. Rembrandt's pupils Govert Flinck (1615–1660) and Ferdinand Bol (1618–1680) were also to marry into distinguished families. Flinck married the daughter of a Dutch East India Company director from Rotterdam[28] and Bol's first wife came from the Amsterdam patriciate.[29] Ferdinand Bol's second marriage, indeed, enabled him to retire and live on his income.[30] Rembrandt's precursor Jan Tengnagel (1584–1635) was able to give up painting after being appointed deputy sheriff of Amsterdam through the intercession of his wife's relatives.[31] Rembrandt was never to enjoy such important patronage in Amsterdam, though Hendrick Uylenburgh had provided him with important contacts in the art trade.

Analysis of Rembrandt's early clients indicates that all denominations were painted by him: Calvinists, Mennonites, Remonstrants and Catholics.[32] In the literature on Rembrandt the Mennonites[33] and Remonstrants[34] have received by far the greatest attention, because it was hoped that this would reveal more about Rembrandt's own religious sympathies. Others have investigated Rembrandt's relations with the stadholder's court and with the ruling élite of Amsterdam.[35] The subject is too extensive to go into here, but the possibilities in this area have not yet been fully explored, as one small example will show.

Among the last commissions probably painted in Uylenburgh's studio in 1635, are those of the former governor of Amboina, Philips Lucaszn (c.1600–1641) and of his wife. Philips Lucaszn had just been appointed a councillor of the Dutch East India Company and at the beginning of May was to set sail again for the Indies with his wife.[36] On 12 April he had been a witness at the christening of the son of his brother-in-law, the ex-Governor General Jacques Specx (1589–1652). In 1653 the two portraits of Philips Lucaszn and his wife are listed as Rembrandts in the inventory of Jacques Specx's possessions, together with a *Ship of St Peter*, a *St Paul* and a *Europa* of Rembrandt's.[37] Among the christening witnesses on 12 April we find mention of the ex-Governor General Pieter Carpentier (1586–1659), with whom Specx was closely associated. In 1713 two chimney-pieces by Rembrandt, a *Magi* and a portrait were listed in Carpentier's house in the Nieuwe Doelenstraat.[38] This groups together a number of former high officials of the Dutch East India Company, that was still less than thirty years old, who were among Rembrandt's early clientèle. The shipbuilder Jan Rijcksen had also made his fortune in the Company's service.

Rembrandt and Saskia made their first home in a house completed in 1635 in the fashionable Nieuwe Doelenstraat; two houses beyond the Kloveniersdoelen with a view over the Amstel (Fig. 70).[39] They lived next door to their landlord, Willem Boreel (1591–1668), who had been solicitor to the Dutch East India Company since 1618.

In 1637 Rembrandt moved, probably on the customary moving day of 1 May, to the *Suyckerbackerij* (sugar refinery) on the Binnen-Amstel (Fig. 71), part of which he rented from the heirs of Emanuel van Baseroode (d. 1637).[40] The *Suyckerbackerij* complex was situated in an inner courtyard on the north side of the Amstel. The property had a covered exit running under the backs of the houses to the Lange Houtstraat. Bordering the garden on the west side was a large fives court. It was a less prestigious address than the Nieuwe Doelenstraat, but possibly Rembrandt had more workspace there.

In January 1639 Rembrandt signed a contract for the purchase of what was to become the Rembrandt House in the Sint-Anthonisbreestraat (Fig. 72). Rembrandt did not acquire the house outright, but the contract contained a schedule for payment of the outstanding amount. The purchase price was 13,000 guilders.[41] This elegant merchant's house, dating from about 1606, had been converted about ten years earlier by the architect Jacob van Campen (1595–

69: The publication of the banns of Rembrandt and Saskia's marriage. Amsterdam, Gemeentearchief.

70: Anonymous drawing, c. 1636. Amsterdam, Gemeentearchief. View of the Binnen-Amstel looking towards the Kloveniersburgwal with the spire of the Zuiderkerk on the right. In the centre is Rembrandt's house in the Nieuwe Dolenstraat (no. 20). Behind the marked shutters is the Great Hall of the Kloveniersdoelen where *The Nightwatch* hung.

71: Balthasar Florisz. Detail of the town plan of Amsterdam showing the 'Suyckerbakerij' on the Binnen-Amstel, where Rembrandt lived from 1637 to 1639. Amsterdam, Gemeentearchief.

1657)[42] and had been on the market for some time.[43] Rembrandt was able to move into the property on 1 May 1639, and was once again in a choice residential area.

The Sint-Anthonisbreestraat was familiar territory to the painter. In 1624 he had lodged there as a pupil of Pieter Lastman[44] and since 1631 had been a regular guest at the house of Hendrick Uylenburgh. They both lived close to the lock around which part of the Amsterdam art trade centred (Fig. 73). At the beginning of the street stood the Sint-Anthonis weighhouse, the headquarters of the St Luke guild since 1619, where Rembrandt's *Anatomy Lesson of Dr Tulp* hung in the surgeons' guild chamber. From an early date Flemish painters such as Jaques Saverij (c.1566–1603) and his brother Roelant Saverij (1578–1639)[45] had settled in the first section of the street, together with Joos van Meerle (1578–before 1614)[46] and David Vingboons (1576–1632).[47] We also find that Dirck Santvoort (1610–1689) and Jan Tengnagel lived by the lock until about 1620.[48] In the newest section of the street beyond the lock we find Adriaen van Nieulant (1587–1658),[49] Cornelis van der Voort (1576–1624)[50], and Nicolaes Eliaszn Picquenoy (1588–1650/56).[51] In about 1605, Pieter Isaacszn (1569–1625) had a large house built[52] at the lock and in the vicinity of the new Sint-Anthonis Gate Werner van den Valckert (c.585– after 1627), Pieter Codde (1599–1678), François Venant (1590–1636), Pieter Potter (1597–1652)[53] with his son Paulus Potter (1625–1654) and most probably also Thomas de Keijser (1597–1667)[54] were all tenants of the regents of the Leper House.

We know the residents from two large-scale militia paintings: one of 1613 by Jan Tengnagel[55] and one of 1637 of the '*Meagre Company*' by Frans Hals (1582/83–1666) and Pieter Codde. The painters in the Sint-Anthonisbreestraat excelled in the production of militia paintings and other group portraits. At the time Rembrandt was apprenticed to Pieter Lastman in 1624, the latter's brother was engaged on a militia piece.[56] When this genre reached its apotheosis in the decoration of the great hall of the Kloveniersdoelen, the painters of the neighbourhood received a large proportion of the commissions. Rembrandt's purchase of the Rembrandt House may have been connected with the commission for the painting of *The Nightwatch*.[57]

Rembrandt was earning large sums at this time. For a portrait of the later mayor Andries de Graeff (1611–1678) he received 500 guilders. This was also the price paid for double portraits and Rembrandt was still able to command it for his work in the 1650s.[58] Nevertheless Rembrandt

was not at the very top of the price league for portraits, since Bartholomeus van der Helst (1611–1670) surpassed him in 1652 by agreeing a price of 1,000 guilders with Pieter van de Venne (1623–1666) for a painting of Venne with his wife and young son.[59] Rembrandt on the other hand received an average of 100 guilders per portrait for the painting of *The Nightwatch*, while in 1633 Frans Hals had made do with 60 guilders a portrait for painting the '*Meagre Company*'.[60]

In order to be able to make the down payment of 1,200 guilders on the house in the Sint-Anthonisbreestraat, Rembrandt was forced to insist on payment from Prince Frederik Hendrik for the two passion paintings he had delivered to him, the *Entombment* and the *Resurrection*. He received 1,200 guilders for these, but in 1646 was to receive double that amount for a *Nativity* and a *Circumcision of Christ*.[61]

Rembrandt's *Nightwatch* (Fig. 58), his most famous painting, is a group portrait of sixteen citizens led by their captain Frans Banninck Cocq (1605–1655) and Lieutenant Wilhem van Ruytenburch (1600–1652). It owes its world renown to the unusual arrangement of the militiamen in the composition. *The Nightwatch* represented the culmination of an Amsterdam tradition of militia paintings more than a century old. Up to then it had been customary as far as possible to represent all the members of the company the same size in order to stress their equality. The story that the militiamen in *The Nightwatch* were unhappy about their unequal treatment is a later invention unsupported by any source.[62]

The name *Nightwatch* by which the painting is now known to the public at large, has nothing to do with a nocturnal patrol in the city. The reason for this name was that the painting quickly darkened due to inferior layers of varnish and the accretion of dirt, causing it to look like a night painting and making certain portraits indistinct. Restorations since the Second World War have once again revealed to visitors the original colours of the painting in all their splendour.

Four children were born to Rembrandt and Saskia, the two youngest in the Rembrandt House. None of the first three lived beyond the age of two months, but the last-born, Titus (Fig. 74), survived. In the summer of 1642, at the age of nine months, Titus lost his mother. In general, widowers with small children remarried quite quickly, but Rembrandt departed from that practical custom.

In 1615 Frans Hals had been left with two small children, the eldest under four, in similar circumstances. He soon found a nurse for the children and married her at the beginning of 1617.

Nine days after the wedding their first child was christened.[63]

Geertje Dircks (1600/10–1656?) joined Rembrandt's household as a dry nurse for Titus. It is not inconceivable that she arrived during Saskia's illness. Geertje's attentions appear to have extended from little Titus to his widowed father, who subsequently treated her as a common-law wife.

Although both Frans Hals and Rembrandt engaged in extramarital sexual relations, this was contrary to expectations given the prevalent morality of the time. In 1642 Rembrandt was a wealthy and famous artist, who could easily have found a suitable new wife. In 1647 his fortune was estimated at 40,750 guilders[64]. The fact that he was bound to transfer half their joint assets to Titus on remarriage cannot have been a problem at the time. If money had been a consideration, he could easily have indemnified himself by looking for a wealthy wife; his status was quite high enough. The affair with the *femme fatale* Geertje Dircks did nothing to help Rembrandt's social standing. Relations with the Mennonite Hendrick Uylenburgh must have cooled dramatically and for ten years there were no more portrait commissions.

The twenty-year-old Hendrickje Stoffels (1626–1663) probably left Bredevoort for Amsterdam to go into service in about 1647 (Fig. 75). Her parental home had been broken up in January 1647 when her mother remarried and was charged with the care of a widower's three small children ranging in age from one to five.[65] Quite soon Hendrickje Stoffels found work in the Sint-Anthonisbreestraat, where she was to prove a formidable rival for Geertje Dircks who was probably some twenty years her senior.

In June 1649 Geertje Dircks and Rembrandt separated with considerable acrimony. Rembrandt had offered his ex-servant a maintenance allowance of sixty guilders a year, but Geertje played her trump card by accusing the painter of breach of promise before the Commissioners of Marital Affairs. A promise of marriage was considered binding at the time, but Geertje Dircks knew perfectly well that she had no chance at all of her petition to marry the painter being granted; the social gap between them was far too great. Accordingly her main aim was not marriage but an improvement in her alimony, with which Rembrandt had been none too generous. Rembrandt offered to increase the amount to 160 guilders, but according to the 'marital disputes register' was finally sentenced to pay an annual allowance of 200 guilders. After that things took a still more unpleasant turn as Rembrandt showed

72: Reconstruction of Rembrandt's house in the Sint-Anthonisbreestraat in Rembrandt's time after the renovationn of c.1627 by Jacob van Campen. Note the goods hatches in the loft and the lower cellar (which was jacked up only in 1661).

73: Detail from a map of the city by Balthasar
Floriszn., 1625

The Staalhof where *The Staalmeesters*
(Cat. No. 48) hung

Sint-Anothonisbreestraat no.59*
Jonas van Meerle (1578–c.1614)
Pieter Lastman (1583–1633)
Claes Lastman (1586–1625)

Sint-Antonisbreestraat no. 81*
Owned by Anthonie Waterloo (c.1610–1690)

Sint-Anthonis Lock*
Jan Tengnagel (1584–1635) lived nearby

Jodenbreestraat no. 2*
Cornelis van de Voort (1576–1624)
Hendrick Uylenburgh (c.1587–1661)
Nicolaes Eliaszn. Pickenoy (1588–1650/56)

Zwannenburgerstraat no. 41*
The former 'Suyckerbackerij' on the
Binnen-Amstel
Rembrandt's home from 1637 to 1639

Jodenbreestraat no. 2–4*, The Rembrandthuis
Rembrandt's home from 1639 to 1658

Jodenbreestraat no. 13*
Joes Goeimare (1575–1610)

Houtkopersgracht no. 25
Ephraim Bueno (1599–1665)

Houtgracht no. 33–37
The Synagogue 'Talmud Tora' 1639

The Leper House

Sint-Anthonisbreestraat*
Werner van de Valckert (c.1585–c.1627)
François Venant (1590–1636)
Thomas de Keijser (1597–1667)

Sint-Anthonisbreestraat (Leper House)*
Pieter Potter (1599–1652)
Paulus Potter (1625–1654)

The new Sint-Anthonis Gate

Sint-Anthonisbreestraat (Leper House)*
Pieter Codde (1599–1678)

Jodenbreestraat no. 23
Nicolaes Bambeeck (1596–1661) and
Agatha Bas (1611–1658) (Cat. No. 34 & 35)

Jodenbreestraat no. 5*
Adriaen van Nieulant (1587–1658)

Jodenbreestraat no. 1
built around 1605 for the painter
Pieter Issacxzn; Jan Pellicorne (1597–1651?)
and Susanna van College (1606–1637)

Grimburgwal
Aletta Adriansdr. (1591–1656) and her
daughter Maria Trip (1619–1683)

Nieuwe Doelenstraat no. 20*
Rembrandt's home from 1635 to 1637

The Kloveniersdoelen
where *The Nightwatch* (Fig. 58) hung

Kloveniersburgwal no. 103
Jan Six (1618–1700) (Fig. 60)

Kloveniersburgwal no. 105
Floris Soop (1604–1657)
The Standard Bearer (Fig. 26a)

The Zuiderkerk
where Rembrandt's children were buried

Sint-Anthonisbreestraat no. 53, 'Kronenburg'*
Pieter Isaacxzn. (1569–1625)
Hendrick Uylenburgh

Sint-Antonisbreestraat no. 60*
Dirck Santvoort (1610–1680)

O.Z.Achterburgwal nr 173
Cornelis Claeszn. Anslo (1592–1646)
and his wife Aeltje Gerritsdr.
Schouten (1598–1657) (Cat. No. 33)

Nieuwe Hoogstraat no. 9
Maerten Soolmans (1613–1641) and his wife
Oopjen Coppit (1611–1689) (Cat. No. 17 & 18)

Sint-Antonisbreestraat no. 40*
David Vingboons (1576–1632) and his sons,
the architects Philips Vingboons (1607–1678)
and Justus Vingboons (1621–1698)

Kloveniersburgwal no. 29, The Trippenhuis
Jacob Trip (1575–1661) and his wife
Margaretha de Geer (1583–1672) (Fig. 77 & 78)

Kloveniersburgwal no. 27
Joannes Wtenbogaert (1608–1680)

Koestraat no. 13*
Jan van de Capelle (1626–1679)

Start of Sint-Anthonisbreestraat*
Jaques Saverij (c.1566–1603)
Roelant Saverij (1578–1639)

Koningsstraat no. 27
Willem Duyster (1599–1635)
Symon Kick (1603–1652)

The Sint-Anthonis Weighhouse
St Luke's and Surgeons' Guild Halls
where *The Anatomy Lesson of Dr Tulp* (Fig. 56)
and *The Anatomy Lesson of Dr Deyman*
(Cat. No. 44) hung

Geldersekade no. 119
Abraham Wilmerdoncx (1604–c.1668)
Anna van Beaumont (1607–1686)

*indicates a painter's address

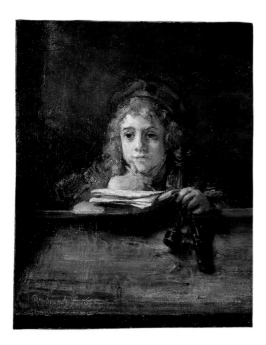

74: Rembrandt, *Titus*
Rotterdam, Museum Boymans-van Beuningen.

75: Rembrandt, *Hendrikje at a window*. Drawing.
Stockholm, Nationalmuseum.

his worst side by engineering Geertje Dircks's detention at his expense in the Gouda house of correction for women, after she had pawned jewellery belonging to Saskia in her possession.[66]

In the summer of 1654 Hendrickje Stoffels was found to be pregnant. This news reached the ears of members of the church council, who summoned her to answer the charge that she had 'given herself over to harlotry with Rembrandt the painter'; not because the church classed her as a prostitute, but because she had indulged in nonmarital sex, which it severely condemned.[67] Rembrandt, not being a member of the Calvinist church, was not censured by them. After her appearance Hendrickje was urged to repent and was denied Holy Communion. However, when their daughter Cornelia was christened on 30 October 1654 in the Oude Kerk, she was simply entered in the baptismal register as the child of Rembrandt van Rijn and Hendrickje Stoffels, without any indication of her illegitimacy.[68] A subsequent marriage could have annulled this offence against church ordinances, but once again Rembrandt did not marry.

There was no question of a marriage between Rembrandt and Hendrickje Stoffels in the autumn of 1654, because the painter was not in a position to assign the 20,000 guilders or more due to his son Titus before the Orphans' Chamber. He no longer had the funds for this and without the authorisation of Saskia's family for the winding up of the estate, a second marriage could not proceed.

Furthermore, Rembrandt was having some problems with the house, for which he had still not paid in full. In January 1653, the owner had forced him to arrange for the transfer of the property. Only 6,000 of the purchase price of 13,000 guilders had been paid, and the owner had not received a penny since 1649. He wished the outstanding sum to be repaid with interest. Subsequently Rembrandt took out a number of loans totalling 9,380 guilders. He could easily have paid the remainder from this loan, but since he had other debts, the transfer was not concluded until December 1654, with a mortgage on the final 1,137 guilders.[69]

During the re-modelling of the adjoining house in the spring of 1653, Rembrandt had stubbornly resisted paying his share of the cost of shoring up the house, with which he shared a party wall.[70] For months he was prevented from painting because of the demolition, sawing, carpentering and bricklaying and the only known painting from 1653 is his *Aristotle*, now in New York, for which he was to be paid 500 guilders on delivery in the summer of 1654.[71] The painter must have

had very little income, and had difficulty in laying hands on liquid funds. Even the collection of his outstanding debts cannot have gone smoothly in 1653.[72] Rembrandt was forced to absent himself from the famous St Luke celebrations of 1653 and 1654, possibly because of his financial worries.

Rembrandt had not invested his fortune in houses, land and securities, as was the customary pattern among Amsterdam merchants, but like Hendrick Uylenburgh had used it principally for his art dealing: paintings, drawings, prints, curiosities, antiquities and *objets d'art*, often acquired for large sums. Unlike Rembrandt, Uylenburgh lived in rented accommodation. In 1647 the inventory of Rembrandt's goods and effects had taken two months to complete and his joint assets with Saskia were calculated at 40,750 guilders.[73] According to a completely different source from 1659 the value of his paintings was put at 6,400 guilders and that of his prints and drawings, curiosities, antiquities, medals and marine flora and fauna at 11,000 guilders.[74] Rembrandt was unable to raise enough cash on these items from his art business either to pay off the outstanding amount on his house in 1653 or in the following year to assign Titus his rightful share in the family's property.

There is some evidence that at the end of 1654 Rembrandt tried to cut his coat according to his diminishing cloth. In an attempt to move into more modest accommodation, he offered 7,000 guilders for a recently-built house in the Handboogstraat, of which 4,000 could be borrowed at interest and the rest paid in paintings and prints. The neighbouring house in the Handboogstraat had been sold in April 1654 for 7,200 guilders to the Dordrecht painter Adriaen van Eemont (1627–1662); 4,000 was borrowed at interest, 500 paid for in hats and the remaining 2,700 in paintings. Money was obviously a scarce commodity in 1653 and 1654. Rembrandt's purchase finally fell through, however; probably because he could not arrange a mortgage.[75]

Another attempt to raise cash was a personally organised five-week sale of his possessions in the Keizerskroon inn in the Kalverstraat.[76] When this failed to yield a sufficient return, Rembrandt was forced to acknowledge the gravity of the situation and in June 1656 applied to the Supreme Court in The Hague for a *cessio bonorum*. This surrender of his property put him in the hands of the Chamber of Insolvent Estates, which took charge of further proceedings. He had given the reason for his unhappy circumstances as 'losses in business, as well as damage and losses at sea'.[77] The expression 'losses at sea' may strike one as rather odd in relation to Rembrandt. It did not mean that he

had become involved in overseas trade, but that he occasionally sent works of art abroad by sea, like the *Aristotle*, which was shipped to Messina in Sicily in 1654.[78]

For a better understanding of Rembrandt's financial debacle, a comparison with the liquidation of the renowned international art dealership of Uylenburgh in 1675 may prove illuminating. Gerrit Uylenburgh (c.1625– after 1677), who had continued his father's art business, had got into difficulties in 1672 when a consignment of Italian works of art worth 30,000 guilders for the Elector of Brandenburg was not accepted for delivery. Shortly afterwards the Third Anglo-Dutch War (1672–1674) broke out and at a personally organised sale in February 1673 the paintings did badly, since Amsterdam merchants and regents were not investing in expensive works art at the time. A year later Gerrit Uylenburgh was insolvent.[79] Rembrandt's surrender of his estate had taken place shortly after the end of the First Anglo-Dutch War (1652–1654). Hendrick Uylenburgh had also had financial problems in 1654 and for two years could not pay his rent arrears of 1,400 guilders to the city.[80] 'These troubled times and the miserable condition of our "beloved country"' which Gerrit Uylenburgh saw as the cause of his problems, had already affected the art trade during the First Anglo-Dutch War.

The Calvinist church took a different view of insolvency from that of the state: in judging the severity of the sin it made a careful distinction between insolvency (*faillissement*) and bankruptcy (*bankroet*). In the latter case the emphasis was on deceit and fraud, while with insolvency one had got into difficulties through no fault of one's own. However, the manner in which insolvency was dealt with could still lead to someone being branded a bankrupt. There were two possible ways of satisfying creditors. In the first place one could try to come to an arrangement with them and agree a schedule of repayment, preferably to the last penny. The second option was to surrender one's property so that the creditors were faced with a *fait accompli* and were assigned a share. This second option was not favoured by the church, which watched carefully to see that no goods were withheld from the liquidation and all creditors were satisfied.[81]

By church standards the way in which Rembrandt's insolvency was handled cannot have been considered honourable. Even before his application for *cessio bonorum* he had tried to withhold the house in the Sint-Anthonisbreestraat by assigning it to his son Titus in the Orphans' Chamber as unencumbered. Litigation on this matter was to drag on until 1665.[82]

Rembrandt did not come to an arrangement but surrendered his property. After all the liquidation sales were completed, Rembrandt entered into a contract with Titus and Hendrickje Stoffels setting up a company trading in paintings, prints and drawings, copper and wood engravings, and curiosities, of which the artist became an employee. The contract was so worded that he could no longer be sued by any of his dissatisfied creditors for recovery of debts.[83] It was clear that he would not be paying out another penny. Although he was not a member of the church, his behaviour made him a bankrupt in the eyes of society. A man like Jan Six (1618–1700), who is often regarded as one of Rembrandt's patrons, distanced himself and disposed of the bond that he held for 1,000 guilders against the artist,[84] although he was not in need of the money.

The Mennonites were equally strict on this point. When the son of the teacher and textile buyer Cornelis Claeszn Anslo (1592–1646) got into difficulties in 1643, his father had repaid the 60,000 guilders to his creditors, on the grounds that:[85]

'I am a preacher who teaches in order to show others their duty, and exhort them in accordance with Matthew 7:12 to do unto others as they would have others do unto them, that being the law and the word of the prophets; and shall I then constantly provoke in the minds of my congregation the same reproach to my head and heart, "do yourself what you teach others"? No! I do not want this (although I am not bound to pay) to make what I preach to ring fruitlessly hollow or lose any of its force.'

The son of the well-known Catholic poet Joost van den Vondel (1587–1679) also became insolvent some months after Rembrandt. His father was appointed as receiver and paid some 40,000 guilders of his own money to settle his son's debts. This did not discharge them completely, but his son's honour was saved and Vondel had managed to keep him out of the books of the Chamber of Insolvent Estates. Vondel himself, however, was completely ruined. To save him from penury in his old age a number of influential Amsterdammers secured him a post as an attendant at the city pawnshop at an annual salary of 650 guilders.[86]

In general, traders who could not completely satisfy their creditors would retire from the city and only return when rehabilitated. As a good Mennonite, Gerrit Uylenburgh left Amsterdam after being declared insolvent and went to London. Rembrandt on the other hand remained in Amsterdam.

Things proceeded very differently in Rem-

brandt's case. After his referral to the Chamber of Insolvent Estates an inventory was immediately drawn up of his paintings, furniture and household effects. Not all the rooms were described, and his painting and etching equipment, clothing and kitchenware are among items missing from the inventory. For the purpose of the inventory the paintings were placed downstairs, where they were described according to Rembrandt's instructions. Consequently this inventory does not give us a picture of what the house was like when the painter lived there.[87] Moreover, much of the property had disappeared.

The works of art subsequently came under the hammer at various auctions in the Keizerskroon inn. The house followed on 1 February 1658 in the Oudezijds Herenlogement inn and in April the furniture and household effects went to the *Lommert* (pawnbroker's) for sale. A minor tragedy was added to the greater one. At the furniture sale Titus had managed to buy back out of his own savings a costly mirror with an ebony frame, which Rembrandt may have needed for his self-portraits, but the mirror broke into pieces while being transported to the Sint-Anthonisbreestraat.[88]

Rembrandt must have left the Sint-Anthonisbreestraat before 1 May 1658. He moved to the Jordaan district, where we find him at the end of the Rozengracht in a small house costing 225 guilders a year to rent (Fig. 76).[89] At that time there were quite a few painters based on the Rozengracht: almost next door lived Jan Beerstraten (1622–1666)[90] and on the other side of the canal in the 'Doolhof' (Labyrinth) Johannes Lingelbach (1622–1674).[91] Other residents included Carel du Jardin (1626–1678),[92] Reijnier Zeeman (1623–1664),[93] François van Hillegaert (1621–1666),[94] Nicolaes Roosendael (1635–1686),[95] Anthony van Borssom (1631–1677),[96] Ludolph Backhuysen (1631–1708)[97] and Jacob Esselens (1626–1687),[98] together with the art dealers Lucas Luce (1575–1661)[99] and Lodewijck van Ludick (1607–1669),[100] while the Uylenburgh art business had moved opposite the Rozengracht on the Prinsengracht.[101] In a document of 1664 Rembrandt's address is given as the Lauriergracht.[102] This must be a mistake, probably caused by the renown of Govert Flinck's '*schilderhuis*' (Painter's House) on the Lauriergracht,[103] near where the painters Pieter de Hooch (1629–1684)[104] and Gabriel Metsu (1629–1667) lived.[105] Joost van den Vondel had also found a modest house on that stretch of the Prinsengracht.[106]

In the quarter of a century that Rembrandt lived in Amsterdam a number of social shifts had

76: Detail from a map of the city by Balthasar Floriszn., 1625

A number of houses, including Flinck and Rembrandt's later ones, had not yet been built in 1625

*indicates a painter's address

The Schouwburg

Konijnenstraat*
Pieter de Hoogh (1629–1684)

Prinsengracht on the corner of the Berenstraat
Joost van den Vondel (1587–1679)

Prinsengracht no. 272*
Jan Basse (1571–1637)

Lauriergracht no. 25*
Isaac Luttichuys (1615–1673)

Prinsengracht, between no. 361 and 371*
in the passage of the 'Gecroonde Hert'
Brewery: Gabriel Metsu (1629–1667)

Reestraat no. 4*
Jan Bloem (1622–1674)
leased in 1662 to Johannes Lingelbach

Keizersgracht no. 224, 'Saxenburgh'
Christoffel Thijs (1603–1680)

Prinsengracht no. 283
The dealer's shop of Henrick Uylenburgh
(c.1587–1661) and Gerrit Uylenburgh
(c.1625–after 1677), before 1660

Keizersgracht no. 209
Mr. Gerrit Reijnst (1599–1658)

Keizersgracht no. 210
Dr Nicolaes Tulp (1593–1674) (Fig. 56)
Jan Six (1618–1700) (Fig. 60) lived with
his father-in-law for some time

Keizersgracht no. 208
Dr Arnout Tholincx (1607–1679)

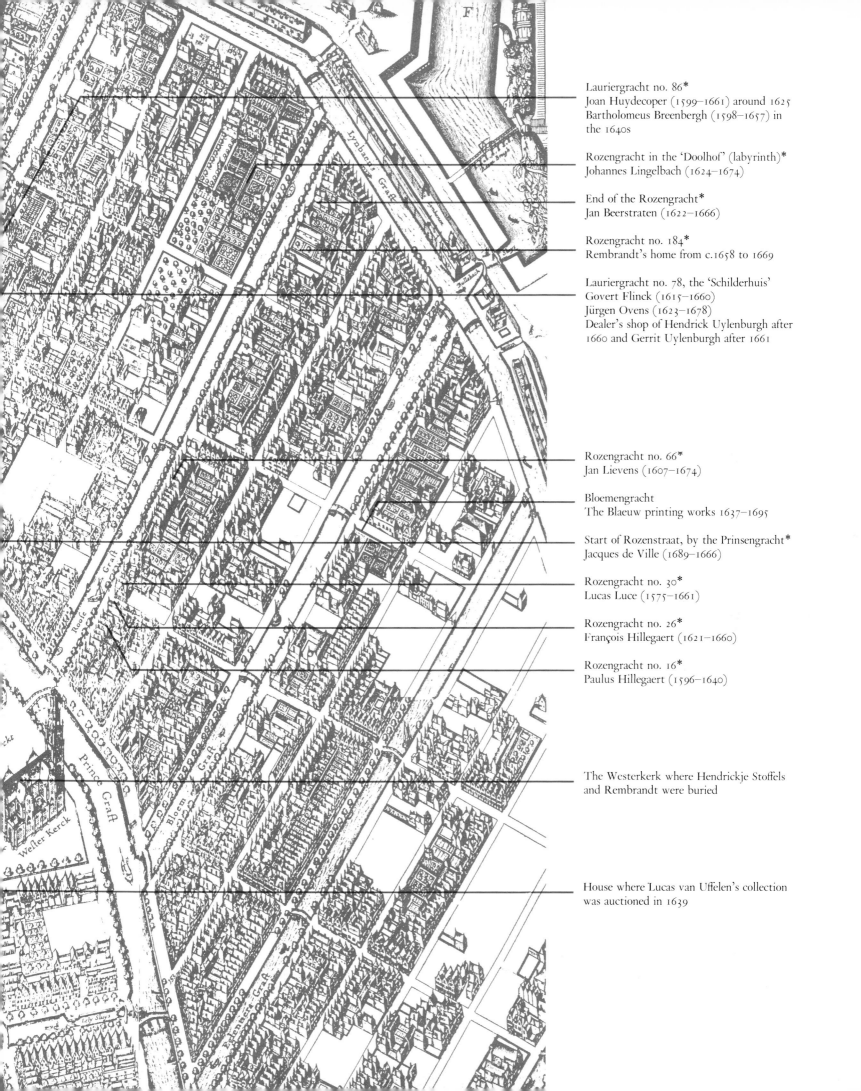

Lauriergracht no. 86*
Joan Huydecoper (1599–1661) around 1625
Bartholomeus Breenbergh (1598–1657) in
the 1640s

Rozengracht in the 'Doolhof' (labyrinth)*
Johannes Lingelbach (1624–1674)

End of the Rozengracht*
Jan Beerstraten (1622–1666)

Rozengracht no. 184*
Rembrandt's home from c.1658 to 1669

Lauriergracht no. 78, the 'Schilderhuis'
Govert Flinck (1615–1660)
Jürgen Ovens (1623–1678)
Dealer's shop of Hendrick Uylenburgh after
1660 and Gerrit Uylenburgh after 1661

Rozengracht no. 66*
Jan Lievens (1607–1674)

Bloemengracht
The Blaeuw printing works 1637–1695

Start of Rozenstraat, by the Prinsengracht*
Jacques de Ville (1689–1666)

Rozengracht no. 30*
Lucas Luce (1575–1661)

Rozengracht no. 26*
François Hillegaert (1621–1660)

Rozengracht no. 16*
Paulus Hillegaert (1596–1640)

The Westerkerk where Hendrickje Stoffels
and Rembrandt were buried

House where Lucas van Uffelen's collection
was auctioned in 1639

77: Rembrandt, *Jacob Trip*. c. 1661.
London, The National Gallery.

78: Rembrandt, *Margaretha de Geer*. c. 1661.
London, The National Gallery.

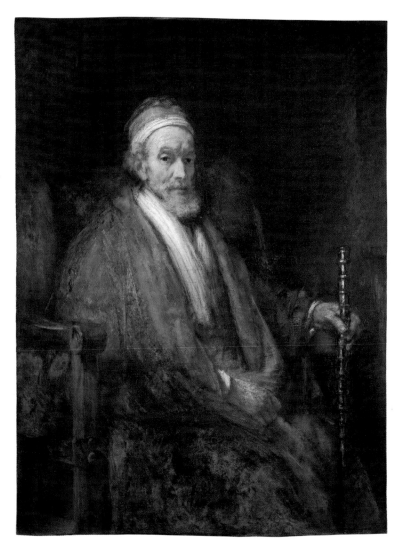

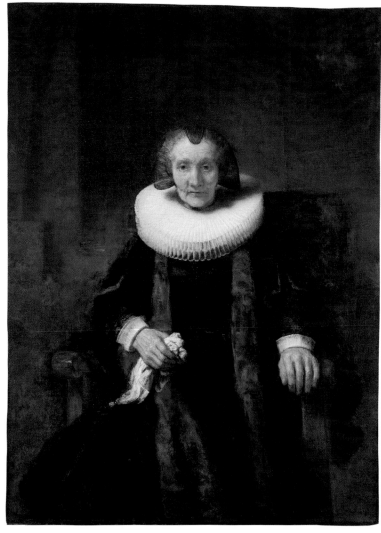

taken place in the city. Many prosperous merchants and regents had moved from the old town centre into the new districts on the Herengracht and Keizersgracht. It was this concentration of the town's élite that represented the potential market for art. The places vacated in the Sint-Anthonisbreestraat were mostly occupied by Portuguese Jews, which eventually led to the street becoming known as the 'Jodenbreestraat' (Jews' Broad Street). A number of Portuguese Jews were in the tobacco trade and Rembrandt had let out his cellars and possibly part of his loft for the storage of bundles of tobacco.[107] Hendrick Uylenburgh had moved his art business to the canal ring even before 1647.[108] Rembrandt was

one of the last painters to move to the new artists' quarter in the Jordaan.

At the time of Rembrandt's arrival in the Jordaan, Govert Flinck was the most acclaimed painter in the city. In about 1633 he had found employment with Hendrick Uylenburgh, and had met Rembrandt. After Rembrandt's departure from Uylenburgh's shop Flinck stayed on as master painter. He was given the portrait commissions previously executed by Rembrandt.[109] In the 1640s Uylenburgh may have continued to refer his clients to Flinck, who had moved to the Jordaan in 1644. Meanwhile Flinck had managed to free himself from Rembrandt's style of painting and had begun working in a more

Italianate manner better attuned to changed public taste and in 1655 ideal for the decoration of the new Town Hall on the Dam. In addition Flinck was on very good terms with the De Graeff family, which at the time occupied the highest offices in the city. Thanks to this connection Flinck was commissioned to produce two chimney-pieces at 1,500 guilders apiece, and in 1659 to secure the commission to paint the twelve lunettes in the gallery for 12,000 guilders. This meant that Rembrandt had missed the largest artistic commission in the city. Two months later Flinck was dead and Hendrick Uylenburgh moved his art business into the *Schilderhuis* on the Lauriergracht.

After Flinck's death the town councillors were hesitant to award the large commission to a single artist. Ultimately it was shared among a number of painters. Possibly Rembrandt had put in a bid for a chimney-piece called *Moses and the Tablets* for the Aldermen's Chamber as early as 1659,[110] for which the commission finally went to Ferdinand Bol. In 1661 Rembrandt was given a chance to paint one of the lunettes with *The Conspiracy of Claudius Civilis*. This enormous painting, measuring 6 m × 6 m was in all probability painted *in situ*, because it is mentioned as being there in the summer of 1662.[111] A few months later the huge canvas was removed and Jürgen Ovens (1623–1678) was commissioned to complete Govert Flinck's sketch. At the time Ovens worked for Uylenburgh's art business. Rembrandt was disillusioned and had earned nothing from the town hall.

We know only a few clients by name from the last years of Rembrandt's life: the Trip family (Figs. 77 & 78),[112] the Syndics of the Clothmakers' Guild [113] and Frederick Rihel (1621–1681, Fig. 103),[114] but the identity of whoever commissioned the *Jewish Bride*, the Brunswick *Family Group* and a number of important portraits remains unknown. Their names might give us an insight into who supported the painter in his final period.

After the Town Hall fiasco, poverty forced Rembrandt to sell Saskia's grave in the Oude Kerk, which had been excluded from the insolvency proceedings.[115] The following year there was a severe outbreak of plague which claimed 1,752 lives in 1663 alone, including that of Hendrickje Stoffels who died in July. She was not buried in the paupers' graveyard in the Jordaan, but was given a respectable funeral in a rented grave in the Westerkerk. For Rembrandt things went steadily downhill. Soon he could no longer afford to pay his rent[116] and lived on his young daughter Cornelia's savings.[117] Meanwhile the epidemic flared up again and claimed many lives among his fellow-artists on the Rozengracht. In 1668 Rembrandt lost his son Titus, who had just married. Though a granddaughter, Titia, was born to Rembrandt the following year, he had become very isolated. His last paintings are a few self-portraits. Rembrandt died on 4 October 1669 and was buried four days later in an unknown rented grave in the Westerkerk.[118]

At the time of the launch of his professional career in 1631–32, Rembrandt made several portraits of himself in bourgeois clothes and wearing a hat (Fig. 79).[119] These are the only portraits of him featuring the status symbol *par excellence* of a gentleman: the hat.[120] His other self-portraits show him with a beret or painter's cap: in short as a painter (Fig. 63). In official documents he is invariably given the title 'Sr.' (sinjeur) or 'mr.'(meester [master painter]), as befits a tradesman from the prosperous middle class. Although his marriage, house and collections appear to point to upward social aspirations, he never realised them. He was never referred to as 'Heer' (a gentleman) during his lifetime and remained a painter-businessman who dealt in art. He does not fit the Renaissance ideal of the universal painter of the previous century. But then he had never wanted to go to Italy!

Huygens already stated that Rembrandt could 'vie with the greatest geniuses' and that he expected him soon 'to surpass them on the strength of his astonishing debut'. This was proved true ten or so years later when Orlers reported in 1641 'that he has become one of the most renowned painters of our time.' Towards the end of his life he was even known as *nostrae aetatis miraculum* (the wonder of our age).[121] His celebrity as a painter was a nice visiting card which maintained interest in his work, but Rembrandt also made use of his honorary title in a completely different way.

During his dispute in 1649 with Geertje Dircks Rembrandt had himself awarded the title of 'the Honourable and renowned painter Rembrandt van Rijn'.[122] It is the only time that he is described in this way in official documents, and his only conceivable intention must have been to make clear to the commissioners his superiority to his former servant. Did Rembrandt perhaps believe that his celebrity allowed him to take greater liberties than ordinary citizens? His attitude to Geertje Dircks, his fraudulent dealings,[123] and his sometimes arrogant behaviour with his clients[124] give some indication. Was he perhaps blinded by his great celebrity and did he not realise that society might close ranks against him when he broke social taboos as in his affair with Geertje Dircks (and later with Hendrickje Stoffels) and in his insolvency (or bankruptcy)? Social rejection was succeeded immediately after his death by rejection of his work by art critics.

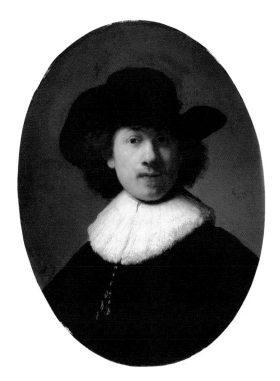

79: Rembrandt, *Self-portrait*. 1632. Panel. Glasgow, The Burrell Collection.

For Dr I.H. van Eeghen

With thanks to P.J.M. de Baar, Drs. Marten Jan Bok, Drs. J. Fox, Prof. Dr. E.O.G. Haitsma Mulier, Prof. E. Haverkamp-Begemann, Drs. Bas de Melker and Ir. H.J. Zantkuijl.

1. R.E.O. Ekkart, 'Familiekroniek Van Heemskerk en Van Swanenburg', *Jaarboek Centraal Bureau voor Genealogie* 32 (1978), pp. 41–70; 33 (1979), pp. 44–75.
2. A. Bredius and N. de Roever, 'Pieter Lastman en François Venant', *Oud-Holland* 4 (1886), pp. 1–23, esp. pp. 5–6. S.A.C. Dudok van Heel, 'De familie van de schilder Pieter Lastman (1583–1633)', *Jaarboek Centraal Bureau voor Genealogie* 45 (1991), [in print].
3. S.A.C. Dudok van Heel and J.H. Giskes, 'Noord-Nederlandse pre-Rembrandtisten en Zuid-Nederlandse muziekinstrumentmakers. De schilders Pynas en de luit-en citermakers Burlon en Coop', *Jaarboek Amstelodamum* 76 (1984), pp. 13–37.
4. S.A.C. Dudok van Heel, 'De schilder Claes Moyaert en zijn familie', *Jaarboek Amstelodamum* 68 (1976), pp. 13–48.
5. J.F. Jacobs, 'Rembrandt verwant aan Philips van Leyden', *De Nederlandsche Leeuw* 112 (1985), col. 457–65.
6. C. White (with annotations by H.F. Wijnman), *Rembrandt*, The Hague 1964, pp. 140–41, note 6.
7. C. Wilson, *Queen Elizabeth and the Revolt of the Netherlands*, London 1970, p. 23.
8. *Genealogisches Handbuch des Adels, Freiherrliche Häuser*. Vol. 4, Limburg an der Lahn 1967, pp. 266–75.
9. W.L. Strauss and M. van der Meulen, *The Rembrandt documents*, New York 1979, (hereafter referred to as *Documents*), 1640/9.
10. *Documents* 1641/8. The text has been modernised in this quotation.
11. Information from P.J.M. de Baar, archivist of the Leiden Municipal Archives. H.Wansink, *Politieke wetenschappen aan de Leidse Universiteit 1575–± 1650*, Utrecht 1981, pp. 24–32.
12. S.A.C. Dudok van Heel, 'Dr Nicolaes Tulp alias Claes Pieterszn. Deftigheid tussen eenvoud en grandeur', *Nicolaes Tulp, leven en werk van een Amsterdams geneesheer en magistraat*, Amsterdam 1991, pp. 41–120, esp. pp. 55–59.
13. C.L. Heesakkers, *Constantijn Huygens' 'Mijn Jeugd'*, Amsterdam 1987, pp. 84–89.
14. E. van de Wetering, 'Isaac Jouderville, a pupil of Rembrandt', *The Impact of a Genius. Rembrandt, His Pupils and Followers in the Seventeenth Century*, exhib. cat., Amsterdam 1983 (Waterman Gallery), pp. 59–69.
15. The collaboration between Rembrandt and Jan Lievens has given rise to the hypothesis that they shared a studio in Leiden. This is unsupported by any source. See P.J.M. de Baar, 'Rembrandt en zijn zg. atelier in de Muskadelsteeg', unpublished manuscript, Leiden Municipal Archives
16. Amalia gave birth to a daughter on 28 April 1632. See A.W.E. Dek, *Genealogie van het vorstenhuis Nassau*, Zaltbommel 1970, p. 80. *Documents* 1632/3.
17. *Documents* 1634/7.
18. Heesakkers, op. cit. (note 13), pp. 88–89. A.M.Th. Leerintveld, '"Tquam soo wel te pass": Huygens' portretbijschriften en de datering van zijn portret geschilderd door Jan Lievens', *Nederlandse portretten. Bijdragen over de portretkunst in de Nederlanden uit de zestiende, zeventiende en achttiende eeuw*, The Hague 1990, pp. 159–183 (*Leids Kunsthistorisch Jaarboek* 8).
19. Van de Wetering, op. cit. (note 14), p. 60.
20. E. van de Wetering, *Studies in the workshop practice of the early Rembrandt*, Amsterdam 1986, p. 58. Strictly speaking, this should be described as Uylenburgh's studio rather than Rembrandt's.
21. *Documents* 1631/4 and 1632/2.
22. J. Bruyn, 'A descriptive survey of the Signatures', *A Corpus of Rembrandt Paintings*, Dordrecht/Boston/Lancaster, I, pp. 53–59 and idem, 'A selection of signatures, 1632–1634', II, pp. 99–106. Hereafter referred to as *Corpus*.
23. See *Corpus*, II, A49, A50, C57, C58 (Jouderville), C59, C60 and C61. This model, with blonde, springy curls and the same physique as Rembrandt, does not appear in his work after 1632. The red velvet dress with gold brocade worn by some models (A38, A47 and A64 with C9 (Jouderville)) does not appear after 1632/33 and was probably a Leiden accessory. In Amsterdam Rembrandt could take his pick of far more elegant 'classical' costumes (A85 and A93).
24. S.A.C. Dudok van Heel, 'Abraham Anthoniszn Recht (1588–1664), een remonstrants opdrachtgever van Rembrandt', *Maandblad Amstelodamum* 65 (1978), pp. 81–88.
25. *Documents* 1634/10.
26. *Documents* 1635/1.
27. D.J. van der Meer, 'Ulenburg', *Genealogysk Jierboekje* 145 (1971), pp. 74–99, esp. p. 86 ff.
28. S.A.C. Dudok van Heel, 'Het 'Schilderhuis' van Govert Flinck en de kunsthandel van Uylenburgh aan de Lauriergracht te Amsterdam', *Jaarboek Amstelodamum* 74 (1982), pp. 70–90, esp. p. 71.
29. J.E. Elias, *De Vroedschap van Amsterdam 1578–1795*, Haarlem 1903–05, p. 222.
30. A. Blankert, *Ferdinand Bol (1616–1680), Rembrandt's Pupil*, The Hague 1982, pp. 22–24.
31. His last signed work is dated 1624 and his appointment as deputy sheriff took effect on 18 January 1625.
32. C. Tümpel, *Rembrandt*, Amsterdam 1986, pp. 101–31.
33. H.F. Wijnman, *Uit de kring van Rembrandt en Vondel*, Amsterdam 1959. S.A.C. Dudok van Heel, 'Doopsgezinden en schilderkunst in de 17e eeuw— leerlingen, opdrachtgevers en verzamelaars van Rembrandt', *Doopsgezinde Bijdragen* N.S., 6 (1980), pp. 105–23.
34. Dudok van Heel, op. cit (note 24). S.A.C. Dudok van Heel, 'Mr Joannes Wtenbogaert (1608–1680), een man uit remonstrants milieu en Rembrandt van Rijn', *Jaarboek Amstelodamum* 70 (1978), pp. 146–69. G. Schwartz, *Rembrandt; zijn leven, zijn schilderijen*, Maarssen 1984, pp. 149–54.
35. Schwartz, op. cit. (note 34), Chapters 12, 13 and 19.
36. I.H. van Eeghen, 'De portretten van Philips Lucas en Petronella Buys', *Maandblad Amstelodamum* 43 (1956), p. 116.
37. W.Ph. Coolhaas, *Het huis 'De Dubbele Arend'*, Amsterdam 1973, pp. 55–62.
38. A. Bredius, 'Rembrandtiana', *Oud-Holland* 28 (1910), p. 1–18, esp. p. 16. Not. H. de Wilde, N.A.A., No. 6458, akte 117, 1–9–1713: Inventory of Mr. Willem van Dam, director of the Dutch East India Company, resident in the Nieuwe Doelenstraat: In the reception room: 'A chimney-piece of the Three Kings by Rembrandt valued at 350 guilders' . In the large back room: 'A portrait by Rembrandt for the chimney-piece, 50 guilders', and 'A small portrait by Rembrandt, 30 guilders'.
39. I.H. van Eeghen, 'Waar woonde Rembrandt in zijn eerste Amsterdamse jaren?', *Maandblad Amstelodamum* 46 (1959), pp. 151–53. Recent research has shown that Jan Reyniersz.'s widow rented the house from Boreel only after Rembrandt had left.
40. *Documents* 1637/7 and 1639/2 and 6. In 1648 the eldest daughter, Anna van Baseroode (1627–1669), married François de Coster (1625–1653), who in 1653 was authorised by Rembrandt to collect his outstanding debts (see *Documents* 1653/14). The inventory of Anna's possessions of 20 February 1670 contains the item: 'A portrait (*conterfijtsel*) of an old woman by Rembrandt'. See C. Hofstede de Groot, *Die Urkunden über Rembrandt (1575–1721)*, The Hague 1906, p. 376, no. 313.
41. *Documents* 1639/1.
42. R. Meischke, 'De vroegste werken van Jacob van Campen', *Bulletin van de Koninklijke Nederlandsche Oudheidkundige Bond* 65 (1966), pp. 131–45, esp. pp. 143–45. The conversion can be dated at about 1627, the year in which Pieter Belten married Constantia Coymans, a member of the family of Van Campen's first client.
43. I.H. van Eeghen, 'Onze Lieve Heer op Zolder en het Rembrandthuis', *Maandblad Amstelodamum* 69 (1982), p. 31.
44. S.A.C. Dudok van Heel, 'Waar woonde en werkte Pieter Lastman (1583–1633)?', *Maandblad Amstelodamum* 62 (1975), pp. 31–36.
45. S.A.C. Dudok van Heel and M.J. Bok, 'De familie van Roelant Roghman', in: W.Th. Kloek, *De Kasteeltekeningen van Roelant Roghman*, Vol. 2, Alphen aan den Rijn 1990, pp. 6–14, esp. p. 11.
46. Dudok van Heel, op. cit. (note 4), p. 33.
47. Fr. Lammertse, Inleiding, in: *Het kunstbedrijf van de familie Vingboons, schilders, architecten en kaartmakers in de gouden eeuw*, exhib. cat., Amsterdam (Koninklijk Paleis) 1989, pp. 6–14.
48. Schwartz, op. cit. (note 34), p. 26. Dudok van Heel, *op. cit.* (note 3), p. 29.
49. I.H. van Eeghen, 'Over Rembrandt de schilder', *Maandblad Amstelodamum* 73 (1986), p. 23. Adriaen van Nieulant owned No. 5 Jodenbreestraat from 1614 to 1651.
50. N. de Roever, 'Drie Amsterdamse schilders (Pieter Isaaksz, Abraham Vinck, Cornelis van der Voort)', *Oud-Holland* 3 (1985), pp. 171–208, esp. pp. 187–204. Hans van der Voort sold the house on the corner of the Jodenbreestraat (No. 2) to Nicolaes Pauw on 5 March 1620 (see Kwijtschelding 40, fol. 145), after which Hans and Cornelis van der Voort rented the property from him.
51. S.A.C. Dudok van Heel, 'De schilder Nicolaes Eliasz. Pickenoy (1588–1650/56) en zijn familie. Een geslacht van wapensteensnijders, goud- en zilversmeden in Amsterdam', *Liber Amicorum Jhr. Mr. C.C. van Valkenburg*, The Hague 1985, pp. 152-160.
52. De Roever, op. cit. (note 50), pp. 152–60. No. 1 Jodenbreestraat.
53. J.G. and P.J. Frederiks, *Kohier van den tweehonderdsten penning voor Amsterdam, over 1631*, Amsterdam 1890, p. 36 (Venant and Codde). Thesaurie extra-ordinaris No. 281 (Verponding (Property Tax) 1650–1652), fol. 158–158f (Codde and Potter). G.J. Hoogewerff and J.Q. van Regteren Altena, *Arnoldus Buchelius' Res Pictoriae*, Th Hague 1928, p. 47.
54. A.W. Weissman, 'Het geslacht De Keyser', *Oud-Holland* 22 (1904), pp. 64–91, p. 80. The sale mentioned here took place in the Sint-Anthonisbreestraat near the new gate. See Archief Weeskamer, No. 960, 19 January 1629.
55. M. Carasso-Kok and J. Levy-van Halm (eds), in: *Schutters in Holland, kracht en zenuwen van de stad*, exhib. cat., Haarlem (Frans Halsmuseum) 1988, pp. 365–66, No. 185. In this painting Jan Tengnagel appears with

Adriaen van Nieulant and Hans van der Voort,
the first owner of the Rembrandt House.

56. A. Blankert and R. Ruurs, *Amsterdams Historisch Museum, schilderijen daterend van voor 1800, voorlopige catalogus*, Amsterdam 1975–79, pp. 168–70.

57. S.A.C. Dudok van Heel, 'De galerij en schilderloods van Rembrandt of waar schilderde Rembrandt de "Nachtwacht"?', *Maandblad Amstelodamum* 74 (1987), pp. 102–6. S.A.C. Dudok van Heel, *Dossier Rembrandt/ The Rembrandt Papers*, Amsterdam 1987, pp. 48–51.

58. *Documents* 1654/10, 1659/18, 1659/21 and 1661/5. S.A.C. Dudok van Heel, 'Het maecenaat De Graeff en Rembrandt', *Maandblad Amstelodamum* 56 (1969), pp. 150–55 and 249–53. S.A.C. Dudok van Heel, 'Rembrandt's dubbelportret van de koopman Abraham Wilmerdoncx en Anna van Beaumont', *Maandblad Amstelodamum* 74 (1987), pp. 88–89.

59. A. Bredius, *Künstler-Inventare, Urkunden zur Geschichte der holländischen Kunst des XVI. und XVII. Jahrhunderts*, 7 Vols, The Hague 1915–1922, pp. 402–4. Bredius's presentation of the document's content was incorrect. It is not a commission for the painting of a portrait, but an arrangement for payment after a dispute.

60. I.H. van Eeghen, 'Pieter Codde en Frans Hals', *Maandblad Amstelodamum* 61 (1974), pp. 137–40. I. van Thiel-Stroman, 'The Frans Hals Documents: Written and Printed Sources, 1587–1679', in: S. Slive, *Frans Hals*, exhib. cat., Washington/London/Haarlem 1989, pp. 371–414, p. 390, No. 75 and pp. 252–57.

61. *Documents* 1639/7 and 1646/6.

62. E. Haverkamp-Begemann, *Rembrandt: The Nightwatch*, Princeton 1982, pp. 7–8.

63. Van Thiel-Stroman, op. cit. (note 59), p. 376–77, Nos. 14, 23 and 24.

64. *Documents* 1659/12.

65. H. Ruessink, 'Hendrickje Stoffels, jongedochter van Bredevoort', *Kroniek van het Rembrandthuis* 89 (1989), pp. 19–24, esp. p. 22.

66. D. Vis, *Rembrandt en Geertje Dircx*, Haarlem 1965. H.F. Wijnman, 'Een episode uit het leven van Rembrandt: de geschiedenis van Geertje Dircks', *Jaarboek Amstelodamum* 60 (1968), pp. 103–18.

67. H. Roodenburg, *Onder censuur. De kerkelijke tucht in de gereformeerde gemeente van Amsterdam, 1578–1700*, Hilversum 1990, pp. 230 and 233.

68. *Documents* 1654/18. S.A.C. Dudok van Heel, 'Het buitenechtelijk kind of de blinde vlek bij de genealoog', in: E.W.A. Elenbaas-Bunschoten *et al.* (eds), *Uw Amsterdam*, Amsterdam 1987, pp. 165–86, p. 184.

69. *Documents* 1653/1,2,3,5,6,7,11,12 and 1654/20.

70. S.A.C. Dudok van Heel, '"Gestommel" in het huis van Rembrandt van Rijn. Bij twee nieuwe Rembrandt-akten over het opvijzelen van het huis van zijn buurman Daniel Pinto in 1653', *Kroniek van het Rembrandthuis* 91 (1991), [in press].

71. *Documents* 1654/10.

72. *Documents* 1653/14. After the death of François de Coster in the summer of 1653 Abraham Francen was appointed as his replacement in November 1653 (Documents 1653/17). See note 40.

73. *Documents* 1659/12 and 1662/14.

74. *Documents* 1659/14.

75. I.H. van Eeghen, 'Handboogstraat 5', *Maandblad Amstelodamum* 56 (1969), pp. 169–76. See also p. 168.

76. I.H. van Eeghen, '"De Keizerskroon", een optisch bedrog', *Maandblad Amstelodamum* 56 (1969), pp. 162–68.

77. *Documents* 1656/10.

78. *Documents* 1654/10, 1661/5 and 1662/11.

79. Dudok van Heel, op. cit. (note 28), pp. 81–87.

80. J.C. Breen, 'Topographische geschiedenis van den Dam te Amsterdam', *Jaarboek Amstelodamum* 7 (1909), pp. 101–207, esp. p. 162.

81. Roodenburg, op. cit. (note 67), pp. 377–81.

82. *Documents* 1656/6 and 1665/13.

83. *Documents* 1660/20.

84. *Documents* 1657/3.

85. I.H. van Eeghen, 'De restauratie van het voormalige Anslohofje', *Maandblad Amstelodamum* 56 (1969), pp. 199–205, esp. p. 202.

86. P. Leendertz jr., *Het leven van Vondel*, Amsterdam 1910, p. 320 ff.

87. *Documents* 1656/12. R.W. Scheller, 'Rembrandt en de encyclopedische verzameling', *Oud-Holland* 84 (1969), pp. 81–147. Too little account is taken of the commercial aspect of Rembrandt's collections. After his insolvency he resumed trading. See *Documents* 1660/20, and J. van der Veen, 'Zeventiende-eeuwse rariteitenverzamelingen te Amsterdam', unpublished diss., 1983, pp. 54–57.

88. *Documents* 1658/12.

89. I.H. van Eeghen, 'Het huis op de Rozengracht', *Maandblad Amstelodamum* 56 (1969), pp. 180–83. W. Hofman, 'Afbeeldingen van Rembrandt's sterfhuis', *Maandblad Amstelodamum* 56 (1969), pp. 184–88.

90. W.F.H. Oldewelt, 'De schilder Johannes Abrahams Beerstraten en zijn naaste familieleden', *Jaarboek Amstelodamum* 35 (1938), pp. 81–87. Beerstraten bought the house from the painter Jan Colaert.

91. D.C. Meijer, 'Het Oude Doolhof', *Oud-Holland* 1 (1883), pp. 119–35.

92. A. Bredius, 'De nalatenschap van Carel du Jardin', *Oud-Holland* 24 (1906), pp. 223–32.

93. When Reijnier Zeeman was buried at the Westerkerkhof on 31 August 1664 his address was given as the Rozengracht. See Begraafregisters Weeskamer (Archief 5004), No. 25.

94. Bredius, op. cit. (note 59), pp. 828–30. Thesaurie extra-ordinaris No. 284 (Verponding (Property Tax) 1647–1649), fol. 247 f.

95. Bredius, op. cit. (note 59), pp. 541–48.

96. Doop-, trouw- en begraafregisters Amsterdam, No. 495, fol. 397, 24 October 1670.

97. Bredius, op. cit. (note 59), pp. 100–1. During his third marriage Ludolph Backhuysen lived on the north side of the Rozengracht. See Archief Burgemeesters: Kohier 1674, fol. 388f, and D.T.B. No. 1102, fol. 71, 7 November 1678.

98. Bredius, op. cit. (note 59), pp. 549–56.

99. Bredius, op. cit. (note 59), pp. 1142–49.

100. Van Eeghen, op. cit. (note 85), p. 172.

101. Dudok van Heel, op. cit. (note 28), p. 78.

102. *Documents* 1664/6.

103. Dudok van Heel, op. cit. (note 28). On the other painters on the Lauriergracht, see p. 70.

104. P.C. Sutton, *Pieter de Hooch*, Oxford 1980, p. 147. On 22 November 1668 De Hooch's residence is given as the Konijnenstraat.

105. L. Stone-Ferrier, 'Gabriel Metsu's Vegetable Market at Amsterdam: Seventeenth-Century Dutch Market Paintings and Horticulture', *The Art Bulletin* 71 (1989), pp. 427–52.

106. I.H. van Eeghen, 'Vondel's huis op de Prinsengracht bij de Berenstraat', *Maandblad Amstelodamum* 54 (1967), pp. 158–61.

107. S.A.C. Dudok van Heel, 'In de kelder van Rembrandt. . . Bij een nieuw Rembrandt-document', *Kroniek van het Rembrandthuis* 90 (1990), p. 3–5.

108. Thesaurie extra-ordinaris No. 284 (Verponding (Property Tax) 1647–1649), fol. 232v. (north side of Nieuwe Leliegracht, now No. 12).

109. Van de Wetering, op. cit. (note 21), p. 58.

110. A. Blankert, *Kunst als regeringszaak in Amsterdam in de 17e eeuw. Rondom schilderijen van Ferdinand Bol*, Amsterdam 1975, p. 30.

111. *Documents* 1661/13 and 1662/6–15. I.H. van Eeghen, 'Wat veroverde Rembrandt met zijn Claudius Civilis?', *Maandblad Amstelodamum* 56 (1969), pp. 145–49.

112. S.A.C. Dudok van Heel, 'Het maecenaat Trip. Opdrachten aan Ferdinand Bol en Rembrandt van Rijn', *Kroniek van het Rembrandthuis* 31 (1979), pp. 14–26. I.H. van Eeghen, 'De familie Trip en het Trippenhuis', in: *Het Trippenhuis te Amsterdam*, Amsterdam/Oxford/New York 1983, pp. 27–125, p. 73 and p. 122, n. 105.

113. I.H. van Eeghen, 'De staalmeesters', *Jaarboek Amstelodamum* 49 (1957), pp. 65–80.

114. I.H. van Eeghen, 'Frederick Rihel, een 17de eeuwse zakenman en paardenliefhebber', *Maandblad Amstelodamum* 45 (1958), pp. 73–81. N.H. Schneeloch, *Aktionäre der Westindischen Compagnie von 1674. die Verschmelzung der alten Kapitalgebergruppen zu einer neuen Aktiengesellschaft*, Bamberg 1982, pp. 297–301.

115. *Documents* 1662/9.

116. *Documents* 1662/2.

117. *Documents* 1669/5.

118. I.H. van Eeghen, 'Het graf van Titus van Rijn', *Maandblad Amstelodamum* 76 (1989), pp. 123–26.

119. H. Perry Chapman, 'Rembrandt's "burgerlijk" self-portraits', in: *Nederlandse portretten. Bijdragen over de portretkunst in de Nederlanden uit de zestiende, zeventiende en achttiende eeuw*, The Hague 1990 (*Leids Kunsthistorisch Jaarboek* 8), pp. 203–15.

120. For the significance of headgear, see *The Anatomy Lesson of Dr Tulp*, in which only the lecturer wears a hat while the surgeons are bareheaded, and the *Syndics*, in which only the guild attendant is without a hat.

121. R. Schillemans, 'Gabriel Bucelinus and "The Names of the Most Distinguished European Painters"', *Mercury* 6 (1987), pp. 25–37, esp. p. 35.

122. *Documents* 1649/6–7.

123. *Documents* 1637/7 and the insolvency papers.

124. *Documents* 1662/12.

Rembrandt's workshop: its function & production

Josua Bruyn

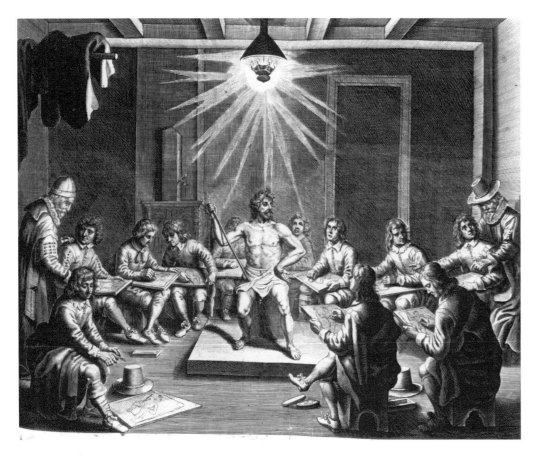

80: Crispijn de Passe the Younger, *Drawing from the life in the Utrecht Academy.* Engraving from *La Luce del dipingere. . .*, Amsterdam, 1643.

The highly individual fascination of Rembrandt's art does not make it any easier to realise that the century he lived in was in many respects still dominated by medieval views and customs. This was certainly true of the vocational training of young craftsmen including painters. In the Netherlands, as in many other countries, the old guild system was still in force, to be abolished only during the French Revolution. This meant that one had to be admitted as a master, pay fees, report the arrival of a new pupil, and, in general, fulfil obligations as laid down in the corporation's statutes. The local guilds protected the interests of their members; they controlled the number of masters active in the city (and thus the measure of competition), the number of pupils a master took on and they often instituted rules to guarantee the quality of the goods produced. In these respects the position of the painters did not differ from that of other craftsmen. It is true that the notion of the superiority of the artist's creative gift over purely manual or mechanical crafts was not totally lacking. Recognition of the artist's *ingenium*, or natural talent, had originated in fourteenth-century Italy and had gained ground during the High Renaissance. Artistic theory, based on antique manuals of rhetoric, had added to the respectability of the *arte del disegno*— the art of designing—and painters as well as sculptors and architects had occasionally been held in high esteem, especially if they worked for popes and princes.

The dual function of the seventeenth-century workshop
Yet the impact of this appreciation of the artist's natural gifts on his social prestige in the Netherlands should not be overrated.[1] The position Rubens held in Antwerp as a courtier-painter and diplomat was quite unique. In general, the power of the local guilds was unbroken and the socio-economic framework in which the seventeenth-century painter found himself remained little changed. His workshop continued to serve two purposes: the training of young painters which ensured the continuity of the craft, and the production of works either for the free market or for individual patrons. This is not to say that all painters enjoyed equal status. On the contrary, financial success and social distinction, closely bound up with one another, fell to the lot of only a few. Rembrandt's career may be seen as an illustration of Fortune's fickleness in this respect. Other artists are known to have lived in modest circumstances, or to have earned their living by practising other trades.

The information available on the operation of the seventeenth-century painter's workshop is

relatively scanty and mostly circumstantial. As is usually the case, traditional procedures were taken for granted and never received a full description. Guild archives have often survived only incompletely or, as in Amsterdam, hardly at all. Recent studies of apprenticeship contracts, of which only a small number have come down to us, have however yielded valuable insights.[2] Owing to the considerable fee to be paid and the duration of the training, the young painter's apprenticeship was a costly affair and the choice of the painter's profession was certainly not within everybody's reach.[3] The fee agreed on by the contracting parties—the master and the pupil's parent or his guardian—reflects in some instances clearly the fact that during the first years the pupil was considered an item of loss for which the master had to be compensated. After that period of some three or four years, when the pupil had reached the age of about sixteen, the youngster was supposed to have become an asset; he could now take his share in the production of the studio and his tuition-fee would go down correspondingly. The position of the pupil, first that of an apprentice (leerjongen, or just jongen), then of an assistant or collaborator (knecht or, occasionally, jonggezel),[4] thus illustrates the dual function of the workshop under the régime of the guilds—providing training and producing pictures. In particular where painters are concerned, it seems to have been fairly common that after having received his basic training the pupil entered the workshop of a second master, apparently to earn a living before he could qualify as independent master and sometimes especially, as we shall see in the case of Rembrandt's pupils, to acquire a fashionable handelinge or manner of painting. This lastnamed motive may in fact be seen as evidence of the recognition Rembrandt received as an artist from quite early in his career.

The population of Rembrandt's workshop

Rembrandt's workshop, then, appears to have attracted mainly young painters who had already spent some years with another master and learned from him the basics of their craft, beginning with drawing, 'the Father of painting' (as the painter and writer Karel van Mander had called it). One may infer this from the biographies of those Rembrandt pupils who became sufficiently well-known to be included in contemporary or later publications. This does not apply to the earliest pupils, who came to Rembrandt when he still worked in Leiden and had not yet acquired the fame that was to mark his position in Amsterdam. Gerrit Dou, for instance, had learned with an engraver and a glass painter before entering Rembrandt's studio early in 1628, when he was almost fifteen. He obviously received his training as a painter only then and stayed on until Rembrandt moved to Amsterdam late in 1631. The case of another Leiden pupil, Isack Jouderville, is of special interest for us because he became an orphan late in 1629 and his guardians' accounts provide us with detailed information on payments made on his behalf. These include Rembrandt's receipts for his tuition-fee, which was paid over a period of two years, from November 1629 until November 1631, though he may have entered the studio earlier, prior to his parents' death. He appears to have followed Rembrandt to Amsterdam and to have worked there as a studio assistant for quite some time without, however, further fees being paid.[5] Govert Flinck, on the other hand, who was slightly younger than Jouderville, had already studied with the Mennonite painter Lambert Jacobsz. in Leeuwarden before joining Rembrandt's Amsterdam workshop probably in 1633, at the age of eighteen. He was then probably an already fully-trained painter for according to Arnold Houbraken's biography of him (based on information this early-eighteenth-century author received from Flinck's son) he stayed with Rembrandt for only one year.[6] Another well-known Rembrandt pupil from the 1630s, Ferdinand Bol, had probably been trained in the circle of Abraham Bloemaert in Utrecht, whose style is reflected in a signed early work. Bol was already describing himself as 'painter' in his native Dordrecht in December 1635.[7] He must have been no less than twenty years old when he entered Rembrandt's workshop shortly after and was, judging by his signed and dated works, to settle as an independent master in Amsterdam only in 1641, at the age of twenty-five.

Other examples could be cited but they would only confirm the picture just given. In one or two cases a young artist would arrive while still in an early phase of his training—Samuel van Hoogstraten was not yet fourteen years of age when, after the death of his father and teacher in 1640, he came from Dordrecht to Amsterdam, and when Nicolaes Maes arrived, also from Dordrecht, in all probability in 1646, he was twelve and had only received drawing lessons from 'an ordinary master' (again according Houbraken, who came himself from Dordrecht and was particularly well-informed on artists from that city). The far from complete material at our disposal suggests however that most of Rembrandt's pupils were hardly 'pupils' in the proper sense but rather journeymen or assistants who had already spent a number of years with another master, sometimes their own father, and were ready before long to take some responsibilities in the production of the workshop. This is true, for instance, of a number of pupils who came from abroad. These include Bernhard Keil from Denmark, who was eighteen years old when he arrived, and Heinrich Jansen from Schleswig, who was twenty.[8] It also applies however to such well-known Dutch artists as Carel and Barent Fabritius, sons and no doubt pupils of a schoolmaster-sexton-painter. They entered the workshop about 1641 (aged nineteen) and 1646 (aged twenty-one) respectively. Another case is Aert de Gelder, the most important pupil of Rembrandt's last years, whose first teacher had been Samuel van Hoogstraten in Dordrecht and who (according to Houbraken) stayed with Rembrandt for only two years.

To the names of pupils just mentioned quite a few could still be added.[9] Yet a report by an eye-witness, the German painter and writer Joachim Sandrart—later von Sandrart—comes as a surprise. In his Teutsche Academie, published in 1675, Sandrart drew partly on memories from the years around 1640, which he had spent in Amsterdam. He mentions the fact that Fortune not only had bestowed considerable riches on Rembrandt but also 'filled his house in Amsterdam with all but countless prominent children for instruction and learning'. Their paintings and prints (Sandrart continues) brought Rembrandt considerable sums of money, some 2000 or 2500 guilders a year besides the annual fee of one hundred guilders which they had to pay.[10] This statement raises a number of questions. When considering these one has to keep in mind that Rembrandt and Sandrart had been competitors as far as portrait commissions were concerned. Although quite successful himself, Sandrart may well have envied Rembrandt his fame[11] and particularly resented the eclipse of the civic guards' group portrait he had done in 1640 for the new hall of the Kloveniers Doelen (Arquebusiers' headquarters) by the adjacent Nightwatch (Fig. 58) of 1642.[12] As will be mentioned below, he appears to have been especially bent on stressing Rembrandt's greed and wealth and we should perhaps not take his reference to 'all but countless' pupils too literally. Yet it remains likely that Rembrandt's workshop included many more pupils than is suggested by the names that happen to be known to us. The fact reported by Sandrart that the proceeds from the sale of their works contributed substantially to Rembrandt's income is in accordance with the assumption that the majority of them were already fully-trained and capable of making saleable products. Sandrart specifies that these consisted of paintings and etchings and, even if he

may again be exaggerating the amounts involved, his statement is credible and provides us with a valuable starting point for analysing the production of Rembrandt's workshop.

Sandrart's statement contains two further points of interest. He describes the pupils as 'fürnehme Kinder'—prominent children or, rather, children from prominent families. It has been deduced from this, that there were among Rembrandt's pupils well-to-do young men who, without any professional purpose, received drawing lessons as part of their general education.[13] Although one cannot entirely rule out this practice,[14] Sandrart clearly meant something different. According to him, the 'prominent children' were the very pupils whose paintings and prints Rembrandt sold at good profit, which is perfectly logical in the case of advanced professional pupils but would be inconceivable had these works been amateurs' products. The other interesting piece of information to be found in Sandrart's text is that, besides selling his pupils' work, Rembrandt charged them a fee of no less than one hundred guilders a year, and one senses in these words the author's barely concealed exasperation. The most likely explanation for this is that, as we have seen, the fee to be paid was usually in inverse proportion to the pupil's productivity.[15] Would Rembrandt really have infringed this generally accepted rule? The only thing we know for certain is that the amount of one hundred guilders is exactly what young Isack Jouderville's guardians had to pay annually for Rembrandt's teaching their pupil, excluding board and lodging, during the years 1629/30 and 1630/31. Sandrart's statement appears therefore to be based on the correct amount that Rembrandt charged for teaching an inexperienced apprentice; whether he was correct in taking the same amount to apply to more advanced pupils, one may well doubt. In the case of Jouderville there is no evidence that any fee was due when he had apparently completed his apprenticeship and continued to work as an assistant under Rembrandt's guidance.[16]

Rembrandt's studio does not seem to have deviated substantially from the average seventeenth-century workshop in status and organisation. Even if the fact that master and pupils must sometimes have been drawing together from the nude (Fig. 99) reminds one of what was sometimes called an 'academy', there is no evidence that Rembrandt ever joined other masters to organise regular drawing classes, as was done not only in Italian academies but also occasionally in Holland.[17] (Fig. 80) What little detailed information we have on Rembrandt's workshop may be said to be in agreement with general rules and practice as laid down in guild regulations and apprenticeship contracts. If there was something conspicuous about his studio, it must have been, as Sandrart's words suggest, the number of pupils working or assistants employed there. Even in this respect however, it was certainly not unique. As has recently been pointed out, there were painters' workshops of a comparable size in Haarlem (Frans Pietersz. de Grebber), Utrecht (Abraham Bloemaert and Gerard van Honthorst) and Amsterdam (Hendrick Uylenburgh).[18] In order to be considered a great master already during his lifetime, Rembrandt needed not to transgress the rules of conduct of the period, nor transcend to current notions about his trade.[19]

Rembrandt: teacher and merchant

The reason why numerous young artists chose Rembrandt as their teacher (often their second teacher) was directly connected with the reputation he must have already earned early in his career. Houbraken, who had himself been a pupil of Samuel van Hoogstraten at the time the latter had turned away from Rembrandt's style and adopted a classicist concept of art, wrote quite explicitly and disapprovingly of what made pupils flock to Rembrandt's studio. He did so most clearly in his biography of Aert de Gelder: 'As something novel at the time Rembrandt's Art had general approval, so that artists were forced (if they wanted to have their work accepted) to accustom themselves to his manner of painting: even though they themselves might have a far more commendable manner (behandelinge). This was why Govert Flinck and others joined Rembrandt's school. These included also my fellow-townsman Arent de Gelder who, after having been taught the basics of Art by S. van Hoogstraten, went to Amsterdam to learn Rembrandt's manner of painting...'[20] In this biography and those of other Rembrandt pupils Houbraken furthermore informs us that their works resembled Rembrandt's so closely as to cause confusion[21] and even were sold under his name.[22]

One might be inclined to discount such statements as coming from a figurative manner of speaking if not just as malicious gossip; but neither explanation is entirely satisfactory. There is every reason to take Houbraken's words literally. This appears not only from numerous similar instances where painters managed to imitate their master's style to an astonishing degree, but also from at least one guild regulation that has come down to us. It was issued in Utrecht in 1651 and expressly forbade masters 'to keep or employ any persons (whether foreign or native) as disciples or painting for them if they work in another [than the master's] manner (handelinge) or sign their own name'.[23] Given the conservative nature of guild ordinances in general, one may take it that this regulation was intended to protect standard practice. This means that productive workshops—and Rembrandt's was certainly one of them—may be expected to have turned out pictures in the master's style that were not necessarily from his own hand but had been executed by assistants who were not allowed to sign their own name (though that of the master might of course be appended either by the master himself or by the assistant responsible for the execution).[24]

To Sandrart's information, according to which Rembrandt sold his pupils' works with great profit, we may therefore now add that these works were meant to resemble his own to an almost deceptive degree. The question then arises whether or not Rembrandt sold them under his own name and, in general, how much importance was attached to the hand that executed a picture. In a well-known letter Rubens once explained to Sir Dudley Carleton, British ambassador to the States-General in The Hague, that he priced his paintings higher as his own share in their execution was greater. Rembrandt's letters to Constantijn Huygens, though dealing in part with the price of the pictures he was to do for Prince Frederik Hendrik of Orange, do not make any mention of this point, probably for the simple reason that the paintings in question were entirely from his own hand. There is however evidence to show that connoisseurs and buyers were not indifferent to the hand that was responsible for the execution of Rembrandt paintings at least up to around 1650 and especially during the 1630s.[25] In the second half of the century the awareness of the difference between a principael (original) and a painting 'naer Rembrandt' (after Rembrandt) appears to have faded away.[26] One cannot even be sure that Rembrandt himself always made that distinction when dictating the inventory drawn up of his possessions in 1656. Are we to assume, for instance, that after delivering his picture of the Deposition to the stadholder in about 1633 he still owned two authentic versions of the subject in 1656?[27] This is hardly likely and can virtually be disproved with regard to a Resurrection also listed as by Rembrandt in the 1656 inventory.[28] This picture may confidently be identified with a workshop copy formerly carrying an inscription Rembrandt F. 1647 beneath which a signature F. bol f. was recently discovered. It reproduces the

original delivered to Frederik Hendrik in 1639 in a state in which the latter was still to undergo several changes before its final completion.[29] From this and further evidence to be discussed below one may conclude that Rembrandt himself in all probability had a hand in the merging of works he had executed himself and those done by his assistants.

It may be clear, then, that Rembrandt's two rôles as a *chef d'atelier*—those of a teacher on one hand and of a merchant on the other—were intimately connected. As a teacher his task was to impart his manner of painting to the pupils who had joined his studio precisely for that purpose. As a merchant he was by law and custom entitled to the proceeds of the works they produced while 'painting for him' (as the Utrecht ordinance quoted above puts it). In accordance with a romantic picture of the artist as one far above any financial preoccupation, Rembrandt as a businessman has not been a popular topic. This may also be due in part to the paucity of information at our disposal. Virtually nothing is known, for instance, of the business arrangement Rembrandt is likely to have had with the art dealer Hendrick Uylenburgh, in whose house he lived from 1631 or 1632 to at least 1635. We do know however that Rembrandt was among the shareholders in Uylenburgh's business and the connection with this enterprising dealer (who was later to employ Govert Flinck) must have been quite close.[30] What is more, Rembrandt had himself described as 'merchant' on at least two occasions.[31] This designation must have referred to his activities as a dealer in works that were not necessarily products of his own workshop. We happen to know of transactions involving paintings by Rubens, Giorgione and Palma Vecchio and the inventory of Rembrandt's possessions drawn up in 1656 gives an idea of the range of works of art he had then in store. Among the works he offered for sale, those from his own hand and by his assistants must have taken an important place. A note he scribbled on the back of a drawing of around 1636 mentions the sale of works by Ferdinand Bol, Leendert van Beyeren and probably a third pupil[32] and this note was certainly not the only one of its kind he made during his career. Yet such scraps of information, many of them concerning loans and debts, do not provide any real insight into the success and failure of Rembrandt's business. One may suppose however that the financial situation that caused him to apply for *cessio bonorum* (voluntary bankruptcy) in 1656 had to do with inept management rather than with any lack of appreciation of his art on the part of the public. Five years later, his son Titus

and his mistress Hendrickje Stoffels had the firm they had started earlier legalised as 'a company trading in paintings, prints and drawings, copper engravings and woodcuts as well as prints therefrom, rarities and everything pertaining to them',[33] without, one suspects, any change taking place in the actual course of business.

Rembrandt's teaching from the evidence of the studio production

Rembrandt as a teacher has been a much more frequently-discussed topic. He has been called an 'unorthodox teacher'[34] and his 'attitude toward his pupils' was even described as 'that of a very great pedagogue' who 'did not enforce a uniform manner upon them, but developed their individual talents'.[35] In view of what has just been said such ideas, though understandable when seen in the context of the romantic tradition, no longer carry conviction. Rembrandt was expected to put his personal stamp on his pupils' style and that is apparently what he did. If, in a number of cases, we can recognise a pupil's hand in a product of the studio, it is in spite of rather than thanks to the master's teaching. Yet, given the paucity of written evidence, it is precisely the studio production that is our most valuable source of information on what actually went on in the workshop. The paucity of written evidence may perhaps in itself be called significant in that the traditional nature of Rembrandt's teaching did not give rise to the recording of any specific peculiarities. What Hoogstraten, once a faithful pupil, found worth mentioning many years later in connection with his stay in the studio is disappointingly uninformative and amounts to nothing but a couple of commonplace tenets of current artistic theory put into the mouths of his fellow pupils.[36] More helpful, though not really illuminating, is an anecdote related by Houbraken and involving cubicles Rembrandt had constructed for individual pupils to work in. The reliability of this information is confirmed by the deed concerning the sale of the artist's house in the St Anthonis Breestraat in February 1658; it was stipulated there that he was to take with him 'various partitions in the attic placed there for his pupils'.[37] It is hard to tell whether or not such an arrangement was peculiar to Rembrandt.

When one surveys the works that can, with a varying amount of certainty, be connected with the studio production, the picture one gets is inevitably open to discussion on many points and, of course, fragmentary, if only because the etchings, expressly mentioned by Sandrart, need further examination from this view-point. It is nevertheless possible to distinguish a number of

81: Jan Lievens, *Samson and Delilah*. Panel. Amsterdam, Rijksmuseum.

82: Rembrandt, *Self-portrait in oriental costume with a poodle at his feet*. Panel. Paris, Musée du Petit Palais.

83: Rembrandt workshop (Isack Jouderville) after Rembrandt, *Rembrandt in oriental costume*. Panel. Whereabouts unknown.

types of product and it is tempting to postulate something like a regular curriculum in which every one of them—the drawn copy, the painted copy, the freely painted head or 'tronie', the drawing from life, the portrait, the history painting—has a fixed place of its own.[38] Yet the material that has come down to us rather suggests that certain types date from limited periods while others form clusters that can be dated to other moments. There may therefore be some point in surveying them in a roughly chronological order[39] and considering them primarily as the individual contribution various pupils made to the studio production.

The first name that usually crops up in connection with Rembrandt's early years in Leiden is that of Jan Lievens. He can admittedly in no way be termed a pupil of Rembrandt and there is even insufficient reason to believe (as has long been done) that the two young artists ever shared a studio. Yet they must have been in close contact. Lievens, Rembrandt's junior by one year but reputed to be a child prodigy, visibly impressed his colleague with such works as the Raleigh *Esther's feast* (Cat. No. 52), the boldness of which did not escape a contemporary connoisseur like Constantijn Huygens and is echoed in Rembrandt's earliest known painting, the *Stoning of St Stephen* of 1625 in Lyon.[40] Lievens's bright colouring and dramatic chiaroscuro are applied here to a composition that otherwise owes its character mainly to the fresh example of Rembrandt's (and incidentally Lievens's) Amsterdam teacher Pieter Lastman. It is however noteworthy that Rembrandt's use of Lievens's prototype is characterised from the start by an idiosyncratic refinement in both surface texture and expression which, once it has been recognized, marks a decisive difference between the works of the two young and almost equally spectacular Leiden artists. It was only in the course of the next five or six years that they arrived at a balance of mutual influence. Lievens's artistic potential diminished however from the moment he left Leiden in 1632 and went to work in England and subsequently in Antwerp. But before it came to that disappointing sequel he had provided Rembrandt with prototypes (Fig. 81) from which the latter profited in his own more mature or, as Huygens put it, more 'judicious' style.[41] Even years later, about 1635, when trying out in *Belshazzar's feast* (Cat. No. 22) a new compositional type with half-length figures expressing vehement emotions in complicated movements, Rembrandt appears to have remembered Lievens's daring experiments with similar problems in *Esther's feast*.

As mentioned earlier, we know of two genuine

and well-documented pupils during Rembrandt's Leiden years. By far the more important of them was Gerrit Dou, whose entrance into the workshop was recorded by the town historian Jan Jansz. Orlers as having taken place on 14 February 1628. Dou's importance lies of course more in the rôle he was to play as champion of a meticulous painting style now known as Leiden *Feinmalerei* than in his activities as a Rembrandt pupil. Of the latter we are, frankly, very poorly informed. There is however at least one picture that stands a fair chance of having been done by Dou when still working in Rembrandt's studio, and that is the unsigned *Tobit and Anna* in the National Gallery, London (Cat. No. 55). It clearly exhibits reminiscences of Rembrandt's work from 1628 and 1629—the Melbourne *Peter and Paul disputing* of 1628 and even the 1629 *Judas repentant*[42]—and at the same time an emphasis on detail and a halting rhythm in the linear structure that remind one of the later Dou. A nearly contemporary etching reproducing it is however inscribed '*Rembr van Rijn in[venit]*'. This intriguing fact may be accounted for by assuming that here is a case where the master let a work executed by an assistant go under his own name.[43] Further instances of this will be discussed below but if the interpretation given here is correct, it is interesting to see how Rembrandt at the age of approximately twenty-four was apparently already in a position to exercise his rights as the head of a workshop. As far as Dou's relation to his teacher is concerned, so much is clear that the attention paid to minute detail already noticeable in the *Tobit and Anna*, which was to become one of the main characteristics of Dou's mature work (Cat Nos. 56 and 57), reflects an aspect of Rembrandt's early style as we know it from the *Peter and Paul disputing*. In this work, which dates precisely from the year Dou entered the workshop, Rembrandt's dynamic composition and dramatic chiaroscuro are coupled with the acute observation of an armchair's construction, the curling of the pages of an open book or the wrinkling, however slight, of the skin of a lighted face. It must have been on these latter features that Dou's attention focussed and from them he subsequently developed his own style. In this respect he exemplifies already the way many Rembrandt pupils reacted to the master's art; they made use of certain facets of it and possibly—who can tell—of instructions contained in his teaching, without however achieving the balance and richness of his own performance.

If this is true of Dou, who became a highly original and successful artist in his own right, it

applies to an even greater extent to the other Leiden pupil mentioned earlier, Isack Jouderville, who up to his early death (in 1648 at the latest) was never anything but a very minor artist. A reconstruction of his early career as an assistant in Rembrandt's workshop has to start from his only signed work in a Rembrandtesque style, the Dublin *Bust of a young man*, presumably a self-portrait (Cat. No. 59). The mere fact that it bears a signature (albeit on the back of the panel) points to a date after, probably shortly after, he had settled as an independent painter, i.e. about 1635. The stylistic features found here—a peculiar stylisation of the chiaroscuro, a slightly disturbing linearity in the rendering of facial features, the use of confused highlights in the decoration of the scarf—may be recognised in other pictures, where they sometimes appear more successfully integrated in a Rembrandtesque chiaroscuro. One of these is a straightforward copy (and as such to be considered a beginner's work) done after Rembrandt's *Self-portrait in oriental costume with a poodle at his feet*, now in the Petit Palais, Paris.[44] (Figs. 82 & 83) Copying the master's pictures had been common studio practice in the Netherlands at least from the fifteenth century onwards, and was considered part of a pupil's training. That this particular copy was indeed done in the studio is evident from the fact that it reproduces the original as it appeared (on the evidence of the X-rays) after Rembrandt had completed it for the first time in 1631 and before he made a number of changes to it, probably in 1633. First he reduced the length of the legs and then hid the feet altogether by the addition of a dog.[45] Jouderville, whose characteristics are unmistakeably present, does not show any of these alterations in his copy. He must therefore have produced it, no doubt at the master's behest, in or soon after 1631, that is just about the time his guardians stopped paying his tuition-fee and he was now apparently sufficiently advanced to take an active part in the studio production. The same prototype served him subsequently as a starting point for works of somewhat greater originality, free variations on the same theme: representations of a young woman or an old man standing in a bare interior.[46] Similarly, he had other Rembrandt paintings before his eyes when doing such works as the Windsor Castle *Bust of a young man in a turban* (Cat. No. 58) largely modelled on Rembrandt's *Self-portrait* of about 1629 in The Hague (Cat. No. 4), a *Bust of a young woman* at Chapel Hill (Fig. 84) based on a similar 'tronie' formerly on loan to the Boston Museum of Fine Arts,[47] or a *Minerva* at Denver incorporating motifs from various Rembrandt paintings done between 1629

and 1631.[48] From the number and variety of Jouderville's studio works, which also include a pair of knee-length portraits now in New York,[49] one may gauge the diversity of tasks with which an advanced student could be entrusted. Even after Jouderville had left the studio he remained for a while a faithful, though increasingly spineless, follower of his master's work from the early 1630s. One may feel inclined to hold his lack of imagination responsible for this dependence and there is some justification for that judgment. It is only fair, however, to remember that as long as he acted as a studio assistant and was 'painting for' Rembrandt, he was expected to work in the master's style. His limited gifts are evident not so much from the mere fact that he followed Rembrandt's prototypes as from the increasing impotence he showed in doing so.

Just how many assistants worked in Rembrandt's studio simultaneously with Jouderville we do not know. Judging by the variety of hands one can distinguish in the production, there must have been quite a few. Owing to the very nature of the works concerned, it remains difficult to distinguish groups showing common characteristics, which can inform us about the artistic personality of their author and thus clarify the somewhat confused picture we have of the studio up to now. Fortunately there are exceptions, groups that do betray a common hand,[50] which may even turn out to be stylistically related to later, signed works of a known pupil. Govert Flinck is a case in point. As was said earlier, he entered the workshop probably in 1633 and stayed for only one year. Being a much more gifted and versatile artist than Jouderville, he easily surpassed the latter in his understanding of Rembrandt's style, which he assimilated with astonishing facility. While Jouderville's picture of it remained basically static over a number of years, Flinck was able to revise his view constantly in accordance with Rembrandt's own stylistic development, even (as we shall see below) long after he had left the workshop. It was only around 1645 that he chose with equal ease to adopt what was considered to be a Flemish, i.e. more elegant and colourful, manner.

Given the short period of Flinck's activity in Rembrandt's shop, it is not surprising that the number of studio works attributable to him is small. One of them is of special interest as it informs us of a new type of task set to a pupil: the conversion of a grisaille from the master's hand in a fully-fledged painting of the same size. This interpretation appears at least to be the most plausible solution to the enigma of the *Good Samaritan* in the Wallace Collection, London (Fig.

84: Rembrandt workshop (Isack Jouderville), *Bust of a young woman*. Panel. University of North Carolina, Chapel Hill.

85: Rembrandt workshop (Govert Flinck)
after Rembrandt, *The Good Samaritan*. Panel.
London, The Wallace Collection.

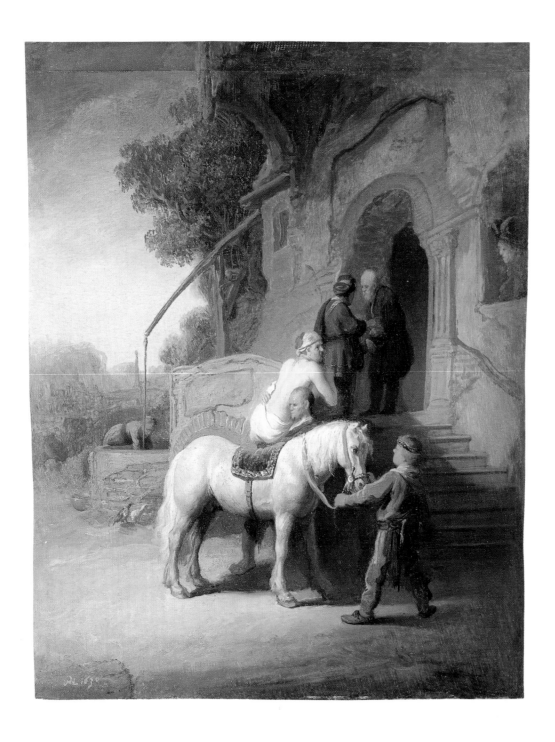

85), the attribution of which to Rembrandt was in dispute for some seventy years.[51] This small panel is closely linked to Rembrandt's well-known etching of the subject and was understandably considered by most connoisseurs as his own design for the print (which is exactly the same size). The sketches Rembrandt is known to have done in preparation for etchings, including the National Gallery *Ecce homo* (Cat. No. 15), are however mostly done on paper and in a sketchy grisaille technique rather different from the execution of the Wallace Collection *Good Samaritan*. Yet it would have been difficult to arrive at a convincing conclusion had not the manner of painting, in the landscape background in particular, proved to resemble closely that in corresponding passages in one other studio work,[52] evidently from the same hand, as well as in signed works by Flinck from 1636 onwards. The *Good Samaritan*, then, may be taken to illustrate the way Flinck, already fully trained before he entered Rembrandt's workshop, started out under his new master's guidance in 1633. There is however no reason to believe that his studio works should have been limited to pictures in the relatively meticulous style of the *Good Samaritan*. Three larger heads showing a markedly broad treatment would seem to foreshadow his later style sufficiently to justify a tentative attribution to him as well. They include a *Bust of Rembrandt* in Berlin that was formerly considered a self-portrait by the master (Cat. No. 60) and two commissioned portraits, one in Dresden[53] and one in Amsterdam,[54] (Fig. 86) all of them marked by an identical lively treatment of the background and almost over-emphatic wide strokes used in the dress.

According to our present knowledge, a new studio product appears on the scene around 1635 in the form of the drawn copy, extensively washed in greys, after a Rembrandt painting. The educational function of such a drawing is evident and was described later in the century as the third step when learning how to draw (the first step being the elementary construction of a head and the second the copying of prints and drawings).[55] Curiously enough the drawn copy seems, judging by the preserved specimens, to have been practised in the studio almost exclusively in the mid-1630s and the mid-1640s, with one exception, a drawing after the London *Self-portrait* of 1640 (Cat. No. 32). There has been a tendency to attribute those dating from the 1630s to Ferdinand Bol, whose name occurs on one of them.[56] However, there are considerable stylistic and qualitative differences between them. More than one hand seems therefore to be involved and it is

attractive to think of them as the work of successive new-comers to the studio at an early stage of their activities there. Two particularly brilliant specimens by the same hand are in the British Museum—one after Rembrandt's 1635 *Flora* in the National Gallery, London (Cat. No. 23; Fig. 87) and the other after his 1636 *Standard-bearer* in a private collection (Cat. No. 26). It may or may not be a coincidence that Rembrandt's note about works by various pupils (including Bol) being sold by him, refers to precisely these subjects: once to a '*vaendrager*' and three times to a '*floora*'.[57] Drawings of this kind must at all events have been among the commodities Rembrandt sold at relatively low prices.

Among the painted copies, history paintings (biblical or otherwise) take an important place in the studio production of the 1630s. Some of these are faithful copies and can sometimes be proved to have been done in the studio because they, like Jouderville's copy after Rembrandt's *Self-portrait in oriental costume*, reproduce certain details as Rembrandt painted them before introducing later changes. Others must be termed copies though they deviate from the original in colour or design, or both. Just as Flinck turned out to have added colour to his master's sketch for the *Good Samaritan*, so other studio assistants were obviously instructed in the course of the 1630s to introduce new elements and were, one may suppose, left to their own imagination to find a new solution to the problem at hand. The best-known example of this class of works is a copy after Rembrandt's great *Abraham's sacrifice* of 1635 in Leningrad (Cat. No. 21). The equally ambitious copy, now in Munich,[58] is by no means a slavish one. The brushwork has a boldness of its own, the colours of some of the garments have been altered and, above all, the angel flying in from a different direction and the ram 'caught in a thicket by his horns', a feature that was missing from the original, appear to be the copyist's invention. A most unusually elaborate inscription containing the date of 1636 informs us that Rembrandt too had a hand in the execution.[59] A comparable case is presented by an equally boldly painted copy after Rembrandt's 1637 *Angel leaving Tobit and his family* now in the Louvre.[60] (Figs. 88 and 89) Again it is the position of the angel that the copyist changed—against all logic it would seem. In other instances the pupil extended a composition by the addition of figures[61] or, possibly at a later stage of his training, he borrowed motifs from one or more Rembrandt works and made them appear in a new context.[62] An example of such a procedure is due to the impression the bed in Rembrandt's

86: Rembrandt workshop (Govert Finck), *Portrait of Gosse Centen*. Panel. Amsterdam, The Rijksmuseum.

87: Rembrandt workshop after Rembrandt, *Flora*. Brush in greys and black over pen and ink. London, The British Museum.

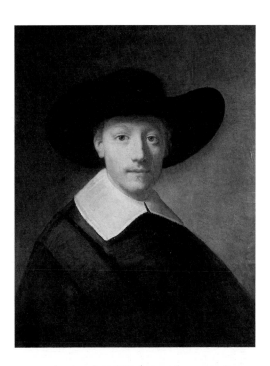

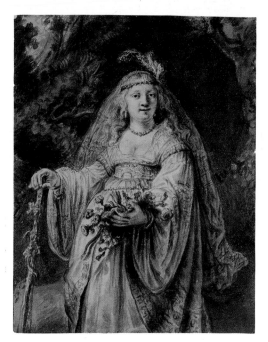

88: Rembrandt, *The angel leaving Tobit and his family*. Panel. Paris, Musée du Louvre.

89: Rembrandt workshop after Rembrandt, *The angel leaving Tobit and his family*. Panel. Whereabouts unknown.

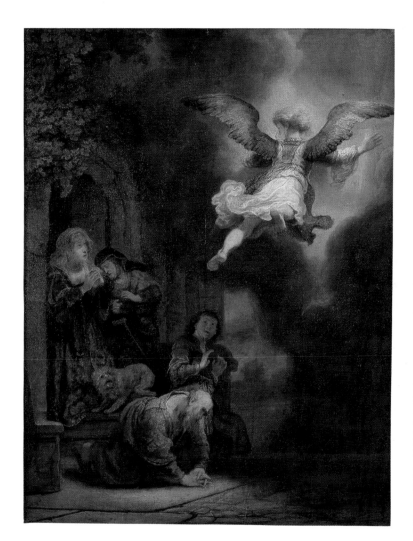

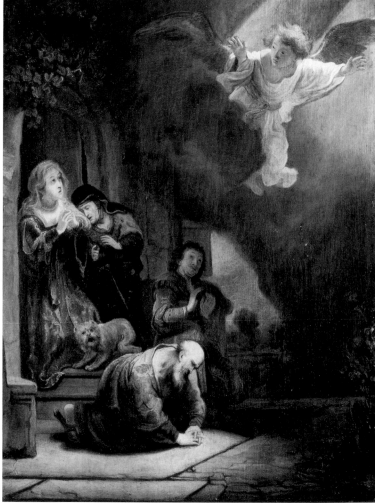

Leningrad *Danae* of 1636 seems to have made on Ferdinand Bol, who presumably joined the workshop in precisely that year. He put the bed to very different use when depicting first (and probably while he was still working with Rembrandt) *Isaac refusing Esau his blessing*[63] (Fig. 90) and subsequently *David's dying charge to Solomon*, the latter painting being dated 1643, when he had already left the workshop but still adhered to Rembrandt's style.

The later 1630s was the stage of Rembrandt's career when the painted copy, either faithful or free, and the assemblage of copied motifs seem to have been practised most frequently by studio assistants. This may have been occasioned by commercial considerations, but it may not be fortuitous that at this period Rembrandt himself was also particularly interested in borrowing single motifs from works by sixteenth- and early seventeenth-century artists (such as Maerten van Heemskerck and Antonio Tempesta) as well as his immediate predecessors (such as Jan Pynas and, of course, Pieter Lastman). A predilection for artful borrowing, permitted and even admired in art as well as literature, appears to have marked not only his own work but also his teaching during these years.

At the same time the production of portraits flourished and the assistants' share in it was considerable. This may have had to do with Rembrandt being engaged on *The Nightwatch*, which he seems to have executed alone between some time well before December 1640 and its completion in 1642. One may distinguish in these portraits the hands of a few individual pupils, who often based themselves on 'formulas' Rembrandt himself had used earlier.[64] A striking case is offered even by such a seemingly unassuming work as Rembrandt's portrait of Herman Doomer (reputedly his frame-maker) of 1640, now in New York (Fig. 91). It must have presented something of a novelty to the studio assistants possibly because of the stress on diagonals which emphasise the three-dimensional effect of the bust. Carel Fabritius obviously had this prototype in mind when executing his astonishingly vigorous and mature *Portrait of a man*, probably dating from 1642, in the Duke of Westminster's collection (Fig. 75c). But it surprisingly also impressed Govert Flinck many years after this artist had left the studio. His 1640 *Portrait of a man* in the Thyssen-Bornemisza Collection, Castagnola,[65] (Fig. 92) though lacking the subtle atmospheric effect seen in the *Portrait of Herman Doomer*, is clearly based on this work, with the exception however of the flapping hat. This motif seems to contradict the tectonic build of the bust and

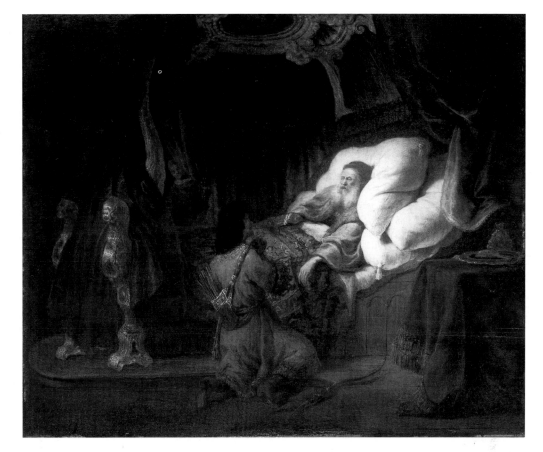

91: Rembrandt, *Portrait of Herman Doomer*, Panel.
New York, The Metropolitan Museum of Art.

92: Govert Flinck, *Portrait of a man*. Panel.
Lugano-Castagnola, Thyssen-Bornemisza
Collection.

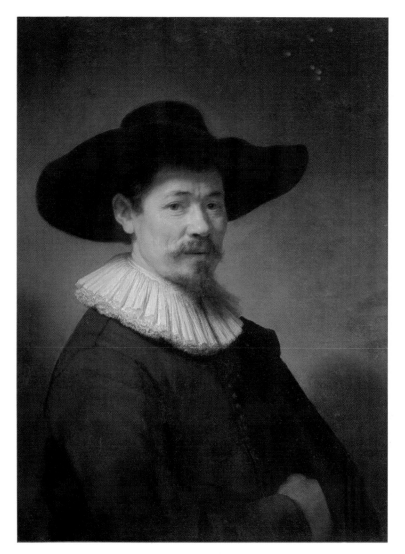

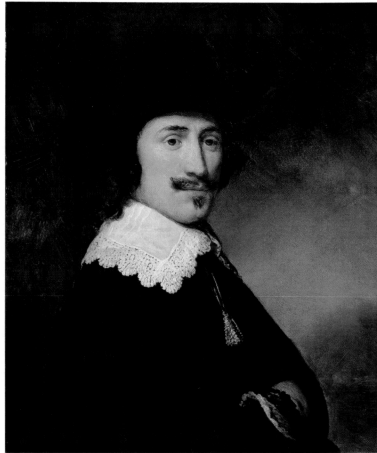

therefore looks strangely out of place. Even this hat can however be traced back to a Rembrandt invention; it is to be found in the *Portrait of Nicolaes van Bambeeck* in Brussels (Cat. No. 34), which bears a date of 1641 but must already have been well on its way in 1640. This work exhibits considerable social pretence and a correspondingly grand style. One may surmise that Doomer's old-fashioned collar and simple hat would not do for Flinck's sitter, and the artist could apparently think of nothing better than modelling the head on Bambeeck's, without realising that combining elements from such widely different sources as the two Rembrandt portraits concerned was a rather unfortunate idea. As said before, borrowing was permitted, but it should be done discriminatingly so as not to be too easily detectable and on detection it should provoke admiration for the homogeneity of the overall result. In this respect Flinck seems not always to have succeeded.

Apart from some by now familiar types of pupils' work, such as a number of drawn copies[66] or the free copy Barent Fabritius painted of Lastman's Hamburg *Dismissal of Hagar* of 1612 (Cat. No. 81), Rembrandt's teaching of his more advanced pupils as it is reflected by studio works from the 1640s seems to have focussed mainly on two types of activity: the production of 'tronies' (heads, or rather, busts) often taken from his own compositions, and drawing from the nude. 'Tronies', whether or not based on figures in Rembrandt's narrative scenes, had been fairly common during the 1630s and even before.[67] There is however a distinct cluster of them datable to the mid-forties as they are based on Rembrandt originals from the years 1644–46.[68] They used formerly to be considered as preliminary sketches by the master himself. This idea is unlikely enough in itself: the 'sketches' often contain all sorts of redundant detail; but it may definitely be ruled out because they betray a variety of hands, some of which may actually be connected with known pupils. This is true for instance of the Detroit *Bust of a woman weeping*, probably a life-study but based in essence on the adulteress in Rembrandt's 1644 *Christ and the woman taken in adultery* in the National Gallery, London (Figs. 93 and 94). This 'tronie' may be attributed to Samuel van Hoogstraten,[69] who must have been a fairly experienced assistant at the time he did this picture in, or shortly after, 1644. Another case is the Rotterdam *Woman holding a swaddled child* (Cat. No. 80),[70] which clearly is an elaborate version of a figure in a *Circumcision* (now known only through a copy) that Rembrandt did for Prince Frederik Hendrik

and delivered in 1646. The Rotterdam work may, with some caution, be attributed to Barent Fabritius, who entered the workshop just about this year. His elder brother Carel's influence may well have been responsible for the picture's light background, which is highly unusual by Rembrandtesque standards. We would then have two paintings by Barent done while he was a studio assistant: the free copy after Lastman already mentioned (Cat. No. 81) and the Rotterdam 'tronie', probably executed in this order. Besides these two works, a drawing after Rembrandt's Berlin *Susanna and the elders* (Cat. No. 37) has been attributed to him,[71] which would, according to the logic of the teaching method described earlier, have preceded them both. It is certainly exceptional that the learning process of an individual pupil can be seen so fully illustrated as in the case of Barent Fabritius.

One more thing must be said about these two paintings. Both the Hoogstraten *Woman weeping* and the Barent Fabritius *Woman holding a Child* are already described as works by Rembrandt during his life time and (in the case of the latter painting) even by Rembrandt himself—at least if one is to assume that it was he who was responsible for the description of his possessions in the 1656 inventory.[72] This confirms the suspicion already raised by the number of Passion scenes listed in the same inventory, that Rembrandt, probably in accordance with common practice, lent his own name to works that followed his design more or less closely but had in fact been executed by his assistants.

In 1646 the studio production shows signs of sessions Rembrandt held together with his pupils to draw from the nude. Drawing from the nude was of course no novelty, although it may have been difficult (and possibly expensive) to find models. From about 1590 onwards we hear occasionally about artists taking part in what was sometimes (in Haarlem) called an 'academy'[73] or later (in Amsterdam) a 'collegie'.[74] We even know of a formal 'Drawing School' or 'Academy' that existed in Utrecht during the first half of the seventeenth century, where pupils from various workshops were taught to draw from the live model under the direction of experienced masters.[75] As far as Rembrandt is concerned, extant drawings of female nudes by him or from his circle can be dated to the 1630s or even the late twenties. It is however not until the mid-forties that he seems to have worked together with his pupils from the live model, as he must also have done during the 1650s and early sixties. One may deduce this from coherent groups of studies from the nude that include drawings by Rembrandt as

93: Rembrandt, *Christ and the Woman taken in Adultery* (detail).
London, The National Gallery.

94: Rembrandt workshop (Samuel van Hoogstraten), *A Woman weeping*. Panel. Detroit, the Detroit Institute of Arts.

95: Rembrandt workshop (Samuel van Hoogstraten), *Life-study from the nude*. Pen and wash in brown ink with white body colour. Paris, Musée du Louvre.

96: Rembrandt workshop, *Life-study from the nude*. Pen and wash in brown ink. Vienna, Graphische Sammlung Albertina.

97: Rembrandt workshop, *Life-study from the nude*. Pen and wash in brown ink with white body colour. London, The British Museum.

98: Rembrandt, 'The walker'. Etching. Amsterdam, The Rijksmuseum.

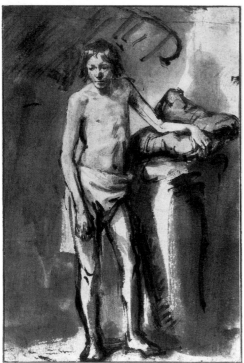

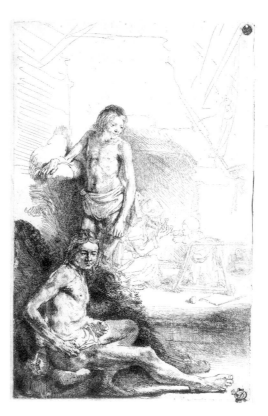

well as by pupils. Of these groups, one that is connected with three etchings by Rembrandt, two of them dated 1646, provides the most unambiguous documentation. Among the drawings belonging to this group there are three from different hands showing the same skinny boy in an identical posture—a somewhat awkward *contrapposto*—but each time seen under a different angle (Figs. 95–97). The same model recurs, again seen from a different view-point (and naturally in reverse), in one of Rembrandt's etchings (B. 194), this time combined with a seated model and a domestic scene of a child learning to walk—the latter intended as an example of the same 'learning through practice' that marks the activity of the young artist working from life.[76] (Fig. 98) The inference would seem to be, that all four renderings were done by different hands, the etching by the master himself and the three drawings by advanced pupils. In one of them, in Paris, the hand of Samuel van Hoogstraten has been recognised,[77] the other two, in Vienna and London respectively, have to remain anonymous for the time being.[78] How we should visualise such sessions may be seen in a number of drawings, all of them copies, which seem to represent Rembrandt surrounded by his pupils in the act of drawing from a reclining female model.[79] (Fig. 99) The scene depicted would then refer to later sessions, when a female model was used.

Rarely do we get so immediate a picture of Rembrandt's relations with his pupils as from the body of material connected with the drawing sessions that may be called 'academies' (in the informal sense of the word). There is one more class of works that gives an equally intimate glimpse of those relations—the drawings done by pupils and corrected by the master. Whereas in paintings his corrections are inevitably hard to detect,[80] a number of drawings show unmistakable traces of his intervention. These consist mostly of vigorous pen lines that lend emphasis to certain elements or even bring radical changes to the composition. This is very clearly the case in a number of drawings by Constantijn van Renesse who came to Rembrandt in the late 1640s and seems to have joined the studio only occasionally. This special position, unusual for a pupil, may account for the relatively numerous drawings from his hand that exhibit more or less clearly Rembrandt's corrections. They are particularly clearly seen in a drawing of the *Annunciation* in Berlin (Fig. 100), where vigorous pen lines indicating an almost exaggerated increase in size of Mary's pulpit and the figure of the angel seem to betray the teacher's impatient reaction to the

pupil's somewhat timid composition.[81]

While the various drawings just mentioned shed some light on certain aspects of Rembrandt's teaching, other activities going on in the studio during the later 1640s and the 1650s are still less well explored. The personalities of a number of pupils have gradually emerged but important questions still remain unanswered. Familiar though we are with the later work of a gifted artist such as Nicolaes Maes, for instance, there is no clear idea of what share he took in the studio production while still an assistant. Confusion reigns concerning minor figures such as Karel van der Pluym, who is also thought to have joined the studio about 1646—at the same time as Barent Fabritius and Nicolaes Maes. About two other artists who appear to have worked there around 1650, Abraham van Dijck and Willem Drost, we are still far from well-informed. Yet it is possible to offer some comment on their work and their contribution to studio production.

Abraham van Dijck owes what little fame he earned to the somewhat sentimental 'genre' scenes from his later years, particularly of old women praying or reading reminiscent of Maes (and denoting pious old age). An unsigned *Portrait of a minister* was recently and convincingly attributed to him,[82] thus revealing a hitherto unknown aspect of his activity. A further portrait, signed and representing a fifty-year-old woman, has come to light since.[83] (Fig. 101) Besides the signature it bears a date that can be read as 1655, which makes it likely that the picture was done shortly after Van Dijck had left Rembrandt's studio. From these two works the artist emerges as an unexpectedly competent Rembrandtesque portrait painter with a strong sense of simplified, almost monumental forms seen in a strong light. He may well have belonged to the numerous studio assistants who used to be entrusted with the execution of commissioned portraits.[84]

If Abraham van Dijck may be called an underestimated artist in at least one respect, the same is certainly true to an even greater extent of Willem Drost. In a mature work such as his Oxford *Ruth and Naomi* (Cat. No. 83) one has to look very closely to detect the numerous borrowings from Rembrandt etchings—so expertly have they been blended and integrated in a homogeneous whole. Drost deserves a place among the most remarkable Rembrandt pupils. His later works include several pictures once acclaimed as Rembrandts, such as the *Vision of Daniel* in Berlin (Cat. No. 82) and the *Sacrifice of Manoah* in Dresden.[85] The same is however true of some of the paintings he did while still a studio

99: Rembrandt school (copy), *Rembrandt (?) with pupils drawing from the nude*. Pen and wash in brown ink over black chalk with white body colour. Darmstadt, Hessisches Landesmuseum.

100: Constantijn van Renesse with corrections by Rembrandt, *The Annunciation*. Pen and wash in brown ink over red chalk with white body colour. Berlin, Kupferstichkabinett SMPK.

101: Abraham van Dijck, *Portrait of a 50-year old woman*. Panel. London, Raphael Valls Ltd.

102: Rembrandt workshop (Willem Drost),
The Centurion Cornelius.
London, The Wallace Collection.

assistant. Two of these, recorded as by a 'disciple of Rembrandt',[86] can still be identified. One is the well-known *Centurion Cornelius* in the Wallace Collection (Fig. 102), probably a fragment of what was described in 1712 as 'a very big painting... being an original by a disciple of Reynbrant'.[87] There can be little doubt that this 'disciple' was in fact Drost, whose peculiar lapidary composition and broad yet subtle brushwork can be recognised throughout. The other studio work, first described as by a disciple and then, in the early eighteenth century, surprisingly as by Drost, is a *Dismissal of Hagar*. This work may be recognised in a picture that, even though its present whereabouts are unknown, may be said from reproductions to bear so clearly the mark of the author of the *Ruth and Naomi* and the *Sacrifice of Manoah* that Drost's authorship cannot be doubted.[88] Even these early works— or at least the *Centurion Cornelius*, for the *Hagar* is no longer known to us in the original— already show the Rembrandtesque, yet highly personal sense of colour and intensity of expression that lend also his later works a distinct poetical mood. The fact that these qualities could manifest themselves so early testifies to the strength of Drost's personality. It is also indicative of the freedom the master left his assistants during these years when letting them execute history paintings of their own design and, sometimes, considerable dimensions.

Given the relative freedom a pupil would enjoy after probably having gone through the various stages of copying and other 'exercise', it becomes clear that being an assistant in Rembrandt's workshop meant taking one's own share in the studio's output rather than—as was the case with, for instance, Rubens—assisting the master in the execution of large paintings. The scarcity of large-scale commissions may have favoured this state of affairs but neither Rembrandt's large group portraits, from the 1632 *Anatomy lesson of Dr Tulp* to the 1662 *Syndics* (Cat. No. 48), nor the only preserved fragment of the huge *Conspiracy of Claudius Civilis* done for Amsterdam's new Town Hall in the early 1660s, give evidence of the participation of assistants' hands the way Rubens' large decorative canvases or altar-pieces often do. On the whole, one may say that with Rembrandt design and execution were closely bound up. Instead of making use of sophisticated workshop procedures which could in part replace the share of the master's hand, he seems to have allowed invention and execution to be separated only in the early stages of the assistants' activities. Later, they would be welcome to their own design and only rarely did they intervene

103: Rembrandt and assistant, *Portrait of Frederick Rihel on horseback*. London, The National Gallery.

104: Rembrandt workshop (Aert de Gelder?),
Bust of Rembrandt. Stuttgart, Staatsgalerie.

105: Rembrandt, *Homer dictating*.
Pen and wash in brown, heightened with white.
Stockholm, Nationalmuseum.

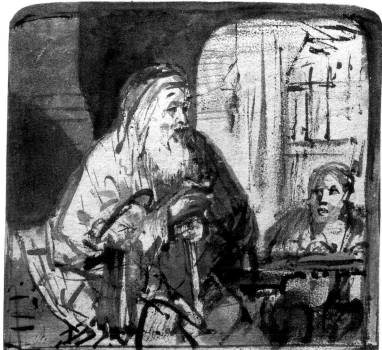

with his own work. What seems to be an exception to this last conclusion has recently been found to exist in the intervention of an assistant's hand in the 1663(?) *Frederick Rihel on horseback* in the National Gallery, London.[89] In this large picture the horse, because of a peculiar lack of luminosity, strikes a false note such as is hardly compatible with Rembrandt's mastery of chiaroscuro (Fig. 103). Together with a small group of stylistically related pictures,[90] Rihel's horse seems to be the work of an assistant who in a most unusual, and perhaps unique, way appears to have assisted the master in the execution of a large-size canvas.[91]

From the last years of Rembrandt's activity the only pupil whose name was recorded is Aert de Gelder. A number of drawings, including studies from the nude, have been attributed to him and suggest that in the early 1660s he was among the pupils who took part in drawing sessions like those held earlier in Rembrandt's workshop (see Drawings Cat. Nos. 48 & 49).[92] It has however as yet proved impossible to recognise his hand in any of the paintings that appear to have been done in the studio during these years, with the possible exception of the beautiful *Bust of Rembrandt* in Stuttgart.[93] (Fig. 104) This appears to be one of those fairly numerous 'self-portraits' that on close inspection are more likely to be portraits of the master done by studio assistants (see also Cat. No. 60). In this instance it is tempting to recognise in the broad application of paint and the relative autonomy of warm colour the effect Rembrandt's work from the early 1660s had on the young De Gelder on his arrival from Dordrecht. One may even feel inclined to see in the intensity of expression that marks the rendering of Rembrandt's face a reflection of the painter's fascination with his subject. For, curiously enough, Rembrandt's last known pupil was the only one to remain under the spell of his teacher's art for the rest of his life. Whereas the others sooner or later all opted for a different style, better attuned to their own temperament or the public's taste, De Gelder alone persevered in his native Dordrecht in elaborating in ever fresh colours and technical subtleties his refined and singularly light-hearted vision of Rembrandt's work. A picture such as the Boston *Homer dictating* shows the way he recreated, after some forty years, Rembrandt's version of 1663 in his own, very personal idiom.[94] (Figs. 105 & 106) While the other pupils, besides assimilating Rembrandt's style of the moment, had only occasionally borrowed ideas from the master's earlier works, De Gelder appears to have made a comprehensive study of Rembrandt's production

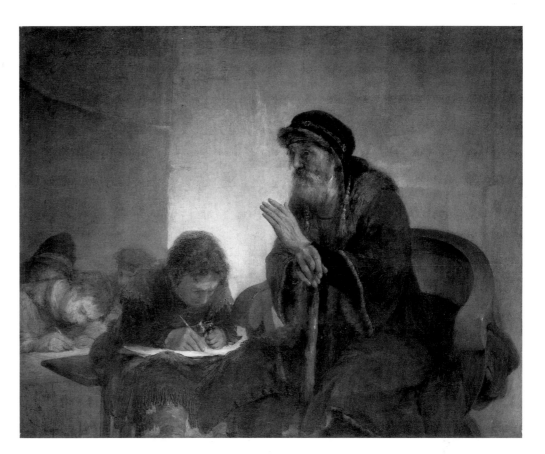

106. Aert de Gelder, *Homer dictating*. Boston, Museum of Fine Arts.

and grafted his style not just on the *Claudius Civilis*, the *'Jewish bride'* or the *Homer* but also on etchings, and perhaps even paintings, from Rembrandt's earlier periods.[95]

Aert de Gelder thus holds a unique position—that of one who was intimately familiar with what was going on in the studio during his activity there, but who also remained a lifelong admirer of what now belonged to a historical past that could be viewed at a distance. His work inaugurated a series of highly diverse visual interpretations of the magic world Rembrandt had conjured up, just as his fellow-townsman Houbraken started the production of ever changing comments that will be discussed elsewhere in this catalogue.

This essay could not have been written without the longstanding collaboration of my co-members of the Rembrandt Research Project team and the support of the Netherlands Organization for Scientific Research (N.W.O.). As will be clear from the following notes, I am particularly indebted to Professor Ernst van de Wetering's research on the Rembrandt studio and Professor Werner Sumowski's publications on the paintings and drawings of the Rembrandt school.

1. See the fundamental article by H. Miedema, 'Kunstschilders, gilde en academie. Over het probleem van de emancipatie van de kunstschilders in de Noordelijke Nederlanden van de 16de en 17de eeuw', *Oud Holland* 101 (1987), pp. 1–34.
2. See for instance E. van de Wetering, 'Problems of apprenticeship and studio collaboration' in: J. Bruyn, B. Haak, S.H. Levie, P.J.J. van Thiel and E. van de Wetering, *A corpus of Rembrandt paintings* (to be cited henceforward as *Corpus*), Vol. II, Dordrecht-Boston-Lancaster, 1986, pp. 45–90, esp. 52 ff.; a recent and very thorough contribution is: R. de Jager, 'Meesters, leerjongens, leertijd. Een analyse van zeventiende-eeuwse Noord-Nederlandse leerlingcontracten van kunstschilders, goud- en zilversmeden', *Oud Holland*, 104 (1990), pp. 69–111.
3. See for instance J.M. Montias, *Artists and artisans in Delft A. socio-economic study of the seventeenth century*, Princeton, 1982, pp. 117–19, 153, 325.
4. The word 'disciple' which is sometimes used in 17th-century documents (see notes 23, 86, 87 and 88) also refers to this kind of advanced pupil or assistant.
5. Van de Wetering, *op. cit.* (note 2), pp. 76 ff.
6. A. Houbraken, *De groote schouburgh der Nederlantsche kunstschilders en schilderessen*, 3 Vols. ed.princ. 1718–21, edn The Hague, 1753, Vol. II, pp. 20–21.
7. A. Blankert, *Ferdinand Bol (1616—1680). Rembrandt's pupil*, Doornspijk, 1982, p. 17.
8. There is no detailed information on other foreign Rembrandt pupils: Jürgen Ovens (b. 1623) from Tönning (Eiderstedt), Franz Wulfhagen (b. 1624) from Bremen, Christoph Paudiss (b. 1630) from Hamburg and Johann Ulrich Mayr (b. 1630) from Augsburg.
9. For a critical survey see B. Broos, 'Fame shared is fame doubled' in: A. Blankert *et al.*, *The impact of a genius*, exh. cat. Amsterdam (K. & V. Waterman)—Groningen, 1983, pp. 35–58.
10. A.R. Peltzer ed., *Joachim von Sandrarts Academie der Bau-, Bild-, und Mahlerey-Künste*, Munich 1925, p. 203.
11. Sandrart's success in obtaining portrait commissions during his years in Amsterdam appears to have been mainly with members of the powerful Bicker family: portraits of Hendrick Bicker and his wife of 1639 (Amsterdam, Rijksmuseum Nos. C26 and C27), portraits of Jacob Bicker and his wife of 1639 and 1641 respectively (Amsterdams Historisch Museum Cat. Nos. 389 and 391) and the *Company of Captain Cornelis Bicker* of 1640 (Rijksmuseum No. C393). For Joan Huydecoper, a member of another influential family, he did a chimney-painting of *Odysseus and Nausicaa* (Rijksmuseum No. A4278).—On Sandrart's bias in respect of Rembrandt see S. Slive, *Rembrandt and his critics 1630–1730*, The Hague, 1953, pp. 86 ff., and J.A. Emmens, *Rembrandt en de regels van de kunst*, Utrecht, 1964 (Ph.D. diss.) and 1969, pp. 66 ff.
12. Far from meeting with general disapproval (as romantic tradition would have it) the *Night watch* appears to have contributed considerably to Rembrandt's reputation. This may be inferred from information that Bernard Keil, probably a pupil about 1642–44 and therefore a witness to the painting's completion, passed on to Filippo Baldinucci. After

having mentioned Rembrandt's militia piece this author writes that the artist '*si procacciò si grande nome, che poco migliore l'acquistò giammai altro artifice di quelle parti*' (F. Baldinucci, *Comminciamento, e progresso dell'arte* (. . .), Florence, 1686, p. 78). Judging by Baldinucci's subsequent comments, however, Keil's information must also have contained criticism.

13. C. Hofstede de Groot, 'Rembrandt's onderricht aan zijne leerlingen', *Feest-bundel Dr Abraham Bredius aangeboden* (. . .), Amsterdam, 1915, pp. 79–96, esp. 80. Quite recently Werner Sumowski still adhered to this interpretation; see W. Sumowski, *Gemälde der Rembrandt-Schüler*, Vol. I- , Landau/Pfalz, 1983– (to be cited henceforward as Sumowski *Gemälde*), Vol. I, p. 14.

14. Drawing lessons as part of a gentleman's education were not unusual, especially (it would seem) in court circles. We know for instance of Constantijn Huygens, his two sons Constantijn and Christiaen, and Princes Willem II and Willem III of Orange receiving them.

15. This explanation was given by Van de Wetering, *op. cit.* (note 2), p. 55. Haverkamp-Begemann on the other hand thought that 'Sandrart's outrage (. . .) may partly have been caused by what in Sandrart's eyes was incompatible with an "academy" as he conceived of it'; E. Haverkamp-Begemann, 'Rembrandt as teacher', in exh. cat. *Rembrandt after three hundred years*, Chicago, 1969, pp. 21–30, esp. 23–24.

16. One is perhaps justified in seeing in Sandrart's exaggeration (whether intentional or inadvertent) of Rembrandt's financial demands an early manifestation of the myth concerning the artist's stinginess. On this see R.W Scheller, 'Rembrandt's reputatie van Houbraken tot Scheltema', *Nederlands Kunsthistorisch Jaarboek*, 12 (1961), pp. 81–118, esp. 94–95.

17. M.J. Bok, '"Nulla dies sine linie". De opleiding van schilders in Utrecht in de eerste helft van de zeventiende eeuw', *De zeventiende eeuw*, 6 (1990), pp. 58–68. Bok quotes Crispijn de Passe the Younger (b. 1594/95) who in the introduction to *La prima parte della luce del dipingere et disegnare*. . . [title and text in Italian, Dutch, French and German], Amsterdam (J. Blaeu), 1643, states that he, together with a son of Paulus Moreelse and others, was taught to draw in Utrecht 'in a renowned Drawing School which was then held by the principal masters' or, in the Italian version, '*l'Accademia dov'erano al hora gli piu Celebri huomini del secolo*' (pp. [11] and [10]). In an Utrecht document of 1616/17 mention is made of an '*acqueedemia*' and Sandrart, who was a pupil of Honthorst in the 1620s, apparently referred to it when writing about '*uns jungen Studenten auf der Academia*' (Sandrart/Peltzer, *op. cit.*, note 10, p. 191). From De Passe's text and illustration (Fig. 1) it is clear that pupils of various masters drew from the nude and received instructions from older artists whom Bok identified convincingly as Abraham Bloemaert and Paulus Moreelse.

18. Bok, *op. cit.*, pp. 63–64.

19. A romantic picture of Rembrandt as a nineteenth-century Bohemian has until quite recently influenced views about his studio; see for instance Sumowski, *Gemälde*, Vol. I, p. 14: '*Die Vorstellung von Rembrandt als Unternehmer und von Unterricht zugunsten der Firma wirkt absurd*'.

20. Houbraken, *op. cit.* (note 6), Vol. III, p. 206.

21. *Ibidem*, Vol. II, p. 153 (Jacobus Levecq) and Vol. III, p. 206 (Aert de Gelder). Observations to this effect were of course traditional—for instance Vasari says the same of works by the young Raphael and his teacher Perugino—but not therefore less true.

22. *Ibidem*, Vol. II, p. 21 (Govert Flinck) and Vol. III, p. 80 (Heyman Dullaert). On this practice see especially Van de Wetering in *Corpus*, Vol. II, p. 50.

23. Van de Wetering, *loc.cit.*; for the relevant text of the Utrecht document of 1651 see S. Muller Fz., *Schilders-vereenigingen in Utrecht*, Utrecht, 1888, p. 76: '*Dat ook die gene, die als gepermitteerde meesters schilderen, niet zullen vermogen eenige vreemde, of ook invoonende personen, op tytels als discipulen, ofte voor haar schilderende, en echter van haar handelinge niet zynde, ende haar eygen naam teekenende, aan te houden, ofte in het werk te stellen*'.

24. See also note 47. De Jager, *op. cit.* (note 2), pp. 77–78, mentioned contracts which allowed pupils to do some business on their own account and obliged them at the same time to pay their master an abnormally high tuition-fee. Samuel van Hoogstraten, who was precocious and possibly also well-off after his father's death, may well have made such an arrangement with Rembrandt. This would explain how he could already sign a number of works with his own name in 1644 and 1645, when he was about seventeen or eighteen years old (see Cat. No. 69), while one must assume that he was still working in the studio as late as 1646 (see below and note 77).

25. See *Corpus*, Vol. II, pp. 48–49 including Fig. 1, and Vol. III, p. 50 note 52.

26. See *Corpus*, Vol. II, p. 49.

27. W.L. Strauss and M. van der Meulen, *The Rembrandt documents*, New York, 1979, 1656/12 Nos. 37 and 293. The versions listed in the inventory may be tentatively identified with an excellent copy after the Munich original in private ownership (see *Corpus*, Vol. III, p. 18, Fig. 6) and a free variant by a pupil now in Leningrad (*Corpus*, Vol. II, No. C49), or even a fragmentary free copy of the latter in the style of the 1650s now in Washington (*Corpus*, Vol. II, No. C49 copy 1). The 1656 inventory also lists a *Resurrection*, a *Circumcision* and a *Flagellation* (Strauss and Van der Meulen, *op. cit.*, 1656/12 Nos. 113, 92 and 302), the two lastnamed expressly described as copies.

28. *Ibidem*, 1656/12, No. 113.

29. This copy was later owned by the painter Lambert Doomer and was copied by him in a drawing as well as described in two inventories of his possessions as by Rembrandt. See W. Schulz, *Lambert Doomer. Sämtliche Zeichnungen*, Berlin-New York, 1974, pp. 37–38, No. 41, and *Corpus*, Vol. III, pp. 21–22 (where further copies after Rembrandt's Passion scenes are discussed).

30. Schwartz touched occasionally on Rembrandt's business (G. Schwartz, *Rembrandt. Zijn leven, zijn schilderijen*, Maarssen 1984, e.g. p. 116, in connection with the Passion series for Prince Frederik Hendrik). Svetlana Alpers went into Rembrandt's supposedly bad relations with his clients and his attitude towards the art market (S. Alpers, *Rembrandt's enterprise. The studio and the market*, London, 1988, pp. 91 ff.). The author's views culminate in a baffling interpretation of the dictum Rembrandt contributed, together with the drawing of an old man, to the *album amicorum* of one Burchard Grossmann, of which she ignored the first line and misunderstood the second: the whole of Rembrandt's 'emblem' clearly refers to pious old age. The only aspect of Rembrandt's business that has repeatedly been dealt with is his *cessio bonorum* in 1656. On his relations with Hendrick Uylenburgh see especially B.P.J. Broos's review of Strauss and Van der Meulen (*Simiolus*, 12, 1981–82, pp. 251–52), and E. van de Wetering in *Corpus*, Vol. II, pp. 57–60 with further references.

31. See Strauss and Van der Meulen, *op. cit.* (note 27), 1634/7 and 1642/8. It may or may not be significant that both these deeds were executed before notaries outside Amsterdam (in Rotterdam and Edam respectively).

32. *Ibidem*, p. 594; *Corpus*, Vol. III, p. 14. From the prices given it is not entirely clear whether the works mentioned were paintings or elaborate drawings of the kind we know from a number of specimens from the mid-1630s (see note 56).

33. Strauss and Van der Meulen, *op. cit.*, (note 27), 1660/20. The wording of the Dutch text is somewhat confused. It runs: '*seeckere compagnie en handel van schilderijen, papiere kunst, kooper- en houtsnede, item drucken van deselve, rariteyten en alle ap- en dependentien van dien*'.

34. Haverkamp-Begemann, *op. cit.* (note 15), p. 21.

35. O. Benesch, 'Rembrandt's artistic heritage', *Gazette des Beaux-Arts*, 6th series 33 (1948), pp. 281–300, esp. 281. This idea is echoed in Sumowski, *Gemälde*, Vol. I, p. 13. Kenneth Clark went even further and declared: 'Rembrandt was the most inspiring teacher that has ever lived, and since almost every talented Netherlandish painter of the time worked in his studio, he could raise their talents to the point of genius. Thus mediocrities could paint masterpieces'; see Lord Clark, [speech at the opening of the exhibition *Rembrandt 1606–1669*, Amsterdam 1969] in: *Bulletin van het Rijksmuseum*, 17 (1969), pp. 115–18, esp. 116.

36. S. van Hoogstraeten, *Inleyding tot de hooge schoole der schilderkonst*(. . .), Rotterdam, 1678, pp. 11–12, 95 and 181. See also Slive, *op. cit.* (note 11), pp. 99–100; Slive rightly observes that Hoogstraten 'never quotes the master as the spokesman for any of the dictums which he wants to give to his reader'.

37. Strauss and Van der Meulen, *op. cit.* (note 27), 1658/3. A school drawing of an *Artist painting an old man* in the Fondation Custodia (coll. Frits Lugt), Paris, may give some idea of how the attic was partitioned; see Alpers, *op. cit.* (note 30), Fig. 3.4. The anecdote (A. Houbraken, *op. cit.* note 6, Vol. I, p. 257), which is about Rembrandt chasing a naked model and an equally naked pupil from their 'Paradise', was surprisingly considered by Svetlana Alpers as support for the (in my view mistaken) notion that theatrical performances were part of Rembrandt's studio practice (Alpers, *op. cit.*, p. 47).

38. Cf. W.R. Valentiner, 'Rembrandt as teacher', in *idem, Rembrandt and his pupils. A loan exhibition*, Raleigh, 1956, pp. 22–39.

39. Instead of by type or subject-matter as I did in *Corpus*, Vol. III, pp. 12–50.

40. *Corpus*, Vol. I, No. A1. On Huygens's comments on Rembrandt's and Lievens's youthful works and particularly his praise of Rembrandt's *judicium*, see P. Tuynman's commentary and translation in *ibidem* pp. 193–94, and Schwartz, *op. cit.* (note 30), pp. 73–77.

41. On the Amsterdam sketch of *Samson and Delilah* and its significance for Rembrandt's version of the subject in Berlin, see: *Corpus*, Vol. I, Nos. A24 and C1.

42. *Corpus*, Vol. I, Nos. A13 and A15.

43. On the London *Tobit and Anna* and Willem de Leeuw's etching after it, see *ibidem*, No. C3 and p. 48, where however no explanation for the inscription on the latter is given. For other instances of Rembrandt attaching his own name to studio pieces, see below and notes 27–29 and 72.

44. For the copy and the original see *Corpus*, Vol. I, No. A40, and Vol. II, p. 840. The attribution of the copy was first made by E. van de Wetering, 'Isack Jouderville, a pupil of Rembrandt', in: A. Blankert *et al., op. cit.* (note 9), pp. 59–69.

45. Other copies reproducing Rembrandt originals prior to their definitive completion are known to exist after the 1631 *Peter in prison*, sale New York, Christie's, 31st May 1990, No. 149 (a painted copy; see E. Haverkamp-Begemann in the sale catalogue), the Toledo *Bust of a young man* of 1631 (a painted copy, see *Corpus*, Vol. I, No. A41 and Vol. II, p. 847), the Frankfurt *Blinding of*

Samson of 1636 (both a drawn and a painted copy, see *Corpus*, Vol. III, No. A116) and the Munich *Resurrection* (a painted copy, see note 29). For a painted copy, probably by Jouderville, of what probably now hidden beneath the Glasgow *Portrait of the artist as a burgher* of 1632, see *Corpus*, Vol. II, No. A58.

46. The former, once considered a Rembrandt, was in the Baron de Schickler collection, Paris (K. Bauch, *Rembrandt Gemälde*, Berlin, 1966, no. 450), the latter is in a private collection (see Van de Wetering, *op. cit*, note 44, Fig. 7, and *Corpus*, Vol. I, p. 506, Fig. 4).

47. On the pictures at Chapel Hill and (formerly) Boston see *Corpus*, Vol. II, Nos. C59 and A50 respectively. The Windsor Castle picture bears an inscription *RHL.* (in monogram) 1631. This inscription as well those on a number of other studio works comprises a plausible and probably correct date. In many instances the handwriting differs sufficiently from Rembrandt's own to suggest that it was not appended by him. The inference would seem to be that Rembrandt's 'signature' was added by the pupil responsible for the execution. On this see *Corpus*, Vol. II, pp. 105–06.

48. *Corpus*, Vol. I, No. C9.

49. For the argument on the attribution of the New York portraits, see *Corpus*, Vol. II, Nos. C68 and C69 and Vol. III, pp. 30–34, and W. Liedtke, 'Reconstructing Rembrandt. Portraits from the early years in Amsterdam (1631–34)', *Apollo*, 129 (1989), pp. 323–31 and 371–72. If the attribution to Jouderville is correct (as I think it is), the woman's portrait offers in her left hand (which was moved to a considerably lower position and is far superior to the other hand) what probably is an interesting case of a correction by Rembrandt in a pupil's work.

50. For groups that have for the time being to remain anonymous see *Corpus*, Vols. II and III, Nos. C65 and C66; C70 and C71; C72, C73, C82, C104 and (?) C105.

51. *Corpus*. Vol. II, No. C48.

52. On this *Rest on the flight into Egypt* in private ownership (at present on loan to the Rijksmuseum, Amsterdam), see *ibidem*, pp. 848–56.

53. *Corpus*, Vol. III, No. C77.

54. J.W. von Moltke, *Govert Flinck 1615–1660*, Amsterdam, 1965, p. 106, No. 200. On the basis of a seemingly trustworthy tradition the sitter is thought to be Gosse or Gosen (Gozewijn) Sents or Centen (son of Vincent or Cent), a Mennonite baker born in 1611/12 from a family that had strong ties with Friesland and particularly with Frisian Mennonites, in whose circle Flinck had probably moved before he came to Amsterdam; see I.H. van Eeghen, 'Ongrijpbare jeugd. Bij een portret van Govert Flinck', *Bulletin van het Rijksmuseum*, 25 (1977), pp. 55–59. The presumed identity of the sitter thus bears out the attribution to Flinck, which was first made on stylistic grounds by C. Hofstede de Groot, 'Kritische opmerkingen omtrent Oud-Hollandsche schilderijen in onze musea', *Oud-Holland*, 22 (1904), pp. 27–38. De Groot dated the picture to 1636/37 and von Moltke even to 1639/40. As was pointed out by Van Eeghen, Gosse Centen had by that time moved to Leeuwarden. The stylistic similarity to the two other pictures discussed here, of which the one in Dresden is dated 1633, points however to a date in 1633/34 when Flinck still worked with Rembrandt and Gosse Centen was about twenty-two. Because of its extremely simple but original frame (see: C.J. de Bruyn Kops, 'De ontdekking en de originele omlijsting van een portret door Govert Flinck', *Bulletin van het Rijksmuseum*, 25 (1977), pp. 60–63) the picture is currently on exhibition in the Sculpture and Applied Art Department of the

Rijksmuseum and it tends to be overlooked.

55. W. Goeree, *Inleydinge tot de algemeene teykenkonst*, ed. princ. Middelburg, 1670, edn Amsterdam 1697, pp. 28 ff. and 33 ff.

56. W. Sumowski, *Drawings of the Rembrandt school*, Vol. I, New York 1979, Nos. 124 (*Zacharias in the Temple*, Paris), 126 (*Minerva*, Amsterdam, signed *F:bol ft*), 127 (*Flora*, London) and 128 (*Standard-bearer*, London); see also No. 142 (*Portrait of Rembrandt*, Washington).

57. See note 32.

58. *Corpus*, Vol. III, No. A108 copy 2.

59. Up to now it has however proved impossible to recognise Rembrandt's share in the picture's execution.

60. *Corpus*, Vol. III, No. A121 and copy 1. It is interesting to note that Rembrandt himself borrowed precisely the angel from a Heemskerck woodcut of the subject and apparently instructed the pupil to find a different solution. For the entire composition and a number of motifs Rembrandt based himself on a painting of *The angel appearing to the shepherds* by Jan Pynas (see *ibidem*, pp. 238–239 and Fig. 9).

61. This happened to Rembrandt's Berlin *Samson threatening his father-in-law* of 1635; see *ibidem* No. A109 copy 1.

62. See a *Rest on the flight into Egypt* in Berlin (von Moltke, *op. cit*., note 54, No. 48, as by Govert Flinck; Sumowski, *Gemälde* Vol. IV, No. 1906, as anonymous), where the head of Rembrandt's Amsterdam *Bust of a young woman* (Saskia?) of 1633 (*Corpus*, Vol. II, No. A75) is superimposed on the body of the Virgin from the Munich *Holy Family* of c. 1634 (*ibidem*, No. A88); see *Corpus*, Vol. III, pp. 28–29.

63. Van de Wetering's attribution of this picture to Bol (E. van de Wetering, 'Het formaat van Rembrandts "Danaë"', *Met eigen ogen. Opstellen aangeboden (. . .) aan Hans L.C. Jaffé*, Amsterdam, 1984, pp. 67–72) was confirmed by Sumowski's discovery of Bol's sketch for the figures of Isaac and Esau (Sumowski, *op. cit*. (note 56), Vol I, No. 199*). The latter figure seems to be based on that of the servant in Rembrandt's 1639 etching *Portrait of Jan Uytenbogaert* ('The goldweigher') (B. 281).

64. See for instance the knee-length *Portrait of a 70-year-old woman* of 1635 in New York (*Corpus*, Vol. III, No. C112), which is based on Rembrandt's full-length *Portrait of Maria Bockenolle* of 1634 in Boston (*Corpus*, Vol. II, No. A99).

65. Von Moltke, *op. cit.* (note 54), No. 259; Sumowski, *Gemälde* Vol. II, No. 695. Another instance of Flinck borrowing a portrait motif from Rembrandt is found in the Malibu *Portrait of a man holding a hat* of 1641 (von Moltke, *op. cit*., No. 308; Sumowski, *op. cit*., No. 697) which is a variation on Rembrandt's *Portrait of a man holding a hat* in the Armand Hammer Museum, Los Angeles (*Corpus*, Vol. III, No. A130).

66. For a survey of these see *Corpus*, Vol. III, p. 16 note 21.

67. See for instance a *Bust of an old man* in Leipzig which is based on Rembrandt's Nürnberg *St Paul at his desk* (Cat. No. 5); on this 'tronie' see (*Corpus*, Vol. I, pp. 44 ff. and No. C25).

68. For a survey of these see *Corpus*, Vol. III, p. 24 note 56.

69. See this author's review of Sumowski, *Gemälde* Vol. III (where the picture is No. 1322 and attributed to Nicolaes Maes) in *Oud Holland*, 102 (1988), pp. 329–30.

70. See Sumowski. *op. cit*., No. 1327 (as attributed to Maes) and this author's review just cited, p. 329. See also exh. cat. *Een gloeiend palet. Schilderijen van Rembrandt en zijn school. A glowing palette. Paintings of*

Rembrandt and his school, Rotterdam (Museum Boymans-Van Beuningen) 1988, No. 6.

71. Sumowski, *op. cit*., Vol. IV, New York, 1981, No. 823*.

72. There can be little doubt that the Detroit *Woman weeping* is to be identified with '*een crytend vroutgen van Rembrandt*' (a little woman weeping by R.) in the Willem van Campen collection, Amsterdam, in 1661 (A. Bredius, *Künstler-Inventare*, Vol. IV, The Hague, 1917, p. 119). The Rotterdam *Woman holding a child* can be identified with '*Een dito* [i.e. een stuckie] *van een vrouwtie met een kintie van Rembrant van Rijn*' (a little painting of a woman with an infant by R. v. R.') in the 1656 inventory of Rembrandt's possessions (Strauss and Van der Meulen, *op. cit*., note 27, 1656/12 No. 3) and with '*een vrouken met een kint in de lueren door Reynbrant*' (a little woman with a child in swaddling-clothes by R.) in the Abraham Heyblom collection, Dordrecht, in 1685 (A. Bredius in *Oud-Holland*, 28, 1910, p. 12).

73. According to the anonymous biography of Karel van Mander that was published as an appendix to the second edition of his *Het Schilder-Boeck* (Amsterdam, 1618), Van Mander, Hendrik Goltzius and Cornelis Cornelisz. van Haarlem '*hielden en maeckten onder haer dryen een Academie, om nae 't leven te studeren*' (made amongst themselves an Academy in order to make life-studies). There is now general agreement that this once much-debated piece of information refers to informal sessions where the three artists drew from the nude. The French word '*académie*' is still today used to denote a life- study from the nude. For Hoogstraten's use of the word '*Academiteykening*' see note 77.

74. Documents that shed some light on the Amsterdam situation around 1650/60 were all meant to give testimony on the disorderly behaviour of women by describing how they served as models. One deposition, dated 27th March 1658, mentions a woman who, some ten years earlier, 'usually sat overtly in the *collegie* of painters and was used to that end [i.e. to be painted]' ('*de welcke ordinaris int collegie van schilders opentlijck sat ende daer toe gebruyckt wert*'); see S.A.C. Dudok van Heel, 'Het "gewoonlijck model" van de schilder Dirck Bleker', *Bulletin van het Rijksmuseum*, 29 (1981), pp. 214–20. Another deposition, dated 27th July of the same year, contains the testimony of five painters: Willem Strijker, Ferdinand Bol, Govert Flinck, Nicolaes de Helt Stokade and Jacob van Loo; they testify that a woman 'sat for them, witnesses, as well as others collegialiter, stark-naked, as a model, and that they, witnesses, drew and painted from her' ('*dat. . . voor haer getuygen als andere collegialiter moeder naeckt als model geseten heeft, en dat sy getuygen daernaer geteeckent en geschildert hebben*'); see: A. Bredius, *Künstler-Inventare*, Vol. IV, The Hague 1917, p. 1255. Serving as a model was obviously frowned upon, certainly as far as women were concerned. This is also evident from a document from 1656 describing life-size paintings done eight years earlier by Flinck and showing three sisters, Catrina, Margriet and Anna van Wullen 'portrayed as stark-naked as one could be portrayed, lying as indecently as possible asleep on a cushion' ('*wesende de selve uytgeschildert so moedernaeckt als jemant uytgeschildert soude konnen werden, so legghende op het alleronneerlijkste op een kussen te slapen*'); see S.A.C. Dudok van Heel, 'Het "schilderhuys" van Govert Flinck en de kunsthandel van Uylenburgh aan de Lauriergracht te Amsterdam', *Jaarboek (. . .) Amstelodamum*, 74 (1982), pp. 70–90, esp. 73–75. From the documents cited one gathers that the use of female models became more wide-spread by the middle of the century. In this connection it is interesting that, whereas boys posed for Rembrandt's

1646 'session', nearly all later studies from the nude by him and his pupils show female models.

75. See Bok, *op. cit.* (note 17); on the problem in general see Miedema, *op. cit.* (note 1).

76. The interpretation is due to Emmens, *op. cit.* (note 11), pp. 155–58. This author also suggested that etching B.194, which is commonly called 'Het rolwagentje' (the walker), may have belonged to a group of 'didactic' etchings to which d'Argenville referred a century later, when he wrote: '*Son livre à dessiner est de dix ou douze feuilles*' (D. d'Argenville, *Abrégé de la vie des plus fameux peintres . . .*, Paris 1745, p. 29). Etching B. 194 would then have been something of a programmatic frontispiece. See also J. Bruyn, 'On Rembrandt's use of studio-props and model drawings during the 1630s', *Essays in Northern art presented to E. Haverkamp-Begemann*, Doornspijk, 1983, pp. 52–60, esp. 57.

77. Sumowski, *op. cit.* (note 56), Vol. V, New York 1981, No. 1253. See also *ibidem*, No. 1250, a drawing formerly in the I. de Bruijn collection and also convincingly attributed by Sumowski to Hoogstraten; it represents the second boy in Rembrandt's etching seen from a different angle. Schatborn, *op. cit.* (note 79), pp. 19–22, rightly connected these and similar drawings with a statement Hoogstraten made in his *Inleyding* published in 1678, when his style and views had radically changed : '*Zeker, ik beklaag my, wanneer ik mijn oude Academeykeningen overzie, dat men ons daer van* [i.e. the posing of the model] *in onze jonkheyd zoo spaerigh heeft onderrecht, daer het niet meer arbeyt is een graesselijck postuur, dan een onaengenaem en walgelijk na te volgen*' (Certainly, when looking over my old studies from the nude, I complain that we were taught so sparingly [how to pose the model] in our youth. For it is no more work to render a gracious posture then a disagreeable and repellant one); see Hoogstraten, *op. cit.* (note 36), p. 294. There does not seem to be any evidence that the boys posing in Rembrandt's studio would have been pupils, as has sometimes been suggested.

78. O. Benesch, *The drawings of Rembrandt*, E. Benesch ed. London, 1973, Vol. IV, Nos. 709 and 710 respectively (as by Rembrandt). The London drawing shows a remarkable similarity, especially in the use of short, almost straight hatchings and the treatment of outlines, to a somewhat later drawing by Nicolaes Maes in the Victoria & Albert Museum, London (Sumowski, *op. cit.*, note 63, No. 1765b). In 1646 Maes was however only twelve years old, which makes an attribution to him seem unlikely.

79. See: [P. Schatborn and E. Ornstein-van Schooten,] exh. cat. *Bij Rembrandt in de leer/Rembrandt as teacher*, Amsterdam (Museum Rembrandthuis), 1984–85, p. 6/ 11 and No. 7, and Miedema, *op. cit.* (note 1), pp. 17– 18. As pointed out by W. Scheidig (*Rembrandt als Zeichner*, Leipzig, 1962, p. 59), not even the Darmstadt drawing can be considered an original because of the misinterpretation of certain details. This applies notably to the dagger carried by the draughtsman on the extreme left, which in a version at Weimar has the more plausible form of an ink-horn.

80. See however note 49.

81. Sumowski, *op. cit.* (note 56), Vol. IX, No. 2191**. On Renesse's life see particularly Sumowski, *Gemälde*, Vol. IV, pp. 2469–70.

82. Canvas 114.5 by 94.5 cm, Aix-en-Provence, Musée Granet. The attribution is due to Sumowski (*Gemälde* Vol. I, No. 387), who gave the first and generally convincing survey of Van Dijck's oeuvre.

83. Panel 75 by 62 cm, London, Raphael Valls Ltd. I owe the photograph and relevant information to the kindness of Mr Valls, who exhibited the picture at the International Art Fair, Maastricht, in 1990.

84. One is reminded of such works as the *Portrait of a young woman holding a pink*, attributed to Rembrandt, in the National Gallery of Art, Washington D.C. (Bredius No. 390).

85. See *Corpus*, Vol. III, No. C83.

86. The term 'disciple' seems to have been used to denote advanced pupils or assistants. One can infer this from documents mentioning Leendert van Beyeren (who acted as bidder on Rembrandt's behalf at an important sale in 1637) and Jacobus Levecq (who figures as witness in 1653); see Strauss and Van der Meulen, *op. cit.* (note 27), 1637/2 and 1653/16. See also notes 23, 87 and 88.

87. The painting described in 1712 was among the goods the late Hillebrand van der Walle had brought in at his marriage in 1672. The text runs: '*een heele groote schilderij daar vier mans in sijn, drie bij een en een sittende, sijnde den hooftman Cornelius, sijnde een principael van een discipel van Reynbrant twintigh jaar geweest*'; see J. Bruyn, *Oud Holland*, 98 (1984), p. 161. If the mysterious last three words may be understood to mean 'twenty years ago', this would result in a date of 1652 for the painting or its purchase (which is plausible enough). For a survey of the varying opinions on the picture's attribution, see Sumowski, *Gemälde*, Vol. IV, pp. 2876 (and note 23) and 2894, where more than one hand (Drost and Van der Pluym?) is held responsible for the picture; this is unlikely, if only because of the wording of the document just cited.

88. The inventory of the estate of Nicolaas van Bambeeck (II), son of Rembrandt's sitter (see Cat. No. 34), who had died in 1671, lists a '*dito* [i.e. a painting], *sijnde een Abraham ende Hagar van een discipel van Rembrant*' (A. Bredius, *Künstler-Inventare*, Vol. III, The Hague, 1917, p. 1022). This description was tentatively related to a picture in the Victoria & Albert Museum (*Corpus*, Vol. III, No. C85) but this has turned out to be incorrect. As Mr Jaap van der Veen kindly informed me, the inventory of the estate of Nicolaas van Bambeeck III, who had died in 1722, lists what was undoubtedly the same picture as '*Een historie van Abraham van Drost*'. The picture thus described may be identified with one that is at present mainly known through an eighteenth-century mezzotint (inscribed 'Rembrandt pinx.') by J. Spilsbury and a copy (? after the print?) in Leningrad (Inv. No. 5601 as Renesse); see Sumowski, *Gemälde*, Vol. IV, No. 1758 (as after Jan Victors). A drawing for the picture, also unmistakeably by Drost, was until World War II in the Kunsthalle Bremen (W.R. Valentiner, *Rembrandt. Des Meisters Handzeichnungen*, Stuttgart-Berlin-Leipzig (1925), Klassiker der Kunst XXXI, No. 428 as copy after Rembrandt; Benesch, *op. cit.*, note 78, Vol. VI, No. C84, not reproduced, as copy after Rembrandt).

89. J. Bruyn, 'An unknown assistant in Rembrandt's workshop in the early 1660s', *The Burlington Magazine*, 132 (1990), pp. 714–18.

90. For these related pictures, one representing *Abraham's sacrifice* and two fragments of an *Ascension*, see, in addition to the article just cited, Sumowski, *Gemälde*, Vol. IV, pp. 2963 and 3043 (No. 1976); 2876, 2884 (notes 36 and 37), 2904 and 2905.

91. It is conceivable, in view of the exceptional form this assistant's share took, that he was Titus van Rijn, Rembrandt's son (b. 1641). Titus is known to have been a painter but his name is never mentioned in connection with paintings in any inventories or sales catalogues (apart from Rembrandt's own inventory of 1656). This precludes forever any secure identification of his paintings, which probably went under his father's name anyway.

92. P. Schatborn, 'Rembrandt's late drawings of female nudes', in W. Strauss and Tracie Felker ed., *Drawings defined*, New York, 1987, pp. 306–19.

93. See this author's review of Sumowski, *Gemälde*, Vol. II, in *Oud Holland*, 81 (1987), p. 228.

94. The authentic drawing in Stockholm (Benesch, *op. cit.*, note 78, Vol. V, No. 1352) can still give some idea of the composition of Rembrandt's painting, of which only a badly damaged fragment in The Hague (Bredius No. 483) survives. For De Gelder's painting see Sumowski, *Gemälde*, Vol. II, No. 760 (as dating from *c.* 1700).

95. See for instance De Gelder's *Circumcision* in Vienna (Sumowski, *Gemälde*, Vol. II, No. 764, as *c.* 1700/10), for which Rembrandt's early etching of the subject (Bartsch 48) seems to have been the main source.

The invisible Rembrandt: the Results of technical and scientific Examination

Ernst van de Wetering

107: Edge of a seventeenth-century oak panel.

In the past few decades a whole battery of technical and scientific techniques has been brought to bear on Rembrandt's paintings.[1] The main focus of interest has been on the supports (panels and canvases) and grounds (the layer or layers applied to the support to prepare it for painting). Since these materials are fairly accessible and can be investigated on a large scale, it was thought that they might help uncover specific features of Rembrandt's workshop practice. It was hoped that the examination would provide firm data that would make it possible to identify later copies or imitations. Such findings were badly needed for the discussion on the authenticity of paintings attributed to Rembrandt.

The dating of panels by measuring the climatically induced variations in the width of the annual growth rings on the cross-cut sides of oak panels (Fig. 107), known as dendrochronological examination,[2] did indeed yield reliable information on the origin and date of the wood, and even provided spectacular evidence for identifying planks which came from the same tree. For instance, it turned out that four large panels by Rembrandt came from adjacent parts of the same tree (Figs. 108–11). These must have been used in the same studio, unless one accepts the very unlikely possibility that Rembrandt forgeries were being produced as early as 1640 in a shop near the lumber yard he used. The canvas of *St John the Baptist preaching* (Cat. No. 20) was glued to one of these panels, and the suspicion that this was done in Rembrandt's studio was confirmed by the dendrochronological data (Fig. 111).

The most important discovery was that the paintings regarded as suspect were on panels the date of which agreed with the corresponding stylistic phase in Rembrandt's career and not a single panel came from a tree felled after his death. This makes it unlikely that the early or middle Rembrandt was imitated or forged on any scale (in his late period he worked almost exclusively on canvas). The panel paintings which are not accepted as autograph for reasons of style or quality were therefore very probably painted in Rembrandt's workshop. This conclusion prompted a closer study of Rembrandt's pupils and assistants, the seventeenth-century norms of workshop production, copying as part of an artist's training, the various guild regulations, and so on. This in turn supported the theory that Rembrandt's studio turned out a large number of works done in the master's style and technique, which is borne out by written sources.[3]

The most interesting feature of the backs of panels is the bevelling along the edges (Fig. 112).[4] Panels were bevelled before they were painted so

Four paintings by Rembrandt on panels sawn from the same tree-trunk.

108: *Portrait of Aletta Adriaensdr.*, 1639. Rotterdam, Museum Boymans-van Beuningen, Willem van der Vorm collection.

109: *Portrait of Herman Doomer*, 1640. New York, The Metropolitan Museum of Art.

110: *The Woman taken in Adultery*, 1644. London, The National Gallery.

111: *John the Baptist preaching*, c. 1634–35. Berlin, Gemäldegalerie SMPK.

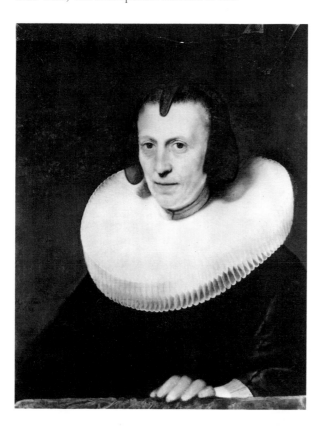

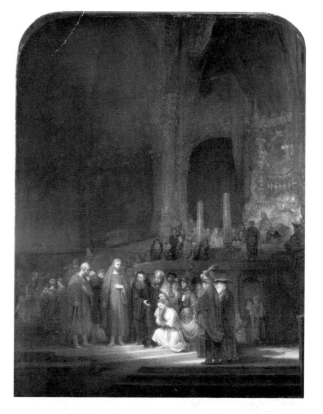

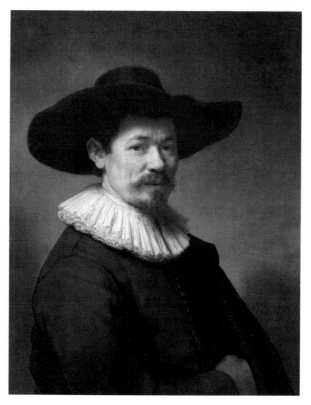

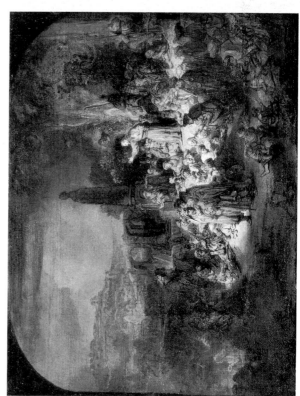

108: *Portrait of Aletta Adriaensdr.*, 1639.

111: *John the Baptist preaching*, c. 1634–35.

112: Back of the panel of Rembrandt's *Baptism of the Eunuch*, 1626. Utrecht, Rijksmuseum Het Catharijneconvent.

that they would seat better into the shallow rebate of the frame. The absence of one or more bevelled edges could indicate that the picture had later been reduced in size. It also proved possible to distinguish a whole series of seventeenth-century standard panel formats, ranging from small (about 15 × 12 cm) to quite large (roughly 120 × 90 cm). Rembrandt, too, used these standard-size panels, which were supplied by joiners and some art dealers. On the basis of these standard sizes it was often possible to establish the original dimensions of panels which had been cut down. Later owners were remarkably nonchalant about altering the size of a picture, usually by trimming. Such changes in format mar the carefully planned lay-out of Rembrandt's compositions, so the reconstruction, on paper, of a mutilated work gives us a clearer understanding of his artistic intentions (Figs. 113, 116–17). This newly acquired knowledge of standard seventeenth-century panel sizes could then be correlated with the names given to stock formats in the seventeenth-century literature.[5]

Using this kind of information it was possible, for instance, to establish that one of the young Rembrandt's most beautiful works, the *Old Man in a gorget and black cap* in the Art Institute in Chicago (Fig. 113), had the width of what was known as the '*guldensmaat*', or guilder size, but not the height. This panel is now almost square, but originally it must have been some 7 cm higher. This was confirmed by the dimensions given for the picture in a sale catalogue of 1767, so someone evidently sawed off a 7 cm strip (from the top) some time after 1767.[6] It is an undated work that was usually allocated to Rembrandt's Leiden period, which lasted until the end of 1631.[7] Dendrochronological examination, though, showed that one of the panel's three planks came from the same tree as a plank used in the Braunschweig *Portrait of a Woman*,[8] which is dated 1633 and is one of a large group of portraits executed by Rembrandt and his assistants in the studio of the Amsterdam art dealer Hendrick Uylenburgh. Given the common origin of two of their planks, both panels must have been put together from the same batch of wood. Could this mean that the *Old Man* was painted in Amsterdam after all? This may seem a trifling and also rather speculative finding, but such research brings all sorts of information to light which, being based on generally verifiable facts, will eventually help us form a clearer image of Rembrandt's art and career.

The canvases were subjected to a similar examination,[9] although here no absolute datings could be established. What can be said with a high

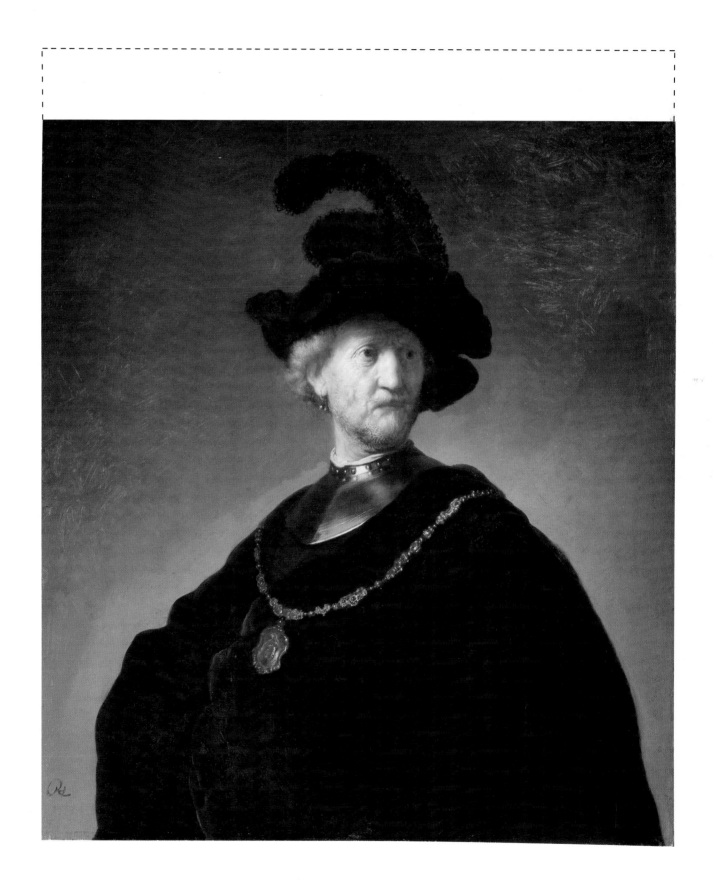

113: Rembrandt, *Old Man with gorget and black cap*, c. 1631. Chicago, The Art Institute of Chicago. The lines indicate the original size of the panel.

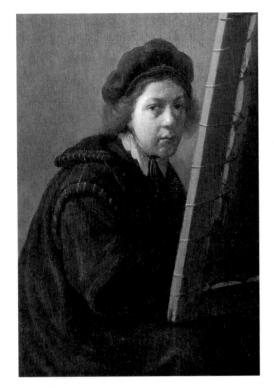

114: Gerard Dou, *An Artist in his Studio*. Private collection. The canvas is stretched in a temporary frame with cords.

115: X-radiograph of the edge of a canvas. The distortions in the fabric (cusping) caused by stretching the canvas are locked into place by the ground.

degree of probability from numerous measurements of the thread density (the number of warp and weft threads per centimetre) taken from hundreds of x-rays of Rembrandt's paintings, is that small groups of canvases came from the same bolt. Rarely, though, were there more than two in a group, which suggests that Rembrandt did not cut his canvases from a large bolt but, as with the panels, bought them separately in a shop in small batches. Canvas priming was a specialist craft in the seventeenth century, so these individual canvases would have been bought ready-prepared with a primary layer of ground. These new data proved to be of great importance for the strategies used in the quest for the authentic Rembrandt, for it meant that he did not prime has canvases in his own studio. This explained the remarkably large variation in the ground layers analysed. Only when there are two ground layers is it possible that the upper one was applied in Rembrandt's workshop.[10] With very few exceptions the canvases of companion portraits turn out to be from the same bolt, and not surprisingly were bought at the same time. It must have been fairly common in the seventeenth century for people commissioning their portraits to buy the supports themselves, probably in their own neighbourhood or city, which helps explain the variation in the grounds.[11] As with the panels, information was gained on the standard sizes used, which in turn were determined by the weaving widths customary in the seventeenth century (expressed in ells and half-ells, one Flemish ell being 69 cm).[12] The *Nightwatch*, for instance (another painting that was later reduced in size), was painted on three strip-widths of 2 ells each (roughly equivalent to 140 cm). No weaver, incidentally, would have known that he was producing artists' canvas, for the fabric used by painters was usually intended for ships' sails, mattress covers, clothing or packaging. At the same time more information was acquired on cusping—a scalloping of the weave pattern that occurs when a piece of untreated linen is stretched in a frame for priming. These local distortions become locked into the fabric when the ground sets (Figs. 114, 115). As with thread density, distortions of this kind can only be studied from x-ray photographs because, like so many old pictures, Rembrandt's canvas paintings have since been lined with a backing canvas, which hides the original linen.

The information gained about artists' canvas and seventeenth-century stretching methods also made it possible to be far more precise about the original format of a canvas painting that was later reduced. Occasionally this led to some surprising

116: Rembrandt, *Portrait of a Man trimming his Quill*, 1632. Kassel, Schloss Wilhelmshöhe.

117: Rembrandt, *Portrait of a young Woman seated*, 1632. Vienna, Akademie der bildenden Künste. The lines indicate the original size of the painting. See Cat. No. 10.

118: Rembrandt, *Danaë*, 1636. Leningrad, Hermitage. This photographic reconstruction of the original size of the painting is based on canvas research and a work from Rembrandt's workshop (see Fig. 90).

discoveries. It turned out, for instance, that the *Man trimming his Quill* dated 1632 in Kassel (Fig. 116),[13] who was usually believed to be the Amsterdam calligrapher Willem Lievensz. Coppenol, was actually married to a very young woman, whereas Coppenol's wife was 52 years old the year the picture was painted. The canvas investigation had shown that the *Portrait of a young Woman seated* in the Akademie in Vienna (Fig. 117) must have been the companion (later reduced in size) to the Kassel picture. The man thus lost his name but regained his lawful wife.[14]

The results of the canvas study were even more far-reaching for the reconstruction of one of Rembrandt's most superb masterpieces, the *Danaë* in Leningrad. A combination of data on thread density, standard strip-widths and cusping, together with the happy discovery of a modified workshop copy (see Fig. 90), were used to reconstruct the original picture (Fig. 118).[15]

In addition to the numerous individual cases where this kind of examination extended our knowledge of specific works, it also provided unexpected information on the way in which Rembrandt came by his materials. The scientific examination of the supports proved to be of little direct relevance in establishing authenticity, but indirectly the results were of inestimable importance, since they substantially enriched our knowledge of seventeenth-century studio practice.

Pigment analysis was of limited value in settling questions of authenticity, for by far the majority of the dubious paintings must have been executed in Rembrandt's workshop. It did, though, tell us a great deal about the procedures followed in the studio (Fig. 119).[16]

It only gradually emerged from a study of the picture surfaces, radiographs and paint samples that those procedures were far more systematic than had been expected. Determining the colour of the painted ground, or *imprimatura*, which is usually visible at scattered points on the paint surface, helped provide an understanding of its role as a mid-tone in the monochrome lay-in of the composition, known as the dead-colouring stage (Fig. 120). As far as we know Rembrandt hardly ever worked from preparatory sketches on paper. Painting one's 'inner vision', as Karel van Mander called it in 1604, meant, in the words of Rembrandt's pupil Samuel van Hoogstraten, that the artist 'first formed the complete design of the work in his imagination and made a picture in his mind before ever putting brush to paint'.[17] From an anecdote he relates about a painting contest it appears that this method was held in high esteem.[18]

One has to imagine that a picture in its dead-colour stage was already a true painting in which the light and dark areas were broadly laid down (see Fig. 126). It hardly needs stressing how important this was for the compositional structure of a painting in the Baroque. Light and shadow played a vital role in pictorial organisation in this period, and this certainly (and especially) applied to Rembrandt. It was not just a question of the function of light and shadow in suggesting the individual forms. Painters were also well aware that a careful gradation of lights and shadows throughout a scene greatly enhanced their control over the composition (Fig. 121).

Although the infrared examination of under-drawings has shed a remarkably detailed light on the preparatory stage in the creation of fifteenth and sixteenth-century pictures,[19] it is rarely possible to get a clear picture of the initial monochrome design in paintings by Rembrandt and many other seventeenth-century artists. X-radiography, which will be discussed below, generally reveals only the light passages in this initial lay-in and not the dark areas, which are the most important. There is one investigative technique, neutron activation autoradiography (not as yet in widespread use), which does provide an image of the dark pigments in the underpainting. It requires careful interpretation, and is based on the fact that chemical elements which are made radioactive emit that radiation at different rates, the so-called half-life (Figs. 122–25). A painting exposed to radiation with neutrons loses all that acquired radioactivity after about three months. Unexposed x-ray films are laid on the temporarily radioactive picture at certain intervals and are 'exposed' by the element in the painting that is radiating most strongly at that moment, hence the term autoradiography. Because the film is changed at fixed intervals the successive images are formed by a different element or group of elements. It is thus possible to chart those part of the painting containing manganese (such as the brown pigment umber, used in the lay-in of the background in Fig. 123), or mercury (the red pigment vermilion, in the mouth in Fig. 124). The pigment bone black, which is thought to be an important constituent of the underpaint and has a high phosphorus content, also shows up in an autoradiographic image (Fig. 124). Of course it is sometimes necessary, in order to interpret the films properly, to carry out pigment analysis as well. Autoradiogrphy was pioneered by the Metropolitan Museum in New York, and was later adopted in Berlin.[20]

The presence of bone black in the underpaint-

119: Microscopic cross-section (175x) of a paint sample from *Flora*, 1635. London, National Gallery. The complex structure of the layers is due to the radical changes which Rembrandt made to this painting. The bottom two layers are part of the ground.

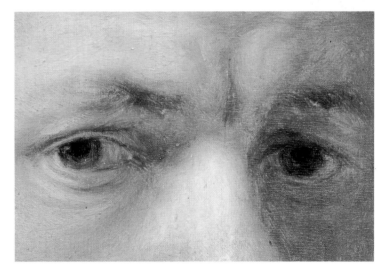

120: Detail of Rembrandt's *Self-Portrait*, 1633. Paris, Louvre. The yellowish ground shows through the translucent brown shadow tints, which are part of the initial monochrome lay-in of the painting known as the dead-colouring stage.

121: Rembrandt, *The Concord of the State*, c. 1639–40. Rotterdam, Boymans-van Beuningen Museum. Although this painting must be regarded as a monochrome design, possibly for a print, its sketchier areas give an idea of how a dead-coloured painting would have looked.

122: Rembrandt, *Portrait of a Woman with a fan*, 1633. New York, The Metropolitan Museum of Art.

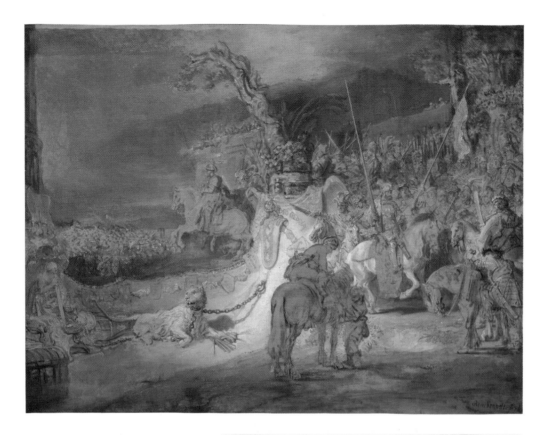

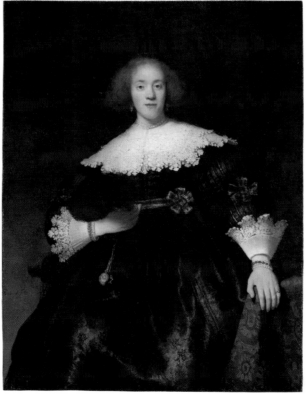

ing of canvases provided interesting autoradiographic images of the monochrome design. The films reveal very freely executed sketches reminiscent of Rembrandt's brush drawings. One also finds some fascinating and occasionally amusing alterations to the composition as it was originally sketched in. A good example is the *Portrait of a Woman with a fan* (Figs. 122–25), which shows a young woman seen frontally and leaning a little to the left. Her elbow is on the arm of her chair, and she holds a fan in her hand. Her other hand rests on a small table covered with a Persian rug. The autoradiographs (Figs. 123–24) show, as does the x-radiograph (Fig. 125), that the woman's voluminous skirt originally extended to the lower right, and from this it can be deduced that Rembrandt only later decided to depict her with her hand on the table. In the initial version the skirt can clearly be seen bulging in the usual fashion through the arm of the chair, and there can be no doubt that the woman's left hand was originally placed on that arm. On closer examination it turns out that both armrests were underpainted at the same height (a ghostly image of the other one can just be seen below the present armrest in Figs. 123–24). However, there is a sizable gap between that first version of the armrest and the woman's elbow as she leans to the left. Rembrandt must then have considered bringing the armrest closer to the elbow to make the leaning pose more logical. That change to the chair, though, would have forced him to raise the other armrest as well, which would have entailed completely repainting the hand and cuff. Instead he decided to leave the hand unchanged but to show it resting on a table. One notes that the table-cloth was then carefully painted around the already completed hand.

One difficulty in reading these radiographic documents is that different stages in the working process can show up simultaneously. In the autoradiograph with the phosphorus image (Fig. 124) one sees not just the bone black of the underpaint but also the delicate surface details which were picked out in bone black (near the cuffs and the bodice, for example), as well as the mercury in the vermilion used in the lips. This technique will probably not be widely applied, because it requires removing a painting from display for a considerable length of time. It is also labour-intensive, and, although perfectly safe, it does involve placing the picture in a specially equipped nuclear reactor to be irradiated.[21]

The success of neutron activation autoradiography in studying works such as those by Rembrandt is partly due to the fact that in his day painting technique was so remarkably 'clean'.

123: Neutron activation autoradiogram of the painting in Fig. 122. The radiation emitted by the pigment umber, which contains the element manganese, shows up as the deepest black on the radiation-sensitive film. Note especially the background around the figure (it seems that there were also traces of this element in the dust on the battens of the stretcher). The armrest reserved in the background on the left appears here at the same height as its counterpart, on which the woman's hand lies. Her skirt can be seen bulging through the armrest to the right of her hand.

124: Neutron activation autoradiogram of the painting in Fig. 122. This image is dominated by the radiation emitted by phosphorus, which is a constituent of bone black. Black was used in the initial lay-in of the woman's dress, and its sketchy nature shows up very well. The small table on which the woman is resting her hand in Fig. 122 is missing, and the skirt of her gown extends to the lower right corner. Her hand is on the armrest of her chair, but Rembrandt replaced it with the table when he raised the left armrest to the same height so as to avoid having to repaint the hand and cuff in a higher position. The mercury in the pigment vermilion has also emitted quite a high dose of radiation in this exposure, which accounts for the woman's dark lips.

125: X-radiograph of the painting in Fig. 122. The x-ray image is dominated by lead white and by thick layers of other materials, such as the wood of the stretcher and the nails around the edges. The traces of the picture's original appearance revealed in Figs. 123 and 124 can also be made out here, with a little difficulty.

126: Rembrandt, *Landscape*, 1640s. Paris, Louvre.
This painting, which is probably unfinished, gives
an idea of Rembrandt's manner of working from
the back towards the front, with the rough,
monochrome lay-in of the composition visible to
guide him.

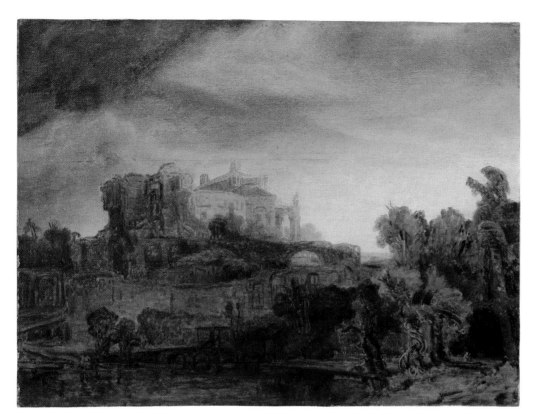

The autoradiographs appear to confirm that as a
rule a fresh, limited palette was prepared for each
individual zone in a picture.[22] It was probably by
no means standard practice for an artist to work
with a large, single palette on which all the
colours were set out, which has been the custom
since the nineteenth century, but with a number
of smaller ones on which he laid out only the
pigments that were required for the flesh tones,
for example, or for a particular part of a costume.
This explains why no traces of blue pigments, for
instance, or the vermilion that was used in lips
and flesh colours, are found elsewhere in a
painting. This seems to have been a simple
question of workshop economics, for it made it
unnecessary to grind the full range of pigments
each time. More importantly, it also typifies an
approach to painting which was the opposite of
Cézanne's, for example, who said that he gra-
dually worked up the full picture over its entire
surface.[23] In the seventeenth century one passage
was completed before moving on to the next,
analogous to the practice in fresco painting, where
the artist worked section by section in so-called
giornate or daily portions. We should be aware
that while the painter was executing the various
passages in colour he still had the monochrome
underpainting in front of him, and that therefore
the overall picture, both as a composition and as a
structure of light and shade, was constantly
before his eyes (Fig. 126). Several of Rembrandt's
most ambitioius etchings, from which proof
impressions were taken while they were still
unfinished (Fig. 127), show that he first executed
the entire background before proceeding to the
foreground figures. Study of the overlaps between
the separate passages in the paintings (Figs. 128,
129) reveals that here too he conscientiously
followed the same procedure. Written sources
confirm that working from the back to the front
was customary in the seventeenth century. The
logic of this method, which was not yet being
practised in the sixteenth century,[24] is largely
governed by the importance which was attached
in the Baroque to the tonal and spatial organisa-
tion of the picture as a whole, which was known
as the 'aspect' ('*houding*'). If, on the other hand, a
painter were to complete the parts in a haphazard
order, the work would, as Gerard de Lairesse put
it, 'take on an inevitable ugliness and deformity
which embarrasses the master more than a bare
canvas'.[25]

Study of Rembrandt's later working methods
is not yet far enough advanced for us to say
whetehr and to what extent he abandoned this
strict procedure, but there is every reason to
assume that he adopted a freer manner in his later

127: Rembrandt, the so-called *Pygmalion* etching of c. 1639. It can be seen from this unfinished state of the etching that the background was completed before Rembrandt started on the sketchily designed foreground.

128: Rembrandt, *Tobit and Anna with the Kid*, 1626
(detail). Amsterdam, Rijksmuseum.
See Cat. No. 1.

work, in which the glaze (the translucent paint layer) became increasingly important. We must not forget, though, that seventeenth-century artists worked according to a more-or-less fixed system, and the painter of the *Nightwatch* would have been no exception.[26] It should also be borne in mind that with this kind of systematic approach it would have been clear from the outset which colours a palette had to have for a particular passage. This means that, in principle, artists must have thought in terms of 'recipes' when rendering different materials.[27] Incidentally, the fact that palettes depicted in scenes of artists' studios are generally complete, with the full set of colours arranged in a specific order, appears to argue against the theory that they worked with limited palettes. The depiction of a complete palette might indicate that it had a representative function in that particular context. A full palette would also have been used for retouching, which was the very last stage in the painting process.[28]

Given the vital importance of tonal values in Rembrandt's work, it almost goes without saying that white was decisive in regulating them. Fortunately, the white used in the seventeenth century consisted mostly of the element lead, and since lead has a very high atomic weight and is almost opaque to x-rays, the radiographic image is dominated by the lead white. This is why radiographs are absolutely invaluable in the scientific examination of paintings. Not only do they reveal many of the modifications (*pentimenti*) hidden beneath the surface layer, but in many instances they also show the extent of the overlaps that resulted from the process of working from the back towards the front. This is due to the fact that the dead-coloured forms were often only approximately reserved in the finished background.

Both *pentimenti* and overlaps are found in the Amsterdam *Tobit and Anna with the Kid* (Cat. No. 1 and Figs. 128–29). One alteration can be seen to the left of the kid, where there was originally a spinning wheel and the turned stiles of the back of a chair, which is in a different position compared to that in the finished painting. These have made way for the dramatically positioned left arm of the hand-wringing Tobit. The sequence in which Rembrandt worked can also be read from the x-ray image. The figure of Anna was clearly painted after the background had been finished, for her shoulder now overlaps part of the wicker basket, which is fully visible in the radiograph. The forms reserved in the background, such as those along Anna's right contour, and the reserves left for the kid's hind legs, which are much smaller than in

129: X-radiograph of the painting in Fig. 128. A spinning wheel was planned in the position occupied by Tobit's left elbow in the finished picture. Comparison with the original contour of Anna's shoulder and arm shows that the paint of her head-scarf, shoulder and arm overlaps the background, which had already been fully worked up. The reserves left for the kid's legs were also much smaller. (The light patch to the left of Anna's head is the image left by a wax seal on the back of the panel.)

the painted version, give an interesting picture of the degree of precision with which such a figure was initially prepared. This could vary from very detailed to extremely sketchy (see the squire in the foreground of Fig. 121). The sketchier the underpainting the more the background encroaches onto the figure, because the artist wanted to be sure that when he came to paint the latter none of the background would be left uncovered. The late Rembrandt would have adhered to this procedure, although probably less rigidly than in his earlier periods. This, though, is something which will only be assessed in the future, for the systematic study of the working methods of the late Rembrandt is only just beginning.

In this essay we have covered a mere selection of the many new facts revealed by the explorations beneath the surface of Rembrandt's paintings. There is one aspect of his technique which has not been mentioned, one that has always intrigued observers, governing as it does the appearance of the paint surface, and that is the medium—the agent in which the particles of pigment are embedded and which governs the consistency and malleability of the paint. This aspect is discussed in the second section of the essay 'Rembrandt's Manner' on pp. 24–31. As already mentioned, the types of examination described above have yielded many new insights into Rembrandt's workshop practice. Seldom, though, have they supplied criteria which are directly applicable to the question of authenticity, because in principle everyone in the shop followed the same method as the master. Nevertheless, our new and deeper understanding of the creative process underlying the many pictures examined increases our ability to differentiate between individual variations in the application of the standard procedures in painting.

Much of what is discussed in this essay is based on my contributions to the Rembrandt Research Project, which receives financial support from the Netherlands Organisation for Scientific Research (NWO). Most of the aspects of Rembrandt's workshop practice dealt with in the following pages are treated at greater length in *A Corpus of Rembrandt Paintings*. Much of the research for that project was carried out in and with the assistance of the Central Research Laboratory for Objects of Art and Science in Amsterdam. I am very grateful to Karin van Nes for her help with this essay.

1. A bibliography up to 1973 was published by Hubert von Sonnenburg in *Rembrandt after Three Hundred Years: a symposium*, Chicago 1973, pp. 83–101; a German translation of which appeared in *Maltechnik/Restauro* 82 (1976), pp. 9–24. For the post-1973 literature see Van de Wetering 1982 and Van de Wetering 1986. The latest publication on the technical and scientific examination of Rembrandt's paintings, with references to the most important recent literature, is London 1988–89.

2. J. Bauch, D. Eckstein and M. Meier-Siem, 'Dating the Wood of Panels by a dendrochronological Analysis of the Tree-Rings' *Nederlands Kunsthistorisch Jaarboek* 23 (1972), pp. 485–96. Important new developments in the dendrochronological examination of Dutch panels are reported in P. Klein, D. Eckstein, T. Wasnyt and J. Bauch, 'New Findings for the Dendrochronological Dating of Panel Paintings of the 15th to 17th Century', *ICOM Committee for Conservation, 8th Triennial Meeting, Sydney, Australia, 6–11 September 1987: Preprints*, Los Angeles 1987 pp. 51–54. See also Bruyn *et al.* 1982–, Vol. III, pp. 783–87.

3. See Van de Wetering 1986.

4. Van de Wetering 1982, esp. pp. 12–17.

5. J. Bruyn, 'En onderzoek naar 17de-eeuwse schilderijformaten, voornamelijk in Noord Nederland', *Oud Holland* 93 (1979), pp. 96–115. See also Hessel Miedema, 'Verder onderzoek naar 17de-eeuwse schilderijenformaten in Noord-Nederland', *Oud Holland* 95 (1981), pp. 31–49.

6. Bruyn *et al.* 1982–, Vol. I, A42.

7. The question of how clean a break Rembrandt made with Leiden is discussed in this catalogue by S.A.C. Dudok van Heel, pp. 50–67.

8. Bruyn *et al.* 1982–, Vol. II, C71.

9. Van de Wetering 1986, pp. 15–43.

10. See London 1988–89, p. 30.

11. See *Documents* 1659/18, p. 448; J.M. Montias, *Artists and Artisans in Delft*, Princeton 1982, p. 163.

12. See Table C in Bruyn *et al.* 1982–, Vol. II, p. 38.

13. Bruyn *et al.* 1982–, Vol. II A54.

13. Bruyn *et al.* 1982–, Vol. II A55.

15. E. van de Wetering, 'Het formaat van Rembrandts Danaë', in *Met eigen ogen, opstellen aangeboden [. . .] aan Hans L.C. Jaffé*, Amsterdam 1984, pp. 67–72; Bruyn *et al.* 1982–, Vol. III, No. A119.

16. See Van de Wetering 1986², pp. 45–76.

17. Van Hoogstraeten 1678, p. 238: '[. . .] eerst in zijn inbeelding 't geheele bewerp van zijn werk formeerde en in zijn verstandt een schildery maekte, eer hy verw in 't penseel nam'.

18. See Van de Wetering 1976–77, pp. 21–31.

19. Cf. the work with infrared reflectography done by Van Asperen de Boer, Faries, Van Schoute, Ainsworth and many others.

20. See M.W. Ainsworth, J. Brealey, E. Haverkamp-Begemann and P. Meyers, *Art and Autoradiography: Insights into the Genesis of Paintings by Rembrandt, Van Dyck and Vermeer*, New York (The Metropolitan Museum of Art) 1982. For an example of the work being done in Berlin see Gerhard Pieh, 'Die Restaurierung des "Mann mit dem Goldhelm"', *Maltechnik/Restauro* (1987), pp. 9–34, esp. pp. 17, 18, 21 and 22.

21. Pieter Meyers, Maurice J. Cotter, Lambertus van Zelst and Edward V. Sayre, 'The technical Procedures and the Effects of radiation Exposure upon Paintings', in Ainsworth *et al.*, op. cit. (note 21), pp. 105–10.

22. Van de Wetering 1982, p. 28, notes 65 and 66.

23. J. Gasquet, *Cézanne*, Paris 1926, p. 130.

24. For a discussion of this method see Van de Wetering 1982, pp. 25–31.

25. Gerard de Lairesse, *Het Groot Schilderboek*, 2nd edition, Haarlem 1740 (ed. princ. Amsterdam 1707), p. 13.

26. E. van de Wetering, C.M. Groen and J.A. Mosk, 'Summary Report on the Results of the technical Examination of Rembrandt's Night Watch', *Bulletin van het Rijksmuseum* 24 (1976), pp. 69–98.

27. This is briefly discussed in my previous essay on p. 31.

28. For Rembrandt's autograph retouchings see Van de Wetering 1982, pp. 27–28.

A delicate Balance:
a brief Survey of Rembrandt Criticism

Jeroen Boomgaard and Robert W. Scheller

130: Pieter Louw (1720–c.1800),
The Standard-Bearer. Mezzotint.
Amsterdam, Rijksprentenkabinet.

Despite the mass of publications on the critical reception of the visual arts and of specific artists that have appeared in the past few decades, this relatively new pillar of art history still rests on uncertain foundations. It has not yet acquired a theoretical basis or a properly structured model developed from a methodological analysis of its practitioners. As a result there is little cohesion between the many and important contributions, or to put it another way, the leitmotifs in reception history have yet to be orchestrated.

This disharmony applies not only to the wider context, but also to the narrower and seemingly more manageable sphere of the critique of a single artist. Rembrandt is a prime example of this. Since the beginning of this century the perception of his life and work has been the subject of all kinds of research, but here too the picture is anything but coherent. One of the reasons is undoubtedly the multiplicity of approaches and aims adopted by the investigators. The history of collecting and the associated research on provenance demands different methods and has different premises from, say, the task of discovering the views of connoisseurs, critics and art historians who have concerned themselves with Rembrandt. Yet another line has to be taken when studying the way in which Rembrandt's work left its traces in the art of the past three centuries. The same applies to his importance for literature or for media like film and television. On top of this, the collation of data in this and other areas is by no means complete.

This essay will inevitably mirror this state of affairs. Lacking a series of studies covering every aspect of the subject, the following remarks are by their very nature exploratory. The authors intend tracing the development of Rembrandt criticism in broad outline, at the same time identifying problems which have received little or no attention. The starting-point is the way in which, down the years, countless critics have assessed Rembrandt in the light of aesthetic, social and ideological norms. His *œuvre* was interwoven with what was known about his life in each period, producing a different picture every time. This interaction between the 'visible' and the 'invisible' Rembrandt (a reciprocal mechanism which is also an important element in the critical reception of other great artists) can be seen as the theme of this essay.

An Exception that proves the Rule
We will pass over the opinions of Rembrandt's work expressed during his lifetime, which are touched upon in other contributions to this catalogue and can also be deduced from the

paintings by his pupils in the exhibition. We have decided to start instead from the year of his death, especially because shortly afterwards publications began appearing that helped set the pattern for later critics. Commentators like Sandrart (1675), Hoogstraten (1678), Félibien (1685), Baldinucci (1686) and De Piles (1699 and 1708) not only supply biographical data but also give their views on Rembrandt's work—although often in a way that the modern reader finds hard to interpret.[1] The tone was generally favourable, but as time passed it became more critical, matching a change in public taste. An early example is the sharp attack launched by Andries Pels in 1681, which established the image of an avaricious, socially maladjusted personality whose undoubted artistic gifts never matured because of his persistence in using brush, paint and etching needle in a manner that was difficult to fathom. There was also less and less sympathy for his unusual choice and treatment of subjects, and for his delight in what were then considered low-life themes. In short, as both man and artist Rembrandt deviated from the standards of 'decorum' enshrined in the contemporary code of conduct and in the academic theory of art.

The fact that he remained an important factor in the discussions on the aesthetic aspects of the visual arts was partly due to his paradigmatic significance.[2] He was held up as the classic example of a painter who did not work within the rules laid down by artists and connoisseurs. Literary artifices of this kind were frequently applied when it was a question of giving concrete form to abstract principles. The introduction of Rembrandt into the discussion was also an implicit recognition of him as an artist and as the founder of a 'school'.

The eighteenth century, during which praise was mixed with criticism, a century in which academic ideas about art gained the upper hand, or so it appears at first sight, brought Rembrandt greater renown than might have been expected.[3] This is clearly indicated by the widespread dissemination of his *œuvre*, in which the etchings played an important part. They were collected by connoisseurs, who may or may not have been interested in the theory of art, while artists bought them as aids to the practice of their craft (just as Rembrandt himself had owned and used graphic work by his predecessors). Publishers issued late and poor impressions, often from reworked plates, and there was also a market for copies and imitations 'dans le goût de' and 'in the manner of'—terms that recur time and again in the eighteenth-century literature. The demand for Rembrandt's graphic works also resulted in

131: Charles Hodges (1764–1837), *The Shipbuilder and his Wife*. Mezzotint. Amsterdam, Rijksprentenkabinet.

132: Valentin Daniel Preisler (1717–65), *Portrait of an old Man.* Mezzotint. Amsterdam, Rijksprentenkabinet.

133: Jan Stolker (1724–85), *Portrait of an 83–year-old Woman.* Mezzotint. Amsterdam, Rijksprentenkabinet.

134: Jan Stolker (1724–85), '*Rembrandt's Father*'. Mezzotint. Amsterdam, Rijksprentenkabinet.

135 & 136: Joshua Reynolds (1723–92), *Two sheets of sketches after etchings by Rembrandt.* Drawing. New Haven, Yale Centre for British Art (Mellon Collection).

the first-ever *catalogue raisonné* in the history of art, which was devoted to Rembrandt's etchings. In this work of 1751 the Paris dealer Gersaint also met contemporary demand by including copies and imitations. It was the 'manner', in other words, that counted.[4]

In western Europe, etchers of varying calibre, from simple copyists to established artists, endeavoured to master Rembrandt's method and technique in order to produce Rembrandtesque compositions on the etching plate. The way in which they did so ranged from the exact copy, through paraphrase to free imitation. They included various English mezzotinters, a number of artists in Dresden, Frankfurt, Bavaria and Austria, famous French reproduction engravers like Watelet, and a group of Venetian artists financed by Vivant Denon.[5]

By now Rembrandt's paintings were also spreading further and further afield. His work was already known throughout western Europe before the end of the seventeenth century, and this was followed by a quite remarkable exodus in the eighteenth century. Commissioned paintings, many of them portraits, were evidently not as much appreciated by the patrons' descendants as one might have expected, and it is striking just how many of Rembrandt's portraits found their way into German, French and English collections in the eighteenth century. Even in Italy, which was seemingly less disposed to appreciate Rembrandt's art, it turns out that collectors and critics did indeed value his work, the etchings in particular.[6]

The paintings, too, spawned imitations. The mezzotint technique, which was so suited to his chiaroscuro, was employed for the reproduction of Rembrandt's own paintings as well as for imitations. Conversely, it could also be said that Rembrandt was chosen as a model precisely because his chiaroscuro lent itself so well to mezzotint (Figs. 130–34). The Rembrandt imitation was a recognised art form which assured its practitioners of a high reputation. A number of English painters turned Rembrandt to good advantage, chiefly in portraits and self-portraits. The interest that Joshua Reynolds took in Rembrandt is well known, albeit more as a painter than in his pontifical pronouncements in the *Discourses* (Figs. 135–36).[7] Several German artists in Berlin, Frankfurt, Bavaria and Saxony, among them the Dresden painter C.W.E. Dietrich, worked 'in Rembrandts Geschmack' (Figs. 137–41).[8] In France, too, there was a vogue for painting 'dans le goût de Rembrandt', as can be seen from the work of Grimou and others. Fragonard is known to have copied two paintings

137: C.W.E. Dietrich (1712–74), *Christ healing the Sick*. Etching. Amsterdam, Rijksprentenkabinet.

138: C.W.E. Dietrich (1712–74), Abraham's Scarifice. Szépmüvészeti Múzeum.

139: Rembrandt, *Abraham's Sacrifice*. Etching. Amsterdam, Rijksprentenkabinet.

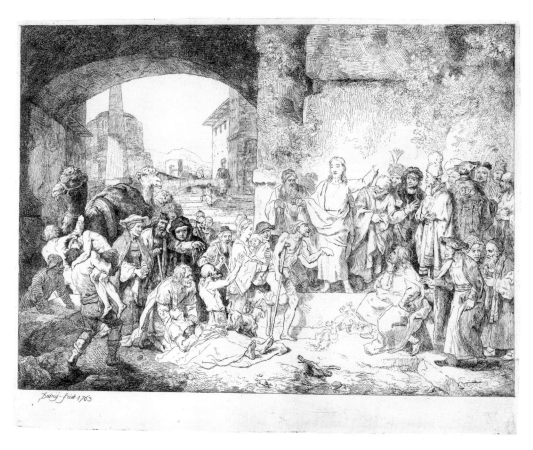

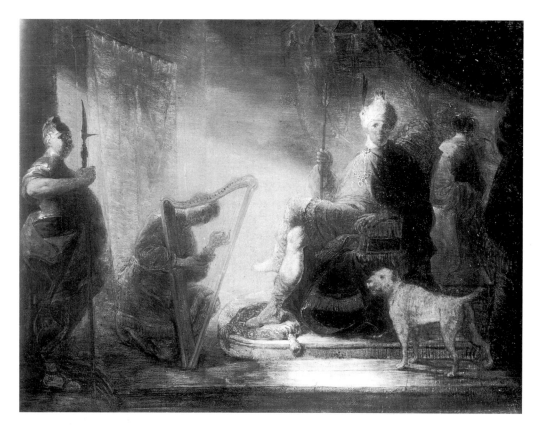

by the master, and even his contemporaries detected the marked influence of Rembrandt in Chardin's work.[9]

The dispersal of Rembrandt's drawings was a different story. They remained in the Netherlands for quite a long time, mainly in Amsterdam. Large groups that had originally come from his estate passed by auction into other collections, and only gradually began to be broken up and to find their way abroad.[10] Nevertheless, even the drawings proved to be a source of inspiration, familiar examples being Bernard Picart's engraved *Impostures innocents* and *Recueil de lions*, two dozen prints of which are based on so-called Rembrandts.[11] This tendency to paraphrase Rembrandt's style of drawing is also found elsewhere in Europe, and was taken to extremes by the Frenchman Norblin de la Gourdaine, who lived for many years in Poland and who, like his contemporary Dietrich, also produced etchings and paintings in Rembrandt's 'manner' (Figs. 142–45).[12] Rembrandt's continuing 'presence' in the eighteenth century is thus amply documented. It was due to the prevailing view on '*goût*' and 'manner'. In Germany, France and England, despite the influence of academic or Classicist theories of art, Rembrandt was still highly regarded, even by the critics. In De Piles's famous *Balance de peintres* of 1708, a diachronic comparative table containing qualitative assessments of leading artists, Rembrandt does very well indeed. Compared to Raphael and Rubens, who held joint first place with 65 points each, Rembrandt scored 50 to tie with Titian. His highest rating was for '*coloris*' and his lowest for '*dessin*'.[13] This was an opinion shared by the painter Antoine Coypel. Speaking in 1721 as the director of the Académie he commented on the rivalry between the 'Poussinistes' (who ranked line above colour) and the Rubénistes (who held the opposite view), saying that 'Les Rembrandts ont été les seuls modèles que l'on a taché d'imiter'.[14]

English writers associated imitation with the desirable intellectual faculty of 'wit' ('*esprit*'), and in doing so were actually subscribing to a long-established concept. It implied the legitimacy of a well-considered choice of models, which the artist was expected to combine into a new composition using his own creative powers. In this respect *aemulatio*—rivalling if not excelling one's predecessor—found not only its justification, but it was even invested with creative elements of a high order, or as John Dryden put it in 1688, 'Emulation is the spur of wit'. It is in this light that the remarkably widespread, eighteenth-century imitation of Rembrandt must be seen.[15]

141: Rembrandt, *David playing the Harp for Saul*.
Panel. Frankfurt, Städelsches Kunstinstitut.

142: Rembrandt, *The Raising of Lazarus*. Etching.
Amsterdam, Rijksprentenkabinet.

143: J.P. Norblin de la Gourdaine (1745–1830),
The Raising of Lazarus. Etching,
Amsterdam, Rijksprentenkabinet.

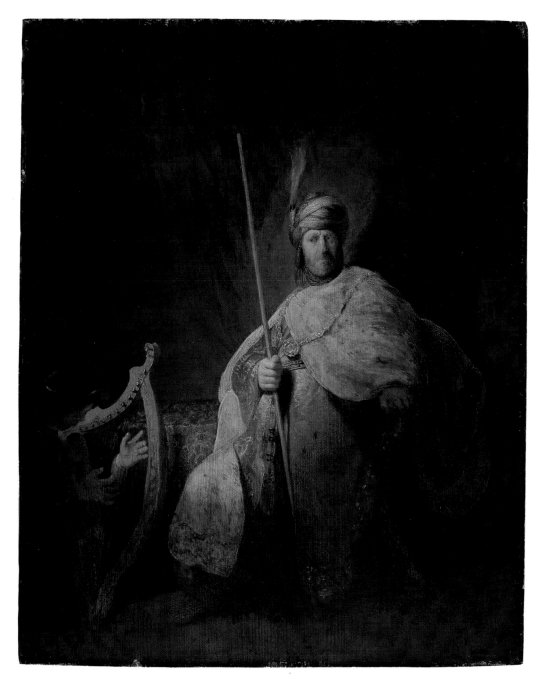

144: J.P. Norblin de la Gourdaine (1745–1830),
Ecce Homo. Warsaw, Museum Narodowe.

145: J.P. Norblin de la Gourdaine (1745–1830),
St John the Baptist preaching. Etching.
Amsterdam, Rijksprentenkabinet.

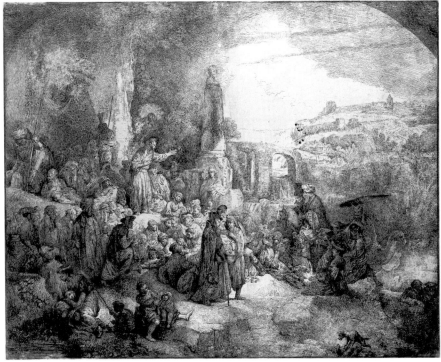

The weighing of Rembrandt's qualities as done by De Piles can also be detected in the terms used of him by various writers. The critic Jonathan Richardson, for instance, considered that Rembrandt lacked 'grace' and 'greatness', but felt that this was more than offset by his 'expression', 'simplicity', 'force', 'harmony', 'variety' and an absence of 'affection' (i.e. affectation).[16] In the auction catalogues gathered together by Hoet and Terwesten in 1752 and 1770, paintings by Rembrandt are quite often recommended to prospective purchasers as 'vigorous' and 'full of detail'. It is interesting to note that other words commonly used by the writers of the catalogues, like 'thinly painted', 'agreeable, 'sound' and 'pleasing' are never applied to Rembrandt, indicating that the distinction between *Feinmalerei* and his broad brushwork was also considered to be an element of style.[17]

In Germany it was above all C.F. von Hagedorn who championed Rembrandt's cause. In a sense he was reacting against his contemporaries Mengs and Winckelmann, whose work can be regarded as a critical rejection by Classicist writers of the prevailing taste of the second half of the eighteenth century, and the work of Rembrandt and his followers suited that taste very well. In Rembrandt Hagedorn saw 'nature' at work, this being the opposite of Richardson's 'affection'. He stressed the pastoral, tranquil element in the landscapes, argued for a subjective approach to Rembrandt's art, and in particular praised his use of *chiaroscuro*. In this respect he regarded Rembrandt's work as worthy of imitation: 'Die ausnehmenden Vorteile, womit dieser trefliche Meister Licht und Schatten geltend macht, das Auge des Betrachters gleichsam mit Gewalt an sich reiszt, bey sich behält, sind eben so viel würdige Vorbilder der Nachahmung.'[18]

That Rembrandt's figurative vocabulary and choice of subject-matter, which were aberrant by academic standards, also found a place in the typology of eighteenth-century art is clear from the repeated references to his work or that of his imitators as 'caprices'. His art was already being characterised as such in the late seventeenth century, and it was also the description applied to his drawings in the Crozat sale in Paris in 1741.[19] The term 'capriccio' had a well-defined meaning, namely a work displaying imagination and originality. In painting it was also associated with paintings done in a free, brushy style with heavy impasto. This was one of the two manners of painting which had had their advocates and critics since the sixteenth century, with Rembrandt serving as a good or bad example depending on one's point of view. In this context

one also comes across expressions like 'painterly', '*mahlerisch*' or 'picturesque', which denoted unusual subjects and technical and stylistic features that departed from the classical standards of beauty. The epithets applied to Rembrandt's style also included terms like '*scherzo*', in the sense of 'jest' or 'sketch', and 'bizarre', 'extravagant' and 'character'—all expressions reflecting liberal views on art, in contrast to the normative, standardised approach.

This interest in 'manner' also led to the work of other painters, like Govert Flinck, Ferdinand Bol, Aert de Gelder and Gerbrand van den Eeckhout, being regarded as suitable models. What mattered to connoisseurs and artists was a stylistic form, with all its implications, and not primarily the œuvre of the master himself: '... he was part of a collective concept which included the artists of his circle, as well as followers of other nationalities', as Benesch put it.[20]

It is understandable, given this background, that by around 1800 Rembrandt had become a phantom, appearing now in this guise, now in that, with *chiaroscuro*, realism, naturalness, *ingenium*, sensitivity, colour harmonies, and brush, reed pen and etching techniques all playing their part. It was a constellation of factors that continued to be associated with a name but not with a clearly recognisable artistic personality. That was to change in the nineteenth century.

A great Artist defined

In the eighteenth century it had been above all the connoisseur and the artist who had formed their own attitudes to Rembrandt, but now, in the nineteenth century, a new professional emerged: the art historian. It would be beyond the scope of this essay to sketch the history of this new discipline in all its ramifications, but in order to trace its evolving perception of Rembrandt it is necessary to touch on a few pertinent aspects.[21]

One of the first requirements was to gather as much information as possible and marshal it into a system. Within the broad division into schools, periods and techniques, research focused on the individual. This was a crucial principle underlying the new historical method, and it enabled the scholar to establish a personal contact with the past. In this process Rembrandt was as it were reincarnated. The emphasis in the preceding period had been on the Rembrandtesque as a stylistic phenomenon, whereas now the primacy of the artist's individuality generated a desire for knowledge about the autograph nature of the works; it was the 'œuvre' that counted. Rem-

brandt's own work, his hand and his spirit, had to be cleansed of everything done in his 'manner' or '*goût*'.

The first tentative steps on the path towards a new kind of knowledge had been taken in the latter part of the eighteenth century. The great royal collections were made public. Curators did their best to arrange and display their collections along new lines. Visitors were presented with what was referred to as 'a visible history of art',[22] and were given the opportunity of relating individual artists to their contemporaries and compatriots, instead of being confronted by the qualitative diachronic arrangement which had formerly dominated both collections and the literature on art. This process was also furthered by the temporary exhibition, which supplemented the established viewing days held by auction houses.[23]

In the early days of art-historical research there was a great deal to be discovered, sifted and described. The travelling art scholar made his appearance, exemplified by figures like Dr Gustav Waagen, whose letters contain detailed descriptions of the collections he saw in England and France.[24] Following the example of historians, and taking advantage of the newly opened archives, art historians embarked on a study of the sources relating to art. Amateurs and art dealers continued the work of Hoet and Terwesten by collecting auction data in an attempt to chart at least part of the floating population of art works— a task which had been made even more urgent by the massive upheavals and relocations caused by the French Revolution.[25] Remarkably enough, the exodus of Rembrandts from the Netherlands continued unabated.

Numerous practical problems had to be overcome in order to purge Rembrandt's œuvre of extraneous works. The reasons for this lay in the circumstances under which that œuvre was created, and in the nature of Dutch biographical writing. In the case of the great Italian masters, who were to be the darlings of art historians for a long time to come, the core œuvre, as it would be called today, was recorded in the biographies cast in the Vasarian mould. It consisted of immovable works: murals, altarpieces and the showpieces of the aristocratic collections. The mobility of Dutch artistic output after the Reformation made such an approach far more difficult. Provenance research, that essential aid in providing a sound foundation for the notion of authenticity, accordingly became an integral part of the study of art in the nineteenth century. The Rembrandt scholars had to begin at the beginning with the systematic collation not only of signatures and dates, but also

of data on provenance and archival material.

The reproduction, which documents the 'visible' Rembrandt, was an important factor in the evolution of what could perhaps be called the logistics of art history.[26] One of the prime requirements after 1800 was to have the most faithful copies possible of paintings and drawings. In addition to the existing mezzotint process, aquatints, lithographs and facsimile impressions vied with each other in replicating the tonalities of works of art. The growing demand for inexpensive illustrations, prompted partly by the advent of the art periodical, was met by the line engraving, followed by wood and steel engravings (Figs. 146–47). The rapid rise of photography after 1850 at last made precise reproduction possible. Photogravure and collotype were used for the more demanding publications. The brownish carbon prints obtained by the pigment process, which could be run off quickly in almost limitless editions, cleared the way for large publishers of individual reproductions like Alinari, Anderson, Bruckmann, Braun, Hanfstaengl and others. Towards the end of the nineteenth century these various developments led to the publication of general works in which the illustrations outweighed the accompanying text, on the principle that 'In der Kunst ist die Beschreibung nichts—die Anschauung alles'.[27] The reader was left to distil his own 'invisible' Rembrandt from the visible evidence set before him.

But even before this the *catalogue raisonné* had made its appearance. It was the English art dealer John Smith who in 1836 produced the first overview of Rembrandt's work,[28] and it contained all the ingredients that have made up the canonical art-historical monograph ever since. Smith introduces the artist with a biographical sketch, and this is followed by a critical analysis of the style, in which Rembrandt's *œuvre* is divided into two periods: an 'early production' and a 'golden age'. This raises the curtain to the central section: a catalogue of some 640 paintings. For each work there is a neutral description of the composition, subject and palette (essential in a book without any illustrations), information on signature, date, provenance and sale prices, as well as a list of reproductions. This is followed by lists of drawings (only 33 in all, so evidently a somewhat arbitrary choice) and etchings, based on earlier summaries, and a chronology of all the dated works. The book closes with a survey of Rembrandt's pupils and followers, almost all of them Dutch.

Although Smith mainly employs the traditional jargon of the older connoisseur, his approach is relatively dispassionate. The key phrases for the early period are 'considerable care', or 'a neat and careful manner'. The mature Rembrandt displayed 'a more accomplished style of execution, increased strength of expression, and richer hues of colouring, and breadth and vigour of execution'. Smith delivers his tersest analysis when comparing the work of Gerbrand van den Eeckhout, whom he considered to be the best of Rembrandt's pupils, with the master's: '. . . you look in vain for that depth of thought and unity of expression, the magical diffusion of *chiaroscuro*, and illusive gradation of tone, and, lastly, for that lustrous brilliancy and transparency of colour, which no imitator has hitherto successfully attained'. In his discussion of the etchings Smith gives an eloquent description of Rembrandt's working method, even if he does betray a lack of technical knowledge: 'A confusion of lines . . . crossing each other in all directions; out of this seeming chaos, his ready invention conceived, and his dexterous hand embodied, the subject . . . came to perfection. . . .' Smith also included an English translation of the 1656 inventory of Rembrandt's possessions, which enabled him to make a number of assumptions about Rembrandt's taste and financial situation. This inventory was one of the first authentic sources to be made public. It ushered in a whole series of archival publications in which the Amsterdam archivist Scheltema took a pioneering role.[29] The urge to collect then extended beyond the actual works of art to include the facts surrounding them.

Rembrandt's significance for nineteenth-century artists was of a very different kind from the imitative approach adopted in the preceding century. His influence was largely determined by the historicising tendencies which governed the entire realm of the visual arts up to around 1850. Painters and etchers in the Netherlands and elsewhere regularly took to studying Rembrandt's work.[30] The art-school curriculum, with its retrospective bias, provided the impetus, and regular visits to public collections and the numerous journeys to the Netherlands left traces which were sometimes permanent, sometimes temporary. The practical exercise of copying Rembrandt's works was one side-effect. However, it is clear from the statements of contemporary artists that they were seeking the image of Rembrandt rather than just the works themselves.[31]

In this they were on a level with the connoisseurs, who by and large used Rembrandt's creations and the growing fund of source material in order to propagate their own ideological convictions. In Germany, Pels's description of Rembrandt in 1681 as a 'heretic of the art of painting' was grafted onto the image of the nineteenth-century German revolutionary,[32] and one finds a similar tendency among some French commentators. As in Germany, the political interpretation went hand in hand with a reference to the antithesis between Protestantism/republicanism/freedom of thought and Catholicism/aristocracy/dogmatism. In 1859 these triads were given an artistic twist by Charles Blanc, who had the classical, heathen notions of beauty enter into an adulterous relationship with the Catholic faith. Against that he coupled medieval views on art with 'les sentiments les plus profonds de l'âme humaine', a conjunction that led to the conclusion: 'Oui, Rembrandt . . . représente encore le moyen âge'.[33] The same sentiment was expressed by others, among them Blanc's contemporary Taine (1865), and later by Carl Neumann, who started out as a medievalist and whose choice of words almost has Rembrandt performing an *imitatio Christi*.[34] Rembrandt's relationship to the religious movements of his day, Judaism included, has remained a popular theme ever since.[35]

John Smith's work is the model for the professional art historian, the conscientious and patient gatherer of facts. It stands at the beginning of the long line of catalogues of Rembrandt's œuvre, and in a different arena the same is true of Scheltema's research in the archives. The first integration of the different approaches, and one without any obvious aesthetic presuppositions, was made by Eduard Kolloff in his classic essay, 'Rembrandt's Leben und Werke nach neuen Actenstücken und Gesichtspunkten geschildert', which was published in 1854.[36]

Kolloff's talent for systematics was an important factor in the formulation of his image of Rembrandt. He dwells at length on the early biographies and the associated adverse reactions of critics and connoisseurs. The bulk of the earlier anecdotes are firmly banished to the realm of fable. Kolloff links the biographical data which had emerged from the documents with a sketch of the chronological development of the artist's œuvre. This is followed by a masterly analysis of Rembrandt's art, often homing in on minute details, which was evidently based on a close study of the paintings and etchings. The linchpins in his argument are the historical facts, not the opinions (and prejudices) of past connoisseurs, with their theoretical and ahistorical frame of reference. Rembrandt's art is viewed in relation to that of his teachers. More than that, Kolloff's

historical perception enables him to lay the groundwork for an analysis of Rembrandt's relationship with earlier tendencies in art.

From balanced Artist to elusive Genius

Shortly after 1850, at a time when the Dutch were taking new pride in their national identity, Rembrandt was accorded an iconic role in the framework of what one Dutch author so splendidly described as 'Holland's glory in the arts and sciences'.[37] Like Dürer in Germany and Rubens in Belgium earlier in the century, he became the vehicle for all that a nation felt it should take pride in. First, though, his image had to be brushed up a bit, since his reputation as a reclusive, grasping enigmatic figure sat uneasily with the part of national standard-bearer. Scheltema's archival research therefore served first and foremost to demolish these tenacious myths. The Rembrandt he unearthed in the archives displayed all the traits with which the Dutchman of those days felt himself blessed: dour but straightforward, simple but never pedestrian.[38]

Yet it would be a simplification to say that Rembrandt now became popular purely and simply as a spruced-up symbol of national pride. His star also rose to unprecedented heights internationally, precisely because he was coming to be regarded as archetype of the artist who, although embodying the Dutch seventeenth century, at the same time transcended space and time in his universality.[39] In this respect it is perhaps no coincidence that the most important writings about him in these years came from the pens of a German living in France (Eduard Kolloff), a Frenchman publishing under a German pseudonym (Théophile Thoré, who called himself Wilhelm Bürger), and a Dutchman who wrote in French (Carel Vosmaer).[40] The Rembrandt they describe is no longer the revolutionary so dear to the French Romantics, but nor is he the worthy *petit bourgeois* whom Scheltema had discovered in the archives. Rembrandt, according to Vosmaer, was not a realist, a Protestant or a passionate democrat, but simply 'le peintre de la vie et de l'âme humaine'.[41]

This characterisation reflects a mental outlook which greatly influenced the nineteenth-century perception of Rembrandt. The new scholarship, early examples of which were the monographs by Kolloff and Vosmaer, not only ensured the diffusion of the visible Rembrandt through the description and analysis of his work, but at the same time created a new, invisible Rembrandt which has since coloured our view of him almost as much as our knowledge of his endlessly reproduced works. This ideal Rembrandt was

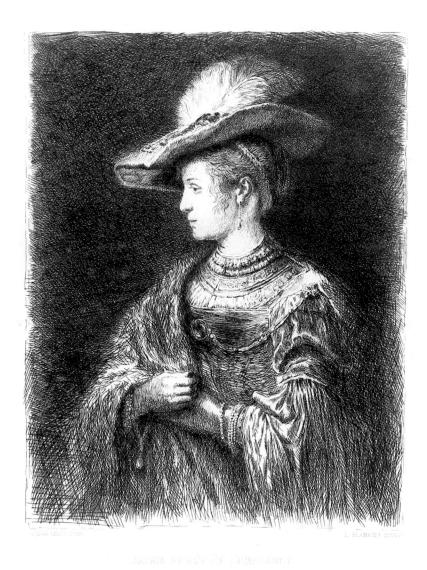

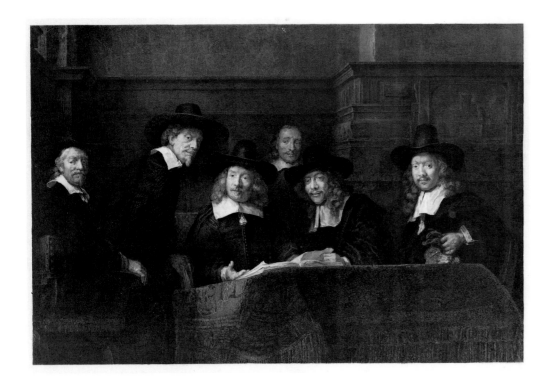

147: J.W. Kaiser (1813–1900), *The Syndics.*
Engraving. Amsterdam, Rijksprentenkabinet.

modelled on the image of the artistic genius hailed by the Romantics. The demolition of the myths surrounding him, which was due to a close study both of his works and the archival records, should therefore be seen not so much as the first faltering step on the treacherous path of objectivity, but as the specific way in which the visible Rembrandt that people had in their mind's eye was linked to the invisible Rembrandt they wished to discover on the basis of their hopes and expectations. The Rembrandt who was revered and reviled in the eighteenth century for his rejection of the classical rules, and the Rembrandt who now tours Europe like a megastar, came into being in a similar way.

It was precisely in order to further the cult of Rembrandt as a universal genius that it became necessary to study his œuvre and the archival documents. Since the days of the Romantics a genius was no longer expected to display the rigid intransigence and individualistic caprice which had been regarded as the hallmarks of true genius in the latter half of the eighteenth century, the age of *Sturm und Drang.* Rembrandt's reputation for nonconformity and the obscurity of his work, which in the eighteenth century had been a precondition for an appreciation of his etchings in particular, had now become a drawback. Although his was among the artists' portraits that adorned the museums founded at the beginning of the nineteenth century, he was not at first counted among the first rank, precisely because of his extreme subjectivity. The artist of genius had to span the divide between subject and object, between man and nature, between individual experience and general exigency, so that his highly personal creations nevertheless gave objective nature the opportunity to manifest itself.[42]

This is also why Kolloff, in his detailed discussion of the works, points out that people always approach Rembrandt assuming that there is a subjective tendency and a hidden intent, whereas it would be difficult to find a more objective artist, in the sense of one who immersed himself so deeply in his subjects.[43] This objectivity of Rembrandt's should not, incidentally, be confused with realism or with the slavish imitation of visible reality. Rembrandt, according to Vosmaer, is above all the incomparable painter of life, and thus of objective truth, because he succeeded in combining visible reality and its guiding principle, the body and the soul, the form and the idea, in a single image, thus portraying nature in all its facets, as it really is.[44] The light in the *Nightwatch* is thus simultaneously magical and 'très-juste et très-naturelle', and it is only in his early works, in Bürger's opinion, that he displays

the everyday realism that is the property of photography.[45] By stressing the unification of the visible and the invisible in great art, the art historian of the day legitimised his own objectivity: the subjective experience of beauty that he undergoes becomes an objective measure of the greatness of that art. At the same time, the penchant for the ideal combination of fantasy and reality embodied an attitude towards contemporary art and the drawing of a sharply defined boundary with the rising medium of photography. The latter was undoubtedly to the great disappointment of countless photographers who, in optimistic identification with the grandmaster of light, had christened their studios 'Rembrandt' where, with their 'Rembrandt' cameras, they immortalised sitters held rigid by 'Rembrandt' headrests.[46]

The fact that Rembrandt simultaneously painted visible and invisible reality, the internal and the external, had various other consequences for his image in this period. In the first place it was a sign of his integrity, and as such was instantly visible proof of the inaccuracy of the stories told about him. If they had been true, wrote Kolloff, 'hätten also in demselben Körper und demselben Kopfe zwei Seelen, zwei ganz verschiedene Rembrandt, gehauset, wovon der eine die geheimsten Denkwürdigkeiten seines inneren Lebens mit dem Pinsel geschrieben, und der andere durch die Geschichte seines äussern nichts Anziehenderes gehabt hätte, als der erste beste Lump'. To Kolloff the 'moralische Gewissheit' of his works made this impossible.[47] Additionally, it was inherent in this viewpoint that Rembrandt shows us the daily life of the seventeenth century, and in particular his own life, as it really was. This led to many of the paintings being interpreted as scenes of his happy family life in which he supposedly portrayed his immediate family as faithfully as possible. Figures were frequently identified as his father, mother, brother, sister, aunt and, foremost of course, Saskia, followed at some distance by Hendrickje (who first had to be discovered in the archives). As one reviewer so graphically observed of Vosmaer's book, it is as if we are witnessing the birth of the great man from close at hand, as if we are being drawn into the bosom of his family.[48]

According to this view, the visible and the invisible Rembrandt formed a single entity, the different stages of his life could be deduced from the evolution of his œuvre, and the documents uncovered in the archives confirmed that development. Rembrandt's paintings and the facts about his life could thus be seen as a more or less recognisable and accessible world governed by

the same moral standpoints that the nineteenth-century middle classes took as the guiding principles for their own behaviour. Since the genius had to serve as a model for the ordinary mortal, the quality of his work and life were considered indivisible and were strictly judged. People went to extreme lengths to demonstrate that he lived up to this high moral standard, but the verdict was damning if he was caught backsliding. In the words of one critic, the *Rape of Ganymede* bespoke a candour in its depiction of natural functions that could only be described as bad taste.[49]

In the last quarter of the nineteenth century Rembrandt underwent another radical transformation, but it did not entail a change in what we have called the logistics of art history. On the contrary, so much emphasis was placed on the garnering of facts about his life and on the study and attribution of paintings that these appeared to become ends in themselves. For instance, one of Bode's main objections to Vosmaer's book was that the latter had only actually seen 150 of the four hundred works he attributed to Rembrandt.[50] To see with one's own eyes, to know and recognise the master's hand, increasingly became the basis of the discipline of art history, and Dutch Rembrandt scholars like Abraham Bredius and Cornelis Hofstede de Groot, when they were not culling the archives in search of snippets of information about Rembrandt's life, travelled the length and breadth of Europe cataloguing his complete œuvre.[51] This was the heyday of connoisseurship; with a well-nigh infallible eye they explored the virgin hinterland, identifying the master's hand at a glance beneath the layers of dust, as one reads in Bredius's compelling account of his discovery of *The Polish Rider* in 1897. 'When I saw a magnificent four-in-hand passing my hotel, and learned from the porter that this was Count Tarnowski, who had become engaged some days before to the ravishing Countess Potocka (pronounced Pototska), who would bring him a very considerable dowry, I had little idea that this man was also the fortunate owner of one of the most sublime works by our great master.' After a laborious journey by train along tiny branch lines ('progress is so slow that one can keep up at a trot alongside'), Bredius finally arrived at the count's castle, and there, while hastily viewing the collection, came the discovery: 'There it hangs! Just one look at it, a few seconds' study of the technique, were enough to convince me instantly that here, in this remote fastness, one of Rembrandt's greatest masterpieces had been hanging for nigh on a century!'[52]

It has taken a great deal more time and effort in the past twenty years to come to the conclusion that this work is very probably not by Rembrandt at all (Fig. 148).

The Polish Rider may perhaps not display the masterly hand that was once detected in it, but other discoveries do. One such is the *Tobit and Anna* in this exhibition (Cat. No. 1), which was first attributed to Rembrandt in 1913 by Wilhelm Bode, the great authority on the early work.[53] However, in addition to some brilliant finds, this diligent detective work also yielded a number of highly improbable attributions. The attempts to complete Rembrandt's family album, in particular, led to the oddest discoveries, such as a *Self-Portrait* in Aix-en-Provence which no one any longer believes to be a Rembrandt (Fig. 149).

The number and diversity of works by Rembrandt which the connoisseurs 'rediscovered' around the turn of the century, and their diversity, made it increasingly difficult to make out a clear stylistic unity in his œuvre. It became less and less cohesive, partly because Rembrandt's life and work were no longer being so directly related to one another. Several less than flattering archival discoveries showed that he had not lived the spotless life that the previous generation had expected of a genius. It was an unpleasant revelation, but the time was ripe for it, for towards the end of the nineteenth century there had been a slight relaxation in the emphasis which the middle classes placed on morality. One could almost say that there was a little more acknowledgment of the animal in man, and artists in particular were given a shade more latitude for unreasonable and immoral behaviour. The Rembrandt who was perceived in his works around this time was a totally different figure. In almost direct accord with the adverse view current at the beginning of the nineteenth century he was once again seen as a subjective solitary who had hewed his own path. He was still the painter of 'life', but 'life' was now redefined. It was no longer regarded as a chain of external phenomena held firmly together by an inner guiding principle, but had become an elusive entity with both light and dark sides, without an underlying idea which could be revealed by the artist. It was precisely because he relied on himself alone, rendering the world around him as he observed it, without hard-and-fast ideas or ideals, that Rembrandt was believed to have portrayed true life. From this standpoint, imbued as it was with notions of 'l'art pour l'art', the object was no longer to depict the fundamental ideas behind visible reality. Art was its own objective, visible reality merely its occasion. Emile Michel, a leading Rembrandt specialist of

the day, wrote in 1881 that even in the case of *The Nightwatch* it was pointless to search for the precise meaning of the scene. According to him Rembrandt was not in the least bit interested in an exact representation of a group of civic guards carrying out one of their duties, but was looking solely for the most picturesque aspects of the things around him.[54]

In this period Rembrandt was regarded as an Impressionist *avant la lettre*, as a truly modern painter, but it was for that reason that some authors would have preferred to ignore him. Jacob Burckhardt, for instance, who represented a more conservative viewpoint, spoke of Rembrandt in his famous lecture of 1877 in terms of almost physical aversion. For him, too, *chiaroscuro* lay at the heart of Rembrandt's skill, but his admiration for the genius of the discoverer of light was matched by a distaste which is evident in every sentence: 'Luft und Licht . . . sind bei ihm die wahren Weltherrscher geworden, sie sind das Ideale bei ihm. Die wirkliche Gestalt der Dinge ist dem Rembrandt gleichgültig, ihre Erscheinung ist ihm Alles Und der Beschauer wird oft völlig mitgerissen und vergisst mit Rembrandt den dargestellten Gegenstand um der Darstellung willen.'[55]

Untiring in his search for the most picturesque in the world around him, Rembrandt, in this new interpretation, went his own way like 'ein reines Kindergemüth, das eine Welt ganz für sich hatte', as Bode put it.[56] In the process he almost inevitably came into conflict with the demands of everyday life, with social obligations. This essential clash, the turning-point in his career, was supposedly precipitated by *The Nightwatch*. He was said to have stubbornly refused to carry out the wishes of his patrons to the letter because he was no longer interested in a painstakingly precise portrayal of a group of civic guards. Unhampered by any factual evidence, the scholars of the day then saw Rembrandt fall from favour, which would help to explain his bankruptcy and his irresponsible behaviour, about which the documents left no room for doubt.[57] A life of poverty and misfortune was then his lot, which is why the works that he created in that period were valued all the more at the end of the nineteenth century. Cast out by society and thrown back on himself, it was only now that he truly became the kind of artist that people so much wanted him to be.

As befits a good artist, however, he does not wrestle just with the world around him, but also does battle with himself. This new slant to Rembrandt's image was first introduced by Eugène Fromentin, the painter and novelist, whose influential book on Dutch painting appeared in 1876. Using a form of words which, like Burckhardt's, appears to have been taken directly from Impressionist art theory (a movement for which, he said, he had no sympathy), Fromentin describes Rembrandt as the painter of light in all its facets: 'His ideal, pursued as in a dream with closed eyes, is light; the halo round the objects is phosphorescence against a dark background. It is fugitive, uncertain, composed of imperceptible lines, quite ready to disappear before they can be fixed.'[58] However, this essence of Rembrandt is not unequivocally evident in all his work, and certainly not in *The Nightwatch*, which Fromentin largely dismisses as a failed compromise. For him it was too much the product of the struggle between the two irreconcilable natures in Rembrandt, two souls which Fromentin described as 'a thinker who bends uneasily to the exigencies of the true, while he becomes inimitable when the obligation to be truthful is no longer present to hinder his hand, and a craftsman who can be magnificent when the visionary does not disturb him.'[59]

It was thus that towards the end of the nineteenth century Rembrandt was no longer the perhaps somewhat recalcitrant but nevertheless level-headed artist who steadily developed his instantly recognisable style from his earliest youth, who lived by the same moral principles that he applied in his work, and whose social decline must therefore be attributable solely to a general economic recession. The impossible, to Kolloff, had come to pass: Rembrandt is split, there are two souls in his breast, there are many sides to his life, some of which can better remain shrouded in darkness, and his work can no longer be reduced to one clearly definable denominator.

In 1898 the first major retrospective of Rembrandt's work was held in Amsterdam, and from then on the public was to be given regular opportunities to become personally acquainted with his œuvre. As already mentioned, though, this was not the only way in which large numbers of people could form an idea of him. His entire output was reproduced in massive illustrated albums, and as time passed and more and more Rembrandts were 'rediscovered' it became necessary to publish supplementary volumes.[60] At the very beginning of the present century several new monographs appeared in which the development of Rembrandt's work and the course of his life were served up again in greater or lesser detail. For the specialist Hofstede de Groot published the first publication of all the archival documents discovered in the preceding fifty years.[61] One could say that as the twentieth century opened Rembrandt had become fully accessible for the first time.

During this same period, though, it became increasingly unclear which Rembrandt could be delineated from all these illustrations and bits of information. Not only did the work lack stylistic unity, but the individual behind it was no longer definable. It was as if the artist had lost all cohesion precisely because he was so accessible. There was growing doubt as to whether documents that revealed details about Rembrandt the man were of any relevance to an understanding of Rembrandt the artist. That doubt found a very odd but clear expression in 1906, when, just after the publication of the *Urkunden*, a supplement was issued with new archival discoveries, one of which was that Rembrandt had been born not in 1606 but 1605. With the curtain just about to rise on the festivities marking the 300th anniversary of his birth, panic ensued. The dismay turned to anger when it emerged that with two exceptions the new documents were bogus and had been intended as a practical joke, and that the perpetrator was none other than Hofstede de Groot himself.[62]

So it was that a new trend in Rembrandt criticism began to materialise at the beginning of this century. Because the archives provided so little insight into his inner development or his evolution as an artist, attention now switched almost exclusively to the works themselves. The new attitude was that the unfolding of Rembrandt's artistic genius could no longer be deduced from the events in his life but had to be reconstructed through the study of series of dated works.[63] The panoramic survey, in which all the artist's works and his life fitted seamlessly into a deceptively real whole, giving one the impression of sharing in the great man's life and in the creation of his masterpieces, was replaced by detailed research, by a microscopic view. The new medium of slide projection not only made it possible to display series of works in rapid succession or in parallel, telescoping the story of Rembrandt's development on the screen, but also enabled the viewer to see minuscule details magnified a hundredfold.[64]

The scrupulous studies of the works of art and their technical features, directed the eye to the artistic problems with which Rembrandt struggled. Scholars analysed the compositional principles in the light of the art-historical precepts of the day, studied the iconographical themes, and tried to discover what Rembrandt had taken from other artists and how he had used those borrowings. In short, they placed Rembrandt within the

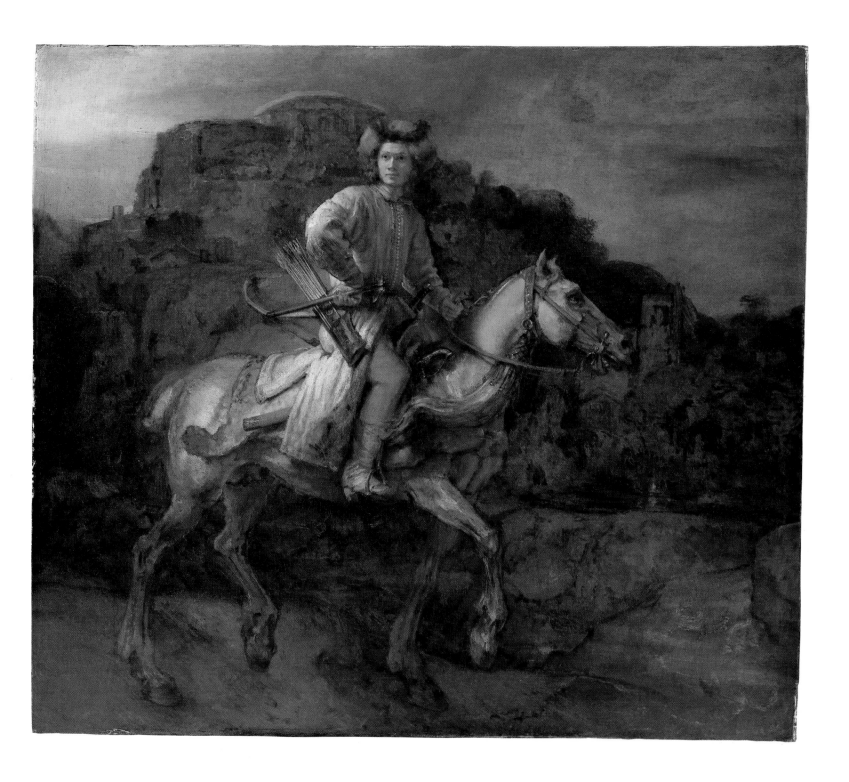

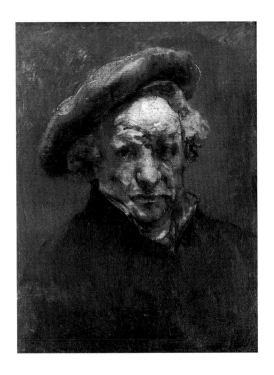

stylistic developments of his period and no longer regarded him as the solitary genius.[65] It was realised for the first time that Rembrandt should not be regarded solely as an opponent of the Italian Renaissance, but that he was in fact greatly influenced by it.

This is not to say, incidentally, that Rembrandt the man was thrust totally into the background. Reference was frequently made to his life, not least because in the popular culture of the day the image of his stormy life and the complete neglect that was ultimately his fate were endlessly recapitulated in novels, plays and films.[66] And although research conducted at the beginning of the century had shown that there was not a shred of evidence for the supposed rejection of *The Nightwatch* by those who had commissioned it, Rembrandt's fall from grace was still being attributed to stubbornness and to a desire to rise above the fashion of the day and to surpass what he had already achieved. Repeated attempts were made to enlist the aid of an invisible Rembrandt in order to fuse the many aspects of the visible Rembrandt apparent in his *œuvre*. When it proved impossible to create a clear-cut image of Rembrandt in this way, it seemed that contradiction was forever to be associated with his name. Or as Schmidt-Degener put it in 1936: 'Thus Rembrandt evades all formulas, or better still: is not every formula applicable to this Proteus.'[67]

The Return of the true Rembrandt

It is true that almost every formula turns out to fit Rembrandt, and as the body of knowledge grows so too does disagreement rather than the expected consensus. The drawn and painted *œuvre* just refuses to take firm shape. The numbers wax and then wane again, and bitter disputes are fought out over these market fluctuations. In the 1920s, in particular, there was a fierce debate among Rembrandt specialists on the subject of the infallibility of connoisseurship, and although the documents were now virtually complete, something was still missing between the lines that would have made it possible to reach through and grasp the 'invisible' Rembrandt.

From the early 1930s it seemed that the experts were prepared to resign themselves to this flawed picture. No more large monographs appeared in which Rembrandt's life and work were woven into a meaningful whole.[68] Studies of specific areas dealing at length with the works but not with their creator dominated Rembrandt research until the 1960s.[69] The best of them broke new ground, although this appeared to accelerate rather than halt the disintegration of the total Rembrandt. The iconological method, for example, which started with Panofsky in the 1930s and had been growing in popularity ever since, led to a number of refreshing reinterpretations of several works but did not paint a different overall picture.[70] A related approach is that taken by Tümpel, who has come up with some startling findings, particularly as regards Rembrandt's religious subjects.[71] Another new departure was the confrontation of Rembrandt's work with the theatre of his day, which was an indication of the greater importance that was being attached to societal influences on the artist's formal vocabulary and choice of subject-matter.[72] That closer attention to the everyday environment in which Rembrandt lived spawned research on the social contexts of Rembrandt's artistry, and specifically on his workshop practice.[73] These, though, were all narrow areas of research; no one dared attempt the 'construction' of the true Rembrandt any more.

In the meantime he continued to be the prey for ideologues of every stripe, who, sometimes with very suspect intentions, were busier than ever conjuring up the invisible Rembrandt. It was undoubtedly the fact that his work was open to so many interpretations that made him so suitable for playing outlandish roles in the alarming spectacles of the day, and it was probably this perversion of their ideal that at the same time forced the researchers to exercise caution. They barely mentioned the invisible, ideal Rembrandt by name any more, but all their words resound with the belief in his imperishable, individual greatness.[74]

It was a long time before new life was breathed into Rembrandt research. It was only in the 1960s, when in the context of the tricentennial of 1969, Gerson found the courage openly to confess his doubts about the possibility of ever perceiving Rembrandt whole, that research was reactivated.[75] Relativistic scholarship, previously prompted by impotence, was now consciously accepted. Art-historical research turned the microscope on itself, and this form of introspection and self-criticism resulted in a far-reaching reassessment of many basic principles which had hitherto been held sacred. Scholars turned away from the fine focus on the individual artist and, responding to the growing interest in the history of art theory, began considering Rembrandt in a new and wider context. He is no longer the great exception; the study of his critical reception made it possible for the first time to regard Rembrandt's *Nachleben* as something more than error and neglect. This shading of interpretation ultimately resulted in the study of Rembrandt's

position within the history of art history itself, with the illusion of an overall picture being abandoned in favour of an analysis of all the characters who had been led onto the stage as 'Rembrandt' down the centuries.[76]

This fundamental differentiation called a counter-movement into being. In the past few years much effort and almost as much polemic have been expended in attempts to create a coherent picture of Rembrandt. In a number of diverse studies, while dutifully acknowledging that the historical truth about Rembrandt cannot be known, various authors are once again presenting us with the true Rembrandt revealed by extremely painstaking archival research and study of the paintings.

The reconstruction of Rembrandt is being done most incisively and at the same time most cautiously within the Rembrandt Research Project. Following the time-honoured practice of connoisseurship, the subjective traps of which are avoided as far as possible by collective research and joint publication, this group of experts is focusing mainly on the painted œuvre. Using scientific methods the researchers are concentrating more than ever before on the master's technique, and for the very first time his paintings are being presented in a catalogue argued down to the very finest detail. In this way Rembrandt is being circumscribed as definitively as possible, his hand distinguished from other wielders of the brush. The subject, however, is not Rembrandt the man but Rembrandt the 'artistic personality'—a species, as the members of the group admit, which is extremely difficult to pin down, if only because the confrontation with the works constantly sets up new frictions as a result of the 'mental structure' of the investigator being projected onto the 'imaginary mental structure' of the artist.[77]

This projection is made with fewer scruples in a number of monographs which have attracted a great deal of publicity. Here Rembrandt's life once again occupies centre stage and serves as the basis for his work. Schwartz is concerned above all with Rembrandt's personal relationships, which he deals with as if they could be reduced to a sociogram. He sketches a total picture in which certain elements of the nineteenth-century approach connecting the life and the œuvre resurface. When he remarks that Rembrandt's lack of self-discipline and untrustworthy character are reflected in his work, and that his art would have gained in clarity and dignity with a little dedication and good will, it is as if the nineteenth-century attitude has been reborn in a modern and thus negative variant.[78]

Similarly, Alpers resurrects notions long thought to have been done to death when she turns Rembrandt into the centre of his own universe, which he rules as a 'pictor economicus', as an 'entrepreneur of the self'. It was a world that he created and stage-managed in his studio, with the help of his family. Although she does not interpret the paintings as illustrations of a happy family life, it is nevertheless Saskia, with her own wishes and opinions, whom Alpers sees sitting on the painter's lap in the story of the Prodigal Son.[79]

The past ten or twenty years have been characterised by a kind of Rembrandt absolutism. One almost gets the impression that the discipline of art history has decided to write 'Finis' to Rembrandt, to flesh out all the initial efforts made at the beginning of the century, and to weave all the preliminary studies on the master's life and work into an elaborate masterpiece. Archival research, which has been resumed again with new enthusiasm, is providing the final details on the painter and his milieu, on pupils and clients, on creditors and colleagues. Study of the paintings has honed our understanding of Rembrandt's working method and of his studio practice. Iconological research, finally, supplies a coherent interpretation of Rembrandt's themes in terms of the cultural currents of his time.

Yet, amid all this clarity, confusion flourishes as never before. The imaginary Rembrandt who is invoked in order to bring unity to the bewildering range of interpretations of his work proves to be a spectre, constantly reappearing in a new guise. In this exhibition every painting presents us with a different Rembrandt.

The authors are extremely grateful to Everdien Hoek for her generous assistance, and not least for the many stimulating discussions in which she participated. J. Boomgaard's research was initially made possible by a subsidy from the Netherlands Organisation for the Advancement of Pure Research (ZWO), and is continuing within the framework of the Stichting ter Bevordering van de Beoefening van de Cultuurgeschiedenis in Nederland, with support from the Prins Bernhard Fonds.

A full bibliography would go well beyond the bounds of this essay, so the reader is referred to the notes for the main sources.

1. S. Slive, *Rembrandt and his Critics, 1630–1730*, The Hague 1953, and R.W. Scheller, 'Rembrandt's reputatie van Houbraken tot Scheltema', *Nederlands Kunsthistorisch Jaarboek* 12 (1961), pp. 81–118.

2. J.A. Emmens, *Rembrandt en de regels van de kunst*, Utrecht 1968.

3. H. Gerson, *Ausbreitung und Nachwirkung der holländischen Malerei des 17. Jahrhunderts*, Haarlem 1942; O. Benesch, 'Rembrandt's Artistic Heritage', in *Collected Writings*, Vol. I: *Rembrandt*, London 1970, pp. 57–82; I.M. Keller, *Studien zu den deutschen Rembrandtnachahmungen des 18. Jahrhunderts*, Berlin 1981 (diss., Munich 1971); E. Herrmann-Fichtenau, *Der Einfluss Hollands auf die Österreichische Malerei des 18. Jahrhunderts*, Vienna & Cologne 1983; J. Bialostocki, 'Rembrandt and Posterity', *Nederlands Kunsthistorisch Jaarboek* 23 (1972), pp. 131–57, and F.W. Robinson, 'Rembrandt's Influence in Eighteenth Century Venice', *Nederlands Kunsthistorisch Jaarboek* 18 (1967), pp. 167–81.

4. E.F. Gersaint, *Catalogue raisonné de toutes les pièces qui forment l'œuvre de Rembrandt . . . mis au jour . . . par Helle & Glomy*, Paris 1751.

5. A list of the principal copyists will be found in G. Biörklund, *Rembrandt's Etchings True and False*, Stockholm etc. 1968, pp. 189–93. See also U. Finke, 'Venezianische Rembrandtstecher um 1800', *Oud Holland* 79 (1964), pp. 111–21, exhib. cat. *In Rembrandts Manier*, Bremen & Lübeck 1986–87, and 'A Catalogue of the Mezzotints after, or said to be after, Rembrandt, compiled by John Charrington, corrected and revised by David Alexander', in C. White, D. Alexander and E. D'Oench, *Rembrandt in Eighteenth-Century England*, New Haven 1983 (Yale Center for British Art), pp. 119–49.

6. F. Simpson, 'Dutch Paintings in England before 1760', *The Burlington Magazine* 95 (1953), pp. 39–42; White *et al.*, op. cit. (note 5), pp. 106–18; J. Cailleux, 'Esquisse d'une étude sur le goût pour Rembrandt en France au XVIIIe siècle', *Nederlands Kunsthistorisch Jaarboek* 23 (1970), pp. 159–66. For Italy see Slive, op. cit. (note 1), pp. 59–64, 80–82, and Robinson, op. cit. (note 3), and for Germany P. Schierenberg, 'De 18e-eeuwse Rembrandtwaardering in Duitsland', Amsterdam 1971 (unpublished graduate thesis).

7. White *et al.*, op. cit. (note 5), pp. 1–45.

8. Keller, op. cit. (note 3), pp. 116–20.

9. P. Conisbee, *Chardin*, Oxford 1986, pp. 118–19, 223, Pl. 220.

10. J.G. van Gelder, 'Frühe Rembrandt-Sammlungen', in *Neue Beiträge zur Rembrandt-Forschung*, Berlin 1973, pp. 189–206; P. Schatborn, 'Van Rembrandt tot Crozat—vroege verzamelingen van tekeningen van Rembrandt', *Nederlands Kunsthistorisch Jaarboek* 32 (1981), pp. 1–54.

11. B. Picart, *Impostures innocentes*, Amsterdam 1734, and idem, *Recueil de lions*, Amsterdam 1729.

12. Bialostocki, op. cit. (note 3), pp. 139–42.

13. Slive, op. cit. (note 1), pp. 219–21.

14. Slive, op. cit. (note 1), pp. 153–56.

15. W. Busch, *Nachahmung als bürgerliches Kunstprinzip; ikonographische Zitate bei Hogarth und in seiner Nachfolge*, Hildesheim 1977 (diss., Tübingen 1973), pp. 82–160. For *aemulatio* see E. de Jongh, 'The Spur of Wit: Rembrandt's Response to an Italian Challenge', *Delta* 12 (1969), pp. 49–67.

16. Slive, op. cit. (note 1), pp. 148–53.

17. G. Hoet and P. Terwesten, *Catalogus of Naamlijst van Schilderijen [. . .]*, 3 Vols., The Hague 1752–70.

18. Keller, op. cit. (note 3), pp. 64–115.

19. Schatborn, op. cit. (note 10), p. 41 and note 66. For *capriccio* see E. Crispolti in *Encyclopedia of World Art*, Vol. V, New York etc. 1961, Cols. 350–57, and L. Hartmann, *'Capriccio'—Bild und Begriff*, Nuremberg 1973 (diss., Zürich 1970).

20. Benesch, op. cit. (note 3), p. 70.

21. For the origins of art historiography in the nineteenth century see H. Dilly, *Kunstgeschichte als Institution*, Frankfurt a/M 1979; G. Bickendorf, *Der Beginn der Kunstgeschichtsschreibung unter dem Paradigma 'Geschichte'. Gustav Friedrich Waagens Frühschrift 'Ueber Hubert und Johan van Eyck'*, Worms 1985; F. Reijnders, *Kunst-geschiedenis, verschijnen en verdwijnen*, Amsterdam 1985. For the reception of old master art in the nineteenth century see also F. Haskell, *Rediscoveries in Art; Some Aspects of Taste, Fashion and Collecting in England and France*, London 1976.

22. The term was coined by Christian von Mechel, see D.J. Meijers, *Klasseren als principe; hoe de k.k. Bildergalerie te Wenen getransformeerd werd in een "zichtbare geschiedenis van de kunst" (1772–1781)*, Amsterdam 1990 (diss.).

23. A. Graves, *A Century of Loan Exhibitions, 1813–1912*, London 1913–15 (reprint Bath 1970).

24. W. Waetzoldt, *Deutsche Kunsthistoriker*, Vol. II, Leipzig 1924, pp. 29–45.

25. For earlier publications by Van der Willigen, Duplessis and Souillé see F. Lugt, *Répertoire des catalogues de ventes publiques*, Vol. I, The Hague 1938, pp. III–IV. Also G. Redford, *Art Sales. A History of Sales of Pictures and other Works of Art . . .*, 2 Vols., London 1888, and G.R. Reitlinger, *The Economics of Taste*, Vol. I, London 1961.

26. The history of the technical development of the reproduction and its influence on art-historical concepts of style has yet to be written. Various valuable remarks will be found in Haskell, op. cit. (note 21), pp. 103–5. See also exhib. cat. *Bilder nach Bildern. Druckgraphik und die Vermittlung von Kunst*, Münster 1976.

27. This catch-phrase appears in the foreword to the first volume of the series *Klassiker der Kunst*, published in 1904 by the Deutsche Verlags-Anstalt, which is devoted to Rembrandt and has an introduction by A. Rosenberg.

28. J. Smith, *A Catalogue Raisonné of the Works of the most Eminent . . . Painters . . .*, Vol. VII: *Rembrandt van Rhyn*, London 1836.

29. P. Scheltema, *Rembrand. Redevoering over het leven en de verdiensten van Rembrand van Rijn . . .*, Amsterdam 1853. A French translation by W. Bürger (the pseudonym of Théophile Thoré) appeared in Paris in 1866. See also note 1 above.

30. O. Benesch, 'Rembrandt's artistic Heritage—from Goya to Cézanne', in *Collected Writings*, cit. (note 3), pp. 159–70; Bialostocki, op. cit. (note 3), pp. 143–55; P. ten Doesschate Chu, *French Realism and the Dutch Masters*, Utrecht 1974, pp. 2–17.

31. See, for example, the remarks by Delacroix cited in Benesch, op. cit. (note 30), pp. 165–67.

32. Scheller, op. cit. (note 1), p. 109.

33. Emmens, op. cit. (note 2), pp. 16–17.

34. Emmens, op. cit. (note 2), pp. 26–27.

35. See, for instance, W.A. Visser 't Hooft, *Rembrandt and the Gospel*, New York 1960; H. van de Waal, 'Rembrandt and the Feast of Purim', *Oud Holland* 84 (1969), pp. 199–223; C. Tümpel, *Rembrandt legt die Bibel aus*, Berlin 1970; E. Panofsky, 'Rembrandt und das Judentum', *Jahrbuch der Hamburger Kunstsammlungen* 18 (1973), pp. 75–108. There are also various editions of so-called Rembrandt Bibles.

36. Reissued with an introduction and notes by C. Tümpel, Hamburg 1971.

37. H. Collot d'Escury, *Holland's roem in kunsten en*

wetenschappen, 7 Vols., The Hague 1824–44.

38. Scheltema, op. cit. (note 29).

39. C. Vosmaer, *Rembrandt Harmens van Rijn, sa vie et ses œuvres*, The Hague 1868, p. 355.

40. Kolloff, op. cit. (note 36); W. Bürger, *Musées de la Hollande: Amsterdam et La Haye*, Paris 1858; C. Vosmaer, *Rembrandt Harmens van Rijn, ses précurseurs et ses années d'apprentissage*, The Hague 1863, and idem, op. cit. (note 39).

41. Vosmaer, op. cit. (note 39), p. 396.

42. The changing views on Rembrandt's genius are traced in J. Boomgaard, 'Rembrandt en het Van Gogh-syndroom', *Groniek* 108 (1990), pp. 115–28.

43. Kolloff, op. cit. (note 36), p. 446: '. . . weil man bei Rembrandt immer eine absonderliche "subjective Richtung" und versteckte Absicht voraussetzt, während man doch selten einen Künstler findet, der so "objectiv" ist, d.h., der sich so ganz in seinen Gegenstand hineindenkt.'

44. Vosmaer, op. cit. (note 39), p. 367: 'Quand je dis vie, je ne dis pas trompe-l'oeil, ni la reproduction matérielle de l'extérieur, mais l'expression profonde et étendue de toutes les manifestations de la nature, corps et âme, forme et pensée.'

45. Bürger, op. cit. (note 40), pp. 13–14: 'Mais, quand on a bien étudié et bien compris la composition, on constate que cette lumière, à laquelle le génie du peintre a donné assurément un caractère magique, n'en est pas moins très-juste et très-naturelle'; p. 201: 'Cette *Leçon d'anatomie* est la nature, mais vu comme tout le monde la voit (est-ce le suprême mérite dans les arts?) et comme la rendrait une belle photographie. Le génie particulier qui saisit un aspect imprévu de la vie n'a point passé par là, et "la griffe du lion" n'y a point gravé son empreinte.'

46. C. Chianzera, 'Notes on aesthetic Relationships between Seventeenth-Century Dutch Painting and Nineteenth-Century Photography', in Van Deren Coke (ed.), *One Hundred Years in Photographic History*, Albuquerque 1975, pp. 20–34.

47. Kolloff, op. cit. (note 36), pp. 478–79.

48. V. de Stuers, 'Rembrandt Harmensz van Rijn door Mr. C. Vosmaer, I', *De Gids*, 3rd series, 8 (1870), pp. 277–92

49. Idem, 'Rembrandt Harmensz van Rijn door Mr. C. Vosmaer, II', *De Gids*, 3rd series, 8 (1870), pp. 507–24.

50. W. Bode, *Studien zur Geschichte der holländischen Malerei*, Braunschweig 1883, p. IX.

51. See, for example, L. Barnouw-de Ranitz, 'Abraham Bredius, een biografie', in *Museum Bredius, catalogus van de schilderijen en tekeningen*, The Hague 1978; H.E. van Gelder, *Levensbericht van Dr. C. Hofstede de Groot*, Leiden 1931.

52. A. Bredius, 'Onbekende Rembrandts in Polen, Galicië en Rusland', *Nederlandsche Spectator* XXV (1897), pp. 197–99: 'Toen ik een prachtig vierspan langs mijn hotel zag rijden, en van den portier hoorde dat dit Graaf Tarnowski was, die sedert eenige dagen met de beeldschoone Gravin Potocka (spreek uit Pototska) geëngageerd was, die hem een zeer aanzienlijk vermogen mee zou brengen, dacht ik weinig, dat die man ook de gelukkige eigenaar van een der heerlijkste werken van onzen grooten Meester was. . . . Dáár hangt 't stuk! Eén blik op het geheel, een onderzoek van enkele seconden naar de techniek waren maar noodig om mij ineens te overtuigen, dat hier in dit afgelegen oord sedert bijna 100 jaren een van *Rembrandts* grootste meesterstukken hing!'

53. W. Bode, 'The earliest dated painting by Rembrandt of the year 1626', *Art in America* 1 (1913), pp. 3–7.

54. E. Michel, *Rembrandt*, Paris 1886, p. 50.

55. J. Burckhardt, 'Rembrandt', in Emil Dürr (ed.), *Vorträge*, Berlin & Leipzig 1933 (Gesamtausgabe, Vol. XIV), pp. 178-97. See W. Kaegi, *Jacob Burckhardt, eine Biografie*, Vol. IV, Basel & Stuttgart 1967, pp. 324–26, Vol. VI/2, 1977, pp. 729–39, and J. Gantner, 'Jacob Burckhardts Urteil und seine Konzeption des Klassischen', in *Concinnitas, Beiträge zum Problem des Klassischen (Heinrich Wölfflin . . . zugeeignet)*, Basel 1944, pp. 85–114.

56. Bredius quoted this remark of Bode's with approval in his 'Lautner und kein Ende', *Nederlandsche Spectator* 24 (1891), pp. 191–92.

57. For an exposé of the mythical rejection of Rembrandt see Emmens, op. cit. (note 2), Ch. 1.

58. E. Fromentin, *Les maîtres d'autrefois*, Paris 1876; here quoted from E. Fromentin, *The Masters of Past Time: Dutch and Flemish Painting from Van Eyck to Rembrandt*, ed. H. Gerson, trans. Andrew Boyle, London 1981, p. 231. The first Dutch edition, translated by Aegidius Hanssen, appeared as early as 1877 under the title *De laatste groote schilderschool*, Nijmegen 1877, and was followed five years later by an English edition, *The Old Masters of Belgium and Holland*, trans. Mary C. Robbins, Boston & New York 1882.

59. Fromentin, op. cit. (note 58), p. 204.

60. In the series *Klassiker der Kunst* mentioned in note 27, Vol. XXVII of 1921 had the title *Rembrandt, wiedergefundene Gemälde (1910–1920)*, and was compiled by W.R. Valentiner. Other standard works from the first few decades of this century are W. Bode and C. Hofstede de Groot, *Rembrandt. Beschreibendes Verzeichnis seiner Gemälde mit der heliographischen Nachbildung. Geschichte seines Lebens und seiner Kunst*, 8 Vols., Paris 1897–1905, and A. Bredius, *The Paintings of Rembrandt*, Vienna 1935.

61. C. Hofstede de Groot, *Die Urkunden über Rembrandt (1575-1721)*, The Hague 1906.

62. *Erstes Supplement von M.C. Visser*, The Hague 1906; the consternation provoked by this publication is described in 'Nieuwe oorkonden over Rembrandt', *Nieuwe Rotterdamsche Courant*, 21 July 1906.

63. W. Martin, *De Hollandsche schilderkunst in de zeventiende eeuw*, Vol. II, *Rembrandt en zijn tijd*, Amsterdam 1936, p. 26.

64. H. Dilly, 'Lichtbildprojektion—Prothese der Kunstbetrachtung', in I. Below (ed.), *Kunstwissenschaft und Kunstbetrachtung*, Giessen 1975, pp. 153–72; see also D. Preziosi, *Rethinking Art History*, New Haven & London 1989.

65. The literature on the formal influences in Rembrandt's work is summarised in B.P.J. Broos, *Index to the Formal Sources of Rembrandt's Art*, Maarssen 1977.

66. See H. van Hall, *Geschiedenis der Nederlandsche schilder- en graveerkunst*, The Hague 1936, pp. 587–91; ibid., Vol. II, The Hague 1949, pp. 329–31; G. Brom, *Rembrandt in de literatuur*, Groningen & Batavia 1936; L.D. Couprie and C. Blotkamp, 'Rembrandt was an honourable Man: Dutch Celebrations in the Past', *Delta* 12 (1969), pp. 89–101; R.W. Scheller, 'Rembrandt als Kultursymbol', in O. von Simson and J. Kelch (ed.), *Neue Beiträge zur Rembrandt-Forschung*, Berlin 1973, pp. 221–34.

67. F. Schmidt-Degener, 'Rembrandt's tegenstrijdigheden', exhib. cat. *Rembrandttentoonstelling*, Amsterdam (Rijksmuseum) 1935, p. 26.

68. The last major monographs to appear in Germany were C. Neumann, *Rembrandt*, 2 Vols., Munich 1922 (ed. princ. 1902), and W. Weisbach, *Rembrandt*, Berlin & Leipzig 1926. The principal Dutch monograph was Jan Veth, *Rembrandt's leven en kunst*, Amsterdam 1906.

69. A very early example was Schmidt-Degener's series of articles about *The Nightwatch*: F. Schmidt-Degener, 'Het genetische probleem van de Nachtwacht', *Onze Kunst* 26 (1914), pp. 1–17, 37–54; 29 (1916), pp. 61–84; 30 (1916), pp. 29–56.

70. E. Panofsky, 'Der gefesselte Eros: zur Genealogie von Rembrandts Danae', *Oud Holland* 50 (1933), pp. 193–217; W. Heckscher, *Rembrandt's Anatomy of Dr. Nicolaes Tulp; an iconological Study*, New York 1958; W. Schupbach, *The Paradox of Rembrandt's 'Anatomy of Dr. Tulp'*, London 1982, and E. Haverkamp-Begemann, *Rembrandt: the Nightwatch*, Princeton 1982.

71. C. Tümpel, 'Ikonographische Beiträge zu Rembrandt; zur Deutung und Interpretation seiner Historien', *Jahrbuch der Hamburger Kunstsammlungen* 13 (1968), pp. 95–126, ibid., 16 (1971), pp. 20–38, and idem, 'Studien zur Ikonographie der Historien Rembrandts; Deutung und Interpretation der Bildinhalte', *Nederlands Kunsthistorisch Jaarboek* 20 (1969), pp. 107–98.

72. G. Hellinga, *'Rembrandt fecit 1642'; de Nachtwacht/Gysbrecht van Aemstel* Amsterdam 1956; H. van de Waal, 'Rembrandt at Vondel's Gijsbrecht van Aemstel', in *Miscellanea I.Q. van Regteren Altena*, Amsterdam 1969, pp. 145–49 (reprinted in *Steps towards Rembrandt; Collected Articles 1937–1972*, Amsterdam & London 1974). See also Schwartz and Alpers, notes 78 and 79.

73. This kind of research was initiated in the Netherlands by W. Martin, 'The life of a Dutch Artist in the Seventeenth Century', *The Burlington Magazine* 7 (1905), pp. 125–28, 416–27; 8 (1905–06), pp. 13–24; 10 (1906–07), pp. 144–54, 363–74; 11 (1907), pp. 357–69.

74. An early instance of a highly charged ideological work which had a great deal of influence is (J. Langbehn), *Rembrandt als Erzieher; von einem Deutschen*, Leipzig 1890. For the discussion of views of this kind see E. de Jongh, 'Ziek en gezond in de Hollandse kunst van de 17de eeuw', *Kunstschrift* 34 (1990), No. 2, pp. 16–27, and J. Boomgaard, 'Rembrandt of het wezen van de kunst', *De Gids* 152 (1989), pp. 927–45.

75. H. Gerson, *Rembrandt Paintings*, London 1968; A. Bredius, *Rembrandt: the complete Edition of the Paintings*, revised by H. Gerson, London 1969; H. Gerson, 'Rembrandt: Oratio pro domo', *Gazette des Beaux-Arts* 77 (1971), pp. 193–200.

76. See above all Emmens, op. cit. (note 2); and also A.B. de Vries, 'Negentiende eeuwse kunstkritiek en zeventiende eeuwse schilderkunst', *Nederlands Kunsthistorisch Jaarboek* 6 (1955), pp. 157–68; Scheller, op. cit. (note 66); S. Heiland and H. Lüdecke, *Rembrandt und die Nachwelt*, Leipzig 1960; J. Bruyn, '300 jaren Rembrandt', *De Kroniek van het Rembrandthuis* 23 (1969), pp. 113–28; H. van de Waal, 'De Staalmeesters en hun legende', *Oud Holland* 71 (1956), pp. 61–108 (reprinted in *Steps towards Rembrandt; Collected Articles 1937–1972*, Amsterdam & London 1974); R.W. Scheller, 'Rembrandt en de encyclopedische kunstkamer', *Oud Holland* 84 (1969), pp. 81–147; J. Boomgaard, '"Hangt mij op een sterk licht". Rembrandts licht en de plaatsing van de Nachtwacht', *Nederlands Kunsthistorisch Jaarboek* 35 (1984), pp. 327–51; idem, 'De signatuur als zegel', *De Negentiende Eeuw* 13 (1989), pp. 55–68.

77. J. Bruyn et al., *A Corpus of Rembrandt Paintings*, The Hague, Boston & London 1982, Vol. I, p. XVI. Of the many reviews see in particular that by L. Slatkes in *The Art Bulletin* 71 (1989), pp. 139–44.

78. G. Schwartz, *Rembrandt, zijn leven, zijn schilderijen*, Maarssen 1984, p. 363.

79. S. Alpers, *Rembrandt's Enterprise*, Chicago 1988, p. 40.

Guide to the catalogue

The paintings in part one are catalogued in chronological order, with the result that this book, like the exhibition, illustrates Rembrandt's development as an artist.

The 'Literature' heading in each entry opens with the picture's numbers in the Rembrandt catalogues of Bredius/Gerson (A. Bredius 1935, revised by H. Gerson 1969), Bauch (K. Bauch 1966) and Gerson (H. Gerson 1968), and in the *Corpus of Rembrandt Paintings* (J. Bruyn *et al.* 1982–). This is followed by a listing of the publications dealing exclusively with the painting in question. Any other literature consulted is given in the footnotes.

The entries on the paintings executed between 1626 and 1642 (Cat. No. 1–35) are based primarily on the *Corpus*, the three published volumes of which cover the following periods: Vol. 1 (1982), 1626–31; Vol. 2 (1986), 1631–34; Vol. 3 (1989), 1635–42. With a few exceptions, the references to the literature given in the *Corpus* are not repeated in the present catalogue. Subsequent publications that have been consulted are mentioned in the footnotes.

The illustrations are numbered in three sequences, which are cited in the following way: Fig. 1 refers to an illustration in the introductory essays; Cat. No. 1 refers to a painting in the exhibition; and Fig. 1a refers to a comparative illustration in the catalogue entry of the same number.

Authors

P.v.Th.	Pieter J.J. van Thiel, Amsterdam
J.K.	Jan Kelch, Berlin
C.B.	Christopher Brown, London
V.M.	Volker Manuth, Berlin
B.S.	Bernhard Schnackenburg, Kassel

I

Tobit and Anna with the Kid

1626

Panel, 39.5 × 30 cm, monogrammed and dated
RH 1626
Amsterdam, Rijksmuseum, Inv. No. A4717

Provenance: Possibly Pieter van Buytene sale,
Delft, 29 October 1748, No. 102: 'De blinde
Tobias met zyn Vrouw, door Rembrand' (The
blind Tobit with his Wife, by Rembrandt); 28
guilders. Possibly Sale Amsterdam, 17/18 April
1759, No. 103 'Tobias zyn Huisvrouw
bestraffende, door Rembrand van Rhyn' (Tobit
chastising his wife, by Rembrandt van Rijn);
to Yver for 27 guilders. Tschugin collection,
Moscow, shortly after 1905. J. Goudstikker
Gallery, Amsterdam, 1917. Baron H. Thyssen-
Bornemisza collection, Schloss Rohoncz,
Lugano. Baroness G.W.H.M. Bentinck-Baroness
Thyssen collection, Paris; loaned to the
museum in 1956. Bought by the museum
in 1979.

Literature: Bredius/Gerson 486; Bauch 2; Gerson
4; *Corpus* A3. W. Bode, 'The Earliest dated
Painting by Rembrandt of the Year 1626', *Art
in America* 1 (1913), pp. 3–7.

Exhibitions: Amsterdam & Rotterdam 1956,
No. 1. Paris 1970, No. 34. Nice 1975, No. 2.
Leiden 1976, No. S27.

Rembrandt's *œuvre* as we now know it opens
with *The Stoning of St Stephen* of 1625 in Lyon
(*Corpus* A1), followed by six paintings of 1626.
Rembrandt's phenomenally rapid development
can be traced so clearly in those six pictures
that they can be ranked in chronological order
with a reasonable degree of certainty. The last
in sequence would appear to be *Tobit and Anna
with the Kid*, which is universally regarded as
the artist's first masterpiece.

Blind Tobit, a wealthy man who has fallen
on hard times, is seated in a small room on a
crude wooden chair beneath a window. He is
wearing a fur-trimmed gown that has seen
better days and has been patched by his wife
Anna, who now has to earn their keep by
spinning. She stands on a raised wooden floor
to the right of him, and has evidently just
entered the room through the door, which is
still ajar. Her arms are around a kid goat,
which she has clasped to her hip. Lying on the
floor beside Tobit's chair is his staff, and on the
right his dog sits in front of a small wood fire.
On a rush-bottomed chair behind the couple
lies a yarn reel with a spool. The wooden
object leaning against the chair is either a
candlestick or perhaps a crutch. Standing in
semi-darkness on two shelves against the back
wall are various household utensils. Beside the
window a string of garlic hangs below a small
birdcage, and in a niche over the door is a
wicker basket. Instead of a ceiling this humble
little room has an open lean-to roof sloping
upwards from right to left. The X-ray
photograph reveals that Rembrandt originally
included part of a spinning wheel behind
Tobit's left arm. He then had second thoughts
and painted it out, but traces can still be seen
as a relief on the surface of the picture.

What immediately strikes one about this
superbly preserved painting is the almost
finicky rendering of materials and details. The
wicker basket, in particular, is an extraordinary
example of Rembrandt's meticulousness. It was
this aspect of his art that made such an
impression on Gerard Dou, who entered
Rembrandt's studio as a 15-year-old apprentice
in early 1628 and remained with him for three
years. Dou, the *Feinmaler*, devoted the rest of
his life to perfecting this manner in an attempt
to achieve a perfect imitation of the visible
world. Rembrandt, though, had loftier
ambitions. His physically convincing and
monumentally conceived figures dominate
scenes with their presence, reducing an object
like the basket to its true proportions as a
pictorially interesting accessory that helps set
the mood. He demonstrated his control of a
complex lighting arrangement by using two
sources of illumination: the window and the

fire. Although the daylight enters from a little
too far to the left (unless one is meant to
imagine that the small room had a second
window), Rembrandt has achieved a
convincing effect that suggests depth and
makes all the key elements of the scene stand
out while shrouding secondary details in a
shadowy gloom. The palette is more restrained
than in earlier works.

The subject is taken from the Book of Tobit,
one of the apocryphal books of the Bible which
Protestants regarded as supplementary to the
canonical books but without their authority.
Rembrandt's choice of this Old Testament
story was probably not a product of his Bible
reading, for he almost invariably took his
subjects from the established visual tradition.
That does not, of course, mean that he never
read the Bible, but his primary sources of
inspiration were sixteenth-century Bible
illustrations and print series.[1] In this case,
though, he based the composition on a more
recent model that stemmed from that same
tradition, namely Jan van de Velde's etching of
around 1619 to a design by Willem Buytewech
(Fig. 1a). Although Rembrandt made radical
alterations to this artistic model (a clear case of
aemulatio—the theoretical concept that dictated
that an artist should outshine his predecessor
by enhancing his image), that print is clearly
recognisable as his formal point of departure
from such details as the reel, birdcage, garlic,
roof, and the two sources of light. However, he
did not just improve upon the design of the
print, he also heightened its meaning.
The inscription beneath the etching runs:

Furtivam Uxor, ait Tobias, age redde capellam,
Corde videns, quamvis lumine captus erat.

In translation: 'Come wife, return that stolen
kid, says Tobit, who sees with his heart
though robbed of his sight.' Buytewech chose
the moment when Tobit accused his wife of
stealing the kid, which she had in fact acquired
perfectly honestly (Tobit 2:21). Tobit makes a
gesture of rejection and Anna raises her hand to
remonstrate with him. In Rembrandt's version
the devout Tobit lifts his unseeing eyes to
heaven and raises his clasped hands, while
Anna stares at him in speechless amazement.
This is the crux of the story, immediately
following their argument, when Tobit, struck
by the realisation of his inner blindness, begs
God to forgive his sins and grant him death
(Tobit 3:1–6). As befits a history painter,
Rembrandt has raised the anecdotal in
Buytewech to the level of symbolism by
portraying the piety of a righteous man. The
question is: how did he arrive at this change of

content? Going on the evidence of his usual creative process, Tümpel believes that he took the idea for this second narrative moment from an anonymous print after Maerten van Heemskerck in which Tobit implores God for release (Fig. 1b).[2] Rembrandt's painting could then be seen as a blend of the subject-matter of the old print after Heemskerck and the design of the modern print after Buytewech.

The authors of the *Corpus* interpret Tobit's gesture as a sign of either despair or remorse,[3] and refer to scenes of the repentant Judas, St Peter and Mary Magdalen. However, various depictions of saints, such as Rembrandt's own etching of *St Jerome praying* (Bartsch 101) of 1632, show that it can also express ecstatic prayer. In the case of Tobit it seems that Rembrandt has united these two possible meanings: despair or remorse, and the inspired invocation of the Almighty.
P.V.Th.

1. Bruyn 1959, *passim*, and for Rembrandt's *Tobit and Anna* in particular, pp. 14–15; Tümpel 1969, *passim*, and esp. pp. 112–13.
2. See note 1.
3. Bruyn *et al.* 1982–, Vol. 1, p. 87.

1a: J. van de Velde after W. Buytewech, *Tobit and Anna with the Kid*. Etching. Amsterdam, Rijksprentenkabinet.

1b: Anonymous artist after M. van Heemskerck, *Tobit's Prayer*. Engraving. Amsterdam, Rijksprentenkabinet.

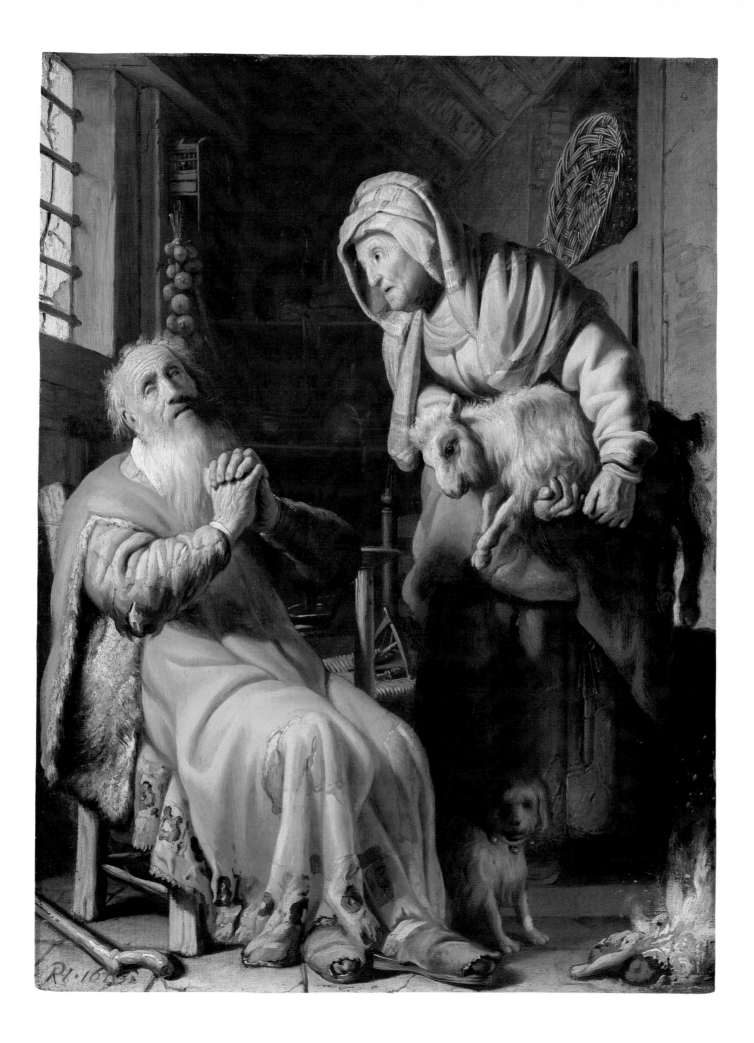

The rich Man from the Parable

1627
Panel, 32 × 42.5 cm, monogrammed and dated
RH 1627
Berlin, Staatliche Museen Preussischer
Kulturbesitz, Gemäldegalerie, No. 828 D

Provenance: M.D. van Eversdijck sale, The
Hague, 28 May 1766, No. 82: 'Rembrant van
Ryn. Een oud Mans Pourtrait, houdende de
hand voor de Kaars; met veel Bywerk. P[aneel].
Breet 1 V[oet] 4 D[uim]. Hoog 1 V[oet]'
(Rembrandt van Rijn. A portrait of an old man
holding his hand before a candle; with many
accessories. Panel. Width 1 foot, 4 inches.
Height 1 foot); to Lemmens for 20 guilders.
Sir Francis Cook collection, Richmond.
Sir Charles J. Robinson collection, London;
donated to the museum in 1881.

Literature: Bredius/Gerson 420; Bauch 110;
Gerson 19; *Corpus* A10.

Exhibitions: Schaffhausen 1949, No. 111.

Seated behind a table in a room which is only
vaguely defined, a bespectacled old man
carefully studies a coin by the light of a candle
which casts its glow on the figure and the
objects around him, drawing them forward
from the shades of night. He is surrounded by
books and papers bearing here and there the
suggestion of Hebrew script. Judging by the
coin in his hand, the goldsmith's scales in front
of him, the large purse by his side and the
money-bags in the open cupboard in the
background, these are not scholarly
manuscripts but ledgers and tally-sheets.
To the left, on a stove, stands a clock.

The picture is executed entirely in opaque
paint, which is modelled with the brush in the
illuminated passages, and displays a close
attention to detail. The range of colour is
extremely limited.

Since the candle-flame is masked by the
man's left hand, the source of light is not
visible, merely its effect. The illuminated
nocturne, with or without a visible source of
light, was the speciality of Gerard van
Honthorst, who lived in Italy for many years,
where he was known as Gherardo della Notte.
He also enjoyed much success with this
Caravaggesque use of light after his return to
Utrecht in 1620. It is difficult to conceive of
Rembrandt's painting without Honthorst's
example (Fig. 2a).[1]

This scene, which was originally regarded as

an observation from the everyday life of a
money-changer, and later as an allegory of
Avarice, is actually a depiction of the rich man
from the Parable of the Rich Fool (Luke 12:13–
21), as Tümpel has demonstrated.[2]

As a warning against avarice, Jesus told his
disciples the story of a rich landowner who,
after a particularly good harvest, decided to
replace his barns with bigger ones so that he
could take his ease and live for years on the
riches he had stored away. But God said to
him: 'Thou fool, this night thy soul shall be
required of thee: then whose shall those things
be, which thou hast provided?' The parable
closes with the moral: 'So is he that layeth up
treasure for himself, and is not rich toward
God.' This explains why Rembrandt's scene is
set at night, the use of Hebrew (i.e. biblical)
script, and the presence of the clock, the
symbol of time, for the hours of this covetous
man, who has sought his happiness and
salvation in worldly things, are clearly
numbered.

The iconography of this unusual subject
originates in the sixteenth century with an
illustration in Hans Holbein the Younger's
Dance of Death, which was published in 1538.
Amplified with several new motifs, including
the clock, it reappears in 1553 in an anonymous
Netherlandish woodcut (Fig. 2b). There the
man is seated on his coffer, perhaps in a literal
illustration of the saying 'to sit on one's
money'. Rembrandt, who was the first to
devote a painting to the subject, has portrayed
this lust for gold by having his rich man stare
fixedly at a coin, very like the woman depicted
by Honthorst a few years earlier.
P.v.Th.

1. Exhib. cat. Atlanta 1985, No. 35, with colour illus.
2. Tümpel 1971, pp. 27–30.

2a: G. van Honthorst, *An old Woman examining a
Coin*, 1624. Private collection.

2b: Anonymous artist, *The Parable of the rich Fool*,
1553. Woodcut. Amsterdam,
Rijksprentenkabinet.

3

The Artist in his Studio

c.1629
Panel, 25 × 32 cm
Boston, Museum of Fine Arts,
Acc. No. 38.1838

Provenance: La Roque sale, Paris (Gersaint),
April 1745, No. 65: 'Deux Tableaux peints sur
bois, de 12½ pouces de large sur 14½ de haut.
Le premier qui est peint par le Rimbrant, et
dont le clair obscur est admirable, représente
un Peintre dans son Atelier, qui regarde dans
l'éloignement l'effet de son Tableau'; the pair
to Nelson for 96 livres. The other picture was
Travellers resting, The Hague, Mauritshuis,
Inv. No. 579, which is now regarded as an
anonymous imitation of Rembrandt (*Corpus*
C12). Sale (Favre and J.B.P. Lebrun), Paris
(Basan), 11 January 1773 and subsequent days,
No. 25: 'Rembrandt, de 16 pouc[es] en quarré.
Rembrandt en robe de chambre & bonnet
fourré, tenant sa palette & s'éloignant de son
chevalet pour voir l'effet d'un tableau qu'il est
après à peindre, un fond uni & très clair fait
détacher en brun le sujet & le rend singulier';
117.1 livres. Sale Earl of Morton (Dalmahoy,
Kirknewton, Midlothian), London (Christie's),
27 April 1850, No. 70 (6 guineas). Sale Lord
Churston (London), London (Christie's),
26 June 1925, No. 14 (£1,417 10s). Capt. R.
Langton Douglas, art dealer, London. Mrs Zoë
Oliver Sherman collection, Boston; donated to
the museum in 1938 in memory of Lillie Oliver
Poor.

Literature: Bredius/Gerson 419; Bauch 112;
Gerson 20; *Corpus* A18. C. Hofstede de Groot,
'Rembrandt's "Painter in his Studio"', *The
Burlington Magazine* 47 (1925), p. 265. W.R.
Valentiner, 'Two Early Self-Portraits by
Rembrandt', *Art in America* 14 (1926), p. 117.
C.H. Collins Baker, 'Rembrandt's "Painter in
his Studio"', *The Burlington Magazine* 48
(1926), p. 42. S. Slive, 'Rembrandt's "Self-
Portrait" in a Studio', *The Burlington Magazine*
106 (1964), pp. 483–86.

Exhibitions: Cambridge, Mass. 1948, No. 2.
Amsterdam & Rotterdam 1956, No. 4.
Indianapolis & San Diego 1958, No. 4. Delft
& Antwerp 1964–65, No. 94. Tokyo 1968–69,
No. 43. Chicago, Minneapolis & Detroit
1969–70, No. 2.

This painting vanished from sight after being
auctioned in London in 1850, and only re-
appeared in 1925. In the interim it had grown
from 25 cm to roughly 37 cm in height, due to
the addition of two strips at top and bottom
which were painted with an extension to the
walls of the room and two extra floorboards.[1]
These excrescences, which were immediately
removed, were not by Rembrandt as Slive
thought, but must have been executed some
time before 1745 by an unknown artist to
enable the picture to pass as the companion
piece to the *Travellers resting* (see *Provenance*),
with which it was auctioned that year.

The discussion prompted by Collins Baker's
speculation in 1926 that the picture might in
fact be the work of Gerard Dou died down long
ago, although Tümpel feels that a tiny
question-mark still hovers over the attribution
to Rembrandt.[2] It has also been suggested that
Rembrandt did not portray himself but Dou,
who became his apprentice in 1628. This
theory has found little support. Comparison
with a series of Rembrandt self-portraits from
the late 1620s, including the etching of 1629
(Fig. 3a), leaves no room for doubt as to the
identity of this painter in his studio (Fig. 3b).

The handling of the paint is extremely
confident, and is everywhere adapted to the
type of material depicted, be it the plastered
walls, the wooden floorboards or the heavy
folds of the gown. The use of colour has been
kept to a minimum. This is typical of the
working method which Rembrandt first
adopted in 1627. Certain features, such as the
use of transparent browns and greys in the
shadows, point to 1629 as the date for this
remarkable painting.

There is no precedent for the way in which
Rembrandt has portrayed himself. That this is
not a work of the imagination but a true-to-life
picture of the artist in his Leiden studio is
borne out by the fact that for once he gives a
clear account of the details of the room, which
he usually (and deliberately) left vague. It is
probably a room on the first floor of a two-
storey house built towards the end of the
sixteenth or early seventeenth century.[3]
Mounted on the easel on the right is a large
panel to which battens have been clamped to
prevent it warping. We see it from behind, but
Rembrandt, who is standing on the left with
his back to the light, is looking at the brightly
lit front. He is standing back to study it, with
the tools of his trade—palette, brushes and
maulstick—in his left hand. In his right
hand he holds another brush at the ready.
Behind him is a table with bottles and some
earthenware, and beside him on a round tree-
trunk is a grinding-stone on which pigments

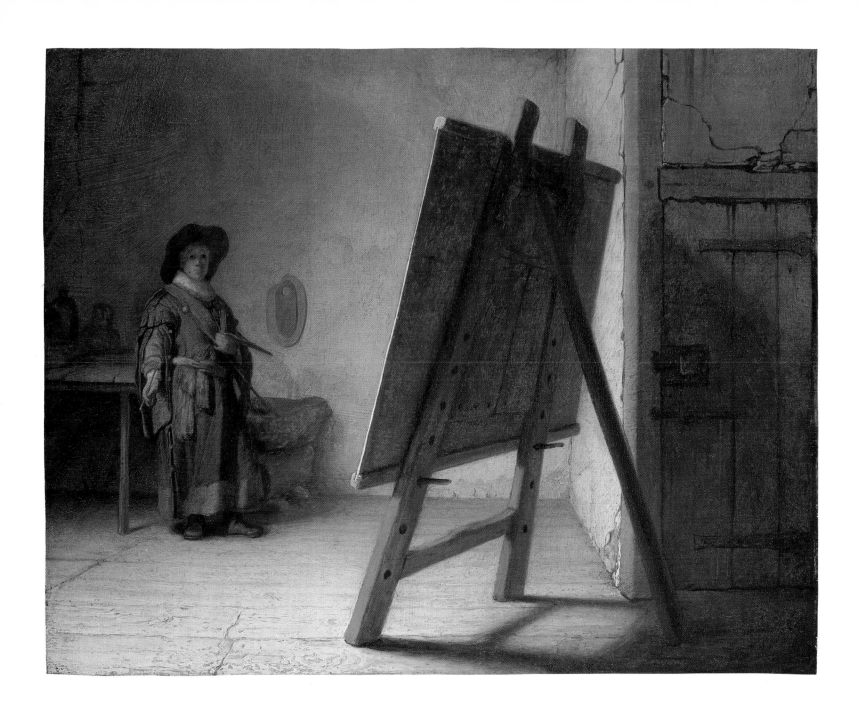

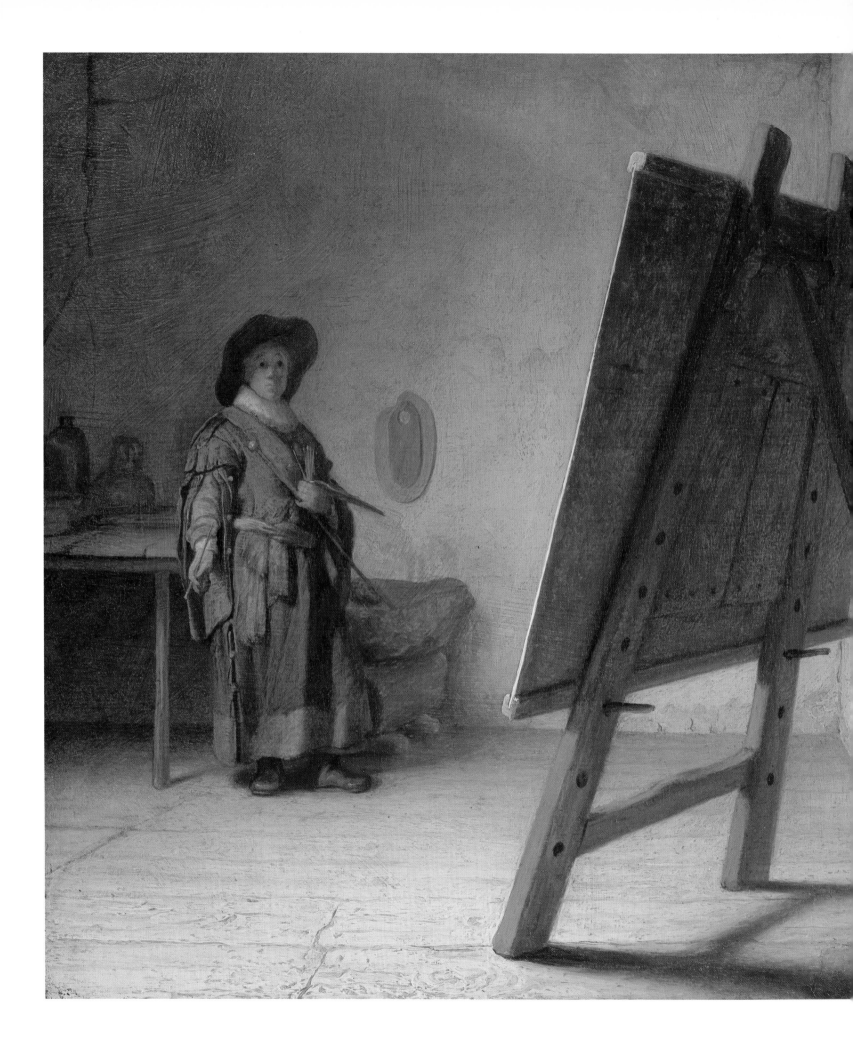

were prepared. Hanging from a nail in the wall above it are two fresh palettes.

From a distance we see the young Rembrandt in full length, standing as far back as possible to get a good view of his large picture. No artist had ever portrayed himself like this before. It was customary to show oneself from close up, sometimes working on an easel painting. By electing to present himself in this original manner—gazing thoughtfully at the panel, which might still be bare, with the brush poised in his hand—Rembrandt is probably giving us his ideas on the artistic calling. To Bauch this recalled Apelles' famous maxim: 'Nulla dies sine linea' (Not a day without a brushstroke),[4] but that fails to account for the distance which Rembrandt has placed between himself and his panel. Van de Wetering[5] has put forward the attractive hypothesis that Rembrandt was depicting a concept from the theory of art concerning the three modes of artistic creation. It was possible to work either from the imagination (*idea*), from chance (*fortuna*) or from routine acquired through practice (*usus* or *exercitatio*). In the first case the artist formed an image of the work in his mind, and once it had ripened began to paint. The second method was to start painting immediately, allowing oneself to be led by flashes of inspiration that welled up during the act of painting. The final approach was to paint spontaneously, without any prior reflection or self-consciousness, just as one writes. Here Rembrandt may be depicting the first of these creative processes, the contemplative formation of an image in the mind, with the artist (Rembrandt himself) brooding on his panel from a distance.

P.v.Th.

3a Rembrandt, *Self-Portrait*, 1629. Etching. Amsterdam, Rijksprentenkabinet.

3b: Cat. No. 3.

1. Bruyn *et al.* 1982–, Vol. I, p. 212, Fig. 4.
2. Tümpel 1986, p. 408, no. 157.
3. Communication from H.J. Zantkuil of Amsterdam to Bruyn *et al.* 1982–, Vol. I, p. 211.
4. Bauch 1960, pp. 140–41.
5. Van de Wetering 1976–77, pp. 26–28.

4

Portrait of the Artist aged about 23

c.1629
Panel, 37.9 × 28.9 cm
The Hague, Royal Picture Gallery,
Mauritshuis, Inv. No. 148

Provenance: Govert van Slingelandt collection,
The Hague: 'Een Jongelings Hoofd, door
denzelven, h[oog] 1 v[oet] 1½ d[uim], br[eed]
11 d[uim]' (Head of a young man, by the same
[Rembrandt], height 1 foot 1½ inches, width
11 inches). Purchased with Van Slingelandt's
entire collection by Stadtholder Willem V some
time between the owner's death on 2 Nov-
ember 1767 and 1 March 1768. The stadt-
holder's gallery was removed to the Musée
Napoleon in Paris in 1795, remaining there
until 1815. In the Royal Picture Gallery,
The Hague, since 1816.

Literature: Bredius/Gerson 6; Bauch 295; Gerson
39; *Corpus* A21.

This self-portrait, which to judge by the
reworking of the back of the panel seems to
have been trimmed by approximately 1 cm all
round, differs from the other early self-portraits
in the careful brushwork and the smooth finish
of the thin, homogeneous paint layer. The
brushstrokes only noticeably enliven the even
surface in the white collar, the highlighted lobe
of the ear and the fashionable lock of hair on
the forehead. Although very different in
execution to the rough-looking *Self-portrait*
dated 1629 in Munich (Fig. 4a), the points of
similarity are sufficiently close to guarantee its
authenticity and to warrant a dating in the
same year.

The disparity in execution, size (the Munich
panel is considerably smaller) and manner of
presentation of these two pictures indicates
that they were made for different purposes.
The Munich painting is in the nature of a
study, while the one in The Hague is a true
portrait. It is not, however, a formal likeness of
Rembrandt the artist, for he has donned a
soldier's gorget and has adopted a haughty
bearing to match. A suggestion based on
anecdote (and thus not to be taken seriously) is
that he got himself up to look like the officers
he saw in The Hague during his supposed
visits to Prince Frederik Hendrik's court.[1] An
equally unconvincing interpretation is that he
is advertising himself as a dyed-in-the-wool
patriot.[2] One hypothesis more in tune with the
moralistic mentality of seventeenth-century
artists is that the gorget, which also features in
vanitas still lifes painted in Leiden, was chosen
to symbolise the idea that youth is transitory.[3]
P.v.Th.

1. Schwartz 1984, p. 60. Tümpel 1986, p. 65.
2. Chapman 1990, pp. 34, 36, 38–40.
3. Bruyn *et al.* 1982–, Vol. II, p. 838 (addendum to
A21).

4a: Rembrandt, *Self-Portrait*, 1629. Munich,
Alte Pinakothek.

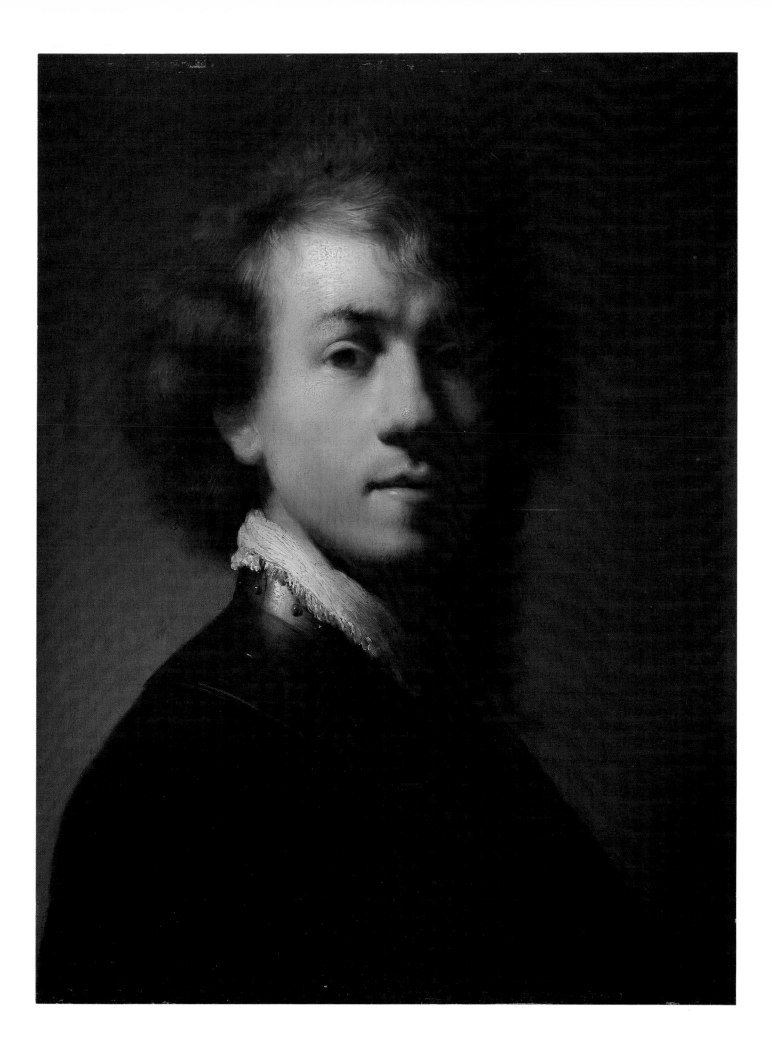

5

St Paul at his Writing-Desk

c.1629/30
Panel, 47.2 × 38.6 cm
Nuremberg, Germanisches Nationalmuseum,
Cat. No. 392

Provenance: Sale Carl Freiherr von Fechenbach
(Prince-Bishop of Würzburg), Berlin, 19 Sept-
ember 1882, No. C: 'Paul Rembrandt van
Ryn. Ein Greis mit vollem weissem Haupthaar
(. . .)'; bought in by the family. Sale Bodeck-
Ellgau (Heidenfeld, near Schweinfurt), Cologne,
10 November 1890, No. 70; purchased by the
museum.

Literature: Bredius/Gerson 602; Bauch 120;
Gerson 23; *Corpus* A26. T. Vollbehr,
'Rembrandts Paulus im Gemache', *Mitteilungen
aus dem Germanischen Nationalmuseum* 1891, pp.
3–7. W. Bode, 'Rembrandts Gemälde des
Paulus im Nachdenken im Germanischen
Museum zu Nürnberg', *Zeitschrift für bildende
Kunst* n.s. 14 (1902/03), p. 48.

Exhibitions: Berlin 1890, nr. 222. Schaffhausen
1949, No. 114. Amsterdam 1935, No. 3.
Amsterdam & Rotterdam 1956, No. 9. Rome
1956–57, No. 238. Brussels 1971, No. 78.
Hannover 1982, No. 14.

In the corner of a room which is very cursorily
defined by a wooden post, beam and arch an
old man sits deep in thought before a large,
open book placed at an angle on a table. He can
be identified as St Paul by his attributes of the
book and the unsheathed oriental sword
(*yataghan*) hanging with its scabbard from the
post. The apostle has draped his right arm over
the back of the chair, and is resting the
knuckles of his clenched left hand on the edge
of the table. He has a pen in his right hand,
and is wearing a long cloak tied with a sash at
the waist. His head stands out in highlight
against the illuminated back wall, his body as a
dark mass. He is lit from the left by subdued
daylight and from the right by bright artificial
light, the source of which is hidden by the
book, with the result that both book and table
cast a dark shadow that conceals his feet.

The forms are less clearly defined than in
earlier works, enhancing the suggestion of
volume and mass. In handling the light Rem-
brandt paid less attention to the difference
between natural and artificial light and more to
the interplay between the two, which results in
numerous gradations in the half-shadow.
Without making any apparent effort, Rem-
brandt has here achieved a greater pictorial
unity than in any of his previous works, which
argues for a date of 1629/30, or perhaps even a
little later.

The figure representing St Paul is known
from a series of chalk studies of an old man
(incorrectly identified by some as Rembrandt's
father) depicted full-length in some cases,
seated on a chair in different poses.[1] Rem-
brandt made these studies between 1626 and
1631, and used them for various etchings and
paintings.[2] None of these studies shows the
figure in the pose adopted in the painting, but
the sheet could of course have been lost. The
position of the body has been superbly caught.
The apostle's head is bent slightly forward and
his gaze has wandered off to the lower left
corner, where there is nothing to be seen. His
right hand hangs idle, but his left is taut with a
controlled energy. It is as if, after a pause for
reflection, St Paul is on the point of pulling
himself upright in his chair again, using the fist
planted firmly on the edge of his desk. The
position of his right arm has been likened to
that of the Greek philosopher Chilo in the
etching of 1616 by Jacques de Gheyn III. That,
though, is a sterile comparison, for Chilo is
reading, and although his right hand, in which
he is holding a pen, is dangling, his arm is not
draped slackly over the back of a chair (in fact
he is sitting on a block of stone). A pose very
similar to the one chosen by Rembrandt is
found in Pieter Codde's *Pipe-Smoker* in Lille

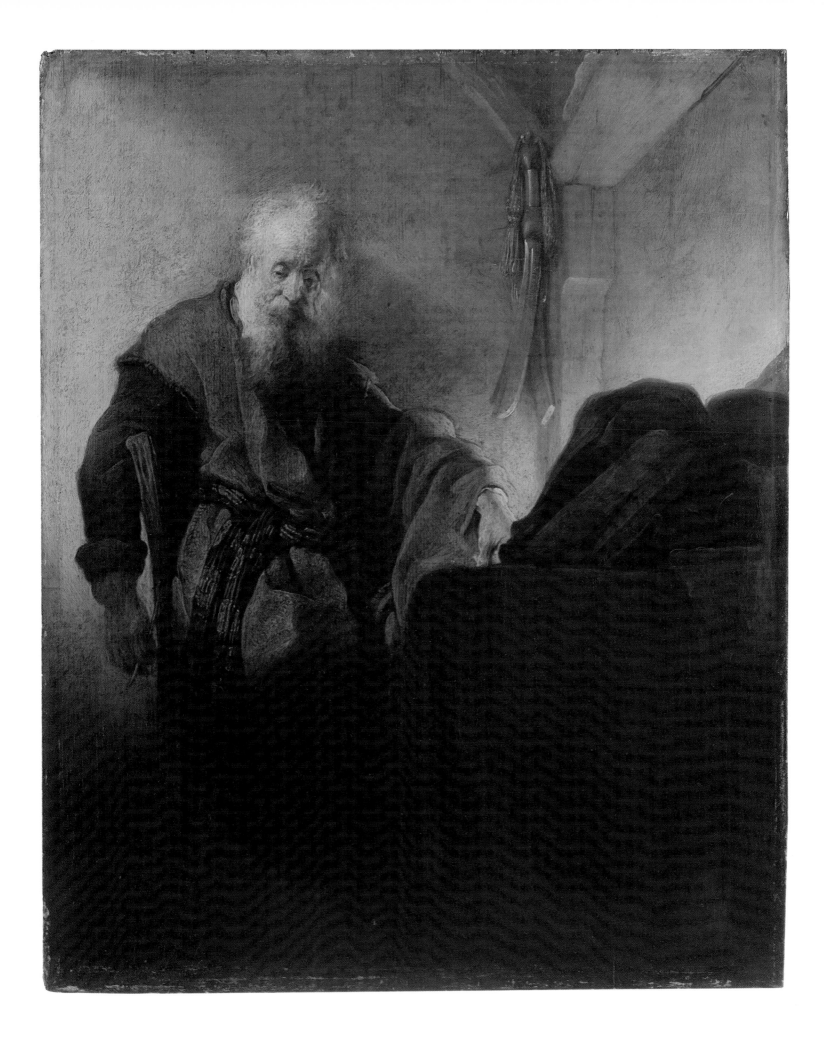

(Fig. 5a), where the young man holds his pipe in his dangling hand while leaning his left elbow on the corner of a table on which there is a large, open book from which he has just turned away. He is leaning his head on his left hand in a pose expressive of melancholy.[3]

A very modern work for its time, it depicts a figure in a reflective mood (very similar to St Paul's), and dates from the same period as Rembrandt's painting. It was also around 1630 that Dirck Hals painted an oil study of a man settled comfortably into a chair with one arm hanging over the chair-back and the other resting on a sword (Fig. 5b).[4] This interest in figures slumped into their chairs seems to have originated in the second decade of the century in the circle around Willem Buytewech and Frans Hals in Haarlem. The motif of the fist on the edge of the table appears to be Rembrandt's own invention, and was later used in his *Double Portrait of Anslo and his Wife* (Cat. No. 33).

P.v.Th.

1. Benesch 7, 16, 19, 20 (Drawings Cat. No.2), 37–42 and 82.
2. Etchings: Bartsch 260, 262, 309, 312, 315 and 325. Paintings: Bruyn *et al.*, Vol. I, Nos. A3, A11–13, A28, A34, A36; see also No. C16.
3. Klibansky, Panofsky and Saxl 1964, *passim*.
4. Schatborn 1973, p. 115, Fig. 16. Exhib. cat. Amsterdam 1989, No. 18.

5a: P. Codde, *Pipe-Smoker*. Lille, Musée des Beaux-Arts.

5b: D. Hals, *Seated Man with a Sword*. Amsterdam, Rijksprentenkabinet.

6

An old Woman at Prayer (commonly called 'Rembrandt's Mother')

c.1629/30
Copper, 15.5 × 12.2 cm, signed *R*
Salzburg, Salzburger Landessammlungen-
Residenzgalerie, Inv. No. 549

Provenance: Johann Ernst Gotzkowski collection,
Berlin, 1762. Pieter Leendert de Neufville sale,
Amsterdam, 19 June 1765, No. 81: 'Rembrant
van Ryn, Een oud biddend Vrouwtje, halver
Lyf geschilderd, als of het van Douw was.
K[oper] hoog 5½ duim breed 4½ duim'
(Rembrandt van Rijn, an old woman at prayer,
painted half-length, as if it were by Dou.
Copper, height 5½ inches, width 4½ inches); to
Locquet for 240 guilders. Pieter Locquet sale,
Amsterdam, 22–24 September 1783, No. 323:
'Door denzelven [Rembrand van Ryn]. Hoog 6,
breed 5 duim. Paneel [*sic!*]. Dit is een biddend
Besje met neergeslaagen Oogen en gevouwen
Handen. zy heeft een rood Fluweele Kap op en
een ruuw haire Mantel over de Schouders, de
eerbied en aandagt hebben iets treffends, de
Teekening en Couleur geeven een hooge
ouderdom te kennen, en alle byzondere deelen
zyn met zoo veel nauwkeurigheid als kunde
behandelt, leverende dit kleine Schilderytje een
bewijs uit van de groote bekwaamheden van
deezen onverlykelyken Meester' (By the same
[Rembrandt van Rijn]. Panel [*sic!*]. This is an
old woman at prayer with eyes downcast and
hands folded. She has a red velvet cap on, and
a rough hair cloak over her shoulders. her
reverence and devotion are striking, the
drawing and colour indicate her great age, and
all special features are done with as much
accuracy as skill, this little painting providing
proof of the great abilities of this incomparable
master); to Fouquet for 455 guilders. First
mentioned in the Czernin collection, Vienna, in
1821. Count Czernin collection, Vienna. Bought
by the museum in 1980.

Literature: Bredius/Gerson 63; Bauch 250; not in
Gerson; *Corpus* A27.

Although Gerson omitted this small copper of
an old woman wearing a red head-scarf and a
fur cape in his catalogue raisonné of 1968, he
nevertheless retained it the following year in
his critical revision of Bredius's Rembrandt

catalogue. The authors of the *Corpus* observed a fairly large letter 'R' to the right of the head which was extremely faint but still unmistakable, and concluded that even regardless of the signature this unusual little painting had sufficient points of similarity with other works to justify an attribution to Rembrandt and to assign it to the period 1629/30. Tümpel reports the signature as 'R 1630',[1] but no one else has discerned a date of any kind. There is a striking resemblance between the woman's slightly parted mouth, with blobs of white paint to indicate the teeth, and that of the *Old Man asleep* of 1629 in Turin (Fig. 55b), and between the chalky white highlights serving as contours on the head-scarf and those on the cloak of the *Old Woman reading* of 1631 in Amsterdam.

Generally speaking, the use of copper as a support was not that unusual, although it is rare in Rembrandt's œuvre. What is remarkable about this painting is that gold leaf was applied to the chalk and glue ground. The same technique was used for *The Artist in a cap and pleated shirt* in Stockholm (*Corpus* B5), and the *Bust of a laughing Man in a gorget* in The Hague (*Corpus* B6), both of which are regarded as possible Rembrandts.[2] This gilt ground, which was probably intended to lend added lustre to the paint layer, can be seen glinting through the old woman's scarf and face, and in the background.

During his Leiden period Rembrandt not only used an old man as a model, whom some believe to have been his father (see Cat. No. 5), but also an old woman who is popularly identified as his mother. Wherever she or a similar woman appears in one of his paintings or etchings she is immediately hailed as his mother. In 1679 the inventory of the estate of the Amsterdam print-seller Clement de Jonghe (1624/25–77), whose portrait Rembrandt had etched in 1651 (Bartsch 272) was already listing an etching by the artist (without any further description, so unidentifiable today) as 'Rembrandt's Mother'.[3] This very early reference, made only ten years after Rembrandt's death, may be taken as an indication that he was known to have portrayed his mother, Neeltje Willemsdochter van Zuytbroek, who was 62 in 1630, but we still do not know what she looked like.

Those who believe that the old woman is Rembrandt's mother have suggested that she is depicted here as the prophetess Anna. Leaving aside the maternal angle, it is certainly true that Rembrandt used the same model for the figure of Anna in his slightly earlier *Simeon in the Temple* in Hamburg (*Corpus* A12). However, the use of a model in a particular role on one occasion does not imply that he or she was typecast for life. In any event, there is no known iconographic tradition of Anna being portrayed as a half-length old woman at prayer. It is more likely that the real subject of this little picture is piety—the weapon of old age ('pietatis id arma senectae'), as stated in the inscription on a print of an old woman with a rosary by Cornelis Bloemaert after his father Abraham (Fig. 6a).

P.V.TH.

1. Tümpel 1986, p. 398, No. 75.
2. Froentjes 1969, pp. 233–37. De Vries *et al.* 1978, pp. 49–51.
3. Münz 1952, Vol. II, pp. 210–11 (No. 10).

6a: C. Bloemaert after A. Bloemaert, *An old Woman with a Rosary*. Engraving. Amsterdam, Rijksprentenkabinet.

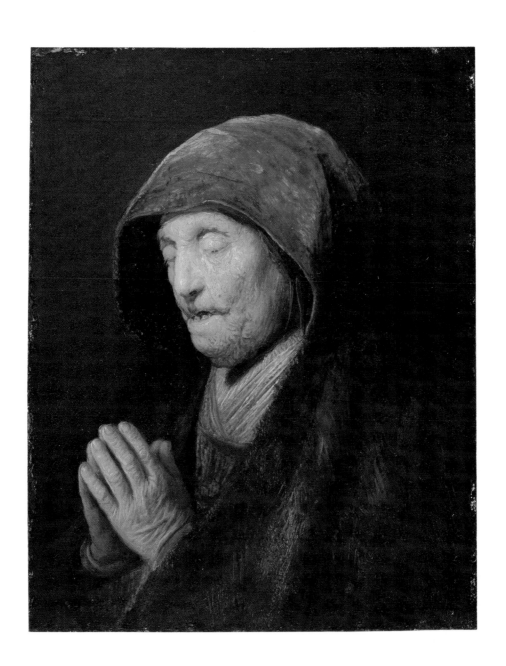

7

Bust of an old Man in a fur Cap (commonly called 'Rembrandt's Father')

1630
Panel, 22.2 × 17.7 cm, monogrammed and dated
RHL 1630
Innsbruck, Tiroler Landesmuseum Ferdinandeum, Cat. No. 599

Provenance: De Hoppe collection, Vienna.
J. Tschager, Vienna, who bequeathed it to the museum in 1856.

Literature: Bredius/Gerson 76; Bauch 124; Gerson 42; *Corpus* A29.

Exhibitions: Amsterdam & Groningen 1983, No. 1.

Oddly enough, around 1928 this distinctly unproblematic painting, which is in an excellent state of preservation and is reliably signed and dated 1630, was taken for a youthful work by Rembrandt's pupil, Gerard Dou.[1] From the technical point of view it is closely related to the *Jeremiah* of 1630 (Cat. No. 8) in its spontaneous and varied handling of paint, and above all in the local exposure of the light yellow ground to the overall effect—a brilliant device that lends an air of translucence to the paint layer.

As was the case with the model for St Paul (Cat. No. 5), this man is commonly referred to as Rembrandt's father, although there is nothing to support this identification. The same man can be recognised in two of Rembrandt's etchings of 1630 (Bartsch 304 and 321) (Fig. 7a), and in two undated etchings (Hollstein XI, Nos. 38 and 39) (Fig. 7b) by Jan Lievens (1607–74). The latter is from a suite of seven etchings titled *Diverse tronikens geetst van J[an]. L[ievens]* (Divers Heads etched by Jan Lievens).[2] Rembrandt's painting can also be classed as a '*tronie*', i.e. a head or bust of an interesting subject executed in an attractive manner. The man's cap is a *kolpak*, a high fur hat worn by Polish Jews until well into the nineteenth century.[3] This accounts for the title *Philon le Juif* which the French graphic artist François Langlois (1589–1647), alias Ciartres, gave to the engraving he made indirectly after Rembrandt's painting (Fig. 7c). Langlois's model was an etching of 1633 by J.J. van Vliet (active in Leiden in the 1630s), which itself may not have been done directly from the painting.[4] The fact that Langlois gave the name of Philo of Alexandria to this 'head' in no way suggests that Rembrandt himself had the first-century Jewish philosopher in mind when he made his painting. There are other prints after 'heads' by Rembrandt which have made-up and even demonstrably incorrect titles. Wenzel Hollar (1607–77), for instance, combined two figures by Rembrandt—his *Laughing Man* (*Corpus* B6) and *Judas* (*Corpus* A15)—in a single etching which he called *Democritus and Heraclitus.*[5]

P.v.Th.

1. *Katalog der Gemäldesammlung*, Innsbruck (Museum Ferdinandeum) 1928, p. 95 ('Nach neueren Vermutungen ein Jugendwerk Gerard Dous').
2. For these etchings see Bruyn *et al.* 1982–, Vol. I, p. 289; and exhib. cat. Amsterdam 1988–89, Nos. 24–31.
3. Rubens 1967, p. 128, Fig. 154.
4. Bruyn 1982, p. 42, Fig. 11.
5. Slive 1953, p. 32, Fig. 15. Blankert 1967, No. 90, Fig. 44.

7a: Rembrandt, *Bust of a Man wearing a high Cap.* Etching.
Amsterdam, Rijksprentenkabinet.

7b: J. Lievens, *Bust of an old Man wearing a fur Cap seen from the side.* Etching.
Amsterdam, Rijksprentenkabinet.

7c: F. Langlois alias Ciartres, *Philon le Juif.* Etching.
Amsterdam, Rijksprentenkabinet.

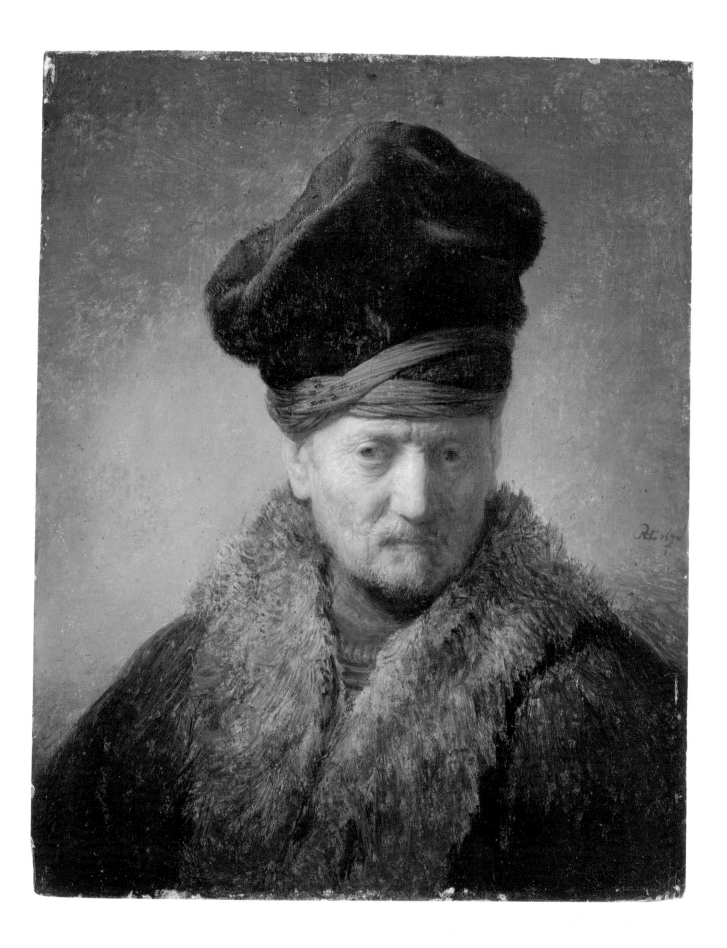

Jeremiah lamenting the Destruction of Jerusalem

1630

Panel, 58.3 × 46.6 cm, monogrammed and dated
RHL 1630
Amsterdam, Rijksmuseum, Inv. No. A3276

Provenance: Sale Margaretha Helena Graafland
(widow of van Jacob Alewijn), Amsterdam, 10
June 1767, No. 13: 'Rembrandt. Een extra fraai
Stuk, waarin Loth verbeeld is, zittende in een
Rots, en rustende met zyn linkerhand onder 't
hoofd, en met de Elleboog op een Boek; voor
hem staat een zilvere Schaal met eenige
Kleinodiën, en in 't Verschiet ziet men de
brandende Stad Sodom. Zeer krachtig en fraai
van Coloriet, en uitvoerig op Paneel
geschilderd. Hoog 23, breed 17½ duim'
(Rembrandt. An extra fine piece, in which Lot
is shown sitting in a cliffside with his head
resting on his left hand and his elbow on a
book; before him stands a silver dish with some
precious objects, and in the distance one sees
the burning town of Sodom. Very vigorous,
fine in colouring and elaborately painted on
panel. Height 23, width 17½ inches); to
Fouquet for 100 guilders. Possibly César
collection, Berlin (?), 1768. Count Sergei
Stroganoff collection, St Petersburg, later Paris.
H. Rasch collection, Stockholm. Purchased by
the museum in 1939.

Literature: Bredius/Gerson 604; Bauch 127;
Gerson 24; *Corpus* A28. J.G. van Gelder,
'Jeremia treurende over de verwoesting van
Jeruzalem', *Openbaar Kunstbezit* 7 (1963), Pt. 15.

Exhibitions: London 1929, No. 132. Amsterdam
1932, No. 3. Brussels 1946, No. 79. Amsterdam
& Rotterdam 1956, No. 8. Kassel 1964, No. 3.
Amsterdam 1969, No. 1.

An old man in a fur-trimmed gown is seated in
a cavernous ruin at the foot of a huge pillar. He
rests his head on his left hand, and is leaning
with his left elbow on a large book marked
'BiBeL' which lies beside him on a stone ledge
partly covered by a richly embroidered, dark
red cloth, and is surrounded by costly metal
vessels, a shawl, a bottle and a satchel. On the
left, through an overgrown archway half-filled
with rubble, is a view of a burning city with a
tall domed building, a city wall and a gateway.
A man is climbing a ladder set against the wall,
and a throng of figures armed with spears are
forcing their way into the city through the
gate. Standing at the top of a broad flight of
steps is a man in a long cloak who is pressing
his fists to his eyes. He has his back to the
burning city, above which a winged figure with
a torch hovers in the flames that leap skyward.

This exceptionally well-preserved picture of
1630, with its grand conception and varied
handling of the paint, is widely regarded as one
of the finest works from Rembrandt's Leiden
period. The figure set at an angle to the picture
plane describes a concave, three-dimensional
diagonal separating the foreground still life on
the stone ledge from the vista of the burning
city on the left. The long contour of the body
is extremely descriptive, and leaves no doubt as
to the presence of the arm held behind the
back and the lower part of the right leg tucked
backwards. Bordering this undulating outline is
a light grey zone in opaque paint which
becomes translucent above and to the left of
the man's head. The paint is also kept trans-
lucent by revealing parts of the light yellow
ground at other points around the figure and
the still life, both of which are executed in
opaque paint with a careful attention to detail,
as in the *Bust of an old Man in a fur Cap* of the
same year (Cat. No. 7). Here and there, in the
foliage beside the arch, for example, and in
Jeremiah's braided doublet, Rembrandt
revealed the light ground entirely by drawing
in the wet paint with the handle of the brush.

The baroque composition with the three-
dimensional diagonal, which establishes a
perfect harmony between the formal structure
and the emotional content of the scene,
probably reached Rembrandt by way of a print
of an Italian prototype. It was a device
developed in Venice in the latter half of the
1500s and was taken up in Bologna and Rome
around the turn of the century.

In the eighteenth and nineteenth centuries
the subject of this painting was interpreted
variously as Lot near the burning town of
Sodom, Anchises mourning the destruction of
Troy, or simply as 'a philosopher in a cave'.
It was at the end of the last century that Bode

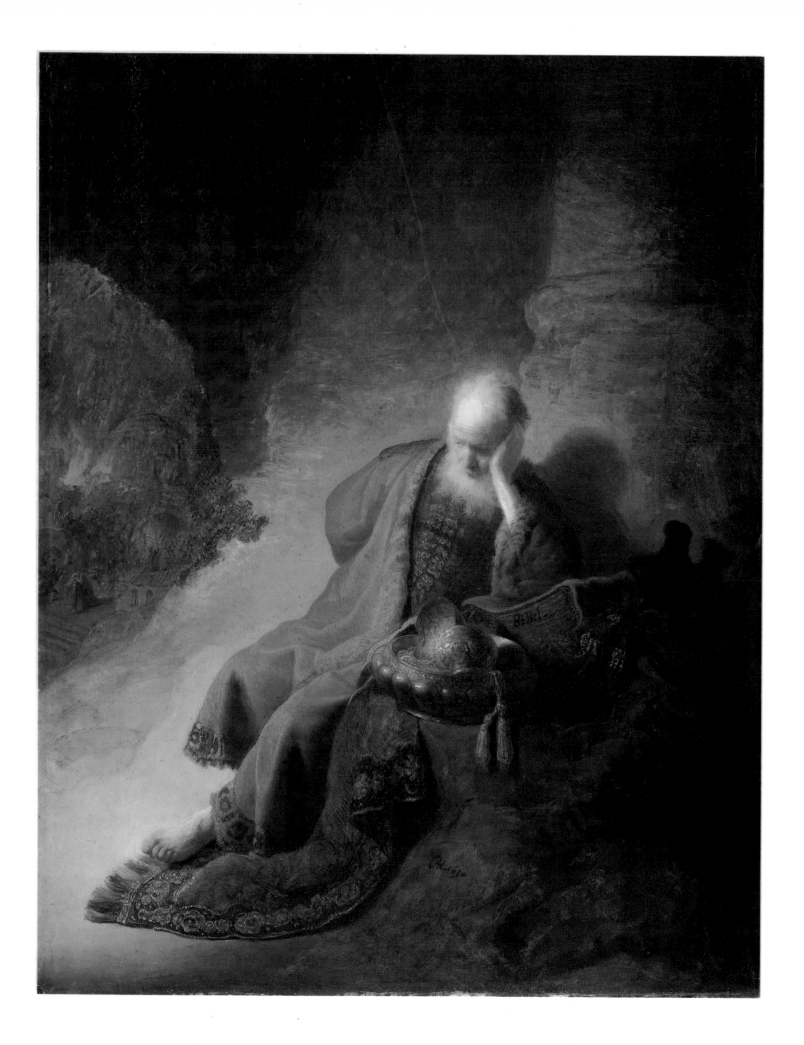

gave it the title that has since proved correct: *Jeremiah lamenting the Destruction of Jerusalem*.[1]

The Old Testament account of Jeremiah's prophecy of the destruction of Jerusalem, the capital of Judah, by Nebuchadnezzar (Jeremiah 32, 33), and the description of the fulfilment of that prophecy (2 Kings 25:1–10, 2 Chronicles 36:11–21, Jeremiah 39:1–8 and 52:1–14), mention a detail that clinches this identification, namely the blinding of Zedekiah, the last king of Judah. There can be absolutely no doubt that the man at the top of the steps holding his clenched fists to his eyes is meant to be Zedekiah, notwithstanding the fact that he fled Jerusalem and had his eyes put out in Riblah after being overtaken by Nebuchadnezzar's army in the plains of Jericho (Jeremiah 39:4–7). The prominent round building with the domed roof could very well represent Solomon's Temple. However, the biblical passages do not explain why Jeremiah sits sorrowing in a ruin outside the city, nor in fact does the Bible say anything about his lamentation, which is here expressed by the figure supporting its head with a hand in the traditional attitude of melancholy.[2] According to the Bible, when Jerusalem was besieged Jeremiah was 'shut up in the court of the prison, which was in the king of Judah's house' (Jeremiah 32:2 and 33:1), but that is clearly not what Rembrandt has depicted. To some extent his scene ties in with the medieval iconography of Jeremiah sitting on a hill outside Jerusalem leaning his head on his hand. A late example of this tradition is the woodcut headpiece to the Book of Lamentations in the Bible printed in Antwerp in 1532 by Willem Vorsterman (Fig. 8a). This illustration does not depict any particular moment from the biblical narrative, but merely presents Jeremiah as the author of Lamentations. The book lying at his feet, needless to say, is the Lamentations, and it seems likely that the one in Rembrandt's painting, on which Jeremiah is pointedly leaning his elbow, is not meant to be the complete Bible but this same book, or both Jeremiah and Lamentations. The word 'BiBeL' painted in black paint on the edge of the pages was very probably added at a much later date.

What the visual tradition does not explain is why Rembrandt has placed Jeremiah in a ruined building surrounded by precious vessels (which until recently were interpreted as the treasures from the temple), a magnificent shawl, a bottle and a traveller's satchel. According to the Bible, the temple treasures had been carried off to Babylon by Nebuchadnezzar (2 Kings 25:13–17), and there is no mention at all of the other objects. Tümpel has come up with the plausible theory that, in

addition to the Bible and the visual tradition, Rembrandt drew on the *Jewish Antiquities* by Flavius Josephus (A.D. 37–c. 95).[3] The 1656 inventory of his estate lists a copy of the 1574 German edition of Josephus, although it is not known when he acquired it. Chapter 9 of the tenth book relates how Nebuchadnezzar ordered the prophet to be freed from captivity and invited him to Babylon. All his wishes would be granted, even if he turned down the invitation. Jeremiah replied that he had no intention of leaving, but wished to remain in the ruins of his native city. The Babylonian king then ordered one Gadalias to look after the prophet. He presented him with valuable gifts and allowed him to move about freely. It is true that this story mentions precisely those elements—the ruined building, the costly vessels and the travelling bag and bottle (kept close at hand for a possible departure)—which are absent in the biblical narrative, but it still does not account for the puzzling figure hovering over the city with a flaming torch, for which no satisfactory explanation has yet been found.

P.v.Th.

1. Bode 1897–1905, Vol. I, No. 39.
2. See Cat. No. 5 for the significance of this pose.
3. Tümpel 1984, p. 185.

8a: Headpiece to the Book of Lamentations by Jeremiah, in *Den Bibel . . .*, Antwerp (Willem Vorsterman) 1532, fol. 101r. Amsterdam, Universiteitsbibliotheek.

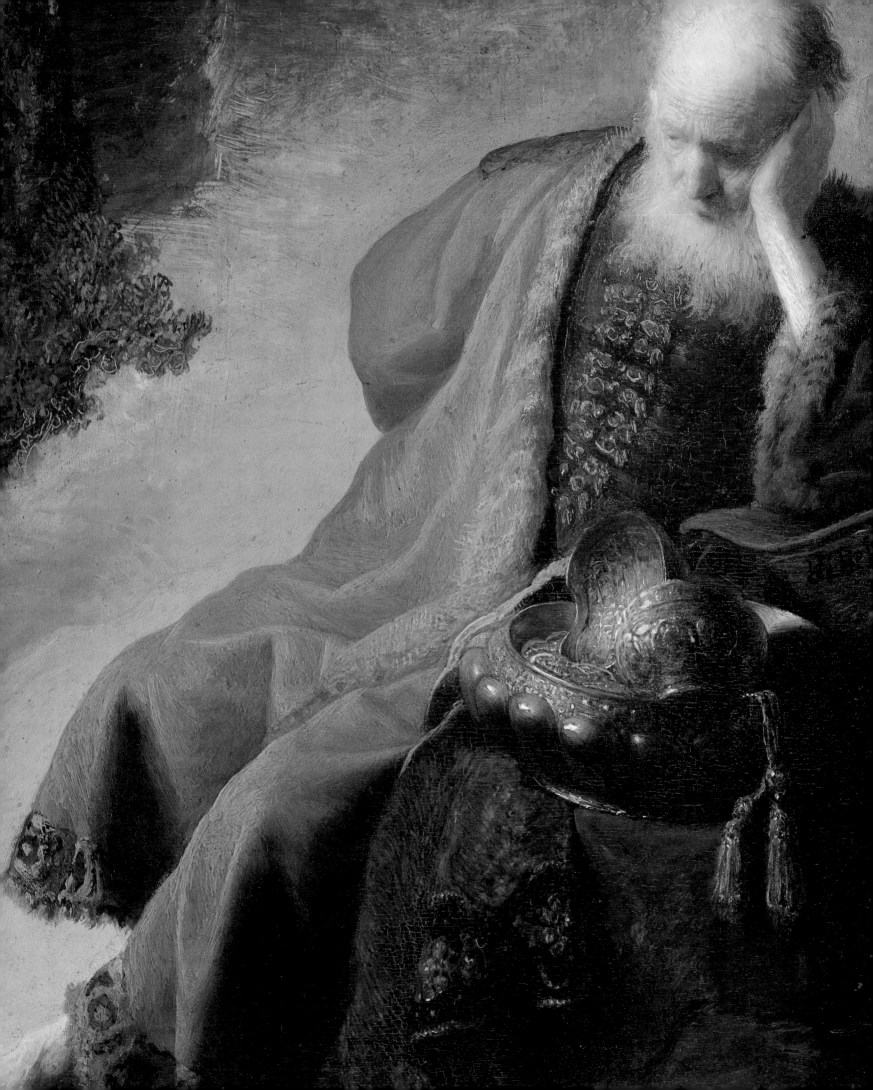

9

*A Man in oriental dress,
known as 'The noble Slav'*

1632
Canvas, 152.5 × 124 cm, signed and dated
RHL [in monogram] *van Rijn 1632*
New York, The Metropolitan Museum of Art,
Acc. No. 20.155.2

Provenance: Possibly Govert Looten sale,
Amsterdam, 31 March 1729, No. 7: 'Een
Turkse Vorst of primo Vizier, door Rembrant
konstig en kragtig geschildert' (A Turkish
prince or First Vizier, skilfully and powerfully
painted by Rembrandt); 71 guilders. Paul
Methuen collection, Corsham Court, Wiltshire.
King Willem II sale, The Hague, 12 August
1850, No. 91 (to Nieuwenhuys for 4,500
guilders). Tomline collection, Orwell Park.
Wertheimer Gallery, London. McKay
Twombly collection, New York. William
K. Vanderbilt collection, New York; donated
to the museum in 1920.

Literature: Bredius/Gerson 169; Bauch 141;
Gerson 103; *Corpus* A48.

Exhibitions: New York 1909, No. 79. New York
1942, unnumbered. New York 1950, No. 3.
Philadelphia 1950–51, No. 38. Amsterdam
& Rotterdam 1956, No. 20. New York 1967,
No. 29. New York 1970, No. 280. Boston 1970,
unnumbered (p. 42). Moscow & Leningrad
1975, No. 22.

Although shown to only just above the knees,
this life-size figure of an oriental potentate
nevertheless gives the impression of a full-
length work. Only the head with the large
turban and the lefthand part of the upper torso
are lit. The fact that the fur-trimmed cuff and
the hand on the stick are in shadow has the
effect of making them stand out from the
remainder of the body, the dark mass of which
appears to recede. The broad distribution of
light and shade over the undefined background
consistently contrasts with the lighting of the
figure, even down to details like the earrings,
and contributes largely to the monumental
appearance of the imposing figure. The
illuminated passages, in which there is a great
deal of detail, attract the greatest attention,
but as the light wanes so suggestion takes over
from description. At one point Rembrandt
corrected himself by reducing the right outline
of the cloak with an opaque overpaint which
has probably become more pronounced over
the years than it was originally.

In Leiden Rembrandt painted almost
exclusively on panel, but this quite large figure
piece, which is one of the first works he
executed in Amsterdam, is on canvas—the
support he was to use often from then on.[1] It is
noteworthy that the ground on his panels is
yellow, whereas on the canvases it is grey. In
the panels he used the bright ground to good
effect by allowing it to contribute to the colour
effect in translucent passages, as a counterpoint
the cooler, opaque areas. The grey ground of
the canvases is not visible on the surface, the
cool tone of which is established by this
underlying layer.

Jan Lievens painted a similar oriental figure
(Fig. 9a), which Constantijn Huygens, Prince
Frederik Hendrik's secretary, mentions in his
autobiography of around 1630. The passage,
translated from the Latin, runs: 'There is, in
my Prince's house, the likeness of a so-called
Turkish potentate, done from the head of some
Dutchman or other.'[2] In other words, paintings
like this one are not portraits of orientals who
had somehow strayed north, but pseudo-
portraits (for which there was evidently a
ready market) of interesting, exotic figures
done from local models with a martial bearing,
dressed to represent curiosities of this kind.

This particular *Oriental* very probably
belonged to the Amsterdam merchant Marten
Looten, whose portrait Rembrandt painted the
same year (Los Angeles County Museum of
Art; *Corpus* A52), for in 1729 'A Turkish prince
or First Vizier, skilfully and powerfully painted
by Rembrandt' was sold at the auction of the
estate of Marten's grandson Govert Looten. In
1845 King Willem II of the Netherlands bought

it for his small but choice collection. Today
this masterpiece would be hanging in the
Mauritshuis in The Hague or the Rijksmuseum
in Amsterdam, but for the fact that six months
before his death the king pawned his paintings
to his brother-in-law the Tsar for 1 million
guilders, forcing his heirs to auction the
collection in 1850, when it became dispersed
abroad. At the sale this *Man in oriental dress*
fetched 4,500 guilders.[3]
P.v.Th.

1. Van de Wetering 1986, pp. 15–43.
2. 'Est apud Principem meum Turcici quasi Ducis
effigies, ad Batavi cuiusdam caput expressa.' Worp
1891, p. 128. Kan 1971, p. 81.
3. Hinterding and Horsch 1989, p. 32, Fig. 30,
Cat. No. 91.

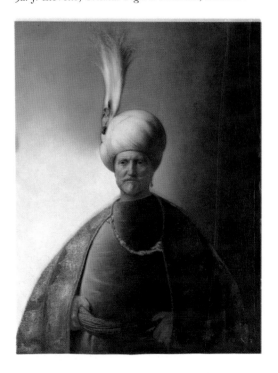

9a: J. Lievens, *Oriental Figure*. Potsdam, Sanssouci.

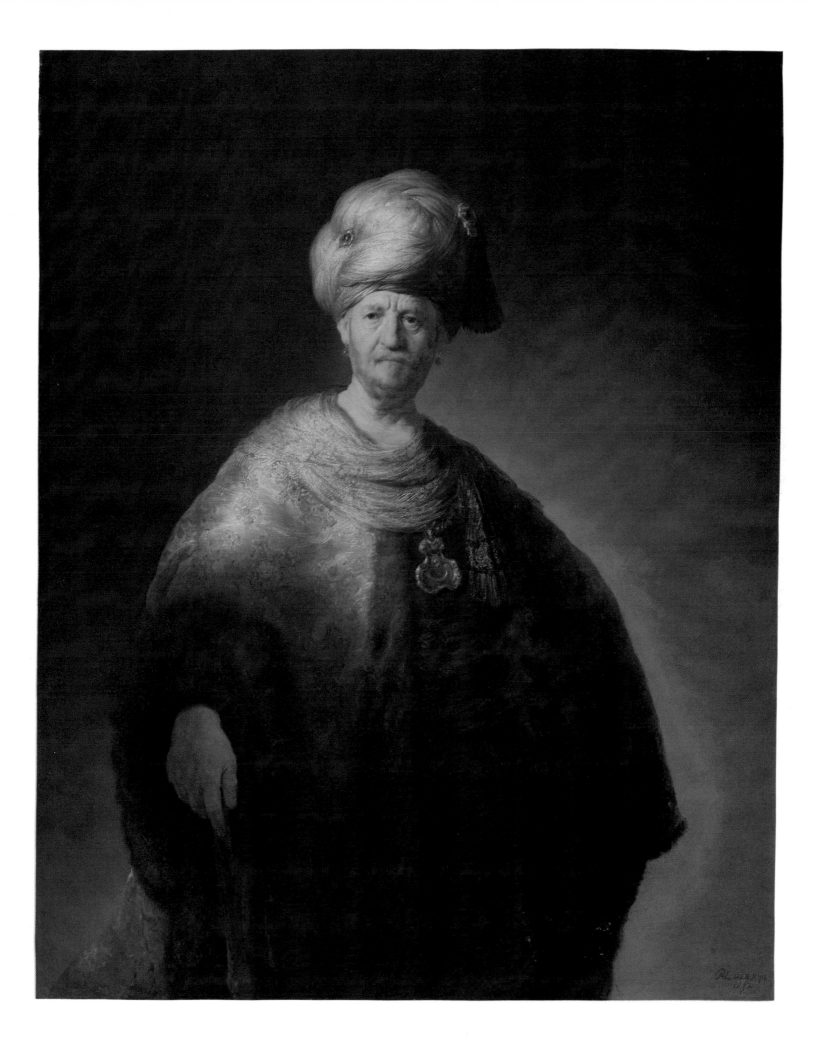

10

Portrait of a young Woman seated

1632
Canvas, 92 × 71 cm, signed and dated *RHL* [in monogram] *van Rijn 1632*
Vienna, Akademie der Bildenden Künste, Gemäldegalerie, Inv. No. 611

Provenance: Count de Fraula sale, Brussels, 21 July 1738 and subsequent days, No. 133: 'Een Portrait van eene Jonge Vrouwe, tot aan de knien, door Rimbrant, hoogh 3 v[oet] 5 duym breet 2 v[oet] 10 duym' (A portrait of a young woman, to the knees, by Rembrandt, height 3 feet 5 inches, width 2 feet 10 inches); 150 guilders. Count Lamberg-Sprinzenstein collection, Vienna, from at least 1798; bequeathed to the museum in 1821.

Literature: Bredius/Gerson 330; Bauch 460; Gerson 128; *Corpus* A55.

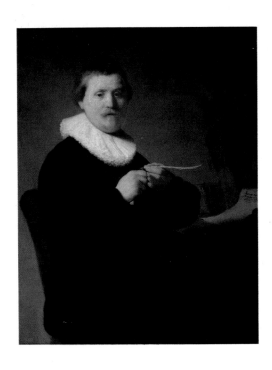

What immediately strikes one about this painting, which is so elegant in its simplicity, is that the head is further up the picture surface than in any of Rembrandt's other portraits. The suspicion that the painting was originally higher is confirmed by the sale catalogue of 1738, which gives the height as 3 (Antwerp) feet, 5 inches, equivalent to 99 cm. The trimming of some 7 cm from the top has reduced the amount of space above the young woman's head (see Fig. 117). The authors of the *Corpus* noted such striking resemblances of a stylistic, compositional and technical nature (both supports are from the same bolt of canvas) between this woman's portrait and the *Portrait of a Man trimming his Quill* in Kassel (*Corpus* A54; Fig. 10a), which is also dated 1632, that they wondered whether they were not companion pieces which had become separated by 1734, the year in which the male portrait is first mentioned. The fact that the picture of the man is slightly higher, at 101.5 cm, than that of the woman is of no significance, for there are often slight differences in dimensions between pendants. The Kassel painting, though, is 81.5 cm wide, which means that not only was the woman's portrait reduced in height after 1738 but that it had also been wider before that year, for the catalogue gives the same width as it has now. This, too, is not an insuperable problem, for canvases have often been tampered with in the past.

Of the many portraits which Rembrandt painted in his early years in Amsterdam, this picture of an unidentified young woman is remarkable for its restrained presentation. The suggestion of space around the figure is inhibited by the dark background, which does however become slightly lighter lower down. The woman is lit quite sharply from upper left, so that her head casts a prominent shadow on her white ruff. Just enough of her plain, dark clothing is visible to establish the relationship between head and ruff, and between the illuminated hands and the white cuffs. The pose, with the woman leaning slightly forward in her chair, gives the picture just that touch of liveliness that prevents the stable, very finely balanced composition from appearing rigid.
P.v.Th.

10a: Rembrandt, *Portrait of a Man trimming his Quill*, 1632. Kassel, Staatliche Kunstsammlungen Kassel, Schloss Wilhelmshöhe.

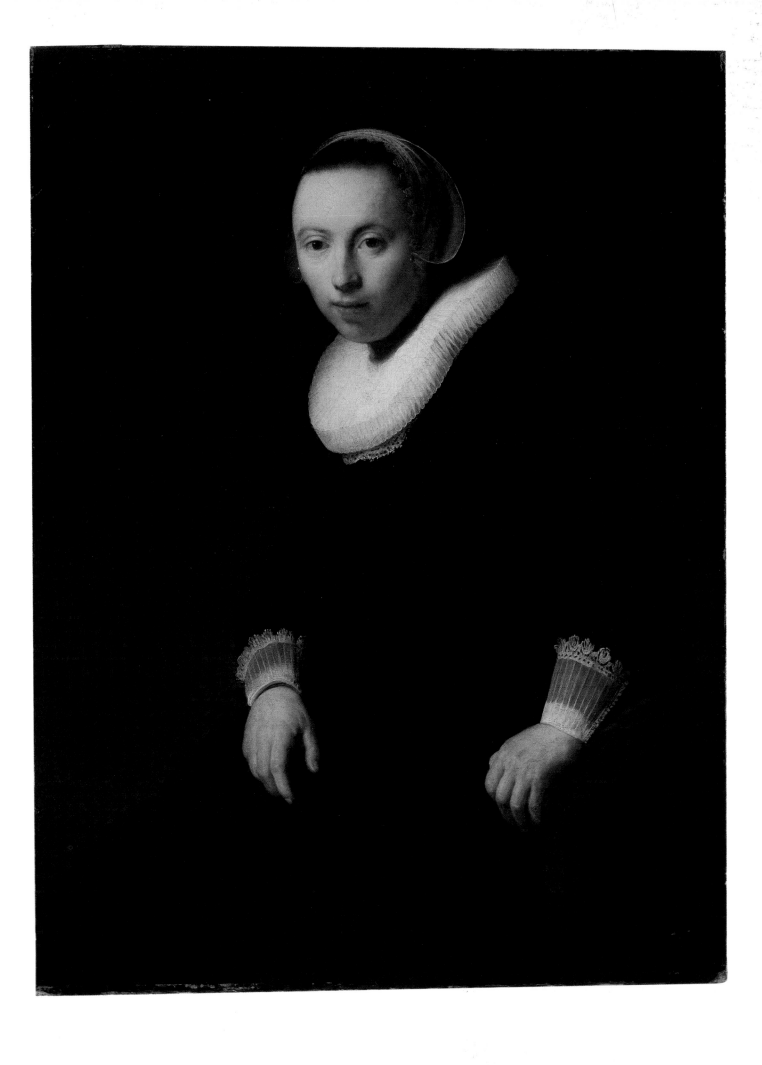

I I

Portrait of Maurits Huygens

1632
Panel, 31.1 × 24.5 cm (later enlarged at the bottom with a strip of wood more than 1 cm wide, and reduced slightly on the right, removing the letter 'n' from the signature), signed and dated *RH* [in monogram] *van Ry[n]* *1632*
Hamburg, Hamburger Kunsthalle, Inv. No. 87

I 2

Portrait of the Artist Jacques de Gheyn III

1632
Panel, 29.9 × 24.9 cm, signed and dated *RH* [in monogram] *van Ryn 1632*
London, Dulwich Picture Gallery, Cat. No. 99

Provenance: In 1641 Jacques de Gheyn III left his portrait to Maurits Huygens in his Will. After Huygens's death in 1642 the two portraits remained together until 1786. Nothing is know of their whereabouts until they appeared in the Allard Rudolph van Waay sale, Utrecht, 27 February 1764, No. 123: 'Twee origineele Pourtraiten uit de Familie van Huigens, door Rembrant. P[aneel] hoog 11½ en breed 9¾ duim' (Two original portraits from the Huygens family, by Rembrandt. Panel, height 11½, width 9¾ inches). They then featured in the Aubert sale, Paris, 2 March 1786 and subsequent days, No. 17: 'Par le même [Rimbrandt van Rhyn]. Deux petits Tableaux, Portraits d'Artistes. Ils sont chacun ajustés d'une fraise autour du cou, & vêtus d'habillemens noirs. Ces deux morceaux portent le caractere de la plus grande vérité, & sont d'une belle couleur: leur maniere moins libre que celle de différens ouvrages connus de Rimbrandt, nous fait juger qu'ils ont été peint dans sa jeunesse, & pendant qu'il suivoit l'Ecole de Gerardow. Hauteur 9 Pouces, largeur 7. B[ois].' Both portraits are thought to have come into the possession of the London art dealer Noel Joseph Desenfans, who bequeathed the portrait of Jacques de Gheyn III in 1807 to his friend Sir Francis Bourgeois, London, who in turn left it to Dulwich College in 1811.

The portrait of Maurits Huygens was auctioned in London (possibly sent in by Desenfans) on 8 June 1786 and subsequent days under No. 264: 'Rembrandt. A head. 1 f[oo]t by 11 in[ches], on pannel'. It is probably this portrait that is listed in the sale of Pieter Cornelis, Baron van Leyden (Amsterdam), Paris, [5 July, postponed to 10 September and then to] 5 November 1804, First Supplement, No. 152: 'Rembrandt [Van Rhin]. Peint sur bois, haut 11, larg[e] 9 p[ouces]. Portrait d'un Personnage vu presque de face, et aussi a mi-corps, dans un Habillement noir, ajusté d'une Fraise indiquant le costume d'un Magistrat. Morceau plein de vérité et de la plus riche couleur'. Sale D. Vis Blokhuysen (Rotterdam), Paris, 1–2 April 1870, No. 60 (to Wesselhoeft for 8,200 francs). J. Wesselhoeft collection, Hamburg. Sold to the Hamburger Kunsthalle in 1889 from the Hudtwalcker-Wesselhoeft collection.

Literature: Bredius/Gerson 161 and 162; Bauch 352 and 353; Gerson 104 and 105; *Corpus* A57 and A56.
11–12: H.E. van Gelder, 'Rembrandts portretjes van M. Huygens en J. de Gheyn III', *Oud Holland* 68 (1953), p. 107.
11: H.E. van Gelder, *Ikonografie van Constantijn Huygens en de zijnen*, The Hague 1957, p. 8, No. 1.
12: H.E. van Gelder, 'Marginalia bij Rembrandt I: De pendant van Maurits Huygens', *Oud Holland* 60 (1943), pp. 33–34.

Exhibitions: 11: Amsterdam 1952, No. 137. Amsterdam & Rotterdam 1956, No. 18. London 1964, No. 60.
12: London 1899, No. 16. London 1947–48, No. 36. Edinburgh 1950, No. 5. Amsterdam 1952, No. 136. London 1952–53, No. 126. London 1964, No. 59.

These paintings of Maurits Huygens and Jacques de Gheyn III are exceptional among the portraits which Rembrandt produced at the beginning of his Amsterdam period. The reason is not so much because they were probably executed in The Hague, where both of the sitters lived, possibly when Rembrandt was staying in the city to paint the portraits of Joris de Caullery (*Corpus* A53) and his son Johan (possibly *Corpus* A60), and of Princess Amalia of Solms (*Corpus* A61), but because of their small size and relationship to each other. The latter is more apparent from their history than from their formal features, which are too dissimilar for them to be referred to unreservedly as companion pieces.

With all the similarities in composition, style and technique, one notices to begin with that the light falls on Huygens from the left and on De Gheyn from the right. In addition, Rembrandt illuminated the dark grey background around the figure of De Gheyn but did not do so with Huygens, employing instead a cast shadow to give the impression of a wall behind him. In De Gheyn's case the light serves primarily to give the figure greater plasticity, and in Huygens's to suggest the atmospheric effect of the space around the sitter.

The Hague families of Huygens and De Gheyn were closely acquainted. Constantijn Huygens (1596–1687), a lover of the arts, was particularly attached to the elderly painter and graphic artist Jacques de Gheyn II (1565–1629), who became his neighbour in Lange Houtstraat in 1627. This was at the time that Constantijn was writing the account of his youth, which included the famous passage praising the young Rembrandt, whom he had got to know in Leiden and greatly admired.[1] He also wrote about Jacques's son, the painter and graphic artist Jacques de Gheyn III (1596–1641), saying that his talent had shown itself at an early age but that, being well-off, he had shamefully neglected it. Jacques III was certainly not a very prolific artist, his extant œuvre amounting to no more than eight painting and 106 drawings.[2] In 1634 he moved to Utrecht, becoming a canon at the Church of Our Lady. He and Maurits Huygens (1595–1642), Constantijn's elder brother, must have been very close friends. In 1624 Maurits succeeded his father Christiaen as Secretary to the Council of State, an administrative body under the States-General of the Republic. Christiaen Huygens had written a long account of his children's early years, just as his son Constantijn was to do, and it opens with the birth of his eldest son Maurits.[3] That Maurits and Jacques were also friendly with Rembrandt can

be deduced from the unusual nature of these two pictures, for the latter's commissioned portraits were invariably larger. It is significant, too, that Jacques was the first owner of Rembrandt's *Two old Men disputing* of 1628, now in Melbourne (*Corpus* A13), and of his *Old Man asleep by the Fire* of 1629 in Turin (*Corpus* A17; Fig. 55b).

The portrait of Maurits Huygens is documented by the inscription on the back of the panel: 'M. Huygens Secretaris vanden Raad van State inden Hage" (M. Huygens, Secretary to the Council of State in The Hague). On the reverse of the portrait of Jacques de Gheyn III there is a partly worn inscription which has been deciphered as: 'JACOBUS GEINIUS IUN^R / H . . . NI IPSIUS / EFFIGIE[M] / EXTREMUM MUNUS MORIENTIS / R / . . . MO.IE.STE. UN. HABET ISTA SECUNDUM HEU:' (the last line has also been read as 'MORIENTE. NUNC HABET ISTA SECUNDUM HEU'). The best possible translation gives: 'Jacques de Gheyn the Younger / [bequeathed] his own / portrait / [to Huygens] as a last duty when he died. / He may rest / [. . .] now this [portrait] has its companion, alas.'[4] This inscription was written at some time in the 15 months separating the death of De Gheyn, who bequeathed his portrait on 3 June 1641 (the day before his death) in Utrecht to Huygens in The Hague ('Item maeckt ende legateert hij comparant aenden den Heere Maurits Huygens, Secretaris vanden Raedt van Staten inden Hage, sijn comparants eijgen contrefijtsel bij Rembrand geschildert' [Item: the testator makes over and bequeaths to Maurits Huygens, Gentleman, Secretary to the Council of State in The Hague, the testator's own likeness painted by Rembrandt]), and Huygens's own death on 24 September 1642. The historical data do not reveal the immediate reason for the execution of the portraits in 1632, nor do they tell us whether Rembrandt painted them on commission or as an act of friendship. They do, however, give a clear picture of the close ties between Maurits and Jacques and of their attachment to each other's portraits, as if the latter would continue to unite them in friendship even after death. Maurits's brother Constantijn had written in his autobiography shortly before, that portrait painters 'do noble work, which is more essential to our human needs than anything else, because through them, in a sense, we do not die'.[5] As it happens, Constantijn did not think very highly of the portrait of his brother's friend (his opinion on his brother's has not survived), for in January and February 1633 he wrote no fewer than eight epigrams on the portrait of De Gheyn,[6] all of them critical of the likeness.

He gave these exercises in Latin versification, which were evidently not meant in bad part, the title: 'In Iacobi Gheinij effigiem plane dissimilem, scommata' (On the portrait of Jacob de Gheyn, which resembles him not at all: jests). The last in the series runs:

> Rembrantis est manus ista, Gheinij vultus;
> Mirare, lector, et iste Gheinius non est.
> (This is the hand of Rembrandt, the face of De Gheyn; look in wonder, reader, it also is not De Gheyn.)

Tümpel regards these epigrams as variations on the traditional Neo-Platonic theme that a portrait is just a likeness of a person, not the person himself,[7] which suggests that Huygens was not giving his personal opinion of the portrait. However, the verses definitely do comment on the poor resemblance, as is clear from the title of the series.[8] The first epigram, for instance, reads:

> Talis Gheiniadae facies si forte fuisset
> Talis Gheiniadae prorsus imago foret
> (Had De Gheyn's face happened to look like this, then this would have been an excellent portrait of De Gheyn.)

Schwartz's speculations on the relationship between Rembrandt, De Gheyn and the Huygens brothers overstep the mark considerably.[9] On the basis of his interpretation of the second epigram he arrives at the quite incorrect conclusion that Huygens was implying that Rembrandt had demanded half De Gheyn's inheritance for painting his portrait. Huygens wrote:

> Haereditatis patriae probus Pictor
> Invidit assem Gheinio, creavitque,
> Quem recreet semisse posthumum fratrem.
> (The worthy painter has begrudged De Gheyn his father's full inheritance, creating a posthumous brother to gladden with half the portion.)

The actual meaning of the verse is that De Gheyn had acquired a brother in this unlifelike portrait, so was no longer in the fortunate position of an only child but would have to divide his inheritance with his new sibling.
P.V.TH.

1. Kan 1971, pp. 77–80.
2. Van Regteren Altena 1983, Vol. II, pp. 162–63 ('The paintings by Jacques de Gheyn III'), and 164–77 ('The drawings by Jacques de Gheyn III').
3. The document is published in exhib. cat. The Hague 1987, pp. 79–83.
4. Bruyn *et al.* 1982–, Vol. II, p. 224.
5. Kan 1971, p. 75.
6. Worp 1892–99, Vol. II, pp. 245ff. Bruyn *et al.* 1982–, Vol. II, p. 223.
7. Tümpel 1986, p. 133 and note 120.
8. Cf. E. de Jongh, in exhib. cat. Haarlem 1986, pp. 20–23 ('Gelijkenis').
9. Schwartz 1984, pp. 95–97.

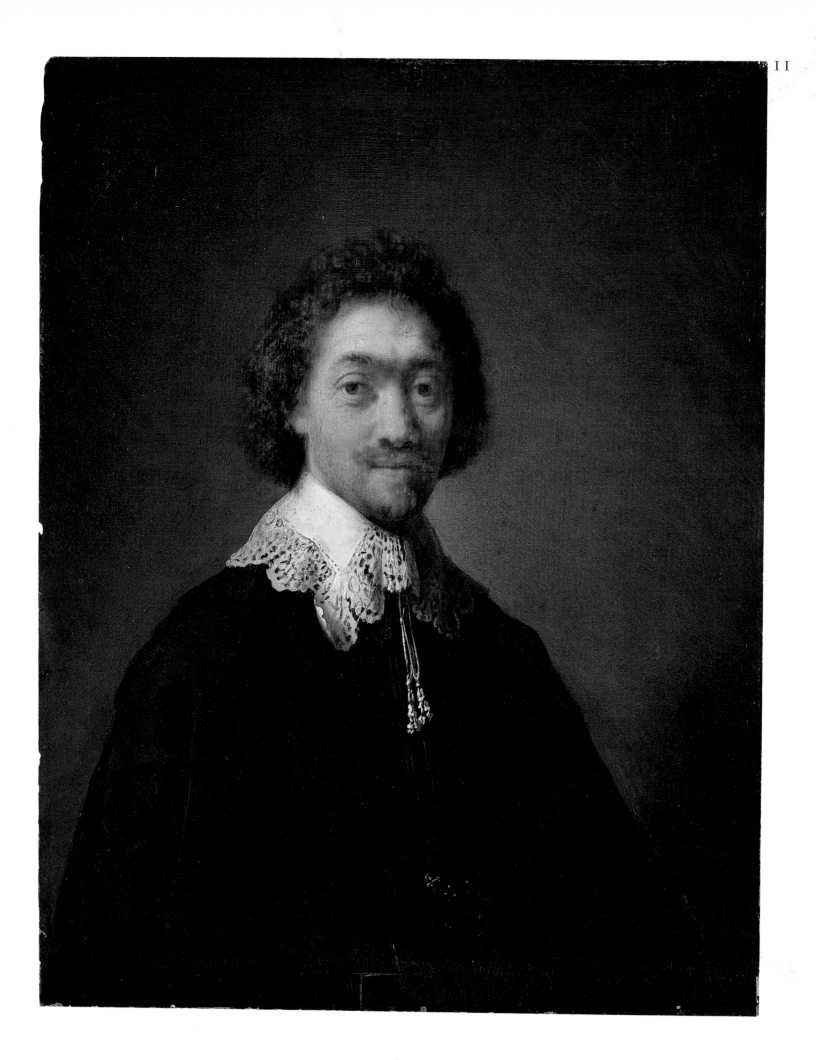

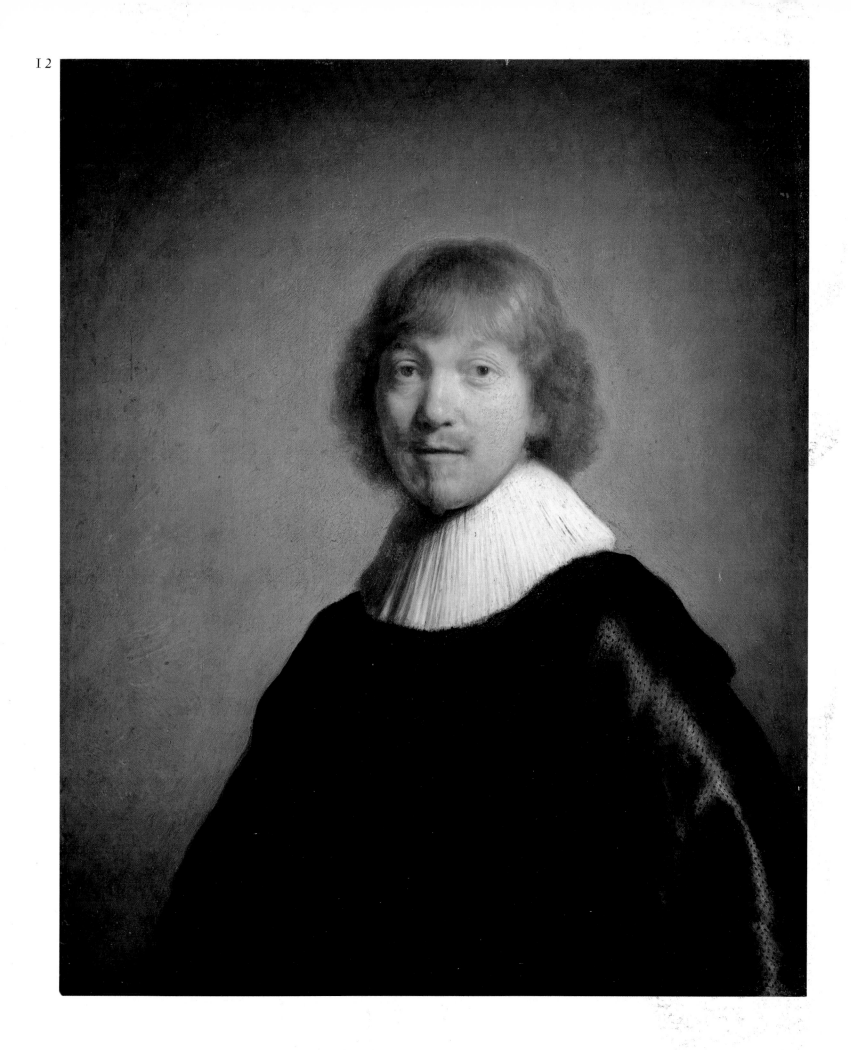

13

The raising of the Cross

c.1633

Canvas, arched, 95.7 × 72.2 cm
Munich, Bayerische Staatsgemäldesammlungen,
Alte Pinakothek, Inv. No. 394

13a: Rembrandt, *The Descent from the Cross.*
Munich, Alte Pinakothek.

13b: Rembrandt, *The Raising of the Cross.*
Munich, Alte Pinakothek.

13c: Rembrandt, *The Ascension, 1636.*
Munich, Alte Pinakothek.

13d: Rembrandt, *The Entombment.*
Munich, Alte Pinakothek.

13e: Rembrandt, *The Resurrection.*
Munich, Alte Pinakothek.

13f: Rembrandt, *The Adoration of the Shepherds,*
1646. Munich, Alte Pinakothek.

Provenance: Collection of Prince Frederik
Hendrik of Orange, probably in the gallery of
the Oude Hof (Old Court) in Noordeinde,
The Hague. The inventory dated 20 March
1668 of Amalia of Solms, widow of Prince
Frederik Hendrik, lists:

Seven stucken schilderije bij Rembrant
gemaeckt, alle met swarte lijsten, boven
ovaelsgewijse ende rontom vergulde gesnede
feuillages:
De eerste sijnde de geboorte Onses Heeren
Jesu Christi.
De tweede de besnijdenisse.
De derde de cruycinge.
De vierde de affdoeninge van den cruyce.
De vijffde de begrafenisse.
De sesde de opstandinge.
De sevende de hemelvaert Onses Heeren
Jesu Christi.

(Seven paintings made by Rembrandt, all
with black frames, oval at the top and with
gilt carved leaves all round:
The first being the nativity of our Lord
Jesus Christ.
The second the circumcision.
The third the crucifixion.
The fourth the descent from the cross.
The fifth the entombment.
The sixth the resurrection.
The seventh the ascension of our Lord Jesus
Christ.)

It is not known who inherited this Passion
series after the death of Amalia of Solms in
1675, or how and precisely when it entered the
collection of Johann Wilhelm, Elector Palatine,
in Nuremberg, before 1716. The Electoral
collection was removed several times under the
threat of war: in 1758 to Mannheim (returned
in 1764), in 1794 to Glückstad (where it
remained for some ten years), and before 1805
to Kirchheimbolanden. In 1806 the collection
was transferred to Munich and incorporated in
the art gallery of the Wittelsbach family. It was
installed in the Pinakothek founded by King
Ludwig I, which opened in 1836.

Literature: Bredius/Gerson 548; Bauch 57;
Gerson 64; *Corpus* A69. J.L.A. van Rijckevorsel,
'Rembrandt's schilderijen voor Prins Frederik
Hendrik', *Historia, Maandblad voor Geschiedenis en
Kunstgeschedenis* 4 (1938), pp. 221–26.
E. Brochhagen, 'Beobachtungen an den
Passionsbildern Rembrandts in München',
in: *Minuscula discipulorum . . . Hans Kauffmann
zum 70. Geburtstag 1966*, Berlin 1968, esp.
pp. 39–40. B.P.J. Broos, 'Rembrandt borrows
from Altdorfer', *Simiolus* 4 (1970), pp. 100–8.
E. Kai Sass, *Comments on Rembrandt's Passion
Paintings and Constantijn Huygens's Iconography,*
Copenhagen 1971, esp. pp. 12–31.

Exhibitions: Amsterdam, Paris & London
1948–49, Nos. 104, 112 and 86 respectively.
Bern 1949–50, No. 44. Moscow & Leningrad
1984, No. 28.

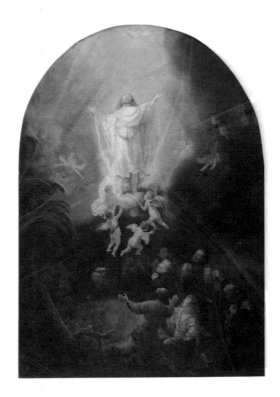

The *Raising of the Cross* is the sole representative in the exhibition of the Passion series which Rembrandt painted in the period 1632–46 for Prince Frederik Hendrik, Stadtholder of the United Provinces from 1625 until his death in 1647. The seven paintings in the series, which opens with the *Nativity* and ends with the *Ascension*, were not executed in biblical order. In 1632/33 Rembrandt first painted the *Descent from the Cross* (Fig. 13a; *Corpus* A65) followed by our *Raising of the Cross* (Fig. 13b), then in 1635–39 the *Ascension* (Fig. 13c; *Corpus* A118), which he delivered in 1636, the *Entombment* (Fig. 13d; *Corpus* A126) and *Resurrection* (Fig. 13e; *Corpus* A127), and finally in 1646 the *Adoration of the Shepherds* (Fig. 13f) and the *Circumcision*, which is now lost. Rembrandt asked 1,200 guilders for each picture, but he only received that amount for the last two. For the other five he was only paid half his price, bringing him a total of 5,400 guilders for the whole project. These facts are known from the seven letters which he wrote to Constantijn Huygens, the prince's secretary (they are the only known letters by Rembrandt),[1] and from the records of payments made by the court in The Hague.

As we know from his diary, Constantijn Huygens (1596–1687) was a great admirer of Rembrandt, who had painted the portraits of his brother Maurits and the latter's friend Jacques de Gheyn III in 1632 (Cat. Nos. 11–12). So it was very probably Huygens who communicated his enthusiasm to Frederik Hendrik, who according to an inventory of 1632 already owned two of Rembrandt's

works, *Minerva in her Study* and *The Abduction of Proserpina*, both thought to date from 1631, which are now in Berlin (*Corpus* A38 and A39). The letters about the Passion series which Rembrandt wrote from Amsterdam to Huygens in The Hague mainly deal with business matters. It can be deduced from the first letter of this correspondence (which may not have survived intact), possibly dating from February 1636, that the *Raising of the Cross* and the *Descent from the Cross* had already been delivered. The most interesting passages are in the letter written in March 1636 or thereabouts, in which Rembrandt announced that he would soon be coming to The Hague to see whether the *Ascension* which he had just dispatched fitted in well with the others, and the letter of 12 January 1639, in which he admitted that he may have spent a long time on the *Entombment* and the *Resurrection*, but that as a result they excelled in the naturalistic depiction of emotions and movement: '[. . .] deesen twe sijnt daer die meeste ende die natuereelste beweechgelickheijt in geopserveert is dat oock de grooste oorsaeck is dat die selvijge soo lang onder handen sij geweest' (In these two pictures the greatest and most natural emotion and animation have been observed, which is also the principal reason why they have been so long in the making).

The entire series, which in the nature of the project displays no stylistic unity and thus constitutes an interesting if fragmentary chronicle of Rembrandt's development over the 15 years he worked on it, suffered quite severe

damage in the mid-eighteenth century, the cause of which is unknown. The restorer's report of 1756 mentions only six paintings, so the *Circumcision* was either beyond saving by then or had already been lost.

Due to the rather poor condition of the *Raising of the Cross* the paint surface offers little of interest in the way of brushwork. The visual impact of the scene, however, has lost little of its force. In a dark and shadowy setting the light falls on the outstretched body of Christ nailed to the Cross, which is being heaved into an upright position. Christ is staring up at heaven, although the X-ray photograph shows that at an earlier stage his head was tilted towards the viewer. The foot of the Cross rests in the hole dug for it (the spade is stuck into the ground just to the right), and while a soldier hauls on a length of rope wrapped around the Cross two men push with all their might from behind. The light also shines on a man assisting them, who has the unmistakable features of Rembrandt himself. Behind and to the left of this group, which forms a diagonal rising from left to right (the spade with its handle introduces this powerful upward thrust, which terminates at the horizontal beam of the Cross), is the centurion seated on his horse. In his right hand he holds a martel, which was the staff of office of cavalry commanders in the seventeenth century. The horse's head disappears rather clumsily behind the Cross. In the half-shadow on the left are the high priest and the scribes mocking Christ from Matthew 27:41–43, and being led up on the right are the

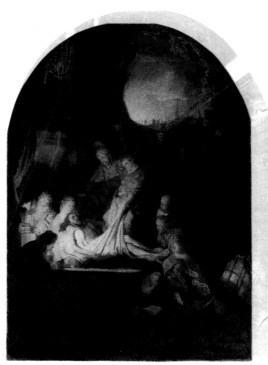

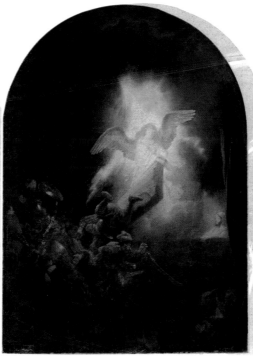

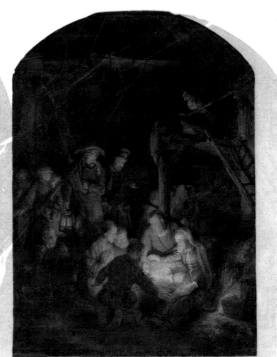

two thieves who were crucified with Christ.

The earliest of the two paintings which, as mentioned above, were already in Prince Frederik Hendrik's possession before Rembrandt's first letter of 1636 was probably not the *Raising of the Cross* but the *Descent from the Cross*. Unlike all the other pictures in the series it was executed on panel, and it is also the only one that Rembrandt translated into print with his large etching of 1633 (Bartsch 81). His point of departure was Rubens's *Descent* of 1612 in Antwerp Cathedral, which Rembrandt knew from Lucas Vorsterman's reproductive engraving of 1620. These factors make it an extremely ambitious painting which could very well have been conceived as an individual work, complete in itself. This has given rise to the modern hypothesis that originally there was no plan for a series, but that Frederik Hendrik bought the *Descent from the Cross* from Rembrandt and only later commissioned him to paint six more to make a Passion series.[2] This plausible theory can be refined even further, to explain the odd order in which the paintings were executed, by assuming that Frederik Hendrik awarded the commission in stages, first ordering just the *Raising of the Cross* as the pendant to the *Descent*, then the *Entombment*, *Resurrection* and *Ascension*, expanding the initial pair to a five-part series depicting the fulfilment of Christ's redemptive death on the Cross, and finally asking for the *Adoration of the Shepherds* and the *Circumcision* to place the entire series in the context of the human nature of God's son and his arrival on earth.

Given the evidence that Rembrandt's *Descent from the Cross* was intended to rival Rubens, it is quite widely believed that the same applies to the *Raising of the Cross*. However, it is unlikely that Rembrandt even knew Rubens's version, which was painted in 1610/11 for the Church of St Walburga (being moved to Antwerp Cathedral in the early nineteenth century), for no print was made of it. Nor are there any specific points of similarity between the two compositions. The features they have in common can be attributed to the iconographic tradition to which both artists paid tribute.

Broos has put forward a theory regarding the visual tradition behind Rembrandt's *Raising of the Cross* by referring to a small woodcut of the subject (Fig. 13g) executed around 1513 by Albrecht Altdorfer as part of a suite of forty prints (later regarded as the work by Albrecht Dürer) on which Rembrandt also drew for his *Descent from the Cross* and his etching of the *Crucifixion* (Bartsch 80). The woodcut does indeed contain the essence of the image, with the figure of Christ lying prone on the sloping Cross, which the men are pushing and heaving upright. It is true that the Cross in the woodcut leans to the left rather than to the right, but that is also the case in a chalk drawing by Rembrandt (Fig. 13h) which was evidently the initial design for the composition. One striking feature of this sketch is the figure straddling the foot of the Cross, who reappears in a copy after another, lost working drawing by Rembrandt (Fig. 13i), where the image is reversed. Rembrandt replaced this figure in the

13g: A. Altdorfer, *The Raising of the Cross.* Woodcut. Amsterdam, Rijksprentenkabinet.

13h: Rembrandt, *The Raising of the Cross.* Drawing. Rotterdam, Museum Boymans-van Beuningen.

13i: Anonymous artist after Rembrandt, *The Raising of the Cross.* Drawing. Boston, Museum of Fine Arts.

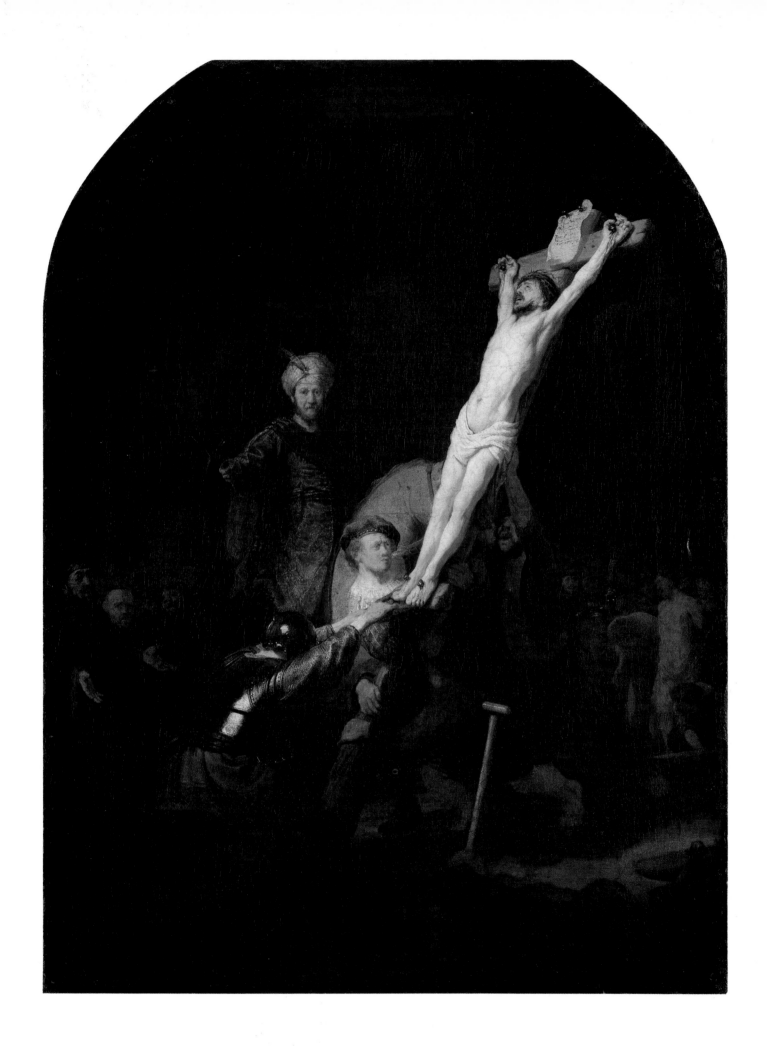

painting with the soldier bending forwards and actually standing on the foot of the Cross, who appears to be a combination of the man standing with his legs apart in the first drawing and the companion behind him with one foot on the Cross.

Rembrandt's self-portrait right beside Christ's nailed feet in the very centre of the painting only fits within a tradition to the extent that artists quite often portrayed themselves in history paintings, but always in the passive role of a bystander.[3] Here Rembrandt is taking an active part in the tragic events, and has even cast himself as one of the executioners. Bergström's explanation that he was depicting himself as Everyman, the fifteenth-century personification of carefree mankind living in sin, does place the artist's conduct in the proper context of Christian ethics,[4] but it was Tümpel who discovered a contemporary literary parallel which may well express exactly what Rembrandt was intending.[5] It is a poem imbued with a deep sense of guilt called *Hy droech onse smerten* (He bore our sorrows), written by the militant Calvinist minister Jacobus Revius (1586–1658) and included in his anthology *Over-Ysselsche Sangen en Dichten* of 1630:

T'en zijn de Joden niet, Heer Jesu, die u
 cruysten,
Noch die verradelijck u togen voort gericht,
Noch die versmadelijck u spogen int gesicht,
Noch die u knevelden, en stieten u vol
 puysten.
T'en sijn de crijchs-luy niet die met haer
 felle vuysten
Den rietstock hebben of den hamer
 opgelicht,
Of het vervloecte hout op Golgotha gesticht,
Of over uwen rock tsaem dobbelden en
 tuyschten:
Ick bent, ô Heer, ick bent die u dit heb
 gedaen,
Ick ben den swaren boom die u had
 overlaen,
Ick ben de taeye streng daermee ghy ginct
 gebonden,
De nagel, en de speer, de geessel die u
 sloech,
De bloet-bedropen croon die uwen schedel
 droech:
Want dit is al geschiet, eylaes! om mijne
 sonden.

('Tis not the Jews, Lord Jesus, who crucified
 you,
Nor they who treacherously brought you
 before the court,
Nor who spat into your face with scorn,
Nor who trussed you and bruised you full
 sore.
'Tis not the soldiers whose brutal fists,
Raised the rod and the hammer,
Or who placed the accursed wood upon
 Golgotha,
Or who diced and cast lots for your cloak:
It is I, O Lord, it is I who have done this to
 Thee
I am the heavy tree that was too much for
 you to bear,
I am the stout rope with which you went
 tightly bound,
The nail, and the spear, the scourge that
 flayed Thee
The blood-spattered crown worn upon your
 head:
For my sins, alas, brought all this to pass.)
P.v.Th.

1. Gerson 1961.
2. Bruyn *et al.* 1982-, Vol. II, p. 283.
3. Raupp 1984, pp. 243–66 (Ch. II, 2.1: 'Das Bildnis des Künstlers in der Assistenz').
4. Bergström 1966, pp. 164–66.
5. Tümpel 1986, p. 136. See also Chapman 1990, pp. 112–13.

14

The Holy Family

c.1634

Canvas, 183.5 × 123.5 cm, unreliably signed
and dated *Rembrandt f 163[1]* (possibly copied
from an authentic but lost signature)
Munich, Bayerische Staatsgemäldesammlungen,
Alte Pinakothek, Inv. No. 1318

Provenance: Probably identical with 'een
schilderij van Joseph en Maria, gedaen door
Rembrandt' (A painting of Joseph and Mary,
done by Rembrandt) described in the
settlement of probate dated 24 June 1660 on
the estate of Maerten Daey (d. 1659), the
second husband of Oopjen Coppit, and
allocated to her son Jan Soolmans from her first
marriage to Marten Soolmans. Probably sale
Isaak van Thye, Squire of Opmeer, Amsterdam,
22 April 1711, No. 1: 'Joseph en Maria, met 't
Kind Jesus aen haer Boesem, konstig van Rem-
brand' (Joseph and Mary with the infant Jesus
at her breast, artfully done by Rembrandt);
900 guilders. Probably anonymous sale,
Amsterdam, 17 August 1735, No. 5: 'Een
ongemeen heerlijk Stuk, van Rembrand, Joseph
en Maria met het Kindeken Jesus' (An uncom-
monly fine piece by Rembrandt, Joseph and
Mary with the infant Jesus); 100 guilders.
Bought in 1760 by the Amsterdam dealer
Hendrik de Winter for the Elector Palatine Karl
Theodor at Mannheim through his court
painter Lambert Krahe. In 1799 the Electoral
collection was transferred to Munich and
incorporated in the art gallery of the Wittels-
bach family; installed in the Pinakothek founded
by King Ludwig I, which opened in 1836.

Literature: Bredius/Gerson 544; Bauch 53;
Gerson 63; *Corpus* A88.

Exhibitions: Amsterdam, Paris & London
1948–49, Nos. 102, 111 & 85 respectively.
Washington & Cincinnati 1988–89, No. 38.

This canvas, which is almost two metres high,
is the first evidence of Rembrandt's ambition
to move on from small pictures of biblical
subjects and to tackle history painting on a
large scale with (near) lifesize figures.
Unfortunately the format of this picture was
altered in the eighteenth century, probably to

make it fit on a chimney-breast. A fairly wide piece of canvas was removed from the left, but only a narrow strip was taken from the right. The two upper corners were then cut away to create an arch set slightly in from the edges, and a curved segment corresponding to the arch was removed from the bottom. The corners and the lower arc were later made good, but the ratio between height and width was never restored, leaving a format which is unusually narrow for a work of the 1630s. There may have been a wood fire on the strip removed from the left, beside the earthenware pots and the thick tree-branch. A fire of this kind, which lent a domestic touch to Rembrandt's *Tobit and Anna* of 1626 (Cat. No. 1) and the *Old Man asleep by the Fire* (Corpus A17; Fig. 55b), would make it clear that the Virgin, who has just suckled the Child, is not just holding his feet but is warming them.

All that remains of the date in the lower right corner after the signature is a tiny fragment of the last digit. The handwriting of the signature and date does not look authentic, but it could have been copied from the lost original signature, which may have been cut off. This fragment has been completed as a 1 on the added strip, but the painting cannot possibly date from 1631, if only because in that year Rembrandt was still signing with a monogram and not with his forename, which only became his regular practice in 1633. The range of colour and certain stylistic features support a dating of 1634 for this large-scale history painting.

The theme of the Holy Family is not based on any passage in the Bible. The evangelists do not speak of the domestic life of the chosen family, let alone that it took place in Joseph's carpenter's shop. Nor is his trade mentioned at the beginning of the gospels, where he is described merely as Mary's husband or espoused husband. It is only revealed later, when Jesus was a grown man, in a passage which relates how he made such an impression in the synagogue at Nazareth that those present wondered where their simple fellow villager acquired all his wisdom, asking 'Is not this the carpenter's son?' (Matthew 13:55). In the iconography of the subject, too, it was some time before Joseph was portrayed as a carpenter, although that of course had nothing to do with the late mention of his trade in the Bible. In the middle ages he was depicted as a rather timid old man, for after all he was not Jesus's natural father, but his foster-father. It was not until the end of the fifteenth century that a more youthful and vigorous Joseph began to make an appearance. From then on he was shown as a carpenter, although not always

plying his trade. When he is shown in his workshop he is often making something that symbolises the Christ Child's role as the Redeemer. Rembrandt has not followed that tradition here, but he did in his *Holy Family* of 1645 in Leningrad, where Joseph is seen making a yoke, which according to Tümpel is an allusion to the Old Testament prophecy that the Saviour would break the yoke of the burden of Israel.[1]

The painting is executed in the manner typical of Rembrandt's early period in Amsterdam. The space around the sculptural figures is suggested by the juxtaposition of light and shade, often sharply contrasted in zones with strong cast shadows. The main subject is brought forward by giving it more detail and leaving the surroundings vague. The detail is less elaborate than in Rembrandt's smaller pictures, which shows that he was making allowance for the fact that this large painting would be viewed from a distance.

This broadly executed composition with two figures describing curved diagonals around an empty space in the centre does not look Dutch. It appears to derive not so much from Rubens[2] as from a north Italian model, a supposition which is borne out by the Virgin's action in grasping the Child's feet—a Byzantine iconographic motif that was still current in Italy.[3] Joseph's pose as he cranes forward for a closer look had already been used by Rembrandt for the third figure from the left in his *Anatomy Lesson of Dr Nicolaes Tulp* of 1632 in The Hague (Corpus A51; Fig. 44b).

The *Holy Family* was very probably bought in 1634 by Marten Soolmans and Oopjen Coppit, members of the Reformed church in Amsterdam whose portraits Rembrandt painted that year (Cat. Nos. 17–18), for in 1660 Jan Soolmans, Oopjen's son from her first marriage, inherited 'a painting of Joseph and Mary, done by Rembrandt' from Maerten Daey, her second husband. This would not have been the only time that Rembrandt sold a history painting to clients who came to him to have their portraits painted. There are indications that in 1632 he sold his *Oriental* (Cat. No. 9) to Marten Looten, whose portrait is now in the Los Angeles County Museum of Art (Corpus A52), and in 1634 his *Scholar seated at a Table*, now in Prague (Corpus A95), to Dirck Pesser and Haesje van Cleyburg, whose companion portraits became separated and are now divided between the Los Angeles County Museum of Art (Corpus A102) and the Rijksmuseum (Corpus A103; Fig. 25).
P.V.TH.

1. Tümpel 1986, p. 245.
2. Van Rijckevorsel 1932, pp. 87–91. Rosenberg 1948, Vol. I, p. 121.
3. Bruyn 1970, pp. 35–38.

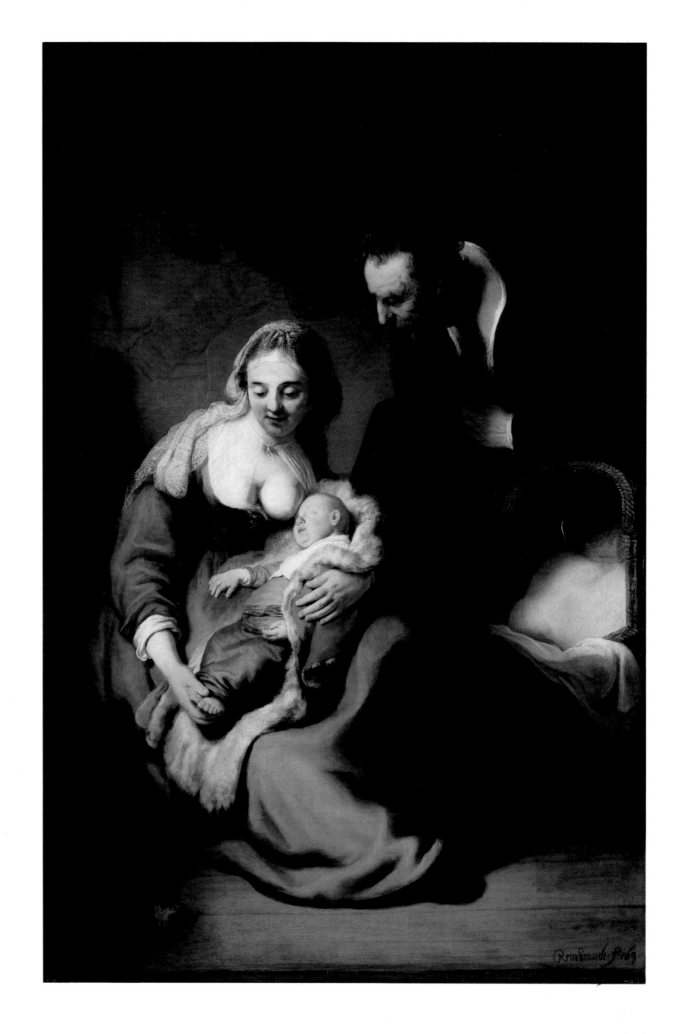

15

Ecce Homo

1634
Paper on canvas, 54.5 × 44.5 cm
London, The National Gallery, Inv. No. 1400

Provenance: Listed in the inventory of
Rembrandt's possessions dated 25/26 July 1656:
'Een excehomo in 't graeuw, van Rembrant'
(An Ecce Homo in grisaille, by Rembrandt). In
the collection of the artist Jan van de Cappelle
(1624/25–79); described in the inventory of his
estate, Amsterdam, 4 January–13 August 1680,
No. 13: 'Een Ecce homo, grauw, van Rembrant
van Rijn' (An Ecce Homo, grisaille, by
Rembrandt van Rijn). Collection of Valerius
Röver (1686–1739), Delft, folio portfolio No. 8:
'de Capitaalste die van Rembrand is bekend,
zijnde de groote *Ecce Homo* met olieverf op
papier in 't graauw' (The most capital known
by Rembrandt, being the large *Ecce Homo* in
oils on paper, in grisaille). J. Goll van
Franckenstein collection, Amsterdam; Sold in
1827 to the art dealer A. Brondgeest,
Amsterdam. Dealer T. Emerson, London.
Jeremiah Harman sale, London (Christie's),
17–18 May 1844, No. 92 (to J. Smith for 112
guineas; sold to G. Blamire). George Blamire
sale, London (Christie's), 7–9 November 1863,
No. 57 (to Mulvaney for 16 guineas). Sir
Charles Eastlake collection, London; bought
from the executors of Lady Eastlake's estate in
1894 for a nominal sum (in accordance with the
terms of Sir Charles's Will) in 1894.

Literature: Bredius/Gerson 546; Bauch 62;
Gerson 72; *Corpus* A89. MacLaren/Brown 1991,
No. 1400.

Exhibitions: London 1948, No. 41. London 1984,
unnumbered. London 1988–89, No. 2.

Rembrandt painted this picture in oils on a
piece of paper which was later pasted onto
canvas. It is executed mainly in opaque white
and translucent brown paint, with some
charcoal added to the white in the sky to give
a greyish-blue tinge. Monochrome paintings of
this kind, known as grisailles, were preparatory
works not intended for sale. Very few of these
technical exercises by Rembrandt have
survived. Two are in the exhibition: this *Ecce
Homo* and *John the Baptist preaching* (Cat. No.
20). Apart from those cases where there is a
definite connection with Rembrandt's graphic
work it is not precisely clear what purpose his
grisailles served.

The *Ecce Homo* of 1634 was the model for an
etching, the first, unfinished state of which is
dated 1635 (Fig. 15a) and the second, finished
state 1636 (Fig. 15b) (Bartsch 77 I and II). The
main group of Pilate and the high priests is
worked up in detail, but other passages are
only roughly indicated. The transitions from
sharp to vague are more abrupt than in
Rembrandt's fully worked paintings, where the
contrasts are finely attuned to each other in
order to enhance the pictorial effect. Here the
amount of detail was dictated by the etcher's
practical requirement for information about
forms and the lighting, which varies from one
part of the picture to the next and was chosen
with the etching in mind. It falls from the
right, so that when the image was reversed by
printing from the plate it would come from the
left, as was customary. The Hebrew script
around the edge of the head-dress of the high
priest holding the rod reads, in transliteration,
'JHWH' (Lord), followed by 'AL' or 'EL'
(possibly the beginning of the word Elohim, or

15a: Rembrandt, *Ecce Homo*. Etching, first state.
London, The British Museum.

15b: Rembrandt, *Ecce Homo*. Etching, second
state. Amsterdam, Rijksprentenkabinet.

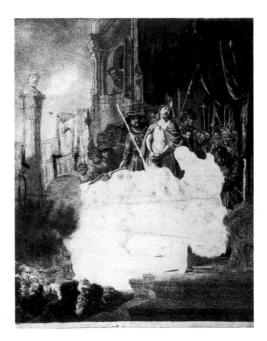

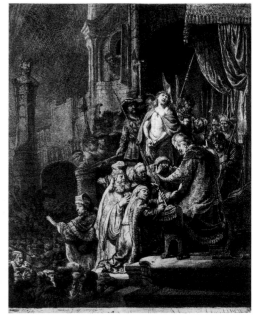

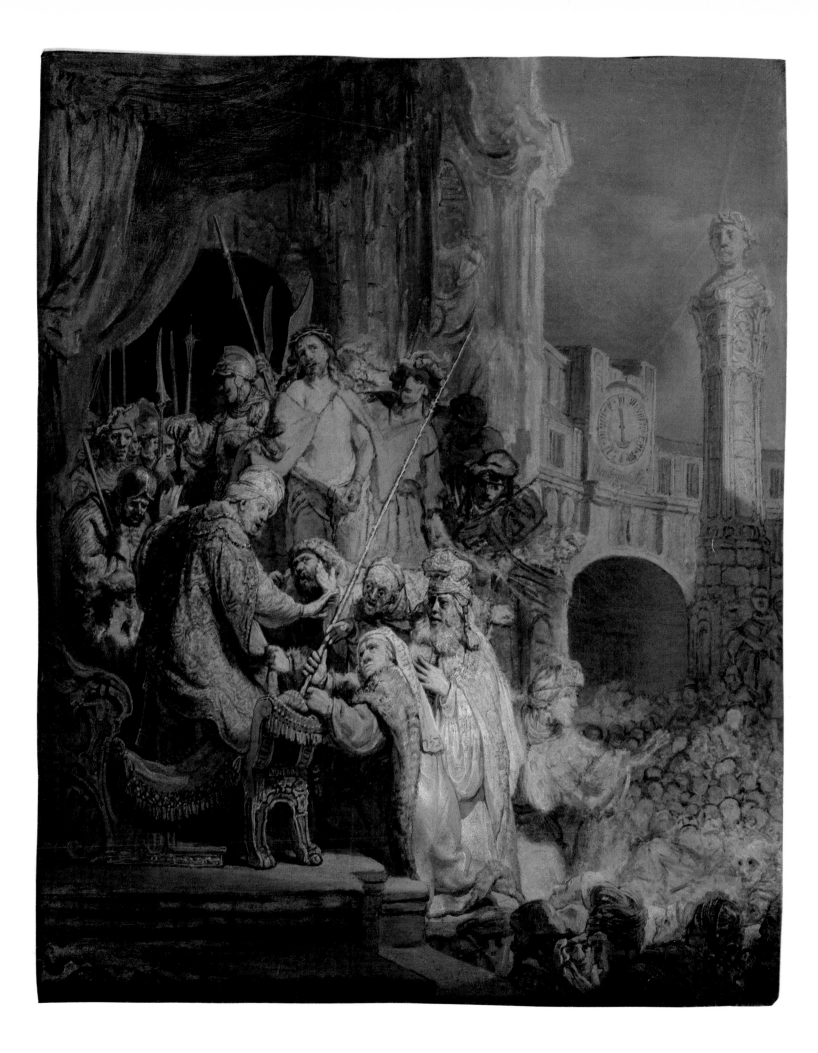

God). Here no account was taken of the reverse effect in the etching, where the inscription is illegible. Furthermore, in the print the characters on the band around the hat of the high priest who is stretching his hand out towards the crowd have so far defied interpretation.

A blank space was reserved for the main group in the proof impression (Fig. 15a). This area was left until last so that its lighting could be harmonised with that of the surrounding passages. The shape of the canopy was altered with the brush in the proof state, and this correction was incorporated in the second (Fig. 15b) and later states. The clock-face and the man behind Pilate's back resting his head on his hand had already been omitted in the first state.

A few years ago it was discovered that the painted version was transferred to the etching plate using a stylus.[1] Clearly visible in raking light (Fig. 15c), the incised lines follow the contours and occasionally define smaller forms within them.

The print, which may not be entirely autograph, was possibly part of a planned series of four large etchings, all the same size, of which the *Descent from the Cross* (Bartsch 81) was also completed, but not the *John the Baptist preaching* or *Joseph telling his Dreams* (*Corpus* A66; Fig. 68a).

'Ecce Homo' is the Latin form of the words 'Behold the man' (John 19:5) with which Pilate presented Christ to the people. The Saviour was given a crown of thorns and a purple cloak to make him look ridiculous, although Pilate considered him innocent of the charge of claiming to be the king of the Jews. This moment in the Passion story had been depicted many times before, and had taken on a standard form in the last quarter of the fifteenth century, with Pilate and Christ standing before the crowd on a dais running parallel to the picture plane. The huge size of the crowd was suggested by showing the foremost figures cut off by the lower edge of the composition. Rembrandt adhered to this programme and also included a number of traditional elements, such as the caricature heads of the priests, the gateway, and the emperor's bust symbolising worldly power. Here, though, Pilate is standing by the seat of judgment mentioned in John 19:13–14, from which, his patience finally exhausted, he uttered the words 'Behold your king' at around the sixth hour (the time shown on the clock above the gateway). The high priests, however, replied: 'We have no king but Caesar', and demanded that Pilate sentence Christ to death. Rembrandt has visualised this conflict in a

highly original way by showing one of the priests urging the rod of justice on Pilate, who rises from his seat to reject it. In the seventeenth century the rod of justice, an ash wand more than two metres long, was still being used in the ceremony surrounding the death sentence and its execution. It is quite clear that, contrary to some opinions,[2] the rod is here being forced on Pilate, not taken away from him.

P.v.Th.

1. Royalton-Kisch 1984, p. 19.
2. Tümpel 1970, No. 96. Tümpel 1986, p. 395, No. 50.

15c: Detail of the grisaille in raking light.

16

Diana bathing with her Nymphs, with the Stories of Actaeon and Callisto

1634
Canvas, 73.5 × 93.5 cm, unreliably signed and dated *Rembrandt. ft. 1634*
Anholt, Museum Wasserburg Anholt
Exhibited in Amsterdam only

Provenance: Sale [J.B.P. Lebrun], Paris, 22 September 1774 and subsequent days, No. 48: 'Rembrandt van Rhyn. Un tableau piquant d'effet, d'un coloris admirable & du meilleur faire de Rembrandt. Un groupe de huit femmes qui découvrent la grossesse de Calisto, sont sur un terrein élevé; proche d'elles un cheval, du gibier, des fléches & des draperies: quinze autres femmmes se baignent dans une riviere. Sur un plan éloigné Actéon commence à être metamorphosé, ses chiens se battent. Ce précieux morceau peint sur toile, porte 27 pouces de haut, sur 34 pouces de large. Il est peint en 1635.' Prince Ludwig Carl Otto zu Salm-Salm collection, Senones, Vosges, before 1778; transferred to Anholt under Prince Constantin zu Salm-Salm before the part of the collection left behind in Senones was confiscated by the French in 1793.

Literature: Bredius/Gerson 472; Bauch 103; Gerson 61; *Corpus* A92.

Exhibitions: Düsseldorf 1886, No. 272. Amsterdam 1898, No. 32. Düsseldorf 1904, No. 365a. On loan to the Mauritshuis, The Hague, 1919–24. Düsseldorf 1929, No. 52. Münster 1939, No. 55. Amsterdam & Rotterdam 1956, No. 29.

In addition to his many biblical paintings Rembrandt occasionally turned his hand to mythological scenes, most of which date from the very end of his Leiden period and the early years in Amsterdam. The first is his *Andromeda* of around 1630/31 in The Hague (*Corpus* A31) and the *Abduction of Proserpina* of about 1631 in Berlin (*Corpus* A39). Unlike Andromeda, who takes up almost the full height of the picture, the figures in the *Proserpina* are small. In 1632 Rembrandt again used this scale, which is ideal for a detailed visual narrative, for his *Rape of Europa* (*Corpus* A47), which has so many points of similarity with this scene of Diana that the

last digit of the indistinct date on this canvas
has sometimes been read as a 2 (or a 3).[1]
Although this unusual painting is not easy to
fit into Rembrandt's œuvre, the use of colour
and above all the links establishing the
relationships between the different groups and
individual figures (which make it a far more
successful work than the somewhat fragmented
picture of 1632) point to the later date of
around 1634.

Rembrandt has here combined two distinct
events from the legend of Diana in Ovid's
Metamorphoses, each of which had been
illustrated separately on many occasions. It is
true that various elements from the two
stories—'The Pregnancy of Callisto' and
'Diana surprised by Actaeon'—were no longer
strictly segregated in the earlier depictions,[2]
but never before had the two episodes been
fused into a single work. In this respect
Rembrandt's version is quite unique.

The first story (*Metamorphoses* II, 401–53)
relates how Jupiter seduced Callisto, one of
Diana's nymphs, who were expected to be as
chaste as the goddess herself. When Diana
discovered that Callisto was pregnant she
angrily turned her into a bear and set the dogs
on her. Jupiter, though, intervened and rescued
her. In the second story (*Metamorphoses* III, 138–
253) Diana transformed the hunter Actaeon
into a stag when he accidentally came across
her when she and her nymphs were bathing.
He was torn to pieces by his own hounds, thus
preventing him from telling his friends that the
goddess had shown herself to him naked.

Since the middle of the sixteenth century
there had been numerous depictions of these
two stories, either as illustrations in the
various editions of Ovid or as individual prints.
Rembrandt must have known most of them,[3]
and in particular the two pendant engravings
by Antonio Tempesta with small figures in a
landscape (Figs. 16a and b), the same artist's
separate print with the story of Actaeon (Fig.
16c), the earlier print of 1566 by Cornelis Cort
after Titian's version of the Callisto legend
(Fig. 16d), and the even earlier Actaeon print
from the circle of Marcantonio Raimondi. It is
a complex business discovering how
Rembrandt freely translated all these visual
sources into his own idiom, selecting and
combining the elements that he liked and
introducing innovations of his own. The
general design of the scene, with the wood
terminating abruptly on the left, appears to
have been inspired by Tempesta's single print,
although Rembrandt did away with the
waterfall and had Actaeon emerge from a dark
forest into the daylight. Raimondi supplied
Actaeon's pose, together with the hounds going

16a: A. Tempesta, *Diana and Callisto*. Engraving.
Amsterdam, Rijksprentenkabinet.

16b: A. Tempesta, *Diana surprised by Actaeon*.
Engraving. Amsterdam, Rijksprentenkabinet.

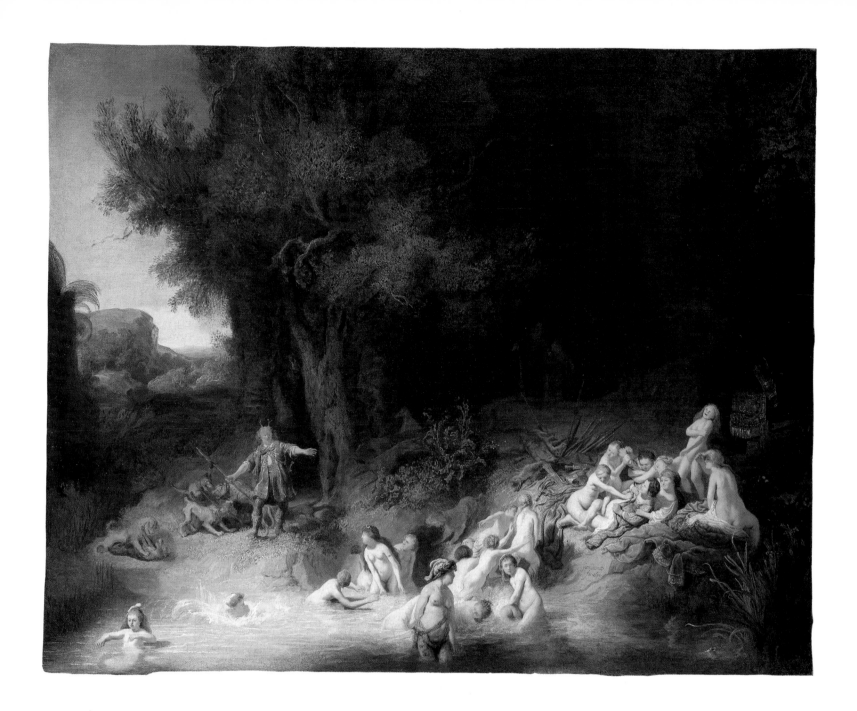

down on their forepaws ready to fly at the throat of their metamorphosed master. The figure of Diana splashing water at him with two hands instead of one (as in most Ovid illustrations) appears to have been taken from Tempesta's companion prints, as do the nymphs scurrying up the bank in panic, and the pile of clothes with the bundle of spears. The tangle of nymphs around Callisto, who are carrying on like raging Furies, echoes the small group in Cort's print after Titian, although now goaded into a frenzy by Rembrandt himself (but also by his Mannerist predecessors).

Under Rembrandt's virtuoso direction these two themes have been merged into a composite image. He adds brilliantly observed little details such as the nymph roaring with malicious laughter at Callisto's discomfiture, the dogs fighting on the left, the nymph wading through the water with her arms raised in the lower left corner, and her companion in the centre foreground. Thus he transforms the composition into a scene as natural as it is fantastical.

P.V.Th.

1. Bredius/Gerson 472. Gerson 61.
2. Sluijter 1986, p. 30.
3. Broos 1977, p. 47. Sluijter 1986, pp. 90–94.

16c: A. Tempesta, *Diana surprised by Actaeon*. Engraving. Amsterdam, Rijksprentenkabinet.

16d: C. Cort after Titian, *Diana and Callisto*. Engraving. Amsterdam, Rijksprentenkabinet.

17

Portrait of Marten Soolmans

1634
Canvas, 207 × 132.5 cm, signed and dated
Rembrandt f. 1634
Paris, private collection
Not exhibited

18

Portrait of Oopjen Coppit

1634
Canvas, 207 × 132 cm
Paris, private collection
Not exhibited

Provenance: Most probably the two paintings described in the inventory of the estate of Maerten Daey, drawn up in Amsterdam on 3 November 1659, as hanging in the entrance-hall: 'twee conterfijsels Marten Soolemans en Oopie Coppit' (Two likenesses of Marten Soolmans and Oopjen Coppit). They were evidently part of the dowry of Oopjen Coppit, the widow of Marten Soolmans, when she married her second husband, Maerten Daey. Although not listed after Oopjen's death in 1689 in the estate of her son from her first marriage, Jan Soolmans (d. 1691), or in that of Hendrik Daey (d. 1712), the son from her second marriage, they must have come into the Daey family at some stage, but by then the sitters' identities were no longer known. In 1798, according to John Smith (1836), the portraits were bought for 4,000 guilders from Hendrik Daey of Alkmaar by R. Priuscenaar (perhaps R.M. Pruyssenaar) and Adriaan Daey. The following year they were sold for 12,000 guilders to the Amsterdam merchant and art collector Pieter van Winter (1745–1807). They then passed to his son-in-law, Jonkheer Willem van Loon (1794–1847), and were evidently sold after the death in 1877 of the latter's widow, Anna Louisa Agatha van Winter. In 1915 they belonged to Baron Gustave de Rothschild in Paris, and later to Baron Robert de Rothschild, also of Paris.

Literature: Bredius/Gerson 199 and 342; Bauch 373 and 478; Gerson 164 and 165; *Corpus* A100 and A101. I.H. van Eeghen, 'Marten Soolmans en Oopjen Coppit', *Maandblad Amstelodamum* 43 (1956), pp. 85–90. R. van Luttervelt, 'Bij het portret van Oopje Coppit', *Maandblad Amstelodamum* 43 (1956), p. 93.

Exhibitions: Amsterdam & Rotterdam 1956, Nos. 25–26.

Anyone wishing to have his or her portrait painted in the seventeenth century had a range of alternatives from which to choose: the bust, half-length (with or without the hands visible), hip-length, knee-length and the full-length figure—from the half-length, standing or seated according to choice, and full-length on horseback if desired—and all lifesize or smaller. The lifesize full-length portrait, the most expensive category, had traditionally been reserved for kings and princes. During the Renaissance the late-classical, monumental emperor's portrait was revived in Italy for the painted state portraits of kings and the higher nobility, and was quite soon being commissioned by prosperous commoners as well, who owed their power and prestige to money, not birth.

In the northern Netherlands it was not until the end of the sixteenth century that commoners made so bold as to have themselves portrayed lifesize at full length. A self-assured group of Amsterdam civic guards did so in 1588 in the militia piece by Cornelis Ketel (Amsterdam, Rijksmuseum). According to Karel van Mander, Ketel (1548–1616) had already painted the companion portraits of a married couple in the same format: 'een [portret] ten voeten uyt als 'tleven, voor eenen Hoopman Neck, desghelijcx zijn Vrouw' (a lifesize full-length [portrait], for one Captain Neck, likewise his wife).[1] Nevertheless, in the first decades of the seventeenth century this type of portrait (of burghers, anyway) seems to have been used mainly for individual male sitters. The surviving specimens from the period 1615–30 by Everard van der Maes, Joachim Houckgeest (see Cat. No. 26, Fig. 26b), Salomon Mesdach, Cornelis van der Voort and Frans Hals certainly give that impression. The portraits attributed to Cornelis van der Voort of *Arent van der Hem* and his wife *Margaretha Vos* (Figs. 17–18a and b) of about 1618,[2] and several other examples from the same time, demonstrate that it was only around then that the full-length pendant portrait came into fashion with the very richest families. The early examples cited by the authors of the *Corpus* are those of *Laurens Reael* and *Suzanna Moor* of 1620 by Cornelis van der Voort (Amsterdam, Rijksmuseum), and the undated pictures of *Cornelis de Graeff* and *Catharina Hooft* by Nicolaes Eliasz. (Berlin, Kaiser Friedrich Museum).[3] The first pair, however, has since proved to be deceptive,[4] while the second dates from after 1634.[5]

So although not without precedent, these companion pieces painted by Rembrandt in 1634 are among the forerunners of a genre of portraiture which became widespread in the

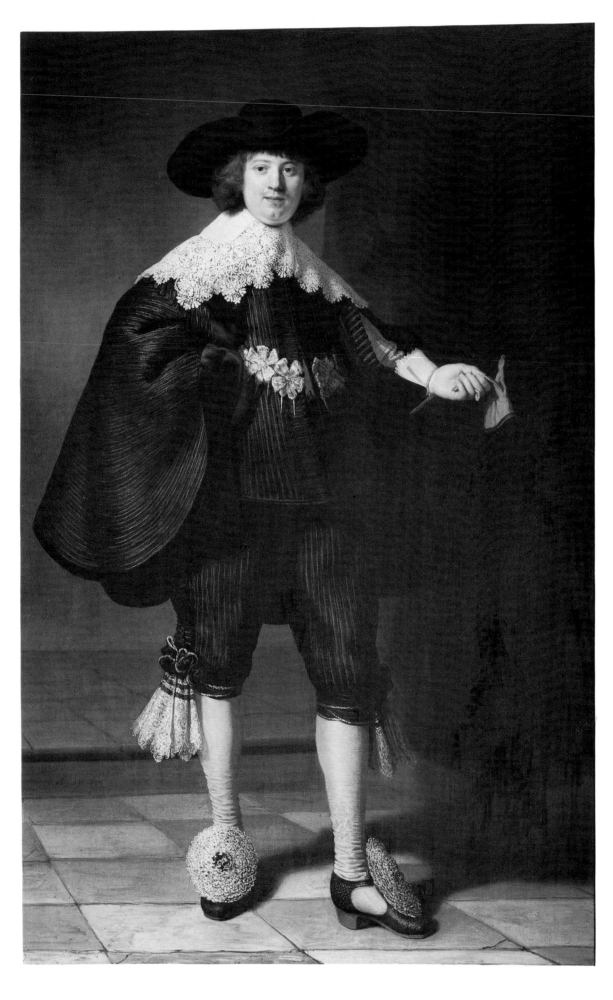

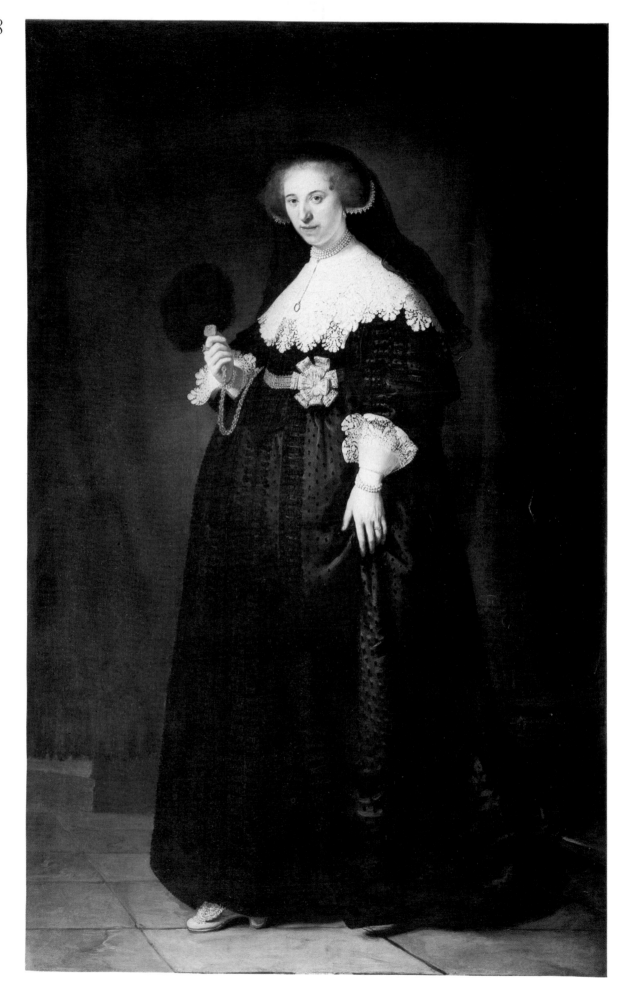

second half of the seventeenth century. In the same year he also carried out an assignment for a pair of full-length portraits of seated figures (Figs. 17–18c and d). After that, as far as we know (and leaving aside a dubious case from 1633),[6] he never again received a commission for companion pieces of this kind, either standing or seated, unless the *Portrait of a Man standing* of around 1639 in this exhibition was one of a pair (see Cat. No. 29), and unless the Anslos had initially ordered pendants in 1640/41 before deciding on a double portrait (see Cat. No. 33).

Unlike Van der Voort around 1618, Rembrandt established a contact between his sitters through their actions. Like his predecessor he placed them on a tiled floor in an interior devoid of furniture that looks like a hallway. As the perspective of the tiles shows, each picture has its own vanishing point (in both cases lying to the left, outside the picture area, and higher in the case of man's portrait). The result is that the interior does not form a geometrical unit, but Rembrandt nevertheless succeeded in establishing a relationship both between the settings and the figures, although it has to be said that it is not entirely convincing. In the first case he did so by allowing the dark curtain in the background to extend into the man's portrait. Secondly, he showed the man, who is standing still, gesturing in the direction of his wife, who is walking towards him (the heel of her shoe is just off the floor) after descending from a step on which the hem of her gown, which she has raised slightly, still trails. The movement is almost imperceptible, and the connection between the two figures is all but nullified by the portrait convention of the day which required the sitters to gaze out at the viewer and not at each other. The effect of the superbly cut and brilliantly painted costumes overshadows the subtle attempt to capture the sitters' characters. They stand there, undoubtedly as they themselves desired, above all as the embodiment of a young, patrician Amsterdam couple, conscious of their status, ennobled by wealth.

In 1798, when the family sold these portraits, they were believed to be of Willem Daey and his wife, an identification later changed to Captain Maerten Daey and his wife. In 1956 Miss I.H. van Eeghen proved that both were incorrect. As so often happened, later generations had attached the wrong names to the portraits of their forebears, although the name Maerten Daey (1604–59) was not so far from the probable truth. In the autumn of 1633 Maerten and his wife Machteld van Doorn (1605–46) left Holland for Dutch Brazil, which had been seized from the Portuguese in 1630. In other words, Rembrandt could not possibly have painted that particular couple in 1634. Back in Holland, and left a widower in 1646, Maerten married Oopjen (Obrechtje) Coppit, the widow of Marten Soolmans, who had died in 1641. Maerten Daey's death inventory of 1659 states that hanging in the entrance-hall of his house on the Singel in Amsterdam were 'two likenesses of Marten Soolmans and Oopjen Coppit', which Oopjen Coppit had brought with her from her first marriage. Since the hall was the highest room in a house it was the ideal place for large portraits. The inventory does not give the artist's name, but does mention two paintings by Rembrandt: the head of an old man and 'a painting of Joseph and Mary, done by Rembrandt'. The latter is probably the *Holy Family* in the present exhibition (Cat. No. 14), which Soolmans and his wife could very well have bought from Rembrandt in 1634, and it too must have been in Oopjen Coppit's possession when she remarried. The plausible assumption that the companion pieces in the entrance-hall were indeed these two pictures of 1634 does not rest solely on the combination of these reliable facts, or on the apparent custom whereby people commissioning their portraits from Rembrandt bought another painting from him as well (see Cat. No. 14). The most persuasive argument is that Marten Soolmans (1613–41)

17–18a: C. van der Voort, *Arent Harmensz. van der Hem*. Location unknown.

17–18b: C. van der Voort, *Margaretha Reijersdr. Vos*. Bad Homburg v.d. Höhe, Schloss Homburg.

married Oopjen Coppit (1611–89) in 1633, which makes it extremely likely that these pendants, which were completed in 1634 and contain symbols alluding to matrimony, were their marriage portraits.

Marten Soolmans was born in Amsterdam into a well-to-do family from Antwerp. He had studied at Leiden for a while, without any notable success, and by marrying Oopjen made a glittering match, for she came from a very prominent Amsterdam family.

Two facts alone—the extremely festive attire worn by the couple, which is remarkably sumptuous even for wealthy people, and the woman's action in walking towards the man— make it very probable that this pair of portraits was commissioned as a memento of their marriage. The evidence is provided by the gesture the man is making with the glove, for handing over a glove had for centuries symbolised the sealing of the contract of betrothal, when authority over the bride was transferred from the father to the groom.[7] In this context the plain gold band that Oopjen is wearing as a pendant from her necklace might also have a symbolic significance.[8]

The identity of this couple and the reason for their exceptional commission from Rembrandt may appear to have been satisfactorily established, but there is one element that is difficult to explain. R. van Luttervelt has pointed out that Oopjen is also wearing a mourning veil, from which he concluded that she did not have her portrait painted until after 1641 (the year of her first husband's death), as a pendant to the existing picture of Soolmans, which in that case would have been executed as a single portrait. Van Luttervelt's reasoning is that, as far as we know, when a woman is shown in mourning it is always for a deceased husband. That, however, cannot possibly be the case here, for Oopjen's portrait is so closely matched to the man's—stylistically, compositionally and in physical structure—that it could not have been executed at a later date. The authors of the *Corpus* have suggested that she might be in mourning for her father, who died in March 1635. This is hardly an ideal resolution of the problem, for it implies that her portrait was only completed in 1635 and that it refers to two events so separated in time and nature as the marriage of 1633 and her father's death in 1635. One wonders, in fact, whether the black veil was not just part of her magnificent bridal gown.

P.v.Th.

1. Van Mander 1604, fol. 275v.
2. Wolleswinkel 1987, Cols. 394–98, Figs. 1–2. Ekkart 1988, p. 10, note 10, endorses the attribution to Van der Voort.
3. Bruyn *et al.*, 1982–, Vol. A, p. 549.
4. Ekkart 1988, pp. 7–10, has shown that the portrait of Reael was originally a solitary work, and that the painting of his wife was only added much later.
5. E. de Jongh, in exhib. cat. Haarlem 1986, pp. 137–38, dates the portraits of De Graeff and his second wife in or shortly after 1635, the year of their marriage.
6. The *Portrait of a Man* dated 1633 in Kassel (*Corpus* A81) may originally have been a full-length which was later cropped to the knees.
7. Du Mortier 1984, esp. p. 195. For the symbolism of the glove see also *Handwörterbuch des deutschen Aberglaubens*, Vol. III (1930/31), Cols. 1407–08, and Smith 1982, pp. 72–81 (Rhetoric and Etiquette: the Iconography of the Glove').
8. For the symbolism of the plain band and the wedding ring, which in those days was usually set with precious stones, see E. de Jongh, in exhib. cat. Haarlem 1986, p. 138, whose references include Voskuil 1975.

17–18c: Rembrandt, *Portrait of the Preacher Johannes Elison*, 1634. Boston, Museum of Fine Arts.

17–18d: Rembrandt, *Portrait of Maria Bockenolle*, 1634. Boston, Museum of Fine Arts.

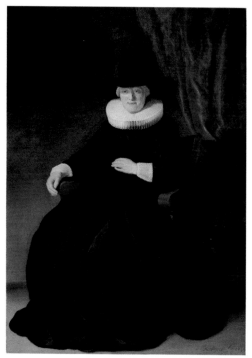

19

Portrait of an eighty-three year-old Woman

1634
Oval panel, 68.7 × 53.8 cm, signed and dated
Rembrandt ft 1634; inscribed *AE SVE 83* ('AE'
and 'VE' in monogram)
London, The National Gallery, Inv. No. 775

Provenance: Sale Klaas van Winkel and others,
Rotterdam, 20–21 October 1791, No. 6:
'Rembrand. Een oude Dames Portrait,
hebbende een witte Kraag om den hals en een
witte Muts op het hoofd, in 't zwart gekleed
op een ligte agtergrond, op paneel ovaal, hoog
29 en breed 24 duim, 1634' (Rembrandt.
Portrait of an old lady with a white ruff around
her neck and a white cap on her head, dressed
in black against a light background, oval, on
panel, height 29 and width 24 inches, 1634).
Dealer C.S. Roos, Amsterdam, 1814. Chevalier
Sébastien Erard sale, Paris, 7–14 August 1832,
No. 121 (bought in at 4,000 francs). Chevalier
Sébastien Erard sale, London (Christie's),
22 June 1833, No. 16: 'Rembrandt's mother';
bought in at 220 guineas. Sale William Wells
(Redleaf), London (Christie's), 12–13 May
1848, No. 115: 'The Artist's Mother'; to
Charles Eastlake for 252 guineas. Sir Charles
Eastlake collection. Bought by the museum in
1867 from the owner's widow.

Literature: Bredius/Gerson 343; Bauch 476;
Gerson 156; *Corpus* A104. MacLaren/Brown
1991, No. 775.

Exhibitions: London 1835, No. 50. London
1988–89, No. 3.

This close-up, frontal portrait of a pensive old
lady is a superb example of Rembrandt's
acutely observant portraiture. It is impossible
to say for certain whether the oval shape,
which fits so snugly around the sitter, is
original, since the edges of the panel were later
encased in a wooden border. The unknown
woman, whose age is given as 83 in the
inscription, is wearing a two-part linen cap
held together with three gold pins, the curved
wings of which are held at the bottom by a
gold head-band. Her linen ruff rests on the
collar of her black overgarment (*vlieger*), which
has round shoulder-coils (*bragoenen*). Beneath
this she is wearing a short bodice fastened with
buttons over a pleated skirt. She appears to
be seated, for her slightly forward-leaning pose
has caused the panels of her wide-open *vlieger*
to flare.

The sharply observed, wrinkled old face is
fluently and freely painted. The underpainting
has been left partly exposed in the shadows.
The translucent look of the paint layer, which
is so characteristic of Rembrandt's develop-
ment towards a free and relaxed manner, is
described at length in the *Corpus*, and as follows
in an excerpt from the exhibition catalogue *Art
in the Making: Rembrandt*, which provides an
insight into both Rembrandt's studio and the
laboratory of the modern-day scientific
researcher: 'The brushstrokes of the face are in
a variety of colours, short, curved, running
mainly along the lines of the form; they cross,
blend and mix and were clearly done rapidly
wet-into-wet. In the face the thickly applied
lead white has been tinted with vermilion and
red iron oxide, and then modified with thin
scumbles of yellow earth drawn across the
surface for the yellowest tones, and a mixture
of red ochre and a little black for the ruddier
passages. The x-ray image shows the structure
of the brushstrokes distinctly, and how they
are combined into almost sculptural masses
forming the forehead, cheeks, eyes, nose and
mouth.'[1]

Hendrik van Limburg (1681–1759) made a
drawing of this portrait in the eighteenth
century, and it was probably he who gave the
sitter the name of Françoise van Wassenhove.
His copy no longer exists, but there is an
annotated drawing made after it by his younger
contemporary Jan Stolker (see *Corpus* A104,
Copies, 2), who presumably did not dream up
this identification himself but copied it down
from Van Limburg. Françoise van Wassenhove
was married to the Remonstrant preacher
Eduard Poppius, who died in 1624. His widow
was aged about sixty in 1634, so Van
Limburg's identification is clearly incorrect.
However, as Schwartz has pointed out,[2] he

could have known that the picture belonged to
a descendant of Poppius, for he himself was a
member of a prominent Remonstrant family.
In the eighteenth century families often made
mistakes about the identity of sitters in
pictures which they had inherited.
P.v.Th.

1. London 1988–89, Cat. No. 3.
2. Schwartz 1984, p. 152.

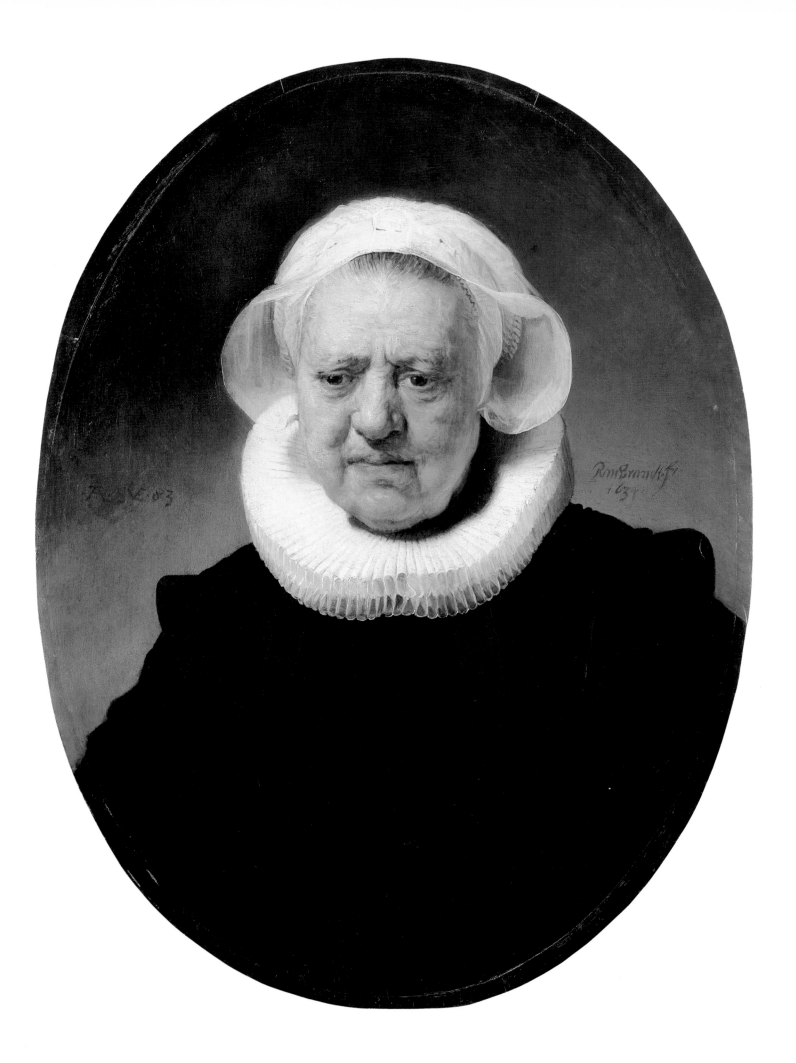

John the Baptist preaching

c.1634/35
Canvas on panel, 62.7 × 81 cm
Berlin, Staatliche Museen Preussischer
Kulturbesitz, Gemäldegalerie, Cat. No. 828 K

Provenance: A deed drawn up in Amsterdam on
13 September 1658 indicates that the painting
had been in the possession of Jan Six (1618–
1700) for some years before that date. Jan Six
sale, Amsterdam, 6 April 1702, No. 38: 'St Jans
Predicatie, in 't Graauw, van Rembrand van
Ryn, zo raar en ongemeen konstig als te
bedenken is' (The sermon of St John, in
grisaille, by Rembrandt van Rijn, done with
such exceptional and uncommon skill as could
be imagined); to Jan Six (1668–1750), the
owner's second son, for 710 guilders. Jan Six
collection. Then in the estate of Pieter Six
(1686–1755), grandson of a brother of the Jan
Six who died in 1700, and thence by descent in
the family until 1803, when it was sold to the
Amsterdam art dealer Coclers. In 1806 a
drawing was made of it by Jean-Pierre Norblin
when it was in an unidentified Paris collection.
Cardinal Fesch sale, Rome, 17 March 1845,
No. 189 (14,000 scudi). P. Norton collection,
1857. Sale Lord Ward, later Earl of Dudley,
London, 25 June 1892, No. 19 (to the museum
for £2,625).

Literature: Bredius/Gerson 555; Bauch 63;
Gerson 71; *Corpus* A106. W. Bode, 'Rembrandts
Predigt Johannes des Täufers in der König-
lichen Gemälde-Galerie zu Berlin', *Jahrbuch
der Preussischen Kunstsammlungen* 13 (1892),
pp. 213–18.

Exhibitions: Manchester 1857, No. 675.
Philadelphia & Detroit 1948–49, No. 94.
Paris 1951, No. 101.

20a: Rembrandt, *Studies of Figures*. Drawing.
Berlin, Staatliche Museen Preussischer
Kulturbesitz, Kupferstichkabinett.

20b: Rembrandt, *Studies of figures*. Drawing.
Chatsworth, Devonshire collections.

Never did Rembrandt bring together such a
multitude and assortment of figures as in this
painting, not even in his famous *Hundred Guilder
Print* (Bartsch 74). In fact, the crowd of one
hundred or so that has gathered around John
the Baptist represents the entire population of
the world. On the left, outside the pool of
light, sits a figure in Japanese armour; a little to
the right, under the horse's head, is someone
who looks like an Indian. Sitting in the
Baptist's shadow is a negro, and behind him is
the unmistakable figure of an Indian with
feather head-dress and bow and arrow. At the
same level on the extreme right is a Turk, and
other exotic characters are scattered through-
out the composition. However, there are also
many familiar types from Rembrandt's
repertoire. The old woman with a hand on her
breast immediately below the Baptist's right
foot has in fact often been described as
Rembrandt's mother, and the man to the left
of her with his hand to his chin (who is the
only person looking out at the viewer) is
claimed to be Rembrandt himself. The whole
sinful world (which is also symbolised by the
dogs fighting, defecating and coupling) has
flocked to listen to the Baptist, who summoned
all the people to come and hear his message
that the kingdom of heaven was at hand, to
confess their sins and be baptised by him in the
Jordan, which is flowing past on the left. Many
are listening intently to his sermon urging
them to repent, but others are indifferent to his
words. Mothers are too busy caring for their
wailing children, two men are talking to each
other, and the fat man at John's feet has
become bored and has nodded off to sleep. The
three men in the middle have certainly heard
his words but have turned away in irritation.
They are the Pharisees and Sadducees to whom
he said: 'O generation of vipers, who hath
warned you to flee from the wrath to come?'

(Matthew 3:7). One of them is wearing a shawl
on which, in Hebrew script, is the insistent
command from Deuteronomy 6:5: '[And thou
shalt] love the Lord thy God with all thine
heart, [and with all thy soul, and with all thy
might]'.

It was not long before writers were
marvelling at this stunning example of
Rembrandt's genius for characterisation (and
many an art-lover must have come calling on
Jan Six in order to see it with his own eyes),
the first being Samuel van Hoogstraten in 1678.
His admiration was not unalloyed, however, for
he was offended by what he saw as Rem-
brandt's lack of good taste.[1] 'I recall having
seen, in a splendidly composed work by
Rembrandt of John preaching, a striking
attention in the listeners of all ranks and
degrees; it was most laudable, but', continued
this stickler for decency in the noble art of
painting, 'one also saw a dog mounting a bitch
in a scandalous manner. Say if you will that
this can happen and is natural, I say that it is
an abhorrent indecency in the circumstances of
this story. [. . .] Such scenes betray the
master's lack of judgment.' Arnold Houbraken,
another critic who did not appreciate unseemly
jokes, described the painting in 1718 as
'admirable for the natural depiction of the facial
features of the listeners and for the variety of
their attire'.[2] Pupils of Rembrandt had told
him 'that he sometimes sketched a face in as
many as ten different ways before committing
it to the panel, and could spend one or two
days arranging a turban to his liking'. This is
illustrated by a few such preparatory drawings,
most of them for the group of Pharisees and
Sadducees (Figs. 20a & b).

Rembrandt's is an unrivalled and highly
imaginative treatment of this biblical subject,
which had a long iconographic tradition and
had already been depicted by Cornelis van

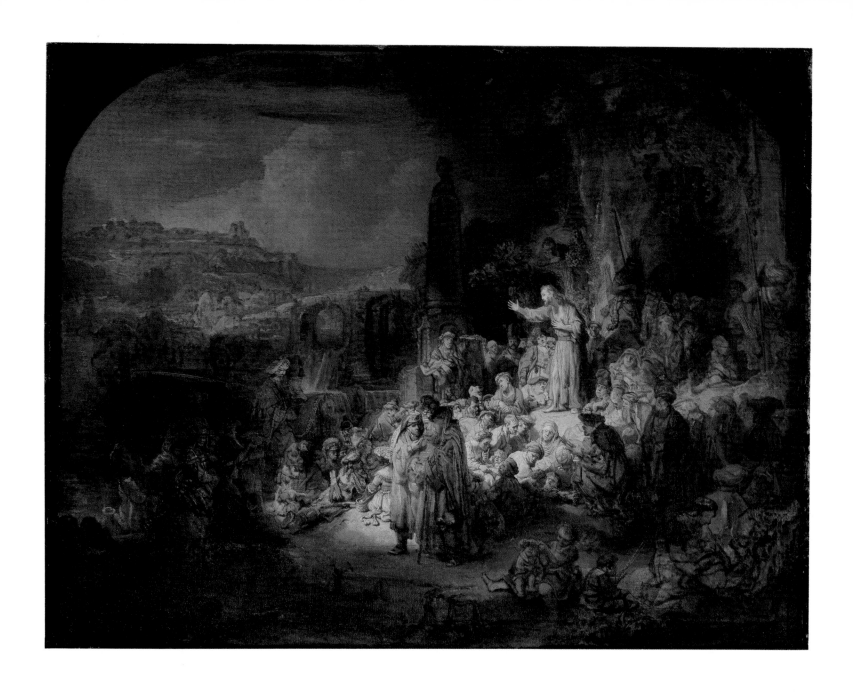

Haarlem, for example, in a detailed but rather dull manner (Fig. 20c).

Technically speaking this painting, executed chiefly in brown paint in a spectrum of tonal values ranging from light and dark, is a grisaille, like the *Ecce Homo* of 1634 discussed above (Cat. No. 15) and the Rotterdam *Concord of the State* from the late 1630s (*Corpus* A135; Fig. 121), to which it is most closely related in its decidedly sketchlike treatment. While it can be shown that the *Ecce Homo* was a draft for an etching, one can only guess at the function of this grisaille of the Baptist. It was probably made for an unrealised etching (smaller than the eventual size of the grisaille, as we shall see) in a planned series of four large prints of the same size, of which the *Descent from the Cross* and the *Ecce Homo* were executed but *Joseph telling his Dreams* (grisaille in Amsterdam; *Corpus* A66; Fig. 68a) and this *John the Baptist preaching* were not.

This painting grew as Rembrandt worked on it, and ended up looking very different from his initial concept. The x-ray photograph (Fig. 20d) clearly shows that he began on a smaller piece of canvas measuring approximately 40 × 50 cm. This he then extended by adding a strip some 3 cm wide on the right. Finally he glued this larger canvas to the panel, slightly off-centre to the right, and took a piece of canvas cut to the size of the panel which he glued to the bare wood around the painting, and then cut a window in it in the same way as a carpet-layer overlaps two pieces and cuts through both to produce a seamless fit.

These three operations are difficult to make out from the painting itself. Rembrandt had probably already introduced radical changes in the second stage, when he extended the canvas on the right, notably in the landscape and in the grouping of the listeners at the Baptist's feet. After the enlargement of the canvas in the third and final stage, when more figures were added and the landscape was expanded and further modified, the nature of the scene had changed drastically, if only because the figures in their more spacious setting now appeared smaller in the illuminated area, which originally probably covered most of the composition but had now been reduced to a circle in the centre. The painting was then given a black painted surround, to which Rembrandt or someone else later added spandrels in the upper corners. Contrary to earlier theories, which place the first stage in the 1630s and the final one in the 1650s, it is now believed on stylistic grounds and on what we know of Rembrandt's repertoire from his paintings, etchings and drawings of those periods, that he started work on this grisaille in 1634 and had it finished by no later than the following year. It is not known whether he was still planning to make a print of the grisaille in its enlarged form, which had probably been his intention when he first started work on the subject.

In the 1650s Rembrandt designed a type of frame for this *John the Baptist preaching* that was unusual for the seventeenth century (Fig. 20e).[3] It seems likely that he did so at the request of Jan Six, who had become the owner of the grisaille well before September 1658.

P.v.Th.

1. Van Hoogstraten 1678, p. 183.
2. Houbraken 1718–21, Vol. I, p. 261.
3. Van Thiel and De Bruyn Kops 1984, p. 15.

20c: Cornelis van Haarlem, *John the Baptist preaching*. London, The National Gallery.

20d: X-ray photograph of the painting.

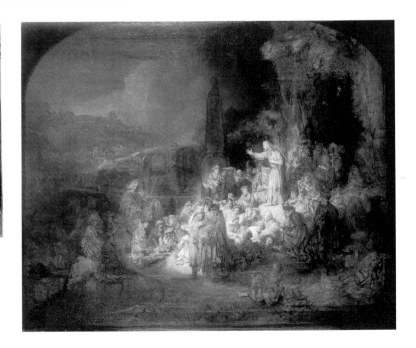

Abraham's Sacrifice

1635
Canvas, 193.5 × 132.8 cm, signed and dated
Rembrandt f. 1635
Leningrad, Hermitage Museum, Cat. No. 92

Provenance: Collection of Robert Walpole, 1st
Earl of Orford (1676–1745), in or before 1736.
Collection of George Walpole, 3rd Earl of
Orford (1730–91). Valued at £300 in 1779 and
sold with the entire Walpole collection
(Houghton Hall) to Empress Catherine the
Great of Russia.

Literature: Bredius/Gerson 498; Bauch 13;
Gerson 74; *Corpus* A108. K. Voll, 'Das Opfer
Abrahams von Rembrandt in Petersburg und in
München', in *Vergleichende Gemälde Studien*,
Munich & Leipzig 1907, Vol. I, pp. 174–79.

Exhibition: Amsterdam 1969, No. 4a.

The subject of this large biblical painting of
1635, which comes closest in size, scale and
execution to the *Holy Family* (Cat. No. 14) and
Belshazzar's Feast (Cat. No. 22), is from Genesis
22:1–13, which relates how God put Abraham's
faith to the test by commanding him to
sacrifice his only son Isaac as a burnt offering
on a mountain in the land of Moriah. Abraham
and his son set off for the appointed place
without a sacrificial animal, the unsuspecting
Isaac carrying the wood for the fire. When he
asked his father where the lamb was, Abraham
replied that God would provide it. Just as he
was about to slay his son an angel appeared and
stayed his hand. A little later Abraham
discovered a ram caught by its horns in a
thicket.

 The compositional logic of the scene, in
which the hands play an important part
(including those of the helpless Isaac, which
cannot even be seen), is utterly convincing.
While Abraham, whose hair, according to a
Jewish legend, instantly turned white at the
prospect of the ghastly task facing him,[1] is still
holding Isaac's head back with his clawlike
hand to expose the throat, the angel, one hand
raised in warning, grasps his wrist and the
oriental-looking knife falls to the ground. On
the right, beside Abraham's elbow, is a pot

20e: Rembrandt, *Design for a Frame for 'John the
Baptist preaching'*. Drawing. Paris, Musée du
Louvre, Département des arts graphiques.

21a: P. Lastman, *Abraham's Sacrifice*. Grisaille. Amsterdam, Rijksmuseum.

21b: Anonymous Rembrandt pupil after Rembrandt, *Abraham's Sacrifice*. Munich, Alte Pinakothek.

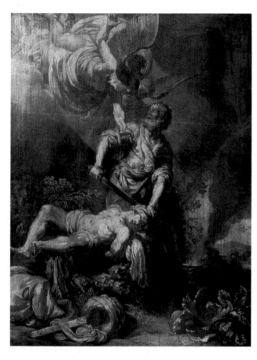

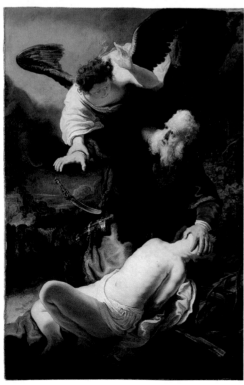

containing fire. The ram is nowhere to be seen.

As in the *Holy Family* (Cat. No. 14), and even earlier in his *Jeremiah* (Cat. No. 8), Rembrandt has again conceived his composition in spatial terms. This time he uses two diagonals (the approaching angel and Isaac's prone body) linked by an arc (Abraham's outstretched arms) which intersects another arc (Abraham's body and head) at right angles.

If, as assumed,[2] Rembrandt's chief models were works by Lastman and Rubens, which were themselves based on Italian examples, then it was he who was best fitted to deduce from such secondhand accounts the underlying monumental concepts. His knowledge of prints of well-known paintings—perhaps Agostino Carracci's *Temptation of St Anthony* (Bartsch 63) and *Mercury and the Three Graces* (Bartsch 117), both after Tintoretto—enabled him to penetrate deeply into the spirit of the early Italian Baroque. The feeble picture by Pieter Lastman (Fig. 21a), who had been Rembrandt's teacher just over ten years before, seems to have been used mainly for the confrontation between Abraham and the angel, which Lastman in his turn must have borrowed from Caravaggio's *Inspiration of St Matthew* in the Contarelli Chapel in S. Luigi dei Francesi in Rome.

There is a full-size copy of this painting which was undoubtedly made in Rembrandt's workshop (Fig. 21b). It is now in the Alte Pinakothek in Munich, and differs from the original in three respects: the angel does not come flying in from the left but from the rear, the ram is shown on the left, and the pot of fire on the right has been replaced with foliage. Along the bottom is an inscription, not in Rembrandt's hand, which reads: *Rembrandt. verandert. En overgeschildert. 1636.* In the past it was believed that this copy was by Rembrandt himself, but that theory was abandoned in the 1950s. Instead it was suggested that it was largely the work of a pupil, with improvements by Rembrandt. The rather puzzling inscription was then taken to mean: 'Rembrandt altered this copy and partly overpainted it.' The difficulty here is that there has been no convincing identification of any overpainted passages, which one would certainly expect to find in those areas where the copy differs from the original. In 1968, after observing that the paint layer appears to be homogeneous and that the X-ray image shows no evidence of alterations, B. Haak concluded that Rembrandt had indeed made the copy himself.[3] In this reading the inscription would mean: 'Rembrandt has altered his earlier version and painted it afresh.' B. Broos came to the same

conclusion,[4] although he gives the words yet another interpretation. The authors of the *Corpus* have based their explanation of the inscription not so much on the results of their study of the painting as on the meaning that the words had in the seventeenth century.[5] The word '*overgeschildert*' is only encountered in the sense of applying paint over earlier paint, usually but not necessarily as the top layer. A new investigation of the paint layers and analysis of the X-ray photographs revealed that in its initial lay-in the copy matched the original. Certain physical evidence indicates that in the course of building up the paint layers—which according to the inscription followed Rembrandt's sketched-in design, or possibly just his instructions—the pupil who made the copy departed from the original design and finished the work himself. Of all the artists whose names have been suggested as the copyist, Govert Flinck among them, the only serious contender appears to be Ferdinand Bol.

The copy is mainly of interest as a document from which we can deduce that Rembrandt was either not entirely happy with his earlier version, or that he had found a second approach which he considered equally valid.

P.v.Th.

1. Tümpel 1986, p. 164.
2. Bruyn 1970, pp. 39–40. Broos 1972, pp. 140–43.
3. Haak 1969, pp. 126–27.
4. Broos 1972, *passim*.
5. Bruyn *et al.* 1982–, Vol. III, pp. 107–12.

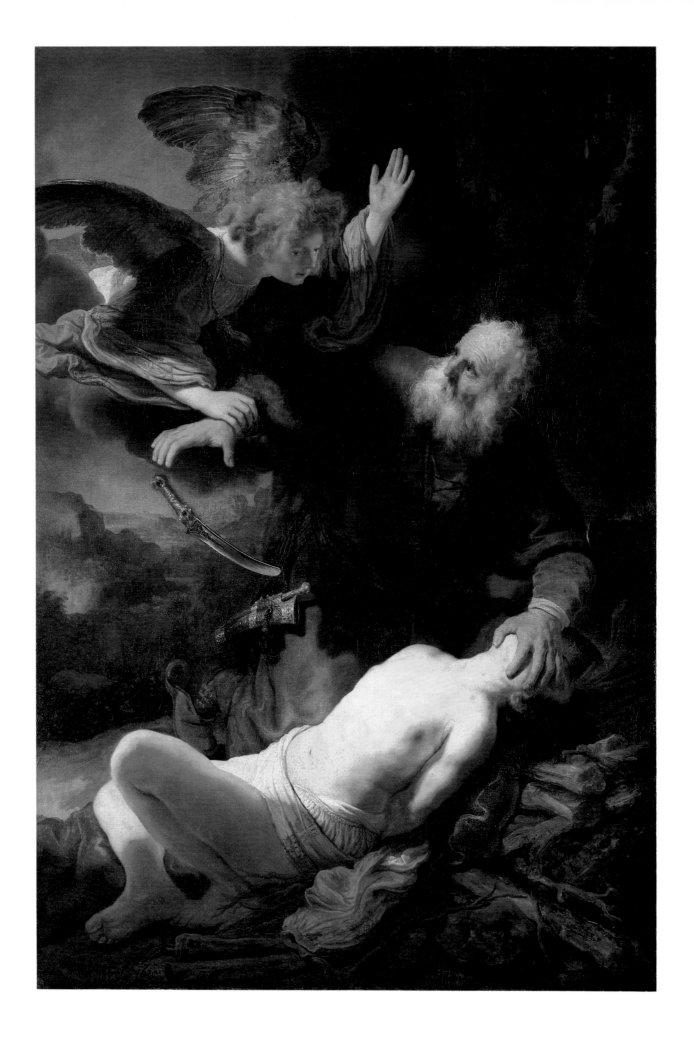

Belshazzar's Feast

c.1635
Canvas, 167 × 209 cm, signed and dated
Rembrand[.] f 163[.] (only visible in ultraviolet
light)
London, The National Gallery, Inv. No. 6350

Provenance: Bought for £125 in or before 1736
by Hamlet Winstanley for James Stanley, 10th
Earl of Derby. Bought by the museum in 1964
from the Earl of Derby's collection, Knowsley
Hall near Liverpool.

Literature: Bredius/Gerson 497; Bauch 21;
Gerson 77; *Corpus* A110. J. Dyserinck, 'Eene
Hebreeuwsche inscriptie op een schilderij van
Rembrandt', *De Nederlandsche Spectator* 1904, pp.
160 and 350. W. Sumowski, 'Eine Anmerkung
zu Rembrandts Gastmahl des Belsazar', *Oud
Holland* 71 (1956), pp. 88–96. R. Hausherr,
'Zur Menetekel-Inschrift auf Rembrandts
Belsazarbild', *Oud Holland* 78 (1963), pp. 142–
49. *The Sixty-First [1964] Annual Report of the
National Art-Collections Fund*, London 1965,
p. 14. *National Gallery Report for 1962–1964*,
London 1965, pp. 41–42. Keith Roberts,
'Rembrandt's "The Feast of Belshazzar"; a
Recent Acquisition by the National Gallery,
London', *The Connoisseur Yearbook* 1965, pp. 65–
71. H. Kauffmann, 'Rembrandts "Belsazar"',
in *Festschrift Wolfgang Braunfels*, Tübingen 1977,
pp. 167–76. MacLaren/Brown 1991, No. 6350.

Exhibitions: London 1822, No. 21. London 1852,
No. 24. Manchester 1857, No. 695. London
1899, No. 58. London 1952–53, No. 160.
Stockholm 1956, No. 18. Manchester 1957,
No. 131. Washington, Detroit & Amsterdam
1980–81, No. 26. London 1988–89, No. 7.

The depiction of moments of intense emotion,
an art which had been perfected in classical
times, as we know from the *Laocoön*, was one of
the most formidable challenges facing a history
painter. It fascinated Rembrandt from the very
start of his career, as can be seen from *Tobit and
Anna* (Cat. No. 1), and he now brings it to a
high pitch of refinement with this scene of the
terror-stricken Belshazzar, which immediately
precedes the climax of his endeavour, the 1636
Blinding of Samson in Frankfurt (*Corpus* A116).

 This Old Testament subject is based on
Daniel 5, which tells how Belshazzar, King of
Babylon, laid on a feast for his nobles, wives
and concubines, despite the fact that the city
was being besieged by Cyrus, the Persian
general, and served them wine in gold and
silver vessels which his father Nebuchadnezzar
had looted from the Temple in Jerusalem.
During the banquet a mysterious hand
suddenly appeared and wrote words on a wall
which only the prophet Daniel could decipher.
They were 'Mene mene tekel upharsin',
meaning 'God hath numbered thy kingdom,
and brought it to an end. Thou art weighed in
the balances, and art found wanting. Thy
kingdom is divided, and given to the Medes
and Persians'. That night Belshazzar was killed.

 What one immediately notices about this
painting is that the table is tilted to the left
and that the wine is not falling perpendicularly
from the goblet held by the women in the
lower right corner. However, if one projects an
imaginary straight line from the table-top it
does cut the stream of wine at right angles, as
one would expect. So it is not Rembrandt who
is at fault. At some time in the past, when the
picture was being restored, it was taken from

its stretcher, and after treatment was remoun-
ted with a slight anticlockwise twist. The
narrow, wedge-shaped segments that had now
become superfluous were trimmed off, so it is
impossible to remedy the mistake without
repainting the missing pieces (Fig. 22a). As a
result, Belshazzar now leans further back than
Rembrandt intended, and appears to be
recoiling in even greater horror from the fiery
letters. It is conceivable that the canvas was
deliberately remounted askew to achieve this
very effect.

 There are several odd features about the
execution of this painting. Unusually for
Rembrandt there is a dark underpaint beneath
the entire surface, even in the light passages,
which gives the scene a sombre cast through-
out, despite the great variety of lighting and
colour accents. The differences in the handling
of the brush are so remarkable that they are
optically almost incompatible, as well as being
difficult to appreciate mentally. The treatment
of the brocade of Belshazzar's cloak, for
instance, looks fussy when compared to the
broad handling of the red gown of the woman
on the right, yet appears superbly elaborated
when contrasted with the coarse execution of
that same gown. Certain contours, like that of
Belshazzar's chin, are reinforced with black
lines in a departure from Rembrandt's normal
practice, while others are strengthened in the
usual way by the juxtaposition of light and
shadow—in both cases undoubtedly to
enhance the visual effect when viewing the
picture from a distance. Finally, the two
conflicting light sources—one of them
invisible, outside the painting on the left, and
the other the dazzling radiance of the divine

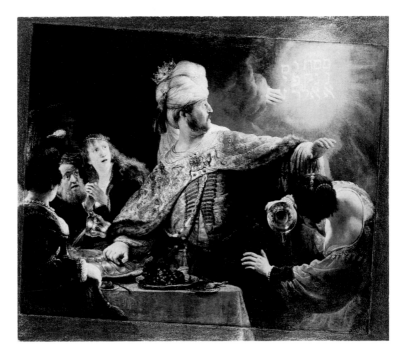

22a: Reconstruction of the painting in its original
position and format.

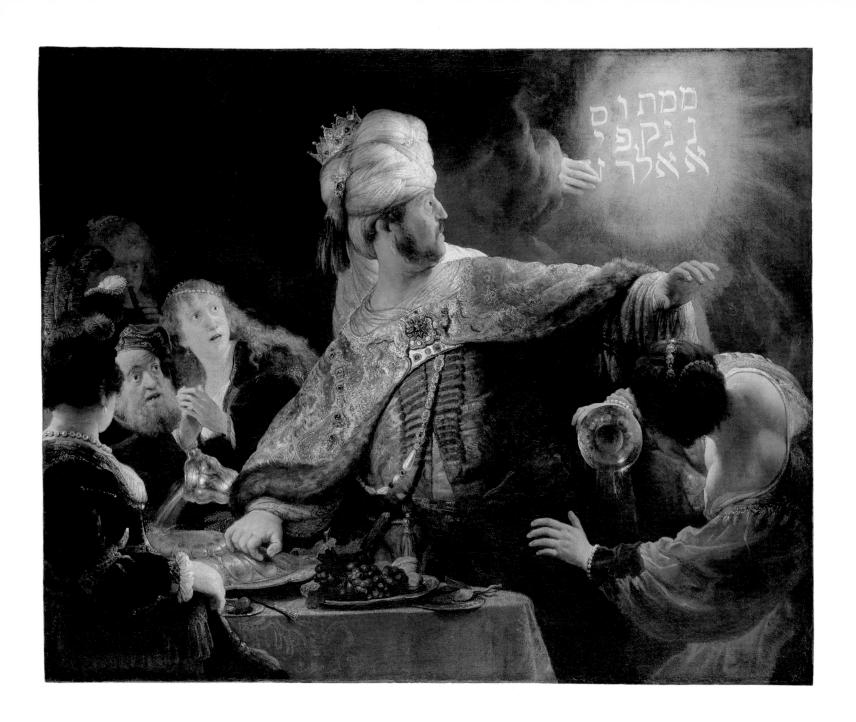

22b: The 'Mene tekel' inscription reproduced in Menasseh ben Israel, *De terminis vitae libri tres*, Amsterdam 1639.

22c: Rembrandt, *Portrait of Menasseh ben Israel*, 1636. Etching. Amsterdam, Rijksprentenkabinet.

160 *Menaſſeh ben Iſrael*
quam poſtea etiam obtinuit: hæc enim mentis rationalis operatio eſt : quæ in illo non fuiſſet , ſi in beſtiam converſus fuiſſe. Ratio eſt, quia in uno & eodem ſubjecto, non poteſt eſſe anima irrationalis, & rationalis.

I I I. Balthefare cũ optimatibus regni ſui convivante viſa eſt manus ſcribentis angeli in pariete:

[Hebrew inscription grid reproduced in image]

Eam ſapientes non potuerunt legere; multo minus ſenſum ejus rei , quæ ſcripta erat, aſſequi : quia legebant linea recta, cum longa debuiſſent. At Daniel ubi acceſſit , legit ſcriptum , ut oportuit , & interpretans illud ait regi, Deum numeraſſe regnũ ejus , quod ei dederat , appenſumque

writing—posed problems for Rembrandt when he came to model the figures and establish their positions in the picture space. In contrast to the almost *trompe-l'œil* effect of the woman in the lower right corner, who is bathed in a Caravaggesque light and is seen in extreme foreshortening (she may have been borrowed from Paolo Veronese *Rape of Europa* in the Doges' Palace in Venice, a copy of which was presumably in the collection of the Amsterdam patrician, Joan Huydecoper, in 1622),[1] the group on the left, where there are no powerful light accents, comes across as rather flat.

The composition is held together as it were by Belshazzar's sweeping arm gesture, reminiscent of Abraham's pose in the *Sacrifice of Isaac* (Cat. No. 21), which is dated 1635. The peculiarities of execution and the lack of balance have led to a wide range of dates being proposed for *Belshazzar's Feast*—all in the 1630s, of course, because it is only the final digit of the date that is illegible. It seemed that the supporters of a late date had been proved right when R. Hausherr noticed that the 'Mene tekel' text, which as J. Deyserinck had pointed out was strange in that it is not written horizontally from right to left but vertically, was reproduced in exactly the same form in 1639 in a book by the learned Amsterdam rabbi and printer, Menasseh ben Israel (Fig. 22b).[2] However, although an interesting discovery, this is no argument for a late dating of the picture. Rembrandt lived across the street from Menasseh, whose portrait he etched in 1636 (Fig. 22c), and he and the rabbi could easily have discussed, many years before the publication of Menasseh's book, the problem of how the moving finger could have written a text which Belshazzar was unable to read but which presented no difficulty to Daniel. Menasseh naturally knew the solution given by the Cabbala, the secret Jewish lore of letters and numbers used to explain hidden meanings in the Bible, namely that the words were written vertically:

S	U	T M M	
		e e e	
I	PH	K N N	
		a e e	
N	R	L	

The most compelling reasons for dating this picture around 1635 are the stylistic affinity with other works from that time, especially the *Sophonisba* of 1634 in Madrid (*Corpus* A94), the *Minerva* of 1635 in a private collection (*Corpus* A114), *Abraham's Sacrifice* (Cat. No. 21), and the *Blinding of Samson* of 1636 in Frankfurt (*Corpus* A116). Examination of its weave

structure has shown that the canvas is from the same bolt as the supports of *Minerva* and the studio copy of *Abraham's Sacrifice* of 1636 (see the commentary to Cat. No. 21).

In the seventeenth century the story of Belshazzar was regarded as an example of what Coornhert called 'evil delight that ends in sorrow'.[3] The authors of the *Corpus* cite such examples as Crispijn de Passe the Elder's print of around 1600 after a depiction of Belshazzar by Maerten de Vos, with the inscription 'Impii convivii tristis exitus' (The unhappy end to an ungodly banquet).[4] Interestingly, early in the sixteenth century Hieronymus van Buysleyden had the dining room of his large mansion in Mechelen decorated with scenes of mythological and biblical feasts to which he attached a moral. There Belshazzar's Feast stood as a warning that those who gratify their craving for pleasure by desecrating sacred objects invite God's wrath. A possible explanation for the remarkably large size of most of the surviving sixteenth and seventeenth-century paintings of the subject is that they were intended to be hung in dining rooms, which also applies of course to Rembrandt's version.
P.v.Th.

1. Tümpel 1986, p. 163 and note 169.
2. Menasseh ben Israel, *De terminis vitae libri tres*, Amsterdam 1639, p. 160.
3. Coornhert 1586, Bk. I, Ch. 13 ('Van blydschap ende vrueghde').
4. Bruyn *et al.* 1982–, Vol. III, p. 132.

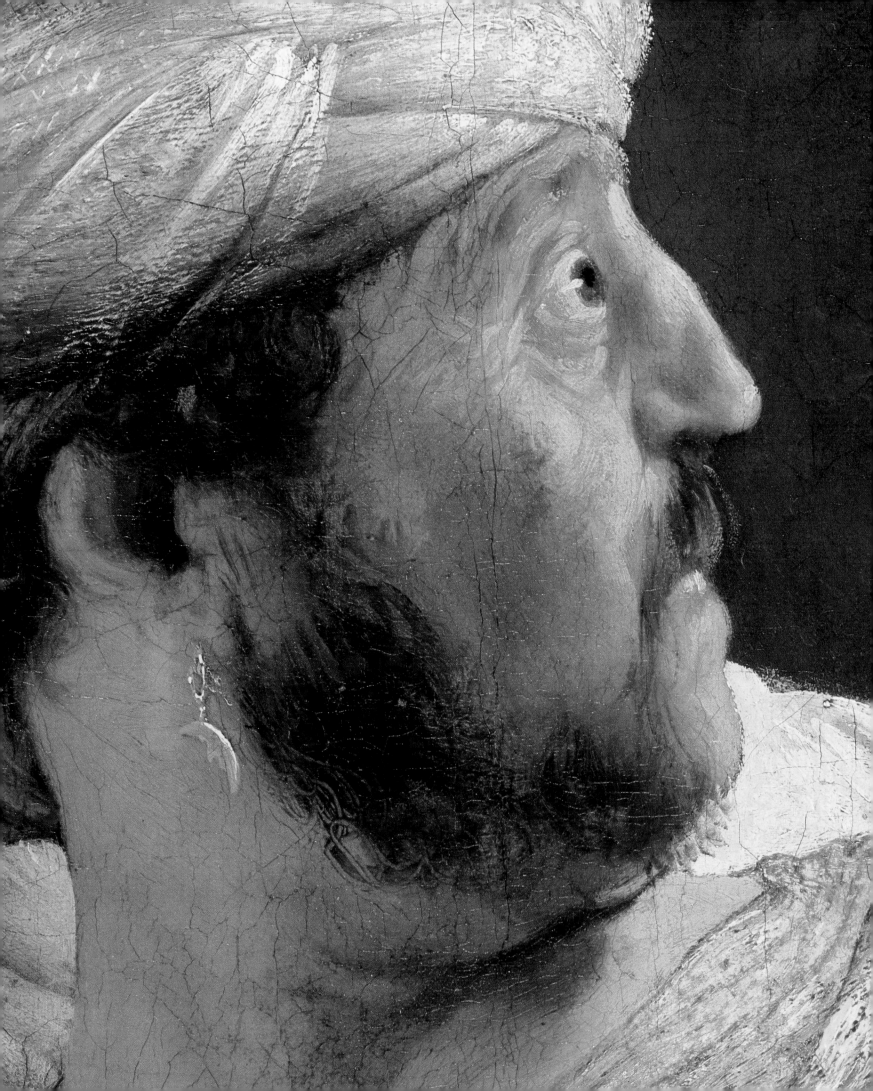

23

Flora

1635
Canvas, 123.7 × 97.5 cm, signed and dated by
another hand *Rem[b.]a[. . .] 1635*
London, The National Gallery, Inv. No. 4930

Provenance: Sale Duc de Tallard, Paris, 22
March–13 May 1756, No. 156: 'Rembrandt.
Une Mariée Juive les cheveux épars, et une
couronne de fleurs sur la tête, elle pose la main
droite sur une canne qui est pareillement
entourée de fleurs, et de la gauche elle tient
un gros bouquet. La Figure est de grandeur
naturelle, et peinte dans ce ton de couleur
vigoureux qu'on admire dans tous les ouvrages
de Rembrandt. La tête est d'un beau caractère
et d'un grand effet. La grandeur de ce Tableau
est de 45 pouces de haut sur 54 pouces de
large'; to Remy for 602 francs, 'pour l'Angle-
terre'. Duke of Montagu collection. In 1790 by
descent to the duke's daughter, who was
married to the 3rd Duke of Buccleuch. Duke of
Buccleuch collection, Dalkeith Palace near
Edinburgh, later Montagu House, London.
Bought by the museum in 1938 from the 8th
Duke of Buccleuch.

Literature: Bredius/Gerson 103; Bauch 261;
Gerson 96; *Corpus* A112. C. Brown,
'Rembrandt's 'Saskia as Flora' x-rayed', in
*Essays in Northern European Art presented to Egbert
Haverkamp-Begemann on his Sixtieth Birthday*,
Doornspijk 1983, pp. 48–51. MacLaren/Brown
1991, No. 4930.

Exhibitions: Manchester 1857, No. 666. Edin-
burgh 1883, No. 421. London 1899, No. 77.
London 1929, No. 154. Amsterdam 1932, No.
6. London 1938, No. 129. London 1945–46,
No. 4. London 1947–48, No. 66. London 1988–
89, No. 5.

At various points in the surface relief of this
picture, notably in the background at top
right, and on the left in the lower part of the
sleeve and in the skirt, strange brushstrokes are
visible which bear no relation to the finished
picture. The logical assumption that they
belong to another, underlying scene is confir-
med by the x-ray photograph (Fig. 23a), which
clearly reveals a bowed head on the right at the
level of Flora's shoulder. It also shows that
Flora's left arm, in which she now holds the
wreath of flowers, was originally extended to
the right and went beyond the present edge of
the painting, which passes through the bare
forearm. These and many other passages in the
x-ray become comprehensible if one accepts
Christopher Brown's theory that Rembrandt
first painted the canvas, which was certainly
considerably wider on the right, with the
subject of Judith outside the general's tent
dropping the head of Holofernes into a sack
held by her maid, similar to the painting by
Rubens in the Palazzo Vecchio in Florence
(Fig. 23b). The iconographic tradition dictated
that Judith should be shown with her sleeves
rolled up and with a sword in her right hand,
as she is in Rubens's picture. Curved lines at
bottom left in the x-ray photograph appear to
indicate the outline of the sword. The broad
diagonal line running up to the top right corner
could be a vestige of the open flap of
Holofernes's tent.

It is not known why Rembrandt abandoned
his *Judith*, which was at an advanced stage or
even finished, and changed it into a *Flora*.
In the process he also removed a broad strip
from the right. After 1756 the painting was
transferred to a new canvas. Judging by a

23a: X-ray photograph of the painting.

23b: Rubens, *Judith with the Head of Holofernes*.
Florence, Palazzo Vecchio.

drawn copy from Rembrandt's studio (Fig. 23c) the picture was then reduced on three sides—at the top, less so on the right and hardly at all at the bottom. Either then or later the background detail was toned down and a plant was added in the lower right corner. The present signature with the trustworthy date of 1635 could have been copied from the original, which may have disappeared during the former restoration.

Rembrandt had painted the same subject one year before. That *Flora* of 1634 (Fig. 23d), which is now in Leningrad, is executed in roughly the same manner: broadly where the folds of the drapery call for it, and quite delicately where the textures of embroidery and flowers demand attention. The latter areas are bolder in the London picture, where the lighting of the figure is also much stronger. The flowers in Flora's hand are largely in shadow, and stand out as a dark mass against the brightly lit skirt, creating a suggestion of depth which is reinforced by the shadow cast by the leaves at the bottom. This effect, which makes the two *Floras* as dissimilar as a free-standing statue and a relief, is also an important element in the *Standard-Bearer* of 1636 (Cat. No. 26).

In 1960, after careful thought, the National Gallery gave this painting the title *Saskia van Uylenburch in arcadian Costume*, but it is now also published as *Saskia as Flora*.[1] In the *Corpus* it is merely called *Flora*. Whether the woman's face is really Saskia's is a question that must be left to the viewer, who can compare it with Rembrandt's silverpoint drawing in Berlin (Fig. 23e), the only portrait of Saskia which is documented by the inscription: 'dit is naer

mijn huysvrou geconterfeyt so sy 21 jaer oud was den derden dach als wij getroudt waeren de 8 Junijus 1633' (This is a likeness of my wife when she was 21 years old, three days after our betrothal on 8 June 1633). If the similarity is felt to be convincing (although it fails to persuade me), the next question is whether this is a portrait of Saskia dressed as a specific character (a *portrait historié*) or a depiction of a particular figure for which Saskia acted as the model. Since the face has no individualised features but is of the idealised type which Rembrandt was using at this time for his portrayals of mythological, biblical and historical women— *Bellona* of 1633 (*Corpus* A70), the Virgin in the *Holy Family* of 1634 (Cat. No. 14), *Flora* of 1634 (*Corpus* A93), *Sophonisba* of 1634 (*Corpus* A94) and *Minerva* of 1635 (*Corpus* A114)—it cannot, in any event, be regarded as a portrait of Saskia, any more than the *Flora* of 1654 (Cat. No. 40) can be taken as a portrait of Hendrickje. Those who believe that they recognise Saskia or Hendrickje in these women can only conclude that here, where the figure is subordinate to the costuming and *mise-en-scène*, they served only as models. The situation is reversed in the painting of 1641 in Dresden (Fig. 23f), where the figure is presented within the framework of the seventeenth-century portrait convention, with the costume subservient to the personality of the woman, who really does look very much like Saskia. The Dresden picture is indeed probably a *Portrait of Saskia as Flora*.

The question as to which female subject Rembrandt chose to replace Judith (for it was she whom he originally depicted)—as Flora, as the goddess of spring, or as an arcadian

23c: Studio copy of the painting. Pen and wash drawing. London, The British Museum.

23d: Rembrandt, *Flora*, 1634. Leningrad, Hermitage.

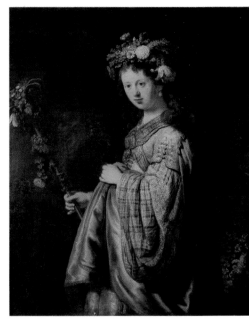

shepherdess—is an iconographical problem.
Flora was rarely portrayed in the north, not
even with her husband Zephyr,[2] but a woman
with a mass of flowers was a familiar allegorical
figure representing Spring in numerous print
series of the Four Seasons, and Smell in series
of the Five Senses. The shepherdess was a new
theme in Dutch art, and is associated with
pastoral literature, a genre introduced into
Holland in 1605 by P.C. Hooft with his play
Granida. In the 1620s and 1630s, when the
pastoral was very much in fashion, the Utrecht
artists Gerard van Honthorst, Paulus van
Moreelse and Abraham Bloemaert painted
scores of shepherdesses, both as portraits and as
a generic type. They are simply and often quite
provocatively dressed, generally wear a large
straw hat and almost invariably have a
shepherd's crook, always with the hooked end
uppermost, but flowers play a secondary role.
If, in Rembrandt's pictures, one is prepared to
ignore the extravagant dress and the absence of
a hat, the problem is reduced to whether or
not the woman has a shepherd's crook. That
appears unlikely in the case of the Leningrad
Flora, where there is no hook to be seen on the
staff, just flowers crowning its top. However,
we can be quite definite that in the London
painting the woman is resting her hand on an
ordinary staff entwined with foliage. There is
therefore no reason to follow Alison Kettering
in believing that Rembrandt combined the
two iconographic themes and painted 'an
unclassical-looking Flora in the guise of a
shepherdess,'[3] but certainly to note that he
changed his history painting of the biblical
Judith into one of the mythological Flora.
Added to this, a note in his handwriting on
the back of a drawing in Berlin (Benesch 448)
about the trade he was doing in works by his
pupils mentions three 'floora(e).' So Rembrandt
himself called some paintings from his studio
Flora. They were probably drawn (see Fig. 23c)
or painted copies after his paintings of Flora of
1634 and 1635, a few of which are indeed
known.[4]

P.v.Th.

1. MacLaren/Brown, 1991, No. 4930. See the article by
C. Brown under *Literature* above and, under *Exhibitions*,
London 1988–89.
2. Sluijter 1986, p. 254.
3. Kettering 1983, pp. 61–62. Schwartz 1984, p. 127,
fully endorsed Kettering's view, while Bruyn *et al.*
1982–, Vol. II, pp. 500–1, though expressing some
reservations, accept her opinion as published in
Kettering 1977, p. 24. Both Held 1961, pp. 207, and
Tümpel 1986, p. 110, believe that the subject is Flora.
4. See *Corpus* A93 (Fig. 6) and A112 (Figs. 7–8), under
section 7, *Copies*.

23e: Rembrandt, *Portrait of Saskia*, 1633. Drawing.
Berlin, Staatliche Museen Preussischer
Kulturbesitz, Kupferstichkabinett.

23f: Rembrandt, *Portrait of Saskia as Flora*, 1641.
Dresden, Gemäldegalerie Alte Meister.

24

The Rape of Ganymede

1635
Canvas, 177 × 129 cm, signed and dated
Rembrandt ft 1635
Dresden, Staatliche Kunstsammlungen Dresden,
Gemäldegalerie Alte Meister, Cat. No. 1558

Provenance: Sale Amsterdam, 26 April 1716,
No. 33: 'Den Arend, opnemende Ganimedes,
levens groote, kragtig en sterk geschildert, door
Rembrand, van Ryn, h[oog] 6 v[oet] br[eed]
4 en een half v[oet]' (The eagle carrying off
Ganymede, life-size, powerfully and boldly
painted by Rembrandt van Rijn, height 6 feet,
width 4½ feet); 175 guilders. W. van
Velthuyzen sale, Rotterdam, 15 April 1751,
No. 46: 'Ganimedes, door Rembrant, extra
captael' (Ganymede, by Rembrandt, most
capital). Bought in Hamburg in 1751 by Carl
Heinrich von Heinecken for Frederik Augustus
II, Elector of Saxony (later King Augustus III of
Poland).

Literature: Bredius/Gerson 471; Bauch 102;
Gerson 73; *Corpus* A113. Margarita Russell,
'The iconography of Rembrandt's *Rape of
Ganymede*', *Simiolus* 9 (1977), pp. 5–18.

Exhibitions: Tokyo & Kyoto 1974–75, No. 46.
Washington, New York & San Francisco 1978–
79, No. 557. Moscow 1982, No. 28. Essen 1986,
No. 485.

Only a few of Rembrandt's many drawings can
be regarded as designs for paintings. One such
is the sheet in Dresden (Fig. 24a) which, as can
be seen from the truncated pen-lines, has
certainly been trimmed a little on the left and
at top and bottom, and possibly on the right as
well, with the greatest loss possibly at the top.
Framing lines have also been added all round.
Both operations must have been done after
Rembrandt's day. This preparatory sketch
encapsulates Rembrandt's idea for the
composition and immediately tackles some of
the practical problems which Rembrandt
realised would present difficulties when it came
to working out his design in a painting. They
include the way in which the bird would grasp
the child in its talons, the struggles of the
child, thrashing about with its legs, and the use
of lighting and detail to focus attention on the
crux of the scene, the face of the crying child,
in the midst of all this turbulent action.

According to Homer, *Iliad* XX, 231–35,
Virgil, *Aeneid* V, 252ff., Ovid, *Metamorphoses* X,
155ff., and other classical writers, Ganymede
was the son of the Trojan King Tros and his
wife Callirrhoë. The child grew into such a
strikingly beautiful boy that the gods desired
that he should become Jupiter's cup-bearer.
Jupiter, who coveted the handsome youth more
as a bedfellow, turned himself into an eagle,
flew down to the Trojan plains and carried
Ganymede off. He later made him immortal
by placing him in the firmament as the
constellation of Aquarius.

The two figures in the lower left corner of
the drawing are undoubtedly Ganymede's
parents. It is not very clear what the father is
doing (looking through a telescope perhaps?),
but the woman is reaching her arms out in
despair towards her kidnapped son. The two
angular penstrokes that meet the lower border
could, I believe, be the battlements of a tower,
showing that the eagle has already climbed
with the child quite high into the cloudy sky,
which is indicated with pen flourishes and areas
of wash.

The painting broadly follows the drawing,
although the boy's parents are missing. In their
place is the top of an almost semicircular
structure standing higher than the battlements
in the drawing. This weakens the suggestion
that the eagle has already climbed quite far
into the sky, which is further negated by the
trees on the right and the horizon—two
elements that are missing in the drawing. This,
as it happens, is a particularly poorly preserved
area of a painting which is anyway not in the
best condition, and alterations have evidently
been made here. Ganymede may well have been
surrounded by clouds originally, as he is in the

24a: Rembrandt, *The Rape of Ganymede*. Drawing.
Dresden, Staatliche Kunstsammlungen,
Kupferstichkabinett.

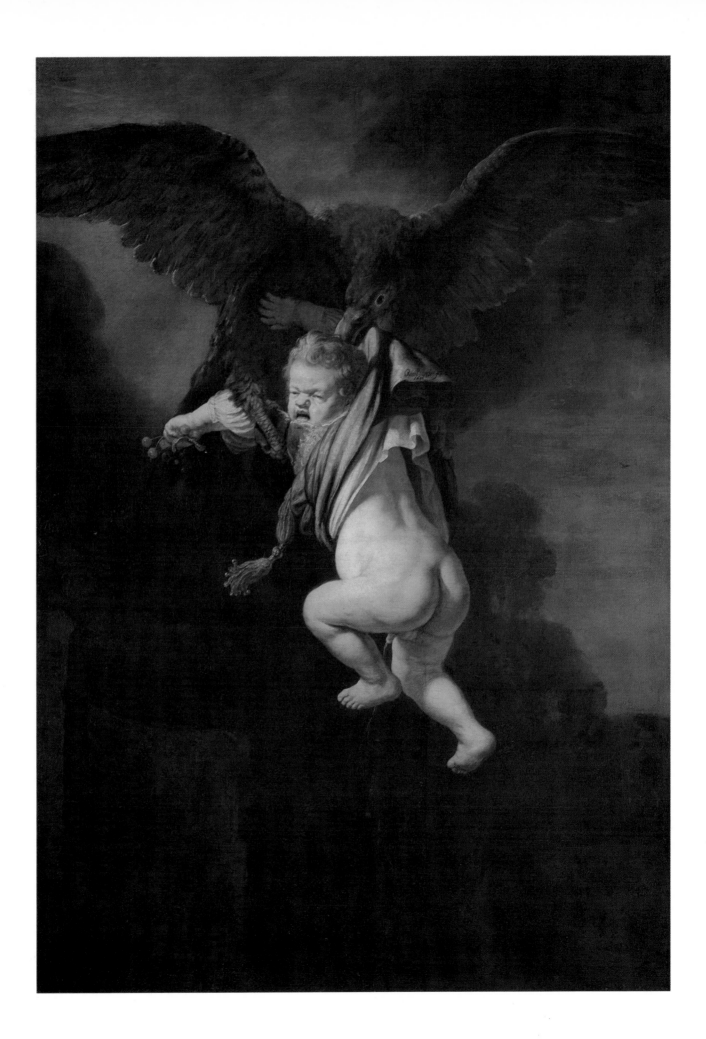

drawing. One wonders, too, whether his distraught parents were also included, and if so whether they were eliminated by Rembrandt or by someone else at a later date. At top left is the flash of Jupiter's lightning, which might also have been visible in the drawing before it was cropped. Missing from the sketch are the cherries in Ganymede's left hand, and something else that was not foreseen was the natural reaction of the terrified child, who is wetting himself in sheer fright.

Although there has been a great deal of research into the meaning of Rembrandt's *Ganymede*, it is a problem which has still not been satisfactorily resolved. Margarita Russell, who like Tümpel[1] before her has made a deep study of the subject, has pointed out that Jupiter's homoerotic interest in the beautiful Ganymede had already become sublimated in classical times, in the sense that the god was attracted not so much by his physical beauty but by the purity of his soul. In the Renaissance this view was held by the Neoplatonists, and was expressed by such writers as Karel van Mander in his commentary on the *Metamorphoses*.[2] According to Van Mander Ganymede signified both the pure human soul that longs for God and is so beloved of God that He often takes the soul prematurely, and rain-bringing winter, for Jupiter gave his cup-bearer immortality by placing him among the constellations as Aquarius, the Water-bearer.

In paintings and prints Ganymede is generally shown as the beautiful youth who had taken Jupiter's fancy, but in the emblem literature he also appears as an infant whose soul yearns for God. This emblematic icon ultimately led to dead children being portrayed in the guise of a Ganymede being carried up to heaven. Nicolaes Maes was particularly fond of this motif, and employed it in a number of paintings in the second half of the seventeenth century. Those blessed children, though, are not terrified; they do not struggle, or cry, or wet themselves. Consequently Russell, who has rightly stressed the importance of Van Mander's text for Rembrandt, does not conclude that his painting is the prototype and therefore the model for this later iconography of the dead child. She believes that he united the two versions of the classical Ganymede myth in a single image: Ganymede is both the spotless soul of the child, delighting in God and, as the urinating infant, Aquarius bestowing life-giving water on the world.

As the authors of the *Corpus* remark,[3] it is difficult to accept that Rembrandt was thinking of the pure soul of the child when he painted this squalling infant. They point out that the picture contains no elements that would justify a definite choice of the Neo-platonic or the homoerotic interpretation, and that this also applies to a detail like the cherries, which Russell regards as a symbol of purity but which can also betoken sensual lust. They conclude by noting that the astrological component is fairly explicit, and that the object held by the father in the drawing, which looks like a telescope, might be associated with this.

If one assumes that Van Mander's text was indeed an important source for Rembrandt, then perhaps it might tell us a little more about his intention. For Van Mander generally explains the myths in the *Metamorphoses* in three ways, corresponding to a pattern of thought current at the time: literally ('*gheschiedigh*'), figuratively ('*natuerlijck*') and allegorically ('*leerlijck*'). In this case, following his hierarchy of the three levels of interpretation, he first explains Ganymede figuratively as the symbol of winter with its rains, and then allegorically as the personification of the pure soul. Rembrandt, or so it appears, was aware of this system and chose the lower-level, figurative interpretation. As the Water-bearer, his urinating child will make the earth fertile.

The meaning of an image often emerges from certain symbolic motifs which the painter included to make his meaning clearer. In this case it is the cherries, but the trouble is that the symbolism of the cherry is anything but clear-cut, so that here the mechanism works in reverse. The sense of the scene has to provide the clue to the meaning of the cherries. Of all the known connotations the one that best fits this high-spirited child and his heaven-sent stream of urine is vitality, the life-force.[4]
P.v.Th.

1. Tümpel 1968, Pt. I, pp. 223 ff. See also Tümpel 1986, pp. 179–81. Exhib. cat. Amsterdam 1976, Cat. No. 29, contains a defence of the old view, now considered outdated by most authors, that Rembrandt's *Ganymede* is a parody of the myth.
2. Van Mander *Wtlegghingh* 1604, fol. 87.
3. Bruyn *et al*. 1982–, Vol. III, p. 166.
4. De Jongh, in exhib. cat. Haarlem 1986, p. 225, and p. 298, note 2.

Susanna and the Elders

1636
Panel, 47.2 × 38.6 cm, signed and dated
Rembr[ant f] f 163[.]
The Hague, Royal Picture Gallery,
Mauritshuis, Inv. No. 147

Provenance: P.J. Snijers sale, Antwerp, 23 May
1758, No. 15: 'Een zeer schoon Kabinet-
stukxken, Verbeeldende Susanna aen de
Fonteyne in den Hof, met eenen Boef die doôr
het hout ziet, doôr Rymbrant van Ryn; hoog
18 duym, breed 15' (A very fine little cabinet
piece showing Susanna by the fountain in the
garden, with a scoundrel peering through the
thicket, by Rembrandt van Rijn; height 18
inches, width 15); to Fierens for 157 guilders.
Govert van Slingelandt collection, The Hague:
'Une Batseba, auprès d'un bain, epiée par
David; par le même [Rembrant]. B[ois].
Hau[teur] 18 Pou[ces] Lar[geur] 15 Pou[ces]'.
Purchased with Van Slingelandt's entire
collection by Stadtholder Willem V some time
between the owner's death on 2 November
1767 and 1 March 1768. The stadtholder's
gallery was removed to the Musée Napoléon
in Paris in 1795, remaining there until 1815.
In the Royal Picture Gallery, The Hague,
since 1816.

Literature: Bredius/Gerson 505; Bauch 18;
Gerson 84; *Corpus* A117.

Exhibitions: Rome 1928, No. 94. London 1929,
No. 162. Amsterdam 1945, No. 85. Brussels
1946, No. 82. Basel 1948, No. 18. Rome &
Milan 1954, Nos. 110 and 113 respectively.
New York, Toledo & Toronto 1954–55,
No. 61. Amsterdam & Rotterdam 1956,
No. 32. Stockholm 1956, No. 17. Oslo 1959,
No. 51. Tel Aviv 1959, No. 91. Kassel 1964,
No. 11. Brussels 1971, No. 79. Washington,
Chicago & Los Angeles 1982–83, No. 28.
Madrid 1985–86, No. 13. Paris 1986, No. 41.

Although now rectangular the composition was
originally bounded at the top by an arch, for
Rembrandt did not extend the scene into the
upper corners. A strip some 4.5 cm wide was
later attached to the right of the panel after at
least 1 cm of wood had been trimmed from
that side (as calculated by reconstructing the
arch, which is truncated on the right),
probably to remove part of the bevel in order
to create a wider and thus better surface for
gluing on the new strip. Rembrandt used a
plain dark grey for the top corners, which were
to be hidden by the frame. Neither the report
on the examination of Rembrandt's paintings in
the Mauritshuis[1] nor the *Corpus*[2] helps clear up
the question of whether it was Rembrandt who
subsequently finished off the corners of the
composition, or a later artist. That this was
done some time later is clear from the fact that
the edge of the arch is visible in the surface
relief, proving that the paint had already
hardened when the grey corners were redone.
This change in the shape of the compositional
field could very well have been made at the
same time as the addition of the strip of wood
on the right, which must have taken place
before 1758, when the picture was auctioned in
Antwerp with its present dimensions. The
original arched format and the added piece of
wood show up clearly in the x-ray photograph
of the painting. The panel may also have been
reduced a little at the bottom.

The enlargement on the right led to the loss
of the letters *andt* of Rembrandt's signature and
part of the final digit of the date. The replace-
ment on the first line reads *ant f*, i.e. without
the *d* and with a superfluous *f* for '*fecit*' (there
was already an *f* on the line below). The
vestige of the final digit of the date was made
good as a 6 but could equally well have been
turned into an 8. That would have been
perfectly acceptable, since the picture is
executed in much the same manner as the *Christ
appearing to Mary Magdalen* of 1638 (Cat. No.
27). In both pictures, although here it is more
pronounced, the main subject (in this case
Susanna and the pile of clothes behind her) is
forcefully modelled and fully elaborated, while
the vaguely defined setting is treated sketchily.
Nevertheless, the 6 is correct, for that is the
date on Willem de Poorter's rather free drawing
after the painting (Fig. 25a).

Rembrandt devoted far more attention to
the figure of the nude Susanna than to her
surroundings. He also placed her and her
clothing in the very centre of the shaft of light,
which enters from the left but is reflected back
onto her lower torso by the white shirt. This
almost exclusive focus on the main subject
isolates it, both spatially and iconographically,

25a: W. de Poorter after Rembrandt, *Susanna and
the Elders*, 1636. Drawing. Berlin, Staatliche
Museen Preussischer Kulturbesitz,
Kupferstichkabinett.

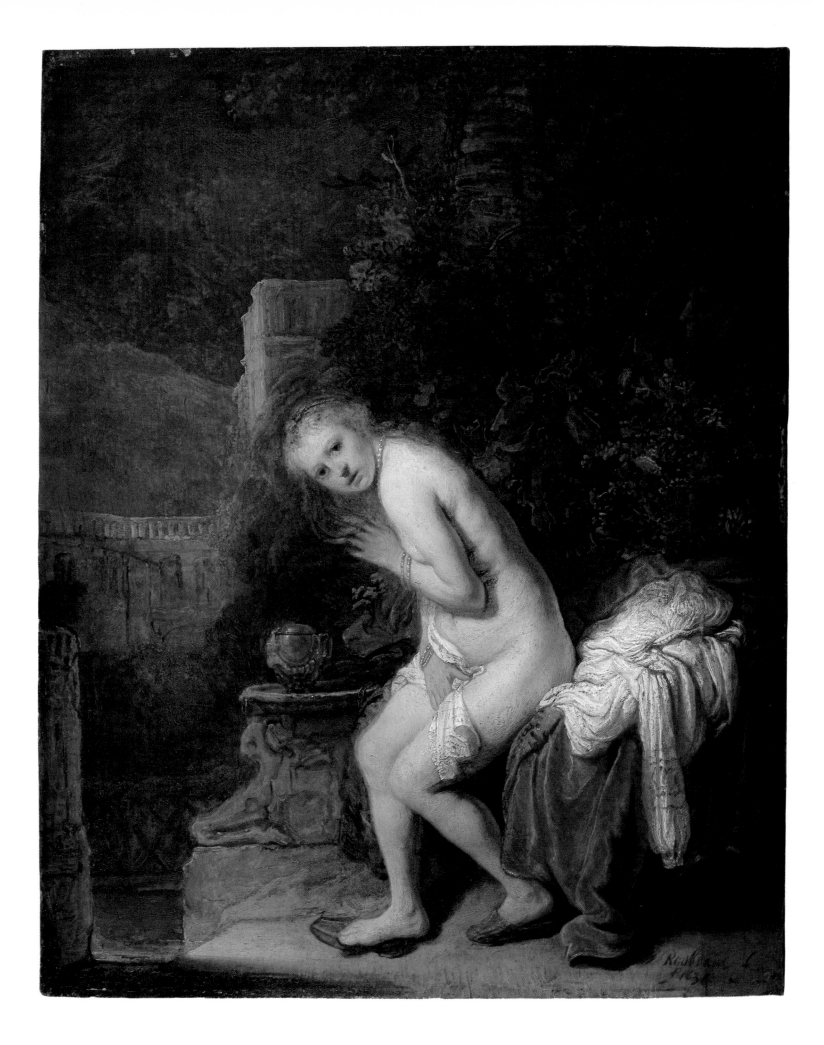

from its setting to such an extent that the narrative context, in which the surroundings play a vital part, is virtually abandoned. The building in the background, for example, could just as well pass for David's palace, which would make the woman Bathsheba, the wife of Uriah the Hittite, who according to 2 Samuel 11:2–4 bathed fearlessly in the king's garden. The story of the chaste Susanna, on the other hand, which is set down in the third apocryphal addition to the Book of Daniel (Daniel 13), relates how two elders, consumed with lust, spied on the beautiful woman from the shrubbery while she was at her toilet, and when she had sent her maidservants away revealed themselves and threatened to have her killed if she resisted their advances. She refused to submit, preferring to face death rather than sin against God. Rembrandt certainly did include both elders, although it might not appear so at first sight. One is clearly visible on the right, and although the greater part of his head is on the piece of wood that was added later, the front of his face is on the original panel and is therefore authentic. Since the wood was first shaved away before the new strip was glued on, Rembrandt must have shown more of the face than just the nose and mouth, although probably not as much as can be seen now. The other man he turned into a real game of 'hunt the elder'. He is wearing a cap with a long feather and is to the left of his companion, superbly camouflaged by the foliage.

Susanna, who has evidently just discovered her lurking tormentors, is bending forwards to shield her body and is looking sideways, straight out of the picture, as if expecting help from that quarter. This was the pose that Rubens had given her in the print engraved by

25c: Roman copy of a Greek original, *Venus*. Marble. Rome, Museo Capitolino.

25d: P. Lastman, *Susanna and the Elders*, 1614. Berlin, Staatliche Museen Preussischer Kulturbesitz, Gemäldegalerie.

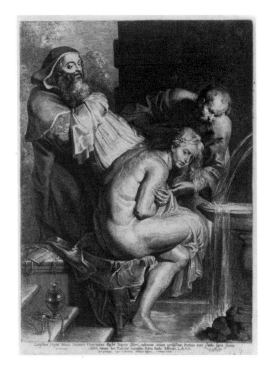

25b: L. Vorsterman after Rubens, *Susanna and the Elders*. Engraving. Amsterdam, Rijksprentenkabinet.

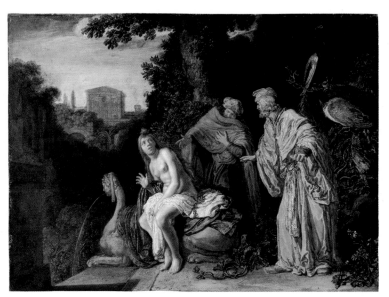

Lucas Vorsterman around 1620 (Fig. 25b), which he dedicated as 'Pudicitiae exemplar' (A model of Chastity) to the Dutch poetess Anna Roemer Visscher.[3] In this engraving, which Rembrandt evidently took as the basis for his own composition,[4] Susanna has crossed her arms over her bosom and has one leg over the other. In Rembrandt's painting she holds one hand in front of her breast and has the other in her lap. Ben Broos has pointed out that this pose was borrowed from the classical *Venus Pudica*, or Venus of Modesty (Fig. 25c).[5] Rembrandt also changed the position of the legs, and depicted Susanna with her right foot planted firmly on her slipper, closing off the opening. This too is an allusion to chastity, for in the seventeenth century the shoe was a symbol of the pudenda. Diametrically opposed to this token of chastity (in both senses) is the sculpted goat's foot on the base of the fountain, which symbolises the lechery of the elders. The moral of the story of the undefiled Susanna is that faith in God enables the virtuous to triumph over vice.

In Rubens's print Susanna is being undressed, but Rembrandt has her seated with her clothes in a pile behind her. He evidently derived this arrangement from two paintings by his former teacher, Pieter Lastman, who died in 1633: his *Susanna and the Elders* of 1614 (Fig. 25d), of which Rembrandt made a drawing around 1635 (Fig. 25e), and a *Bathsheba* (Fig. 25f). The main subject in each case is a woman with her clothes in a heap behind her. The *Bathsheba* seems to have interested Rembrandt primarily for the way in which the clothes are piled on a rock with one sleeve dangling. His own execution of this passage is in fact strikingly reminiscent of Lastman.[6] Broos has also noted that Rembrandt radically altered the position of Susanna's right arm in his drawing after Lastman. Instead of showing it raised either in surprise or to ward off the advances of the two men, he brought it down to her side and had it follow the line of her body, to end with the hand curled protectively in her lap in the classic pose of modesty.

Rembrandt used his 1636 figure of Susanna for a second version of the subject, which he completed in 1647 (Cat. No. 37).

P.V.TH.

1. De Vries *et al.* 1978, pp. 123–24.
2. Bruyn *et al.* 1982–, Vol. III, p. 198.
3. McGrath 1984, pp. 81–84.
4. This connection was pointed out to me by Jan Kelch of Berlin.
5. Broos 1987, p. 290, Fig. 3.
6. Broos 1987, pp. 289–90.

25e: Rembrandt after P. Lastman, *Susanna and the Elders*. Drawing. Berlin, Staatliche Museen Preussischer Kulturbesitz, Kupferstichkabinett.

25f: P. Lastman, *Bathsheba*. Leningrad, Hermitage.

26

The Standard-Bearer

1636
Canvas, 118.8 × 96.8 cm, signed and dated
Rembrandt f 1636
Paris, private collection

Provenance: Possibly identical with the painting
listed in the inventory of the possessions of
Maijke Burchvliet drawn up in Delft on
13 May 1667: 'Een vendrager door Reynbrant
van Rijn' (A standard-bearer by Rembrandt
van Rijn), or that mentioned in the estate
inventory of Herman Becker, Amsterdam, 19
October–23 November 1678: 'een Vaendrager
van Rembrant'. Possibly Allard van Everdingen
sale, Amsterdam, 19 April 1709, No. 34: 'Een
Vaandrager van Rembrant'. Possibly J.M.
Quinkhard collection, Amsterdam. Probably
sale [Mallet], Paris, 12 May 1766 and
subsequent days, No. 87: 'Un Tableau
représentant un Guerrier, peint par Rimbrant
Wanrin, sur toile, de 3 pieds 7 pouces & demi
de haut, sur 2 pieds 9 pouces & demi de large'.
Probably sale Paris, 15 December 1766 and
subsequent days, No. 87: 'Un Tableau
représentant un Guerrier tenant un drapeau sur
son épaule, la main appuyée sur son côté, peint
par Rembrant Vanryn; on prétend que c'est
son Portrait; c'est un très-beau Tableau de ce
Maître, sur toile, avec bordure dorée; il porte
3 pieds & demi de haut, sur 2 pieds 9 pouces
de large'. Probably sale Paris, 2 December 1768,
No. 29: 'Un Tableau représentant un Guerrier
tenant un drapeau sur son épaule, la main
appuyée sur son côté, peint par Rimbrant-
Vanrin, dans sa bordure dorée; il porte 3 pieds
& demi de haut, sur 2 pieds 9 pouces de large'.
Chevalier G.F.J. de Verhulst sale, Brussels,
16 August 1779 and subsequent days, No. 80:
'Rembrant van Ryn, Peint sur Toile, haut 46½,
large 37 pouces. Le Portrait de ce Peintre peint
par lui-même: il s'y est représenté en Porte-
Enseigne cuirassé, à larges culottes & avec un
Echarpe, tenant un drapeau déployé, il a un
chapeau à plumet & rabatu sur la tête.
L'Estampe en est gravée en maniere noire par
P. Lauw'; to Fouquet for 1,290 francs. Sale
[Leboeuf], Paris (Le Brun), 8–12 April 1783,
No. 26, the same description as in the previous
sale, with the addendum: 'Ce beau Tableau a
fait l'ornement du cabinet de Verhulst à
Bruxelles, Hauteur 45 pouces, largeur 39.

T[oile]'; to Devouges for 5,299.19 francs. Sale
Robit, Paris, 11–18 May 1801, No. 117: 'Par le
même [Rhyn (Rembrandt Van)]. Peint sur
toile, haut de 125, large de 105 c[entimètres].
Un autre Tableau, du plus grand caractère, et
de cette force de couleur qui convient aux
morceaux de premier rang dans les cabinets.
Il représente le portrait de Rembrandt, dans un
costume militaire, dénommé dans la curiosité
sous le titre de porte-drapeau. Il provient des
cabinets de Verhulst, à Bruxelles, et de le
Boeuf. Voyez le catalogue de Le Brun, no. 26.
Ces ouvrages marquans ne se rencontrent que
très-rarement, et ne peuvent se trouver que
dans les collections dont l'arrangement d'une
galerie aurait été projeté. Il était destiné pour
le pendant du morceau ci-après. 45 sur 39
pouces'; to Lafontaine for 3,095 francs; the so-
called pendant was the free copy, now in the
Museum voor Schone Kunsten in Antwerp,
after the *Portrait of Saskia* in Kassel (*Corpus*
A85, and *Copies*, 4, with Fig. 10). Collection of King
George IV of England. Dealer Lafontaine,
London. Lady Clarke collection, Oak Hill; sale
Sir S. Clarke, London, 8 May 1840, No. 47: 'Le
Porte Drapeau; Rembrandt in the Character of
a Standard-Bearer'; to Baron James de
Rothschild for £840.

Literature: Bredius/Gerson 433; Bauch 171;
Gerson 95; *Corpus* A120.

This remarkably well-preserved painting is one
of Rembrandt's most brilliant achievements.
The sturdy standard-bearer with his military
moustache, although depicted only half-length,
has the commanding presence of an actor whose
mere appearance on the stage is sufficient to
still the audience. The powerful impact of the
picture is due to a combination of the haughty
bearing of the pugnacious model, the dynamic,
rhythmic brushwork, which defines the
volumes precisely, and the forceful handling of
the light, the lively contrasts between
illuminated and shadowed passages
convincingly suggesting the plasticity of the
figure and the presence of the space around it.
Rembrandt had already experimented with this
kind of lighting in his *Flora* of 1635 (Cat. No.
23), although there it is not yet at full
strength, and is coupled with a fairly bold
colour scheme. In the *Standard-Bearer*, which
dates from the following year, there are only a
few colour accents in a scheme which, although
dominated by browns and greys, nevertheless
hints at a whole range of hues. This tendency
to heighten the contrast and tone down the
palette is characteristic of Rembrandt at this
stage of his development.

The picture may show a standard-bearer,
but comparison with a painting like
Rembrandt's *Portrait of Floris Soop as a Standard-
Bearer* of 1654 in New York (Fig. 26a)
immediately makes it clear that this is no
portrait. Ensigns generally had themselves
portrayed as members of a group in civic guard
pieces, but from the end of the sixteenth
century a few had themselves painted on their

26a: Rembrandt, *Portrait of Floris Soop as a
Standard-Bearer*, 1654. New York, Metropolitan
Museum of Art.

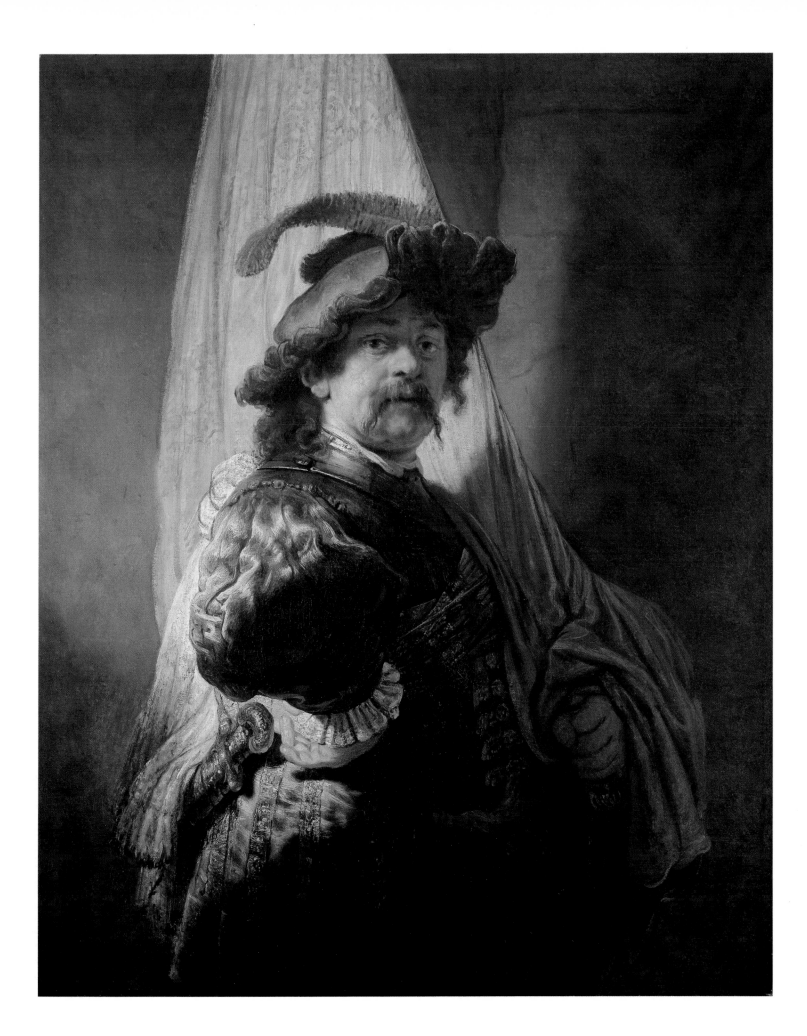

own. The earliest example we have is a life-size half-length of an unknown ensign painted by an unidentified Dutch artist, which is in Munich, dated 1590. Around 1600 an anonymous painter produced a life-size full-length of another ensign (Bologna, Tozzoni collection), and in 1617 and 1621 the Hague artists Everard van der Maes and Joachim Houckgeest (Fig. 26b) each made a similar portrait (The Hague, Hague Historical Museum). In 1626, 1640 and 1641 Thomas de Keyser of Amsterdam, Johannes Verspronck of Haarlem and Herman Doncker of Enkhuizen also painted the portraits of individual ensigns, but, with the exception of the Verspronck, they are not life-size (The Hague, Mauritshuis; Montreal, private collection; and Netherlands, private collection respectively).[1] Like Floris Soop, who was ensign of the Amsterdam guard company for the 15th Precinct, these painted ensigns are all dressed in the clothes they would actually have worn on duty. With a sash or bandolier over their best costume, sometimes with an iron gorget beneath their pleated linen collars, and always with a plumed hat, they are decked out in the very height of fashion, as befitted men who were the ornaments of their company.

Rembrandt's ensign, on the other hand, is wearing a slightly fanciful costume of a decidedly sixteenth-century vintage, with a leg-of-mutton sleeve and a codpiece, a slashed beret and two large feathers. Only the feathers, sash and gorget would have passed muster with Soop and his fellow-ensigns. Rembrandt evidently took the idea for his figure from sixteenth-century depictions of the standard-bearer as a military type, as depicted in prints by Dürer (Bartsch 87), Lucas van Leyden (Bartsch 140) and Goltzius (Bartsch 125, 217, 218). The symbolic significance of Goltzius's standard-bearers is clear from the inscriptions, one of which (Fig. 26c) reads: 'Signifer ingentes animos et corda ministro; me stat stante phalanx, me fugiente fugit' (I, the ensign, furnish great courage and daring: while I stand firm the line holds, but were I to flee it would take to flight). Rembrandt's painting can therefore be taken as a symbolic representation of the ensign *sans peur et sans reproche*, the gallant hero who ran the greatest risk in battle (which is why ensigns always had to be bachelors) and whose dauntlessness stiffened the backbone of the entire company.

Many authors have recognised Rembrandt himself in this figure of the standard-bearer. It could be that he found his own head a suitable model for the type he had in mind, which seems to have been inspired by Goltzius's *Captain* (Bartsch 126), but it is going beyond the bounds of scholarly exegesis to interpret this as a proclamation of Rembrandt's patriotism.[2]

P.v.Th.

1. For illustrations see Bruyn *et al.* 1982–, Vol. III, p. 230, Fig. 5 (the Munich portrait); exhib. cat. Haarlem 1988, Nos. 196 (Van der Maes) and 197 (De Keyser), and p. 126, Fig. 98 (Doncker); exhib. cat. The Hague & San Francisco 1990–91, p. 118, Fig. 23 (Verspronck).
2. Chapman 1990, pp. 141–43.

26b: J. Houckgeest, *Portrait of a Standard-Bearer*, 1621. The Hague, Hague Historical Museum.

26c: H. Goltzius, *The Standard-Bearer*, 1587. Engraving. Amsterdam, Rijksprentenkabinet.

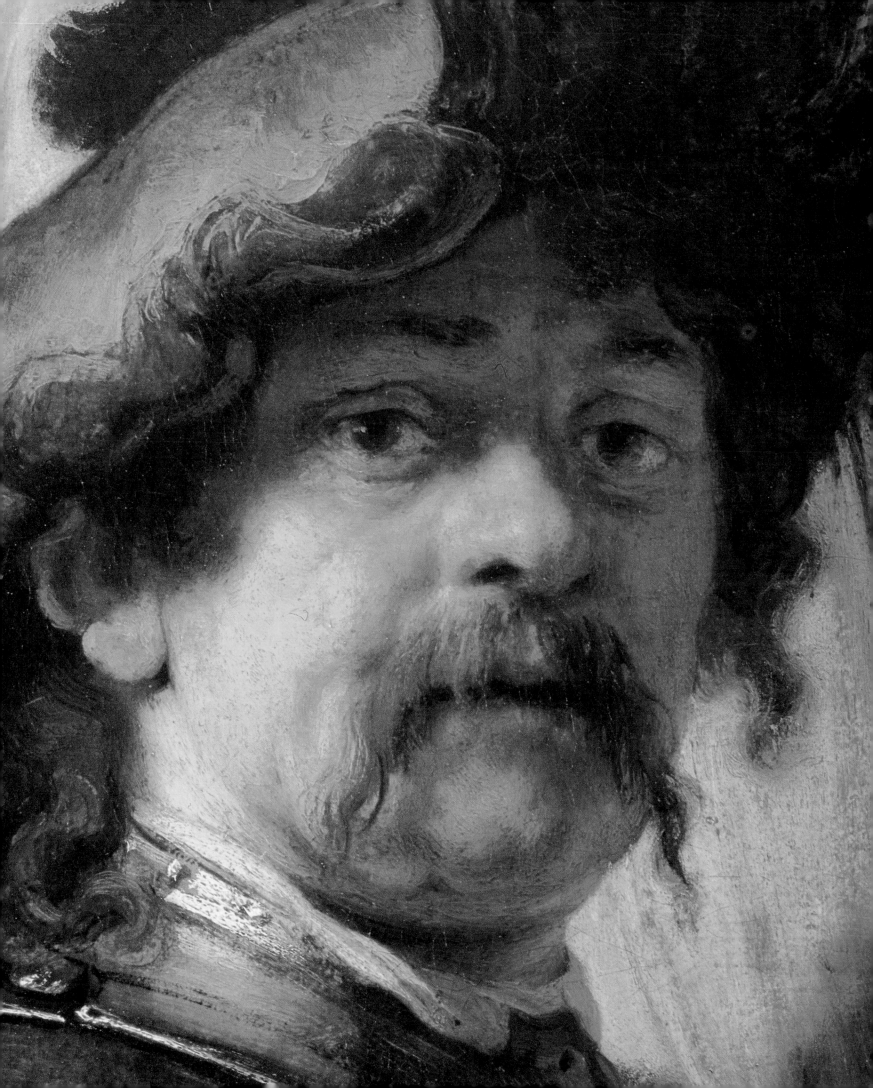

27

Christ appearing to Mary Magdalen

1638
Panel, 61 × 49.5 cm, signed and dated
Rembrandt ft 1638.
Glued to the back of the panel is a piece of
paper with a sonnet about the painting by J. de
Decker, which was copied from a 1726 edition
of his poems (*Rijmoefeningen*, Vol. II, p. 230),
which were originally published in 1660.
London, Buckingham Palace, H.M. Queen
Elizabeth II, Inv. No. 1154

Provenance: Willem van der Goes collection,
tax collector at Leiden in 1730. Collection of
Valerius Röver (1686–1739), Delft, MS. Cat.,
No. 18: 'de Here Christus in de gedaante van
een Hovenier bij het graf aan Maria Magdalena
zig vertoonende door Rembrandt. Gloeyend en
konstig geschildert A° 1638 [. . .] 213 [gulden]
10 [stuivers] hoog 23 duym, breet 19 duym
gekogt van de Hr Willem van der Goes
tegenwoordig Ontfanger te Leiden' (Christ the
Lord appearing to Mary Magdalen by the tomb
in the guise of a gardener, by Rembrandt.
Glowingly and skilfully painted in the year
1638 [. . .] 213 [guilders], 10 [stuivers], height
23 inches, width 19 inches, purchased from
Mr Willem van der Goes, presently collector at
Leiden). Sold in 1750 by Röver's widow
to Landgrave Wilhelm VIII of Hessen-Kassel.
Removed to France in 1806 during the French
occupation, and subsequently in the collection
of Joséphine de Beauharnais at Malmaison.
Probably sold by her son Eugène Beauharnais
to the dealer P.J. Lafontaine. Acquired by
exchange from the latter by the English Prince
Regent (later King George IV) in 1819.

Literature: Bredius/Gerson 559; Bauch 66;
Gerson 82; *Corpus* A124. K.H: de Raaf,
'Rembrandt's Christus en Maria Magdalena',
Oud Holland 30 (1912), pp. 6–8.

Exhibitions: London 1826, No. 24. London 1827,
No. 19. The Hague 1948, No. 6. Edinburgh
1950, No. 36. London 1952–53, No. 113.
Amsterdam & Rotterdam 1956, No. 34.
Manchester 1957, No. 109. London 1971–72,
No. 15. London 1988, No. 35.

This painting of 1638, which is in good
condition, is a splendid illustration of
Rembrandt's varied and relaxed manner. Both
the broad and lightly handled passages, such as
the rock-face around the entrance to the tomb,
and the denser and more detailed areas, like the
small plants and trimmed hedges in the
foreground, are executed with the same facility
which seems to have been brought to bear on
the entire ingenious and absolutely convincing
composition. Rarely did Rembrandt give
nature such a dramatic role in a history
painting as it has here, where the early
morning light rolls back the darkness and,
grazing the two principal actors, illuminates
the angel in a way that suggests he too is a
source of radiance.

After relating how Jesus was buried on the
eve of the Sabbath in a tomb freshly hewn out
of the rock outside Jerusalem, St John (20:11–
18) describes how Mary Magdalen went there
at dawn on the day after the Sabbath and
discovered that the tomb had been opened. In
dismay she ran back to the city and told the
disciples. Two of them returned with her and
entered the tomb, only to discover that it was
empty. The disciples then departed, leaving the
grieving Magdalen behind. She stooped down
and peered into the sepulchre, where she saw
two angels dressed in white. They asked her
why she was weeping, and she replied: 'Because
they have taken away my Lord, and I know
not where they have laid him'. She then turned
away and saw Jesus standing near her, but did
not recognise him. Thinking that he was a
gardener who had removed the body she asked
him where he had put it. Jesus then called her
by her name, and she recognised him. He said:
'Touch me not, for I am not yet ascended to
my Father', and told her to go back to the city
and tell the disciples that he had risen from the
dead and that his Ascension was at hand.

Artists often depicted the moment when
Jesus said to Mary Magdalen 'Touch me not',
as she reaches out a hand to confirm that her
eyes are not deceiving her. Such scenes are
given the title *Noli me tangere*, the Latin form
of Christ's words. That, though, is not the
subject of this painting, nor is the moment
immediately preceding it, when the Magdalen
is startled to discover a man standing behind
her. The action here appears to be taking place
a few seconds later, when she realises that this
is not the man who tended the garden and the
tombs, but the risen Christ. With her
handkerchief still clasped in her hand she
raises her arms in shocked recognition. On the
step in front of her are the unused jar of
ointment and the cloth which she had brought
to anoint the body. In the background the

Temple, recognisable from the two pillars called Jachin and Boaz standing in the forecourt, dominates the view of Jerusalem bathed in the early morning light. The two women seen leaving the garden are not mentioned in St John's gospel. According to St Luke (24:10), Johanna and Mary, the mother of James, were also present, but Mark 16:1 identifies the former as Salome.

There is nothing so welcome as a contemporary witness when trying to give a historically correct explanation of an artist's intentions. Such documents are extremely rare, but in this case we have the following poem by Rembrandt's friend Jeremias de Decker (1609–66), which was first published in an anthology in 1660.[1]

Op d'Afbeeldinge van den Verresen Christus en Maria Magdalene, Geschildert door den uytnemenden Mʳ Rembrant van Rijn, voor H.F. Waterloos

Als ick d'History lese, ons by sint Ian
 beschreven,
En daer benevens sie dit kunstrijck Tafereel,
Waer (denck ick dan) is pen soo net oyt van
 pinceel
Gevolgt, of doode verw soo na gebrogt aen't
 leven?

't Schynt dat de Christus segt: Marie, en wilt
 niet beven.
Ick ben't, de dood en heeft aen uwen Heer geen
 deel:
Sy sulcx geloovende, maer echter nog niet heel,
Schynt tusschen vreugde en druck; en vreese
 en hoop te weven.

De graf rots na de kunst hoog in de lucht
 geleyd,
En rijck van schaduwen, geeft oog en majesteyt
Aen all de rest van 't werck. Uw' meesterlycke
 streken,
Vriend Rembrant, heb ick eerst sien gaen langs
 dit paneel;
Dies mocht mijn' Pen wat Rijms van uw
 begaeft Pinceel
En mijnen Int wat Roems van uwe Verwen
 spreken.

 J. de Decker

(On the representation of the risen Christ and Mary Magdalen, painted by the excellent Master Rembrandt van Rijn, for H.F. Waterloos

When I read the story told us by St John
And then view this artful scene,
Where, I wonder, was pen ever so truly
 followed
By the brush, or lifeless paint so closely
 brought to life?

It is as if Christ is saying 'Mary, do not
 tremble,
It is I, death has no part of your Lord'.
She, believing this, and yet not fully,
Likes to hover 'twixt joy and sorrow, fear and
 hope.

The grave rock raised towering to the sky by
 art's dictate,
And rich in shadows, lends spectacle and
 majesty
To the whole. Your masterly strokes,
Friend Rembrandt, I first saw pass upon this
 panel;
Thus my pen could rhyme your gifted brush,
And my ink extol your paints.

 J. de Decker)

So De Decker, who dedicated his sonnet to H.F. Waterloos, confirms that this is indeed the moment when Jesus reveals himself to Mary Magdalen, to whom comes the dawning rather than sudden realisation that the man beside her really is Christ.

De Raaf and subsequent authors interpreted the title of the poem as meaning that Rembrandt made the painting for the sick-visitor, teacher and poet, Herman Frederik Waterloos (d. 1664), who like De Decker was a friend of his. The authors of the Corpus rightly point out that it cannot be deduced from the title that Rembrandt painted the picture for Waterloos, but simply that De Decker dedicated his poem to Waterloos.[2] He must, of course, have had a reason for doing so, the most likely being that Waterloos was the owner of the painting (possibly but not necessarily the first one) when De Decker wrote his poem. which could have been at any time between 1638 and 1660. The passage 'Your masterly strokes, Friend Rembrandt, I first saw pass upon this panel', is difficult to interpret. Does it mean that De Decker actually saw Rembrandt working on the panel in 1638, as has always been thought? (Some authors took these two lines and the fact that it was only many years later that Rembrandt painted two portraits of De Decker—one

before 1660 which has since disappeared, and another in 1666 which is now in Leningrad—as evidence that the poem refers to another, later painting of the same subject which is no longer traceable.) Or is the explanation, as the authors of the Corpus believe,[3] that it was in this picture that De Decker first discovered Rembrandt's mastery, in other words that the statement refers more to the finished painting than to the act of its creation? This poetic reading does not appear to rule out the factual interpretation automatically.
P.V.Th.

1. Van Domselaar 1660, p. 405.
2. Bruyn et al. 1982–, Vol. III, p. 263.
3. Ibid.

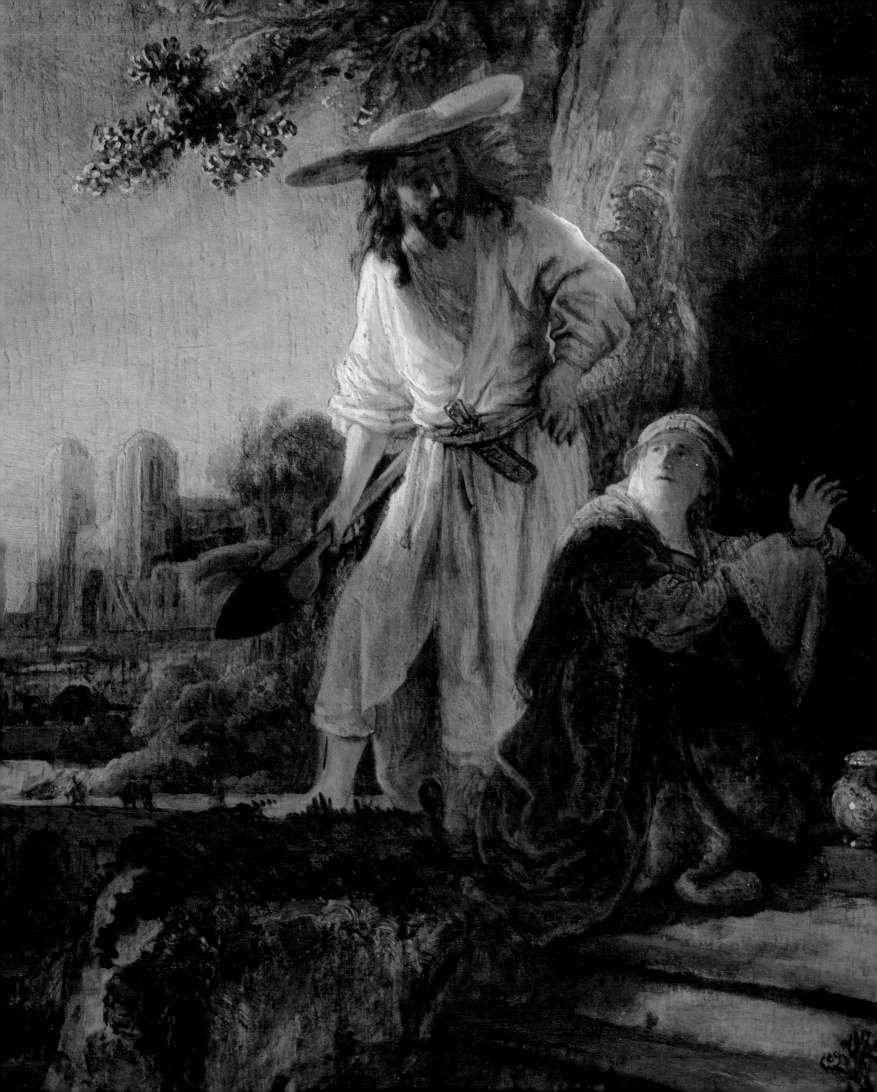

A Man in oriental Costume

c.1639
Panel, with rounded upper corners (slightly inset), 102.8 × 78.8 cm, possibly authentic signature and date: *Rembran[dt] f 1639*
Chatsworth, Duke of Devonshire collection

Provenance: Bought by the 3rd Duke of Devonshire at the otherwise unknown De Piles sale, 29 April 1742, No. 36.

Literature: Bredius/Gerson 179; Bauch 164; Gerson 70; *Corpus* A128.

Exhibitions: London 1878, No. 169. London 1899, No. 83. London 1894, No. 47. Amsterdam 1898, No. 39. London 1929, No. 169. Amsterdam 1932, No. 8. London 1948a, No. 24. London 1976, No. 86.

Judged purely on the handling of form this painting is related to the half-length figures which Rembrandt painted from 1634 onwards—among them the *Flora* of 1635 (Cat. No. 23) and *The Standard-Bearer* of 1636 (Cat. No. 26) in the present exhibition—but the attention to detail recalls earlier work. The blotchy skin of the face and the wrinkled hands are very carefully depicted, as are the turban and the large clasp at the man's breast. The interior in the background (Fig. 28a) is rendered in a manner that is actually reminiscent of paintings from the end of Rembrandt's Leiden period. Contrasted with this eye for detail, however, there is the free handling of the paint, which never gets lost in minutiae, as can be seen from the wrinkles of the hands, which are suggested rather than defined precisely. The subdued, subtle lighting contributes greatly to the monumental volume of the imposing figure and to the illusion of atmospheric space around it. Although the amount of detail is a little surprising, the execution and lighting make it plausible that the painting was executed around 1639, the date given in the barely visible and oddly large signature crammed into a confined space at the extreme left, some 14.5 cm from the lower edge.

The identity of the figure has not yet been satisfactorily established. Some have suggested that he is a rabbi, while others, citing the snake in the background, have proposed Paracelsus, Moses or Aaron, but these hypotheses fail to take proper account of the way in which the snake is depicted—not coiled around a staff but around a gold-coloured, fluted column, which stands on a pedestal on a round table in front of which there is a folding chair. On the capital of the column, between two spherical shapes, is a leonine head with long horns, two fangs and flaring nostrils. A skull lies at the foot of the column.

Other elements which appear to have a bearing on the iconography of the scene include the seemingly religious nature of the setting. In the left background there is a broad pillar with a capital supporting an architrave, while curved lines rising to the right suggest an arch or vault. One suspects that the grey flecks that disfigure the man's face are also essential clues to his identity. They are not due to discolouration of the paint, and it is hard to interpret them as anything but the marks of leprosy.

Tümpel's recent hypothesis that this is Jacob's son Dan,[1] a judge in Israel who was blessed by his father with the words 'Dan shall be a serpent by the way, an adder in the path, that biteth the horse heels, so that his rider shall fall backward' (Genesis 49:17), fails to explain why the snake is twined around a column. Equally unsatisfactory is the earlier theory by Robert Eisler,[2] namely that this is King Uzziah of Judah, who brought great prosperity to his realm but became so puffed-up with pride that he entered the Temple and tried to burn incense to God, which only priests were permitted to do. He was punished by being struck with leprosy (2 Chronicles 26:16–20). Eisler linked this episode with the later story of King Hezekiah, who destroyed Moses's brazen serpent to which the Israelites burned incense (2 Kings 18:4). The difficulty with this explanation is that Rembrandt could hardly have meant the snake twisted around the column to be the brazen serpent of Moses, and that the altar, which stands in a space which does not match the Temple in Jerusalem as usually depicted by Rembrandt, is not an altar of incense. The story of King Uzziah related by Flavius Josephus is of no help in resolving this problem.[3]

Werner Sumowski recently published a painting which he attributed to Ferdinand Bol of the same subject depicted in a very similar manner.[4] Here the man is sitting a chair and supports his head with his right hand in the attitude of melancholy. There are no flecks on his face which might indicate leprosy. The interior in the background corresponds closely to that in Rembrandt's picture, but with the addition of a terrestrial and a celestial globe on the ground, which would appear to identify the oriental figure more as a classical philosopher than a biblical character.
P.v.Th.

1. Tümpel 1986, p. 187, Cat. No. 77.
2. Communicated to the owner of the painting in 1948 and summarised in Bruyn *et al.* 1982–, Vol. III, p. 294.
3. Flavius Josephus, *Jewish Antiquities*, Bk. IX, cited in Schwartz 1984, p. 176, caption to Fig. 183.
4. Sumowski 1983[–1990], Vol. 5 (Nachträge), No. 2010. Canvas, 115.5 × 111 cm; private collection. This work is not identical with one of the four copies mentioned in the *Corpus*, III, p. 296.

28a: Cat. No. 28 (detail).

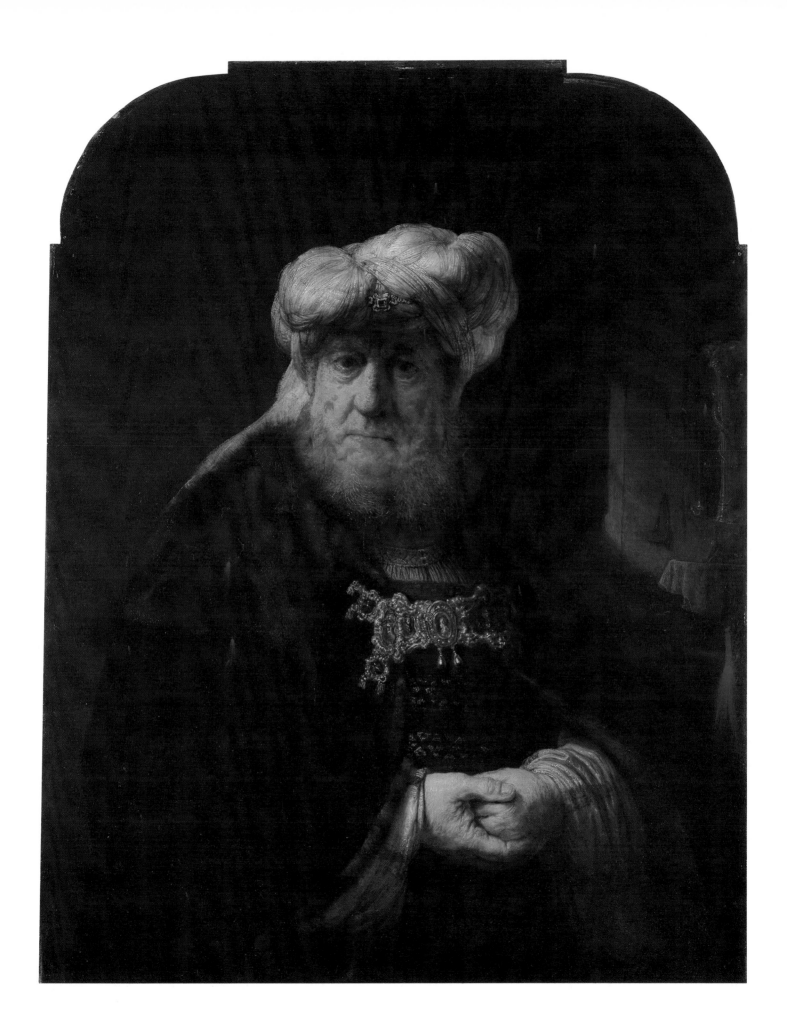

29

Portrait of a Man standing

c.1639
Canvas, 200 × 124.2 cm, unreliable signature and date: *Rembrandt 1639*
Kassel, Staatliche Kunstsammlungen Kassel, Schloss Wilhelmshöhe, Inv. No. GK 239

Provenance: Bought in 1752 for 550 Reichsthaler from the Hamburg art dealer Gerhard Morell for Landgrave Wilhelm VIII of Hesse-Kassel. Expropriated by Napoleon's brother Jerôme, King of Westphalia; returned to Kassel in 1815.

Literature: Bredius/Gerson 216; Bauch 384; Gerson 192; *Corpus* A129. S.A.C. Dudok van Heel, 'Het maecenaat De Graeff en Rembrandt', *Maandblad Amstelodamum* 56 (1969), pp. 150–55 (ill.).

Exhibition: Vienna & Kassel 1955–56, No. 23.

In the discussion of Rembrandt's life-size full-lengths of *Marten Soolmans* and *Oopjen Coppit* of 1634 (Cat. Nos. 17–18) it was pointed out that the life-size individual portrait at full-length only became popular in Holland at a comparatively late date, and that Rembrandt received only a few commissions for expensive paintings of this kind. The present 1639 portrait in Kassel, which has been specially cleaned for this exhibition in order to remove a badly-yellowed layer of varnish, shows a man of quality dressed in black who is standing on a raised stone step by a half-open arched door giving onto a room with a tiled floor. Although the door and its surround are shown in some detail, it is not clear whether the man is standing outside a building by the front door or is in an antechamber. The latter is more likely, since other portraitists of the period, Thomas de Keyser among them, painted sitters in a similar setting (albeit on a smaller scale), but in such a way that there is no doubt that they are indoors. This is not to say that the decor is necessarily as true to life as the portrait, but even if this is not an actual location that would have been recognisable to Rembrandt's contemporaries, the correspondence with reality would probably have been such that this door, with a decorated pilaster and a balustrade let into the wall on the left, aroused a particular association, presumably with a room in a public building rather than a private house.

The man is resting his right arm on a tall pedestal, over which his cloak is draped in a wide flare, and his weight is on his left leg, giving him that relaxed classical pose which history painters had long used for their invented figures but which Dutch portraitists had never before employed so demonstratively for their living models. As a result of the strange concentration of light, which falls from the left onto the raised floor and the lower left part of the picture, and of the finely calculated balance between the amount of detail in the figure and the setting (favouring the former), the man stands free like a statue on a pedestal.

The glove that has fallen to the floor is a strange feature which the modern viewer might take as evidence of the realism of the scene, in which a place has also been found for the chance detail. In fact, the glove was included with a very definite purpose in mind, and testifies to the meticulous stage management of the entire composition, even if we are unable to grasp its significance. Authority is one of the central concepts of glove symbolism, and as noted above (Cat. Nos. 17–18) it plays a part in the imagery of marriage as a token of the man's authority over the woman. If that is its

meaning here, there must have been a pendant portrait of the man's wife, but if that were so it would be a very odd departure from the standard iconography to leave the glove lying on the ground waiting to be picked up. Gloves could be thrown to the ground by way of a challenge, to a duel for example,[1] but that hardly seems applicable here. For the time being, then, the purpose of this discarded glove remains a mystery.

The identity of this elegant gentleman was already unknown by the eighteenth century. Since the 1850s he has been successively named as Jan Six, Rembrandt himself, and Frans Banning Cock, the captain of the *Nightwatch*. Dudok van Heel associated the painting with an expensive (in other words large) portrait of Andries de Graeff by Rembrandt, the existence of which is known from archival documents. De Graeff was 28 years old in 1639, and served several terms as burgomaster of Amsterdam between 1657 and 1671. He would be the ideal candidate, were it not for the fact that two documented portraits of him from later years show a man with very different features. The authors of the *Corpus* accordingly reject this identification, and have put forward a name of their own:[2] Cornelis Witsen, who was 34 in 1639, lent Rembrandt a considerable sum of money in 1653, and was four times burgomaster of Amsterdam in the 1650s and 60s. His appearance, which is preserved in portraits of 1648, 1655 and 1658, is remarkably close to that of this standing man, but no document has yet come to light to confirm that Rembrandt ever painted the portrait of this particular Amsterdam patrician.
P.v.Th.

1. Du Mortier 1984, p. 200, note 35.
2. Bruyn *et al.* 1982–, Vol. III, pp. 303–4.

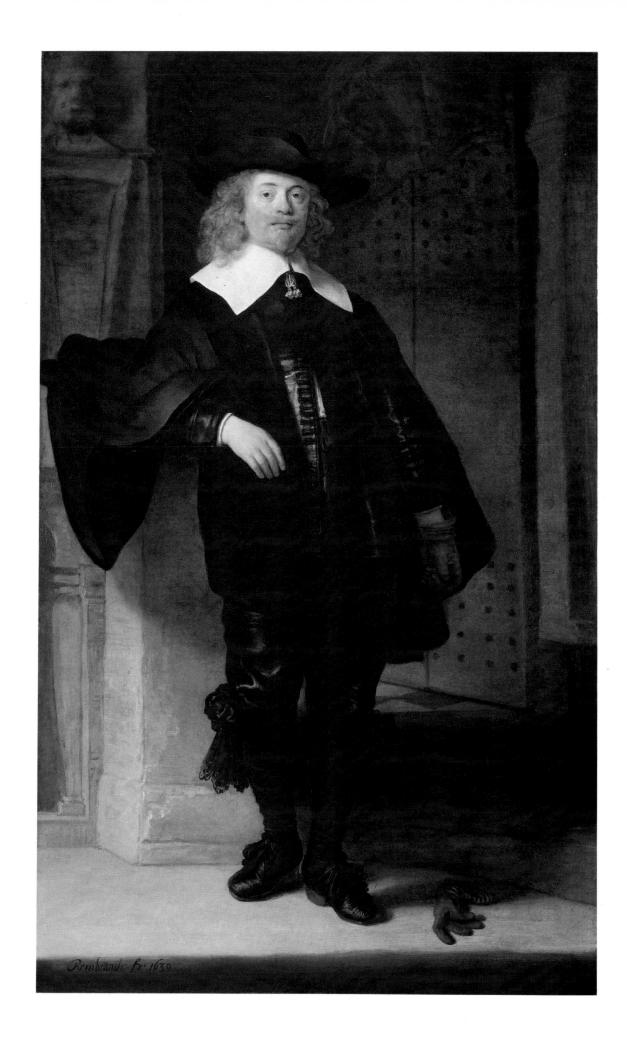

Still Life with two dead Peacocks and a Girl

c.1639
Canvas, 144 × 134.8 cm, unreliably signed:
Rembrandt
Amsterdam, Rijksmuseum, Inv. No. A3981

Provenance: Estate inventory of Clara de Valaer, widow successively of Eduart van Domselaer and of Hendrick van Domselaer, drawn up in Amsterdam on 16 October 1660: 'Een stuck synde twee pauwen ende een kint van Rembrant' (A painting of two peacocks and a child by Rembrandt). Estate inventory of Tobias van Domselaer, second son of Eduart van Domselaer and Clara de Valaer, drawn up in Amsterdam in September 1685: 'Een groot schilderij met twee paeuwen van Rembrandt' (A large painting with two peacocks by Rembrandt). W.C. Cartwright collection, London, c. 1878–99. F. Muller gallery, Amsterdam, c. 1914–18. J.J.M. Chabot collection, Wassenaar (on loan to the Rijksmuseum, 1923–42). From 1948 on loan to the museum from the Stichting Nederlands Kunstbezit (Foundation for Dutch Art Holdings); ownership transferred to the museum in 1960.

Literature: Bredius/Gerson 456; Bauch 558; Gerson 98; *Corpus* A134. F. Schmidt-Degener, 'Rembrandts Pfauenbild', *Kunstchronik und Kunstmarkt* 54 (1918/19), pp. 3–7.

Exhibitions: London 1819, No. 90. London 1839, No. 68. London 1878, No. 95. Amsterdam 1898, No. 49. London 1899, No. 101. London 1929, No. 102. Amsterdam 1932, No. 13. Amsterdam 1933, No. 260. The Hague 1946, No. S 1. Basel 1948, No. 19. Rome 1956–57, No. 242. Tokyo & Kyoto 1968–69, No. 47. Brussels 1971, No. 81. Madrid 1985–86, No. 14. Tokyo 1987, No. 84.

Although the poor script of the ostentatious signature makes it unlikely that it was Rembrandt himself who put his name to this picture, and despite the fact that the subject is not part of his normal repertoire, it is unmistakably an autograph work. This is apparent from the distinctive handling of the paint, the lighting and the colour scheme.

For this display of dead peacocks Rembrandt created an architectural setting which is quite clearly articulated by his usual standards. A thick wall is interrupted by an arched window without lights and a shutter opening to the right, from the bolt of which a peacock hangs by its legs. Running below the window is a broad ledge on which a second bird is lying beside a basket of fruit. A tub stands in the shadow on the far right. A young girl looks out of the window, resting both arms on the sill. From high up on the left a shaft of light shines down on the shutter, bringing out the stretched legs of the peacock, and on the wing hanging down to the left, which is in the centre of the picture and forms the highlight of the brilliant rendering of the bird's plumage.

It can be seen both from the painted surface and the X-ray photograph that Rembrandt altered the composition and the distribution of light while he was working on the picture. In the lower right corner, in particular, the X-ray deviates sharply from the surface. The original arrangement is not entirely clear, but in any event the head of the hanging bird did not cast a shadow on the horizontal ledge, but on a lit vertical surface now occupied by the basket of fruit, which was probably added at a later stage, when the shadow of the head was altered. The opaque layer of paint on the lower part of the window-jamb (above the hanging peacock's short tail) contrasts oddly with the section immediately above, which is executed in thin, translucent paint up to and including the springing of the arch. When the picture was restored recently, long curved shapes were observed in the dark window opening to the left of this opaque passage which do not correspond with the similar but straighter shapes revealed by the X-ray. The latter are evidently in the ground layer, the others in the paint layer. It seems that Rembrandt originally gave the hanging peacock a long tail that swept up in a wide curve to the left, above the girl's head.

This fairly large, grandly conceived painting with the quite finely detailed birds displayed to good effect against the broad surfaces of the massive decor has the same monumental effect as the *Portrait of a Man standing* of 1639 (Cat. No. 29), which is lit in a similar fashion. The relationship in form and approach between

these two pictures supports a date of around 1639 for the *Peacocks*. The only other work in Rembrandt's œuvre with a related theme, the *Dead Bittern held high by a Hunter* in Dresden (*Corpus* A133) must also have been executed in or around that year.

It would be easier to understand this still life with dead birds as an exception within the œuvre of Rembrandt, the history and portrait painter—as an isolated excursion into a genre that fell outside his true domain—if it could only be fitted within the evolution of the seventeenth-century still life, which is the case with that other exception, his etching *The Shell* (Bartsch 159), done after a model by Wenzel Hollar.[1] However, it is as difficult to explain this scene of a young girl at a window with peacocks in the context of the tradition of the Haarlem and Amsterdam kitchen piece, which was introduced into the northern Netherlands by Flemish artists and combined a still life with human figures (invariably voluptuous young women, never an innocent child). It is equally difficult to relate it to the speciality practised by Elias Vonck and others of the still life with dead poultry, which by 1639 had still not brought forth a picture with the grandeur of Rembrandt's.

The *Peacocks* undoubtedly had a meaning which Rembrandt's contemporaries would have understood, but as yet it still eludes us. One can well imagine that this ornamental work would have lent a perfect touch to the decoration of a room, let into the panelling above a door for instance, but unfortunately we know nothing at all about its original function.
P.V.TH.

1. Van Regteren Altena 1959, pp. 81–86.

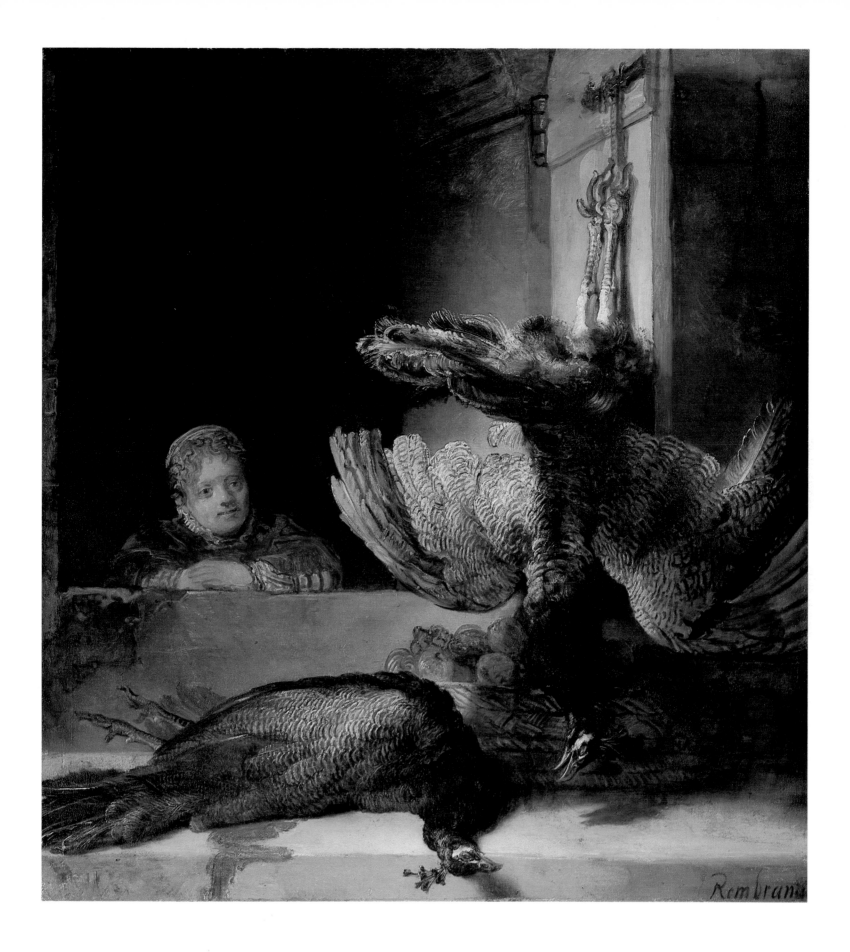

Landscape with a stone Bridge

Late 1630s
Panel, 29.5 × 42.3 cm
Amsterdam, Rijksmuseum, Inv. No. A1935

Provenance: Sale Lapeyrière, Paris, 24 April 1817 and subsequent days, No. 46; to Huybens for 1,505 francs. James Gray, collection, Versailles, 1863. Marquess of Lansdowne collection, Bowood, 1883. Sale James Reiss, London (Christie's), 12 May 1900, No. 63, where purchased by the museum with the aid of Dr A. Bredius and the Rembrandt Society.

Literature: Bredius/Gerson 440; Bauch 543; Gerson 196; *Corpus* A136.

Exhibitions: London 1899, No. 35. Amsterdam 1923, No. 31. Rome 1928, No. 95. London 1929, No. 148. Amsterdam 1932, No. 11. Brussels 1946, No. 84. Paris 1950–51, No. 66. Zürich 1953, No. 111. Rome & Milan 1954, Nos. 111 and 114 respectively. Stockholm 1956, No. 19. Amsterdam, Boston & Philadelphia 1987–88, No. 76.

It was only in 1900 that the Rijksmuseum, which had several Rembrandts on loan but not one in its permanent collection, made the fortunate purchase of this *Landscape with a stone Bridge*—its first authentic painting by the master. The title, conferred at a time when it was automatically assumed that Rembrandt had depicted an actual seventeenth-century landscape near Amsterdam, stresses the fact that the bridge is of stone—a comparative rarity in a period when most country bridges were wooden. It stands in a flat stretch of countryside and spans a small river on which two small boats are being punted along by fishermen. On the right is a meadow with cows. A path on the left bank leads to an inn, in front of which a party of men and women have drawn up in a horse-drawn cart. It is not entirely clear whether this path continues to the right over the bridge or joins another one that crosses the bridge roughly parallel to the picture plane. The latter seems more probable, for a man with a stick over his shoulder is approaching from the left. Across the river the path runs inland past a fence in front of a group of tall trees standing beside a farmhouse and a haystack. Rising over a lower stand of trees to the right is the spire of a distant church. A farmer driving a cow and a few other figures walk along this stretch of the path. It is a charming scene, and would be a perfect picture of rural tranquility were it not for the lowering sky that sends shadows chasing across the land and water and the loom of light from the left striking dazzling accents off the path and the bridge before falling onto the fence, the tall trees and the farmhouse roof with the trees around it.

The brushwork follows the distribution of light. The paint is thin in the dark passages and thinnest in the sky. It is thicker in the lighter areas, tending to impasto where the light is brightest. There, in the trees, the branches and leaves are picked out with a fine brush, more delicately the nearer they are to the viewer, with a keen eye for their structure. Elsewhere the landscape is executed more broadly but no less suggestively.

It is difficult to attach a precise date to this panel, partly because there are only a few known landscape paintings by Rembrandt, only one of which is dated—the *Landscape with the Good Samaritan* of 1638 in Kraków (*Corpus* A125). Rembrandt's earliest dated landscape etching is from 1641, and his drawn landscapes are equally unhelpful as points of reference. Since the Kraków picture is far more a product of the imagination than the realistic work in Amsterdam, and an unwritten law ranks the subjective imagination above objective reality,

and the realistic before the imaginary in intellectual development, most authors have dated the Amsterdam painting before 1638.[1] Leaving aside the fact that artistic development rarely if ever seems to follow this law, there is a new objective datum that negates the sequence in this particular case.

Dendrochronological examination of the panel shows that it was sawn from a tree that was felled in 1636 at the earliest. Under the rules of this scientific dating method, the panel could just possibly have been painted in 1638, but in practice it was probably executed somewhat later.

Attempts to identify the location of this landscape in the area around Amsterdam have not proved very convincing. In fact there is little point in searching there, for this is probably not a real stretch of countryside but an idealised landscape with a hidden moral—a genre that evolved in the southern Netherlands in the sixteenth century. Its central theme is the pilgrimage of life: the laborious road that man must follow on earth and that will eventually bring him eternal salvation, provided he does not succumb to the many temptations that lie in wait for him on the way.[2] Drawing on the vast repertoire of symbolic motifs available for the '*paysage moralisé*' Rembrandt has here blended a number of standard elements to create an allegory rich in meaning. In the first place there is the inn, a place of sin, and the cart, which has stopped outside and will therefore never reach the distant church, where salvation awaits. The river is an image of the fleeting nature of life, and the bridge a symbol of Christ, according to Picinello on the authority of John 14:6: 'I am the way, the truth, and the life'.[3] The fence, the bare-branched trees and the haystack can be interpreted as metaphors of transience and death. The men on the river and most of the figures on the path probably represent those who are indifferent to their fate or who have wandered astray. The only person who is purposefully going to meet his end is the bowed figure with the stick, who is approaching the bridge beneath the threatening sky with the light at his back.

Although this may not be an true-to-life landscape, it is certainly a very believable Dutch scene which has much in common with the realistic school of landscape painting that flourished in Haarlem in the first quarter of the seventeenth century. So as C.J. de Bruyn Kops recently suggested,[4] it is very possible that Rembrandt turned to the extensive print œuvre of Jan van de Velde for inspiration, and that in the latter's etching of *Skaters on a river* (Fig. 31a) he not only found the unusual motif

of the stone bridge but also the basic design for his composition.

P.V.TH.

1. As was recently done by Schneider 1990, p. 169, Cat. No. 1 (c. 1636–38).
2. J. Bruyn, 'Towards a scriptural reading of seventeenth-century Dutch landscape paintings', in exhib. cat. Amsterdam, Boston & Philadelphia 1987–88, pp. 84–103.
3. Picinello 1653, Bk. XVI, Ch. 14, No. 129.
4. C.J. de Bruyn Kops, in exhib. cat. Amsterdam, Boston & Philadelphia 1987–88, No. 76, Fig. 1.

31a: Jan van de Velde, *Skaters on a River*, 1616. Etching. Amsterdam, Rijksprentenkabinet.

Self-Portrait at the age of 34

1640
Canvas, rounded at the top, 93 × 80 cm, signed and dated *Rembrandt f 1640*; inscribed *Conterfeycel* below the signature (an addition probably made by a later seventeenth-century hand)
London, The National Gallery, Inv. No. 672

Provenance: Collection of General Dupont, Paris (Pierre Comte Dupont de l'Etang, 1765–1840, or his brother, Dupont-Chaumont, 1759–1838). Purchased by the museum in September 1861 from General Dupont's heirs.

Literature: Bredius/Gerson 34; Bauch 316; Gerson 238; *Corpus* A139. E. de Jongh, 'The spur of wit: Rembrandt's response to an Italian challenge', *Delta. A Review of Arts, Life and Thought in the Netherlands* 12 (1969), No. 2, pp. 49–67. C. Brown, see London 1980. MacLaren/Brown 1991, No. 672.

Exhibitions: Paris 1861, No. 119. London 1980, unnumbered. London 1988–89, No. 8.

The radical treatment to which this picture was subjected at some stage in the past did little good to the paint layer. The original canvas was replaced by another (an unusual restoration method, for it was and still is customary to reinforce a weakened support by backing it with a new canvas, in much the same way as a shoe is resoled). Later, when the replacement canvas had also deteriorated, the picture was relined by attaching it to a supporting canvas in the normal way, at which time the painting was lengthened by some 9 cm at the bottom. In the 1970s this lining canvas was removed and the painting, together with the added strip at the bottom, was marouflaged to a rectangular synthetic panel. Visible at the top of the x-ray photograph (Fig. 32a) are the curved tacking edges, which have been unfolded, and a series of nail-holes, which show that the picture was at one time attached to a stretcher with an arched top.

The question is whether the present arched shape of the portrait corresponds with the original shape, and if so whether Rembrandt painted his portrait on a rectangular piece of canvas which was later cut to an arch at the top, or on a canvas which he himself gave a curved top edge. Scientific examination suggests that the original canvas was rectangular, but that Rembrandt left the upper corners unpainted (or at least omitted them from the compositional field) because he was planning to mount the picture in a rectangular frame with an arched inlay. It is possible, though, that the portrait was originally rectangular, and that at a later stage Rembrandt trimmed off the upper corners and attached the painting to a stretcher with a curved top. Evidence that the portrait was arched, either from the outset or shortly after it was finished, is provided by a drawn copy in Washington ascribed to Rembrandt's pupil Ferdinand Bol, which shows it in its arched form.[1] The present frame conceals the strip added at the bottom as well as the filled-out corners beyond the arch. The curve of the latter is now slightly tighter than it was originally, because at some time in the past a piece was also trimmed from the very top of the picture, flattening the arch.

The x-ray also reveals several changes made during the actual painting process. The first to catch the eye is the adjustment to the collar. Initially this fell in a gentle, uninterrupted curve, and probably did not look like a standing collar until Rembrandt added the projection near the jawline. Less immediately noticeable are the four light-coloured and slightly curved shapes at lower right. These are the fingers of Rembrandt's left hand, resting on the balustrade. The position of this hand

32a: X-ray photograph of the painting.

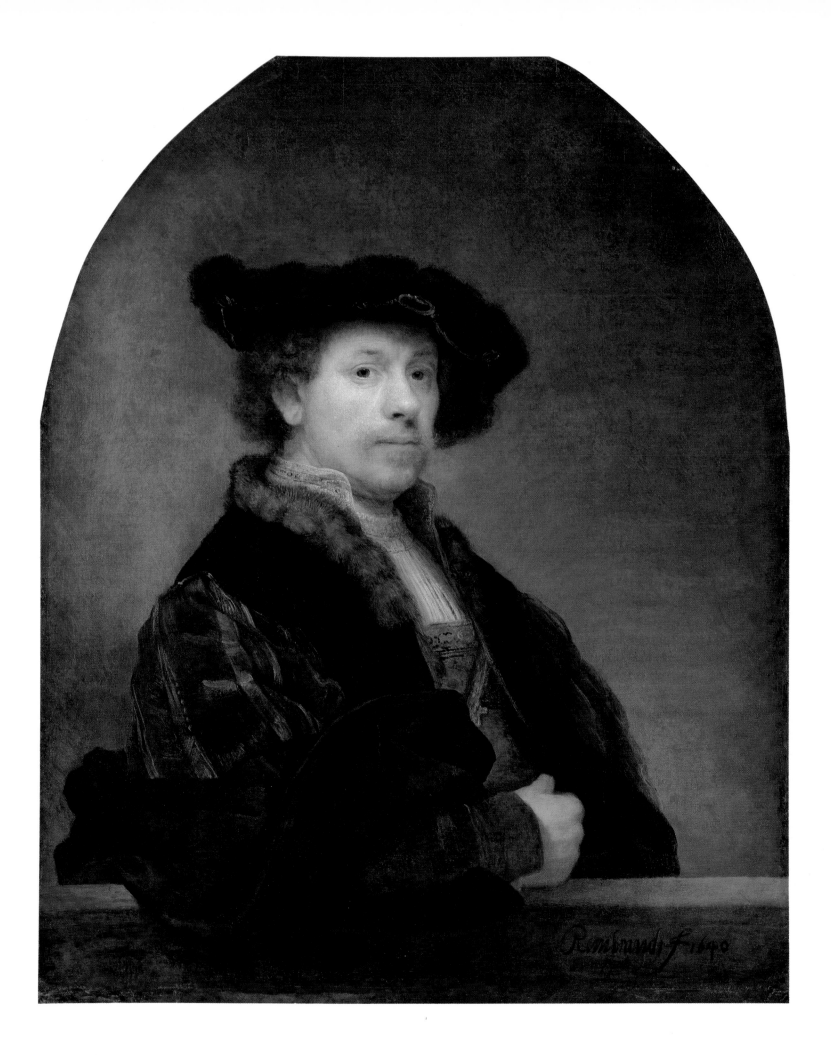

entailed bending the left arm, which left an empty space between the side of the body and the elbow. When the hand was painted out this too was eliminated by overpainting the background. Rembrandt probably made this major alteration, which had repercussions for the spatial effect of the figure, only after the picture had been finished, for a *Self-Portrait* of 1647 by Ferdinand Bol (Fig. 32b), which was plainly painted in imitation of Rembrandt's picture, includes the left hand (and also the standing collar, which means that this detail was changed before the hand was removed). The logical conclusion, that Rembrandt only painted out his left hand after 1647, is contradicted by the fact that both Bol and Govert Flinck executed portraits before that year which also derive from this self-portrait but which do not show the second hand. Bol must therefore have worked from a drawing (not the arched one in Washington, for it lacks the left hand) which he had made of Rembrandt's painting in its first finished state, when the hand was still visible.

As regards the rest of the picture, the x-ray coincides with what one would expect from the surface, which is executed with great refinement and with as much concern for the overall effect as for details. Although the clothing is done with a slightly broader brush than the carefully delineated face and the highly-worked collar, the difference in treatment is minimal. The light contrasts, too, are gradual. The result is a homogeneous painting with the fluently outlined figure set in a muted light which is delicately distributed over the background. It is a distinguished self-portrait in which plasticity and atmosphere are in perfect harmony.

Rembrandt quite clearly took the idea from Titian's *Portrait of a Man* in London (Fig. 32c), which in 1641 was in the collection of Alfonso López, a Francophile Portuguese-Jewish merchant who had converted to Christianity. López lived in Amsterdam from 1636 to 1641, and either then or earlier bought Rembrandt's youthful work *Balaam and the Ass* (*Corpus* A2) directly from the artist. Rembrandt and his contemporaries regarded the Titian as a portrait of the Italian poet Lodovico Ariosto, author of the epic poem *Orlando furioso*. Rembrandt's fascination with this picture by Titian, whom he greatly admired, is evidenced by the fact that he used it as a source of inspiration both for this painting of 1640 and for his etched *Self-Portrait* of 1639 (Fig. 32d).

Much has been written about the formal relationship between these three portraits, and also about the formative role played by two other works: Raphael's *Portrait of Baldassare Castiglione* in Paris (Fig. 32e) and Rembrandt's sketch of it (Fig. 32f), which he made when the picture was auctioned in Amsterdam and bought by Alfonso López, the owner of the Titian. At first it was actually thought that the Raphael was Rembrandt's primary source, due to the position of the head and the hat, which is set at a slant in Rembrandt's sketch and etching but is straight in Raphael's portrait. As E. de Jongh has justly pointed out, however, the essential elements—the leaning posture and the motif of the sleeve—are only found in the Titian, while the alterations to the position of the head (which is at different angles in Rembrandt's painting and etching) and the addition of the hat, either at a slant or straight, were such standard parts of Rembrandt's own repertoire that he had no need of a model.[2] It is illustrative in this respect that in the etching he casually transformed the balustrade into a low wall with vegetation on the top, thus placing himself in an outdoor setting, while in the painting he left the location undefined, as Titian had done.

It is interesting to see how self-assuredly Rembrandt handled the formal aspects of his model, but even more intriguing is the question of what motivated him to derive two self-portraits from Titian's painting. There can be no doubt, as De Jongh has pointed out, that his personal confrontation with a work by Titian presented him with an artistic challenge to excel his illustrious predecessor, in accordance with the highest degree of the tripartite doctrine of *translatio* (style-free imitation), *imitatio* (stylistically equivalent imitation) and *aemulatio* (stylistically enhanced imitation). However, De Jongh is on shakier ground when he says that Rembrandt painted this self-portrait as his contribution to the contemporary debate, known as the *paragone*, on whether painting was superior to literature, i.e. whether sight was more important than hearing, by contrasting himself, the artist, with Ariosto the poet, who was believed at the time to be the subject of Titian's portrait.

Be that as it may, Rembrandt clearly intended this painting to be far more than a straightforward record of his appearance in 1640. In the first place he is not wearing contemporary dress but an elegant costume in

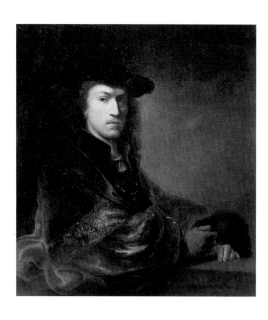

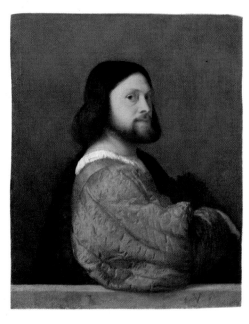

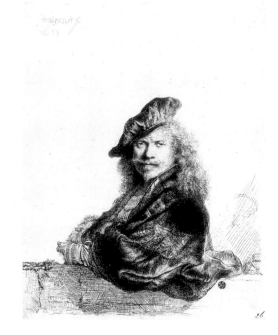

an early sixteenth-century style. It is derived neither from Titian's portrait nor Raphael's, but seems to have been based on other models, which even during the painting process may have given Rembrandt cause to alter the collar into a more authentic type. In his choice of dress Rembrandt appears to be proclaiming himself a kindred spirit of his great Italian predecessors, the direct heirs of classical antiquity. At a time when his features were evidently less well-known than they are now, this misleading costume must have prompted someone who knew how he looked to add the word *Conterfeycel* (the common seventeenth-century Dutch term for portrait) beneath Rembrandt's signature in order to make it abundantly clear that this really is the master himself.

P.v.Th.

1. Washington, National Gallery of Art, Rosenwald Collection. Bruyn *et al.*, 1982–, Vol. III, p. 380, Fig. 5.
2. Bruyn *et al.*, 1982–, Vol. III, pp. 379–80, Brown, in exhib. cat. London 1988–89, No. 8, and Chapman 1990, pp. 72–78, all accord a role to Raphael's *Baldassare Castiglione* in the genesis of these two self-portraits by Rembrandt.

32b: Ferdinand Bol, *Self-Portrait*, 1647. United States, private collection.

32c: Titian, *Portrait of a Man*. London, The National Gallery.

32d: Rembrandt, *Self-Portrait*, 1639. Etching. Amsterdam, Rijksprentenkabinet.

32e: Raphael, *Portrait of Baldassare Castiglione*. Paris, Louvre.

32f: Rembrandt, *Sketch after Raphael's 'Portrait of Baldassare Castiglione'*, 1639. Drawing. Vienna, Albertina.

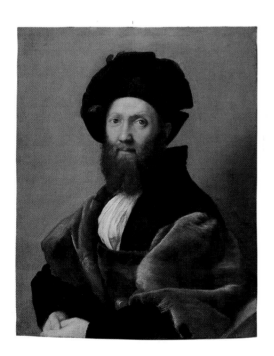

33

Double Portrait of the Mennonite Preacher Cornelis Claesz. Anslo and his Wife Aeltje Gerritsdr. Schouten

1641
Canvas, upper corners rounded, 176 × 210 cm, signed and dated *Rembrandt f 1641*
Berlin, Staatliche Museen Preussischer Kulturbesitz, Gemäldegalerie, Cat. No. 828 L

Provenance: Inherited in 1767 by Cornelis van Vliet, governor of the Anslo Almshouse in Amsterdam, probably through the following family line: bequeathed by Maria, daughter of the sitters, and her husband Anselmus Hartsen to their daughter Teuntje; bequeathed by Teuntje and her husband Jacobus van Laer to their daughter Cornelia; bequeathed by Cornelia and her husband Jan van der Vliet to their son Cornelis, and probably sold shortly after his death in 1780. Sir Lawrence Dundas sale, London, 29–31 May 1794, third day, No. 37: 'Rembrandt. R. Anslo in his study, conversing with his wife. The Admission of the Light, and Effect of the Picture, are truly magical. The Earnestness with which he is speaking, and the profound Attention of the Woman cannot be too much commended, and are only equalled by the Truth of Colouring and the Simplicity of the Composition. Universally allowed to be one of the finest Efforts of his Pencil. High 5 Ft 9 In by Wide 6 Ft 8 In'; to the Earl of Ashburnham for £546. Earl of Ashburnham sale, London, 20 July 1850, No. 91 (bought in at £4,200). Purchased by the museum from the Ashburnham collection in 1894.

Literature: Bredius/Gerson 409; Bauch 536; Gerson 234; *Corpus* A143. E. Galichon, 'Quelques notes à propos d'un portrait de Corneille Nicolas Anslo par Rembrandt', *Gazette des Beaux-Arts* 20 (1866), pp. 234–39. W. Bode, 'Rembrandts Bildnis des Mennoniten Anslo in der Königlichen Galerie zu Berlin', *Jahrbuch der Königlich Preussischen Kunstsammlungen* 16 (1895), pp. 3–12. J.A. Emmens, 'Ay Rembrant, maal Cornelis Stem', *Nederlands Kunsthistorisch Jaarboek* 7 (1956), pp. 133–65. L.C.J. Frerichs, 'De schetsbladen van Rembrandt voor het schilderij van het echtpaar Anslo', *Maandblad Amstelodamum* 56 (1969), pp. 206–11. W. Busch, 'Zu Rembrandts Anslo-Radierung', *Oud Holland* 86 (1971), pp. 196–99. J.-C. Klamt, 'Ut magis luceat; eine Miszelle zu Rembrandts "Anslo"', *Jahrbuch der Berliner Museen* 17 (1975), pp. 155–65.

Exhibitions: London 1815, No. 31. Berlin 1930, No. 373. Schaffhausen 1949, No. 130. Paris 1951, No. 103.

This monumental double portrait, which remained in the sitters' family until the end of the eighteenth century, is in excellent condition, although the upper corners were originally square, not rounded. The Mennonite preacher is sitting behind his work-table in a corner of his study, and has turned to speak to his wife, who is seated on his left in the right of the picture. Set against the back wall is a bookcase almost completely concealed by a curtain. The table is covered with two cloths, the one on top being a heavy oriental rug laid at an angle and heaped in folds at the corner. Lying on a plain book-rest on the table is an open book, on this side of which are some papers and a closed book. Beyond it is a two-branched candlestick with one long candle and a burned-down stump (which, as the x-ray shows, was originally intended to be the same length as the other one). In the drip pan beneath the long candle is a pair of snuffing-scissors. Leaning to the right in his armchair the man gestures towards the book on the lectern with his left hand. The woman, her head slightly tilted as she listens to him and holding her handkerchief (a mark of prosperity) in her lap, looks in the direction indicated by her husband. The light comes from the left and picks out the key elements of the scene: the book, the outstretched hand, the listening woman and her husband addressing her.

The vantage point is so low that one is looking up at the figures, which gives them an even greater presence. This low viewpoint, which Rembrandt also adopted for the *Staalmeesters* (Cat. No. 48), indicates that the

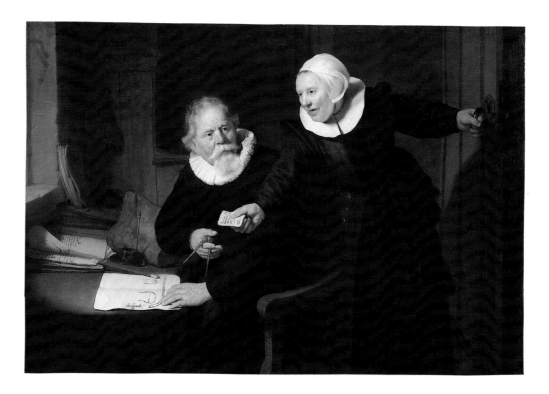

33a: Rembrandt, *Double Portrait of the Shipbuilder Jan Rijcksen and his Wife Griet Jans*, 1633. Reproduced by Gracious Permission of Her Majesty the Queen.

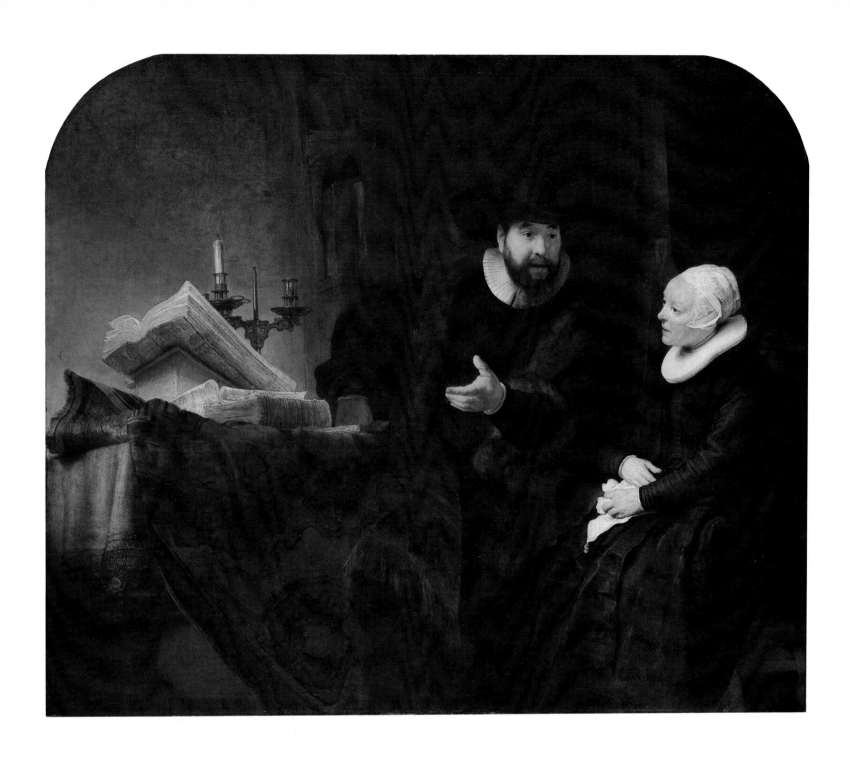

picture was to be hung high on a wall.

The painted double portrait, the origins of which go back to at least the early sixteenth century, presented the artist with even more of a challenge than the pendant portrait, since it required him to enliven the scene by depicting the interaction between the figures, who now share a single pictorial space. Although there were earlier attempts to animate portraits in this way, some more obvious than others, it was Rembrandt who really stimulated the development of this type. His first essay in the genre was the *Double Portrait of the Shipbuilder Jan Rijcksen and his Wife Griet Jans* of 1633 (Fig. 33a), in which he showed the woman bringing her husband a letter—a composition in which his experience as a history painter undoubtedly stood him in good stead. In 1632 he had similarly enriched the tradition of the group portrait with his *Anatomy Lesson of Dr Nicolaes Tulp* in The Hague (*Corpus* A51; Fig. 44b)—a portrait genre which of its very nature demanded even more animation than the double portrait, and which for that reason was already more advanced when Rembrandt first tackled it. But he also introduced a narrative element into pendant portraits, the genre that least called for it, as has already been observed in connection with the portraits of *Marten Soolmans* and *Oopjen Coppit* of 1634 (Cat. Nos. 17–18). In this respect the *Double Portrait of Anslo and his Wife* is closest, chronologically, formally and artistically, to Rembrandt's greatest achievement in this area, the *Nightwatch* of 1642 in Amsterdam (*Corpus* A146; Fig. 58). In both paintings the figures are presented in a generally subdued light in a fairly complex setting, while the preacher's gesture with his hand heralds that of Captain Frans Banning Cocq.

The painting gives the impression of having been executed with absolute self-assurance, and this is confirmed by the x-ray photograph, which reveals that only a few minor alterations were made. The clasps of the open book have been moved to the back cover, one long candle was evidently considered better than two, and the rug hanging over the edge of the table has been rearranged slightly. The subtlest correction is in the hand at the centre of the composition: the contour of the index finger was lowered somewhat, and the little finger was shortened.

All the forms are conceived in a grand manner and broadly painted, in keeping with the size of the picture and the distance from which it was to be viewed. However, the outstretched hand and the faces, the woman's in particular, are very sensitively rendered, with close attention to the form and lighting.

This large and exceptional double portrait was commissioned by the wealthy Amsterdam cloth merchant and shipowner Cornelis Claesz. Anslo (1592–1646), who in 1611 married Aeltje Gerritsdochter Schouten (1589–1657), three years his elder. From 1617 Anslo also served as an unpaid preacher to the Mennonite congregation in Waterland, north of Amsterdam. He was a man of unimpeachable integrity, as he demonstrated in 1642 when he paid his son's creditors 60,000 guilders, although under no obligation to do so. 'I am a preacher,' he explained, 'who comes forward to guide others to their duty, and to urge them, in accordance with Matthew 7:12, to do unto others as they would that others did unto them. [. . .] Although I need not pay, I do not wish to make my preaching redound fruitlessly upon me, or rob the same of any of its force.'[1] Anslo was renowned as an eloquent speaker who, as Cornelis van der Vliet (the last member of the family to own this double portrait) put it in 1767, not only preached the gospel in public but also 'to his wife and children, just as he is most wonderfully portrayed in the aforesaid painting, speaking to his wife about the Bible, which lies open on a table before him, to whom his wife, depicted in an inimitably artful fashion, listens with close attention.'[2] Anslo also wrote a number of theological tracts in which, among other things, he argued against Socinianism. In 1641 the merchant-preacher moved into a large new house on Amsterdam's Oudezijds Achterburgwal (now No. 173), which he bought the following year. The double portrait, which was completed in 1641, was undoubtedly intended for his new home.

The drawing of *Cornelis Claesz. Anslo* (Fig. 33b), which is signed and dated 1640 and shows him seated in his armchair in a pose almost identical to that in the painting, is no longer regarded as a preliminary study for the picture but as a *modello*, or drawing of a proposed painting which the artist submitted for the patron's approval. Since Anslo is turned towards someone who is not shown in the drawing, I believe that there must have been a second sheet with Aeltje Schouten listening to her husband. Anslo had evidently asked Rembrandt to make two large companion portraits, as the clergyman Johannes Elison had done in 1634 (see Cat. Nos. 17–18, Figs. c and d). He appears to have changed his mind when he saw the *modelli*, and decided instead (possibly on Rembrandt's suggestion) to combine them in the double portrait that was completed in 1641. As mentioned above, Rembrandt had already demonstrated his skill in handling this unusual type of commission in his *Double Portrait of Jan Rijcksen and his Wife*.

It is unfortunate that we no longer have the *Double Portrait of Jan Pietersz. Bruyningh and his Wife*, another Mennonite couple, which is mentioned in an archival document and which Rembrandt must also have painted in 1630s (for the wife died in 1640).[3]

In addition to the double portrait, which was to be displayed in his own home for his family and descendants, Anslo also commissioned a single portrait of himself which could be made into a print and distributed among his fellow Mennonites. For this Rembrandt produced another *modello*, also signed and dated 1640, in which the preacher is shown with a pen in his hand as the author of theological works like the one on which he is resting his hand (Fig. 33c). Anslo approved of the composition, and Rembrandt proceeded to transfer it to the prepared etching plate, for which he evidently used a stylus, since the outlines of the drawing are incised. Like the painting, the etching dates from 1641 (Fig. 33d). This chalk drawing, in which Anslo is seated behind his work table, appears to be based on the pen drawing, where the table stands to one side. This is not because the position of the head is identical (in the painting it is not turned so far to the right), but because it seems more logical that a half-length figure should be derived from a full-length rather than the other way round. Actually, the drawing for the etching apparently did not meet with Anslo's unreserved approval, for the print contains two additions which may appear trivial but which instantly alert the informed viewer. They are the bare nail in the wall and the picture which has been taken down from it and is now propped with its face to the wall. Werner Busch has given a plausible explanation for this addition to the original composition, namely that God's message should be proclaimed with words, written or spoken, and not with images. This was an important tenet of Mennonite teaching.

The idea that the word is superior to the image, which was held by all Protestants, not just Mennonites, is also the subject of the masterly quatrain which Joost van den Vondel composed on Anslo's portrait:

Ay Rembrant, maal *Cornelis* stem,
Het zichtbare deel is 't minst van hem:
't Onzichtbre kent men slechts door d'ooren.
Wie Anslo zien wil, moet hem hooren.

(O Rembrandt, paint Cornelis's voice,
His visible parts are the least of him.
Th'invisible is perceived through the ears alone.
He who would see Anslo must hear him.)

In 1956 Jan Emmens devoted a long essay to this epigram, in which he referred to the classical origin of the hierarchy of word and image (the word, spiritual and imperishable, is superior to the image, which being corporeal is doomed to decay), and explained how Vondel came to associate this concept with that of the hierarchy of the senses of hearing and sight, although in the medieval tradition their relative positions were reversed. Emmens assumed that Vondel wrote his poem about the etching (which is very possible, but by no means certain), and put forward the theory that in his double portrait Rembrandt took up the poet's challenge to paint Anslo's voice. This seems unlikely, since the obligatory theme of Vondel's poem contained no personal challenge, and the social relations of the day were not such that a painter could take the liberty of indulging in rivalry with a poet at the expense of their common patron.

This criticism of Emmens's theory appears to be contradicted by the double portrait itself, which is such an evocative depiction of both speaking and listening, but as Klamt has cogently argued, the key to the true meaning of the scene is there for all to see. It is the snuffing-scissors, which were used to trim a wick if the flame got too high and caused the candle to drip wax. According to Picinello this implement symbolises the '*correctio fraterna*', the brotherly admonition that rids the soul of the caked slime of error, just as the trimmer preserves the candle from dripping wax.[4] The admonition, the Mennonite preacher's edifying words based on Matthew 18:15-20, is clearly the main subject of this picture. While listening closely to her husband's pious words, Aeltje

Schouten looks towards the Bible at which he is gesturing rhetorically. At his urging she gives her full attention to God's word, she is being admonished.

In 1759 Johan Maurits Quinkhard (1688–1772) painted a small copy of the double portrait which also remained in the family for a long time, and is now in another private Dutch collection. In 1781, after the original was sold, the English mezzotinter Josiah Boydell (1752–1817) made a print of it with the inscription 'Regnier Hansloe an anabaptist minister and his wife'. The incorrect Christian name was due to confusion with the Anslo's brother, Reyer Claesz. Anslo, or with his son, the poet Reyer Anslo (1622–69). In 1794, when the painting was auctioned for the first time, this mistaken identification was adopted from the print. Since the end of the last century some authors have also wrongly assumed that the double portrait was made for the Anslo Almshouse founded by Claes Claesz. Anslo, Cornelis's father, in 1615 or 1616, and that the woman was one of the residents.
P.V.TH.

1. Van Eeghen 1969, p. 202.
2. This passage, which was first published in 1969 by L.C.J. Frerichs, is conclusive proof that Rembrandt depicted Anslo with his wife and not, as had previously been thought, with a resident of the Anslo Almshouse founded by his father.
3. Strauss & Van der Meulen 1979, *Documents* 1647–1a. Dudok van Heel 1980, p. 112.
4. Picinello 1653, Bk. XV, Ch. 2, No. 94.

33b: Rembrandt, *Portrait of Cornelis Claesz. Anslo*, 1640. Drawing. Paris, Musée du Louvre, Département des arts graphiques (coll. Edmond de Rothschild).

33c: Rembrandt, *Portrait of Cornelis Claesz. Anslo*, 1640. Drawing. London, The British Museum.

33d: Rembrandt, *Portrait of Cornelis Claesz. Anslo*, 1640. Etching. Amsterdam, Rijksprentenkabinet.

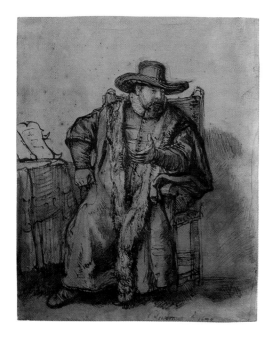

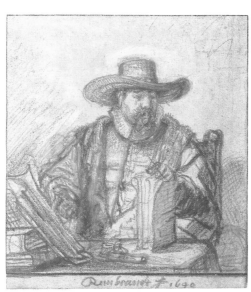

34

Portrait of Nicolaes van Bambeeck

1641
Canvas, 108.8 × 83.3 cm, signed and dated
Rembrandt f. 1641 (possibly not autograph);
inscribed *AE[tatis] 44*
Brussels, Koninklijk Museum van Schone
Kunsten, Cat. No. 367
Exhibited in Amsterdam only

35

Portrait of Agatha Bas

1641
Canvas, 104 × 82 cm, signed and dated
Rembrandt f 1641; inscribed *AE[tatis] 29*
London, Buckingham Palace, collection of
H.M. Queen Elizabeth II, Inv. No. 1157

Provenance: In 1805 both portraits were with
Louis Bernard Coclers, a Liège art dealer living
in Amsterdam. In 1809 they were bought by
the dealers Nieuwenhuys and Dansaert Engels,
who five years later entered them both in a
sale in London (Christie's), 28–29 June 1814,
Nos. 76 and 77: 'Rembrand. Portrait of a Lady
in black drapery with a white lace tippet,
embroidered stomacher, and fan, a wonderful
effort of the art. The delineation from nature
is agreeable and fine, but the golden effect of
light, and the rich and glowing tints are the
nec plus ultra of the art. This extraordinary
performance is apparently of the same time
and degree of rare merit with the celebrated
picture the Woman taken in Adultery, which
R[embrandt] painted for the Burgomaster Six.
Ditto. A male portrait, the companion.'
Neither painting found a buyer and they
were bought in, the woman's portrait by
Nieuwenhuys and the man's by Dansaert
Engels.
 The male pendant was bought by the
Brussels museum in 1841 from the heirs of
Dansaert Engels.
 The woman's portrait appears to have been
sold by Nieuwenhuys to the English dealer
John Smith shortly after the abortive auction.
The latter sold it to Lord Charles Townsend,
from whom it passed into the British royal
collection, as stated in Smith's annotation in a
copy of the 1814 sale catalogue held in the
library of the Boymans-van Beuningen Museum
in Rotterdam: 'This picture was sold by the
writer to Lord Charles Townsend for 1000
g[uinea]s. in his Lordships sale in 1818 it was
knocked down to Lord Yarmouth for the king
at 720 g[uinea]s. J[ohn] S[mith]. If the face of
this portrait was in a slight degree less yellow
it might justly be pronounced the best female
portrait known of the master'. Anonymous sale
(Lord Charles Townsend), London (Robins),
4 June 1819, No. 32: 'Rembrandt. A Lady with
her Fan. Painted in 1641, when the Artist was
35 Years of Age, and in the full bloom of all his
magic powers of Art, which in this Picture is
carried to its acmé; it possesses all his rich,
sparkling, and golden glow of Colour, with the
most comprehensive display of the Chiaro
Scuro that his Pencil ever produced, and has
been unanimously acknowledged the finest of
his productions, and the nec plus ultra of Art';
to Lord Yarmouth for the Prince Regent for
£745 10s.

Literature: Bredius/Gerson 218 and 360; Bauch
386 and 501; Gerson 232 and 233; *Corpus* A144
and A145. F. Schmidt-Degener, 'Portretten
door Rembrandt, I. Titia van Uylenburch en
François Coopal', *Onze Kunst* 24 (1913),
pp. 1–11. I.H. van Eeghen, *Een Amsterdamse
burgemeestersdochter van Rembrandt in Buckingham
Palace*, Amsterdam 1958. I.H. v[an] E[eghen],
'De tekeningen van vader en zoon Andriessen:
Agatha Bas bij Coclers', *Maandblad
Amstelodamum* 72 (1985), pp. 1–3.

Exhibitions: 34: Amsterdam 1935, No. 9. Zürich
1953, No. 112. Rome & Milan 1954, No. 112.
Amsterdam & Rotterdam 1956, No. 44.
Brussels 1961, No. 97. Brussels 1962–63,
No. 57.
35: London 1821, No. 9. London 1826, No. 19.
London 1827, No. 116. London 1873.
Amsterdam 1898, No. 51. The Hague 1948,
No. 7. Edinburgh 1950, No. 27. London 1952–
53, No. 181. London 1971–72, No. 13. London
1988–89, No. 15.

Exhibitions provide an opportunity of
temporarily reuniting paintings that belong
together but which for one reason or another
have become separated, like the portraits of
Maurits Huygens and *Jacques de Gheyn III* (Cat.
Nos. 11–12), and these two pendants of 1641,
which have been apart since 1814. They are
magnificent examples of the kind of
distinguished, tranquil portrait bathed in a soft
light that Rembrandt was painting around
1640. The curtain-raiser to the series, both
stylistically and formally, is the *Self-Portrait* of
1640 (Cat. No. 32), which was inspired by
Titian's supposed likeness of the poet Ariosto
(see Fig. 32c). This is particularly true of the
portrait of the man, for he too is resting his
right arm on a horizontal support. Here,
though, Rembrandt has developed the motif to
create an illusionistic effect, for the surface on
which the man is leaning is not a parapet or
balustrade, but the lower edge of the *trompe-
l'œil* framing of the picture. Rembrandt had
already used such a framing device in a *Portrait
of a Man in an Armchair* drawn on vellum in
1634 (Fig. 34–35a), although there he did not
try to exploit the framing to the full in order
to blur the boundary between the imaginary
space within the composition and the real
world outside. In this portrait of Nicolaes van
Bambeeck the effect is heightened by the cloak
and glove hanging over the edge of the painted
frame, and by the fingers of the left hand
projecting beyond it. The woman rests her
hand against the back of the frame in such a
way as to create the very persuasive illusion
that she and her superbly rendered dress are
not painted at all, but that she is actually
standing before us in the flesh. In her case it is
the fan that is outside the frame. One might for
a moment imagine that the figures are standing
at open windows, but the black colour and
type of moulding clearly show that these are
meant to be arched ebony frames, with the
arches springing from capitals. The portraits
were undoubtedly set in real moulded ebony
frames originally, thus merging semblance with
reality.
 The paintings have been considerably
reduced at the tops and sides, removing much
of the painted frames and weakening the *trompe-
l'œil* effect. This is evident from the fact that
cusping was only observed at the bottom of
each canvas, this being an undulating distortion
set up in the weave by attachment to a
stretcher. Further confirmation that the
paintings have been cropped is provided by a
drawing made by Christiaan Andriessen on 24
May 1805 (Fig. 34–35b) in which the artist
and his father are seen admiring the two
portraits set up on easels in the gallery of the

art dealer Louis Bernard Coclers, and exclaiming: 'That is a Rembrandt!!! I have never seen such a fine one'. This drawing was admittedly done from memory, but Andriessen would never have made the painted frames so broad if they were as narrow as they are now. The reduction must have been done before 1814, when the two pendants went their separate ways.

The discovery of the inscriptions giving the ages of the sitters in 1950 demolished Schmidt-Degener's identification of the subjects as François Coopal and Titia van Uylenburgh (the sister of Rembrandt's wife Saskia). Working with this new data Miss van Eeghen succeeded in tracking down the real sitters: Nicolaes van Bambeeck (1596–1661) and Agatha Bas (1611–58). Rembrandt may have known the man for a long time before he painted his portrait, for Van Bambeeck also came from Leiden. In 1631 both were living in Sint-Antoniesbreestraat in Amsterdam, where Rembrandt lodged with the art dealer Hendrick van Uylenburgh, to whom they both lent money in 1640. Van Bambeeck was a prosperous cloth merchant of fairly humble origins, but his wife Agatha Bas belonged to one of Amsterdam's leading families. Her father, Dirck Jacobsz. Bas, who had died in 1637, served several times as burgomaster of Amsterdam from 1610 onwards. P.v.Th.

34–35a: Rembrandt, *Portrait of a Man in an Armchair*, 1634. Drawing. New York, private collection.

34–35b: C. Andriessen, *Jurriaan and Christiaan Andriessen admiring Rembrandt's Portraits of Nicolaes van Bambeeck and Agatha Bas in the Gallery of Art Dealer L.B. Coclers*, 1805. Drawing. Amsterdam, City Archives, Atlas of Historical Topography.

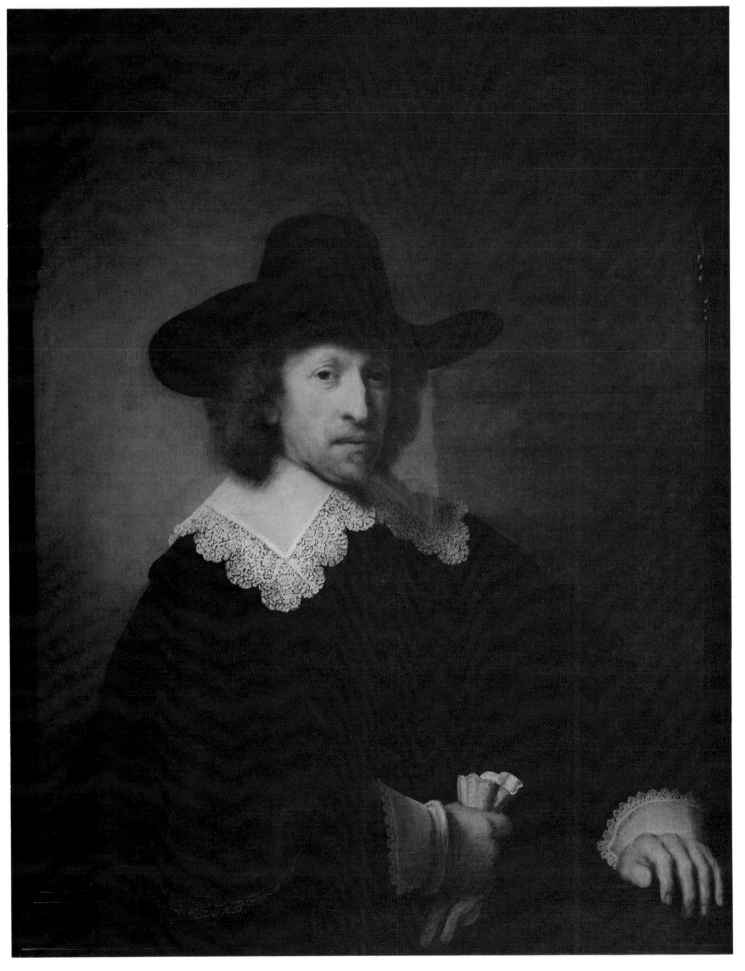

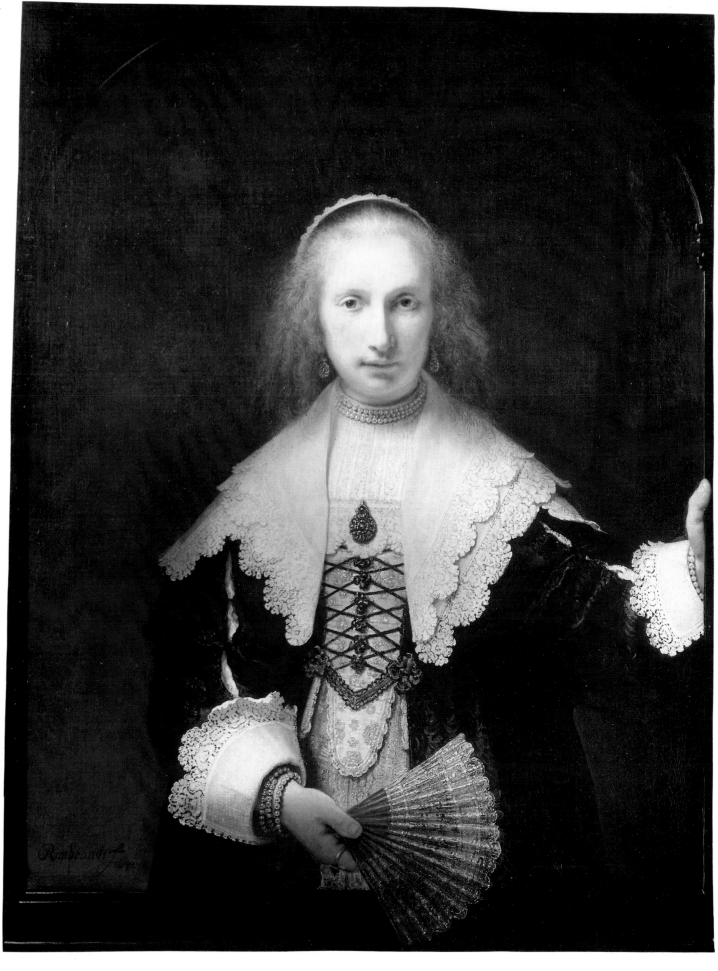

A young Woman in Bed

1645

Canvas, rounded at the top; 81.2 × 67.9 cm, signed and dated *Rembra[ndt] f 164[.]*
Edinburgh, National Gallery of Scotland
Cat. 1957, No. 827

Provenance: Prince de Carignan sale, Paris, 30 July 1742; collection of François Tronchin, Geneva, MS Cat. 1761, No. 25: 'Une femme couchée'; given to Count Vitturi, Venice (no longer mentioned in Tronchin's printed catalogue of 1765); collection of Thomas Moore Slade, about 1776; sold to Lord Maynard, London, about 1790; collection of Sir H. St. John Mildmay, London, before 1836; acquired from the Mildmay collection by Samson Wertheimer, after 1883; Samson Wertheimer sale, Christie's, London, 19th March 1892, No. 702; acquired by C.J. Wertheimer and sold by him for £5250 to William McEwan; bequeathed by McEwan to the National Gallery, Edinburgh, 1892 (Cat. 1900, No. 21).

Literature: Bredius/Gerson 110; Bauch 266; Gerson 227; Tümpel 23.

Exhibitions: London 1865, No. 109; London 1883, No. 235; London 1929, No. 115; Amsterdam, 1932, No. 24; Amsterdam, 1969, No. 7.

It can only be some exceptional event that merits the full attention of the young woman, who leans out of her bed, pushes back the curtain and stares wide-eyed to the right. Her head and body follow the direction of her glance, as does the light which, falling from the upper left, grows gradually warmer as it successively illuminates the brilliant white pillow and the woman's skin before coming to rest on the curtain where it condenses into full colour. Those areas not reached by the intensely bright light are cast in shadows. The powerful plasticity of the life-size half-figure of the woman is set against the dark background. As she leans over the edge of the bed, turning slightly, the light catches and softens her forehead, shoulders and arms, in a manner which dissolves the boundary between the world of the picture and that of the viewer. Even the motif of the curtain itself is stripped of its usual purpose of creating an intricate and isolated sphere; on the contrary, the manner in which it is gathered to one side increases the impression that the entire composition advances towards the viewer.

In *A young Woman in Bed*, a considerable span of Rembrandt's development seems to be represented. This impression is increased by the difficulty in deciphering the fragmentary date,[1] which François Tronchin, in whose collection the work once was, gave as 1641. He must have valued the work. This is suggested by the pastel portrait of Tronchin made by Liotard in 1757, and now in Cleveland, Ohio, in which Rembrandt's work is included as a 'copie en miniature' (Fig. 36a). At a later stage, Smith (1836) and Vosmaer (1877) moved the

year forward to 1650, and Valentiner (1905) even to 1657.[2] Trivas (1937), on the other hand, to whom we owe the reference to Tronchin, spoke up again for the by then forgotten early dating, as did Bauch (1966).[3] With the chronological parameters thus ranging from 1641 to 1657, one can effortlessly introduce each of Rembrandt's love affairs into the discussion. All three women in his life— Saskia, Geertje Dircks and Hendrickje Stoffels—have been mentioned in connection with the picture. The identification of a model, once decided, tends to have a long life. This is especially the case with Hendrickje, the companion of the 'mature' Rembrandt, and the favoured choice of those proposing a later dating of the picture. With corrected, and correct, reading of the date as the 1640s only Hendrickje has survived. In the documents concerning Rembrandt Hendrickje is mentioned for the first time in 1649.[4] Bredius (1935) cited this reference when he dated the picture to the end of the 1640s, calling it 'Hendrickje in Bed'.[5] Gerson accepted this dating, although he had already rejected an earlier date on stylistic grounds. However, his reference to comparable works in Rembrandt's œuvre from the 1650s does not stand up to critical examination. All the same, even Tümpel has recently placed the picture in the years 'around 1649/50.'

Rembrandt's life-size half-figure pictures of the 1650s are distinguished by a calmness of expression, which the artist achieved by covering his canvas with densely executed forms culminating in a monumental effect. But in the picture in Edinburgh the woman is

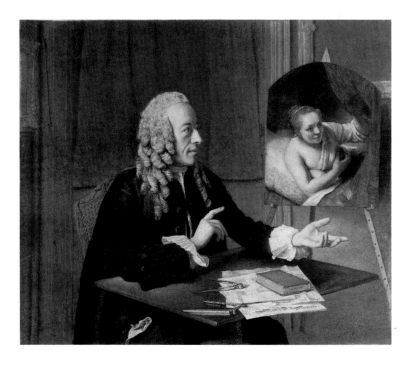

36a: J.E. Liotard, *Portrait of François Tronchin*. 1757. Cleveland Museum of Art.

bathed in fresh light and her spontaneous and complex movement makes her appear life-like and tangible. The artistic principles of the baroque Rembrandt, so magnificently rendered in the *Nightwatch* of 1642, seem to be present in the Edinburgh painting. Another masterpiece of these years is the *Danaë*, in Leningrad (Fig. 36b), although the version finished by Rembrandt probably in 1636 has not been preserved, being re-worked in a great many sections, above all in the area of the female nude. A dated school picture, which includes the alterations undertaken by Rembrandt shows that the changes to the *Danaë* must have been carried out by 1643 at the latest (*Corpus* A119). Hamann's observation—made without considering its implications for dating—that the picture in Edinburgh is a reversed 'detail from the *Danaë*' is surely correct.[6] Alongside analogical details such as the lace-trimmed pillows and the hair ornaments, which although not identical are certainly similar, it is, above all, the pose that recalls the picture in Leningrad. A further indication of the date is the rendering of a comparable perspective in Rembrandt's *Girl at the Window* of 1645, in Dulwich (Bredius/Gerson 36; Fig. 65a). The flesh-tones and the prominent blush of her cheeks, her eyes, as well as the folds of her shirt all correspond. A dating of about 1645 for the Edinburgh figure, as proposed in the Amsterdam catalogue of the Rembrandt exhibition of 1969, is sustainable.[7] The glowing red need not only be seen as a colouristic device of the late Rembrandt; rather it marks the works of precisely those years in which the painter—adhering to the general stylistic tendencies of the time—gave local colour more expressive 'weight' in his compositions. The rather sketchy, loose application of the red of the curtain in the painting *Christ and the Woman*

taken in Adultery, of 1644, now in London (Bredius/Gerson 566), is comparable to that of the picture in Edinburgh; whereas in the *Holy Family* of 1645 in Kassel (Bredius/Gerson 572), the paint is applied more thickly and has greater luminosity.

The pose of the model in *A young Woman in bed*, which is closely related to that of the Leningrad *Danaë*, also points to a comparable iconographic interpretation of the Edinburgh painting, which had been previously seen as simple genre scene or as a genre-type portrait. Sumowski pointed out that the protagonist of the picture could represent Hagar waiting for Abraham, or Sara waiting for her husband Tobias.[8] In Tümpel's view, the scene is related to the latter, and he proposes as a possible source of inspiration Pieter Lastman's painting of 1611, *The Wedding Night of Tobias and Sara*, in Boston (Fig. 36c).[9]

The unusual course of this wedding night was illustrated in detail by Lastman. Sara, the daughter of Raguel, had already been married seven times. However, she was possessed, by the evil spirit Asmodeus, who, unfortunately, murdered each of her husbands on the wedding night (Tobit 3, 8). Following his marriage to Sara, Tobias, on the advice of the angel Raphael, placed a piece of the liver and heart of the largest fish he had caught on a bowl filled with glowing coals. The magic device worked, and Raphael was able to defeat the evil spirit (Tobit 8, 1–3). Sara observes this decisive moment from her luxuriously draped and hung bed, supporting her partially raised body with the pillow and her arm.

The reduction of the narrative to the single figure of Sara, which is Rembrandt's achievement in the picture in Edinburgh, was anticipated in the model provided by Lastman's work. Thus, the bright light falling

on Sara isolates her within the scene, so that compositionally she emerges as an individual figure. Rembrandt has converted Lastman's indirect detachment of the figure into a direct one. All that remains of Lastman's expansive narration of the story is Sara, who raises herself expectantly from her pillow to await her eighth and final husband.[10]

J.K.

1. The year is only preserved in its first three digits. At the time of the restoration of 1966, what appeared to be the remains of the last figure was found to be not original and was removed. See: Amsterdam 1969, No. 7.
2. Smith 1836, No. 151; Vosmaer 1877, p. 547; Valentiner 1905, p. 45.
3. Trivas 1937, p. 251; Bauch, op. cit.
4. Strauss & Van der Meulen 1979, *Documents*, 1649/4.
5. Bredius 1935, No. 110.
6. Hamann 1969, p. 95.
7. P.J.J. van Thiel, in Amsterdam 1969, No. 7.
8. Sumowski, cited by Bauch 1966, No. 266.
9. Tümpel 1969, pp. 176–78.
10. According to Tümpel 1969, p. 175, the interpretation of the picture as Hagar awaiting Abraham, also proposed by Sumowski, is to be rejected, as in both the Bible (Genesis, 16, 3–4) and the iconographic tradition, Hagar is led to Abraham, who is in bed, rather than *vice versa*.

36b: Rembrandt, *Danaë*. 163[6]. Leningrad, Hermitage.

36c: P. Lastman, *The Wedding Night of Tobias and Sara*. 1611. Boston, Museum of Fine Arts.

37

Susanna and the Elders

1647
Mahogany panel, 76.6 × 92.8 cm
Signed and dated at lower right:
Rembrandt. f. 1647.
Berlin, Gemäldegalerie Staatliche Museen
Preussischer Kulturbesitz; Cat. 828 E

Provenance: presumed to be identical with the
Susanna picture acquired from Rembrandt in
Amsterdam in 1647 by the merchant Adriaen
Banck for 500 guilders, and sold by Banck on
31 August 1660 for 560 guilders to Adriaen
Maen, a merchant in Schiedam; Baron
Schönborn sale, Amsterdam, 1738; A.-J.-A.
Aved sale, Pierre Rémy, Paris, 24 November
1766. Cat. p. 12; presumed to be in the
collection of Edmund Burke (who was a friend
of Sir Joshua Reynolds), London; 1769, in
possession of Sir Joshua Reynolds, whose
collection passed by inheritance in 1792 to
Lady Inchiquin, a niece of the painter;
Reynolds sale, Christie's, London, 27 March
1795, No. 82 (re-purchased by the heirs
through Wilson for 156 guineas); sold to
Charles Offlay, London, 22 March 1795
(120 guineas);[2] 1796 in the collection of Joseph
Berwick, London, whose daughter was married
to Anthony Lechmere; collection of Sir
Edmund Lechmere, 1883; Charles Sedelmeyer
art dealers, Paris; acquired for the Königliche
Gemäldegalerie, Berlin, 1883.

Literature: Bredius/Gerson 516; Bauch 28;
Gerson 221; Tümpel 22; H. Kauffmann:
'Rembrandts Berliner Susanna', *Jahrbuch der
Preussischen Kunstsammlungen*, xlv (1924),
pp. 72–80.

Exhibitions: London 1883, No. 236; Berlin 1930,
No. 376; Philadelphia 1948, No. 96; Paris 1951,
No. 107.

Two men, who were Elders and Judges, saw
Susanna, the devout and beautiful wife of
Joacim, and 'their lust was inflamed toward
her.' When Susanna, while bathing in her
garden, sent away her servant women, the two
old men emerged from their hiding place: 'we
are in love with thee; therefore consent unto
us, and lie with us. If thou wilt not, we will
bear witness against thee, that a young man
was with thee . . .'. Brought before the court,
Susanna was condemned to death on the
strength of the false testimony of the old men.
Daniel, however, inspired by God, recognized
Susanna's innocence and unmasked the judges,
who were executed instead of her (The
Apochryphal History of Susanna, 8 and 20–21).

The subject of Susanna bathing—inviting,
as it did, the presentation of female beauty and
the lust it might provoke—was suited to the
sophisticated conceptions of painting in the
baroque era. Rembrandt too addressed the
demands of his subject in a number of drawings
and in two paintings. The Berlin painting is
distinct in character from the intimacy and
freshness of expression of the small-scale female
nude of 1636 in The Hague (Cat. No. 25).
It is on a larger scale, it illustrates the event in
an expressive narrative style and through a
carefully conceived design.

The bathing scene is captured in its
dramatic climax. Susanna has placed her
clothing on a balustrade and is about to step
from the curved stone steps into the water as
she is surprised by the Elders. While one has
crept up behind her and taken hold of the wrap
with which she attempts to hide her nakedness,
the second approaches through the garden gate
and fixes her body with a lustful stare.

Rembrandt does not neglect to prepare the
viewer for this event. The left of the
rectangular-shaped composition shows the
still dark water which becomes somewhat
brighter as it recedes into the distance. In the
background, a palace rises above the trees and
an imposing circular structure dominates the
skyline. The scene is set in Babylon, and the
garden of the wealthy Joacim is an elegant
park, the haunt of peacocks. Like shadows,
these emerge from the darkness along the low
wall that can be seen surrounding the lake in
the middle-ground. Equally vague are the two
figures standing behind this wall, probably
Susanna's servant women. Their departure
made possible the sinister deed which unfolds
in front of an arched rock which is pushed to
the foreground.

From the opening between these rocks,
the narrow steps leading down to the water
determine the placing of the figures. For
Susanna there is no escape: in front of her is

water, while from behind the two Elders loom over her. The threat is reflected in the twofold twist turn of Susanna's body, which is shown in profile. Bent forwards, and with her torso turned inwards she draws her bent left arm towards her breast while gazing out at the viewer. Terror and fear, mingled with the decisive urge to defend herself, characterise her pose: in this respect the depicted moment points to the future.

Poses that transcend any one situation are transferable, and Rembrandt derived the main figure of the Berlin *Susanna* from his own picture in The Hague, even though it presents another moment of the story. There, the danger is not yet imminent. From their hiding place the Elders watch Susanna sitting in a huddled position in the foreground by the balustrade, her clothes beside her and her head turned so that she gazes at the viewer. The heroine is shown in a comparable manner in the reproductive engraving after Rubens by Lucas Vorsterman, published in 1620 and dedicated to the Dutch poetess Anna Roemer Visscher as a *Pudicitiae exemplar* (Exemplar of chastity) (Fig. 25b).[3] Rembrandt modified the pose: Susanna does not cross her arms to shield her breast, but instead lifts one arm while the other is directed towards her pudenda. Broos recognized that this pose is derived from that of the *Venus pudica* (chaste Venus) of Antiquity (Fig. 25c).[4] Enriched through this elevated connection, the image of Susanna is accorded a dominant role in the composition. She is shown as an isolated element, not embedded in the scenic context but as one detached from it. As a means of achieving iconographic differentiation Rembrandt employed this

technique in a variety of ways.[5] The absence of an epic conception of the lone figure in the painting in The Hague makes it quite different from the Berlin *Susanna*. This offers us more: at one and the same time, a situation that is depicted in some detail, and a brightly illuminated figure, Susanna, who is thus detached from the narrative context.

Rembrandt's pictures in The Hague and in Berlin are based on the work of Pieter Lastman,[6] not only in the motif of Susanna's flexed hand, which cuts through the outline of her figure, but especially in the arrangement of the setting. This is yet another measure of Rembrandt's enduring appreciation for the work of his teacher. Rembrandt was very familiar with Lastman's treatment of the subject of Susanna in his painting of 1614, in Berlin (Fig. 25d).[7] Rembrandt had recorded this composition in a red chalk drawing of c.1635, now also in Berlin (Fig. 25e).[8] Copies by great masters are always marked by their independent approach to the original. Through expert pushing and shoving of the figures, and also through modifying specific gestures, Rembrandt has picked out and emphasised the more crucial aspects of this subject.[9] Although his alterations are admittedly minor, nonetheless, they anticipate the dramatic tenor of his Berlin picture, in which, however, much of Lastman's model is retained. The expansively rendered setting of the Berlin picture is derived from the work of Rembrandt's teacher, and not necessarily just from Lastman's *Susanna*. In Rembrandt's picture, the arrangement of the scenery is fundamentally comparable to the treatment of the setting in Lastman's *Toilet of Bathsheba* in

37a: Barent Fabritius (attributed), *Susanna and the Elders*. Drawing.
Budapest, Szépmüvészeti Museum.

37b: X-ray of Cat. No. 37.

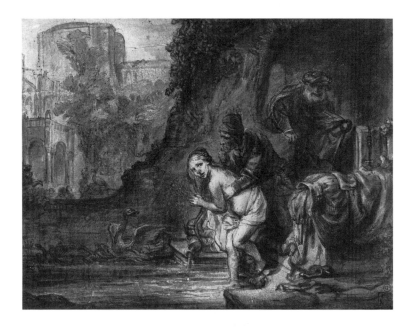

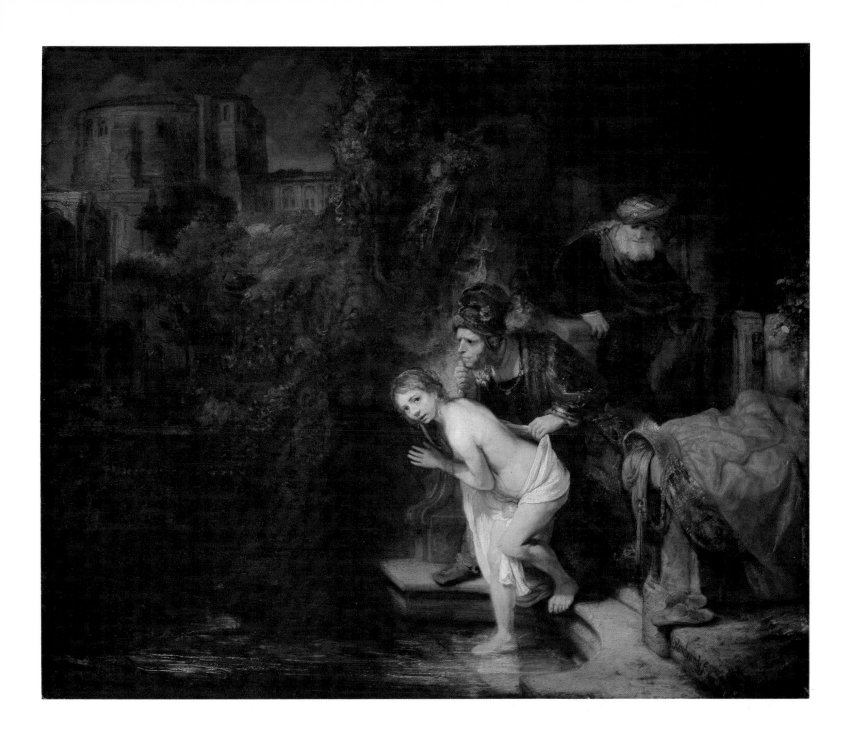

37c: Rembrandt, *Seated female Nude*. Drawing. Berlin, Kupferstichkabinett SMPK.

37d: Rembrandt, *Old Man in a turban*. Drawings, Melbourne, National Gallery of Victoria.

Leningrad (Fig. 25f).[10] On the left, one is drawn deep into the painting before being confronted by the buildings, whereas on the right, the figures are placed directly in front of a backdrop in the immediate foreground. The most notable detail Rembrandt adopted from the *Bathsheba* is that of the clothing draped over the balustrade at the lower right, although he decisively increased its compositional 'weight', especially in comparison with the *Susanna* in The Hague. Picked out, together with the slippers, as a 'still-life' in its own right, this motif has obviously been imbued with considerable significance. Susanna's discarded clothing may point to her vulnerability, while the shoes or slippers, as a familiar symbol of femininity, appear to have been deliberately placed with their 'open' end clearly visible so as to underline the erotic aspect of the event.[11] Even without such an allusion, the ultimate meaning is made perfectly clear by the obscene gesture of the Elder nearest to Susanna whose right hand is clenched into a fist from which his thumb protrudes.

The Berlin painting had a complex evolution. H. Kauffmann concluded, from a study of the *pentimenti* that can be found in the region of the figures and the lake, that there was a first version of the picture existed, which he believed to be recorded in a drawing in Budapest, now attributed to Barent Fabritius (Fig. 37a).[12] Recent examinations of the Berlin painting carried out by the Rembrandt Research Project have both confirmed Kauffmann's observations and also made it possible to refine them.[13] They have shown that instead of the assumed two stages, three different stages may in fact be distinguished, the last of which is the painting in its present state. In addition, it is now possible to re-define the significance of the copy in Budapest: this drawing, which must have been made in about 1646, reproduces the second stage.

Compared with his final solution, in the second stage Rembrandt's attention was directed towards the figures. He altered the positively brutal character of the approaching Elder's gesture of grasping at Susanna's breast, so that he is finally shown grasping only at her wrap. Rembrandt had clearly thought out the consequences of introducing such a gesture. The original outline of the upper body of this Elder, documented in the drawing in Budapest, is placed more to the right and viewed more frontally in the painting as we see it today; while Susanna's left soulder is now drawn downwards, away from her chin, and also somewhat further towards the right. Rembrandt meticulously prepared the final pose for Susanna in a drawing which is now in

Berlin (Fig. 37c).[14] Fictional accessories from the previous version of the painting—such as the overturned oil-jar by the balustrade and the swan, with its young in the lake, seen fleeing with an alarmed beating of wings—never made the final version of the picture. Numerous other changes, such as the pruning of the tall and luxuriant foliage of the tree in the background, are evident.

Rembrandt's study in Melbourne showing the grasping Elder (Fig. 37d)[15] affords an insight into the first version of the Berlin painting. The out-stretched left hand and the outline of the upper torso correspond to the second stage of work on the painting, as recorded in the copy in Budapest. The Melbourne drawing deviates from the Budapest drawing, however, in showing the man's right hand with its obscene gesture, which is somewhat raised so that his clenched fist is not placed below the end of his nose, but above it. His head-dress too is of a different type, being slightly taller in size. X-ray examination (Fig. 37b) confirms that Rembrandt carried out the slight re-arrangements in the placing of these details after completing the first stage of his painting. It is not possible to establish much more about the group of figures, which Rembrandt did not so much re-formulate as simply re-work in his first alteration of the painting. As the dating of about 1635 proposed by Kauffmann for the first stage of the Berlin picture took the Budapest drawing into consideration his view is not entirely unfounded.[16] However the evidence provided by the figure study in Melbourne, made by Rembrandt while engaged on the first version of the painting, allows us to be more precise. The line cutting across the hand of the Elder in this drawing defines the outline of Susanna's back, and the curving stroke to the lower right marks the outline of her cloak, both features already recorded by Rembrandt in his painting at this stage. This drawing is executed with pen and a special ink (gall-nut ink) on paper prepared with a yellowish coating, a technique Rembrandt used in the years around 1638. It is in this period that the first version of the Berlin painting should be placed.[17]

The tall tree on the left, documented in the drawing in Budapest as part of the second phase of the painting, was already in the same position in the first phase as is evident from the x-ray, even though the evidence is somewhat confused by the high lead content of the pigment. Consistent with this is the presence of particles of blue paint in the region of the tower which are visible under a stereo-microscope. In the first version there was no tower and more pale blue sky. With the

exception of the low building at the left, which was there from the beginning, the addition of architectural motifs and the consequent reduction of the visible area of sky were part of the first set of alterations resulting in the second version.

The dominant pale blue sky, that has been reconstructed for the first stage of the painting, leads one to assume that there must have been a tonal equivalent at the second stage. The orginal colouring, as a whole, must have been brighter than that of the second version, in which grey and grey-blue passages have been laid over the previously blue sky. These colour values were retained in the final version of the painting, although with a further reduction of brightness. On the tower, slate-grey shadows mask the area previously covered by tall tree-tops. The water directly below has been worked over in brown and black, not only to erase the motif of the swan that had been placed there, but also to darken the setting as a whole. By this means, Rembrandt ensures greater impact for Susanna's body and for the red of her cloak; two colouristic accents with little in common with what was previously in this section. Traces of grey-yellow, yellow and white are to be found in her cloak, and traces of yellow and a brownish tone in her slippers. On the cloak of the leftmost Elder red shimmers through as the predominant colour, while on his chest some blue can be seen, as well as a spot of light turquoise at his right shoulder. Strokes of ochre-yellow and blue are visible beneath the Elder's cap, and there is a yellowish colour beneath the flesh tones of Susanna. Even though it is practically impossible to establish whether these findings belong to the first or to the second stage of the composition, it can be affirmed that Rembrandt's treatment of his figures was originally more varied in its distribution of colour.

One cannot attribute to Rembrandt a single overriding goal in the complex development of his picture and the unusual duration of its evolution.[18] Neither in the first version of the painting of about 1638, nor in the subsequent stage, did Rembrandt attempt to achieve the solution found for the final version of 1647. The layers of paint beneath the present surface are, accordingly, not to be understood as intermediary steps on the way to something better: rather, in each case, they present solutions that are valid in their own terms. Accordingly the question as to whether the painting was finished down to last detail in its first or second stage is academic. However we account for the long period the *Susanna* spent in Rembrandt's studio, we can say that

Rembrandt used the time well, continually keeping the picture in step with his own artistic development. Left entirely to his own devices, he would probably no longer have taken as his subject the 'ambushing' of Susanna as he shows it in the version we now see. The essentially dramatic implications of the subject are out of character for Rembrandt's works from these years, which tend to be calm in terms of both form and content. Rembrandt did, however, tone down the vehemence and bluntness of his previous versions; he over-painted anecdotal accessories; and he darkened, and thus simplified, the detailed and varied treatment of the setting. The way into the picture on the left leads the eye into a featureless calm, blending both halves of the painting so as to deny the sense of depth. The figures become dazzling forms set against a backdrop that consists entirely of soft dark atmospheric tones. Rembrandt does not make narrative use of local colour for the figures themselves, but combines in them a decisive and formal concentration of light and colour. Susanna is picked out as the gleaming centre-piece of the picture, detached from the inter-linked arrangement of the trio. The bright apparition of her figure is related to the glowing red of her cloak as well as the red of her slippers. Intermediate tones in the figures of the Elders and the pervasive chiaroscuro do not neutralise, but rather strengthen and deepen this contrast of intense brightness and a jewel-like glow.

Sir Joshua Reynolds praised in the highest tones the colour and the overall painterly effect of Rembrandt's picture. Nonetheless, the work, which once belonged to him, did not meet with his unqualified approval. In his assessment of the eponymous protagonist, whom he regarded as 'very ugly' and 'ill-favoured', it would seem that Reynolds the academician triumphed over Reynolds the painter.[19] Traditional ideas of beauty are, it is true, hardly applicable to the Berlin *Susanna*. While Rembrandt did, of course, pay attention to previous treatments of the subject by other artists, he was always concerned to relate his figures to the context of the depicted event and to develop the image accordingly.

J.K.

1. According to Klein 1988, pp. 37–43, the wood is mahogany. The panel is of one piece and reveals, on its reverse, peg holes along the edges. As in many other cases, Rembrandt may be presumed to have used a second-hand material—the mahogany of a packing case that had served as a freight container for raw sugar imported from the New World.

2. I am indebted to F. Broun, 'Sir Joshua's Rembrandts', unpublished manuscript, 1984, for information allowing some expansion of the details regarding provenance.

3. Voorhelm Schneevogt, p. 10, No. 84. See McGrath 1984, pp. 81–85.

4. Broos 1987, p. 290 Fig. 3.

5. Tümpel 1968, pp. 95–128; Tümpel 1969, pp. 160–87

6. Bode 1908, p. 57–66; Freise 1911, pp. 249–57.

7. Berlin, Gemäldegalerie SMPK, Cat. 1719; Freise 1911, p. 48, No. 44.

8. Berlin, Kupferstichkabinett SMPK, KdZ 5296; Benesch 448.

9. Valentiner 1914, pp. 123–24.

10. Leningrad, Hermitage, Cat. 1958, No. 5590; Freise 1911, pp. 42–43, No. 30.

11. On this, see Cat. No. 25, *Corpus* A117; on the symbolism of the shoe, see Amsterdam 1976, No. 68.

12. Budapest, Szépmûvészeti Muzeum; Sumowski 1979, p. 4, No. 823. Kauffmann's theory was disputed by von Baudissin 1925, pp. 263–64 (including Kauffmann's reply on p. 264). Only with the findings of x-rays reported by Borroughs 1931, p. 9 (though these are not correct in their interpretation of all points) has there been definitive proof of Rembrandt's re-workings.

13. The following observations on the evolution of the picture would not have been possible without the support of the Rembrandt Research Project. I am, above all, indebted to Michiel Franken, who made available to me the draft (version B, July 1990) of his account of the technical analysis of the picture.

14. Berlin, Kupferstichkabinett SMPK, KdZ 5264; Benesch 590. The painting in the Louvre in Paris (Bredius/Gerson 518), on the other hand, that corresponds to the Berlin *Susanna*, is a detailed copy by a later hand, as is the study in the Musée Bonnat in Bayonne (Bredius/Gerson 372).

15. National Gallery of Victoria, Melbourne; Benesch No. 157; Gregory 1988, pp. 52–54, Cat. p. 117.

16. Kauffmann's dating is based, among other factors, on the Dresden *Susanna* drawing, that he places in the mid-1630s (Benesch 536, about 1641–44). The attribution of this sheet to Rembrandt has, in the interim, generally been rejected. According to Sumowsky 1957/58, p. 238, it is a pupil's drawing from the 1640s.

17. E. van de Wetering has informed me that the placing of Susanna's legs—one almost stretched out, the other bent—corresponds to the pose of Adam in the etching *Adam and Eve* dated 1638 (Bartsch 28).

18. A separate enquiry is needed into the question of the attribution of the drawings with oriental heads (Benesch 155–159) and their relation to the Berlin picture (and its stages). The painting with the head of the old man on the left, formerly in the Bischoffsheim collection, Paris (Bredius/Gerson 248) is, without doubt, not the work of Rembrandt's hand, but rather a detailed copy after his Berlin painting.

19. F. Broun, op. cit.

38

The Rest on the Flight into Egypt

1647
Oak panel, 34 × 48 cm
Signed and dated: *Rembrandt f. 1647.*
Dublin, National Gallery of Ireland;
Inv. No. 215

Provenance: Richard Colt Hoare, Stourhead
House, Wiltshire; by inheritance to Sir Henry
Hoare, London; sale, Christie's, London, 1 June
1883, No. 68 (£514); acquired by the National
Gallery of Ireland in 1883.

Literature: Bredius/Gerson 576; Bauch 80;
Gerson 220; Tümpel 68; C.P. Schneider,
pp. 47–55 and 194–96, No. 8.

Exhibitions: London 1870, No. 29; London 1894,
No. 91; London 1899, No. 51; London 1929,
No. 140; London 1930, p. 106; Amsterdam and
Rotterdam 1932, No. 22; Amsterdam 1956, No.
57; Amsterdam 1969, No. 8; London 1985, No.
24; Amsterdam, Boston and Philadelphia 1987–
88, No. 78.

On a moonlit night, the holy family rests in a sheep-pen by the water's edge, above which a wooded slope rises. While Mary, with the infant Jesus in her arms, and Joseph settle by the fire, which is tended by a shepherd, other shepherds approach with their flocks. The figures are small and are introduced into the landcape as if they were mere staffage. Dark clouds sweep across the cool blue of the sky, blocking out the moon; and growing gloom heightens our awareness of the jagged silhouette of the higher ground, where—visible from afar—the fortified walls of a castle loom up, their windows picked out in the darkness with silvery points of reflected light. There is a certain discordance in the composition between the cold light of the sky and the warm light of the shepherd's fire that allows us to see a reflection of the figures in the water's surface. The tension created by this imbues the rural setting with a disquiet and uncertain mood. The light of the shepherd's fire, painted in thick, glinting strokes, flickers in the branches and foliage of the tree next to the sheep-pen. An intimate, festively illuminated realm has been prized from the darkness of the night and the unfriendly nature of the countryside; and a delayed shepherd emerges out of the depth of the picture, leading yet other animals towards this realm, by the light of his lantern. He walks along a section of the path used by the holy family on its flight from Herod's henchmen. As our attention shifts from the foreground scene to more distant figures, we note how Rembrandt conveys a sense of space. The sweeping and open landscape is varied in its forms. Yet in the dark of the night, broken only by the light of the moon and that of the shepherd's fire, only some elements emerge. The image of nature appears and disappears in a ghostly manner, rendered as it is in the subtly perceived nuances of tone; and yet everything is brought together into a unified whole. Land and sky are each held in place by a firm diagonal, that both dramatically divides the composition and, at the same time, unifies it.

The Bible does not have much to say on the flight into Egypt. There is, of course, some mention of the event and its cause—the massacre of the innocents in Bethlehem—but there is no indication of what occurred during the flight itself (Matthew 2, 13–14). Apochryphal texts, and specifically the 'Legend of the Palms' recorded by the Pseudo-Matthew, embroiderd the laconic biblical text, paving the long road to the distant destination with an ever-changing succesion of miraculous occurrences. Exponents of late medieval mysticism readily took up the narrative of the

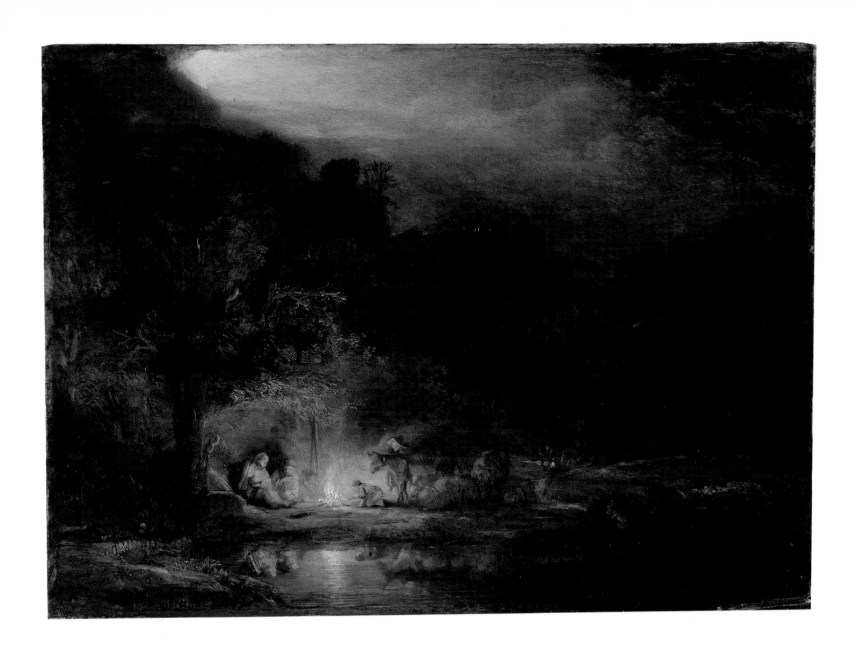

various stages of the journey in its iconographic programme and developed out of these separate subjects, whose legendary value and didactic motivation proved to be enduring. But only in the baroque era were all attempts at illustrating the theme in a narrative context abandoned. The 'Flight into Egypt' and 'The Rest on the Flight into Egypt' were shown as incidents that spoke for themselves. The weariness and exhaustion of the flight, and the effort of caring for the child are directly conveyed to any who contemplate these scenes.[1]

It was in this sense that Rembrandt interpreted this theme, which he deals with in no other painting, although he does treat it in some drawings and a series of etchings. In the context of these works as a group, it has to be observed once again that the theme in Rembrandt's graphic œuvre is independent of his treatment in the painting. In the two etchings of *The Rest on the Flight into Egypt*, which date from the mid-1640s, and of which one shows the holy family by the light of a lantern (Fig. 38a), it is the figures that dominate the scene. The painting in Dublin, on the other hand, is conceived and composed principally in terms of the landscape. It is hardly surprising that the figural narrative, apparently so insignificant in proportion to the landscape, was misunderstood as mere staffage.[2] Bode was the first to recognise a religious subject in the work, and also to identify the model on which the composition is based.[3]

Adam Elsheimer's *Flight into Egypt*, painted on copper in 1609, and now in Munich (Fig. 38b), opened-up new possibilities for the early Netherlandish night scenes.[4] Instead of the endlessly repeated depictions of the sack of Troy, or other catastrophic fires taking place at night, Elsheimer rendered the night itself: a clear, starry sky, the light of the full moon, and—something entirely new in the history of painting—the hazy gleam of the Milky Way. The Utrecht artist Hendrik Goudt, who had brought the small copper plate from Rome in 1610 and who owned it until 1628, reproduced the composition in an engraving of 1613 (Fig. 38c). The following year, Rubens painted his *Flight into Egypt*, now in Kassel, a tightly-packed scene with figures viewed against a watery landscape in which a crescent moon is reflected.[5] Rembrandt knew of Elsheimer's work above all through Pieter Lastman, and also through the Pynas brothers. When Rembrandt produced the silhouetted figure of Christ in his *Emmaus* scene of 1629, now in Paris (*Corpus* A16), he did so with a work by Hendrick Goudt in mind—Goudt's engraving of 1612 after Elsheimer's nocturnal interior,

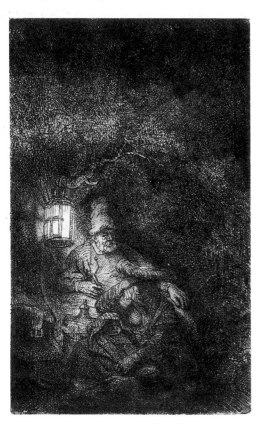

38a: Rembrandt, *The Rest on the Flight into Egypt*. Etching. Berlin, Kupferstichkabinett SMPK.

Jupiter at the House of Philemon and Baucis, now in Dresden.[6] Rembrandt, in turn, passed on to some of his earliest pupils his admiration for the objective narrative style of the older master and for his treatment of light not only as a means of unifying elements in the picture but also as an organisional tool. This is aptly demonstrated by the *Flight into Egypt* painted in about 1630 and now in Tours (*Corpus* C5).

In the ordering of the landscape, the work in Dublin corresponds to the painting by Elsheimer and not to the reversed arrangement of the engraving. Rembrandt, however, can hardly have seen the original; it is more likely that he saw a painted copy of it.[7] In any case, Goudt's engraving was certainly available; and the accomplished etcher would have had no difficulty in reversing its mirror-image. Whatever Rembrandt's starting point may have been, he altered the older master's composition both formally and contextually. We no longer see the 'Flight', but the 'Rest on the Flight'.[8] Elsheimer's work, indeed, invited this change of subject in as far as it showed not only those fleeing, but also their destination. Rembrandt adopted the motif of the distant place of rest with shepherds, using it to bring together the two figural groups. He also retained the kneeling shepherd tending the fire: this secular motif attains a new and higher value through the presence of the holy family, and also alludes to an earlier stage of the story—the adoration of the shepherds.[9] The rough sheep-pen, in which the holy family has found refuge, is equally appropriate in this context. It is, though, hardly possible to make out the child. 'He flees into the darkness, the Light of the World, and the Creator of the Earth; as one banished, He goes into hiding . . .' runs the caption under the reproductive engraving by Hendrick Goudt.[10] The familiar metaphor must have occurred to Rembrandt as he painted the hidden group of figures, introducing into a setting so full of disquiet the peaceful communion of the holy family and the shepherds.

Rembrandt did not strive for the accuracy of Elsheimer's presentation of nature. Out of his own imagination, and perhaps also with reference to the mountain silhouettes set with Roman architectural motifs of the 'Pre-Rembrandtists',[11] Rembrandt created a landscape that plays an active part in the scene. With its jagged disposition, and set below a turbulent sky, the landscape itself appears as a dramatic 'agent' in the picture. Its topography has an idealised character that is to be explained in terms of Rembrandt's intention of illustrating the difficulties and dangers of the long flight. The flight leads through a part of

the real world, and, in keeping with good Netherlandish tradition the landscape probably symbolises a world that is hostile towards the child. The few landscape pictures by Rembrandt do not go to great lengths to establish an objective record of a location which has no further significance beyond its appearance. This is true in general of Dutch landscape painting of the period, in which 'realism', indeed, only seemingly displaced the symbolic language of the sixteenth century.[12] A subject such as that of the 'Journey of Life' was still current and, as J. Bruyn has shown, it was also taken up by Rembrandt.[13] This interpretation may be assigned to the *Landscape with a Stone Bridge*, in Amsterdam (Cat. No. 31), and it is precisely the compelling 'realism' of this scene that elevated the traditional context to one compatible with contemporary views and understanding. The landscape in the Dublin painting, clearly born of imagination and suggestive of a 'foreign' country, is also composed in 'realistic' terms and so gives an illusion of being a depiction of reality. Rembrandt reveals his sensitive understanding of the forms of nature, for example, in the foreground where he records the curving course of the low strip of earth along the water's edge. This detail emerges in the light of the shepherd's fire, that picks out the region with an orange glow, and it is reflected in the same tones in the water. In a similar manner, Aert van der Neer, who established his own style

in the mid-1640s, captured the effect of the setting sun or of the moon in their refracted glow across a countryside darkened by night over a still watery landscape. But it is, above all, the spirit of the age that may be understood to account for this similarity. Rembrandt's approach in his painting in Dublin cannot really be linked with the rather restrained manner of Aert van der Neer, who was the main representative of the Dutch night scene. The poetically intensified expression of Rembrandt's *Rest on the Flight into Egypt* depends on the exciting way in which its elements are set off against each other: the landscape and the event that links the figures, calm and disquiet, light and darkness.

J.K.

1. On the iconography of the Rest on the Flight into Egypt, see Tümpel in: Berlin 1970, Nos. 54, 56.
2. On the early interpretations of the figural narrative, see Sutton in: Amsterdam, Boston and Philadelphia 1987–88, No. 78, and Schneider 1990, p. 194, No. 8.
3. Bode 1883, pp. 491–92, No. 261.
4. Stechow 1966, pp. 173–82.
5. Kassel, Staatliche Gemäldegalerie, Cat. 1958, No. 87.
6. As Kieser, 1941–44, p. 147, observed, Goudt's copper engraving after Elsheimer's *Philemon and Baucis* also served as the model for Rembrandt's painting of the same name of 1658, in Washington, the authenticity of which is, however, questioned (Bredius/Gerson 481). Hercules Seghers provided the occasion for a rather curious case of reference to Elsheimer. Seghers's plate with the etching *Tobias and the Angel*, based on Goudt's engraving after a lost painting by Elsheimer, was partially polished away by Rembrandt

and re-worked to a *Flight into Egypt*, dated 1653 (B. 56). See Tümpel in: Berlin 1970, No. 57.
7. According to Schwartz, 1984, p. 246, in 1642 there was a painted copy after Elsheimer in the estate of the Delft art-dealer Herman de Neyt.
8. Schneider 1990, p. 52.
9. Stechow 1966, p. 176.
10. Translation from the Latin, cited from Frankfurt am Main 1966–67, No. 275.
11. Potterton, see London 1985, p. 64.
12. Raupp 1980, pp. 85–109.
13. J. Bruyn, 'Towards a Scriptural Reading of Seventeenth-Century Dutch Landscape Paintings,' in: Amsterdam, Boston and Philadelphia 1987–88, pp. 84–103 (English edition).

38b: Adam Elsheimer, *The Flight into Egypt*. Munich, Alte Pinakothek.

38c: Hendrik Goudt, after Adam Elsheimer, *The Flight into Egypt*. Engraving. Berlin, Kupferstichkabinett SMPK.

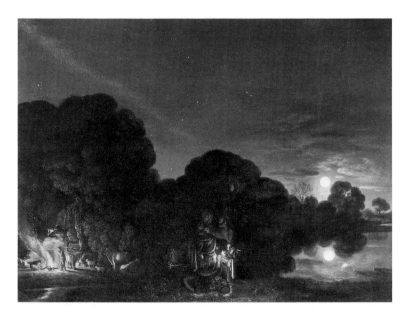

39

Bathsheba with King David's Letter

1654
Canvas, 142 × 142 cm
Signed and dated: *Rembrandt ft. 1654*
Paris, Musée du Louvre; M. I. 975

Provenance: W. Young Ottley sale, Christie's, London, 25 May 1811, No. 90 (sold for 189 guineas, to Philipps); W. Young Ottley sale, Christie's, London, 4 March 1837, No. 92 (sold for 110 guineas, to Peacock); Peacock art dealers, London; Count Maison collection, Paris; sale, Paul Périer, Paris, 16 March 1843, No. 35, as 'Suzanne au bain' (6350 francs); Louis La Caze collection, Paris (Cat. No. 97); La Caze bequest to the Musée du Louvre, Paris, 1869.

Literature: Bredius/Gerson 521; Bauch 31; Gerson 271; Tümpel 4; J. Foucart: *Les Peintures de Rembrandt au Louvre* (Paris, 1982), pp. 54–62, 91.

Exhibitions: Paris 1945, No. 57; Paris 1955, No. 15; Amsterdam 1956, No. 65; Paris 1969; Amsterdam 1969, No. 13; Paris 1970–71, No. 178.

In the evening King David saw from his palace '. . . a woman washing herself; and the woman [Bathsheba, the wife of Uriah] was very beautiful to look upon . . . And David sent messengers, and took her . . . and he lay with her.' When Bathsheba discovered that she was pregnant, the king called Uriah back from the war and ordered him to visit his wife. Uriah, however, refused and subsequently David ensured that Uriah was killed in the fighting. 'When the wife of Uriah heard that Uriah her husband was dead, she mourned for her husband.' When her period of mourning was over, Bathsheba became David's wife. (II Samuel 11: 2, 4 and 26)

The life-size nude figure of Bathsheba is alloted a generous share of the square panel. She sits in the right foreground, at the edge of the water on a bank covered with a shawl and draped with a richly pleated shirt. Whereas her head and crossed legs are turned to the left, in profile, her torso is shown so as to be almost fully visible to the viewer. Uriah's wife supports her upright sitting pose with her left hand, and in her right, which rest lightly on her knee, holds the letter with David's message. With her head lightly bent forwards, Bathsheba gives the impression of being lost in thought rather than paying attention to the old servant woman who is washing her feet. Pushed into the shadows of the lower left corner of the picture, only the maid's hand, head and upper torso are shown. Prime importance in the composition is given to the female nude. Brightly lit from the side, it combines both sculptural clarity and painterly softness. Rembrandt avoids foreshortening in the turns and gestures of the figure who is positioned parallel to the picture plane. The other motifs are subject to the same principal: the outline of the servant woman, the cascade of gold brocade drapery in the middle-ground, which forms a semi-circle linking the two women in the foreground, as well as the softly gleaming, drawn curtains in the background, that seal the scene off from the unrelieved darkness of the sky. The emphasis on horizontals and verticals, partly visible in the architectural elements, contributes to the overall static impression of the composition. Given this, it is less the expansively unfolded rendering of Bathsheba's beauty but rather her 'spiritual' image which emerges as the more decisive feature of the painting.[1]

In an effort to account in terms of content for the depth of expression found in the scene, Freise conjectured that the picture might be related not to the beginning of the story but to its conclusion. He argued that Rembrandt showed Bathsheba, after the death of her

39a: Peter Paul Rubens, *Bathsheba at the Fountain*. Dresden, Gemäldegalerie Alte Meister, Staatliche Kunstsammlungen.

39b: X-ray photograph of Cat. No. 38 (detail).

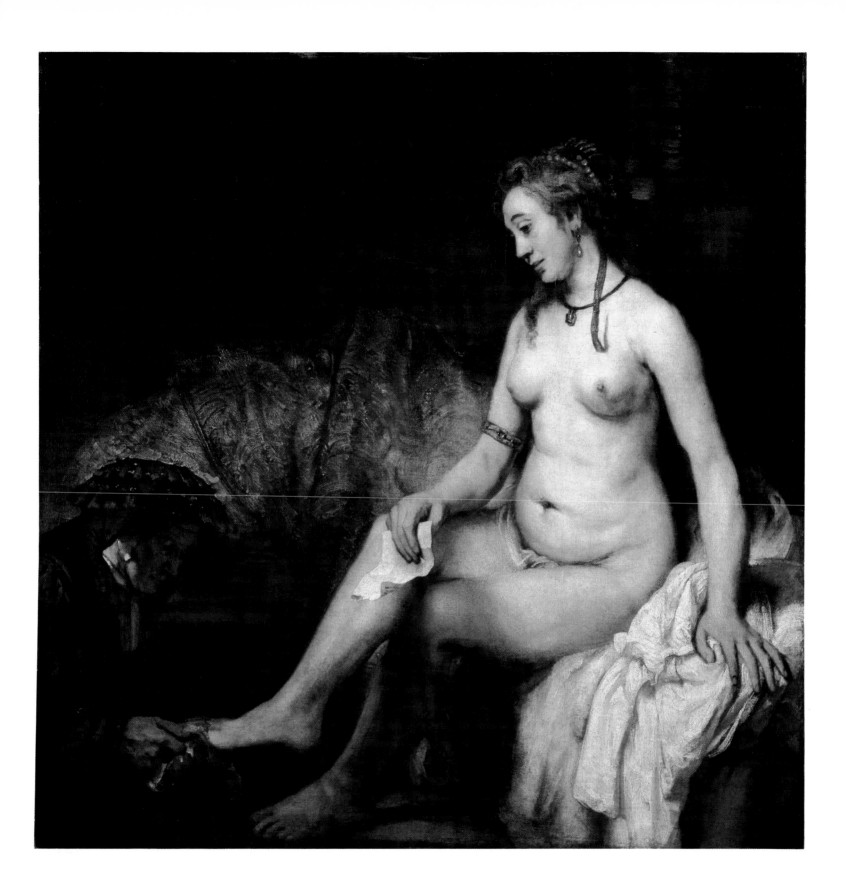

39c: Copy after Rembrandt, *Bathsheba*. Rennes, Musée des Beaux-Arts.

39d: Willem Buytewech, *Bathsheba*. Etching. Düsseldorf, Kunstmuseum, Graphische Sammlung.

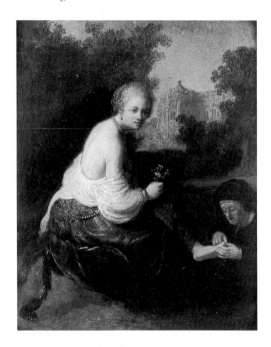

husband and after the period of mourning had run its course, receiving David's request that she become his wife, and for this reason having her servant wash and dress her.[2] The text of the Bible which describes only one bathing scene with Bathsheba, contradicts this interpretation, as does the iconographic tradition, which has added the visible prop of a love letter to the delivery of the message which was, in fact, carried by word of mouth—'And David sent messengers, and took her.' In his painting *Bathsheba at the Fountain* of c.1635, in Dresden (Fig. 39a), Rubens combined in a single scene, the two sequential phases of David observing Bathsheba while bathing, and the handing over of the king's *lettre d'amour*. Rembrandt's work also draws from this iconographic situation which foreshadows the impending tragedy. Little remains, however, of the expansive and splendidly decorated setting devised by Rubens. Rembrandt did not wish to illustrate the pomp of royal courtship. Instead, his depiction is intended to capture the very substance of the story.[3] Rather than showing the delivery of the letter, as was traditional, he concentrated on a subsequent moment. In a silent dialogue with David's message, Bathsheba is caught in an unresolved moment of tragic entanglement, in having to decide between obedience to her king and fidelity to her husband. This decision, which really leaves her no choice, can only be made by her.[4] It is for this reason more than any other that David and his messenger, although both are central to the story, have been banned from the scene; and it is for this reason too that the letter, which constitutes both the beginning and the end of the tragedy, is placed at the centre of the picture.

In the last phase of work on his picture, Rembrandt embarked on corrections which were not of a formal nature, but rather served to heighten expression. X-rays have shown that Bathsheba's head and her glance were originally directed upwards (Fig. 39b).[5] Rembrandt consequently abandoned this turn of the head with its focus on something or someone in the external world. Only the retention of her gaze within the picture is appropriate to the situation in which Bathsheba is thrown back entirely on herself.

Rembrandt was familiar with the demands of the subject. Two versions of the related theme of the story of Susanna, in The Hague and in Berlin (Cat. Nos. 25 and 37), presuppose Rembrandt's study of Pieter Lastman's *Toilet of Bathsheba* of 1619, now in Leningrad (Fig. 25g). The same is true of the *Bathsheba* of 1643, painted in the Rembrandt workshop and now in New York.[6] In Lastman's work the handing

over of the royal message is omitted. Only the genre-like aspect of the bath or toilet scene observed by David is treated, and a cultivated park landscape is introduced as a foreground. In about 1632 Rembrandt himself contributed a small-scale treatment of the subject along these lines; although the original is untraced, it has been preserved in a series of copies, the earliest of which, now in the Musée de Rennes (Fig. 39c), was once regarded as a work from Rembrandt's hand.[7] Here, Bathsheba has already been provided with the supporting figure of the old servant who, reduced to a crouching figure weighed down by her clothing, contrasts vividly with the openly proffered youth and beauty of her mistress. This unmatched pair must be intended to allude to the idea of transcience, a connection assumed in Willem Bytewech's Bathsheba etching of 1616 (Fig. 39d).[8] This sheet, bears the title 'Vanitas' and transforms the role of the old woman into the negative one of the procuress, from whom Bathsheba has just received David's message. As in the case of Rembrandt's painting, it is not the delivery of the letter that is shown but its reception and the resulting emotion. While Bytewech's Bathsheba, in compliance with the explicit designation of the work, behaves in accordance with the allegory and receives the news with obvious excitement, the figure in Rembrandt's Louvre picture remains calmly self-contained. Violent reaction is not compatible with the state of inner tension embodied in the image of Bathsheba.

The simplicity and clarity of the pictorial structure, which imbue the statuesque character of the nude with an increased plasticity, was connected by H. Bramsen to Rembrandt's interest in an antique relief.[9] Rembrandt may have known the work concerned from an engraving by François Perrier, which appeared in 1645 (Fig. 39e).[10] Connections between the relief and Rembrandt's painting may be seen in the poses of the figures, in their relation to each other, in the parallel arrangement of the whole composition and, not least, in the role played by the curtain in the background with its numerous folds. Rembrandt has put this motif to double use: as a tightly-drawn screen protecting the intimacy of the figures and—as Gerson observed—as an element in its own right which repeats the concentrically curved form of Bathsheba's brocade gown.[11] One may presume Rembrandt's knowledge of the antique model, even though J. Foucart argued firmly against this; however Rembrandt's own inventions cannot be excluded as a model for the compositional solution adopted in the *Bathsheba*.

In the copy in Rennes the two women take up the open-air foreground in a way that anticipates the solution adopted in the Louvre picture. The figure of Bathsheba, for which Hendrickje Stoffels must have served as model, is recorded in a common enough pose.[12] Using her arm as a support to make sitting easier would have been welcomed by the model, posing in long studio sessions. The pose occurs in an early etching which shows a seated female nude (Fig. 39f), and also, in a surprisingly comparable guise, in the etching *Woman by a Stove* of 1658 (Fig. 39g), whose 'ordinary' features may be seen as an indication that Rembrandt was here working directly from a live model. The nude half-figure is not, however, left without stylization. The outline forms of the body emerge as the dominating feature of the image. As a complement to the simple, geometric treatment of the rest of the etching, the figure is firmly rendered in large, rounded forms. The 'classicism' of the Bathsheba, affirmed by Bramsen, is not a lone example in Rembrandt's œuvre. His *Aristotle with the Bust of Homer* (Fig. 41a), painted in 1653 and now in New York,[13] is conceived in large and simple forms, just as is the Paris picture; it is worked up from the picture plane, and then held within this plane by the sweeping line of the figure's arms. The same may be said of the *Flora*, also in New York (Cat. No. 41): although no less severe than the *Bathsheba* in its forms, it lacks the harshness in the treatment of colour and light. Rembrandt was not interested in being a painter of polished surfaces. His manner of painting remains soft and he reveals his admiration for Titian and the Venetian painting of that age by choosing for his palette deep red and tones of gold-yellow, which, set against the dark background, underscore the glowing flesh-tones of the female nude. The classicism of the Bathsheba is harmoniously linked with the brilliance of Venetian colouring—restrained, and yet conveying the appearance of all that is most choice and most sumptuous.

J.K.

1. Jantzen 1923, p. 62.
2. Freize 1909, pp. 310–13.
3. Jantzen 1923, pp. 60 and 62; Tümpel 1986, pp. 287–88.
4. Kunoth-Leifels 1962, p. 71.
5. Hours 1961, pp. 34–35.
6. New York, Metropolitan Museum, Bequest of Benjamin Altman, 1913 (14.40.651); Bredius/Gerson 513. Tümpel 1986, p. 419, Cat. A1, takes up the doubt expressed by Gerson as to whether the work was entirely by Rembrandt, and attributes the picture, rightly, to the Rembrandt workshop.
7. *Corpus* C45.
8. Haverkamp-Begemann 1959, p. 178, vG 35.
9. Bramsen 1950, pp. 128–131.
10. The title off this engraving reads: 'Icones et segmenta illustrium e marmore tabularum quae Romae adhuc extant a Francisco Perrier, Romae 1645.
11. Gerson, p. 112.
12. The seated female nude in a pen drawing in the Victoria and Albert Museum in London (Benesch 1345) is shown in a different pose. The only connection to this work is the oriental hat which, however, in the painting is worn by the servant woman.
13. New York, Metropolitan Museum, 61.198; Bredius/Gerson 478.

39e: François Perrier, *Antique Relief.* Engraving. Amsterdam, Rijksprentenkabinet.

39f: Rembrandt, *Seated female Nude.* Etching, c. 1631 (reversed). Berlin, Kupferstichkabinett SMPK.

39g: Rembrandt, *Woman by a Stove.* Etching, 1658 (reversed). Berlin, Kupferstichkabinett SMPK.

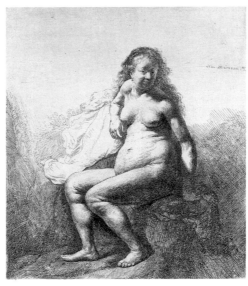

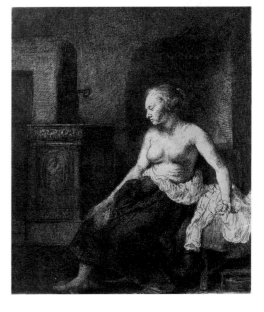

40

A Woman Bathing

1654

Oak panel, 61.8 × 47 cm, signed *Rembrandt f 1654* (the last figure of the date, which has, on occasion, been read as '5', is unmistakably written as a '4')

London, National Gallery; Inv. No. 54

Provenance: 4 May 1739, presumed to be in the Andrew Hay sale, London, as No. 20 (sold, for £6.19s.); 18 March 1756, Blackwood sale, No. 60 '. . . A Woman going into the water holding her Coat pretty high, and laughing at what she sees reflected' (sold, for £19.8s.6d., to Raymond); passed, presumably after 1811, to the collection of Baron Gwydyr; 9 May 1829, Lord Gwydyr sale, Christie's, London, No. 72 (sold, for £165, to Rev. William Howell); 1831, Howell Carr Bequest to the National Gallery, London.

Literature: Bredius/Gerson 437; Bauch 278; Gerson 289; Tümpel 122.

Exhibitions: London 1947/48, No. 68; Amsterdam 1969, No. 14; London 1988/89, No. 11.

A young woman has stepped down into the water from the steep bank where she has laid her dress. As she moves forwards with care— treading on apparently uneven ground—to slip deeper into the liquid coolness, she uses both hands to lift the undershift she is still wearing above her legs. The bathe brings delight, and a smile lights up her face as she gazes down into the water.

The bathing girl is shown as a full-length figure, slightly turned to her right. The small-scale and upright format of the picture allow the figure to dominate the scene; and the light, entering from the upper left, picks out from the surrounding gloom this radiantly lit image in its calm movement. The brush-stroke is sketchily free: in the background it creates an atmospherically soft distribution of tonal values, in the application of the white of the shirt it is used in bold impasto, and yet, in some places, it leaves the priming uncovered. At both the upper left and upper right, the ground remains visible, its yellow-brown tone adding warmth to the overall colouring and blending harmoniously with the yellow-ochre and the red of the sumptuous dress. Only those parts that the woman uncovers—her décolletage and her legs—are more firmly modelled and given a well-rounded appearance through sensitively graduated nuances of tone. The mirroring water surface registers what is taking place above it—but in the smudged manner reminiscent of a watercolour. Here, the oil paint has been applied in a markedly fluid state: thus even its transformed material quality has a significant part to play in the presentation of this scene.[2]

The small scale and the generally clear traces of the brush-strokes convey the impression of swiftly captured figure study. There is, however, no evidence of a completed painting for which this work might be understood as preparation. Rembrandt did not adopt Rubens's practice of using oil sketches as preparation for large-scale commissioned works, at least not as preparation for paintings. The 1636 etching, *Ecce Homo*, on the other hand, did evolve from an oil sketch, although this—*nomen est omen*—was prepared as a *grauewtje* (grey-in-grey, i.e. grisaille) (Cat. No. 15). The *Woman Bathing* can hardly be compared with such a grisaille, of which several were produced by Rembrandt during the 1630s. One cannot accuse this picture of a lack of colour; nor can one find evidence for the assumption that it is an unfinished work. The picture is signed and dated; and this would certainly suggest that it was finished to Rembrandt's satisfaction.

The free, painterly treatment restrains the openly proffered eroticism of the subject, and

yet increases the casual air of the figure's pose and the suggestion of the passing moment in the depicted situation. Not least, it also serves to place some limits on the imagination of the viewer. One might conclude, among other things, as Hamann suggested, that the young woman is smiling at her own nakedness reflected in the water surface.[3] One cannot, however, agree with Eisler's interpretation— that the painting is an instance of the 'kräftigsten erotischen Exzesses des Meisters' (the painter's erotic excess at its most compelling).[4] The woman is not displaying herself, as she imagines that she is alone and unobserved. Her body, moreover, is not fully uncovered—although it has to be said that the raised undershirt below and the deep décolletage above amount, together, to much the same thing.

In an attempt to provide the picture with a meaningful basis in terms of content, commentators have mostly turned to the question of the model. She is presumed to be Hendrickje Stoffels, the companion of the ederly Rembrandt until her death in 1663. No securely documented portrait of Hendrickje has survived; but the features of the model seen here may often be encountered in Rembrandt's works from the 1650s. It would seem reasonable to place the model in the painter's immediate circle (see Cat. No. 45); but this is not true with regard to the situation we are shown here, which is unusual. The picture can certainly not be defined as the expression of Rembrandt's sudden inspiration upon seeing his companion bathing.

The repertoire of artists' subjects in this period did not afford a great many alternatives in the context of which a female figure bathing in the darkness would constitute an artistically significant motif. Bauch presumed that the picture was 'probably a study, after Hendrickje Stoffels, for Susanna or Bathsheba'. Brown, however, has pointed to a work comparable to Rembrandt's picture in several respects— Rubens's portrait of his second wife, Hélène Fourment, *Het pelsken*, now in Vienna (Fig. 40a)—in which the subject, draped only in her fur, is depicted, with a degree of mythological and allegorical exaggeration, as Venus. Rubens has made the most of the *portrait historié* of his wife, and has placed Hélène in the classical pose of the *Venus pudica* (chaste Venus).[6] Chastity, however, is not the epithet one would choose for Rembrandt's *Bathing Woman*. She embodies, rather, its opposite. Rembrandt must have had in mind the reproductive engravings by G.F. Greuter after the antique sculpture of the *Mulier impudica* (unchaste woman) (Fig. 40b), when he showed his bather lifting her under-

40a: Peter Paul Rubens, *Portrait of Hélène Fourment, 'Het pelsken'*. Vienna, Kunsthistorisches Museum.

40b: G.F. Greuter, *Mulier impudica*. Engraving. Amsterdam, Rijksprentenkabinet.

shirt above her thighs. According to Jan van de Waals, who refers to the reception of this motif, the dubious significance of such uncovering was familar in the seventeenth century. The motif was understood literally 'Dat gaat 'er na toe, zei de meyd, en ze nam haar hembd tussen haar tanden' (This is the way, said the girl, and took her shirt between her teeth).[7]

Rembrandt can hardly have intended to allude to lack of chastity in any personal sense. In the year the picture was painted, Hendrickje had to undergo humiliation enough: pregnant with Rembrandt's daughter Cornelia, she was summoned before the Church Council and, there, had to confess to the charge of her 'Aoeretige' (whoring) with Rembrandt, being punished by being barred from receiving communion. It would seem more likely that the picture may be linked to one of the two beauties of the Old Testament—Susanna or Bathsheba—although the former would have to be excluded on the grounds that she was a *pudicitiae exemplar* (exemplar of chastity) (see Cat. Nos. 25, 37). Bathsheba, on the other hand, did not resist King David's overtures, made after he had watched her one evening while bathing (II Samuel 11, 2–4). The dress of gold brocade that lies on the bank in the London picture, and which indicates a woman of high social standing, is the same dress as found in the *Bathsheba* now in Paris (Cat. No. 39), also dating from 1654. The image of David, a figure so central to the story of Bathsheba, is also omitted from the latter picture, where Bathsheba is, notably, given a pose that sparks the viewer's sympathy. It is not her own lack of chastity, but an unavoidable fate, that forces her to comply with the king's message of love, which she has just received. The *Woman Bathing* in London, however, cannot be regarded as a tragic heroine. From at least the time of the Medieval *Bible historiée*, another view of Bathsheba was current —not that of Bathsheba as one seduced, but that of Bathsheba as a seductress, who dazzled David through the vain display of her beauty, thus establishing a prelude to both infidelity and murder.[8] Such a woman was painted by Willem Drost. His *Bathsheba*, also dated 1654 and now in Paris (Fig. 45c), certainly reveals Rembrandt's influence; and yet it remains close in its figure type to that of Venetian courtesan portraits.[9] In this context it would not seem unreasonable to understand the raised under-shirt of Rembrandt's *Woman Bathing* as an attribute of the unchaste Bathsheba. In terms of composition, the picture in London has nothing in common with the large-scale version of *Bathsheba* in Paris. It

recalls, rather, a drawing (Benesch 977) for a related subject—The *Susanna and the Elders* now in Berlin (Fig. 40c)—in which the heroine is not shown sitting by the water, but rather stepping into it. Dominating the picture in a comparable manner, the bather in the London painting emerges from the confused gloom of the background; and the viewer watches her— with her seductively lifted gown—just as David watched Bathsheba.

J.K.

1. Brown, see London 1988/89, p., 96. No. 11.
2. The cleaning of the picture, carried out in 1946 by H. Ruhemann in London, provoked violent controversy between those in favour of more conservative methods of restoration and those who argued, in all awareness and conscience, for thoroughness. See: London 1947/48, No. 68. Gerson (Gerson/Bredius 437, Gerson 289) has correctly emphasized that the cleaning was undertaken with care and that the partial visibility of the paint surface is an integral aspect of the generally 'sketchy' character of Rembrandt's manner of painting here.
3. Hamann 1969, pp. 185–86. See also the description in the sale catalogue of 1756.
4. Eisler 1927, p. 83.
5. Brown, see: London 1988/89, at No. 11; MacLaren/Brown 1991, p. 54.
6. Held 1967, pp. 188–92.
7. Van de Waal 1988, pp. 63–64, especially p. 67, note 113. A proof of the copper engraving by Giovanni Frederico Greuter—after a sculptural work in the Giustiniani Collection in Rome—was to be seen, in Rembrandt's day, in the collection of Michiel Hinloopen (1619–1708) in Amsterdam. Hinloopen had acquired a large collection of prints, among other occasions during the journey through France amd Italy from which he returned in 1648, and had ordered this collection in a systematic manner. Greuter's sheet was included in the 'atlas van Rome' (Book 1, fol. 79).
8. Kunoth-Leifels 1962, pp. 15–43.
9. Miller 1986, pp. 75–82. See also Cat. No. 45.

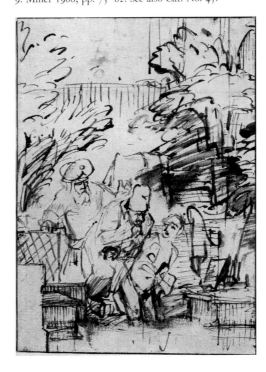

40c: Rembrandt, *Susanna and the Elders*. Drawing. Berlin, Kupferstichkabinett SMPK.

41

Flora

c.1654/55
Canvas, 100 × 91.8 cm
New York, Metropolitan Museum of Art;
Acc. No. 26.101.10.

Provenance: The Earls Spencer, Althorp House,
Great Brington, Northants., about 1822; in
possession of the Spencer family until 1916;
Duveen art dealers, New York and London;
about 1920, collection of Mrs Collis
P. Huntington, New York; about 1920,
collection of Archer M. Huntington, New
York; 1926, given by Archer M., Huntington,
in memory of his father, Collis Potterton
Huntington, to the Metropolitan Museum of
Art, New York.

Literature: Bredius/Gerson 114; Bauch 282;
Gerson 288; Tümpel 111.

Exhibitions: Amsterdam 1898, No. 106; London
1899, No, 95; New York 1920, p. 9; New York
1942; Cambridge, Mass., 1948, No. 11;
Worcester, Mass. 1949; New York 1950, No.
20; Amsterdam 1956, No. 74; Rotterdam 1956;
Boston 1970, p. 43; Tokyo 1976; Kyoto 1976.

With an outstretched right hand, the young
woman offers flowers; more of which are to be
found in her hitched-up skirt which she holds
with her left hand. The flat, broad hat she
wears is decorated with a branch of cherry
blossom. Rembrandt depicted Flora, the
goddess of flowers and of Spring, several times.
Little has remained, however, of the baroque
exuberance of the life-size three-quarter figures
of 1634, in Leningrad (Fig. 23d), and of 1635,
in London (Cat. No. 23). In the New York
figure, all movement is aligned with the picture
plane. The body is caught in a frontal view,
but the head is seen almost in profile. This
pose corresponds with the treatment of the
light, which enters from the upper left at an
unusually low angle, somewhere between the
dark ground and the shadow of the caught-
up skirt, and flickers over the life-size half-
figure. The light brings the white, shirt-like
dress to life and the now visible vertical folds
form an attractive contrast to the gathered,
tucked and frilled puff-sleeves. The cut of the
costume creates an abstract-ornamental effect,
most suitable to the ideal world to which the
graceful female figure belongs. Whereas in both
the earlier paintings the goddess's floral riches
were elaborately and realistically illustrated,
here they are confined to a few spots of
impasto red. The costly material effect of the
paint is deceptive enough to allow us to
recognise it in the natural beauty of flowers.
Form and colour speak virtually for themselves,
even if not in every detail of the picture.
Through carefully nuanced tonal values, and
cheeks lightly blushed with red, Flora's face
comes to life; its softness markedly different
from the hard, linear yellow and white of her
costume.

As Rembrandt painted the richly folded
white of Flora's sleeves, he must have recalled
his *Aristotle* of 1653 (Fig. 41a), now also in
New York. In that picture, however, the
cascade of folds is more expansive and, at the
same time, is given a more painterly softness.
This is true of the figure of the philosopher as a
whole; he is placed on a slight diagonal to the
picture plane and blends into the surrounding
darkness of the setting. Flora, however, is
portrayed with a distinct silhouette, and as
such is formally close to Bathsheba in the
painting of 1654 (Cat. No. 39), in Paris, whose
profile is sustained in a comparable manner by
the impressive sweep of her arms and
shoulders. The close relationship is evident not
only in expression and pose, but also in such
details as the partially incisive structure of the
folds of the cloth on which Bathsheba's left
hand rests; and in its extremely large size, this
hand is comparable with Flora's left hand that

41a: Rembrandt, *Aristotle with the Bust of Homer.*
1653. New York, Metropolitan Museum of Art.

she uses to gether up her skirt against the picture plane. The classicism noted by Bramsen in the Paris *Bathsheba* is by no means less a characteristic of the broad conception of the *Flora*.[2] A dating of the picture, which is unsigned, to the years around 1654/55 would seem to be justified. Gerson and Tümpel have proposed a dating around 1657; yet figures with such a decisive contour are not known so late in Rembrandt's œuvre.

The Paris *Bathsheba* and the New York *Flora* could be twin sisters. They are both based on the same model, who is generally identified as Hendrickje Stoffels, the companion of the late Rembrandt. No known portrait of Hendrickje has survived; but the features of the model seen here can be found in a number of Rembrandt's works from the 1650s. It therefore seems plausible to place, or at least seek, the model in Rembrandt's personal circle (see Cat. No. 45). It remains open to question, however, whether the title deriving from Bode and subsequently accepted by many—'Hendrickje as Flora'—can be upheld. Kieser saw Hendrickje in the figure, interpreting the picture as Rembrandt's vindication of his companion, who, in 1654, had had to answer before the Church Council to the charge that she had 'committed the acts of a whore' with Rembrandt and who had, accordingly, been barred from receiving communion: 'she may be a whore to you, but for me [Rembrandt] she is a pure, blossoming, generous goddess such as Flora of the Ancients, who was a prostitute before becoming a goddess.'[3] In Rembrandt's œuvre there is often only an ill-defined boundary between the role portrait—*portrait historiée*—and the individual figure with historical significance based on a model. In as far as no definite information on the New York *Flora* is available, a distinction between these two genres must remain a matter of subjective preference. The unassuming title, *Flora*, which has recently been given to both the Leningrad and London versions, does at least go back to Rembrandt, who 'dealt in' (i.e. sold) works by his pupils—probably copies—with this title.[4] The *Saskia as Flora* of 1641, in Dresden (Fig. 23f), on the other hand, is rightly so called. The subject is shown as if ready to engage in conversation with the viewer, in a free and open disposition that suggests a portrait, and without the floral riches of the other works. The female figure of the picture in New York does not seek external contact; instead she keeps to herself, as the embodiment of her own realm, shielded from what lies beyond by her skirt that is both gathered up high as a *repoussoir* element and, at the same time, pushed flat against the picture plane. It is, above all,

through the profile turn of the head—the most extremely withdrawn pose for a portrait—that the viewer feels himself excluded. Neither the continuous contour of the head's profile, nor a pure *en face* view, suggests movement. The transitory comes to rest, is consolidated, and evokes the appearance of permanence. If Rembrandt intended to present only the goddess and her divine nature, than he choose the right pose for this purpose.

Rembrandt's interpretation of the figure of the Roman goddess, which may be traced through two decades of his work, has repeatedly been assessed as an expression of his enduring admiration for the art of Titian. Voss saw in Rembrandt's picture of 1634, in Leningrad, the influence of the Venetian master, whose own *Flora*, now in Florence (Fig. 41b), was for a period prior to 1641 in the Amsterdam collection of Alfonso López.[5] The pose and costume of Titian's *Flora*, however, are decisively different. As has lately been convincingly demonstrated, Rembrandt referred to a late Gothic figure type for his earliest version of the subject (*Corpus* A93). It is, rather, the painting in London (Cat. No. 23) which suggests Titian's influence. The sweep of the outstretched right arm with its wide sleeve and the brightly lit, generously opening neckline, are features present in the painting from the López collection. Titian's Flora reaches for the drapery that has fallen from her shoulder. This gesture, revealing more than it conceals, was adopted by Rembrandt, although he eliminated the folded drapery gathered to the body and replaced it with the much more appropriate, though no less decorative, floral wreath. This motif anticipates the *repooussoir* effect of the flowers collected in the skirt in the New York picture.[6] The Dresden *Saskia as Flora*, however, as Stechow realised, is more significantly indebted to Titian's model.[7] Rembrandt's knowledge of Titian's painting is evident both from the movement of the figure's right hand with the carnation, and that of her left hand holding the diaphanous shawl to her dress open at the breast. Rembrandt has imbued his own work with the erotic allure exuded by Titian's beauty. Rembrandt was aware of the ambivalence surrounding Flora's role— she was both *flora mater* and *flora meretrix* [i.e. a prostitute]. Like Titian, Rembrandt illustrated the latter Flora, who, instead of retaining her attribute, proffers the flower as a symbol of greater pleasures. In this way, it was possible for artists to indicate or symbolise sensual pleasures. As Held has pointed out, the flower had become a symbol of the prostitute.[8] Titian's young woman, however, is a courtesan

41b: Titian, *Flora*. c. 1515/16. Florence, Galleria degli Uffizi.

of high birth. She looks sideways while she offers both her flowers and her bare shouldered self. Rembrandt too has avoided excessive boldness in this respect. Saskia's gesture is certainly generous, yet, through the glance of her large eyes, it is transformed into something personal and intimate. The delectable game is not intended for the attention of a third person.

In the New York picture nothing seems to remain of Flora the courtesan. Nonetheless, it is precisely this version that owes the most to Titian, from whose work is derived the vigorous outline of the figure, the thin, white shirt with its stream of folds flowing into wide sleeves, and also the flowers which lie as if heaped up in Flora's hand. Clark rightly observed that, in addition to individual connections, the arrangement of the whole— the simply and expansively treated composition of the figure, and the evenly distributed illumination—is indebted to the Venetian painter's model.[9] Finally, the pose of Rembrandt's New York Flora is also anticipated by Titian in the sideways turn of his figure's head. Rembrandt, however, had been preoccupied with profiles at an earlier stage, as shown by the 1632 portrait of Amalia von Solms, in Paris (*Corpus* A61), commissioned as a pendant to a profile portrait by Honthorst of her husband, Prince Frederik Hendrik of Orange (The Hague, Collection of the Queen of the Netherlands). About 1633/34, Rembrandt was engaged on the *Portrait of Saskia*, completed in 1642 and now in Kassel (Fig. 41c; *Corpus* A85). Its now famous 'antique' profile was, as drawn copies and x-ray photographs show, originally less severe because part of Saskia's other eye could be seen; such a turn of the head corresponds exactly to that of Flora (and that of Bathsheba in Paris). Rembrandt refrained for a long time from parting with this picture of his wife; and only in 1652 did it come into the possession of Jan Six. Thus, subsidiary aspects of this portrait were certainly still in Rembrandt's mind when he produced the Flora. The hairstyle and hair decoration are shown in a comparable way, as is the flat head-covering draped with full blossoming branches.[10] Shepherdesses belong to the pastoral iconography of the Utrecht school, such as the *Fair Shepherdess* painted by Paulus Moreelse in about 1630, now in Amsterdam,[11] who wears a comparably outspread floral decoration in her well-ordered hair. Whatever impulses Rembrandt may have received and re-worked—be it in a critical selection from all that came before his mind and eye, either externally or in the context of the development of his own work—the result, in the end, was

yet another picture of striking clarity and depth of expression. Nothing is left to be added, or altered, in this image of woman unfurling across the level surface of the almost square picture plane as a creature from a higher order, evoking the impression that Rembrandt here came closer to antiquity than did Titian himself, even though the latter's *Flora* is based on the classicism of antique sculpture.[12]

J.K.

1. Alterations to the background, dating from the eighteenth century, were removed during the restoration recently undertaken by John Brealy (information from Walter Liedtke, New York). The picture has now won back much of its original allure. In places, the paint layers appear to be slightly abraded. We may presume that the structure of the shirt folds was originally somewhat less incisive in its appearance. The emphasis on the planar construction of the figure, however, is derived from Rembrandt and is not to be attributed to the picture's state of preservation.
2. Bramsen 1950, pp. 128–31.
3. Kieser 1941/42, pp. 138–39.
4. See Cat. No. 23 and *Corpus* A93, A112.
5. Voss, 1905, p. 156–62.
6. See Kieser 1941/12, p. 155, note 9.
7. Stechow 1942, p. 141.
8. Held 1961, pp. 213–18.
9. Clark 1966, p. 137.
10. A similarly flat head-covering is worn by the young shepherdess in Rembrandt's etching of 1642, *The Man with a Flute* (Bartsch 188).
11. Amsterdam, Rijksmuseum, Cat. 1976, A276.
12. Held 1961, pp. 205–206.

41c: Rembrandt, *Portrait of Saskia van Uylenburgh*. Kassel, Staatliche Kunstsammlungen.

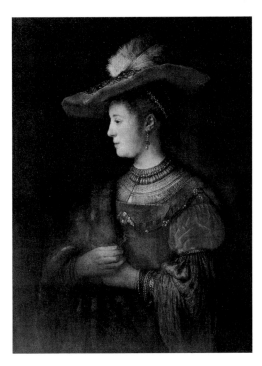

Titus at his Desk

1655
Canvas, 77 × 63 cm
Signed and dated (it is presumed not by
Rembrandt): *Rembrandt f, 1655.*
Rotterdam, Museum Boymans-van Beuningen;
Inv. No. St. 2.

Provenance: collection of the Earl of Crawford
and Balcarres, Haigh Hall, Wigan; given by the
Vereniging Rembrandt and 120 Friends of the
Museum to the Stiftung Museum Boymans,
1940.

Literature: Bredius/Gerson 120; Bauch 411;
Gerson 325; Tümpel 184.

Exhibitions: London 1866, No. 75; Amsterdam
1898, No. 90; London 1899, No. 23; London
1922, No. 13; London 1929, No. 108;
Amsterdam 1932, No. 31; Brussels 1946, No.
86; New York, Toledo and Toronto 1954–55,
No. 65; Stockholm 1956, No. 33; Amsterdam
and Rotterdam 1956, No. 70; Sophia 1985,
with illustrations; Leningrad 1986, No. 26;
Rotterdam 1988, No. 22.

42a: Rembrandt, *Titus reading*.
Vienna, Kunsthistorisches Institut.

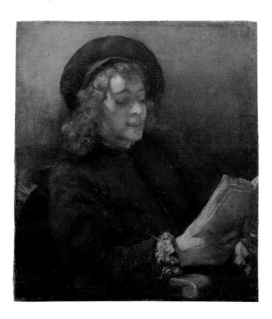

Only the boy's head and hands are visible
behind the desk at which he sits. Our
viewpoint is low. The piece of furniture is
pushed up frontally against the picture plane,
thus forcing our attention upwards to the life-
size bust of the sitter who seems, in fact,
removed from reality. The now forgotten
papers lying before him on the desk, had, a few
moments earlier, been the focus of his
attention. Lost in thought, he rests his chin on
his right thumb, the flexibility of which
betrays his youth; with his right hand he holds
his pen; from his left dangles a portable pen
and ink case.

Rembrandt has brought to life the scene of
his model momentarily musing over his
unfinished work. From the dark background
which throws deep shadows across the sitter's
shoulders and arms, his brightly lit and firmly
modelled face and hands emerge. The light,
streaming in from the left, also highlights the
front of the desk. Placed parallel to the picture
plane, the desk occupies the full breadth of the
picture and also more than a third of its height.
It is not made of a polished piece of wood but
rather bears the signs of wear and tear left by
generations of users. The richly nuanced
painted marks, showing traces of use and
damage, are executed in a variety of techniques,
and are like secret ciphers that have been
scratched with a palette knife in the paint
while it was still wet.

This area of the picture is not without
reference to the sitter. The figure forms a
broad-based and firmly anchored triangle, a
form extended by the shadow on the left and
the ink holder on the right. The extension of
the form thus binds together the two separate
zones. Into this geometrical arrangement, as
simple as it is clear, Rembrandt introduces
hints of imminent or completed movement.
Through the slight shifting of the vertical axes
between head and hands, and between the
papers and their soft support, Rembrandt
suggests that the boy has just released his grip
on his tools; in showing him thus, the artist
provides a penetrating characterisation of the
contemplative mood of the sitter. The softly-
nuanced brown colouring, only differentiated in
the area of the clothing, corresponds to the
overall calmness of mood. Crimson is applied to
the boy's cap and to his sleeves, and the use of
this costly material, which harmoniously
combines with the blond splendour of the boy's
curls and the warmth of his flesh-tones, leaves
little doubt about the artist's human, loving,
close relationship to his little model.

According to information obtained when the
picture underwent conservation (restoration
took place in 1985), it is unlikely that the

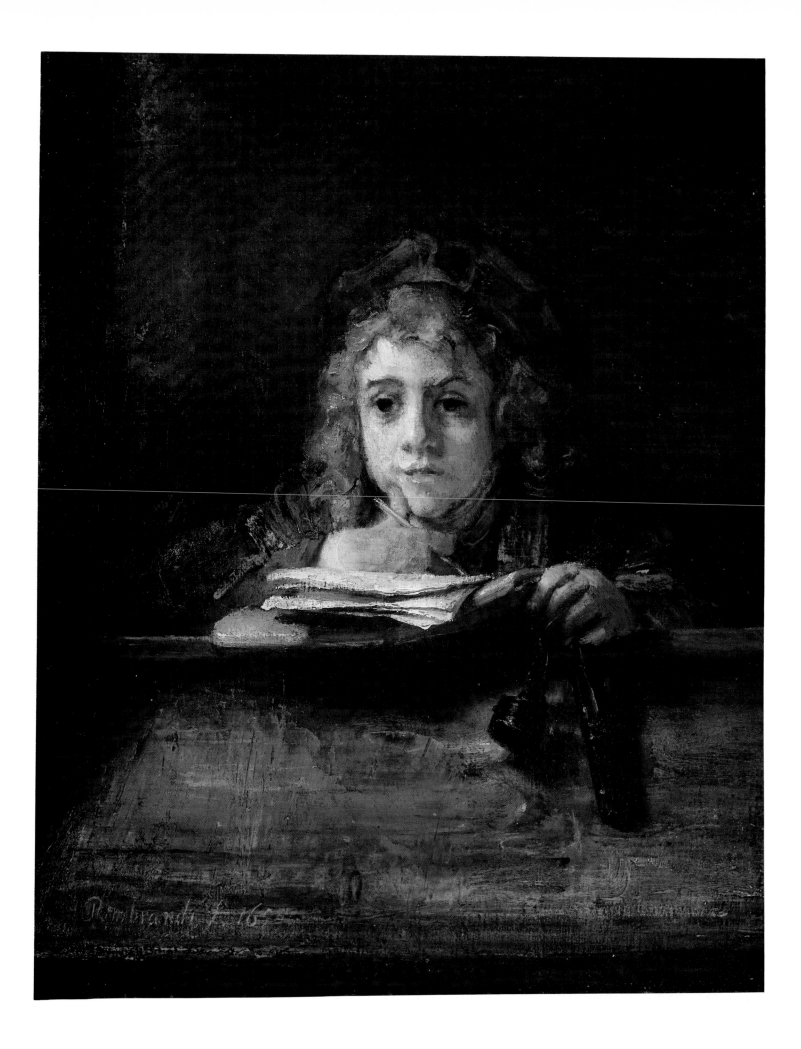

signature at the lower left is authentic; a frequent occurrence on works which are undisputedly from Rembrandt's hand.[1] None-theless, the given date does correspond to Rembrandt's style at that period. The glowing palette finds a parallel in that of the *Slaughtered Ox* of 1655 (Bredius/Gerson 457), as well as in the painting *Joseph accused by Potiphar's Wife*, in Berlin, from the same year (Bredius/Gerson 524). Moreover the geometrically balanced planar composition of the present picture compares favourably with the frontally viewed half-figure of the *Old Woman reading*, of 1655 in the collection of the Duke of Buccleuch (Bredius/Gerson 385). Furthermore, the date on the Rotterdam picture is consistant with the presumed age of the sitter, and no conclusive arguments have been proposed to prove otherwise.

Titus, Rembrandt's son, was born in 1641.[2] Less than a year after his birth, his mother, Saskia van Uylenburgh, died. Rembrandt himself took on the responsibility of his son's upbringing, receiving from about 1643 the help of the widow Geertje Dircks. When Geertje became ill in 1648, she made Titus her heir— presumably on the assumption that Rembrandt would then fulfill his earlier promise of marriage. In 1649 Rembrandt and Geertje quarrelled; and, in a most abrupt fashion, Rembrandt got rid of her and turned his attention to the considerably younger Hendrickje Stoffels. Hendrickje dutifully cared for the young Titus and for his father. Nonetheless, private happiness was increasingly over-shadowed by financial worries. In order to save what could be saved, in 1655 Rembrandt transferred to Titus the ownership of his large house in the Breestraat, payment for which was long overdue; and he had Titus draw up a will to ensure that his own estate, should he die young, would pass back to his father. When the voluntary sale of a part of his collection brought no significant change, Rembrandt declared himself insolvent in 1656. In the following years all his property, including the house, was put up for sale. Towards the end of 1660, Titus and Hendrickje set up an art dealing business as a protection from creditors, and to ensure that any future earnings would not be confiscated. Rembrandt was given the post of advisor in return for food and lodgings. The strain of these years cannot have helped the development of the young Titus, whom Rembrandt had instructed in drawing and painting. Hardly any traces of Titus's artistic activity exist. In Rembrandt's 1656 sale inventory, three paintings by Titus are listed: showing three puppies, a painted book and a head of the Virgin.[3] These have not survived,

although there are several drawings, one signed and dated 1659.[4] J. Bruyn has recently proposed a connection between Titus and a group of paintings reflecting Rembrandt's late style and coming from the same hand.[5] Should this hypothesis be confirmed, Titus's work as a painter would not count as among the best that his father's school had produced. Titus also carried on the art dealing business after Hendrickje's death in 1663. In 1655 he went to Leiden to negotiate with a publisher the commission of a portrait engraving to be executed by Rembrandt. In 1668 Titus married Magdalena van Loo, the niece of Hiske van Uylenburgh. Rembrandt's irresponsible dealings with the assets left by Saskia (Titus being Saskia's heir) had always been regarded with suspicion by the Uylenburghs, to the extent that legal steps were taken. That it was, in fact, Titus who was Rembrandt's principal creditor naturally affected Rembrandt less. He must have been more deeply disturbed by the conflict with the influential Uylenburghs, especially when, through the marriage of his son to Magdalena, they in fact removed Rembrandt's principal source of support. Titus died at the end of 1668, a year before his father.

The features of Titus frequently appear in Rembrandt's work. In a painting of 1660, in Amsterdam (Fig. 42c),[6] Rembrandt shows him in a monk's habit; although it is hardly possible to decide whether the picture is to be understood as a depiction of Titus or as that of a monk.[7] Perhaps Rembrandt intended to show Saint Francis, using his son as a model. Nor can one discount the possibility that Rembrandt also wished to paint a *portrait historié*, a portrait of his son as a monk. A pure *conterfeytsel* (portrait), however, is to be found in an etching (Bartsch 11) which shows Rembrandt's son at the age of about thirteen, seen from the front and—as if the boy did not enjoy posing—glancing sideways and downwards. This 'conventional' type of portrait is also found in the head and shoulders *en face* record of the late 1650s in the Wallace Collection in London (Fig. 42b),[8] a striking work in which the boy's beauty—as Rembrandt himself would have seen it—and the beauty of colour and light augment each other. The boy's gaze directly fixes the viewer, and the elegant costume and the gold chain emphasise that, in this portrait, Rembrandt is concerned with outer appearances. On the other hand, the picture in Vienna, from about the same time (Fig. 42a), showing Titus in a relaxed seated pose and reading a book, has no relation to the world of the viewer. As in the Rotterdam portrait, Titus is shown engaged in activity.

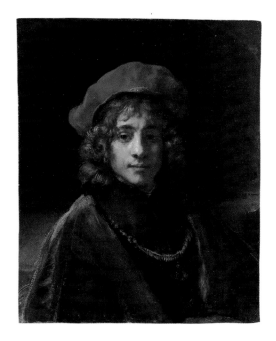

42b: Rembrandt, *Portrait of Titus*. London, Wallace Collection.

Reading, and the intellectual and psychic reaction which it sets off, are condensed into the experience of a single moment. This sense of unity is lacking in the Rotterdam picture. The boy and his work are two separate elements in the picture. The viewer feels it necessary to deliver an iconographic explanation for the interruption which—in view of the positively 'heraldic' character of the painting's composition—can only have an elevated character.

It is difficult to follow the interpretation proposed by E. van de Wetering (verbally) that Rembrandt used Titus as a model for the figure of Saint John the Evangelist recording his Revelation.[10] While it is true that, from the Middle Ages, John the Evangelist is always shown as a young man, and the motif of his inspiration and the attribute of writing instruments also form part of the iconographic tradition, at no time was the disciple given such child-like features. So it would seem that Rembrandt was principally concerned with Titus himself, whom he also recorded in an unusual situation in the Vienna portrait.

In these two pictures, the book Titus is reading as well as his interrupted writing attest to his intellectual leanings. The question as to whether it is, indeed, writing that lies on the desk has been answered decisively in the affirmative by H. van de Waal.[11] One does not draw on loose sheets of paper lying on top of one another and placed on a soft support that can easily be lifted by the left hand.[12] G. Schwartz also cited these considerations, when he proposed that the Rotterdam picture shows Titus drawing up his will in favour of his father in 1655, the very year inscribed on the picture.[13] However, the sobriety of such a legal transaction seems incompatible with the far-away expression in the boy's large, dark eyes. On the same grounds, one may dismiss the popular and unimaginative proposal that Rembrandt observed his son brooding over the mundane task of schoolwork.

There can, however, be no doubt that the boy is brooding. His pose recalls that of the *Young Man with a Pipe* painted by Pieter Codde, in Lille (Fig. 5a).[14] Codde's anonymous student, who rests his head in his hand, is shown in the traditional pose of the *melancholicus*. He has turned away from his books and thus indicates that he is to be seen as the personification of the dark side of melancholy, which includes *acedia* (sloth and indolence). The open, clear eyes of Titus, who still holds in his hands the tools needed for his work, point to the opposite qualities. Instead of melancholy, sadness or sloth, it is the ideas running through his head which account for the

momentary pause. In the view of the Florentine philosopher Marsilio Ficino, who in turn invoked the teachings of Aristotle, melancholy spurs the intellect and imagination in as far as it remains well-tempered under the sign of Saturn.[15] It is, above all, the latter virtue of imagination which is celebrated in Dürer's famous *Melancolia I*, of 1514; his figure must be seen as the embodiment of the creative genius. H.-J. Raupp has pursued this inconographic concept of melancholy in Netherlandish portraits and scenes of artists in the seventeenth century.[16] The view that melancholy was a sign of, and prerequisite for, creative and intellectual talent was common, and this may have moved Rembrandt, as a proud father, to see these virtues in his own son. Rembrandt shows us a figure in the pose of the melancholy thinker—indicating the moment of artistic creation—and looking out at us over the high base of the desk, almost as if it were an image imbued with special authority. It belongs, however, to the ways of a child to leave as yet undecided his further development.

J.K.

1. E. van de Wetering's observations cited by Giltaij, in: Rotterdam 1988, Cat. No. 22.
2. The information on the biography of Titus is taken from: G. Schwartz 1984, pp. 293–300.
3. Strauss and Van der Meulen 1979, *Documents*, 1656/12, Nos. 298–300.
4. Welcker 1938, pp. 268–73, and Sumowski 1979, 9 (1985), pp. 4957–63.
5. Bruyn, in: Rotterdam 1988, No. 25; idem 1990, pp. 715–18.
6. Rijksmuseum, Amsterdam, A3138; Bredius/Gerson 306.
7. Valentiner 1956, pp. 390–404, especially p. 400.
8. Wallace Collection, London, P29; Bredius/Gerson 123.
9. Kunsthistorisches Museum, Vienna, Inv. No. 410, Bredius/Gerson 122.
10. E. van de Wetering, cited by Giltaij, in: Rotterdam 1988, No. 22.
11. Van de Waal 1965, No. 9.
12. It cannot be definitely established whether Titus was writing or drawing. Rembrandt, in any case, drew and perhaps etched on a soft support. See his etching of 1648, *Self-portrait as a Draughtsman* (B. 22). A sketch in Dresden, that is probably not by Rembrandt (Benesch 1095), shows Titus drawing and sitting at a similarly high desk—perhaps, indeed, the very same one.
13. G. Schwartz 1984, p. 296.
14. Musée des Beaux-Arts, Lille, Inv. No. 240. P.C.S. Sutton, in: Philadelphia, Berlin and London 1984, No. 27.
15. Klibansky, Panofsky and Saxl 1964, passim.
16. Raupp 1984, pp. 226–41. In the Rembrandt circle it was, above all, F. Bol who treated the positive qualities of the melancholic temperament in pictures with scholars (Blankert 1982, Nos. 69, 70); and also in a self-portrait of about 1647 (Blankert 1982, No 65).

42c: Rembrandt, *A young Monk (Titus)*. Amsterdam, Rijksmuseum.

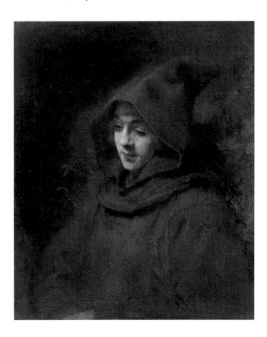

43

A Man in Armour

1655

Canvas, 137.5 × 104.5 cm. The canvas has been enlarged on all four sides. The largest addition is at the bottom, the smallest at the left. The original canvas size appears to have been about 115.5 × 87.5 cm. Signed, lower left, and dated *Rembrandt f / 1655*[1]
City Art Gallery and Museum, Glasgow; Inv. No. 601

Provenance: Probably 'Rembrandt's son with Helmet, shield and armour' in the Count de Fraula sale, Brussels, 21 July 1738, No. 309 (133.35 × 107.95 cm); collection of Sir Joshua Reynolds, London by 1764 (when engraved by J.G. Haid, see below under Engraving);[2] sold by Reynolds to the Earl of Warwick early in 1790; Anon. [Earl of Warwick] sale, Christie's, London, 29 June 1833, No. 93, bought by Woodburn; collection of John Graham-Gilbert by 1860; Bequest of Mrs John Graham-Gilbert to the City Art Gallery and Museum, Glasgow, 1877.

Literature: Bredius/Gerson 480; Bauch 280; Gerson 294.

Exhibitions: London 1860, No. 60; London 1893, No. 111; Amsterdam 1898, No. 86; London 1899, No. 85; Paris 1921, No. 38; London 1929, No. 112; Manchester 1929, No. 16; Bristol 1946, No. 4; London 1952–53, No. 201; New York/Toledo/Toronto, 1954–55 Pl. IV; London 1976, No. 93; London 1980, No. 24.

Engraving: Engraved in mezzotint by J.G. Haid in 1764 as *Achilles* while in the collection of Sir Joshua Reynolds (40.5 × 35.5 cm).[3]

43a: X-ray of Cat. No. 43.

The painting has additions on all four sides. In an attempt to establish the date of these additions, the Scientific Department of the National Gallery, London, took paint samples from the picture in 1991. The ground—the priming of the canvas—in the main area is a single layer of the 'quartz' type, comprising principally silica with small quantities of brown ochre, lead white and calcite in an oil medium.[4] This ground is similar to those of other late canvas paintings by Rembrandt, such as the *Self-Portrait* of 1669 in the National Gallery, London (Bredius 55) and the *Family Portrait* of about 1668 in the Herzog Anton Ulrich-Museum, Brunswick (Bredius 417). The grounds of the added strips differ from each other, but are all double grounds of a type common in the seventeenth century: the lower layers are composed of reddish ochre and the upper layers contain substantial amounts of lead-white and are greyish or fawn in colour.[5] The presence of these double grounds can be clearly made out on the x-ray (Fig. 43a). Moreover, there are no pigments present on the added strips which are inconsistent with a seventeenth-century origin. It is therefore possible that the painting was enlarged in the seventeenth century, perhaps during Rembrandt's lifetime, although it cannot be ruled out that the additions were made later, using strips of prepared seventeenth-century canvas. The continuations of the composition onto the additions is obscured by much subsequent overpainting and therefore the apparent crudeness of the handling in these areas probably distorts their original appearance. The yellow highlights on the armour are very similar to those on the gold chain worn by Aristotle in *Aristotle with the Bust of Homer* of 1653 in the Metropolitan Museum of Art, New York (Bredius 478) and the brocade on the coat worn by Frederik Rihel in the *Portrait of Frederik Rihel on Horseback* of 1663 in the National Gallery, London (Bredius/Gerson 255).

Examination of the picture surface seemed to confirm the reading of the date as 1655 and revealed that the painting had apparently been unevenly cleaned when it was restored in Holland by De Wild in 1930: the darker areas of the background had only been partially cleaned of discoloured varnish, thus exaggerating the contrast with the lighter areas.

An important *pentimento* can be seen by the naked eye and even more clearly in the x-ray (Fig. 43a). The helmet originally had a flange which covered much of the left cheek and ear. This was painted over but can now be seen—and gives a rather disturbing effect—just to the right of the eye. The x-ray of the painting reveals that the canvas was first used for a quite different painting. Above the helmet, and at right angles to it, is the figure of a woman who appears to be shown standing and seen in profile from the right. A cross-section taken in the area of her shoulder revealed the presence of lead-tin yellow which explains the dense image in the x-ray. She is wearing a yellow headdress (with green shadows), and raises her right hand, in admonition or in prayer. The scale of the figure is far smaller than that of the *Man in Armour* and it would appear that Rembrandt at first planned to use the canvas for a multi-figured history painting, perhaps a scene from the Old Testament. The woman's headdress is of the type worn by Asnath, Joseph's wife, in *Jacob blessing the Children of Joseph* of 1656 in Kassel (Bredius 525). It also recalls the headdresses worn by Esther in paintings of her story by members of Rembrandt's workshop, for example the *Esther and Mordecai* by Aert de Gelder in Budapest. As far as can be seen from a study of the x-ray this woman was the only figure in the first composition to have been painted. There are, however, a number of broad strokes containing lead white and made with a large brush or palette knife to the left of the profile of the *Man in Armour*, which may have been made in order to cover up or scrape away other parts of the first composition before Rembrandt began work on the *Man in Armour*.

The identity of the figure is uncertain: in the extensive literature on the Glasgow painting it has been variously identified as the Archangel Michael, Achilles, Mars, Alexander

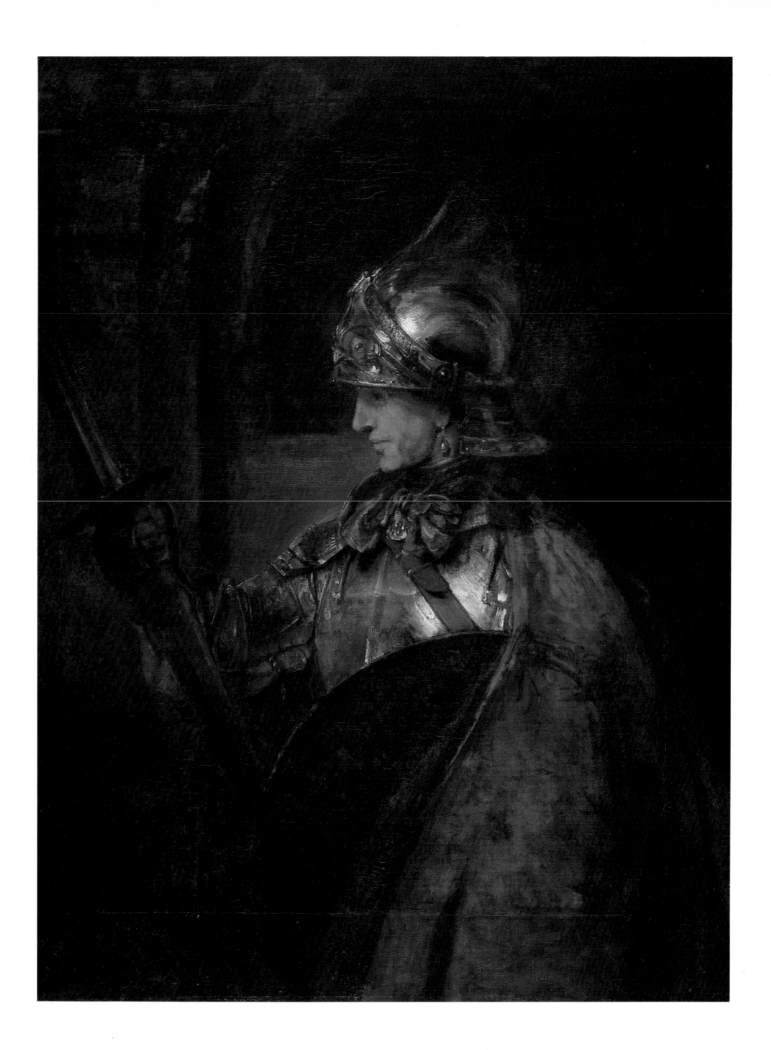

the Great, Apollo, Erechtheus, and two goddesses, Pallas Athene and Bellona.[6] The painting shows a half-length figure, who appears to be male, in armour, holding a shield in his left hand and a lance in his right. His long hair escapes from the back of the helmet. A pearl earring hangs from the left ear and the crimson cape is tied in a bow at the throat. The helmet is decorated with a stylised owl. In a related painting attributed to Rembrandt, in the Gulbenkian Collection in Lisbon (Bredius 479; Fig. 43b), the owl is more prominent, being a clearly recognisable statuette on top of the helmet. In that painting the long hair is also more visible and the head of Medusa with her snakes' hair can be made out on the shield. All these attributes are consistent with an identification as Pallas Athene. However, in the Glasgow painting, the figure appears to be male and it has been argued from numismatic evidence[7] that the identifications of Athene and Alexander the Great were often confused in the seventeenth century, appearing as they did on the obverse and reverse of the same Greek coins. The shield of Medusa and the long hair can also be found on portraits of Alexander.

The *Man in Armour* has been associated with a commission which Rembrandt received from the Sicilian collector, Don Antonio Ruffo, since publication of the relevant documents in 1916.[8] It was probably in 1652 that Ruffo, who lived in Messina, asked Rembrandt to paint a 'philosopher'. This picture, which was described in a later catalogue of Ruffo's collection as 'Aristotele che tiene la mano supra una statua, mezza figura al naturale', is now in the Metropolitan Museum of Art, New York (Bredius 478). It is signed and dated 1653. The collector paid the high price of 500 guilders for the picture which arrived in Messina in the summer of 1654. Ruffo was evidently pleased with the painting as he ordered two more from Rembrandt which arrived in Messina late in 1661 and were identified on the shipping bill as Alexander the Great ('un quadro nominato Gran Alessandro fatto della mano del Pittore Rembrant van Ryn') and Homer. Both are said to be eight *palmi* high and six *palmi* wide (c. 192 × 144 cm).[9] A year later Ruffo, whom we know to have been pleased when the pictures first arrived, complained to the artist that the *Alexander* was made up of four separate pieces of canvas and that the seams were disturbingly visible. He suspected that Rembrandt had simply taken a head painted earlier and enlarged it into a half-length by adding strips of canvas. Ruffo said, however, that he would keep the picture if Rembrandt halved the price (which, he noted, was already more than Italian artists received). Otherwise,

Rembrandt ought to paint a replacement. There was no difficulty about the *Homer* which Rembrandt had sent unfinished. Ruffo agreed to accept it if it was finished and it was duly returned to Amsterdam and shipped back to Sicily in 1664. Rembrandt replied robustly that he was amazed by Ruffo's criticisms of the *Alexander* 'which is so well done' and that the seams would not show if the painting were to be hung in a good light. He declared that he was willing to paint a replacement only if Ruffo was willing to pay 600 guilders (100 more than for the first painting) and return the first picture at his own expense and risk. The surviving documents, which are among the Ruffo family papers in Messina, do not tell us how the matter was resolved.

Ruffo was evidently planning a series of half-length classical figures. He asked Rembrandt simply for a 'Philosopher, half length' and it appears to have been Rembrandt's idea that the philosopher should be Aristotle and that Homer, Aristotle's great predecessor, and Alexander, Aristotle's pupil, should complete the series. Rembrandt owned busts of Socrates, Homer and Aristotle, which were presumably after the antique, according to his 1656 inventory (They are Nos. 162–64).[10] Ruffo asked Guercino to paint a pendant to the Rembrandt *Aristotle* and Mattia Preti was also asked to paint a picture for the series.

Of Rembrandt's works, the *Aristotle* is the painting of 1653 in New York and the *Homer* is generally thought to be the picture of 1663 in the Mauritshuis (Bredius 483), which is in a fragmentary state. It has been argued, most recently by Gerson, in his third, revised edition of Bredius's catalogue, that the Glasgow picture is the first version of the *Alexander* and that the painting in Lisbon, which is not dated, is the second version, although we do not know whether a second version was in fact ever painted. Questioning the authenticity of the date on the Glasgow picture (and suggesting that the additions, which he did not consider original, may have replaced earlier additions), he thought it credible hypothesis that the Glasgow painting was, to judge from Ruffo's complaints, a painting already in the studio, perhaps even a portrait of his son Titus (who was born in 1641), transformed into Alexander. The Glasgow painting would therefore be a picture of the late 1650s, reworked in the early 1660s and the Lisbon painting would date from 1664–65.

The recent technical examination of the additions, which has revealed their probable seventeenth-century origin, tends to support Gerson's interpretation. The date of 1655 would, on the other hand, be difficult to

43b: Rembrandt (here attributed to a pupil), *Figure in Armour*. Lisbon, Gulbenkian Foundation.

43c: Willem Drost, *Man in Armour* ('*Mars*'). Kassel, Gemäldegalerie.

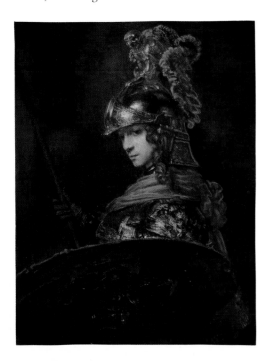

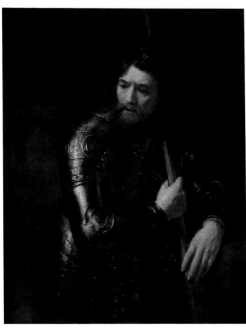

reconcile with Gerson's account. It is quite possible, therefore, that this was the painting of *Alexander the Great* which was ordered from Rembrandt by Ruffo in 1660 and delivered to Messina late in 1661. In addition, there is the problem of the subject: while it is possible that both paintings show Alexander, it is equally likely that the Lisbon painting (in which the figure is distinctly androgynous) shows Pallas Athene. However, if the Glasgow painting was in the Count de Fraula sale in Brussels in 1738, it cannot be Ruffo's *Alexander*, which was still in Messina in 1743. At the time of writing (March 1991) the Glasgow painting is being cleaned and more technical information will undoubtedly emerge, which may clarify some of these outstanding questions.[11]

There is undoubtedly a close relationship between the Glasgow and Lisbon paintings and the latter may well be a development, painted a few years later, of the former. In my view the Lisbon painting contains such notable weaknesses of draughtsmanship and modelling that its attribution must be questioned. It is probably best considered as a pupil's derivation of the Glasgow painting. The small reed pen drawing in the Hermitage which was associated by Agafonova with these paintings[12] is, in fact, far more closely related to the Lisbon painting than the Glasgow picture and so is probably not by Rembrandt but by the pupil who was responsible for the Lisbon canvas.

It is true to say that the group of paintings which have been under discussion—those in Glasgow and Lisbon as well as the *Aristotle* and *Homer*—are unusual in Rembrandt's work by virtue of their subject-matter. In the early 1630s Rembrandt had painted three three-quarter length female figures from classical history and mythology: *Bellona* (dated 1633; Metropolitan Museum of Art, New York; Bredius 467), who wears a decorated helmet and carries a Medusa-head shield; *Sophonisba about to drink from the poisoned goblet* (1634; Prado, Madrid; Bredius 468; *Corpus* A94); and *Minerva* (1635; private collection, Tokyo, on loan to the Bridgestone Art Museum, Tokyo; Bredius 469; *Corpus* A114), whose decorated helmet can be seen on her left and whose Medusa-head shield hangs on the wall behind her. These figures, particularly the *Bellona*, have intriguing echoes in the classical figures of more than twenty years later. However, while rare in Rembrandt's work, figures in armour, particularly figures of Mars—as in Hendrick ter Brugghen's painting in Utrecht—are by no means unknown in Dutch seventeenth-century painting and the Glasgow painting belongs in this tradition. There are other examples of this subject from the circle of Rembrandt: Herman

Dullaert's *Mars* in the Metropolitan Museum of Art, New York (Sumowski, I, No. 345; Willem Drost's *Man in Armour*, perhaps also a Mars, in Kassel (Sumowski, I, No. 321; Fig. 43c) and *The Man in a Golden Helmet* in Berlin (Bredius 128), formerly attributed to Rembrandt but now thought to be by a seventeenth-century follower (Fig. 43d).

1. The signature can be clearly seen but it is difficult to make out the date with the naked eye. However strong light and infra-red photographs reveal an abraded date, 1655 (the two 5s are painted without cross strokes), below the signature, and following the loop in the tail of the f).

2. Reynolds discussed the painting in his *Eighth Discourse*, delivered on 10 December 1778: 'Rembrandt, who thought it of more consequence to paint light, than the objects that are seen by it, has done this in a picture of Achilles, which I have. The head is kept down to a very low tint, in order to preserve this due gradation and distinction between the armour and the face ; the consequence of which is, that upon the whole the picture is too black. Surely too much is sacrificed here to this narrow conception of nature . . .' (Reynolds 1975, p. 162).

3. White, Alexander and D'Oench 1983, No. 4 and Charrington Cat. No. 67.

4. Exhib. Cat., London 1988–89, pp. 30–31.

5. Exhib. Cat., London 1988–89, pp. 30–31.

6. These identifications are discussed in Miles 1961, No. 601, pp. 109–11.

7. K. Kraft, 'Der behelmte Alexander der Grosse', *Jahrbuch für Numismatik und Geldgeschichte*, 14, pp. 7–32.

8. *Documents*, 1654/10, 1654/16, 1660/7, 1660/14, 1661/5, 1662/11.

9. The size of the paintings in the document, which is in Rembrandt's own hand, has always been read as 6 by 8 *palmi*. However, Sebastian Dudok van Heel points out that the 8 could be read as a 6. This reading would accord more closely with the present dimensions of the *Aristotle* which are 143.5 × 136.5 cm.

10. *Documents* 1656/12.

11. Glasgow City Art Gallery and the National Gallery are preparing a collaborative publication on the findings of the cleaning and examination of the painting.

12. K.A. Agafonova, 'Two Drawings by Rembrandt', *The Burlington Magazine*, 107 (1966), pp. 402–5.

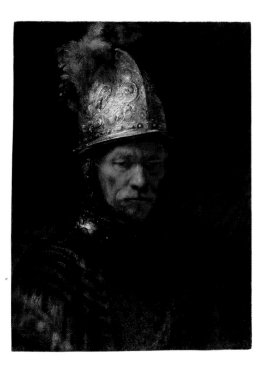

43d: Follower of Rembrandt, *The Man in a Golden Helmet*. Berlin, Gemäldegalere SMPK.

44

The Anatomy Lesson of Dr Joan Deyman

1656
Canvas, 100 × 134 cm, signed, on the slab, centre bottom, *Rembrandt f. 1656*
Rijksmuseum, Amsterdam (On loan from the City of Amsterdam); Inv. No. C85

Provenance: Painted to be placed in the Anatomy Theatre in Amsterdam which was constructed in 1639 in the attic storey of the small meat market building, formerly St Margaret's Church, just off the Nes. The Anatomy theatre was in use until 1690 when a new theatre was created in a new part of its former home, the St Anthony's weigh-house.[1] The painting hung after 1690 in the Surgeons' guild room in the Nieuwe Waag where it was substantially damaged by fire on 8 November 1723. At some time between 1723 and 1760 (when a drawing was made by Johannes Dilhoff, see below) the figure of Deyman was painted out. It remained in the Nieuwe Waag until 1841 when on 20th December, with other paintings belonging to the Surgeons' Guild, it was sold at auction to benefit the fund for surgeons' widows. It was bought by Chaplin for 600 guilders and brought to England.[2] It was subsequently in the collection of the Rev. E. Price Owen of Cheltenham. After his death it was deposited, in 1879, at the South Kensington Museum in London. In 1882 on the initiative of Prof. Dr J. Six it was purchased from the Rev. Owen's heirs by the city of Amsterdam and placed on loan at the Rijksmuseum.[3]

Literature: Bredius/Gerson 414; Bauch 538; Gerson 326. Six 1905, p. 37; I.H. van Eeghen 1956, p. 35 ff.; A.M.Cetto 1959, pp. 57–62; I.H. van Eeghen 1969, pp. 1–11.

Exhibitions: Paris 1921, No. 35; Amsterdam 1932, No. 32; Brussels 1946, No. 87; Stockholm 1956, No. 34; Moscow/Leningrad, 1956, p. 57.

Drawing and woodcut: There is a drawing of 1760 by Johannes Dilhoff in the Rijksprentenkabinet (Fig. 44a). (Black chalk, 298 × 292 mm. Inscribed, lower left, *Rembrandt pinxit* and lower right, *J:Dilhoff.Del.1760*). It shows the painting as it was after the figure of Deyman had been painted out at some time after the fire of 1723. A woodcut was made after this drawing which illustrated articles by Carel Vosmaer in 1873 and 1874.[4]

This is a fragment of a painting which would originally have been about 275 by 200 cm. It shows Dr Joan Deyman performing a dissection of the brain, watched by Gysbrecht Matthijsz. Calcoen, a Master of the Amsterdam Guild of Surgeons, who holds the upper section of the cranium in his hand. Dr Deyman (1620–66) was Praelector Anatomiae in the Guild from 1653. He succeeded Dr Nicolaes Tulp, whom Rembrandt had painted in *The Anatomy Lesson of Dr Tulp* in 1632 (Mauritshuis, The Hague; Bredius 403; Fig. 44b). In 1656, the year in which Rembrandt applied for a cessio bonorum, a form of bankruptcy, he received this important commission from the Surgeons' Guild. In spite of the long period of Dr Tulp's praelectorate, from 1628 to 1653, the Guild of Surgeons returned to Rembrandt with the commission to paint Dr Deyman, an indication of Rembrandt's continuing popularity among a wealthy and influential group of Amsterdammers and the surgeons' confidence that he would produce another portrait which would be as effective as the first.

Anatomy lessons were given by the praelector every Thurday and Friday in the Anatomy Theatre: they did not require the presence of a corpse. What is being commemmorated here was an 'anatomie', an anatomical praelectio, which did require a corpse and took place only a few times a year.

44a: Johannes Dilhoff, *The Anatomy Lesson of Dr Deyman*, after Rembrandt. Drawing, 1760. Amsterdam, Rijksprentenkabinet.

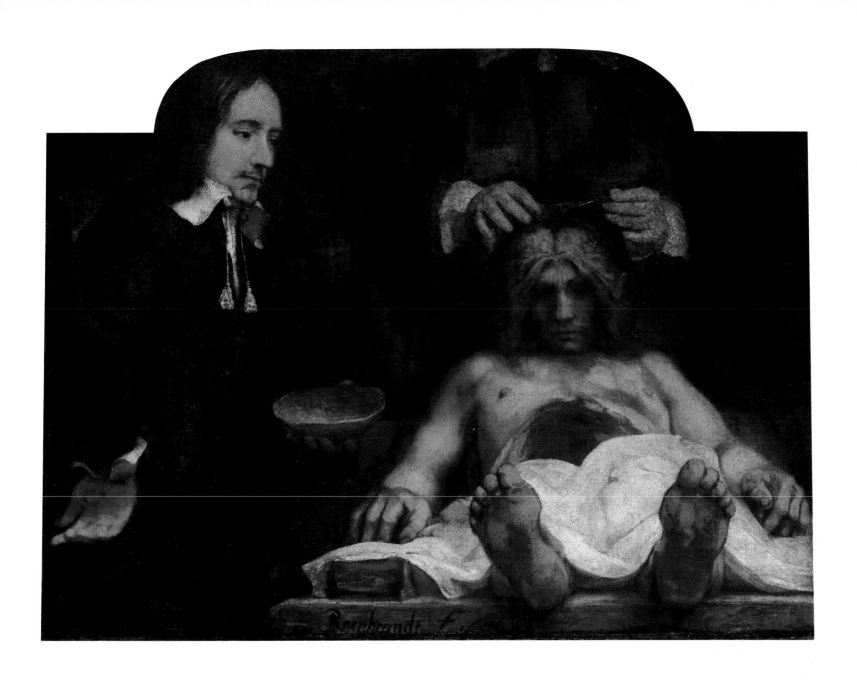

As was usual in such dissections, Deyman has removed the stomach and intestines before beginning the dissection of the brain. The top of the skull is held by Calcoen, and Deyman is in the course of removing the thick outer lining or meninge of the brain; the *dura mater*. He holds a scalpel between the thumb and forefinger of his left hand and appears to hold in his right hand, also between thumb and forefinger, a part of the *dura mater* which from its scythe-like shape is known as the *Falx cerebri*. Calcoen has been assisting Deyman: the position of his right hand, with his palm and fingers turned away from the body, has been adopted to prevent smearing his clothes with the blood on his hands.[5] The records of the Anatomy Theatre in Amsterdam record that 'on January 28th 1656, there was punished with the rope Joris Fonteijn of Diest, who by the worshipful lords of the law court was granted to us as an anatomical specimen. On the 29th Dr Joan Deyman made his first demonstration on him in the Anatomy Theatre, three lessons altogether.' The entry also records the names of the other members of the guild who attended, two *proefmeesters* (who were responsible for examining aspirant surgeons) and the four *overluyden*, who were the officers of the guild. It notes that the body of Fonteijn, a Fleming who had drawn a knife in the course of a robbery, was buried on 2nd February at 9 o'clock at night and that Dr Deyman was presented with six silver spoons worth 31 guilders and 19 stuivers in recompense for his three demonstrations. [Dutch text : "Den 28 Januarij Ao 1656 is met de coorde gestraft Joris fonteijn van diest, die ons van de EE. Heeren van de gerechte tot uns subjectum Anatomicum is vergundt. ende 29 dito heeft de heer Prelector—Dr Johan Deijman sijn eerste demonstratie daer over gedaen op de hal jn de ordinari snij plaets en heeft daer over drie lessen gedaen, heeft de ene dach. door d'ander opgebracht jnt geheel de somme van f187/6. Als proefmeesters waren—Abraham de Hondecoeter/ Dirck Vis/ Overluijden—Klaes Janson Fruijt/ Daniel Florianus/ Laurens de Langhe/ Augustus Maijer. {There is then a further entry in the same hand but a different ink} De 2 Februari op woensdach des avonts de clocke 9 uren ist' lichaem op het suijder kerkhof met een redelijke statie jn d'aerde geset. Vereert aan de Docter van sijne gedane lessen 6 silverde lepels bedragende f31/19 stuivers"].[6]

Our knowledge of the appearance of the painting before it was damaged by fire depends on a reed pen drawing by Rembrandt which is in the Rijksprentenkabinet (Fig. 44c).[7] It was made after the painting was completed in order to show how it should be framed and displayed in the relatively small space of the Snijcamer. At the top edge of the drawing the beams of the ceiling were drawn by Rembrandt and at the bottom a dado or a balustrade. On the left is the edge of the window which opened into the room. Deyman can be seen standing just to the left of centre, above the body of Fonteijn. Calcoen, whose father was portrayed with Dr Tulp, stands with three other figures to Deyman's right and there are four to his left. These were the two *proefmeesters*, four *overluyden* and another member of the guild. All except Calcoen watch the dissection from behind a circular balustrade. They cannot be identified individually but they included Abraham van Hondecoeter, Dirck Vis, Nicolaes Fruyt, Daniel Florianus, Augustus Meyer and Laurens de Langhe. The *overluijden* would have worn hats, as they were of higher status in the guild than the *proefmeesters*. On the back wall is a broad pilaster just to the left of centre with a sculpted ornament in the centre and two shallow semicircular arches to the left and right.

The two *Anatomy Lessons*, of the successive Praelectors, Tulp and Deyman, hung on either side of the fireplace in the Anatomy Theatre in the Nieuwe Waag. They are described there by a German traveller, Zacarias Conrad von Uffenbach whose *Merkwürdige Reisen durch Niedersachsen, Holland und Engelland* was not published until 1753 but records a visit to Amsterdam in 1711. He wrote that 'in the Anatomy Theatre the guide particularly praised among the pictures there, the painting on the doors where the corpse is foreshortened so that the soles of the feet are seen. It is to be sure a good painting, he adds but not the best.

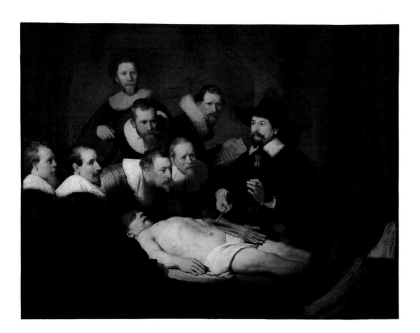

44b: Rembrandt, *The Anatomy Lesson of Dr Tulp*, 1632. The Hague, Maruitshuis.

On the right hand side of the fireplace is an incomparable piece.'⁸ [German text: „Den 20. Febr.[1711] morgens waren wir op de Schneykamer oder Theatro Anatomico ...Der Junge, so uns herumführte, rühmte die Schilderey an der Thüre insonderheit, allwo der Todte in der Verkürzung liegt, so dass man ihm unter die Fussohle siehet. Es ist zwar eines gutes Stück, doch nicht das beste. Eines rechter Hand des Camins is demselben weit vorzuziehen und war unvergleichlich .."] When Sir Joshua Reynolds saw the painting in 1781 he noted simply that 'the whole is finely painted, the colouring much like Titian.'⁹ That he did not comment on its being a fragment is explained by the fact that the figure of Deyman had been painted out at some time before 1760: its appearance at that time is recorded in the drawing by Dilhoff. When Smith wrote about it in 1842 he also failed to comment on its fragmentary nature.¹⁰

In *The Anatomy Lesson of Dr Tulp*, painted in 1632, twenty-four years earlier, Rembrandt had deliberately abandoned the traditional format of the Anatomy Lesson. In, for example, *The Anatomy Lesson of Dr Willem van der Meer* by Michiel van Miereveld of 1617 (Delft, Museum het Prinsenhof; Fig. 44d) the doctor stands rigidly in the centre of the composition while his colleagues are stiffly gathered around him. In the *Tulp* Rembrandt applied his experience as a history painter to the problem of creating a lively composition of this inherently formal subject. He placed Tulp off-centre, to the right, showed him demonstrating with his own hand the actions of the muscles which he has revealed in the dissection and placed five of the surgeons in a human pyramid within an arched recess which gives a sense of depth to the whole composition. *The Anatomy Lesson of Dr Tulp* is essentially a group portrait interpreted as a history painting. In *The Anatomy Lesson of Dr Deyman*, however, Rembrandt returns to a far more traditional composition, presumably at the clients' request. Deyman is more or less at the centre and, although Calcoen carefully observes the dissection, his colleagues— judging from the drawing—look directly out of the painting.

The position of the corpse, shown lying directly facing the spectator is an important innovation. For many, this bold foreshortening recalls Mantegna's *Dead Christ* in the Brera in Milan, but it has been pointed out that a closer prototype would be an etching after a *Lamentation over the Dead Christ* by Orazio Borgianni;⁶ a painting in the Galleria Spada in Rome, of about 1615. However, a number of other precedents have also been suggested— Dürer, Rubens, Baldung Grien and Goltzius,

44c: Rembrandt, *The Anatomy Lesson of Dr Deyman*, Drawing. Amsterdam, Rijksprentenkabinet.

44d: Michiel van Miereveld, *The Anatomy Lesson of Dr. Willem van der Meer*, 1617. Delft, Museum het Prinsenhof.

among them—and we may conclude that by Rembrandt's time this image was quite widely available in art, though Rembrandt may well have observed it in the anatomical theatre itself. Haverkamp-Begemann is surely correct to note that 'even if Mantegna was the first to depict the body thus foreshortened, by the time it reached Rembrandt it had become common property and had lost its particular Mantegnesque or Renaissance flavour.'[11]

A particular source can, however, be identified for another important element of the painting. Dissections of the brain were rare occurrences and even more rarely depicted. The only other known Dutch example is *The Anatomy Lesson of Dr Theodore Hoogeveen*, painted by Nicolaas Rijnenburg in 1773 (Delft, Museum het Prinsenhof) in which the doctor performs his dissection before seventeen colleagues. Cetto has noted three possible graphic precedents—two titlepages of English books and a Dutch drawing of uncertain date.[12] None is in fact very close to *Dr Deyman* and it is unlikely that Rembrandt would have known any of them. He may well, however, have had access to a copy of Vesalius's *De Humani corporis fabrica, Libri septem*, of which the editio princeps was published in Basel by Joannes Oporinus in 1543. In this part of Vesalius's great work, there is a large series of cranial figures, any one of which may have been Rembrandt's source (Fig. 44e).[13]

CB

44e: Jan van Calcar, *The dissection of the Brain*, in Vesalius, *De Humani Corporis Fabrica*, Libri septem, Basel, 1543

1. It is intended to reconstruct this Anatomy Theatre in its original location in the near future.
2. It is included in the ninth, supplementary, volume of John Smith's *Catalogue raisonné*, published in 1842, p. 794: '5. This masterly and powerful production of Rembrandt, represents, on the right [*sic*], a gentleman of about forty years of age, of a mild and intelligent countenance, seen in nearly a profile view, habited in a dark dress, relieved by a plain white pendent collar, attached with strings and tassels; he holds in his left hand a portion of a cranium, and the right is placed on his hip; he appears to be engaged in a professional discourse upon a male subject placed before him, in a fore-shortened view to the spectator, and covered in part with some linen. The figure is shown to the knees, and the name of the painter is written in bold characters at the bottom of the picture. This was painted at the most energetic period of the master, for the members of the Surgeon's [*sic*] Hall, at Amsterdam.'
3. The latter history of the painting is discussed in Van Eeghen 1969 and Broos 1989, No. 17.
4. Exhib. Cat. Amsterdam 1989, Cat. No. 59 (Catalogue entry by P. Schatborn).
5. I owe the identification of the *falx cerebri* and the explanation for Calcoen's pose to Dr William Schupbach of the Wellcome Institute for the History of Medicine, London, who was kind enough to discuss the painting with me at length. It is his opinion that Deyman's gesture "demonstrating the *falx cerebri* [is] a punning reference to the scythe as a *vanitas*-motif". He intends to discuss this idea at greater length in an article.
6. The Anatomy Books of the Surgeons' Guild are in the Gemeentelijke Archief, Amsterdam. This account of Deyman's dissections is in ms. 294. It is quoted in Heckscher 1958, pp. 191–92.
7. Pen and brush in brown, some red chalk, 109 × 131 mm. Broos 1981. Schatborn 1985, No. 45.
8. Uffenbach, III, pp. 545–46. Quoted by Slive, 1953, p. 168.
9. Reynolds 1819, II, pp. 357–58.
10. Smith, op. cit.
11. Yale Review, 51, 1966–67, p. 301–9 (Review of K. Clark, *Rembrandt and the Italian Renaissance*).
12. Cetto, op. cit., cites the title-pages of Helkiah Crooke, *Microcosmographia*, London, 1631, and William Marshall, *The Manuall of the Anatomy or dissection of the body of Man*, London, 1638 and a pen drawing by an unidentified Dutch artist in a private collection in New Haven.
13. Heckscher, op. cit., notes on p. 70 that, in a large series of cranial figures presented by Vesalius, only one has an unbearded face.

45

Woman at an open Door (Hendrickje Stoffels?)

c.1656/57
Canvas, 88.5 × 67 cm
Berlin, Gemäldegalerie Staatliche Museen
Preussischer Kulturbesitz; Cat. No. 828 B

Provenance: T.G. Graham White sale, Christie's, London, 23 March 1878, No. 39; 'Artist's Wife in Rich Dress', sold for £472.10.s. to John Wardell; John Wardell sale, Christie's, London, 10 May 1879, No. 34; 'Artist's Wife', sold for £666.15s., to E. Warneck; E. Warneck art dealers, Paris; 1879, acquired in Paris for the Königliche Gemäldegalerie, Berlin.

Literature: Bredius/Gerson 116; Bauch 518; Gerson 339; Tümpel 188.

Exhibitions: Berlin, 1930, No. 384; Philadelphia 1948, No. 102; Detroit 1948/49, p.28.

The life-size half-figure of a woman leans against the left frame of a door while resting her left arm on the closed lower section of the half door. Turned to the left, her head slightly bent, she looks with large, dark eyes directly at the viewer. The manner in which the cord with the ring tied around her neck appears as if accidentally pushed to one side, underlines the play of axes, contrasting as it does with the verticals and horizontals of the door-frame and her arms. The presentation of the figure is linked to movement within the pictorial plane, an adjustment to which the manner of painting also contributes. The woman's dress is only summarily shown, captured in a few broad strokes. In her face, her low neckline and her hands, however, the brush strokes are concentrated to achieve firm modelling. Light and colour increase the contrast between open and closed, between fragmentary and complete forms. Glowing red flickers from the depths of the brown-black shadows of her robe. The strokes applying these colours form a radial pattern on the picture plane and, with the fluffy, ridged white of her shift, form a striking contrast to the execution of her skin. There, softly nuanced values give added plasticity to the woman emerging from the darkness of the interior to lean against the door, faintly lit from the side.

Without any visible desire for social recognition, the figure is bound into this multiplicity of forms, colours and illumination. Her appearance is informal and relaxed. The position of her arms and the fall of her richly pleated house-robe with its generous decolletage, also contribute to this impression. But this *déshabillé* is not indicative of an ulterior motive. Instead, the slight turn in the woman's pose suggests an intimacy typical of a close personal relationship between the painter and his model. It is not surprising that the figure was previously connected with Saskia, the painter's wife.[1] But it is not Saskia, as she died in 1642. More plausible is the assumption that the picture shows Hendrickje Stoffels, who until her death was Rembrandt's companion during his later years. Hendrickje's claim is supported by the universally accepted dating of around 1656/57. No documented portrait of Hendrickje has survived; but the sitter here occurs in a variety of guises in Rembrandt's work from the 1650s, not only in portraits but also in a variety of roles in paintings with 'historical' content.[2] She must have been the model for, among other works, the *Bathsheba* in Paris (Cat. No. 39), the *Flora* in New York (Cat. No. 41) and the *Woman Bathing* in London (Cat. No. 40).

There seems to be a general unwillingness to

treat portraits of women as independent works. The *Portrait of Hendrickje Stoffels* of 1660, in New York (Bredius/Gerson 118), has been connected with a painting made in about the same year, now also in New York—Rembrandt's *Self-portrait* (Bredius/Gerson 54). According to Müller-Hofstede, the pendant to the Berlin picture is the *Self-portrait with a Sketchbook*.[3] There is, however, no way of checking this claim, especially as the original of the latter is lost and known only through a mezzotint by Jacob Gole and several painted copies (Bredius/ Gerson 46, 478 47 A).

Hendrickje Stoffels (about 1625/27–1663) is first mentioned in documents relating to Rembrandt in 1649—in the year of his separation with the widow Geertje Dircks. Hendrickje looked after Rembrandt's house, cared for his son, Titus, and lived with Rembrandt—although the couple were never legally married—as his wife. In 1654, when Hendrickje became pregnant, she was summoned before the Church Council. When, finally, in July, the fourth summons arrived, she had to acknowledge 'dat se met Rembrandt de schilder Hoererije heeft ghepleecht' (that she had committed the acts of a whore with Rembrandt, the painter). For this offence she was severely punished, 'tot boetvardigheit vermaent en van den taffel des Heeren afgehouden' (being urged to atonement and barred from receiving communion).[4] In October 1654, she gave birth to a daughter who was given the name of Rembrandt's mother, Cornelia. Schwartz presumes that pictures such as the *Bathsheba*, painted in 1654, also contributed to Hendrickje being summoned to appear before the Church Council. At that time it was by no means a matter of course for a woman to pose unclothed.[5] After Rembrandt's financial collapse, Hendrickje and Titus set themselves up as art dealers, with Rembrandt acting as *adviseur* in return for board and lodgings as well as any future income from his work. Although the legal status of this business had been devised by Rembrandt himself—as a protection against the demands of his creditors—he was greatly assisted by Hendrickje in these years. In a notary's record of 1661, signed by her—with a cross—in the presence of neighbours, she is referred to, without any discrimination, as Rembrandt's *huysvrouw* (common-law wife).[6]

It is possible that in the Berlin picture Rembrandt wished to draw attention to this double moral, and to depict simultaneously both the *huysvrouw* and the woman who—according to the church—had abandoned herself to whoring. The ring which Hendrickje wears on a cord around her neck and that on

45a: Attributed to Palma Vecchio, *Portrait of a young Woman*, Ms catalogue from the Vendramin Sale. London, British Museum.

45b: Palma Vecchio, *Portrait of a young Woman*. Berlin, Gemäldegalerie SMPK.

her left hand give her the status of a *de facto* wife. Her relaxed pose and open neckline, on the other hand, are features that would usually not be found in portraits of a *huysvrouw*.

Venetian painting lifted such features in the genre of courtesan portraits to great heights.[7] Clark has pointed out that examples of this type of portrait were in the collection of Andrea Vendramin, which in the 1640s came to Amsterdam and was sold there by Gerrit van Uylenburgh. He also notes that one of these portraits—a half-figure picture of a young woman found on folio 51 of the manuscript catalogue (Fig. 45a)—anticipates the pose of Rembrandt's figure.[8] This now lost courtesan portrait was probably painted by Palma Vecchio and a related version from the artist's own hand is now in Berlin (Fig. 45b).[9]

As D. Miller has shown, Willem Drost was also interested in Palma Vecchio.[10] Drost's *Bathsheba* of 1654, in Paris (Fig. 45c), is presented as a courtesan, though his initial inspiration came from Rembrandt, whose version of this subject, painted in the same year, must have encouraged Drost to condense the biblical story into a single figure of Bathsheba, and to set her expansively illuminated fateful beauty before a dark background. Drost, however, did not show a tragic heroine who sees herself the victim of an unavoidable fate. Among the reactions set off by the love letter from King David, we note her slightly tilted head, but above all, a sign of her willingness expressed by her shirt which, as if by chance, has slipped from her shoulders. Such readiness is in accordance with morality of a courtesan and explains the similarity between Drost's picture and the Venetian model, which Drost may have stumbled on himself, or which may have been pointed out to him by his former teacher.

Rembrandt influenced Drost, who in turn influenced Rembrandt. Regarding their knowledge of Palma Vecchio, Miller proposes a reversal of the usual teacher-pupil relationship: Drost's *Bathsheba*, she maintains, was the more 'exemplary' painting, as it reflects the Venetian influence to a far greater degree than Rembrandt's *Woman at an open Door*. This hypothesis, however, does not take into account Rembrandt's ability to absorb into his work the achievements of others, but only after subjecting them to critical examination. Corrections undertaken during the course of the evolution of Rembrandt's painting strongly suggest that he, in fact, had studied in depth the Venetian model.

The x-ray photograph of Rembrandt's painting (Fig. 45d) is difficult to interpret; but one cannot adhere to the view that Rembrandt originally showed the head of the woman turned to the front rather than to the side.[11] The vertical mark, which can be made out in the area of white lead heightened on the face (a nose?), is not related to the present picture, but rather to a completely different depiction underneath. When Rembrandt painted the *Woman at an open Door* he used a canvas on which he had already worked. Traces of parts of a considerably smaller proportioned figure: a head with a high hairline that leaves an ear free (a child?), and below this a carefully modelled neck and a shoulder draped with a cloak are visible to the left of the present figure. Of the first picture nothing more can be made out. The white pigment at the upper left, however, suggesting the rejected outline of a hand originally placed against the head, belong to the evolution of the second and final painting.

Neutron-autoradiography (Fig. 45e) confirms not only these findings but also offers others.[12] The left half of the picture is marked by a fan-like structure composed of different arm positions. Hendrickje's right arm, which now rests lightly against the door-frame, was at an earlier stage of work on the painting, bent at the elbow and touched her head. Another position for it was tried out; probably the first in the complex evolution of the position of the woman's arm. At the lower left a somewhat brighter section indicates the area which was originally intended for a hand, which, bent at the wrist, was inspired by Palma Vecchio's figure. Rembrandt entered into direct dialogue with the Venetian model, which was perhaps available to him in the form of a drawn copy, and from it he developed his own compositional solution. From the various tested poses, it was the least unusual one that survived. Also modified was the original position of the cord hanging around the woman's neck, which, in the final picture, is out of line with the main vertical axis of her body. Clearly, Rembrandt wanted to draw more attention to the ring attached to this cord than had been his original intention.

J.K.

45c: Willem Drost, *Bathsheba with King David's Letter*. Paris, Musée du Louvre.

1. Meyer 1880, pp. V–VI.

2. MacLaren/Brown 1991, pp. 332–33, No. 54.

3. C. Müller-Hofstede, cited by Gerson, in: Bredius/Gerson 116.

4. Strauss and Van der Meulen 1979, *Documents* 1654/11–12, 14–15.

5. Schwartz 1984, p. 293. Although from the Renaissance onwards, working from the nude model was central to training in every humanistically inclined studio, it would seem that this was easy to realise. The women who were prepared to pose were, on the whole, prostitutes. Dudok van Heel 1982, pp. 70–90 has pointed out that the three models used by the Rembrandt pupil Govert Flinck, the Van Wullen sisters, kept 'een fameus huys'. Rembrandt, on the other hand, compensated for the lack of models through members of his own household. There is, however, no evidence that this practice placed his women in a compromising position. Interest in the identity of models, and in artists' intimacy with them, was less marked in the seventeenth century than it is today. Even those sitting on a Church Council must have realised that a painting such as the *Bathsheba* could not be satisfactorily rendered without emphasising female beauty, as called for by both the biblical text and iconographic tradition. Hendrickje was summoned because of the illegal nature of her relationship with Rembrandt, but above all because of the child born from this relationship.

6. Strauss and Van der Meulen 1979, *Documents* 1661/12.

7. Rembrandt was not unfamiliar with the demands of the subject. A painting by him, *Eene Cortisana haer pallernde* (*A Courtesan combing her Hair*), is mentioned in his 1656 sale inventory. See Strauss and Van der Meulen 1979, *Documents* 1656/12, fol. 30, No. 39. This is, perhaps, identical with the *Young Woman at a Mirror*, in Leningrad (Bredius/Gerson 387).

8. London, British Museum, Vendramin catalogue (Sloane MSS, No. 4004, folio 51). Clark 1966, p. 132. Broos 1977, p. 39.

9. Berlin, Gemäldegalerie SMPK, Cat. No. 197A. On the Venetian courtesan portrait and the social significance of this type of portrait, see: Venice 1990, *passim*.

10. Miller 1986, pp. 75–82. Sumowski 1983, Vol. 2, pp. 608–609, 613, No. 319.

11. J. Kelch, in: Berlin 1978, p. 352, No. 828B.

12. Analysis of the picture with the help of neutron-autoradiography was carried out in Berlin by the staff of the Gemäldgalerie in collaboration with the Rathgen-Forschungslabor SMPK and the Hahn-Meitner-Institut für Kernforschung. Illustrated here is the fifth autoradiograph of the picture, its blackening caused largely by the phosphorous isotope P_{32} that is present in bone-black. Rembrandt (like other Dutch painters) applied the underpainting of his pictures with bone-black in his brush. Bone-black, however, is a pigment not just confined to the early stages of a painting but used throughout. Its brownish black tone is to be found both in the expansively applied shadow values, and in the linear values of the drawing of both outer and inner contours. Like an x-ray photograph, neutron-autoradiography registers information simultaneously from all layers of the picture. On the procedure used, see Ainsworth 1987, pp. 105–110; C.O. Fischer, in: Kelch 1986, pp. 38–47.

45d: X-ray of Cat. No. 45.

45e: Neutron-Autoradiograph of Cat. No. 45.

46

Moses breaking the Tablets

1659
Canvas, 168.5 × 136.5 cm,[1] Signed and dated,
lower right, on a rock, *Rembrandt f. 1659*
Berlin, Gemäldegalerie Staatliche Museen
Preussischer Kulturbesitz; Inv. No. 811

Provenance: In the collection of Frederick the
Great at Sanssouci by 1764. Moved from the
Royal Palace to the Museum, 1830.

Literature: Bredius/Gerson 527; Bauch 226;
Gerson 347. Heppner 1963, pp. 142–49.

Exhibitions: Amsterdam 1935, No. 24; Jerusalem,
1965, No. 32.

Engraving: Engraved by Krüger in 1770.

46a: Pupil of Rembrandt, possibly retouched by
Rembrandt, *Hannah in the Temple*, 1650(?). Panel.
Edinburgh, National Gallery of Scotland (On loan
from the Duke of Sutherland).

There are two occasions described in the Book
of Exodus in the Old Testament when Moses
lifted up the tablets bearing the ten
commandments to the Israelites. Moses was
called by God to the summit of Mount Sinai
and received there instructions about the
construction of the temple and the ritual of the
priests 'and he gave unto Moses, when he had
made an end of communing with him upon
mount Sinai, two tables of testimony, tables of
stone, written with the finger of God.' The
Israelites, however, in Moses' absence had
made a golden calf which they worshipped.
When Moses came down from Mount Sinai and
found them dancing around the golden calf his
'anger waxed hot, and he cast the tables out of
his hands, and brake them beneath the mount.'
When the Israelites had been punished and
repented, 'the Lord said unto Moses, Hew thee
two tables of stone like unto the first : and I
will write upon these tables the words that
were in the first tables, which thou brakest.'
After spending forty days and forty nights on
Sinai, 'when Moses came down from mount
Sinai with the two tables of testimony in
Moses' hand . . . Moses wist not that the skin
of his face shone while he talked with him. And
when Aaron and all the children of Israel saw
Moses, behold, the skin of his face shone; and
they were afraid to come nigh him.' (Exodus
31, 32 and 34). There has been disagreement
about which of these incidents is represented in
this painting. Traditionally it has been thought
to show Moses raising the tablets, which
contain the last five of the ten commandments
written in Hebrew, above his head before
smashing them on the rock in the right hand
corner. Heppner, however, argued that the
painting shows Moses raising the second set of
tablets above his head to display them to the
Israelites. More recently Tümpel[2] has returned
to the first interpretation of the subject as the
breaking of the tablets. He pointed to the
iconographic tradition, according to which
Moses held the tablets above his head on his
first descent, when he was about to break
them, and in front of his chest in order to show
them when he descended a second time from
Sinai. The key would seem to be Moses's face,
whether it is dark with anger, or whether it
shines. The Hebrew word for shining or
emitting rays also meant to have horns. In the
Latin Vulgate the word was translated as being
horned and it is for this reason that in medieval
and later art Moses is often shown with horns.
In this painting Rembrandt has interpreted this
phenomenon in a naturalistic manner: Moses's
hair forms two small horn-like peaks on the top
of his head. There is a strong fall of light on
Moses's face which could be a naturalistic

device to suggest the shining face which
frightened Aaron and the other Israelites. On
the other hand Moses's facial expression is one
of considerable distress. Tümpel has argued
that Rembrandt is showing the first incident
and conflating it with the second. He has
outlined an iconographic (and formal) tradition
which can be seen, for example, in an engraving
of 1644 by D. Fontana after the figure of Moses
in Parmigianino's fresco in the church of the
Madonna della Steccata in Parma. In my view,
this explanation is unnecessarily complex and it
may be questioned whether Rembrandt had
direct access to this engraving or was familiar
with this tradition. It is more likely that
Rembrandt was simply intending to show
Moses breaking the tablets: the horns are a
usual attribute of Moses and the fall of light a
device often used by Rembrandt to highlight
a figure in his history paintings.

Moses holds two tablets on which are
inscribed the ten commandments. Boards with
rounded tops on which the commandments are
inscribed in Dutch were a familiar feature of
Dutch Reformed churches in the seventeenth
century. In this painting the inscriptions on the
tablets are in Hebrew. Both the tablets
containing the ten commandments in Hebrew
are shown in a painting at the National Gallery
of Scotland in Edinburgh, *Hannah in the Temple
in Jerusalem* (On loan from the Duke of
Sutherland: Bredius 577), which is apparently
dated 1650 (Fig. 46a). The picture is a school
work, perhaps retouched by Rembrandt
himself. The formulation of the commandments
in Hebrew was therefore already known in
Rembrandt's studio: it is almost exactly the
same as that in the Berlin *Moses*. In the *Moses*
the tablet at the back carries the first five
commandments and that which we see the
second five. The sixth, seventh and eighth
commandments—thou shalt not kill, thou
shalt not commit adultery, thou shalt not
steal—are correctly rendered in Hebrew. In
the ninth—thou shalt not bear false witness
against thy neighbour—one character is
missing from the third word. The tenth—thou
shalt not covet thy neighbour's house, thou
shalt not covet thy neighbour's wife, nor his
manservant, nor his maidservant,nor his ox,
nor his ass, nor anything that is thy
neighbour's—is, for purely practical reasons,
substantially abbreviated to 'thou shalt not
covet thy neighbour's house, his manservant,
his maidservant, . . [two characters of the
words 'his ox'] that is thy neighbour's.' These
words are very close together. Thus, despite
the omission of one character and the
contraction of the tenth commandment, the
Hebrew is largely accurate and, as with the

Hebrew inscription in *Belshazzar's Feast* of about 1635 in the National Gallery, London (Bredius 497; Cat. No. 22),[3] it was presumably transcribed with the help of Jewish friends of Rembrandt. In the case of *Belshazzar's Feast* he was probably assisted by Menasseh-ben-Israel. Rembrandt may well have attended a Jewish religious service where he would have seen the scroll of the Torah, after the reading, being raised up with the words 'And this is the Law which Moses set before the children of Israel . . .' This action could have suggested Moses's pose to him.

The size of the painting and its date led Heppner to associate it with the scheme of decoration for the Town Hall in Amsterdam. In the Town Hall on the chimney-piece in what used to be the Magistrates' Court is a treatment of the subject of Moses' second descent from Sinai by Ferdinand Bol (Fig. 46b).[4] It was probably commissioned in 1664 and Bol was paid 1200 guilders for it in May 1666. The decoration of the Town Hall had been planned considerably earlier: in his *Inwydinge van 't Stadthuis* of 1655, Vondel describes a painting which shows 'how Moses . . . descends from the mount with the law.' He praised it again in another poem of 1659.[5] These references must, however, have been anticipatory as a detailed account of the Magistrates' Court in 1662 does not describe the picture in place. Heppner suggested that Rembrandt received this commission first and painted the *Moses* but it was rejected and replaced by Bol's picture. There is no documentary evidence for this argument and it depends on two assumptions. The first is that Rembrandt shows the same subject as Bol, that is, Moses's second descent from Sinai. As is discussed above, this is unlikely, unless Rembrandt ignored the iconographic tradition. Secondly, Rembrandt's painting would have had to have been cut down. It has been suggested in the past that the painting was cut down at the bottom edge and the rock with the signature and date on it added. Technical investigation of the painting in Berlin has shown this not to be the case. X-ray examination reveals stretcher marks on all sides and these are especially distinct along the bottom edge. The rock and the signature and date have been shown to be integral to the original painting. Moses's robe does not continue beneath the rock but is curtailed in order to leave space for it. In short, there is no evidence at all to connect the painting in Berlin with the decoration of the Town Hall.

Heppner also associated *Jacob wrestling with the Angel* in Berlin (Bredius 528; Fig. 46c), both with *Moses* and with the Amsterdam Town Hall commission. The *Jacob* is not dated but was painted in about 1660, and certainly the scale of the figures is similar to the *Moses*. However the paintings are of different sizes— the *Jacob*, which has probably been cut down, is 137 × 116 cm—and have different provenances (the *Jacob* came to the Berlin Museum with the Solly collection in 1821). The similarities are nonetheless intriguing: the figure size, the broadly brushed technique and the restricted palette as well as the way in which the figures are cut off at the bottom of the picture space are strikingly alike. They may have belonged to a series of Old Testament paintings which Rembrandt was planning in the years around 1660.
C.B.

1. The painted canvas is folded over the edge of the stretcher on all sides, at the top by about 8 cm.
2. Tümpel 1969, p. 169 ff.
3. This inscription is discussed in Haussherr 1963, pp. 142–49 and in MacLaren/Brown 1991, No. 6350.
4. Blankert 1982, Cat. No. 47.
5. Quoted by Blankert, op. cit.

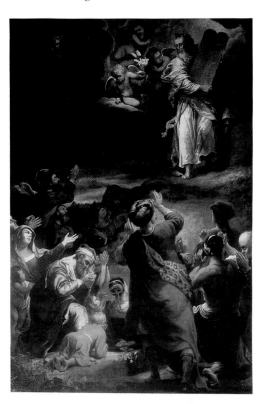

46b: Ferdinand Bol, *Moses descends from Mount Sinai*. Amsterdam, Royal Palace on the Dam (formerly the Town Hall).

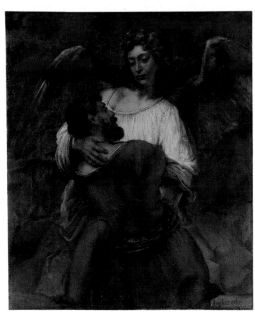

46c: Rembrandt, *Jacob wrestling with the angel*. Berlin, Gemaldegalerie SMPK.

Saint Matthew and the Angel

1661

Canvas, 96 × 81 cm, signed and dated, centre
right, *Rembrandt f. 1661*
Paris, Musée du Louvre; Inv. No. 1738

Provenance: The painting was seized by the
revolutionary government from the Comte
d'Angiviller, Director of the Bâtiments du Roi,
in Paris on 16 Thermidor of the Year 2 (4 July
1794), together with another Rembrandt in the
Louvre collection, *The Supper at Emmaus*
(Bredius 597). It is not known whether these
paintings were owned by d'Angiviller himself
or by the Crown. The *Saint Matthew* does not
appear in earlier royal inventories and it is
most likely that it was purchased by Louis
XVI. The painting was on show at the
Luxembourg Palace between about 1800 and
1820 and later was at the Château de
Compiègne between 1874 and 1901.[1]

Literature: Bredius/Gerson 614; Bauch 231;
Gerson 359.

Exhibitions: Paris 1955, No. 10; Stockholm 1956;
Moscow-Leningrad 1965, p. 36; Paris 1970–71,
No. 182.

47a: Rembrandt, *The Apostle Simon*, 1661.
Zurich, Kunsthaus (Ruzicka Foundation).

47b: Rembrandt, *The Apostle Bartholomew*, 1661.
Malibu, J.P. Getty Museum.

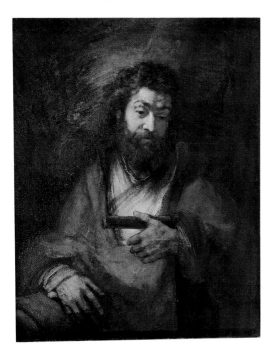

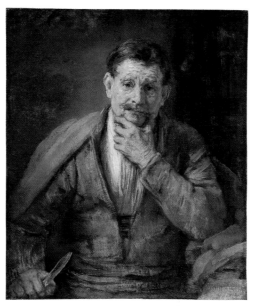

In the years around 1660 Rembrandt painted a
number of half-length apostles and evangelists,
which are all characterised by their powerful
individuality. Others of this type include *The
Apostle Simon* of 1661 in the Kunsthaus, Zürich
(Ruzicka Collection; Bredius 616A; Fig. 47a)
and *The Apostle Bartholomew*, also of 1661, in the
Getty Museum, Malibu (Bredius 615; Fig.
47b). Among this group are two other half-
length figures writing who have been described
as evangelists, at Rotterdam (Bredius 618; Fig.
47c) and Boston (Bredius 619) and it is possible
that Rembrandt painted a series of apostles and
a series of evangelists at this time. However,
while the apostles display their traditional
attributes—St Simon his saw and
St Bartholomew his knife—the two so-called
evangelists do not, unlike St Matthew, show
their symbols. It is possible that Rembrandt
wished to abandon this unnaturalistic
convention and attempted to differentiate the
evangelists in other ways. The evangelist in

Boston is young and has a dreamy expression which could have been intended to suggest the visionary aspect of St John's gospel; the evangelist in Rotterdam wears a professional man's beret and robes and may have been intended to be St Luke, who was a doctor. Certainly we may imagine that Rembrandt would have been reluctant to disturb the sense of a powerful and intense human presence by introducing an eagle and an ox, the traditional symbols of St John and St Luke. All three paintings have roughly the same dimensions: the Rotterdam Evangelist is 102 × 80 cm and the Boston Evangelist 105 × 82 cm. However, the real difficulty with any hypothesis of a series of the Four Evangelists is the attribution of the Rotterdam and Boston paintings. Neither is certainly by Rembrandt and they are probably products of his workshop in the early 1660s.

The angel who, resting his hand on Matthew's shoulder, leans forward to whisper in the evangelist's ear, has traditionally been identified with Titus, Rembrandt's son, who was born in 1641 and died shortly before his father. He certainly seems to be the same young boy who appears in a number of portraits and studies of the 1650s and early 1660s and has been thought to be Titus. The Rotterdam portrait of 1655 (Cat. No. 42) and the portrait of him reading in Vienna (Bredius 122; Fig. 42a) show the same boy, with prominent nose and deep-set eyes, a few years earlier, while the Louvre portrait (Bredius 126; Fig. 47d) shows the same features some years later. Titus is recorded to have been an artist and he was presumably trained by his father. He must have worked in Rembrandt's studio,

assisting his father, until his premature death in 1668.[2]

The x-ray does not reveal any substantial pentimenti, but it does show very clearly the vigorous application of lead-white with which Rembrandt built up his heads, working from light to dark and adding glazes in order to give his faces a remarkable luminosity.

There are four head studies or 'tronien' in Bredius's catalogue which he considered to be studies for *St Matthew* (Bredius 302–5). Gerson thought the painting in a private collection in Paris (Bredius 304) the best of these but in my view none are by Rembrandt and all seem to be later imitations of the *St Matthew* rather than studies for it.

C.B.

1. Foucart 1982, pp. 83–85 and 92.
2. Josua Bruyn has recently claimed to identify an assistant in Rembrandt's workshop in the 1660s and very tentatively identified him with Titus (Bruyn 1990, pp. 715–18).

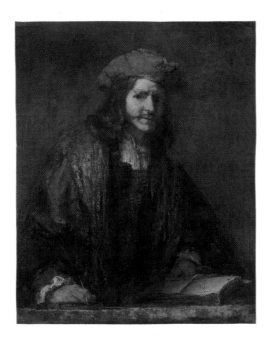

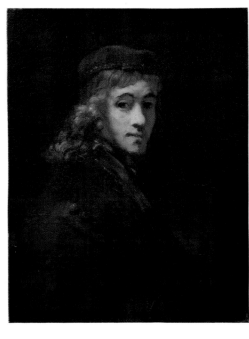

47c: Workshop of Rembrandt, *An Evangelist Writing (St. Luke ?)*.
Rotterdam, Museum Boymans-van Beuningen.

47d: Rembrandt, *Titus*. Paris, Musée du Louvre.

The Sampling Officials of the Amsterdam Drapers' Guild (The 'Staalmeesters')

1662
Canvas, 191.5 × 279 cm, signed, on the table carpet, in the centre: *Rembrandt f. 1662*[1] and, probably by a later hand, top right, on the wall, *Rembrandt f. 1661*.[2]
Amsterdam, Rijksmuseum (On loan from the City of Amsterdam); Inv. No. C6

Provenance: Painted for the sitters and placed in the Staalhof, the hall of the Drapers' Guild, in the Staalstraat, Amsterdam. On 27 November 1778 the painting was transferred from the Staalhof to the 'Konstkamer' in the Town Hall. It was lent by the City of Amsterdam to the Rijksmuseum (then the Royal Museum, housed in the Town Hall) on 15 August 1808. With the rest of the Royal Museum, it was transferred to the Trippenhuis in 1815 and to the present Rijksmuseum in 1885.

Literature: Bredius/Gerson 415; Bauch 540; Gerson 404. Van Schendel 1956, pp. 1–23; Van de Waal 1956, pp. 61–107; Van Eeghen 1957, pp. 65–80; Van Eeghen 1958, pp. 80 ff.

Exhibitions: Brussels 1946, No. 89; Amsterdam/Rotterdam 1956, No. 92.

Mezzotint and Etching: A mezzotint was made after the painting by Richard Huston in 1774 ('From a Original Picture by REMBRANDT In the Academy at the Stadt House in Amsterdam') and an etching by De Frey in 1799 ('Staalmeesters van Lakenen Ao 1661 na het schilderij van Rembrandt geplaatst op 't Stadhuys van Amsterdam').

The sitters in this, the last of Rembrandt's group portraits, have been identified as the Sampling Officials of the Amsterdam Drapers' Guild, the 'waardijns van de lakenen', a body whose function was to maintain the quality of dyed cloths manufactured and sold by members of the guild. They were appointed by, and responsible to, the City burgomasters. The waardijns were appointed for a year from Good Friday to Good Friday, but could be appointed for more than one term of office.[3] The painting is dated 1662 and it was usual for group portraits of this type to be painted at the end of the sitters' period of office. The names of the waardijns for the year 1661–1662 are contained in the papers of the Drapers' Guild which are preserved in the Gemeente Archief in Amsterdam. In an article in 1957 Miss I.H. van Eeghen has identified the individuals in the painting on the basis of their status and age: no comparative portraits of any of them are known. The central seated figure, who has the open book in front of him, is the chairman (*voorzitter*), Willem van Doeyenburg who was born in 1615 and so about 46 at this time. Born in Utrecht, he had established himself in Amsterdam as a leading cloth merchant and had married the daughter of another leading cloth merchant. It has been suggested that the book in front of Van Doeyenburg is the Staalboek, the book of dyed cloth samples by which the quality of the rest were judged.[4] There are, however, a number of objections to this idea. A number of staalboeken survive in the Lakenhal in Leiden and these are smaller, roughly stitched bundles of cloth. The book here is larger and has white pages. It is known from the account of the staalmeesters' activities given by Wagenaar (see below) that they only saw blue and black cloths and so it would be likely that any book of samples would be coloured blue or black. The book would seem, in fact, to be an account book, as was usual in corporation portraits of this kind, and Van Doeyenburg's gesture indicates the careful management of the payments made by drapers to the Staalmeesters for the appraisal of the cloths and the attachment of lead seals.

The man rising from his chair who is on the left of Van Doeyenberg is Volckert Jansz., who was born in about 1605–1610. While Van Doeyenberg had been a member of this board since 1649, Volckert Jansz. had only been appointed in 1660. He was a Mennonite and in his house on the Nieuwendijk he had assembled an interesting collection which in the 17th-century tradition was a cabinet of curiosities which included shells and stuffed animals as well as books, prints and paintings. On the extreme left sits the oldest staalmeester, Jacob

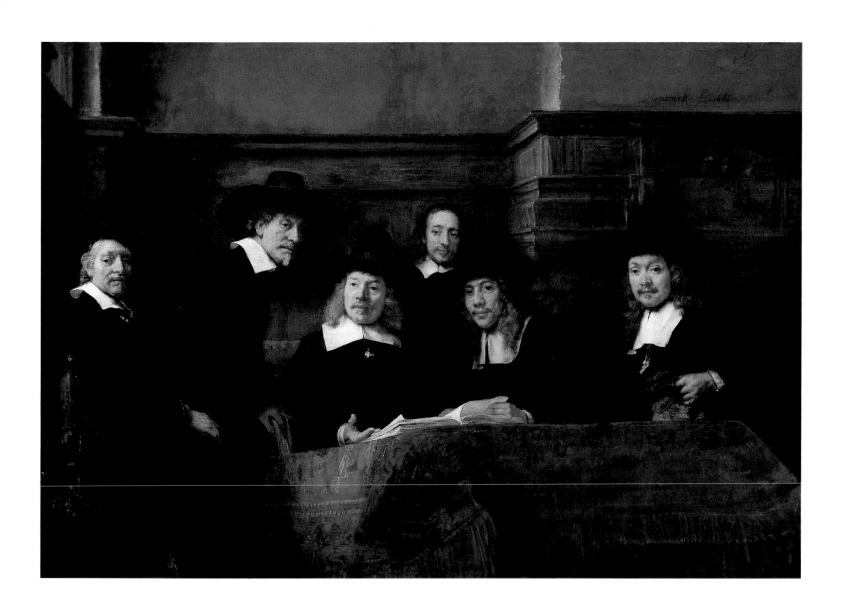

van Loon, who had been born in 1595. Like Volckert Jansz. but unlike his other colleagues, he wears his hair short and has a small collar, both of which marked him out as being old-fashioned. Van Loon, who lived in one of the most prominent houses in the city on the east corner of the Dam where it meets the Kalverstraat, was a Roman Catholic. The identification of the two remaining seated figures is less certain but the staalmeester on the far right is probably Aernout van der Mye, who was born in about 1625, and had been elected for the first time in 1661. Like Van Loon, he was a Roman Catholic. Van der Mye came from a successful family of brewers: his grandfather owned the De Lelie brewery in Amsterdam. The staalmeester to the left of Van der Mye, holding the account book with his left hand, is probably Jochem de Neve, the youngest staalmeester, who was born in 1629. De Neve was distantly related to Willem van Doeyenburg: both were descended from the leading cloth merchant in Amsterdam in the early 16th century, Jacob van Houff (before 1460–1540). He came from a distinguished Amsterdam family with Remonstrant sympathies. De Neve's father, François, was a regent of the city orphanage (burgerweeshuis) in 1635 and had been painted in a portrait group of the Regents by Abraham de Vries (Amsterdams Historisch Museum, Inv. No. 492). The sixth figure, who stands in the background in the centre and wears only a skull cap rather than a hat is the servant ('knegt') of the Staalhof, Frans Hendricz. Bel, probably born in 1629 and appointed to that position in 1652. He had living-quarters in the Staalhof and was responsible for its maintenance. Bel was later to develop a new technique used in the process of dyeing. As Miss van Eeghen remarks, this group of six men is a remarkable cross-section of Amsterdam society: the servant-inventor; the two Catholic cloth merchants, both of whom had hidden churches (schuilkerken) in their houses; the Mennonite merchant, who formed a distinguished collection which was sought out by foreign visitors to the city; the merchant with Remonstrant sympathies who came from a patrician family; and the cloth-dyer who belonged to the Reformed Church, who although from a well-known family had devoted himself not to municipal office but, as his grandfather had done, to business.

The painting, and others in the Staalhof, were described by Jan Wagenaar in 1765:[5] 'Downstairs in the Staalhof, apart from the steward's dwelling, is a large room where the cloth is sampled or leaded [with a seal] and a courtyard where it is first hung up for

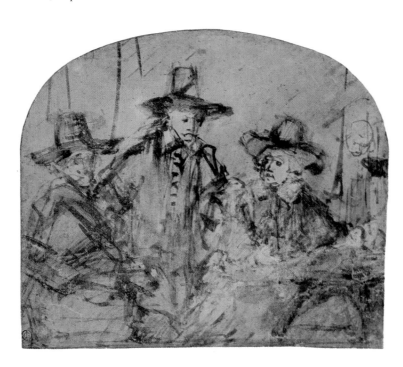

48a: Rembrandt, *Three Staalmeesters*, Drawing. Berlin, Kupferstichkabinett SMPK.

inspection; a room where the five cloth wardens, also called sampling officials [staalmeesters: literally, sample-masters], appear in turn, one at a time, three times a week, on Tuesday, Thursday and Saturday, to judge the materials and put their seal on the blue and black cloths that are the only kind brought to the Staalhof. In this room hang six paintings of syndics from the sixteenth and seventeenth centuries. The oldest is marked with the year 1559. In each of the paintings are portrayed five wardens seated and the Staalhof steward standing. In front are boards with the names of the cloth wardens. The earliest is from 1539. Above are two substantial rooms . . .' ('Het Staalhof heeft, beneden, behalve de wooning voor den knegt, een groot vertrek, daar de Lakens gestaald of gelood, en eene Binnenplaats, daarze, vooraf, opgehangen en bezien woorden ; eene Kamer, daar de vyf Waardyns der Lakenen, ook Staalmeesters genaamd, beurtswyze, en een voor een, driemaal ter weeke, des Dingsdags, des Donderdags en des Saturdags, verschynen, om de blauwe en zwarte Lakens, de eenigsten, die aan 't Staalhof gebragt worden, te keuren en te loden. In dit vertrek, hangen zes schilderyen van Waardyns der zestiende en zeventiende eeuwe. De oudste is, met het jaartal 1559, gemerkt. In ieder deezer stukken, zyn vyf Waardyns, zittende, en de knegt van 't Staalhof, staande, verbeeld. Voorts, ziet men 'er de Naamborden der Waardyns. Het oudste begint, met het jaar 1539. Boven, zyn ook nog twee bekwame vertrekken . . .') From Wagenaar's account, it is clear that the basic format of the portrait—five seated men and the standing servant—was given to Rembrandt in order to fit into an established formula. Presumably the artist was also told where the painting was to hang and this accounts for the *di sotto in sù* perspective and the strong fall of light from the left. It may be that the panelling at the back of the painting related to the internal architecture and fittings of the room in the Staalhof. Unfortunately the other paintings referred to by Wagenaar have not survived.

Despite the fact that the sitters and the location of the painting were known—although the sitters have in the past been incorrectly identified as the governors of the drapers' guild—the painting has given rise to a remarkable 'legend' which was analysed and refuted by Van de Waal in a brilliant essay. Previous writers, among them Scheltema, Thoré, Schmidt-Degener and De Tolnay, were misled by the immediacy of the painting to imagine that the staalmeesters were seated on a dais and were on the point of ending their meeting when a question was unexpectedly raised by a member of the audience: hence Volckert Jansz.'s pose, rising out of his chair. Van de Waal has shown this to be impossible. The staalmeesters met in private in their room in the Staalhof. Quoting a report of 1801, Van de Waal concluded that they are 'simply five gentlemen in black who are just sitting to have their portraits painted.'[6]

There is, however, one important symbolic feature of the portrait: set into the panelling above the fireplace on the right is a painting or a bas-relief of a watchtower in which beacons are burning. Van de Waal related this image to an emblem in Jacob Cats's *Emblemata Moralia* (1627) which shows a lighted beacon guiding a ship safely to port with the motto '*Luceat lux vestra coram hominibus*' (Let thy light shine forth amongst men). The watchtower in the context of the portrait stands for the civic virtues of care and prudence, which guide the city's trade and manufacture and, in particular, the deliberations of the Staalmeesters. In addition, the gesture of Van Doeyenburg, with his palm open and thumb raised, is clearly expository: he presents his accounts in an honest and responsible manner. In a manual of gestures published in 1664, this gesture carries the legend '*perspicuitatem illustrat*', which has the sense of showing an unchallengeable or irrefutable fact.[7]

The existence of three preparatory drawings for this group portrait is most unusual in Rembrandt's work: none survive for any of the other group portraits and very few of Rembrandt's drawings are related to paintings. All three drawings, in pen and wash, are for the three staalmeesters on the left of the painting. The Berlin sheet (Benesch 1178; Fig. 48a) appears to be a fragment of a larger drawing which may have contained more—the hat of a fourth staalmeester can be seen on the right—or all of the composition. The central figure, Volkert Jansz., stands almost upright, just bending slightly towards Willem van Doeyenburg. In the painting he bends over further towards Van Doeyenburg and gazes out of the painting. The small circular object on the right is an indication of the position of Bel's head. As will be seen in the discussion of the x-ray of the painting, Rembrandt did not decide to place Bel in this position until he had tried out two others: the drawing shows, therefore, the composition at an advanced stage, probably shortly before he painted the final version. Volkert Jansz.'s pose in the drawing, however, accords with his original position in the painting, as revealed by study of the x-ray so that it is likely that the change in his pose was one of the last made by

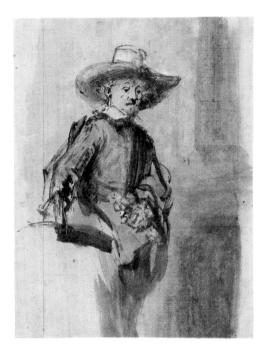

48b: Rembrandt, *A Staalmeester standing*. Drawing. Rotterdam, Museum Boymans-van Beuningen.

Rembrandt. The second drawing (Benesch 1180), which is in Rotterdam (Giltaij 1988, No. 36; Inv. No. R 133; Fig. 48b), is a three-quarter length study of Volkert Jansz., standing upright—as in the Berlin drawing and the x-ray—and looking out of the painting: Rembrandt has left a space for the chair of Jacob van Loon in the lower left hand corner. On the right, behind him, Rembrandt has indicated, in wash, the position of a column or pilaster. The third drawing (Benesch 1179; Drawings Cat. No. 40; Fig. 48c) is in the Rijksprentenkabinet, Amsterdam (Schatborn 1985, No. 56; Inv. No. A3172): it shows the seated figure of Jacob van Loon, on the extreme left in the painting. His pose is close to that in the finished painting. This drawing explores the effects of the fall of light from the left on the figure of Van Loon. The lower part of the drawing is boldly washed, leaving the upper half in a light which illuminates the back of his chair and his back and right arm. The shape of the chair has changed in the painting: in the drawing it has straight legs and no pommel or fringes. Schatborn has noted that the drawings of Van Loon and Jansz. were both made on paper from an account book, as can be seen from the lines on the verso of the Amsterdam sheet. All three drawings appear to be made for pose and composition rather than to be portrait studies. The heads are drawn in a cursory and schematic manner: they are of a generalised type rather than showing the particular features of the three staalmeesters. We must imagine that the men sat, either individually or together, to Rembrandt and that he painted their portraits directly onto the canvas.

An x-ray of the painting was made by the Rijksmuseum and published by the Director, Van Schendel, in 1956. A new x-ray has recently been made by Guido van de Voorde and is reproduced here (Fig. 48d): it reveals no significant new features but is clearer than the older x-ray. The x-ray shows many interesting changes made during the course of Rembrandt's work on the painting. They will be described here from left to right. There is no visible change in the figure of Jacob van Loon on the far left: his head can be seen to have been forcefully brushed in. There is, however, a major change in the figure of Volkert Jansz., who stands up. His head was originally about 25 cms to the left; his whole body was more upright and the pose far closer to that in the drawings in Berlin and Amsterdam. His left hand, which holds a book, can scarcely be seen at all on the x-ray: it is thinly painted, in pigments which do not contain significant amounts of lead white. The head of Van Doeyenburg, next to the right,

was painted by Rembrandt no fewer than three times, one slightly to the left of the present position and a second, almost entirely worked up, slightly to the right. Rembrandt also had difficulty with his right hand: it too was painted in three positions. There are no significant changes in the figure of Bel nor in that of the next staalmeester, who is probably Jochem de Neve. The outline of his hat has been slightly altered and there is a large patch of lead white on the sleeve of his left arm, perhaps the hand of the staalmeester to the right resting on it. In the space between the fourth and fifth staalmeesters are three heads, without hats but with collars which can be made out. These would appear to be early attempts at the figure of the servant, Bel. The third head is difficult to make out, and may be the earliest, very sketchy version of this figure. The staalmeester on the far right, probably Aernout van der Mye, presents the most confused area of the x-ray. He appears to have been placed further to the right originally, presumably when the servant stood between him and De Neve, and his right hand rested on the table. There are puzzling bold strokes of lead white over his neck and face. Further to the right in the x-ray is another standing figure, not wearing a hat: his collar can be made out very clearly. This seems to be yet another position for Bel. It was traditional practice, as we know from Wagenaar's description of the Staalhof, for the servant to be included in the group portraits of the staalmeesters, and yet this figure clearly gave Rembrandt the utmost difficulty. He appears to have painted the staalmeesters themselves first and then fitted the servant in. He was tried on the far right; he was tried, three times, between De Neve and Van der Mye, and finally he was placed between Van Doeyenburg and De Neve. Even this was not an entirely successful solution, as his pose denies the exaggerated perspective of the group as a whole. The other area of difficulty was that of the second and third men from the left. In order to give the left hand side of the painting more visual interest, Rembrandt decided to show Volckert Jansz. bending towards the seated Van Doeyenberg: this meant that he had to move the latter's head to the right. Initially he moved it too far but then corrected himself.

The Staalmeesters is painted on two pieces of canvas, the seam of which runs through the centre of the picture. They have a pronounced herringbone weave. This type of canvas is relatively rare in the northern Netherlands but Van Schendel noted that it could be found in three large paintings by Jordaens and Lievens in the Town Hall of Amsterdam and four late

48c: Rembrandt, *A Staalmeester*. Drawing. Amsterdam, Rijksprentenkabinet.

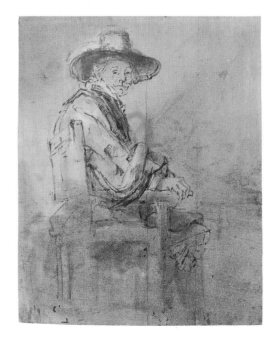

paintings by Rembrandt, the *Claudius Civilis*, the *Family Portrait* in Brunswick and the pendant portraits of a *Man with a magnifying Glass* and a *Woman holding a Pink* in the Metropolitan Museum of Art, New York.

The Staalmeesters was seen in the Town Hall by Sir Joshua Reynolds in 1781: 'The academy of painting is a part of this immense building [the Town Hall]: in it are two admirable pictures, composed entirely of portraits: one by Rembrandt, and the other by Bartholomeus van der Helst. That of Rembrandt contains six men dressed in black, one of them, who has a book before him appears to have been reading a lecture; the top of the table not seen. The heads are finely painted, but not superior to those of his neighbour. The subject of Van der Helst is the society of archers bestowing a premium: they appear to be investing some person with an order. The date on this is 1657; on the Rembrandt 1661.'[8]

A payment is recorded in the Amsterdam Municipal Treasurer's accounts (Amsterdamse Thesauriers Memorialen) on 4 July 1771 'aan Jacobus Buys voort repareren en overschilderen vant schilderij van Rembrandt en onkosten f175–.' Relinings and treatment of the varnish are recorded in 1851, 1929 and 1955. The painting has been cleaned and restored in the Restoration Studio of the Rijksmuseum for this exhibition. It proved to be substantially discoloured and the cleaning has revealed not only the vividness of the heads but also the remarkable colour of the table-carpet, which is painted in bright reds, yellows and browns with bold strokes of the brush and the palette knife.

C.B.

1. The signature is written in dots as if it is stitched into the table carpet.
2. A. van Schendel, *Kunsthistorisk Tidskrift*, 25, 1956, p. 39, states that this signature is later and probably copied from an etching. There seems no real reason to think that it must be copied from an etching rather than an painting but it is most unusual for a painting to be signed twice, with different dates. The signature on the table carpet is certainly authentic and it is hoped that scientific investigation being currently carried out (March 1991) in connection with the restoration of the painting will clarify the status of the second signature.
3. Wagenaar 1765, p. 438 : '. . . jaarlyks, op Goeden Vryday, vier of vyf waerdeyns van der Draeperye van de Laeckenen, die in de Stad gemaakt zouden worden, te kiezen.'
4. By Pieter van Thiel in a lecture. This lecture is referred to in Bredius/Gerson.
5. Wagenaar, op. cit., Vol. 2, p. 42.
6. The letter was written by C. Roos, Inspector of the National Gallery of Art in the Huis ten Bosch to the Minister of Finance following an unsuccessful attempt to acquire *The Staalmeesters* for the nation. 'In the long run', he concluded, 'this painting would not have suited you—in the first place it is 10 feet broad and eight feet high and would thus have taken up a terrible amount of space. . .furthermore it is simply five gentlemen in black who are just sitting to have their portraits painted . . .'
7. Quoted by Van Gelder 1964, pp. 11a, b.
8. Reynolds 1819, II, pp. 355–56.

48d: X-ray of Cat. No. 48.

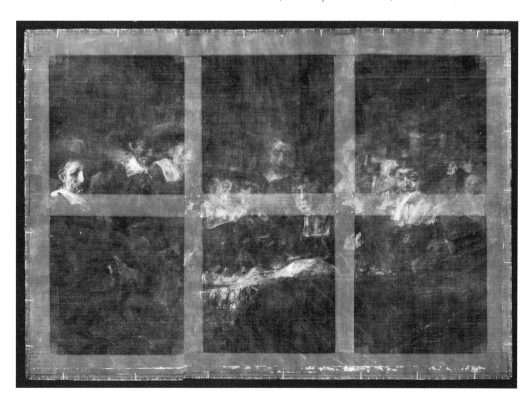

49

Self-Portrait

c. 1665
Canvas, 114.3 × 94 cm.
Iveagh Bequest, Kenwood, London; Inv. No. 57

Provenance: Comte de Vence collection, Paris, 1750; his sale, Paris, 11 February 1761: '55 ans, vue de face, avec une casque blanche, veste brune, un manteau brun borde de fourrure, sa main gauche porte sa palette et ses crayons et la droite est placée sur sa hanche.' (481 francs) Hennessy collection, Brussels, 1767; Danoot collection, Brussels, 1781;[1] Danoot sale, Brussels, 1828, No. 53 (9450 florins, to Héris); Purchased by Buchanan and Nieuwenhuys, imported into England and sold to the Marquess of Lansdowne, 1836; Purchased by the Earl of Iveagh through Agnews, 1888.

Literature: Bredius/Gerson 52; Bauch 331; Gerson 380; Broos 1970, pp. 150–84.

Exhibitions: London, Royal Academy, 1877, No. 32; Amsterdam, 1898, No. 99; London, Royal Academy, 1899, No. 20; Amsterdam, 1925; London, Royal Academy, 1928, No. 202; Manchester, 1928, No. 9; London, Royal Academy, 1952, No. 176.

Drawing and Engravings: It was drawn by Fragonard and engraved by A. de Marcenay (in 1755)[2] while in the Comte de Vence collection. Later engraved by P.D. Vlamynck.

This is one of the most powerful images of Rembrandt in his later years. He shows himself in his working clothes, palette, brushes and maulstick in hand, standing in front of a canvas on the easel in his studio. Only the edge of the canvas can be seen in the top right hand section of the portrait. The base of the easel or a chair can be seen in the lower right hand corner. Behind Rembrandt is a hanging on which two half-circles can be made out: it is not stretched tightly and can be seen to be sagging from the folds which Rembrandt has indicated at the top edge towards the right. The self-portrait appears to be unfinished in a number of areas: notably, the turban, where the form has been outlined in black but the white of the material has been only partially brushed in; the left hand, where the brushes, palette and the hand itself are only indicated in a schematic manner; and the right hand, resting on his hip, which has only been blocked in. It is neither signed nor dated. In the sequence of Rembrandt's work, it should be placed after the Louvre *Self-Portrait* of 1660 (Bredius 53; Fig. 49a) and the Rijksmuseum *Self-Portrait as the Apostle Paul* of 1661 (Bredius 59; Fig. 49b), both of which are painted in a far tighter and more descriptive style, but is not as late as the two more broadly painted *Self-Portraits* of 1669 in London (Bredius 55) and The Hague (Cat. No. 51). Rembrandt also appears to be significantly older in those last self-portraits and a dating of about 1665 for the Kenwood painting would seem acceptable.

The painting was cleaned and restored in the late 1940s. This treatment revealed that the painting had suffered from a harsh relining in the past and that some of the rich impasto, which is such a notable feature of Rembrandt's

49a: Rembrandt, *Self-Portrait*, 1660.
Paris, Musée du Louvre.

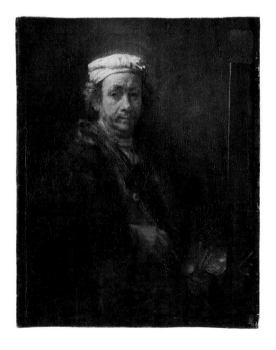

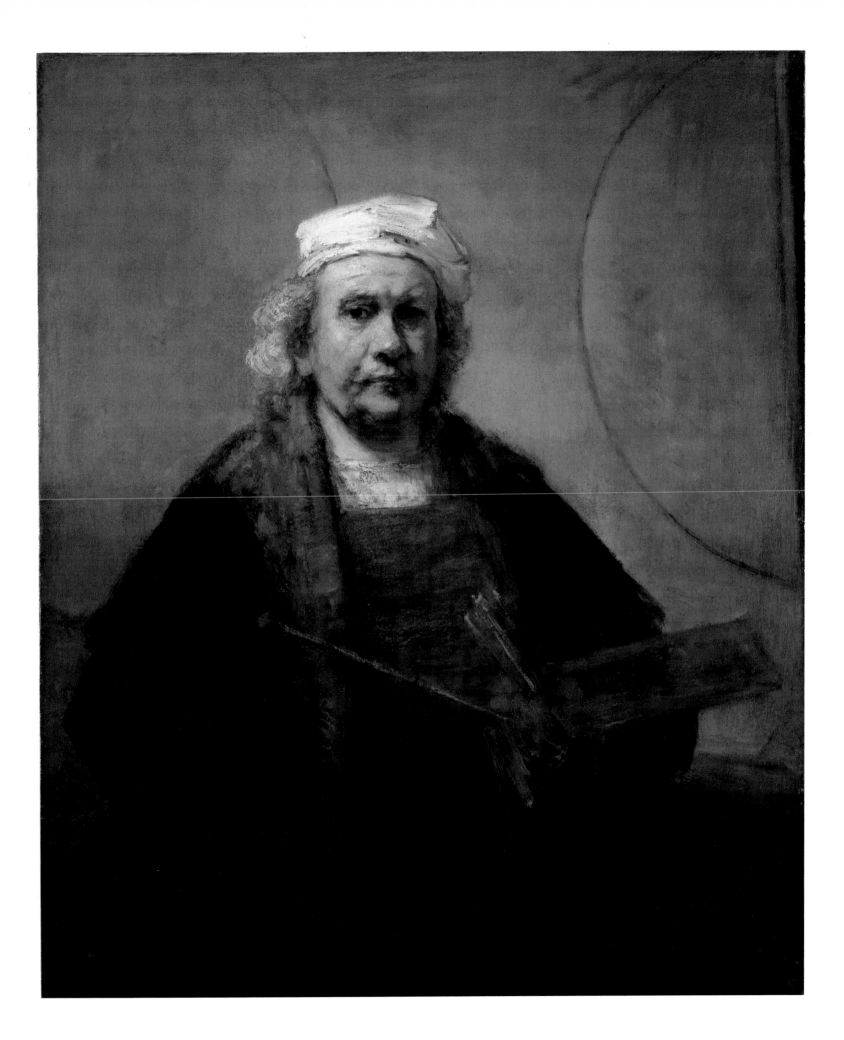

later work, had been flattened. The head, however, is the least affected area. The painting's x-ray is reproduced here for the first time (Fig. 49c). In the face and turban it shows the characteristically broad application of lead white, which can be found in all the late works. The deep eye sockets are also typical of the x-rays of the later paintings: the sockets were left empty in the underpainting and the eyes worked up with carefully applied glazes.[3] The most fascinating feature of the x-ray is the change in the position of the hands. Originally, Rembrandt, looking in a mirror, had shown himself with his left hand holding a brush and raised to the canvas; his palette, his other brushes and his maulstick were in his right hand. Rembrandt was, however, right-handed and so he subsequently moved his palette, brushes and maulstick to his left hand and put his right hand on his hip. It was a major change in the nature of the self-portrait. He had intended to show himself actually at work, as for example in the *Self-Portrait* of Frederick Vroom in Darmstadt (Fig. 49d), but settled instead for a self-portrait in the studio.

There has been a great deal of discussion about the half-circles on the canvas behind Rembrandt. They have been seen as cabalistic signs and as circles which represent the perfection of God. Van Gelder identified them as the 'rota aristotelis.'[4] Emmens, basing his argument on Cesare Ripa's *Iconologia*, considered that on the left to be an emblem of *ars* (theory), the attribute of which is a compass, and that on the right to stand for *exertatio* (practice), the attributes of which are a ruler as well as a compass, with Rembrandt himself standing between the two as the embodiment of *ingenium* (inborn talent).[5] There are a number of reasons to doubt this interpretation, not least that Emmens, as Broos pointed out, had taken from Ripa only those elements of his emblems which suited his thesis. Chapman has noted that the ruler or ruled line which according to Emmens intersects the right-hand circle is actually the edge of the picture on Rembrandt's easel.[6]

Rembrandt had never before concerned himself with such theoretical demonstrations and there is nothing to suggest that he started to do so at this late stage in his career. The evidence of the x-ray also refutes an over-elaborate interpretation, as Rembrandt clearly changed his entire conception of the self-portrait because of the practical problems of showing himself at work and at the same time presenting himself full-face to the spectator. Broos also argued for the symbolic value of the circles. He related them to the circles drawn by calligraphers to demonstrate their skill in drawing freehand, and in particular the one drawn by Lieven van Coppenol in Rembrandt's etched portrait of him. According to Broos, they are symbolic references not just to the artist's skill but to 'eternity and perfection' and so 'the painting is one of the rare instances of a direct statement by Rembrandt concerning the "Rules of Art".' This argument clearly provokes the same general criticisms as Emmens's. Van de Waal[7] proposed a far more matter-of-fact explanation: they derive from world-maps which were hung on the walls of Dutch houses. This was taken up by Bauch and, except for the lack of any geographical detail on the map, seems the most persuasive solution. In his edition of Bredius Gerson commented that this explanation 'is only right in so far as these circles, as they appear now, suggest, but do not reproduce the prototypes [i.e. the world-maps].' Chapman also supports this interpretation, pointing to the frequency with which maps and globes appear in Dutch paintings of artists' studios and self-portraits: she notes, in particular, Jan Miense Molenaer's *Studio of a Painter* of 1631 (Fig. 49e), in which a world map, also without any geographical detail, hangs on the studio wall, and Vermeer's *Art of Painting* (Kunsthistorisches Museum, Vienna; Fig. 49f) in which there is a large wall map showing the seventeen provinces of the Netherlands. In Vermeer's allegory the map has a symbolic value, referring to the fame which the artist brings to his native country. Chapman attempts to transfer this sense to the wall-map in the Kenwood *Self-Portrait*, suggesting that 'it stands for Rembrandt's universality—as a painter of the visible world, accomplished in all techniques.' I consider this to be unlikely: it is out of character with Rembrandt's view of himself and his art, as far as we can deduce it from documents and a study of his work.

The view of the author of an editorial in *The Burlington Magazine* at the time of the reopening of Kenwood in 1950 is preferable, emphasising the purely formal aspect of the background: 'It seems as though Rembrandt . . . had wished to experiment with straight lines

and curves, to try out on a private canvas for possible public use certain devices which tend toward geometry. No other explanation will fit the circles on the wall behind him, the angular, 'unrealistic' contours of the right sleeve, the diagrammatic palette, the continuation of the line of the mahlstick into the background, or the studied placing of the head a little to the left to allow for the inclusion of the sharp triangle of canvas in the top right-hand corner [which, previously painted out, had been revealed by the cleaning] . . . The portrait . . . is more than a startling essay in composition: its geometry is the only solid framework in which fierce sensations are left to glow.' In other words, the circles of the wall-map are there to give a pictorial structure to this assertive image of the painter in his studio.
C.B.

1. The painting was seen by Reynolds in the Danoot collection: 'Rembrandt's portrait, by himself, half-length, when he was very old, in a very unfinished manner, but admirable for its colour and effect: his palette and pencils and mahlstick are in his hand, if it may be so called; for it is so slightly touched, that it can scarce be made out to be a hand.' (Reynolds 1798, Vol. II, p. 266).
2. It was engraved (in reverse) by A. de Marcenay in *Cabinet de Monsieur Le Comte de Vence, Marechal de Camp des Armees du Roy*, Paris, 1755.
3. See discussion of the National Gallery's 1669 *Self-Portrait* in Exhib. Cat. London, 1988, No. 20.
4. *De Gids*, 119, 1 (1956), pp. 408–9.
5. Emmens 1968, pp. 174–75.
6. Chapman 1990, pp. 97–101.
7. Van de Waal 1956, p. 199.

49b: Rembrandt, *Self-Portrait as the Apostle Paul*, 1661. Amsterdam, Rijksmuseum.

49c: X-ray of Cat. No. 49.

49d: F. Vroom, *Self-Portrait*, Panel. Darmstadt, Hessisches Landesmuseum.

49e: Jan Miense Molenaer, *Studio of a Painter*, 1631. Berlin, Staatliche Museen, Gemäldegalerie.

49f: Jan Vermeer, *The Art of Painting*. Vienna, Kunsthistorisches Museum.

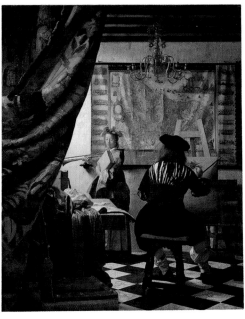

50

Portrait of a Man

1667
Canvas, 108.9 × 92.7 cm, signed and dated
Rembrandt f. 1667, upper centre[1]
Melbourne, National Gallery of Victoria;
Inv. No. 2372/4

Provenance: Vincent Donjeux sale, Paris, 29 and
following days April 1793, No. 148: 'Un
portrait d'homme, de grandeur naturelle, et vu
à mi-corps; il est presque de face, avec des
cheveux blancs, portant un rabat, et vêtu de
noir. Une de ses mains est appuyée sur le bras
de son fauteuil: le fond est en partie occupé par
un rideau rouge. Ce tableau, de la manière la
plus colorée et heurtée de ce maître, est de son
meilleur faire. Haut 39 pouc., larg. 33
[105.3 × 89.1 cm];[2] said to have been in the
collection of Lord Aylesford (Heneage Finch,
5th Earl of Aylesford, 1786–1859) before 1836;
collection of Alfred Beit by 1899; collection of
Sir Alfred Beit; Marshall Spink, London;
purchased from Marshall Spink by the National
Gallery of Victoria, 1951.

Literature: Bredius/Gerson 323; Bauch 445;
Gerson 414.

Exhibitions: London 1899, No. 59; London 1905,
No. 13; Amsterdam 1956, No. 99.

This portrait of an unidentified man, who
appears to be in his late forties or early fifties,
is an outstanding example of Rembrandt's late
portrait style.[3] He wears his hair long, as was
fashionable among younger Dutchmen in the
1660s (Cf. Cat. No. 49). He holds a wide
brimmed hat under his left hand. In the
broadness of the handling, the concentration
upon the face and hands and the forcefulness of
the pose, it is very similar to the *Portrait of an
elderly Man*, also of 1667, in Lord Cowdray's
collection (Bredius 323A; Fig. 50a) and the
Portrait of the painter Gerard de Lairesse, who also
wears his hair long, of 1665 in the Lehman
collection at the Metropolitan Museum of Art,
New York (Bredius 321; Fig. 2). The
Melbourne and Cowdray pictures are the last
dated portraits by Rembrandt. Of these three
masterpieces of the late style, the Melbourne
painting has the most detailed treatment of the

face. Much of the power of this remarkable
portrait lies in the contrast of technique
between the refinement of the face, with its
detail built up in successive, carefully applied
glazes and the broadly scumbled painting of the
hands in which the form is scarcely more than
blocked in. It recalls the discussion of
Rembrandt's late style in Félibien's *Entretiens
sur les vies et sur les ouvrages des plus excellents
peintres anciens et modernes*, in which he defends
Rembrandt's 'grands coups de pinceau' against
the more graceful style of Van Dyck. In some
paintings Rembrandt handles the paint so
broadly, placing tones and half tones next to
each other, and adding the lights and shadows
in such a crude manner that the painting has
the appearance of a sketch and the detail
cannot be made out from close quarters.
However, when you step away, the whole
composition blends together and is very
effective.[4] ('Car souvent il ne faisoit que donner
de grands coups de pinceau, et coucher ses
couleurs fort épaisses, les unes auprès des
autres, sans les noyer et les adoucir ensemble.
Cependant, comme les gousts son différens,
plusieurs personnes ont fait cas de ses ouvrages.
Il est vray aussi qu'il y a beaucoup d'art, et
qu'il a fait de fort belles testes. Quoy-que
toutes n'ayent par les graces du pinceau, elles
ont beaucoup de force; et lorsqu'on les regarde
d'une distance proportionnée, elles font un très-
bon effet, et paroissent avec de beaucoup de
rondeur.')

The x-ray reveals no significant *pentimenti*,
but there are small changes in the outlines of
the head and the forehead and in the cuff of the
left hand. It shows the vigorous application of
lead-white in building up the structure of the
head that has been encountered in other late
paintings, notably the *St Matthew and the Angel*
of 1661 (Cat. No. 47).
C.B.

1. The position of the signature, in the centre of the
wall above the sitter's head, is unusual but it seems to
be authentic. It is written in grey paint with pinkish-
red highlights on the last two strokes of the m and the
small r.
2. First published in Gregory & Zdanowicz 1988,
p. 74, note 37 (with acknowledgement to J. Bruyn).
3. Hoff 1973, pp. 120–21.
4. Félibien 1666–88, 5 vols. The life of Rembrandt is
contained in Vol. 4, published in 1684, pp. 150–57. His
discussion of Rembrandt is transcribed in full in Slive
1953, Appendix F.

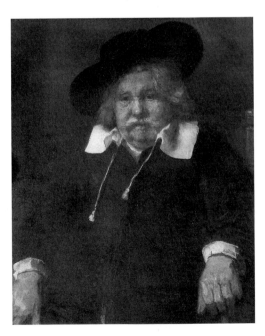

50a: Rembrandt, *Portrait of an Elderly Man*, 1667.
Collection Lord Cowdray.

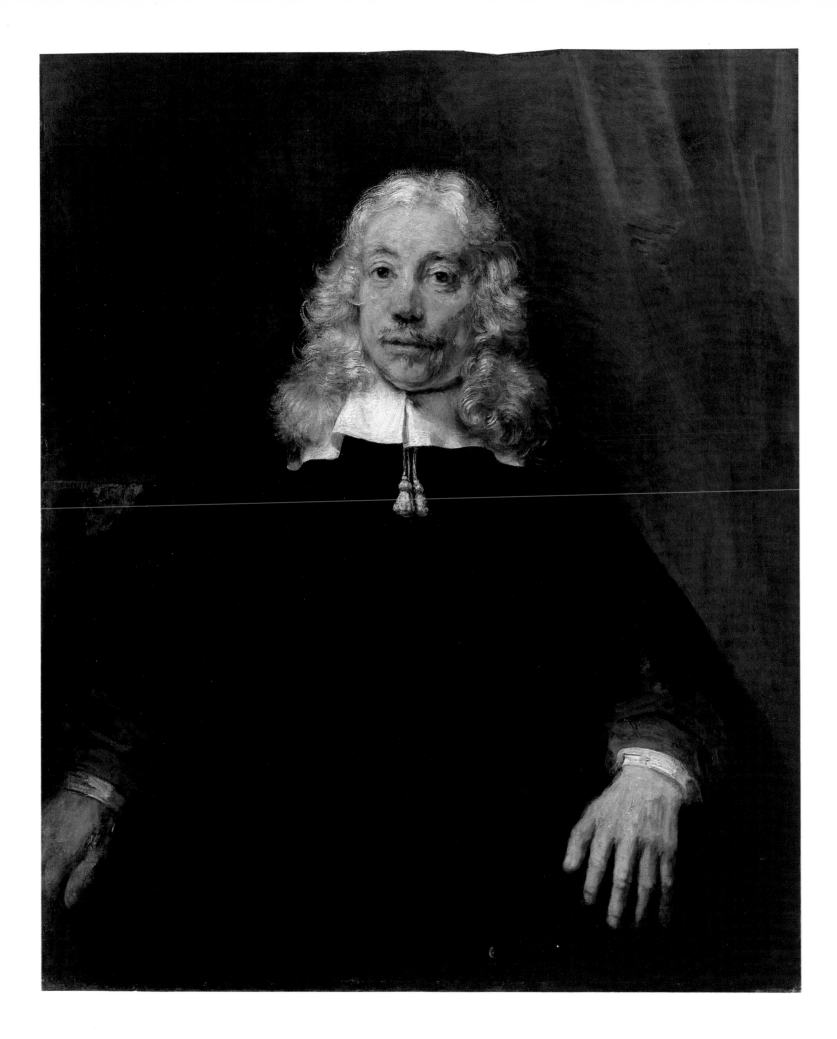

51

Self-Portrait

1669
Canvas, 63.5 × 57.8 cm, signed and dated,
centre left: *Rembrandt f 1669*[1]
The Hague, Mauritshuis; Inv. No. 840

Provenance: collection of Sir Joseph Neeld,
London, before 1850; collection of Sir John and
Audley W. Neeld, Grittleton House, Wiltshire,
c. 1885–99; R.L. Douglas, art dealer, London;
Knoedler and Co., London; collection of M.
Kappel, Berlin, c. 1912—c. 1930; collection of
E.G. Rathenau and E. Ettlinger-Rathenau,
Berlin, Oxford and New York, c. 1930–47;
Placed on loan at the Rijksmuseum, 1925–1940;
Removed from the Rijksmuseum by German
occupying forces in 1940 and taken to Alt-
Aussee in the Salzkammergut,[2] where it
remained until 1945; Purchased from the
Rathenau family by the Dutch State and placed
in the Koninklijk Kabinet van Schilderijen
'Mauritshuis', The Hague, 1947.

Literature: Bauch 342; Bredius/Gerson 62;
Gerson 420; Broos 1987 52.

Exhibitions: London 1899, No. 4; Amsterdam
1925, cat. p. 524; Amsterdam 1935, No. 32;
Washington, Chicago, Los Angeles & The
Hague 1982–83, No. 29; Paris 1986, No.42.

This is one of two self-portraits which are
dated in Rembrandt's last year. The other is in
the National Gallery in London (Bredius 55;
Fig. 51a)[3] and shows the artist half-length, his
hands clasped together in front of him and
wearing a cap. The x-ray of that painting (Fig.
51b) reveals that Rembrandt originally
intended to show himself holding his palette
and brushes and wearing a higher hat, probably
a white turban of the kind he wears in the
Kenwood *Self-Portrait* (Cat. No. 49) of a few
years earlier. The London painting shows
Rembrandt with shorter hair, fuller in the face
and without the sagging chin of the *Self-Portrait*
in The Hague, which seems, therefore, to be
the later of the two and so is probably
Rembrandt's last *Self-Portrait*. The x-ray of the
London painting shows very heavy application
of lead white, whereas that of the painting in
The Hague reveals a relatively light application
of lead white in the face, except for the
highlight on the top left-hand side of the
forehead which is heavily impastoed. It also
shows changes to the beret. As in the London
painting, he may have originally intended it to
be a painter's white turban which he then
replaced with the present iridescent beret, the
material and indeed the colour of which are
difficult to make out: it seems to be orange-
brown, with white highlights. A close
inspection of the surface of the painting reveals
numerous touches of dull red, presumably a
burnt siena, on the cheeks, lips, edge of the
nose and beneath the eye. This flecked
technique can also be seen, as Professor Bruyn
has pointed out, in the *Portrait of Jeremias de
Decker* of 1666 in Leningrad (Bredius 320; Fig.
51c).

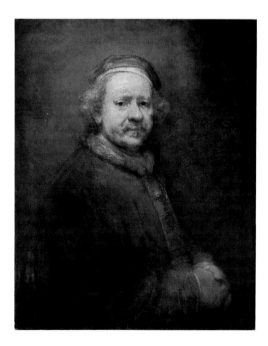

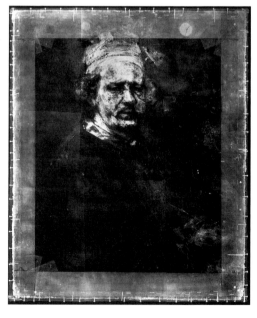

51a: Rembrandt, *Self-Portrait*, 1669.
London, National Gallery.

51b: X-ray of Fig. 51a.

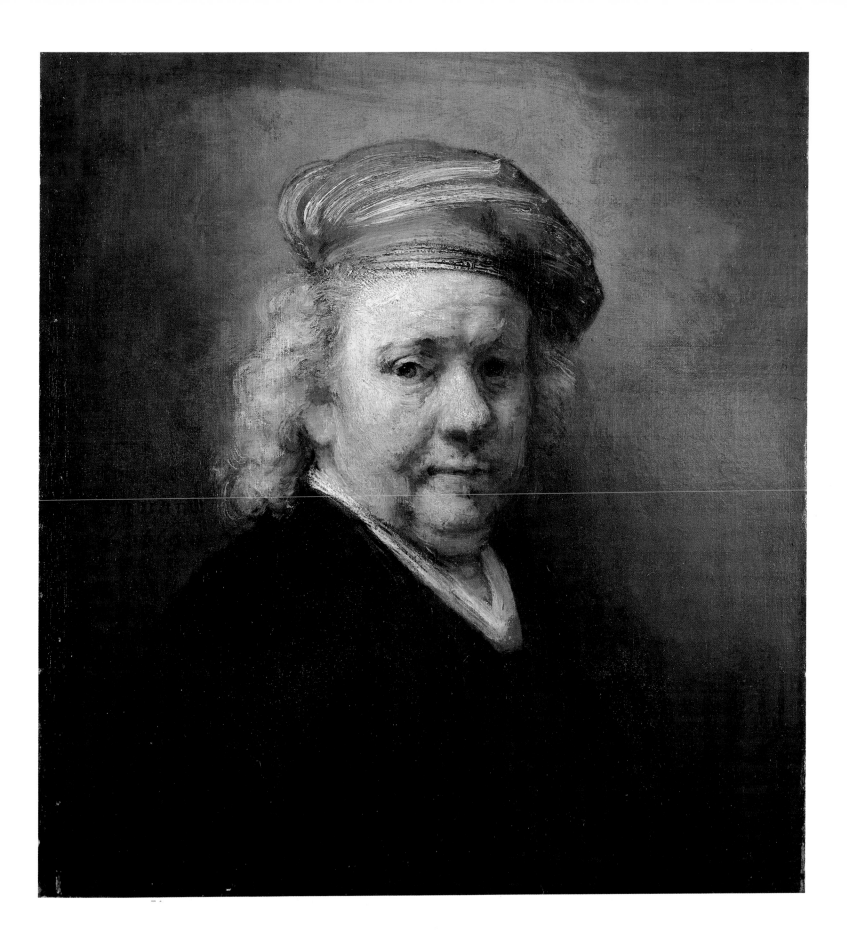

The painting was relined, prior to its exhibition in the United States in 1981–82. This treatment revealed the remains of an old starch relining on the back of the canvas; this 18th or 19th century relining had subsequently been removed. The traces of starch used in the relining clearly contain the impressions of the second, relining canvas.[4] There is a heavy, dark line which is between 2 and 3 centimetres thick at the top edge of the canvas: it is concealed under the frame. This line appears to be original and presumably once extended along all four edges of the painting.

C.B.

1. The signature and date may have been strengthened but are certainly authentic.
2. This was a saltmine in which the looted treasures intended for Hitler's projected museum at Linz were stored.
3. For the London painting, see Exh. Cat. London, 1988, No. 20; and MacLaren/Brown 1991, No. 221.
4. Van de Wetering interpreted this substance on the back of the canvas as paint which had seeped through from the front (*Corpus*, II, p. 20, Figs. 5–6). Subsequent analysis has shown it to be starch from the earlier relining.

51c: Rembrandt, *Jeremias de Decker*, 1666. Panel. Leningrad, Hermitage.

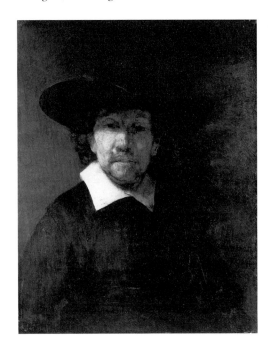

The Master & his Workshop

Jan Lievens
Gerrit Dou
Isack Jouderville
Govert Flinck
Ferdinand Bol
Jan Victors
Gerbrand van den Eeckhout
Samuel van Hoogstraten
Carel Fabritius
Nicolaes Maes
Barent Fabritius
Willem Drost

Jan Lievens (1607–1674)

Lievens was born in Leiden on 24 October 1607, the son of an embroiderer who had moved from Ghent. He was a pupil of Joris van Schooten in Leiden and at about the age of ten went to study with Pieter Lastman in Amsterdam. He seems to have stayed with Lastman for about two years and then returned to Leiden where he subsequently worked as an independent painter. He is recorded there in 1624, 1626 and 1629; in 1626–27 he painted a portrait of Constantijn Huygens, the Stadholder's secretary. In the late 1620s Lievens was closely associated with Rembrandt and their works of this period are sometimes difficult to distinguish. Lievens left Leiden in 1632 and travelled to London, where he worked for the court and met Van Dyck. Lievens had settled in Antwerp by 1635, when he entered the guild. He had moved to Amsterdam by March 1644 and is recorded there until 1653. In 1650 he painted a large picture of Five Muses for the royal palace, Huis ten Bosch near The Hague. He lived in The Hague from 1654–58 and was among the founders of Pictura, the painters' confraternity, in October 1656, the year in which he painted Quintus Fabius Maximus and his Son for the new Town Hall in Amsterdam. In 1661, when he had been back in Amsterdam for two years, he was commissioned to paint an episode in the struggle of the Batavians against the Romans for the decoration of the Town Hall. He received a number of other important commissions for public buildings in the 1660s, among them two paintings for the Rijnlandhuis in Leiden. He spent short periods in The Hague and Leiden, and died in Amsterdam on 4 June 1674.

Lievens was a precocious artist; according to Orlers, the historian of Leiden, he was painting independently in 1621 when he was fourteen. He was also very eclectic. His earliest known works are broadly painted large-scale figures representing the Four Elements. Subsequently he painted small-scale religious scenes, very similar to those of Rembrandt's Leiden period. At the English court he came under the powerful influence of Van Dyck and subsequently both his portraiture and his history painting reveal the overwhelming impression Van Dyck made on the young Dutch artist. After his return to Holland he largely concerned himself with portraits and with official commissions for historical and allegorical subjects on a monumental scale. In his later years Lievens evolved an individual landscape style based in the first place on Rubens and Adriaen Brouwer. His landscape drawings are highly original and he also made many etchings and some woodcuts.
C.B.

52

Attributed to

JAN LIEVENS
The Feast of Esther

Canvas, 130 × 165 cm
Raleigh, North Carolina Museum of Art

Provenance: A painting of this subject attributed to Rembrandt was in the collection of the Amsterdam art dealer, Johannes de Renialme, in 1657; collection of the Comte de Calonne, Paris; his sale, London, 25–28 March 1795; collection of B. Sommelinck, Ghent; his sale, Brussels, Fievez, 16 December 1936, No. 80 (as dated 1632 and by Aert de Gelder); P. de Boer, art dealer, Amsterdam, 1937; collection of Charles A. de Burlet, Basel, 1952; Schaeffer Gallery, New York, 1952. Purchased in that year from the Schaeffer Gallery by the North Carolina Museum of Art.

Literature: Bauch 1966 A1; Bredius/Gerson 631; Schneider S349; *Corpus*, I C2; Sumowski, Lievens 1181.

Exhibitions: Raleigh 1956, No. 1; Raleigh 1959, No. 68; Sarasota 1960, No. 17; Oberlin 1963, No. 11; Toronto & Montreal 1969, No. 1; Leiden 1976–77, No. S29; Washington, Detroit & Amsterdam 1980–81, No. 31.

The painting shows the moment in the Old Testament Book of Esther (Chapter 7, verses 1–6) when Esther, at a feast to which she has invited Ahasuerus and Haman, informs Ahasuerus of Haman's persecution of the Jews: 'For we are sold, I and my people, to be destroyed, to be slain and to perish.' Ahasuerus, realising the extent of Haman's treachery, clasps his fists in anger, while Haman recoils in fear, realising that he faces the wrath of the King. Harbonah, the King's chamberlain, stands behind Esther.

This large, broadly painted and boldly coloured canvas came to light in 1936 and was purchased by the North Carolina Museum in 1952 as a Rembrandt. As well as the attributions to Aert de Gelder (at the sale in 1936), Lastman and Rembrandt, it has been suggested that the painting is a collaboration between Rembrandt and Lievens. In 1969 Gerson suggested an attribution to 'the early Jan Lievens (around 1625), who, in my view, is an artist of great power and imagination.'

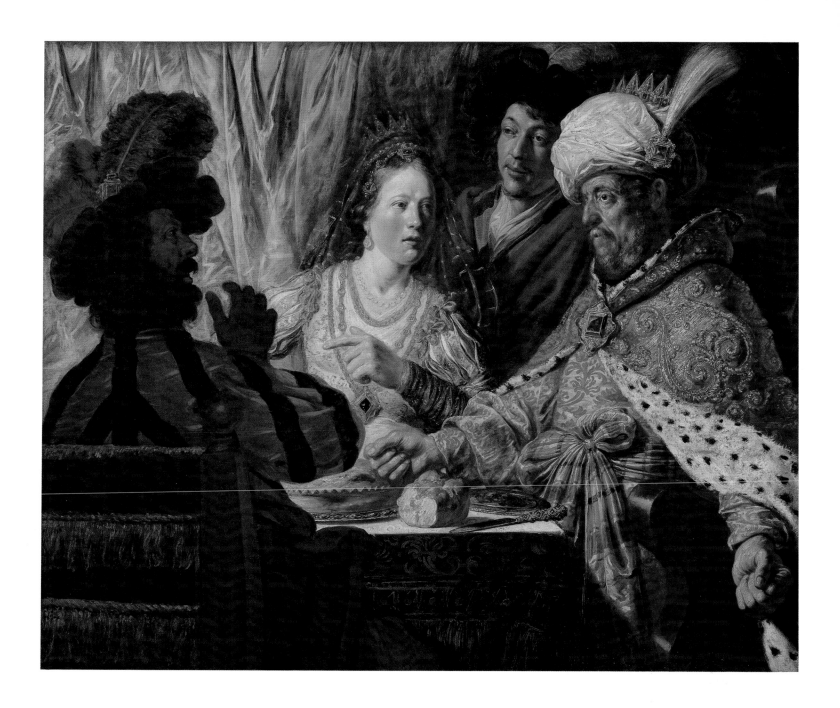

This view has gained wide acceptance. An important part in this process has been played by the rediscovery of a number of other early works by Lievens which show similar formal and stylistic characteristics and two of these, *Christ at the Column* (Cat. No. 53), which is monogrammed by the artist, and *Pilate washing his hands* (Cat. No. 54), are exhibited alongside the *Feast of Esther*. All three works, as I believe the juxtaposition will make clear, were painted by Lievens at about the same time, that is, in the years around 1625, after he had left Pieter Lastman's Amsterdam studio and set up on his own account in Leiden. All these early works are rough and broad in handling and they all show life-size, half-length figures.

Among Lievens's very earliest works, painted when he was in his mid-teens, would seem to be a series of four paintings of the elements (Sumowski 1216–19) and two panels showing boys blowing on hot coals (Sumowski 1225–6; Fig. 52a). Both of the latter are boldly signed with Lievens's Latin signature: *J. Livius*. In the sequence of his development *Pilate washing his Hands* and *Christ at the Column* come shortly after, followed by *The Feast of Esther*, which shows greater confidence in spatial organisation and the description of rich fabrics. An important influence was that of Lievens's teacher, Pieter Lastman. Lievens has in effect taken Lastman's linear, highly coloured and dramatically-lit style and employed it on a far more ambitious scale, using a technique which is broader, coarser and more vigorous than that of his master. A new element is the placing of Haman's head in shadow and silhouetting his features against a light background: this dramatic device was learnt by Lievens from the Utrecht followers of Caravaggio, and in particular from Gerrit van Honthorst who had returned from his extended stay in Rome late in 1620.

In a full discussion of this painting, the authors of the *Corpus* stress the close links of the painting with contemporary developments in Utrecht, particularly with Honthorst and Ter Brugghen. They note that the colour scheme, with its contrasts between lilac and pinkish-red on the one hand and light blue and blue-grey on the other recall Utrecht painters of an earlier, late-Mannerist generation such as Abraham Bloemaert and Paulus Moreelse and can also be found in Ter Brugghen and that 'fabrics striped with broad bands frequently appear in Utrecht paintings, in Honthorst and especially in Ter Brugghen, and are found hardly anywhere else.' After careful comparison with early works by Lievens and a consideration of the innovations in the painting—'the broad red areas of sheen on Haman's sleeve, for instance, and the bold treatment of Ahasuerus's cloak, as well as the supple modelling of the head of the servant'—they judiciously conclude that 'the similarities in pictorial temperament [to the work of Lievens] are strong enough for these innovations to be accepted as additions to the means of expression employed by one and the same artist.' It is 'the masterpiece of his youth.'

C.B.

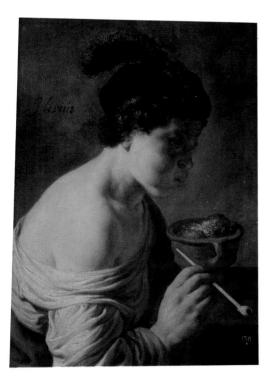

52a. Jan Lievens, *Young Man with a pipe blowing on a glowing coal*. Panel. Warsaw, Muzeum Narodowe.

53

JAN LIEVENS

Christ at the Column

Panel, 106.5 × 74.5 cm, signed, lower left : *IL* Amsterdam, Charles Roelofsz.

Provenance: Sale, Christie's, London, 21 November 1930, No. 102 (as Hemling); W.E. Duits, art dealer, London, 1931; Leger and Sons, art dealer, London, Exhibition, May 1931, No. 23; P. de Boer, art dealer, Amsterdam, Exhibition, July to September 1932, No. 73; J. Verheugen, Eindhoven; S.J.M. Slaats-Verheugen, Aarle-Rixtel; Sale, Sotheby-Mak van Waay, Amsterdam, 24 April 1978, No. 74; S. Nystad, art dealer, The Hague.

Literature: Schneider 33; Sumowski 1220.

Exhibitions: Leiden 1976, No. 17; Brunswick 1979, No. 9; The Hague 1982, No. 51.

This monogrammed painting by Jan Lievens has been chosen for inclusion in this exhibition in order to support the attribution of *The Feast of Esther* to the artist. Lievens was a prodigy: according to the historian of Leiden, Orlers, he amazed contemporaries with his work at the age of twelve and two years later in 1621 he painted his mother (who was to die in 1622) with such skill that everyone was astonished.[1] The *Four Elements* and the two paintings in Warsaw of *Boys blowing on coals* stand at the very outset of his career, but this painting must come shortly afterwards, that is, in about 1623. It probably predates both *Pilate washing his hands* and *The Feast of Esther*, which are more ambitious and show clearer (though not very clear) spatial arrangements of the figures. Here the tormentor on the left seems not to occupy the same space as Christ. Despite such weaknesses, the confident modelling of the body and head of Christ is impressive. The treatment of the face is very similar to the broadly painted features and bold highlights of the heads in The *Feast of Esther*: note, in particular, the eyes of Christ and the eye of Ahasuerus. Another valuable point of comparison can be found in the clasped hands of Christ and those of Ahasuerus. Here we find the same simplification of form and heavily impastoed, creamy highlights.

In this painting Lievens employs a dramatic

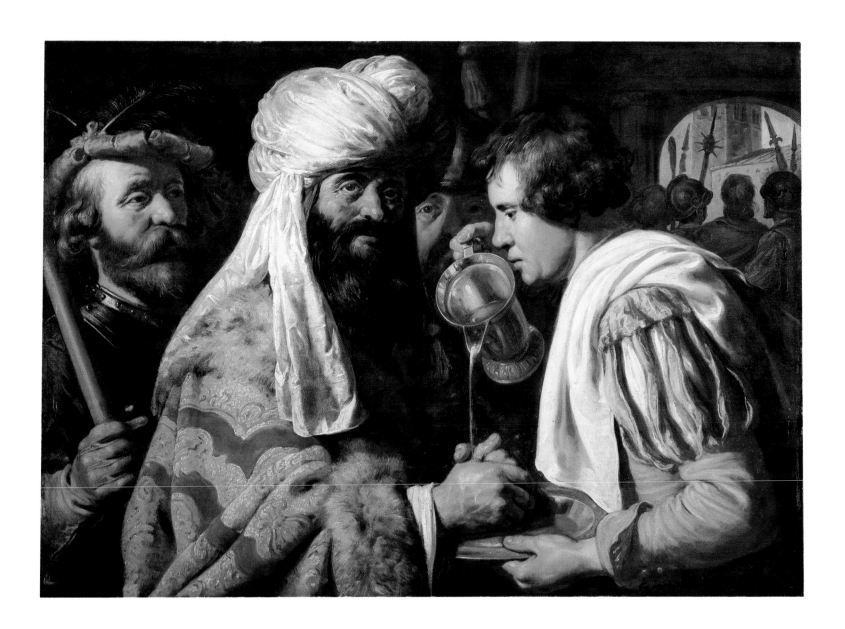

chiaroscuro, highlighting the body which is described with remarkable naturalism, outlining the ribs and throwing a strong shadow from Christ's right arm on the wall behind. The tormentor, who awkwardly carries the Cross, is shown in shadow. Such powerful use of light and dark is a feature of Lievens's early work: it was learnt from Lastman and probably also reflects his study of contemporary developments in Utrecht. It is less evident in *The Feast of Esther* but is still powerfully present in the figure of Haman, the shadowed table-carpet in the foreground and the shadows behind Ahasuerus on the right.
C.B.

1. Orlers 1641, pp. 375ff.

54

JAN LIEVENS

Pilate washing his Hands

Panel, 83.8 × 105 cm.
Leiden, Stedelijk Museum 'De Lakenhal';
Inv. No. 2198

Provenance: collection of Sir Joseph B. Robinson, London (Robinson sale, Christies, London, 6 July 1923, No. 57, as Aert de Gelder: bought in); collection of Princess Labia, London and Kapstadt, South Africa; E. Speelman, art dealer, London.

Literature: Schneider 1973 S351; Sumowski, Lievens 1180.

Exhibitions: London 1958, No. 59 (as 'Manner of Rembrandt'); Leiden 1976–77, No. 61; Brunswick 1979, No. 8.

54a: Hendrick Ter Brugghen, *Pilate washing his Hands.* Kassel, Gemäldegalerie.

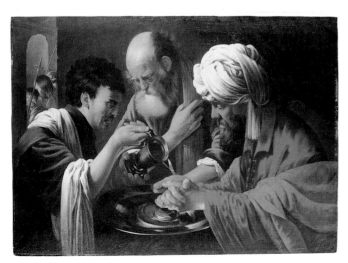

Pilate washed his hands before condemning Christ to death. The incident is recorded in the Gospels of St Matthew (Chapter 27) and St John (Chapter 19). Christ is seen being led away through an arch by two soldiers in the background.

This painting presents further evidence of Lievens's close contacts with Utrecht in his early years. It is based on Hendrick Ter Brugghen's treatment of this subject in the painting of about 1621 in Kassel (Fig. 54a). While taking over Ter Brugghen's compositional scheme, Lievens has intensified the colour and modelled the figures, not in the Utrecht painter's flat planes but with a bold, linear use of the brush. The handling of the heads and the hands has obvious analogies with *Christ at the Column:* the same treatment of the pupils and the whites of the eyes, the same yellow highlights on the light brown skin of the nose and cheeks, the same simplification of the knuckles and fingernails and the same highlights on the bones of the fingers. The figure of the soldier on the left in *Pilate washing his Hands* is treated in an almost identical way to that in *Christ at the Column:* it might be the same model, seen from a different angle, in light and in shadow.

Christ at the Column is monogrammed by Lievens. The *Pilate* is unsigned but is clearly by the same hand and, as was clear in their juxtaposition in Leiden in 1976, *The Feast of Esther* is by the same artist as *Pilate washing his Hands.* In recent years research into problems of attribution in the work of Rembrandt, his contemporaries and his pupils has broadly taken two forms. There has been a frontal assault, as it were, on Rembrandt's own work, the most spectacular example of which is the reductionism of the Rembrandt Research Project. At the same time there have been many studies, foremost among them Sumowski's *Gemälde der Rembrandt-Schuler,* in which the œuvres of the artists around Rembrandt have been reexamined and redefined. This particular case is a good example of the second approach at work, carried out in publications and, very importantly, in the mounting of exhibitions. In these ways the early work of Lievens has been clarified and, as a consequence, *The Feast of Esther* given an entirely convincing attribution and removed from the discussion of Rembrandt's œuvre.
C.B.

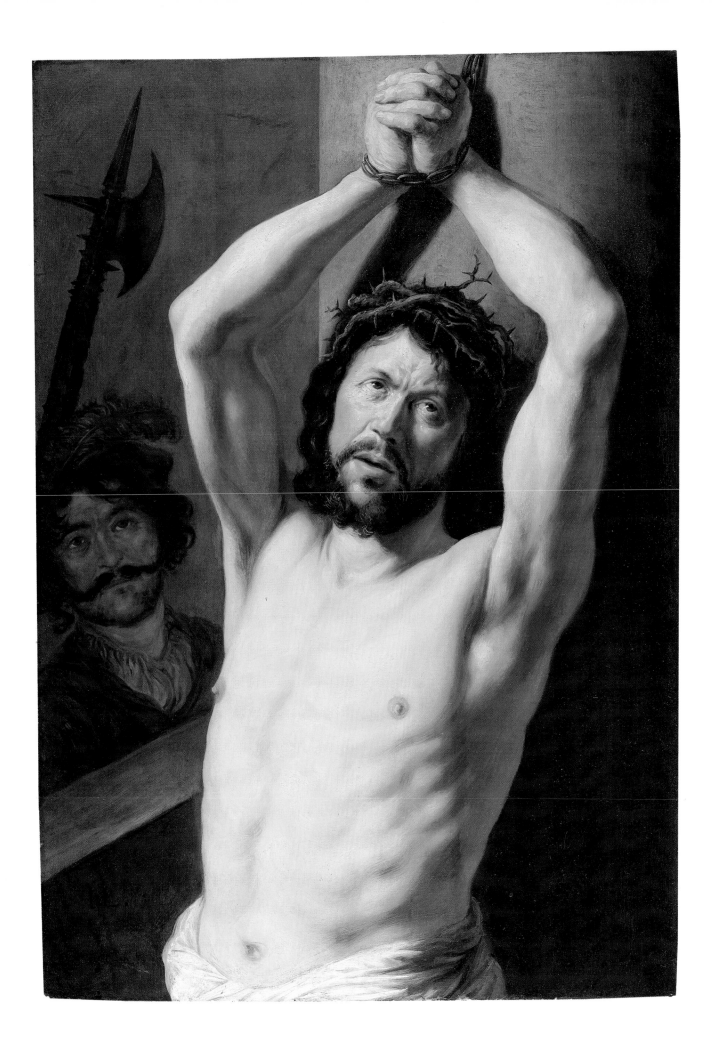

Gerrit Dou (1613–1675)

Gerrit Dou was born in Leiden on 7 April 1613. (His Christian name is sometimes given in the gallicized form, Gerard, in contemporary documents.) He was the son of a glass-engraver, Douwe Jansz. As a child he was trained by his father as a glass-engraver and subsequently by the engraver (on copper) Bartholomeus Dolendo and the glass-painter Pieter Couwenhorn. In February 1628 Dou became a pupil of Rembrandt and was with him until about 1631–32. He remained in Leiden throughout his life and was one of the first members of the Leiden Painters' Guild which was founded in 1648. In 1665 Johan de Bye, a local collector, organised a display of Dou's work in Leiden, which included twenty-seven of the artist's works. According to Houbraken, he worked very slowly and was fastidious about his working conditions: he is said to have waited for the dust to settle in his studio before beginning work. Dou remained a bachelor and was buried in the Pieterskerk in Leiden on 9 February 1675.

Dou's highly finished genre paintings, many of which show figures placed within a carved stone niche, and his small-scale portraits were greatly admired by contemporaries and he was one of the most successful Dutch painters of his time, his reputation extending far beyond Holland. Among his patrons were King Charles II, Queen Christina of Sweden and the Archduke Leopold Wilhelm. In addition to genre subjects and portraits, Dou painted still lifes and historical scenes. His pupils included his nephew, Dominicus van Tol (c. 1635–76), Frans van Mieris the Elder (1635–81), Abraham de Pape (before 1621–1666), Godfried Schalcken (1643–1706), Matthijs Naiveu (1647–c. 1721) and Carel de Moor (1656–1738). He was the founder of the school of 'fine painters' (fijnschilders) in Leiden which continued into the nineteenth century.

C.B.

55

Attributed to
GERRIT DOU
Anna and the blind Tobit

Panel, 63.8 × 47.7 cm
London, The National Gallery; Inv. No. 4189

Provenance: Collection of John Bell, Glasgow; his sale, North Park, Glasgow, 1–5 February 1881, lot 357 (50 guineas): 'Gerard Douw. Interior, old Man and old Woman seated at a window, on panel 25 inches by 18 1/2 inches'. Bought by Sir Renny Watson of Braco Castle, Perthshire. On the death of Sir Renny's widow, it passed to his cousin's son, Dennis Elliot Watson, from whom it was purchased by the National Gallery in 1926.

Literature: Bauch A6 (as Dou and Rembrandt); Sumowski, Dou 243; *Corpus* I C3 (Dou); MacLaren/Brown 1991 4189

Engraving: Line engraving in reverse by Willem van der Leeuw, inscribed: 'Rembr. van Rijn inv. WPLeeuw fecit' (WPL in monogram) and 'Paupere sub tecto Tobias perpendit manes / Delicias hominum, et gaudia fluxa pius./ Sorteq[ue], divitiae veniunt, et sorte recedunt : O pietas, laus est semper, honorq[ue] tibi./ C.G. Plempius.' (Tobit meditates devoutly, beneath his shabby roof./upon the vanity of human pleasure and the transitoriness of joy./ Fate lets riches come and has them go./ To you, O piety, be ever praise and honour).

The subject, from the Book of Tobit, Chapter 2, is identified by Willem van der Leeuw's engraving after the picture, which bears a four-line Latin inscription describing Tobit's meditations. Van der Leeuw's engraving, which attributes the design of the composition to Rembrandt, is almost contemporary with the painting.[1] Willem van der Leeuw's exact dates are not known: he is said to have been born in Antwerp in about 1603, studied with Pieter Soutman and died in about 1665.[2] Few engravings by him are known, but they include five after Rembrandt and one after Lievens. The other four after Rembrandt are: *David playing before Saul*, after the painting now in Frankfurt (Bredius 490);[3] *Bust of a young Man with a Neckerchief and a feathered Cap*, after a painting dated 1633 and formerly with Sedelmeyer in Paris (HdG 431; not in Bredius);[4] *Mariane*, after a lost painting (HdG

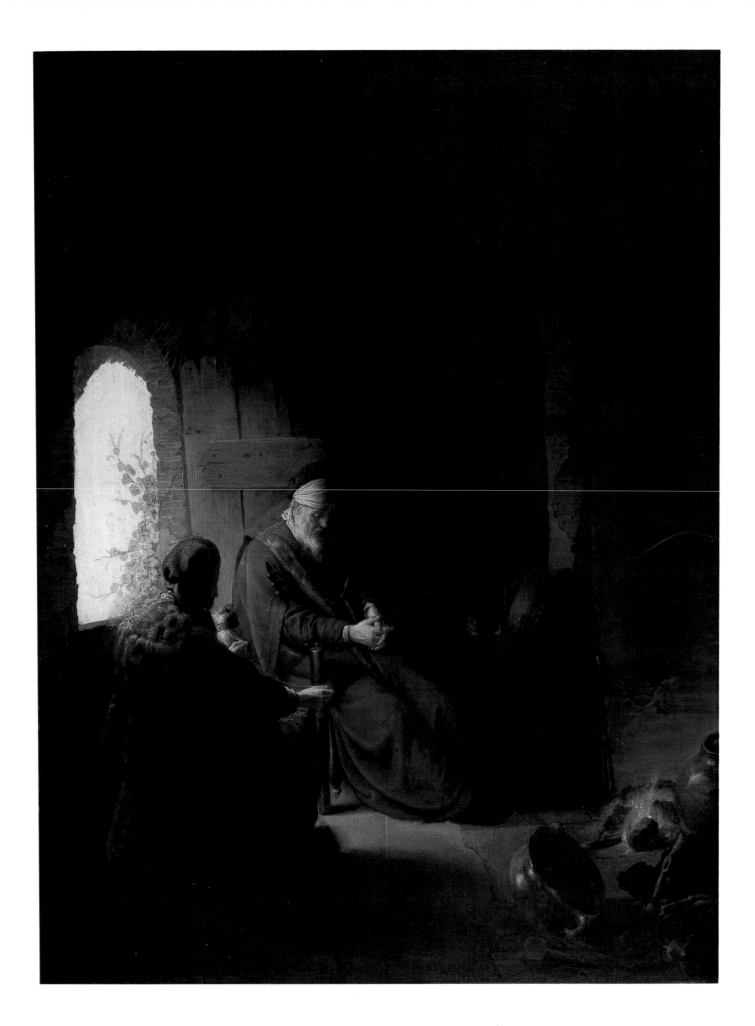

55a: Rembrandt, *A seated old Man*. Drawing. Berlin, Kupferstichkabinett SMPK.

55b: Rembrandt, *An old Man asleep at the Hearth*, 1629. Panel, Turin, Galleria Sabauda.

55c: Gerrit Dou, *Tobit and Anna*, Panel. Paris, Musée du Louvre.

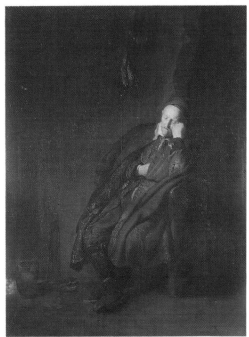

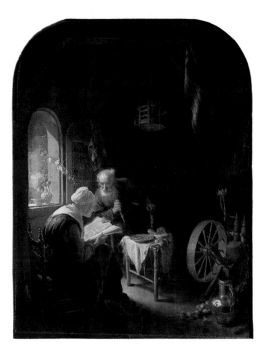

519 ; not in Bredius);[5] and *Rembrandt's Sister*, a painting of 1632 in the Nationalmuseum, Stockholm (Bredius 85).[6] The Lievens is after a painting in the Spencer Collection at Althorp, known as *A Capuchin Monk* but identified in the inscription on Van der Leeuw's print as St Anthony.[7] These five prints are all after paintings of the 1630s and Van der Leeuw does not seem to have been active as an engraver after the 1630s. The unpublished verses, which the engraving after this painting and two of the other five[8] bear, are by Cornelis Gijsbertsz. Plemp, who presumably wrote them especially for Van der Leeuw's engravings. Plemp died in 1638. There are, therefore, good grounds for assuming that Van der Leeuw's print was made after *Anna and the blind Tobit* in the 1630s, not long after it was painted, and that the picture was then considered to be by Rembrandt.

A careful study of the painting shows, however, that the highly finished and precise execution is more like that of the young Dou than of Rembrandt. While this has been recognised for some time, and the picture was sold as a Dou in 1881, a number of writers have thought some parts of the picture to be superior to the rest and have argued that it is a collaboration between Dou and his master. MacLaren[9] argued that the fire and Tobit's head should be attributed to Rembrandt: he felt that the head was very close to that of the *St Paul* at Nuremberg (Cat. No. 5). He also felt that the corrections to the outlines of Tobit's right shoulder and Anna's back, and the ivy seen through the window, might be by Rembrandt, and conceivably some scattered touches elsewhere, such as the flax held by Anna, and Tobit's fur collar. He considered

that the composition was probably by Rembrandt, comparing it with the *Two Scholars disputing* of 1628 in Melbourne (Bredius 423). He related the figure of Tobit to a drawing by Rembrandt of an old man seated, with clasped hands, in Berlin (Benesch 41; Fig. 55a), which can be dated c. 1630–31. For these reasons MacLaren thought that the painting was made in Rembrandt's studio, and after his design, by Dou and retouched by Rembrandt. Bauch concurred with this view, as did Rosenberg and Slive.[10]

Such a collaboration between master and pupil would be possible and indeed there is a mention in the 1657 inventory of the art dealer Johannes de Renialme of a painting said to be by Rembrandt and Dou.[11] However, in my view, there is no stylistic divergence within this painting, which is entirely by Dou. It is true that the composition and the individual figures are strongly indebted to Rembrandt: there are striking similarities to, for example, the *Old Man asleep at the hearth* of 1629 (Turin, Galleria Sabauda; Bredius 428; Fig. 55b) and the *Prophet Jeremiah lamenting the Destruction of Jerusalem* of 1630 (Cat. No. 8). There is, however, no need to think that Rembrandt had a direct hand in the design. There are other early paintings by Dou which show figures in similar interiors and two of them are included in this exhibition (Cat. Nos 56 and 57). No. 56 uses a model which also appears in early paintings by Rembrandt. This group of early interior scenes by Dou, which must have been painted before his earliest dated works such as the *Flute-player* of 1636 (Proby collection, Elton Hall)[12] and the *Violinist* of 1637 (Edinburgh, National Gallery of Scotland),[13] was painted either while Dou was in Rembrandt's studio or shortly after he had left it. *Anna and the blind Tobit* should probably be dated about 1632–35, although the *Corpus* prefers a date of 'shortly after 1630'.

The subject of Tobit and Anna was painted several times by both Rembrandt and Dou. Two of Dou's versions, one in the Louvre[14] (Fig. 55c) and a lost picture known from an engraving by Reveil,[15] are related to the present painting. On the evidence of Plemp's verses, the subject was considered to be an exemplum of piety in adversity.

The x-ray reveals one major *pentimento*: at first there was a spinning-wheel standing between Anna and Tobit.

C.B.

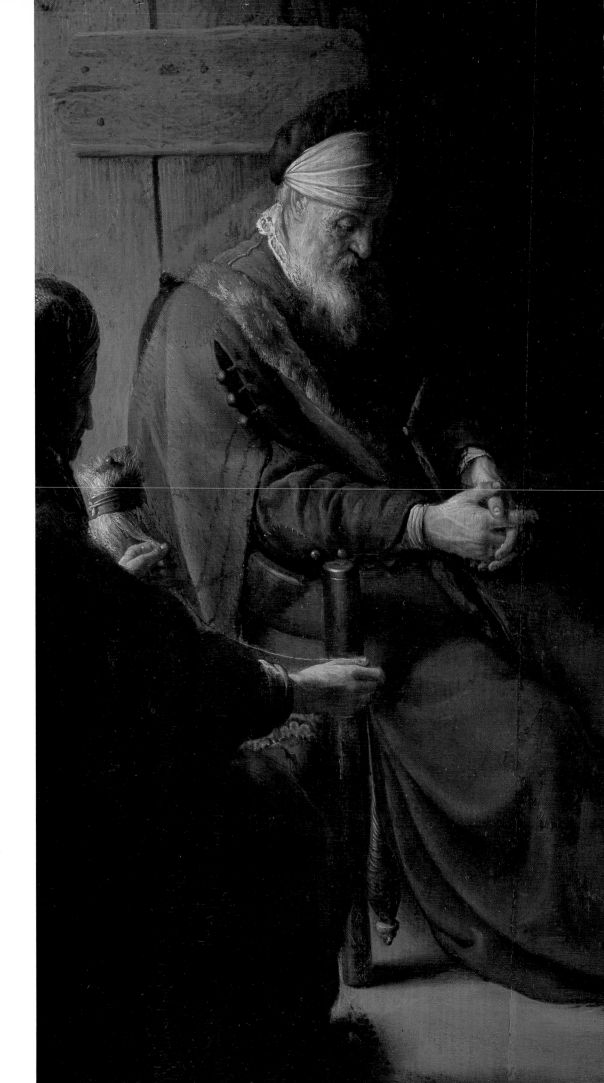

1. The painting, Van der Leeuw's engraving and the question of attribution are discussed by the present author at greater length than is possible here in MacLaren/Brown 1991, No. 4189.

2. For the early literature on Van der Leeuw, see MacLaren/Brown 1991, p. 111, note 5.

3. Hollstein 2

4. Hollstein 14

5. Hollstein 15

6. Hollstein 16

7. The print is Hollstein 6. The painting is No. 66 in Schneider 1973.

8. Hollstein Nos. 2 and 6.

9. MacLaren 1960, No. 4189.

10. Rosenberg, Slive and Ter Kuile 1966, p. 83.

11. Bredius 1915, p. 235, No. 302.

12. HdG, Dou, No. 83.

13. HdG, Dou, No. 82.

14. HdG, Dou, No. 95. Sumowski, Dou, No. 272 (as *The Bible Reading*). The subject is certainly Tobit and Anna.

15. HdG, Dou, No. 48.

56

GERRIT DOU

A Man writing in an Artist's Studio

Panel, 31.5 × 25 cm.
Signed, on the book on the table behind the seated man : *GD . . .* (GD in monogram)
Private Collection, Montreal.

Provenance: Said to have been in the collection of King William III; Collection of Bicker van Zwieten; his sale, The Hague, 12 April 1741, No. 65 (400 guilders, to Van Heteren); Adriaen Leonard van Heteren, The Hague, 1752; Purchased by the Koninklijk Museum, Amsterdam, 1809; Rijks Museum sale, Amsterdam, 4 August 1828 (510 guilders to Brondgeest); with the art dealer Emmerson, London, 1829; Charles Brind sale, London, 10 May 1849 (£96. 12 shillings to Lord Northbrook); Collection of Lord Northbrook, London (1889, Cat. No. 53); Agnew, London, 1976.

Exhibitions: London, British Institution, 1848; London, Burlington Fine Arts Club, 1900, No. 27; Philadelphia/Berlin/London, 1984, No. 31 (Catalogue entry by O. Naumann).

Literature: Sumowski, Dou 267.

This signed painting by Dou uses a composition which is very similar to that in No. 57. The scene is lit by the same casement window on the left and a similar winding stair can be seen. The details of the still life have, however, been altered. An easel in the centre of the room indicates that this is an artist's studio. In front of it, the artist wearing a beret and a full-length robe writes or draws in a large book. In the right foreground is a martial still-life, a helmet, shield and drum, and in the background are a violin, a globe, a book and candle. Dou rearranges the same studio props in other paintings from this time: the drum and shield reappear, for example, in a painting in Budapest (Sumowski, Dou 268; Fig. 56a). The shield and helmet reappear in an artist's studio in a painting which was on the London art market in 1980 (Sumowski, Dou 262; Fig. 56b): the books and globe can be seen on a shelf above the easel. In this case, the painting on the easel, which shows an Old Testament subject, can be seen. The reappearance of the martial studio props and the globe and books (and the violin and candle) suggest that a particular symbolic meaning is intended. The active world of the soldier is presumably being contrasted with the contemplative life of the painter.

As in the case of No. 57, this painting has been chosen for inclusion in this exhibition in order to confirm the attribution of *Anna and the blind Tobit* to Dou. Both signed paintings well demonstrate Dou's painstaking technique in the early 1630s. They show similar compositions—seated figures seen in a fall of light from a window on the left—and both contain still life elements which can be compared to the still life in the bottom right hand corner of the London painting. These similarities in the details of the handling support the attribution of *Anna and the blind Tobit* to the young Gerrit Dou in the years following his departure from Rembrandt's studio in about 1631.

C.B.

56a: Gerrit Dou, *Standing Soldier with Weapons*. Panel. Budapest, Szépmüvészeti Museum.

56b: Gerrit Dou, *Painter in his studio*. Panel. London, with Robert Noortman Ltd.

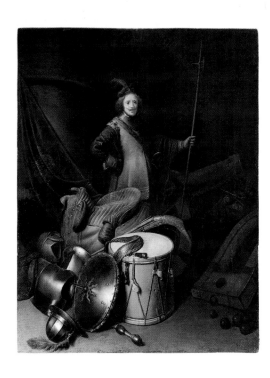

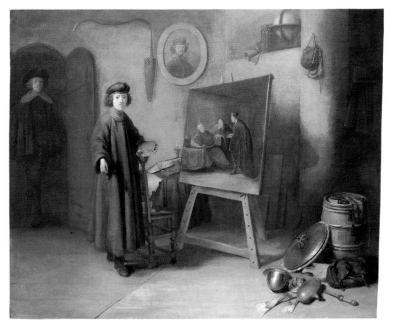

57

GERRIT DOU

An Interior, with a Woman eating Porridge

Panel, 51.5 × 41 cm
Signed, lower right, *GDou* (GD in monogram)
Private Collection.

Provenance: Crawford of Rotterdam sale, Christie's, London, 26 April 1806, No. 10, to Payne Knight (as Dominicus van Tol); Collection of Thomas Andrew Payne Knight, Downton Castle, Ludlow, Shropshire; By descent to Denis Lennox: his sale, Christie's, London, 4 May 1979, No. 107.

Exhibitions: Birmingham 1934, No. 135; London, Leger Galleries 1948, No. 2; Shrewsbury 1951, No. 10; London, David Carritt Ltd. 1980, No. 4; Amsterdam and Groningen 1983, No. 15; Philadelphia/Berlin/London 1984, No.32 (Catalogue entry by O. Naumann).

Literature: Sumowski, Dou, under 264

This signed painting is an outstanding example of Dou's early, independent style. It should be dated shortly after the *Anna and the blind Tobit* (Cat. no. 55), that is, c. 1632–37. The handling is very similar to that painting and confirms its attribution to Dou. In particular, the precise painting of the still life in the bottom right-hand corner of both paintings, the hard and linear treatment of the draperies and the similar disposition of the light falling from the windows on the left are strikingly close. The model appears to be the same as in Rembrandt's *Prophetess Hannah* in the Rijksmuseum, Amsterdam (Bredius 69; Fig. 57a): she appears again in Dou's *Old Woman dressed in a fur Coat and Hat* in Berlin (Sumowski, Dou, 253; Fig. 57b). This model has traditionally identified as Rembrandt's mother.

What is new in Dou's painting, as he seeks to establish his own independent style, is the use of bright colour, particularly the brilliant blues and purple of the woman's skirt and cloak and the table-cloth. The interest in still life, a genre in which Dou was to work, also sets the painting apart from the art of Rembrandt. Dou liked to describe individual objects in detail, treating them so precisely that they are almost isolated within the composition. Rembrandt preferred to create a more unified composition in which detail is subsumed to the whole. He lacks Dou's almost obsessive desire to describe in painstaking detail every object within the picture space.

There is what appears to be an autograph replica of this painting in the Museum at Schwerin (Sumowski, Dou, 264; Fig. 57c).

The composition includes some new details: a bowl and spoon at the woman's feet and a cat eating from a dish and an earthenware jar on the left. The monogram, on the barrel at the right, is too crude to be by Dou and must be a later addition, but there seems no reason to doubt the attribution of the painting to Dou. Such repetitions are not uncommon in Dou's work.

C.B.

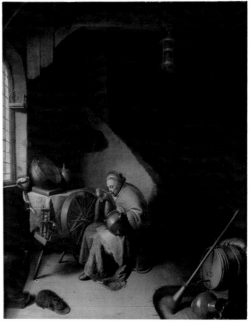

57a: Rembrandt, *The Prophetess Hannah*, 1631. Panel. Amsterdam, Rijksmuseum.

57b: Gerrit Dou, *Old Woman dressed in a fur coat and hat*. Panel. Berlin, Gemäldegalerie SMPK.

57c: Gerrit Dou, *An Interior, with an Old Woman eating Porridge*. Panel. Schwerin, Staatliches Museum.

Isack Jouderville (c. 1612–before 1648)

A document of 1632 states that Jouderville is twenty, so he was born in about 1612, in Leiden. Jouderville's father was from Metz and had settled in the town as an innkeeper. Both his parents died late in 1629 and the six documents which concern his apprenticeship with Rembrandt in Leiden were drawn up on behalf of his guardians. They record payments to Rembrandt of an annual fee of 100 guilders in 1630 and 1631. It is possible, however, that Jouderville began his apprenticeship with Rembrandt before his mother's death in December 1629, as he was already 17 at that time which would have been late to begin an apprenticeship. Jouderville, while retaining his residence in Leiden, made two journeys to Amsterdam (for which his guardians paid) after he had completed his apprenticeship in November 1631. It has been suggested that he followed Rembrandt to Amsterdam and worked in his studio there. Jouderville enrolled at Leiden University in April 1632 and married in Leiden in February 1636. In 1641 he moved to Deventer and in 1643 was in Amsterdam, where he died between 1645 and 1648 (when his widow remarried).

Jouderville's œuvre has been studied and expanded in the last few years, notably by Ernst van de Wetering. The only securely signed work (although the signature is no longer clearly visible) is the Bust of a Young Man *in the National Gallery of Ireland (Cat. No. 59). On the basis of stylistic similarities to this painting, other attributions have been made to the artist, which are discussed below. Whether he assisted Rembrandt in the painting of portraits in his Amsterdam studio in the early 1630s is more hypothetical.*

C.B.

58

Attributed to

ISACK JOUDERVILLE

Bust of a young Man in a Turban

1631
Panel, 65.2 × 50.9 cm, signed, lower right, *RHL* (in monogram) *1631*
Windsor Castle, Collection of Her Majesty Queen Elizabeth II; Inv. No. 63
Only exhibited in Amsterdam and London

Provenance: perhaps identical (despite the different measurements) with a painting acquired by King George III from Consul Smith in 1762 : '26 Rembrandt. His own Portrait in a Turban on board 2–1 × 2–1' [64.5 × 64.5 cm.]; In the collection of King George III by 1775 according to the label on the back: 'A Man's Head in Black / with a Turbant on his head / By Rimbrant / Sent by his Majesty 1775'; In the King's Gallery at Kensington Palace in 1818; moved to Windsor in 1835.

Literature: Bauch 136; Bredius/Gerson 142; Gerson 106; White 1982 159; *Corpus* II C54.

Exhibition: Manchester 1857, No. 686.

This painting, which bears Rembrandt's Leiden monogram (Rembrandt Harmenszoon Leidenensis) and the date 1631, had always been considered to be by Rembrandt[1] until its reattribution to Isack Jouderville in Volume 2 of the *Corpus*, published in 1986. If it is by Rembrandt, it should exhibit the same delicacy of brushwork and nuances of colour as the *Self-Portrait* of 1629 in The Hague (Cat. No. 4). In fact it shows an absence of the forceful modelling of that painting: there is a flatness and evenness of the treatment of the features of the face, combined with a meticulousness in the description of the highlights on the turban, scarf and chain. The background, with the fall of light on the wall behind the figure, is closely modelled on that in the 1629 *Self-Portrait*. All these features suggest a close follower of Rembrandt who was entirely familiar with his technique in the years around 1630.

Jouderville was a pupil at this time and in his small œuvre, there are a number of features which suggest that he is the artist of this painting. Van de Wetering characterises Jouderville's style in this way: 'An important individual mark of his work might perhaps best be described as the development of a peculiar

58a: Isack Jouderville, *Bust of a laughing Man*. Panel. The Hague, Bredius Museum.

58b: Isack Jouderville, *Woman in Oriental Costume*. Panel. Private Collection.

58c: Isack Jouderville, *Minerva in her Study*. Panel. Denver, Colorado, Art Museum.

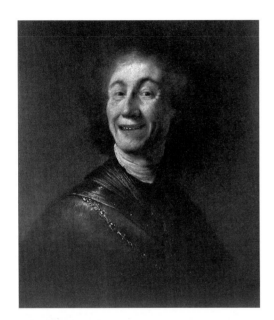

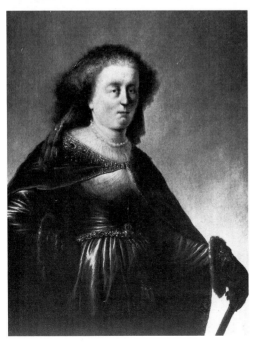

stylisation in the rendering of light and shade in the heads, with the borderline between the two taking on a somewhat independent course that simplifies the plastic rendering in a quite individual way. A second characteristic is his inability to drape the clothing convincingly round the figures depicted; the way edges and folds run close to the outlines of the figure mar the suggestion of plasticity, and the contour of the body, too, does little to help this. The clothing at these places seems, at one and the same time, to be both flat and clinging to the body. A third feature is Jouderville's liking for a plethora of highlights that are scattered over certain parts of the costume in such a way as to create an effect which differs character-istically from the way Rembrandt dealt with his highlights in comparable passages. In Rembrandt these highlights invariably have a clear hierarchy in importance and function, and they are employed shrewdly and economically to serve an effective handling of light. In Jouderville the random distribution of highlights undermines the opportunity for creating a concentrated play of light and fails to convey satisfactorily the material being rendered. A further characteristic feature is the tendency towards a cramped brush-movement and to the use of impasto that does not flow organically from its function as part of the treatment of light. In Jouderville, impasto is frequently applied as what looks like artificial islands, so that the transitions from impasto passages to thinner painted areas are more abrupt than they are in Rembrandt. And finally, one notices a certain penchant for a ruddy, copperish light brown in parts of the

clothing that in Rembrandt is to be found only in his *Artist [Self-Portrait] in Oriental Costume* in the Petit Palais, Paris.'[2]

Although Jouderville's early life is well documented, few paintings are known from these years. There is only one securely documented work, the *Bust of a Young Man*, which may well be a self-portrait, in Dublin (Cat. No. 59). On the basis of compositional and stylistic similarities to that painting, the *Bust of a laughing young Man* in the Bredius Museum, The Hague (Sumowski 941; Fig. 58a), has also been attributed to him. The strikingly individual facial type, with the eyes close together, a long nose and small mouth, can also be found in a *Woman in oriental Costume* (Sumowski 944; Fig. 58b) and the *Minerva in her Study* in Denver (Sumowski 947; Fig. 58c). Around this core, Van de Wetering and Sumowski have constructed a coherent oeuvre of paintings, all of which reflect Jouderville's familiarity with Rembrandt's work. Jouder-ville's *Man in oriental Costume* (Sumowski 948) is, for example, a variation on Rembrandt's *Self-Portrait in oriental Costume* of 1631 (Bredius 16) in the Petit Palais, Paris. It is with this group of paintings that the authors of the *Corpus* believe the Windsor *Bust of a young Man in a Turban* belongs. Its juxtaposition with Jouder-ville's only documented work will enable this attribution to be put to the test.

C.B.

1. Most recently, the attribution has been defended by Christopher White, who was aware of the Rembrandt Research Project's reservations (White 1982, No. 159): 'There is a pallor in the flesh tones in No. 159 and a lack of strong modelling, which make it a not entirely satisfactory picture, although there seems no compelling reason to classify it as the work of a pupil rather than of the master himself. The monogram and date appear entirely genuine, although it could be argued that these were added by Rembrandt to give a studio replica authenticity.' White gives further details of the provenance and lists copies of the picture.
2. *Corpus*, II, pp. 84–85.

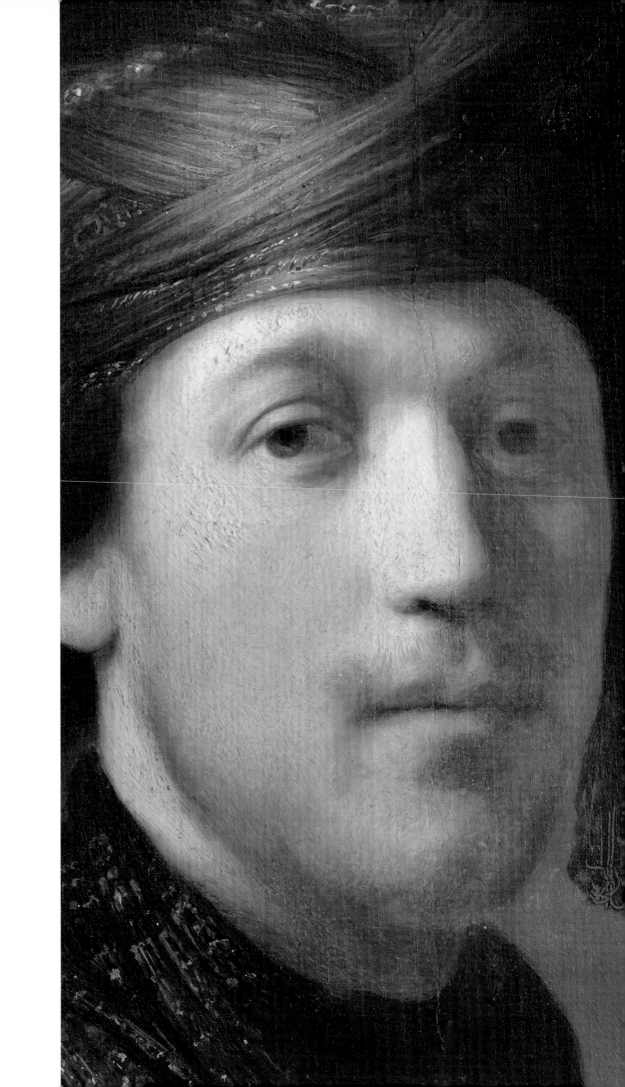

59

ISACK JOUDERVILLE

Bust of a young Man

Panel, 48 × 37 cm. (Oval)
Signed, centre right, Jouderville (not clearly
visible) and falsely, lower left, just above the
shoulder, *GDOU* (GD in monogram)
Dublin, National Gallery of Ireland;
Inv. No. 433

Provenance: Lawrie and Company, London, from
whom purchased in 1895 for £150.

Literature: Sumowski, Jouderville 940; Potterton
1986, 433.

59a: Detail of the signature of Jouderville.

The painting was first discussed by Hofstede
de Groot in 1899.[1] He said that when the
picture was being cleaned in 1895, prior to its
acquisition by the National Gallery of Ireland,
the false signature of Gerrit Dou was removed
and underneath, the signature of Jouderville
appeared. The then owner of the picture
immediately instructed that the original
signature be painted over again and replaced by
a new, false signature of Dou. Since that date
the painting has been the lynch-pin of all
attempts to assemble an oeuvre for this well-
documented pupil of Rembrandt. The painting
was cleaned at the National Gallery of Ireland
in 1986 and the signature of Jouderville
revealed on the right-hand side of the painting
(Fig. 59a) and not, as Hofstede de Groot
implied, underneath the false signature of Dou
on the left.[2] Sumowski has published two more
signed paintings by Jouderville but both show
small-scale figures in an interior and are
entirely unlike the Dublin painting.[3]

The portrait has the intensity of expression
and oblique glance which often characterise
self-portraits. The features of the face are
modelled in deep but soft shadow, the fall of
light creating highlights on the forehead,
cheeks and the bridge of the nose. The hair
bushes out from the head in a fuzzy mass and
lacks the detailing of individual strands which
is found in Rembrandt's early portraits. The
highlights on the scarf and chain are hard and
precise; they fail to create the effect of
glistening materials, seeming to be instead
simply dots of colour. The background, with
light falling behind the figure, is derived from
Rembrandt and, in particular, from the *Self-
Portrait* of 1629 in The Hague (Cat. No. 4).
It is very thinly painted, with the ground
showing through the overlying paint, a
technique which is in direct imitation of

Rembrandt. The stylistic characteristics of
Jouderville's work and the place of this
painting at the centre of a group of paintings
attributed to him are discussed in the previous
catalogue entry.

C.B.

1. Hofstede de Groot 1899, pp. 228 ff. and p. 234
2. Potterton 1986, No. 433.
3. Sumowski, Jouderville 951 (*An Artist playing a violin
in his studio*), and 953 (*Interior with a lace-maker next to a
cradle and a woman by the hearth*).

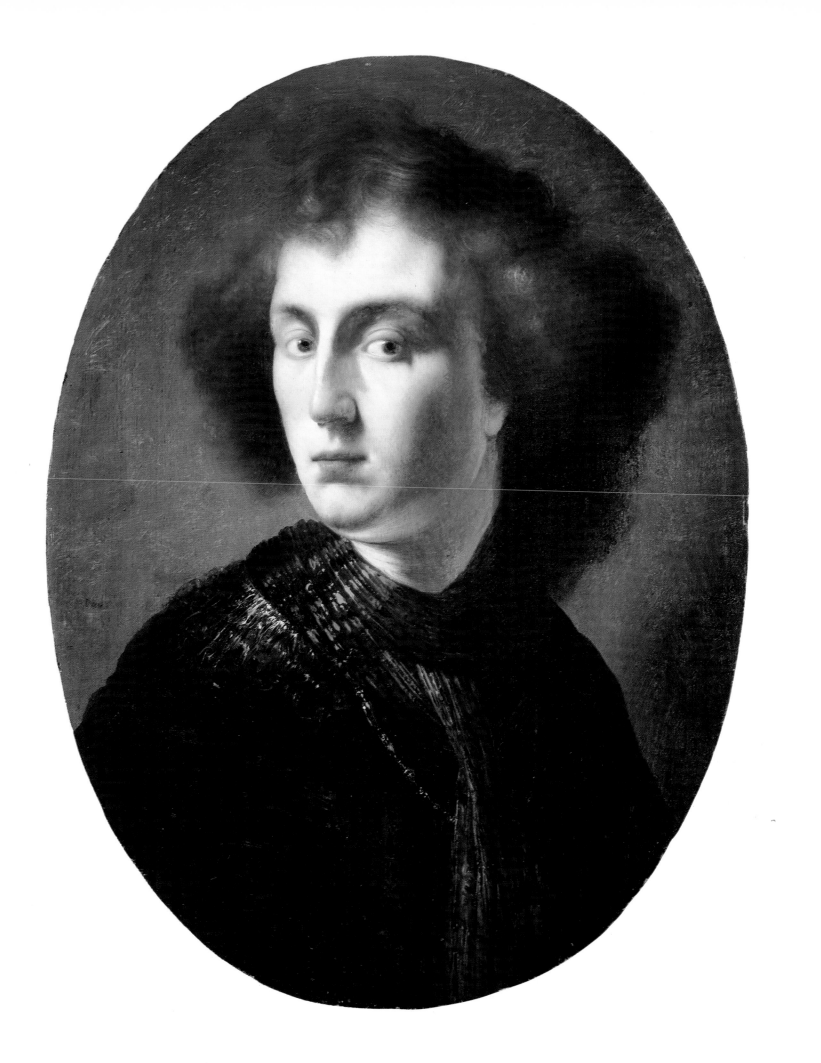

Govert Flinck
(1615–1660)

Govert Flinck was born on 25 January 1615 in Cleves. He received his artistic training in Leeuwarden under Lambert Jakobsz., who also taught Jacob Backer's, seven years Flinck's senior. After completing his apprenticeship, which lasted the usual three years, Flinck went to Amsterdam in order, as Houbraken remarked, to give 'proeven van zyn Konst' (put his skills to the test). However, as Houbraken goes on to say, Rembrandt alone enjoyed the public's favour at this time and, in order to please, all other artists had to trim their talents to match his. Flinck lost no time in doing so. In about 1633 he entered Rembrandt's studio, where he worked for a year, not as a pupil, which he no longer was, but rather as a knecht or jonggezel (assistant or collaborator). Like Rembrandt, Flinck lodged in the house of the art dealer Hendrik van Uylenburgh. The earliest known signed and dated paintings by Flinck are from 1636. Only at about this time would Flinck have established himself as an independent artist, at least in a financial sense. From an artistic point of view, however, he carried on as he had started—producing works of a rembrandtesque character. Houbraken, who was a friend of Flinck's son, informs us that Flinck's paintings were taken as authentic works by Rembrandt and even sold as such. Even Flinck's repertoire of subjects coincided with that of Rembrandt. Flinck produced large- and small-figured history paintings, tronies (individual figures with symbolic significance), portraits and landscapes, the earliest dated 1637. Among the principal works of these years was the Isaac blessing Jacob of 1638 (Amsterdam, Rijksmuseum), a large-scale history painting in which the arrangement of the figures is derived from Rembrandt's work, while the glowing velvety lustre of the colouring is akin to that in the paintings of Flinck's former fellow-pupil, Jacob Backer. It was, above all, Flinck's portraits that met with approval, and moved Joachim von Sandrart (1675) to remark that while they followed Rembrandt's 'manier', they were 'judged to be more felicitous in the exactness and in the pleasing quality of the portrayal'. Flinck's ability to flatter his sitters' cravings for 'recognition' brought its reward. In 1642, the year of Rembrandt's Nightwatch, Flinck finished his first group portrait. It is clear that Flinck had learnt from Rembrandt's outstanding achievement of coaxing the Dutch group portrait out of its previous status as a mere sum total of individual figures. Flinck's Four Regents of the Amsterdam Kloveniersdoelen (Amsterdam, Rijksmuseum) are captured and shown as a body. Flinck, however, did not adhere to this ambitious conception in his subsequent work. In his group portraits of 1645 and 1648 he may be found, once again, merely adding figure to figure. We see no integration, no sense of a interrelated group, but rather a collection of individual portraits: a crowded arrangement of self-satisfied males pose in elaborate costumes, which are compelling in their varied textures and smoothly applied colour. Flinck appears to have sought the company of Bartholemeus van der Helst, virtuoso in showing textural structures and a lightened range of colours. Flinck increasingly distanced himself from Rembrandt, as he increasingly succumbed to the changes brought by the opening up of Dutch painting in the 1640s to a Flemish type of courtly baroque and to the dominant classicist spirit of the time. However, the change was not easy. According to Houbraken, the influence of Italian painting ensured that 'het helder schilderen weer op de baan kam' (a brighter palette again came into favour), it was only 'met veele moeite en arbeid' (with great effort and struggle) that Flinck had 'weer afgewent' (got out of the habit) of painting in Rembrandt's style. As Flinck acquired an international style of expression, commissions of a corresponding kind came his way—from Berlin, among other locations. Flinck's Allegory on the Birth of Prince Wilhelm of Brandenburg (Potsdam, Neues Palais), was produced towards the end of the 1640s on the orders of the Great Elector, who is said to have been pleased with the painting. In 1656 Flinck completed his Allegory in memory of Frederik Hendrik Prince of Orange (Amsterdam, Rijksmuseum). Amalia von Solms, the Prince's widow, had commissioned this large-scale picture for the Huis ten Bosch in The Hague. The large, top-lit studio that Flick had had built in 1649 had become a popular meeting place for Amsterdam notables. It is said that Flinck enjoyed friendly relations with the mayors Cornelis and Andries de Graeff. Joost van den Vondel, Holland's most celebrated poet, provided panegyrics and epigrams to accompany Flinck's works. In this context, it is not surprising that Flinck also contributed to the decoration of the new Amsterdam town hall, delivering two large-scale history paintings, in 1656 and 1658 respectively. When, in November 1659, the decoration of the town hall's Great Gallery was under discussion, Flinck was able to secure the contract for the whole project. However, he died on 2 February 1660. One may perceive a form of reconciliation in the fact that Flinck's sudden death should have a positive effect on a painter whose virtue it was that he did not adapt his work to changing fashion. The individual commission for The Conspiracy of Claudius Civilis (Stockholm, Nationalmuseum) was given to Rembrandt. His painting did not, however, hang for long in the Great Gallery. It appears to have been found lacking in terms of the current measure of 'decorum'—of what, at the time, was regarded as 'proper' and 'fitting'. The city fathers had the enormous lunette picture returned to Rembrandt, requesting that he revise it.

J.K.

60

Attributed to
GOVERT FLINCK
Bust of Rembrandt(?)

c.1633
Oak Panel; 56 × 47 cm.
Berlin, Gemäldegalerie Staatliche Museen Preussischer Kulturbesitz; Cat. No. 808

Provenance: presumed to be in the collection of the Comte de Wassenaar d'Obdam; sale, The Hague, 19 August 1750, No. 2: 'Rembrandt: Portrait van hem zelve, met een gouden Ketting om' (Rembrandt: portrait of himself, with a gold chain); 'h. 21½d., b. 18½' (measured in Rhenish feet; equivalent to 56.1 × 47.6 cm) acquired, for 202 guilders, by Brouwer for Avet; an anonymous collection or sale referred to in the label on the back of the picture with the inscription, in an eighteenth-century hand: 'Nr. 19. Rembrandt van Rijn, le portrait de l'auteur'; Bildergalerie, Potsdam; transferred from the Königliche Schlössern to the Königliche Gemäldegalerie, Berlin, 1830.

Literature: Bredius/Gerson 23; Bauch 304; Gerson 133; Corpus C56; Tümpel A65; E. van de Wetering, 'Isaak Jouderville and Govaert Flinck among Rembrandt's workshop assistants', in: Bruyn et al., 1982, Vol. II (1986), pp. 88–89.

Exhibition: Berlin 1930, No. 368.

The picture shows the life-size head and shoulders of a young man who has Rembrandt's features and who is dressed in a soft cap with a feather, an iron collar and a gold, richly interlinked chain, which—like a garland—adorns his shoulders and chest. His body is turned three-quarters to the right, while his head turns sideways to stare at the viewer out of rather small eyes. Gently flowing curls, which on the left were in places scratched with the end of the brush while the paint was still wet, frame the face which is shown in light and shadow from left to right respectively.

In the past, art historians doubted neither the authenticity of the (unsigned) painting, nor its traditional identification as Rembrandt's Self-portrait from the years around 1633/34.[1] Nonetheless, reservations regarding the work's quality were expressed. In comparison with

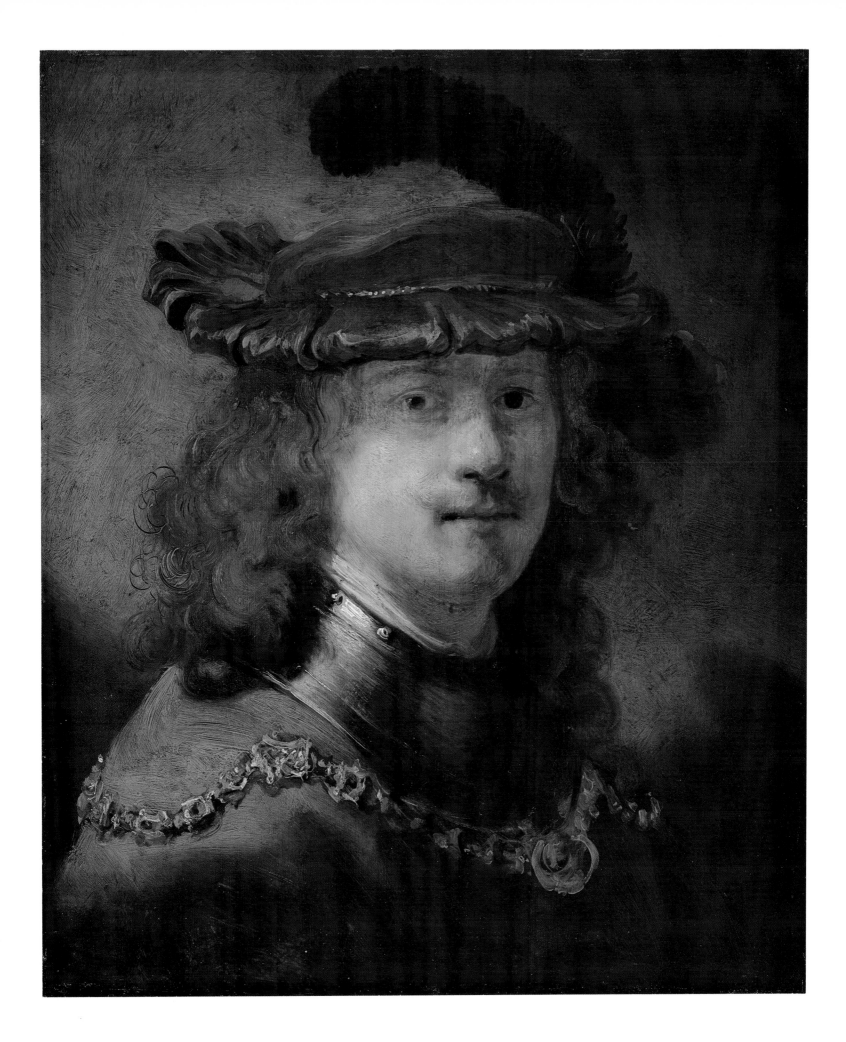

Rembrandt's dated *self-portrait* of 1634 in Berlin (Fig. 62a), Bode regarded the present work as 'less appealing'. In particular, he objected that the shadowed flesh-tones were 'dull', and that 'an unpleasant grey-greenish tone dominates the subdued colouring'.[2] Pinder did not discuss the compositional features of the painting, but considered its expression too 'shallow in terms of spirit'.[3] Further critical assessments cannot be cited here. The vigorous, broad brush-strokes provoked wide admiration, inspiring Gerson to the following comment: 'Although not signed, a vigrously painted work of high quality'; and—following the suggestion of G. Schwartz—he argued that it is the pendant of the *Portrait of Saskia* dated 1633 and now in Dresden (Fig. 60c).[4] In 1633 Rembrandt was betrothed to Saskia; it thus seemed plausible to look for possible 'betrothal portraits'. The format, pose and costume, but in particular the complex genesis of the Berlin painting, all encouraged this search. The x-ray photograph published by W. Sumowski show that the young man, who looks like Rembrandt, was originally shown without his soft cap (Fig. 60b).[5] It could thus be argued that the head-dress was only added during a reworking of the picture so as to match the Berlin painting with that in Dresden, showing Saskia wearing a feather-decorated velvet beret. The fact was not overlooked that this added element of costume is, in itself, insufficient to support the claim of two individual works being real pendants. Schwartz himself pointed this out and thus untied the knot he had previously made.[6] Since then, an even greater degree of estrangement has set in: the picture in Berlin has now lost its connectionm not only with the *Saskia*, but also with the real Rembrandt.

Rembrandt was fascinated by his own physiognomy like no other painter; and from his youth until his old age produced a multitude of 'autobiographical' records. These works are not only concerned with his own appearance, but also with his relationship to his inner self, and to his environment. The self-portraits of the years around 1633/34 were painted in this spirit. They offer variations on the theme of Rembrandt himself. In the Berlin painting, however, no new or altered perspectives are expressed; rather it follows an already existing 'autobiographical analysis'. This is supported by E. van der Wetering's assessment of the x-rays, which show that the sitter without a soft cap in the first version of the picture in Berlin is comparable in several respects to Rembrandt's *Self-portrait* dated 1633 and now in Paris (Fig. 60a). The x-rays reveal a comparable treatment of the light, the turn of the head, the gaze, as well as in the slightly

raised brow on the left and the partially uncovered ear. They also show that the hair on both sides of the head was originally shorter, the clothing was more richly folded at the shoulder, and that he probably was not wearing an iron-collar.

The Berlin picture seems to be derived from an authentic self-portrait; an approach which would have been untypical of Rembrandt, but for a pupil wishing to familarise himself with his master's style it would have been a meaningful and practical method of learning. Gerson has pointed out that Rembrandt's self-portraits would have been easily accessible in the studio, and accordingly provided a convenient starting point for experimentation.[7] In the Berlin picture, the elements of costume added at a later stage may be considered experimental, especially the soft cap, which sits quite differently from the hat in the *Portrait of Saskia* in Dresden. There, the maleable beret—like a mark of the authentic Rembrandt—is placed at a jaunty angle. The inviting smile of the sitter is reflected in the sprightly feather, not to be compared with the drooping specimen squashed by the edge of the Berlin picture. There, the soft cap appears flat and broad, in spite of the vigorous application of paint with impastoed highlights. Moreover, it also does not seem to follow the axis of the head, but is instead somewhat to the left, and thus impedes the turn of the sitter's head. The outline of the curls, which, as the x-ray photograph reveals, have grown fuller and longer on both sides, also contributes to this impression, as do the transparent shadows that, in the final version of the picture, lie across the forehead and the area of the eyes. As a whole, this area is dynamic, but without any notable nuances. The distribution of light in the face is even, applied in swift broad strokes. In these years, Rembrandt did indeed employ a broad stroke, but he did not do so with absolute consistency. His *Self-portrait* of 1634 (Fig. 62a), is more finely structured in its details. The light is applied to the face with a relatively pointed brush, and in short, narrow strokes. The x-ray photograph confirms this observation (Fig. 62b). Rembrandt does not simply paint objects but rather deliberately constructs them so as to achieve the greatest possible degree of plasticity. He moulds and accentuates. But it is precisely this feature which is missing from the Berlin painting, although in all other aspects it is convincing enough to convey the impression of a straightforward Rembrandt. His virtuosity, his expressive overtone is present, but not the subtler notes that lie in between. For this reason, the image as a whole remains

undifferentiated, lacking a focal point; and besides having additional faults, E. van de Wetering has pointed out the compositionally cramped placing of the figure. Moreover, the colouring too must give rise to doubt, for a palette consisting of predominantly olive-green tones is not to be found in Rembrandt's works from these years.[8]

The traditional attribution of the picture to Rembrandt has correctly been abandoned. Nonetheless, the work remains closely connected with Rembrandt. A work which derives, in its original version, from a self-portrait by Rembrandt—in all probability from the painting dated 1633 and now in Paris—can really only have been painted in Rembrandt's workshop by one of his pupils. In about 1633 Govert Flinck—at this point no longer a mere beginner—was employed there. He had earlier trained under Lambert Jacobsz. in Leeuwarden. According to Houbraken, Flinck was only in Rembrandt's workshop for a year. Subsequently—probably before the end of 1634—he entered the services of the dealer Hendrick van Uylenburgh. The earliest signed works by Flinck are dated 1636. The chronological difference between the Amsterdam *Rembrandt (?) as a Shepherd* (Cat. No. 61) and the *Young Man with a Feathered Velvet Cap and an Iron Collar* in Lausanne (Cat. No. 62) on the one hand, and the earlier picture in Berlin, on the other, is not inconsiderable. Nevertheless, stylistic characteristics linking these works are apparent; and can be used to support E. van de Wetering's proposed new attribution of the Berlin picture to Govert Flinck.

Even in his later pictures, the manner of

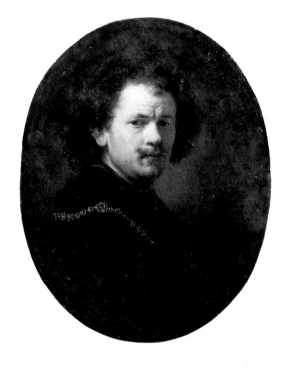

painting is consistently expansive and free. In both later and earlier works, the light is applied in broad strokes, particularly in the faces. Flinck not only adhered to, but also strengthened, the principle of more or less retaining the silhouette of a figure emerging from a relatively pale background. A striking characteristic of such silhouettes is the outline of the shoulders, which slopes swiftly from the neck. These figures appear to play no real part in the settings into which they are diagonally inserted. They remain predominantly dependent on the movement of the picture plane, in spite of their relatively large scale. The arrangement of light and shadow contributes to this impression. Flinck certainly adopted Rembrandt's use of chiaroscuro, but he employed it more to emphasise particular objects. Light attaches itself to these and, in so doing, forfeits something of the mediating role of a ubiquitous force. There is no continuity and no spatial connection between a lit shoulder or iron collar and the shadows they cast—half sharp and half blurred—on the wall behind. Light and shadow, and increasingly also colour, seem rather to be distributed according to a point of view that is aiming at a richly varying, decorative planar pattern.

A similar procedure is also to be found in the case of individual details. Among other things, the reflections on both of the iron collars are shown in a similar manner. The light, applied in broad brush-strokes, follows the form of the objects it illuminates, This is also the case with their outlines, as each is heightened with white on the left. The hat feathers are structured in a similar manner, in broad, diagonal strokes—in one case rather

rough, in the other somewhat neater. The *Shepherd* in Amsterdam betrays a routine hand, with the area around the chin and mouth recalling the same features in the Berlin picture.

This latter is not the only painting to have been eliminated from the group of works hitherto regarded as by Rembrandt and to have acquired a new, if for the moment hypothetical, authenticity under the name of Flinck. The *Portrait of a Man*, in Dresden (*Corpus* C77), is closely related to the Berlin painting, and, like it, anticipates the earliest, signed paintings by Flinck from 1636. From the group of works ruled out as paintings by Rembrandt and dating from the period around 1633/34, Van de Wetering has extracted three further pictures—including portraits—and tentatively voiced the possibility of an attribution to Flinck (*Corpus* C72, C73, C82). Flinck has certainly profited from efforts to identify the 'real' Rembrandt, with his early work assuming clearer contours. What has long been assumed would seem to be confirmed. Flinck, who consciously followed Rembrandt's example, must have worked intermittently as Rembrandt's 'stylistic double', and contributed to the high output of rembrandtesque portraits and *tronies* from the first half of the 1630s—to the benefit of Rembrandt and the art dealer Hendrick van Uylenburgh, for whom Flinck worked from 1634.[9] Houbraken's report, that in Amsterdam Flinck's paintings passed for authentic works by Rembrandt and were sold as such, tallies with this situation.[10]

J.K.

1. An exception to the rule was provided, in this case as in others, by the idiosyncratic scholar Van Dyke, 1923, p. 120: 'The work agrees with the authentic pictures of Jan Lievens'.
2. Bode 1897–1905, Vol. III (1899), p. 84, No. 168.
3. Pinder 1943, p. 51.
4. Gerson 133; Schwarz, cited by Gerson.
5. Sumowski 1957/58, p. 225.
6. Schwartz 1984, p. 188.
7. Gerson, p. 66.
8. The painting is in serious need of restoration. Its original condition is marred by a varnish which has darkened and yellowed with the passage of time.
9. Van de Wetering 1986, pp. 58–59.
10. Houbraken, 1718/21, Vol. II, p. 21.

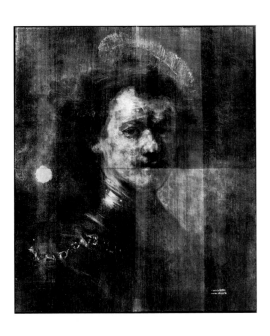

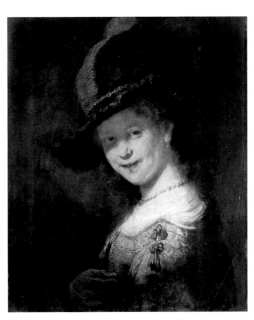

60a: Rembrandt, *Self-Portrait*. 1633. Paris, Musée du Louvre.

60b: X-ray of Cat. No. 60.

60c: Rembrandt, *Portrait of Saskia van Uylenburgh*. Dresden, Gemäldegalerie Alte Meister, Staatliche Kunstsammlungen.

GOVERT FLINCK

Rembrandt (?) as a Shepherd

1636
Canvas, 74.5 × 64 cm, signed *G. Flinck f.*
Amsterdam, Rijksmuseum; A3451.

Provenance: Herzogliche Bildergalerie, Schloss Salzdahlum, Cat, 1776, No. 40 (as a pendant to No. 41: 'A Shepherdess', now in the Herzog Anton Ulrich-Museum, Braunschweig, Cat. 1983, No. 252); 1880, collection of R. Bergau, Nuremberg;[1] 7 October 1920, sale of works owned by Ober-Morlem and others, Frankfurt am Main, No. 420; 10 May 1921, Sale, Lepke, Berlin, No. 162; 1923, T. von Wijngaarde art dealers, The Hague; collection of H. de Haas, Wassenaar; 1942, acquired from Jonas and Kruseman art dealers for the Riksmuseum, Amsterdam.

Literature: Moltke 1965, 130; Sumowski 655.

Exhibitions: Amsterdam 1946, No. 12; Leiden 1956, No. 57; Cleves 1956, No. 20.

61a: Govert Flinck, *Saskia as a Shepherdess.* 1636. Braunschweig, Herzog Anton Ulrich-Museum.

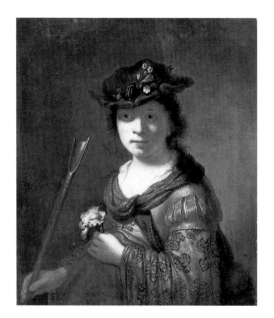

The young man is shown as a half figure in the costume of a shepherd, and with a flute and a shepherd's crook.

The picture's female pendant, bearing the title *Saskia as a Shepherdess*, and dated 1636, is in Braunschweig (Fig. 61a).[2] The traditional identification of the models as Rembrandt and his wife Saskia van Uylenburgh has not gone unquestioned. Moltke and Sumowski proposed partial solutions which, however, differ from each other. The former recognises the wife and not the husband, the latter the husband and not the wife. Flinck's *Shepherdess* does not resemble the only documented portrait of Saskia—Rembrandt's silverpoint drawing of 1633, now in Berlin (Fig. 23e), as Sumowski has rightly observed. Sumowski does not, however, question the identification of Rembrandt. One may, nonetheless, assume that the pendants—which they undoubtedly are[3]—were painted to illustrate the motto 'a sorrow shared is a sorrow halved'. Bearing in mind Rembrandt's real appearance, however (Figs. 60a, 62a), no certain identity can be established for the *Shepherd*. The depicted pair only vaguely resemble Rembrandt and Saskia. That such a resemblance should emerge at all, derives from the fact that Flinck, as Rembrandt's pupil, not only assimilated his style, but also adopted the cast of Rembrandt's pictures, which included Rembrandt himself, in addition to members of his family. In the first instance, Flinck had access to his master's self-portraits which he diligently studied and assimilated (see Cat. No. 60).

Flinck frequently painted pastoral scenes. He must have known the lively compositions contributed to this genre, in the 1620s and 1630s, by representatives of the Utrecht school such as Gerard von Honthorst, Paulus Moreelse and Abraham Bloemart. Most fashionable of all were paired pictures.[4] The inspiration for the earliest examples of this type painted by Flinck, however, came from Rembrandt. Hofstede de Groot recognised that Flinck's *Shepherdess* in Braunschweig presupposes knowledge of Rembrandt's *Flora* painted in 1634, and now in Leningrad (Fig. 23d).[5] A comparable model is not known for Flinck's *Shepherd*. Left to his own artistic devices, Flinck tended to produce large, and coarsely formed figures, in which the colouring was much more restrained—as exemplified in the *Portrait of Rembrandt* painted in about 1633, and now in Berlin (Cat. No. 60).

J.K.

1. For details concerning provenance see Willem van de Watering in: Amsterdam 1983, p. 156, at No. 33.
2. Klessmann 1983, pp. 66–67, No. 252.
3. The pictures have the same dimensions and, in the eighteenth century, they were brought together in the gallery of Schloss Salzdahlum (see notes on provenance).
4. Kettering 1983, p. 64.
5. Hofstede de Groot 1916, p. 98.

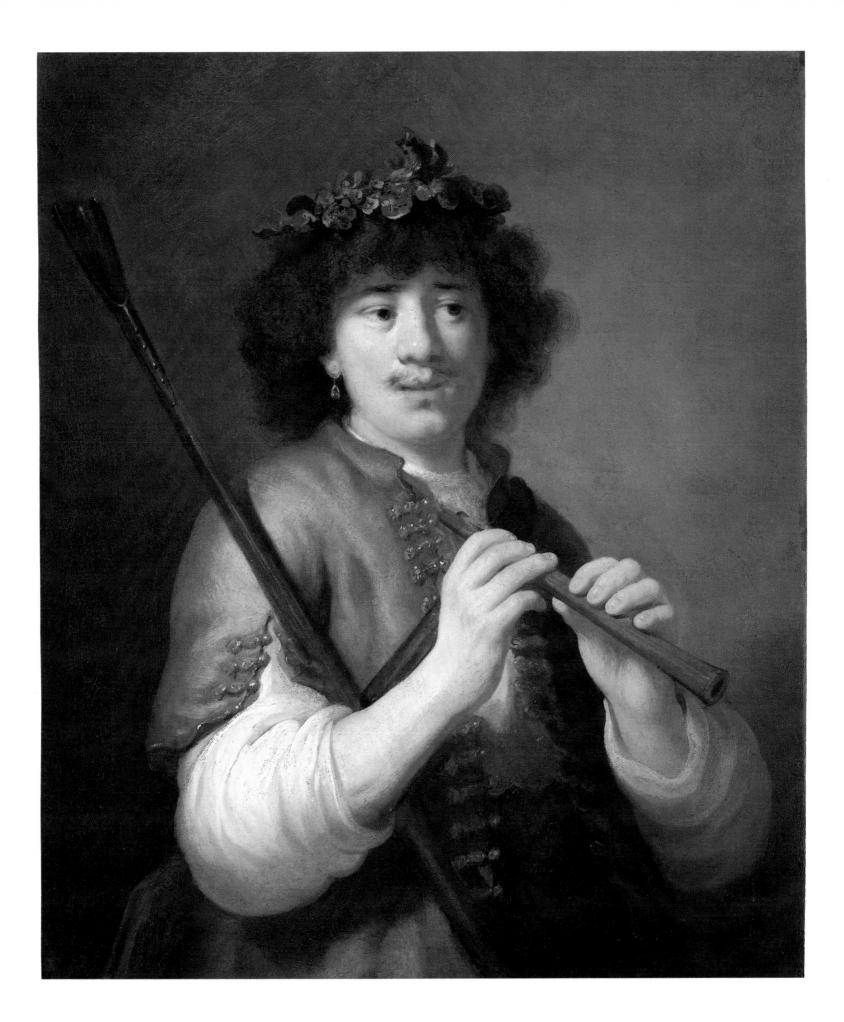

GOVERT FLINCK

A young Man with a feathered cap and a gorget

c.1636
Canvas, 66 × 53 cm, signed *G. Flinck. f 1636*
Lausanne, private collection

Provenance: 1875, collection of R. Bergau, Nuremberg; Germanisches Nationalmuseum, Nuremberg, Cat. 1909, No. 398; collection of J.V. Mayring, Hollfeld, Bavaria; 29–30 March 1951, sale, H. Rudolph, Hamburg, No. 439; 1963, P. de Boer art dealers, Amsterdam; 1965, private collection, Lausanne.

Literature: Moltke 1965, 224; Sumowski 658.

Exhibition: Cleves 1965, No. 32.

62a: Rembrandt, *Self-Portrait.* 1634. Berlin, Gemäldegalerie SMPK

62b: X-ray of Fig. 62a.

The picture shows the bust of a young man wearing a gorget and a gilded bandoleer. His face is attractively framed with curls and clearly illuminated. On his head he wears a foppishly tilted cap decorated with a white impastoed feather, which greatly contributes to the apparently nonchalant freshness of the young man's expression. The pose and costume, as well as the manner of painting, are closely related to the painting known as *Rembrandt's Self-Portrait*, in Berlin (Cat. No. 60), formerly regarded as an authentic work by the master, but rightly attributed to Govert Flinck by E. van de Wetering (*Corpus* C56).

The traditional identification of the present painting as a *Portrait of Rembrandt*, supported by Moltke and Sumowski, cannot be accepted. The facial features are captured in a lively manner—the mouth is open as if speaking, and the glance is direct—but do not bear the mark of unmistakeable individuality. Flinck's young man has nothing in common with the naturally wide face and irregular features of Rembrandt's physiognomy, as recorded in his 1634 *Self-Portrait*, now in Berlin (Fig. 62a). It is, rather, the unusual attire of the sitter that recalls the work of Rembrandt. While still in Leiden, Rembrandt had portrayed himself wearing an iron gorget (*Corpus* A20).[2] In the etched *Self-Portrait* of 1634 (Bartsch 23), to which Moltke refers, Rembrandt is shown both with a gorget and a cap with a feather. However, he also portrayed other sitters with these accessories (*Corpus* A8, A41, A42), and their repeated use indicates that they must have had a particular significance for him.

J. Bruyn has clearly shown that both a feather proudly worn in the cap, and rich jewellery—also present in Flinck's picture—

were understood as symbols of transience. The vainly displayed self-confidence and the dandified demeanor may be interpreted in this sense. This is also true of the gorget: pieces of armour are common accessories in Dutch *vanitas* still-lifes.

Taking its starting point in the scenes of this type produced by Rembrandt, Flinck's painting must, likewise, be alluding to the transcience and insignificance of all that is earthly. Flinck did not intend to depict a particular person. His picturesquely dressed subject is Everyman, an individual figure with symbolic significance—a *tronie*.[4]
J.K.

1. Van de Wetering 1986, pp. 88–90.
2. Hofstede de Groot 1916, p. 98.
3. Bruyn et al. 1982–, Vol. I (1982), pp. 223–24, at No. A20; Vol. II (1986), p. 838, at A21.
4. Bruyn et al. 1982–, Vol. I (1982), p. 40; Vol. III (1989), pp. 22–26.

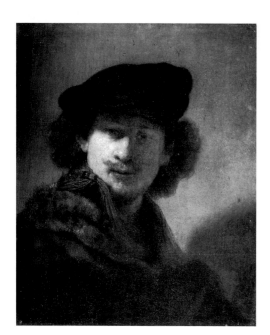

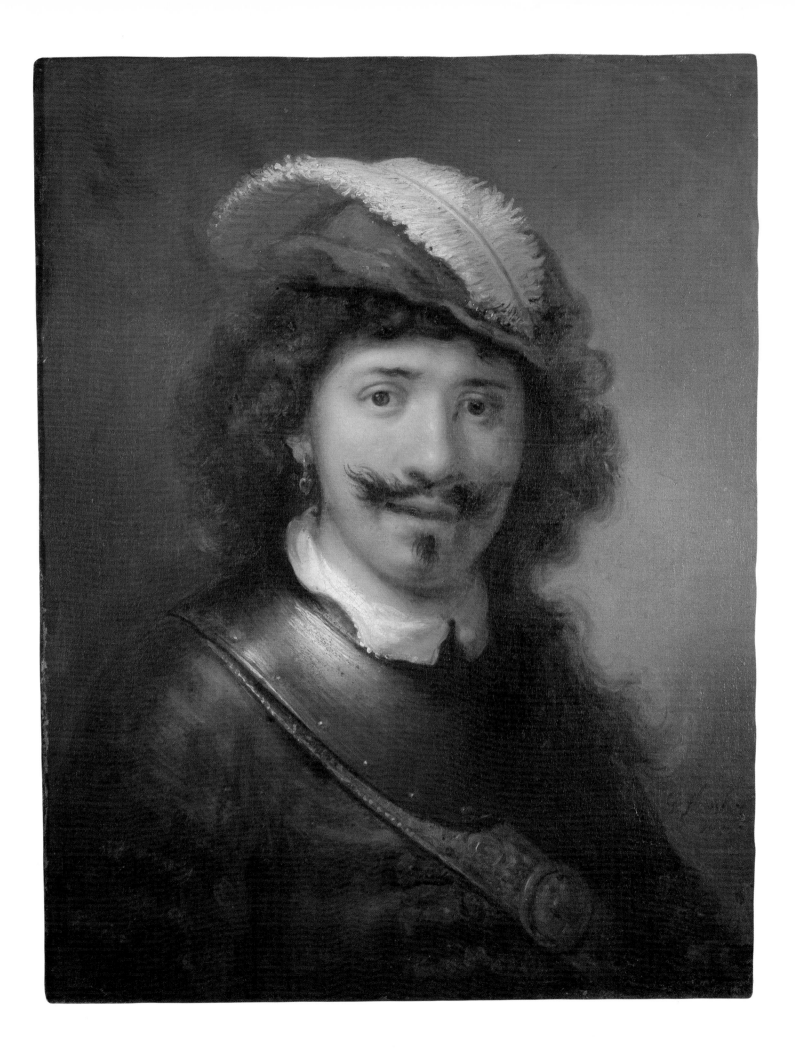

Ferdinand Bol
(1616–1680)

Ferdinand Bol was born in Dordrecht in 1616 as the son of a doctor. In his youth he may have learned the rudiments of painting either in Dordrecht from Jacob Gerritsz. Cuyp or in Utrecht from Abraham Bloemaert. In December 1634, he signed a legal document in Dordrecht as 'Ferdinandus bol, painter'. Presumably he went to Amsterdam shortly afterwards to work with Rembrandt. The written evidence for his period in the latter's studio consists of a note in Rembrandt's handwriting on the back of a drawing of his of about 1636 (Benesch 154), which includes mention of the sale of work by 'fardynandus', and the signature 'Ferdenandus Bol' of 30 August 1640 witnessing a legal declaration by Rembrandt. It is assumed that Bol worked with Rembrandt until about 1642, after which he set up as an independent painter in Amsterdam, obtaining his citizenship on 24 January 1652. In 1653 he married Lijsbeth Dell, and, especially after his marriage, received a great many commissions. In 1655 he was one of the officers of the Amsterdam guild of St Luke. His wife died in 1660. In 1666 Bol served as a sergeant in an Amsterdam militia company and subsequently occupied a number of socially prestigious posts. In 1669 he remarried; his second wife, the widow Anna van Arckel, died in April 1680. Bol himself, who had become very wealthy and appears not to have continued painting after his second marriage, died in July of the same year.

Apart from a very early work from his youth, with Utrecht characteristics, his œuvre as we know it begins with a series of notably Rembrandtesque works, the earliest of which is dated about 1640/41. After a few years other influences began to assert themselves and from 1650 Bol increasingly conformed to the widely-appreciated, colourful, classically-orientated Flemish baroque style. Nevertheless, even in the 1650s he occasionally produced paintings in the style of Rembrandt and borrowed motifs from the latter's work.
P.v.Th.

63
Attributed to
FERDINAND BOL
Portrait of Elisabeth Jacobsdr. Bas

Canvas, 118 × 91.5 cm
Amsterdam, Rijksmuseum; Inv. No. A714

Provenance: Possibly came into the possession of H. Muilman (died 1812) through a bequest from the Rey and Meulenaer families. Bequeathed to the latter's son, W.F. Mogge Muilman (died 1849) and subsequently to the latter's daughter A.M. Mogge Muilman. The portrait was inherited by her stepson, Jonkheer J.S.H. van de Poll, who bequeathed it to the museum in 1880.

Literature: Smith 553 (Rembrandt). Hofstede de Groot 622 (Rembrandt). Sumowski, Bol (Nachträge) 2016. J.G. Frederiks, 'Het portret der weduwe van den Admiraal Zwartenhond door Rembrandt', *Obreen's Archief voor Nederlandsche Kunstgeschiedenis* 6 (1884–87), pp. 265–78. C.V.[osmaer], 'Berichten en mededeelingen', *De Nederlandsche Spectator* 1887, pp. 121–22. Jan Six, 'Rembrandt's Elizabeth Bas', *Bulletin van de Nederlandsche Oudheidkundige Bond* 4 (1911), pp. 311–13. A. Bredius, 'Heeft Rembrandt Elisabeth Bas, Wed. van Jochem Hendricksz Swartenhont, geschilderd?', *Oud Holland* 29 (1911), pp. 193–97. A. Bredius, 'Did Rembrandt Paint the Portrait of Elizabeth Bas?', *The Burlington Magazine* 20 (1911–12), pp. 330–41. C. Hofstede de Groot, 'Meeningsverschillen omtrent werken van Rembrandt', *Oud Holland* 30 (1912), pp. 65–81. A. Bredius, 'Kantteekeningen op Dr. Hofstede de Groot's "Meeningsverschil"', *Oud Holland* 30 (1912), pp. 183–84. C.G. 't Hooft, 'Le portrait d'Elisabeth Bas', *La revue de l'art ancien et moderne* 31 (1912), pp. 459–66. A. Bredius, 'The "Elisabeth Bas" portrait again', *The Burlington Magazine* 24 (1913–14), pp. 217–18. [Anonymous] 1927, 'Elisabeth Bas een Kamper dochter', *Maandblad Amstelodamum* 14 (1927), pp. 68–69. A. Bredius, 'Rembrandt, Bol oder Backer?', in *Festschrift für Max J. Friedländer*, Leipzig 1927, pp. 156–60. G. Kolleman, 'Admiraal Swartenhondt en zyn vrouw Lysbeth Bas', *Ons Amsterdam* 19 (1967), pp. 57–62.

Exhibitions: Brussels 1946, No. 7. London 1952–53, No. 223. New York, Toledo and Toronto 1954–55, No. 9. Leiden 1956, No. 21. Chicago, Minneapolis and Detroit 1969–70, No. 30.

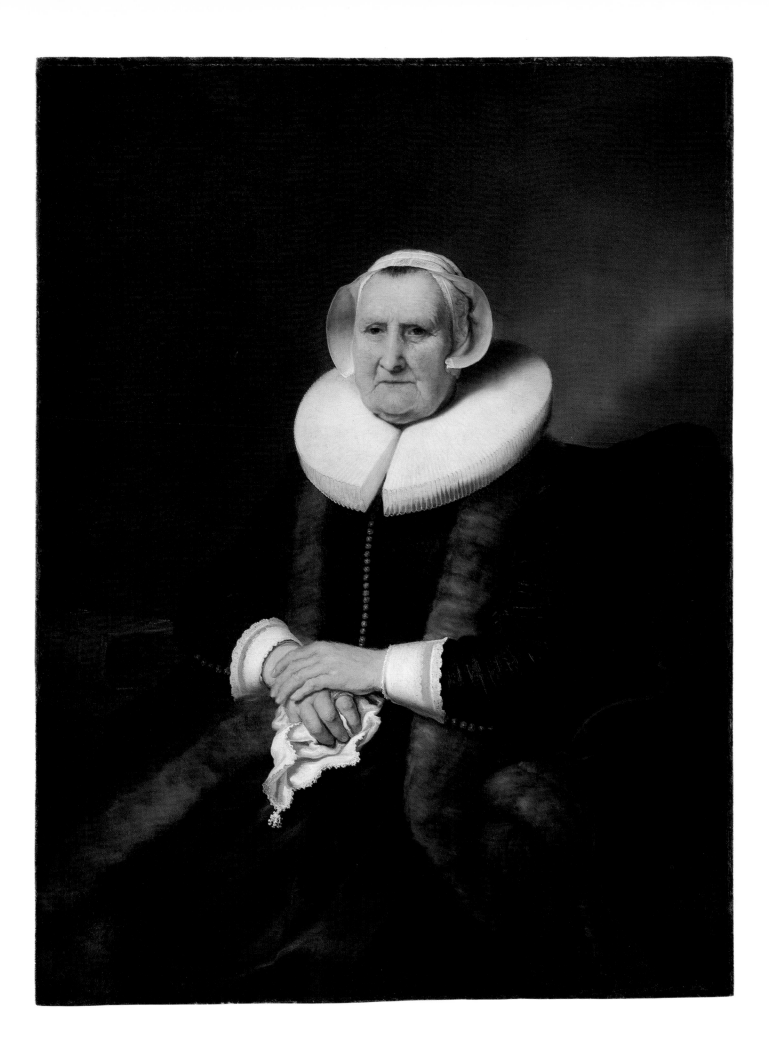

'While Mrs Bas was on show in the Amsterdam Rembrandt exhibition, DR EISENMANN, then Director of the Kassel Museum, which has such a distinguished collection of REMBRANDTS, with whom I was standing in front of the painting, said to me, 'My dear Bredius, the time will come when no one believes that that was painted by REMBRANDT!' At the time I laughed at my colleague. I'm not laughing any more . . . He was right.!' This was how Abraham Bredius concluded his sensational article of 1911 in the art-historical journal *Oud Holland*, in which he attributed the portrait of Elisabeth Bas to Ferdinand Bol. Oscar Eisenmann (director of the Gemäldegalerie in Kassel, 1877–1909) had made the remark which set Bredius thinking as early as 1894 and may have repeated it in 1898 during the Rembrandt exhibition in the Stedelijk Museum in Amsterdam—though certainly not at the exhibition, since the painting was not included, due to the high insurance costs.[1]

Bredius was immediately attacked by Jan Six and Cornelis Hofstede de Groot, but also quickly found his first ally in C.G. 't Hooft. The difference of opinion between scholars grew into a public issue in the Netherlands in the years before the First World War thanks to numerous publications in the national press[2] and also attracted international attention when *The Burlington Magazine* immediately reprinted Bredius's first *Oud Holland* article and 't Hooft gave vent to his opinions in the *Revue de l'Art ancien et moderne*.

The attribution of supposed Rembrandts to his pupils was nothing new even at that time (in order to sweeten the pill Bredius had begun his article by summing up nine recent examples), but writing off the *Portrait of Elisabeth Bas* was particularly embarrassing, seeing that the painting was the pride of the museum and the favourite of the public. The Rijksmuseum had begun its existence without a single Rembrandt. In 1808 it had assumed custody of *The Nightwatch* and *The Staalmeesters*, but these works were the property of the city of Amsterdam and were always to remain so. After the receipt of this unique loan the museum stopped building up its own Rembrandt collection, on which an undistinguished beginning had been made.[3] When in the 1870s Rembrandt's reputation rose to unprecedented heights and the plan for new accommodation for the museum (the present Rijksmuseum building, opened in 1885) took firmer shape, new efforts were undertaken to build such a collection. The first acquisitions were soon discredited,[4] but such a fate, so it seemed, could never befall the *Portrait of Elisabeth Bas*, which the museum had received in 1880 as part of the Van de Poll legacy. In 1883 no less an authority than Emile Michel called it a masterpiece: 'De tous les portraits peints par Rembrandt à cette époque, c'est certainement le plus remarquable et l'un des chefs d'œuvre du maître.' Three graphic artists made prints of the painting: the Frenchman Ch.A. Waltner (1846–1925) in 1887, the Dutchman P.J. Arendzen (1846–1932) also in 1887 and his compatriot C.L. Dake (1857–1918) a few years later. The public felt more attracted to the 'little old woman', as the painting was familiarly called (many people of course saw Rembrandt's mother in her), than

63a: Albert Hahn, *Museum-Idylle*, 1906

63b: Ferdinand Bol, *Portrait of a Woman*, 1642. Berlin, Gemäldegalerie

63c: Ferdinand Bol, *Portrait of a Woman*. Warsaw, Muzeum Narodowe

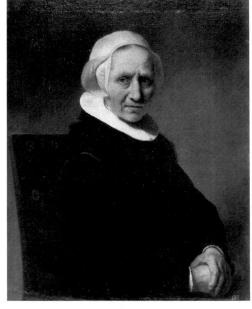

to the respectable *Nightwatch*. On the three-hundredth anniversary of Rembrandt's birth in 1906 public adulation inspired Albert Hahn's illustrated satirical poem *Museum Idyll* (Fig. 63a):[5]

> On the settee
> Next to the fop with turned-up nose
> The frail, anaemic liberal rose
> Swoons in front of Widow Bas—
> A dame of sterner stuff, alas,
> Than he or she!
> In ecstasy,
> Rose cried, 'What warmth, what pulsing life,
> Created by his palette-knife . . .!
> The fop sighed, 'Quite *superbe*, oh my!
> Behold our Rembrandt . . ., and die!'
>
> Meanwhile, 'It's only quarter past,'
> Thinks the attendant. 'Damn and blast!'
> Impatiently.

Bredius had originally thought not of Bol, but of Jacob Adriaensz. Backer.[6] This attribution was argued for in 1923 by Van Dyke and the following year by Otto Benesch.[7] In 1926 Kurt Bauch[8] even included the portrait in his catalogue of the complete works of Backer, though with the reservation 'that he [Backer] may be supposed to be the original author of the portrait later reworked by Rembrandt, the more so as the subject had close links with Backer's home town of Leeuwarden and with probable acquaintances of Backer's.' Gustav Glück[9] rejected this reservation in his review of Bauch's book, but Bredius gave little credence to the Backer theory in the *Festschrift für Max J. Friedländer*.

In 1960 the whole controversy from the beginning of the century seemed to have been reduced to a storm in a teacup, when Eduard Plietzsch[10] gave as his verdict: 'I believe that in the not too distant future the marvellous portrait will be re-attributed to Rembrandt.' In 1976 his prediction was proved true. In that year Albert Blankert, in his thesis on Ferdinand Bol,[11] pronounced himself in complete agreement with Plietzsch, with the reservation that one or more of Rembrandt's assistants may have helped in the execution of the commission. Werner Sumowski no longer mentioned the portrait in 1983 in his lengthy essay on Bol in the first volume of his *Gemälde der Rembrandt-Schüler*,[12] but in 1990 in the supplementary fifth volume again incorporated it in the latter's œuvre,[13] obviously convinced by J. Bruyn, who in 1989 had again attributed the portrait to Bol, albeit tentatively.[14]

In fact, there have been three views. Advocates of the original attribution to Rembrandt depended mainly on their intuitive certainty and so left little room for discussion. In their eyes the portrait was simply too good for Bol or any other of Rembrandt's pupils.[15] Those who nevertheless did not find the quality adequate in every respect for an unconditional attribution to Rembrandt, sought a compromise, according to which Rembrandt had had helpers or had improved on the work of a pupil.[16] These are not realistic possibilities, since during the restoration of the painting in 1983[17] the paint layer proved to be an homogenous whole, without a trace of working by two or more hands. The remainder rejected the notion of Rembrandt entirely and opted for Bol or Backer. Van Dyke's attribution of the portrait to the un-Rembrandt-like Jacob Backer, who is still erroneously regarded as Rembrandt's pupil, on the basis of two female portraits also attributed to him (Sumowski 59 and 60),[18] has been overtaken by research.

Bredius and his supporters[19] have based their attribution to Bol on the signed *Portrait of a Woman* of 1642 in Berlin (Fig. 63b; Sumowski 160), the signed *Rest on the Flight into Egypt* of 1644 in Dresden (Sumowski 81), the signed *Historiated Portrait of an 81 year-old Woman* of 1651 in Leningrad (Cat. No. 64), the attributed *Portrait of a Woman* in Warsaw (Fig. 63c; Sumowski 2017) and the *Portrait of a Woman with a feather fan*, once in the collections of Lord Ashburton and Alfred de Rothschild (Halton Manor) and last recorded in 1957 on the London art market, which has since been called into question by Blankert and is not included by Sumowski.[20] They pointed to the pictorial parallels between the Bas portrait and these works: the hands were compared with the Ashburton/De Rothschild portrait and with the hand of Mary in the Dresden painting. Bruyn added to this the comparison with the hand holding a glove in the unsigned *Portrait of a young Woman* in Dublin attributed to Bol by Sumowski (Sumowski 159; significantly it is reproduced next to the 1642 Berlin portrait); he compared the handkerchief, the cuffs and the collar with those in the Berlin portrait and the treatment of the face, particularly the area of the eyes, with that of the face in the Warsaw portrait. One telling argument was the formal correspondence with the portrait in Leningrad: the book on a table on the left and the garment draped expansively over the back and arm of the chair. In addition there were more general considerations, such as the imitative nature of Bol's art, which tends towards the decorative, his superficiality and uniformity, at least compared with Rembrandt, his lack of imaginative power and his dependence on the strength of his example, which in the case of Elisabeth Bas might be a figure like Anslo's

wife (Cat. No. 33) and a head like that of the 83 year-old woman (Cat. No. 19).

The suggested datings for the *Portrait of Elisabeth Bas* generally fluctuate around the year 1640. Bredius initially dated it at 1641/42, but later felt that it might well have been produced before 1640. J.G. van Gelder suggested the late 1630s, J.R. Judson proposed the period around or shortly after 1640.[21] Sumowski gave 1640/41, Bruyn opted for the period during which Bol worked with Rembrandt, i.e. no later than about 1642.

The identity of the woman has never been questioned. J.G. Frederiks, who reconstructed the biography of Elisabeth Bas in 1884/87, never queried the linking of her name to the portrait. The query would have been a legitimate one, since in 1836 John Smith had called the sitter 'Mrs Mogge Muilman'. The collector Hendrik Muilman (died 1812) also owned family portraits, which were inherited by his son Willem Ferdinand Mogge Muilman (died 1849).[22] His sole heir was his daughter Anna Maria Mogge Muilman, who in 1850 married Jonkheer Archibald Jan van de Poll (1800–70), a full cousin of her mother's. Her husband had one son from a previous marriage, Jacob Salomon Hendrik van de Poll (1837–80). After the death of her husband Anna Maria appointed her stepson sole heir, so that on her death the paintings of the Muilman family came into the possession of Jonkheer J.S.H. van de Poll. In his will he bequeathed the collection to the state. It is possible that there were good reasons to attach the name Elisabeth Bas to the portrait after 1836, but what those reasons are has not become clear to me.[23] According to the Rijksmuseum catalogues the painting was handed down via the Rey, Meulenaer and Muilman families, but this provenance is undoubtedly based on the assumption that the portrait represents Elisabeth Bas.[24]

Elisabeth Jacobsdr. Bas (1571–1649) was born in Kampen. In 1585 the family moved to Amsterdam, where in 1596 Elisabeth married Jochem Hendricksz. Swartenhondt (1566–1627), a military man who fought mainly at sea but also on land. During the Twelve-Year Truce (1609–21) in the war against Spain he managed the 'Prince van Orangien' inn in Amsterdam, at that time the town's five-star hotel, frequented by the nobility and used by the burgomasters to accommodate their guests. Setting sail again in 1620, this time as Lieutenant-Admiral of Holland, he defeated the Spaniards off Gibraltar. Prince Maurits presented him with a golden chain in honour of his victory. The portrait of a military man wearing such a chain, dated 1627 and

attributed to Nicolaes Eliasz., which was also part of the Van de Poll bequest to the Rijksmuseum (Cat. No. A705) is supposed to represent him. Maria (born in 1598), the couple's eldest daughter, married Marten Reyersz. in 1617. She died in 1630, her husband shortly afterwards. Their three children were brought up by Elisabeth Bas, their grandmother. The youngest of the three, Maria (1630–1703), married Roelof Meulenaer (1618/19–91). This couple were painted by Ferdinand Bol in 1650 and these portraits (Sumowski, Nos 166 and 167)[25] are also included in the Van de Poll bequest (Inv. No. A683 and A684). Given this family history it is understandable that the grandmotherly figure should have been, rightly or wrongly, identified with Elisabeth Bas. She was quite well-off, and on her death on 2 August 1649 left 28,000 guilders.

While the assumed identity of the elderly woman is dubious, the attribution of her portrait to Bol remains problematical to the extent that few people agree wholeheartedly with it. The reason for the hesitation appears to be that everyone is determined to place the painting in the period during which Bol worked with Rembrandt and has difficulty in locating it there. The prevailing opinion that in the second half of the 1640s Bol moved further and further away from Rembrandt stylistically, but occasionally made incidental formal borrowings from the work of his former teacher for his own purposes, does not tally fully with the complexity of Bol's activity as a painter. His attitude was not only eclectic but also chameleon-like. One may wonder what date would have been assigned to the *Portrait of a Man standing at his front door* in Brunswick (Sumowski 174) if this were not dated 1658. The same applies to the *Portrait of a seated Woman* (Cat. No. 65) of 1653. Only the costumes would have prevented these paintings from being dated at the beginning of the 1640s. Precisely this relatively late female portrait lends itself admirably to a comparison with the Bas portrait. The structure and shape of the head, the convincing but rather dully and dutifully treated eye section, the slightly over-emphatic transition from the lit forehead to the shadow around the temple and especially the expertly but routinely executed hairline are closely related. The shadow of the head on the collar is just as lifeless. The collar is just as flat and materially expressionless, but still is depicted with the same formal precision which makes it functionally acceptable. The same applies to the lacework on the collar, cuffs and handkerchief, which seldom provides anything of pictorial interest. Where that does happen,

as on the left around the lower sleeve which is separated from the arm by a line of shadow, the similarity to the corresponding cuff edge of Elisabeth Bas is striking. Just as in the Bas portrait the head and cap and the collar on the one hand and on the other hand the folded hands with the cuffs and the handkerchief form scarcely related, autonomous sections, so the same thing happens in the woman's portrait— and is all the more noticeable because of the parted hands. The treatment of light is in both cases flat and for that reason the spacial relationship of the figures to their surroundings is restricted. The portrait of Elisabeth is certainly more attractive than that of the other woman, but with Bol the external appearance of his models to a large extent determined the captivation of his portraits.

As has been said, in 1927 Bredius pointed out the formal relationship between the *Portrait of Elisabeth Bas* and the *Portrait of an 81 year-old Woman* of 1651 included in this exhibition, but no one has attached any importance to this connection in relation to the dating of the painting. This is understandable, because when it comes to such borrowings Bol often reaches far back into the past. This habit may provide a reasonable explanation for the assumed difference in time, but it is not a compelling argument. It by no means precludes the later dating implicitly proposed here. If the portrait really depicts Elisabeth Bas, then the year of her death, 1649, is of course the *terminus ante quem*. If it is not, then a dating at the beginning of the 1650s is feasible. Whatever the case, the woman is dressed in an old-fashioned manner, but that is not all that strange for someone of about eighty.

The *Portrait of an elderly Man* (Cat. No. 65), recently attributed to Bol, has no value as evidence in relation to the *Bas* portrait, but the juxtaposition is still useful, since it seems so close to the latter painting in concept and execution that it may extricate it from its relatively isolated position.
P.v.Th.

1. Hofstede de Groot 1912, p. 75.

2. Hofstede de Groot 1912, pp. 74–75 and 174–75, lists the most important articles. These were written by himself, Jan Veth, J. Goekoop-De Jongh, C.G.'t Hooft, W.R. Valentiner, C. Scharten and of course Bredius. The Institute for Art History (RKD), The Hague, has a scrapbook with a large number of newspaper cuttings; the archive of the Rijksmuseum possesses a similar file.

3. In the first decade of the Rijksmuseum's existence (at that time it was still called the Nationale Konst-Gallery) the following 'Rembrandts' were acquired: 1801 *The Beheading of John the Baptist* (now Inv. No. A91 C. Fabritius); 1808 *Portrait of Lumey* (now Inv. No. A358 copy of an original by Rembrandt; 1809 *Portrait of the Tax-Collector Johan Uyttenbogaert* (now Inv. No. 582 G. Flinck).

4. In 1877 *Portrait of a Rabbi* was purchased (now Inv. No. A946 Rembrandt imitation), in 1885 *Hera hiding during the Battle of the Gods with the Giants* (now Inv. No. A1282 attributed to G. Flinck). The *Portrait of Gozen Centen*, lent to the museum in 1900, was thought to be a Rembrandt (now Inv. No. A4166 G. Flinck; purchased in 1970). In 1900 the museum acquired its first genuine Rembrandt, the *Landscape with a Stone Bridge*, which is in the exhibition (Cat. No. 31). Although purchases have not always been beyond reproach since then (five paintings have been unable to withstand critical scrutiny), the museum can now pride itself on possessing fourteen genuine Rembrandts and having five on permanent loan.'

5. Op canapé
 Zit naast 't modieuse snobje
 't Teer-anemisch ethisch popje
 Te smelten voor de Weduw Bas.
 't Was vroeger toch een stoerder ras
 Dan die twee!

 't Popje zee:
 'Oh, wat en gloed en wat een verve,
 Legde Rembrandt in zijn verven . . .!'
 En 't snobje zuchtte: 'Ah superbe!
 Rembrandt zien . . ., en dàn sterven!'

 Onderwijl denkt bij zich zelven
 De zaalsuppoost: 'Pas kwart na elven,
 G.V.D.!'
Het land van Rembrandt. Prentjes van Albert Hahn, Amsterdam [1906], no page numbers.

6. Hofstede de Groot 1912, p. 75.

7. Van Dyke 1923, pp. 7, 46, pl. vi, Fig. 22. Benesch 1924, pp. 150–51, Fig. 5 (in 1956 Benesch came out in favour of Bol). Rifkin 1969, pp. 30, 32, also opted for Backer.

8. Bauch 1926, pp. 33–35, 44, Cat. No. 137, Fig. 26a.

9. Glück 1926, p. 103.

10. Plietzsch 1960, p. 179, Fig. 325.

11. Blankert 1982, pp. 13, 57, Cat. No. R200, Fig. 50; English commercial edition 1982. Cf. Bruyn 1983, p. 211.

12. Sumowski 1983[–1990], vol. 1, pp. 282–425.

13. Sumowski 1983[–1990], vol. 5, pp. 3084–85, no. 2016.

14. Bruyn 1989, p. 36.

15. Besides those already mentioned (Six, Hofstede de Groot and Plietzsc, see also Kauffmann 1926, p. 246.

16. The above-mentioned options of Blankert and Bauch.

17. The painting underwent conservation in 1890, was re-lined in 1911, cleaned in 1950 and restored in 1983.

18. Bruyn 1984, p. 160 note 13, rightly rejected the attribution of Sumowski, No. 60.

19. Besides Bredius and 't Hooft, both of whom have already been mentioned, and the organisers of the exhibitions listed, the following authors have come out in favour of Bol: Martin 1935, Vol. 2, p. 120; Münz 1952, Vol. 2, p. 179; Van Gelder 1953, p. 38; Benesch 1956, p. 202; Michalkowa 1957, p. 264; Haak 1969, p. 165 (tentatively).

20. Bredius 1911, pp.193, 197 with Fig. Blankert 1983, Cat. No. D10, Fig. 95.

21. Van Gelder 1953, p. 38. Judson, in Exhib. Cat. Chicago, Minneapolis and Detroit 1969–70, No. 30.

22. De Hoop Scheffer 1958, pp. 88–89. The writer states that the son bought back the Bas portrait when his father's collection was put up for auction, but no family portraits are listed in the catalogue of the Hendrik Muilman sale, Amsterdam, 12–13 April 1812.

23. In a private collection there is a primitive bust of a woman on an oak panel, probably painted in about 1825, to which is attached a slip, with a damaged right side which carries the following inscription in (early?) nineteenth-century handwriting: 'Portret van Elisabeth Jacobs . . . Weduwe van den Admiraal Jochem Hendricksz Swartenh. . . Luitt. Admiraal van Holland. E. J. Bas geb. te Kampen omtrent 1570. be. . . Amsterdam 2 Augs1649. J.H. Swar. . . April 1566. begraven 4 Juni 1627.' (Portrait of Elisabeth Jacobs .. Widow of Admiral Jochem Hendricksz Swartenh . . . Lt. Admiral of Holland. E.J. Bas b. in Kampen in about 1570. bu . . . Amsterdam 2 Aug. 1649. J.H. Swar . . . April 1566. buried 4 June 1627.) The woman has a much thinner and younger face than the woman in the Rijksmuseum painting, but her dress, collar and cap (on which a strange hat has been placed) have been borrowed from it without any grasp of the form of the costume. This strange portrait (photograph in Rijksmuseum, Department of Paintings, dossier A714) sheds no new light on the problem of identification.

24. The dossier on the Van de Poll bequest in the archive of the Rijksmuseum contains a handwritten list of the paintings. The portrait is listed under No. 37 as a 'Female Portrait' by Rembrandt, but all other portraits are also listed without any first or second name. However, in the *Verslagen omtrent 's Rijks verzamelingen van geschiedenis en kunst, III: 1880*, The Hague 1881, p. 4a, No. 38, the name Elisabeth Bas is mentioned.

25. Blankert 1982, Cat. Nos 145 and 146, plates 156 and 157.

64

FERDINAND BOL

Historiated portrait of an 81 year-old Woman

Canvas, 129 × 100 cm, signed *Bol 1651*, inscribed *out 81 jaer* [=81 years old]
Leningrad, Hermitage; No. 763

Provenance: Collection of the Duke of Portland. Collection of George Walpole, third Duke of Orford (1730–91), 1775. Sold in 1779 with the whole Walpole collection to Catherine the Great of Russia.

Literature: Bredius 1927, pp. 158–59, Fig. 2. Isarlo 1936, p. 34. Blankert 1982, pp. 32, 40, 58 No. 130, Fig. 139. Sumowski 1983[–1990], Vol. 1 No. 141.

The mention of the woman's age proves that this signed and dated painting of 1651 by Bol is a genuine portrait. But cloaks of the kind held together with a large clasp such as that in which the old woman is enveloped in her majestic pose were not worn in the seventeenth century. She is represented in the form of an historical figure, possibly the prophetess Anna or a Sibyl, in view of the presence of a book, the Bible or a Sibylline volume, and the column, an indication of the temple or a symbol of steadfastness or spiritual power.[1]

Blankert has pointed out that the left sleeve and hand are virtually identical with those on an etching of Bol's (B. 5) and that the composition corresponds with the so-called *Portrait of Rembrandt's Mother* (B. 344; Blankert, Fig. 87), an etching now attributed to a pupil of Rembrandt's (Bol or K. van der Pluym), which was formerly regarded as Rembrandt's work because of its similarity to the latter's etched portrait of his mother (B. 343).

See the commentary on the *Portrait of Elisabeth Bas* (Cat. No. 63) for a discussion of the formal link between the two portraits.
P.V.TH.

1. De Jongh 1981–82, pp. 155–58.

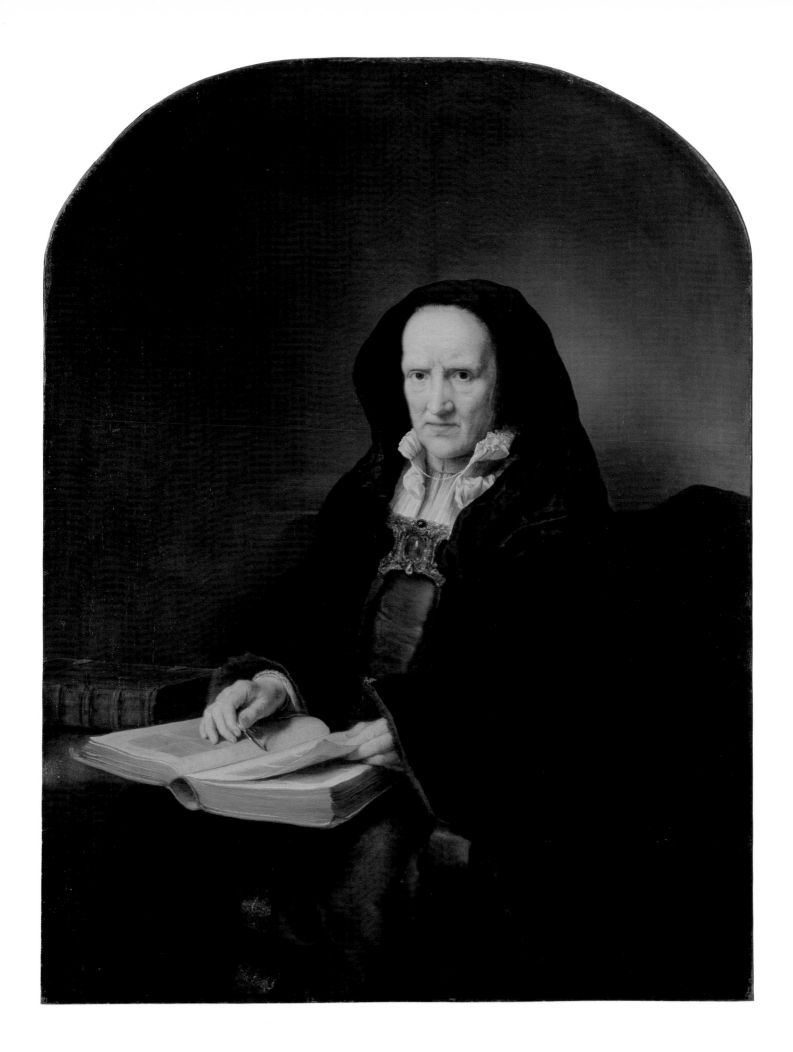

65

FERDINAND BOL

Portrait of a Woman

Canvas, 88.6 × 72.6 cm,
signed and dated *Bol fecit 1653*

Private collection

Provenance: Collection of Camillo Roth, London
1888. Collection of Lichtenstadt, Knight, until
1931. Art dealers Asscher & Welcker, London,
1931. Art dealers Frank Knight & Rutley,
London, 1931. Art dealers D. Katz, Dieren,
1933–34 (Exhib. Cat. Zutphen, No. 1; Exhib.
Cat., The Hague, No. 28). Collection of Mrs
E.M.E. ten Bosch-Verheyden, Almelo, until
1956. Sale, Amsterdam (F. Muller), 11
December 1956, No. 10 with illus. Private
collection, Nijmegen, 1972. Sale, Amsterdam
(Christie's), 18 May 1988, No. 104 with illus.

Literature: H.P. Bremmer, *Beeldende Kunst* 22
(1935) 27. Blankert 1982 125, plate 134. Not in
Sumowski 1983[–1990].

Exhibitions: London 1888, No. 53. Brussels 1935,
No. 707. Rotterdam 1938, No. 58, ill. 150.
Almelo 1953, No. 4, ill. 36. Rotterdam 1955,
No. 46, ill. 92.

The unknown woman in this signed and dated
portrait of 1653 is leaning still further to the
left in her chair than Elisabeth Bas, so that the
right-hand side of the chair back can also be
seen. The handkerchief with which Bol often
depicted women, is both a sign of prosperity
and a symbol of chastity, that is, of
unimpeachable sexual behaviour.[1]

See the comments on the *Portrait of Elisabeth
Bas* (Cat. No. 63) for a fuller discussion of this
painting.
P.v.Th.

1. E. de Jongh, in: Haarlem 1986, Cat. No. 15.

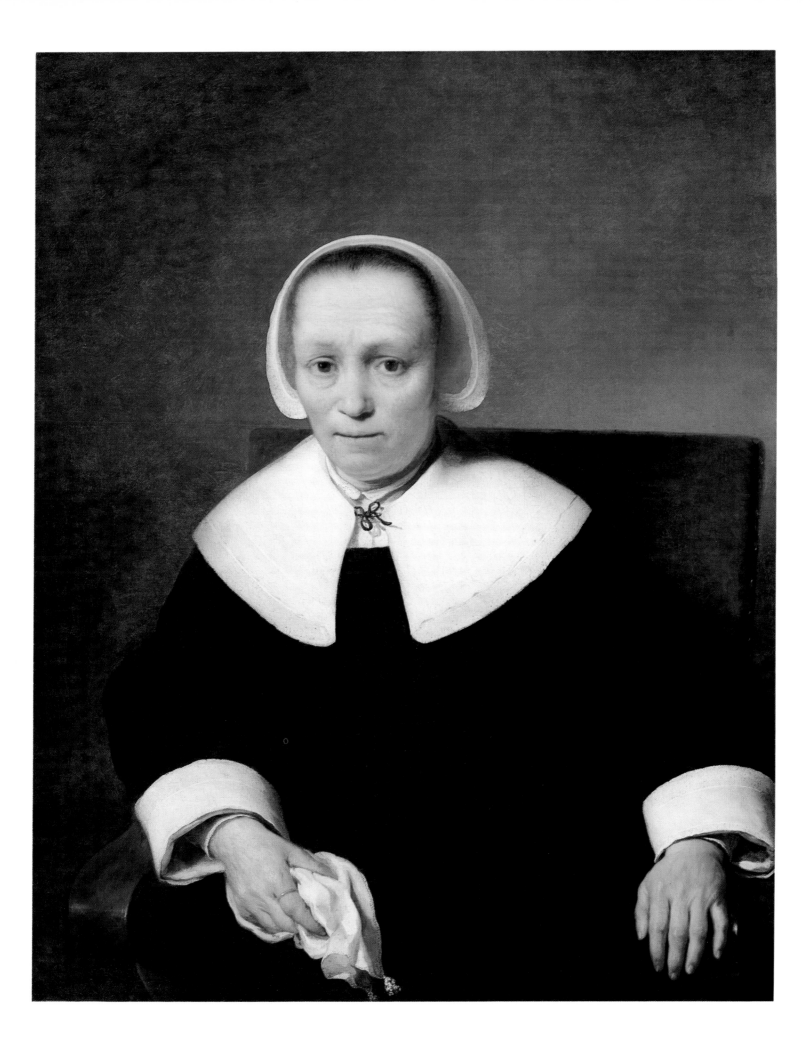

FERDINAND BOL

Portrait of a seated Man

Canvas, 89 × 64.8 cm, imitation of
Rembrandt's signature added later
The National Trust, Kedleston Hall
Only exhibited in Amsterdam

Provenance: Purchased in 1761 by John Barnard,
Berkeley Square, London ('Ephraim Bonus' by
Rembrandt). Collection of Lord Scarsdale,
Kedleston Hall, 1836 (as Rembrandt). Sale of
the Scarsdale Heirloom, London (Christie's), 18
July 1930, No. 109 with illus. (sold for 19,000
guineas to Hopkins for Sulley; as Rembrandt.
Art dealers Van Wisselingh, Amsterdam, 1932
(Cat. *Dutch and Flemish pictures of the 17th
century*, No. 7 as Rembrandt). Art dealer M.
Knoedler, New York, 1993 (Cat. *Loan Exhibition
of Rembrandts*, No. 4 as a Rembrandt). Private
collection, Rhode Island (as a Rembrandt).
Sale, London (Christie's), 13 December 1985,
No. 75 with ill. (attributed to F. Bol).

Literature: Smith 352 (Rembrandt). Hofstede de
Groot 740 (Rembrandt). Dodsley 1761, Vol. 1,
p. 286. Bode 1883, pp. 497, 582. Dutuit 1885,
pp. 48, 63, 68. Michel 1893, pp. 305, 556. Bode
1897–1905 276. Bell 1899, p. 143. Valentiner
1908, pp. 251, 557, illus. Hind 1932, p. 83, Fig.
69. Siple 1933, p. 190 with illus. Sumowski
1983[–1990], Vol. 5 (*Nachträge*) 2018.

Exhibition: Manchester 1857, No. 684. Leeds
1868, No. 802. London 1899, No. 12.

The catalogue of the auction held in London in
1985 mentions that this portrait, which had
always been regarded as a Rembrandt was
attributed to Bol some decades previously by
S.J. Gudlaugsson (note RKD, The Hague), an
attribution which was accepted by W.
Sumowski. It also mentions that A. Blankert
places the picture in Rembrandt's immediate
circle (perhaps the result of collaboration
between Rembrandt and Bol around 1637–40)
and that J. Bruyn attributes it to a pupil of
Rembrandt's active at the beginning of the
1640s, probably the same pupil (Bol?)
responsible for the *Portrait of Elisabeth Bas*. In
his *Nachträge* Sumowski dates the painting
around 1640/42 and compares it with the
Portrait of an old Man with a beard in
Buckingham Palace (Sumowski, No. 132),
also attributed by him to Bol, and with the
women's portraits in Dublin, Berlin and
Warsaw (Sumowski, nos 159, 160 and 2017),
previously mentioned in the discussion of the
Portrait of Elisabeth Bas.

 The painting may have been trimmed
slightly all round, but definitely at the bottom,
because the hand on the arm of the chair must
have been fully visible, and consequently also
the other hand with the glove.
P.v.Th.

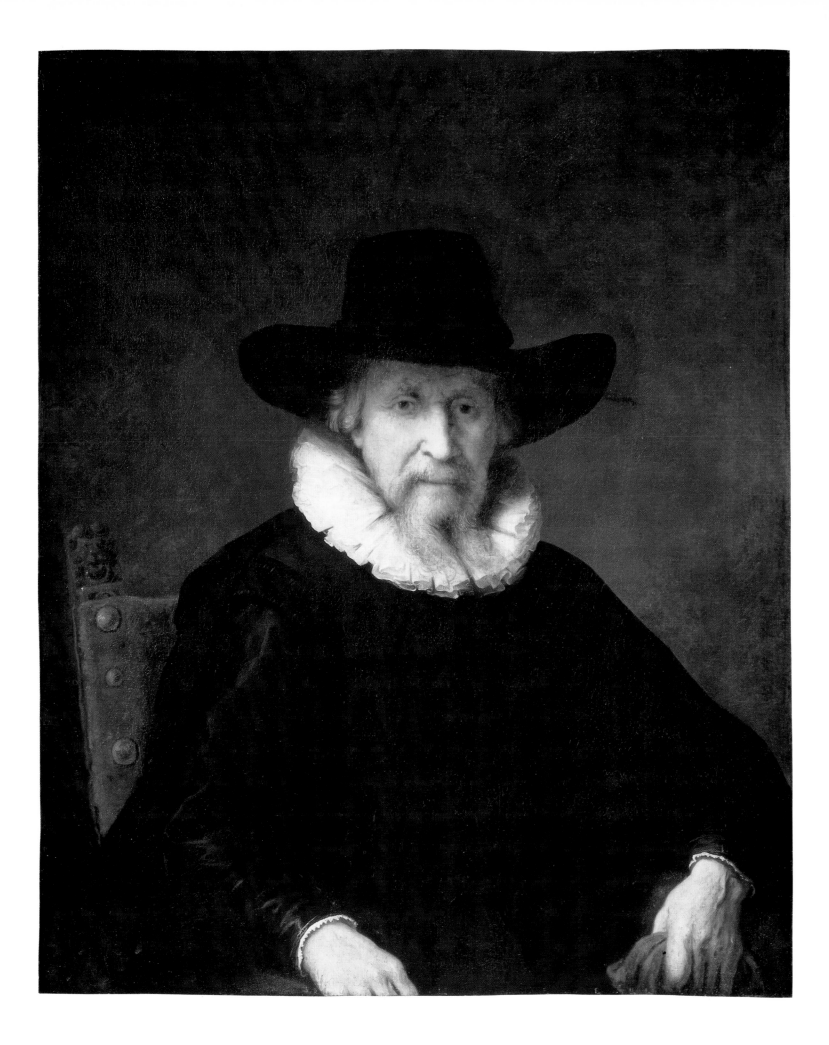

Jan Victors
(1619–after 1676)

On 13 June 1619 Jan Victors, the seventh of ten children born to Louis Victors and Stijntje Jaspers, was baptised with the name Hans at the Oude Kerk in Amsterdam. He came from the poor family of a stoelmaker (carpenter), a trade plied by his grandfather, who had emigrated from Antwerp, and then by his father before the latter started, in 1625, to work as a messenger (bode op Dordrecht). Jan's younger step-brother, the bird painter Jacobus Victors (1640–1705), was the son of Louis Victors by his third marriage. In 1642 Jan Victors married Jannetje Bellers, who bore him nine children before dying in 1661. In the early 1660s Victors executed a few commissioned works for prominent institutions and figures in Amsterdam. Among these were two large-scale group portraits of the female Regents of the Reformed Church Orphanage (Diaconieweeshuis), which had opened in 1657, as well as a portrait of the Amsterdam mayor Jan Appelmann, dated 1661, now in the Frans Halsmuseum in Haarlem. Nonetheless, it seems that Victors was unable to secure long-term commissions from members of the wealthy ruling class of Amsterdam. Throughout his career he maintained a rather conservative style of portraiture, making no concessions to the current changes in taste. The painter's last years were marked by constant financial worries. Around 1670 he appears to have given up painting. In 1673 he joined the service of the East India Company, as a visitor of the sick. Thereafter, he worked, in return for little pay, as a medical orderly and a lay preacher on the trading company ships until he died in the East Indies in 1676 or at the beginning of 1677.

The painter's extensive oeuvre includes history paintings of Old Testament subjects, a few scenes from Antiquity, rural genre scenes, individual figures in fantasy costumes and portraits.

Until now, no documentation has been found concerning his artistic training. Stylistic and iconographic features of his dated works from 1640 onwards would seem to indicate that Victors was a member of Rembrandt's studio during the second half of the 1630s. The character of some of his paintings leads one to conclude that he was close to another Rembrandt pupil, the somewhat older Govert Flinck.

As a strict Calvinist, whose personal commitment to his faith influenced his artistic activity, Jan Victors was a notable exception among Rembrandt's Protestant pupils. It appears that, in the rendering of biblical subjects, he followed, throughout his life, the instruction found in the Ten Commandments never to depict God the Father. Accordingly, Victors also eschewed the representation of Christ, the Son of God; and he thus avoided, in particular, New Testament subjects.

V.M.

Canvas, 122 × 161 cm
Leningrad, Hermitage; Inv. No. 791

Provenance: acquired, between 1763 and 1774, by Empress Catherine II.

Literature: Waagen 1870, p. 179, No. 791 (Rembrandt); Bode 1883, pp. 480 and 599 (Rembrandt); Bode 1897–1906, Vol. III, p. 190 223 with illustration (Rembrandt, with the participation of a pupil); Bredius 1910 a, p. 465 (Rembrandt; mentioned as No. 42 in the 1669 inventory of F. Bol); Hofstede de Groot 1915, pp. 9 ff. 16 (Rembrandt, about 1636/37); Valentiner 1933, p. 244, 247 and Fig. 8 (Rembrandt workshop: G.W. Horst ?); Leningrad 1958, Vol. II, p. 264, No. 731 (school of Rembrandt); Leningrad 1981, pp. 165 ff., No. 731 (Rembrandt and Jan Victors?); Blankert 1982, p. 90, at, No. 2, Fig. 65 (work from the school); Sumowski 1983 ff., Vol. IV, p. 2596, No. 1722, p. 2621 with illustration (mentions the attribution to Victors—with Rembrandt's participation—proposed by Linnik; according to Sumowski, a work by Victors from the late 1630s).

Exhibition: Moscow-Leningrad 1956, p. 65 (school of Rembrandt).

The painting, near in type to a half-figure picture, shows Abraham and the three angels, gathered around a table with a white table cloth in front of the door of a house. The patriarch, dressed in a fur-lined robe with gold-coloured clasps, pauses in astonishment while he offers the strangers meat and bread. He listens, attentively but sceptically, to the prophecy of God the Father, who—unbeknown to Abraham—sits opposite, in the guise of one of the angels. His right hand outstretched, he tells Abraham of the impending birth of a son. The other two angels stare at the patriarch in tense anticipation of his reaction. In the open door of the house, one can make out the figure of Abraham's wife Sarah, rendered in profile, who seems to react with a sceptical smile to this prophecy of a pregnancy at her great age. Thematically, the scene follows the biblical account of Genesis 18: 8–15.

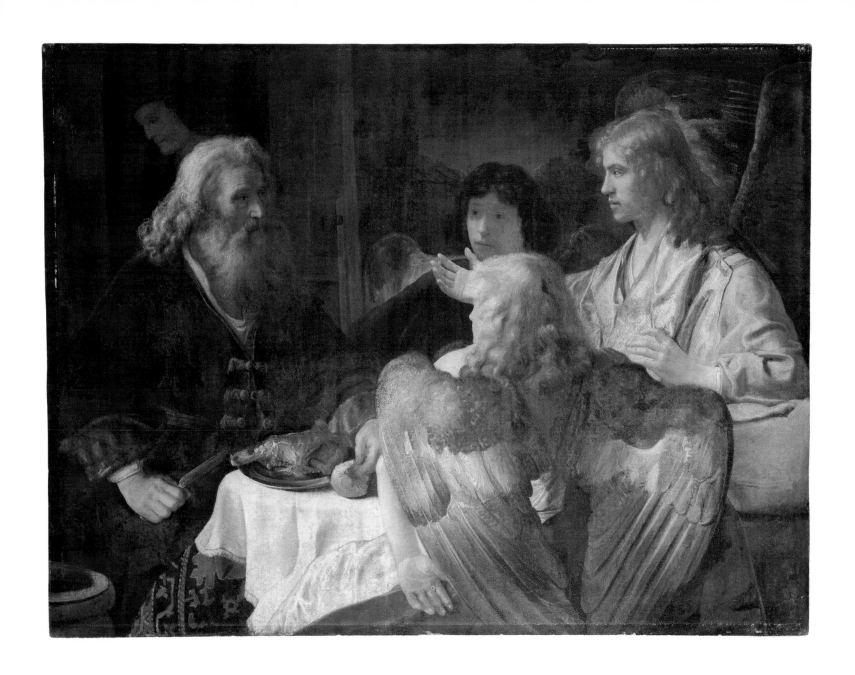

The fate of the Leningrad picture is representative of that of many works struck from Rembrandt's recognised œuvre even before the compilation of an authoritative catalogue raisonné. One can observe that, once an attribution to Rembrandt has been rejected, a slide into anonymity has often swiftly followed. This has been especially true of works which were, and still are, in locations not easily accessible—as in the present case—as this has prevented the unhindered study of the original. Accordingly, scholarly references to the Leningrad picture have been sporadic. It was not until in 1980 that Linnik attributed it to Jan Victors, unfortunately in an inaccessible publication; this attribution was recently confirmed by Sumowski.[1] On closer inspection, the painting has been found to be a characteristic work by this pupil of Rembrandt.

Although there are no extant records, we may presume that Jan Victors was in apprenticeship during the second half of the 1630s.[2] During this time, Rembrandt was at work on a number of history paintings with large figures who act in striking proximity to the viewer. In particular, the *Belshazzar's Feast* of 1635, in the National Gallery in London (Cat. No. 22), seems to have had a lasting impression on Victors.[3] This would seem to be the origin of the characteristic features of many of his own biblical paintings, in which the extremely close-up view of life-like figures creates a visual convergence of the pictorial space and the viewer. By this means, the painter combines his true-to-the-text 'translation' of the subject with a concern for detailed precision, which is evident from the virtuoso painting of cloth textures and a profusion of decorative accessories. In many cases, Victors captures the viewer's attention with displays of his painterly abilities. Thus, in the present case, the complex motif of the back view of the angel seems to be merely a pretext to demonstrate his ability to depict the outspread wings, the exquisite colouring of which gives them the quality of a still-life.

Quite early in his career, Victors developed a fixed repertoire of figure types which turn up repeatedly in his biblical paintings. If one compares, for example, Abraham from the Leningrad painting with Jacob from *Joseph recounting his Dreams* of 1651, in Düsseldorf (Cat. No. 68), one is immediately struck by the positively sibling-like resemblance of these two figures. The same applies to a comparison between the Leningrad Abraham and Abraham from the *Expulsion of Hagar* of 1650, in the Israel Museum in Jerusalem (Cat. No. 69).[4] Victors apparently drew the faces of his protagonists from models. On the one hand this made his figures contextually more convincing, but on the other such striking physiognomic verism could not always mask a certain theatrical rigidity in Victors's compositions. While Rembrandt's figures are contextually unified through both their gestures and facial expression, in general Victors appears to confuse inner tension with affected and statuesque poses. In aiming for a psychologically convincing illustration of the prophecy to Abraham and Sarah, Victors unintentionally creates the impression of a judicial hearing; in this respect his *Joseph recounting his Dreams* of 1651 is similar.

Compositionally, the Leningrad painting reveals similarities with caravaggesque half-figure pictures. The influence of Caravaggio and of his followers in Utrecht is clearly visible, the rembrandtesque colouring notwithstanding. In this connection, one might mention

67a: Caravaggio, *Supper at Emmaus*. London, The National Gallery.

67b: Ferdinand Bol(?), *Abraham and the three Angels*. Whereabouts unknown.

Caravaggio's versions of the Supper at Emmaus, in the National Gallery in London (Fig. 67a) and in the Pinacoteca di Brera, Milan,[5] which the young Jan Lievens studied around 1625, while at work on his *Feast of Esther*, now in the Museum of Art at Raleigh, North Carolina (Cat. No. 52). Victors's iconographic solution is found in a painting of c.1650, that is attributed to, among others, Ferdinand Bol (Fig. 67b).[6] Also closely connected to Victors's composition is a pen and wash drawing in the Museum Boymans-van Beuningen in Rotterdam, also attributed to Bol.[7] Rembrandt's 1646 version of the same subject[8] has, until now, been seen as a starting point for both, which, at least in the case of the half-kneeling figure of Abraham in Bol's painting, appears to be correct. On the other hand, the grouping of the angels around the table follows almost literally the Leningrad picture by Jan Victors, dated by Sumowski to the late 1630s.

In comparison with Rembrandt and many of his pupils, Jan Victors rarely rendered scenes with angels.[9] In the present case, he follows an iconographic tradition for the subject in which three angels are shown, even though the biblical text speaks only of three men (see Genesis 18:2). In the spokesman of the trio—rendered more prominent through his slightly raised sitting position—Abraham would, at a later stage recognise the Lord (see Genesis 18:27). The textually true 'translation' of the biblical record, otherwise usual for Victors, would here have necessitated depicting God as a man, thus violating the instruction in the Ten Commandments. When illustrating biblical scenes Victors adhered closely to this maxim, no doubt because of his orthodox Calvinist faith.[10] Anthropomorphic representations of God the Father are not known in his extensive œuvre.

V.M.

1. According to Sumowski 1983 ff., Vol. IV, p. 2596, at No. 1722, the attribution to Jan Victors is due to Irina Linnik who, nonetheless, presumed that Rembrandt had also worked on the picture. This author's argument could not be checked, as the published text (in Russian)—*Dutch Paintings of the Seventeenth Century and Questions of Attribution* (Leningrad, 1980)—could not be obtained. References to Rembrandt's collaboration in the work cannot be confirmed. Sumowski (as cited above) rightly questioned Linnik's hypothesis on this matter.
2. Extensive research on the life and work of Jan Victors has been carried out by Zafran (1977), Miller (1985), Manuth (1987) and Sumowski 1983 ff., Vol. IV (1989), pp. 2589–2722. In spite of the lack of sources relating to the artist's training, the three last authors have argued that Jan Victors was trained in Rembrandt's workshop from about 1635 to 1640. Only B. Broos, 'Fame shared is fame doubled', in: Amsterdam-Groningen 1983, pp. 35–58, especially p. 50, assumes Govert Flinck was the teacher of Jan Victors.
3. On the significance of the London painting for the development of Jan Victors, see Miller 1985, p. 41 and Sumowski 1983 ff., Vol. IV, p. 2590.
4. Inv. No. 219.79; canvas, 143.5 × 178.7 cm; signed and dated 1650. On this painting, see Zafran 1977, pp. 92 ff., and Fig. 1; Miller 1985, p. 289, No. 31; Manuth 1987, pp. 164 ff., No. 9 and Fig. 117; Sumowski 1983 ff., Vol. IV, p. 2602, No. 1745, p. 2644 with colour illustration; see Cat. No. 69.
5. On this, see, most recently, Mina Gregori in: *The Age of Caravaggio*, Metropolitan Museum of Art, New York and Museo Nazionale di Capodimonte, Naples 1985 (New York/Milan, 1985), pp. 271–76 (on the London painting), and pp. 306–10 (on the version in the Pinacoteca di Brera, Milan). On the many copies, see A. Moir, *Caravaggio and his Copyists* (New York, 1976), pp. 87 ff., 100.
6. Present whereabouts unknown, canvas, 55.8 × 73.2 cm; see Sumowski 1983 ff., Vol. V, p. 3082, No. 2006 (with bibliography), p. 3136 with illustration. Blankert 1982, p. 162, No. R[ejected] 5, does not accept the painting as a work by F. Bol.
7. On the Rotterdam drawing, see Sumowski 1979 ff., Vol. I, p. 494, No. 235* with illustration (with bibliography), and most recently, Giltaij 1988, p. 124, No. 42 with illustration.
8. Formerly in the collection of C. von Pannwitz, New York; now in the collection of the Aurora Trust; panel, 16 × 21 cm, signed and dated: *Rembrandt f. 1646*; Bredius 515; Bauch 27; Bredius/Gerson 515; Tümpel 21.
9. Jan Victors showed the figure of an angel in only two other paintings. These are the 1649 and 1651 versions of the *Angel departing from the Family of Tobias*, in the J. Paul Getty Museum, Malibu, and in the Bayerische Staatsgemäldesammlungen in Munich, respectively; see Sumowski 1983 ff., Vol. IV, Nos. 1742 and 1750 with illustration (with bibliography).
10. On the problem of the Reformed Church in relation to the fine arts in general, see, most recently, C. Tümpel in *Theologische Realenzyklopädie*, Vol. XX, 1/2 (1990), p. 150, (under the heading Künste, Bildende III). On Jan Victors's idiosyncratic choice of subjects in the context of Calvinist ideas on the instruction not to depict God the Father, see Manuth 1987, pp. 72–83.

68

JAN VICTORS
Joseph recounting his Dreams

Canvas, 172 × 160 cm
Signed and dated at the lower left:
J. Victoors f. 1651
Düsseldorf, Kunstmuseum; Inv. No. 61

Provenance: c.1900, Dowdeswell & Dowdeswell art dealers, London; C. Lambert collection, Belle Vista Castle, Paterson, New Jersey; C. Lambert sale, American Art Galleries, New York, starting on 12 Febuary (24 February), 1916, No. 359 (school of Rembrandt, sold for $3000 to Kleinberger); sale in New York, 23 January 1918, No. 79 with illustration (sold to J.S. Miller); 1925, Van Diemen art dealers, The Hague; sale, A. Preyer, Amsterdam, 8 November 1927, No. 35 (sold for 5200 guilders to Goudstikker); 1935, given by Baron Thyssen-Bornemisza, Lugano, to the city of Düsseldorf.

Literature: Hofstede de Groot 1925 a, p. 75, Plate II B; Isarlov 1936, p. 34, Addendum III; Hamann 1936, pp. 502 ff.; Thieme-Becker, Vol. xxxiv (1940), p. 330; *Kunstsammlungen der Stadt Düsseldorf* (no place, no date; c.1947 ?), p. 10 and Fig. 16; Van Guldener 1947, pp. 13 and 22; Pigler 1956, Vol. I, p. 72; *Meisterwerke der Düsseldorfer Galerie* (= Die Rheinbücher. Grosse Reihe IV), ed. H. Peters (Honnef, 1955), p. 33 27 and Plate 16; Sumowski 1961, p. 13 at 649; Düsseldorf 1962, No. 184 with illustration; Zafran 1977, p. 94, Fig. 4, pp. 97, 116 and note 27; Hartford 1978, p. 199, note 9; Miller 1985, pp. 185 ff. and 295 ff. 50; Manuth 1987, pp. 194–196 25 and Fig. 133; Sumowski 1983 ff., Vol. IV, p. 2603, No. 1748, p. 2647 with illustration.

Exhibition: Düsseldorf 1958, p. 25, No. 61.

The picture shows an interior with a beamed ceiling and an arched opening in the back wall which runs parallel to the picture plane. While his family listens attentively, the youthful Joseph recounts his dreams of the sheaves of corn in the field and of the stars bowing down to him as a sign that he is the chosen one (Genesis 37:5–11). Dressed in a multicoloured coat and a flat beret, he turns to his father, Jacob, who watches him with an air of distrust

from his chair. At the patriarch's feet a young girl prepares a meal at an open hearth, while simultaneously watching the proceedings with as great an interest as that shown by an apparently older woman sitting opposite Jacob with her back to the viewer. In the background Joseph's older brothers discuss with great intensity the meaning of Joseph's dreams. One of them leans forward over the back of Jacob's chair and eyes his younger brother with an intrigued if sceptical expression.

In the 1630s Rembrandt was intensely preoccupied with the subject of Joseph's recounting of his dreams. From about 1635 Jan Victors could have closely followed Rembrandt's work on an oil sketch (Fig. 68a)[1] and on the etching (B. 37) executed after it in 1638 in his teacher's studio. Elements from both works were used by Victors in his Düsseldorf painting of 1651.[2] The female figure seen from the back and at the left edge of the picture, and equally the rendering of Jacob's arm and the manner in which his hand tightly grasps the armrest of his chair, point to Rembrandt's etching. In the painting Jacob wears a headdress comparable to that worn by his counterpart in the etching. Joseph's pose, on the other hand, follows, in a modified fashion, the *grisaille* oil sketch in Amsterdam: he turns in right profile towards his father and the explanatory gesture of his right hand seems to allude to the content of the dream of the sheaves of corn standing up in front of him. But even more closely related to the painting is a drawing by Rembrandt from the early 1640s, now in the Albertina in Vienna.[3] The figure of Joseph was repeated almost literally by Victors. The open hearth on the floor next to Jacob's chair can be found in both of the Rembrandt works from the 1630s.

Victors treated this subject in two further versions.[4] The painting dated 1652 in the Wadsworth Atheneum in Hartford, Conn.,[5] in particular, demonstrates Rembrandt's continued influence on the way in which his former pupil contextually structured his history paintings. According to the text of Genesis 37:10, Jacob responded to his son's account with the words: 'What is this dream that thou hast dreamed? Shall I and thy mother and thy brethren indeed come to bow down ourselves to thee to the earth?' Jacob's reply had already led Rembrandt to include in the Amsterdam *grisaille* and in the etching dated 1638, the contradictory scene of a female figure lying in bed, which is most probably to be interpreted as Joseph's physical mother, Rachel, even though she was already dead by the time her son came to recount his dreams (Genesis 35:19).[6] Although Victors eschewed this motif

in his Düsseldorf version of the subject, thus faithfully following the content of the biblical story, it seems that Rembrandt's influence weighed more strongly with him when he came to paint the same subject a year later. Through the addition of the figure of a maid (Bilha or Silpa?) serving Rachel with a meal, Victors enlarges the ancilliary scene of the Hartford painting and gives it a genre-like character.[7]
V.M.

1. Rijksmuseum, Amsterdam, Inv. No. A3477, see *Corpus* A66.
2. For references to Rembrandt motifs, see Hartford 1978, p. 199, note 9; Miller 1985, pp. 185 ff.; Manuth 1987, pp. 194–96, No. 25; and Sumowski 1983 ff., Vol. IV, p. 2603, No. 1748.
3. Pen and brown ink, with wash and white heightening, 175 × 245 mm, signed: *Rembrant f.*; see Benesch 526, Fig. 653 (about 1642/43).
4. These are a painting dated 1652 (now in the Wadsworth Atheneum, Hartford, Conn.), see note 5, and a lost version, which in 1910 was in an American private collection; on this, see Manuth 1987, p. 200, No. 27 and Fig. 135.
5. Canvas, 158 × 202 cm, before 1939 bearing an authentic signature at the lower left: *Jan Victoors fe 1652*; see Miller 1985, pp. 185 ff., 296, No. 51; Manuth 1987, pp. 196–99, No. 26 and Fig. 134; Sumowski 1983 ff., Vol. IV, p. 2604, No. 1753, p. 2652 with colour illustration.
6. According to L. Seelig and C. Tümpel in Tümpel 1970 at No. 14, the motif of the woman in bed may have come about because Rembrandt misunderstood a copper-engraving of 1532 (B. 18) by Heinrich Aldegrever from a series illustrating to the Story of Joseph. On this, see the discussion of the Rembrandt Research Project in *Corpus*, II, p. 296.
7. Manuth 1987, pp. 198, traces the scene in the background of the Hartford painting, where Victors, unlike Rembrandt, adds the figure of a maid, to scenes of lying-in after childbirth. In this context, it is probable that—alongside the model provided by Rembrandt—Victors was inspired by a engraving by Philip Galle after Maarten van Heemskerick (see Holl., Vol. VII, p. 78, No. 191) showing Elizabeth lying in bed and served by a maid, on the occasion of the naming of her son John, subsequently to become Saint John the Baptist.

68a: Rembrandt, *Joseph recounting his Dreams*. 163(?). Oil sketch. Amsterdam, Rijksmuseum.

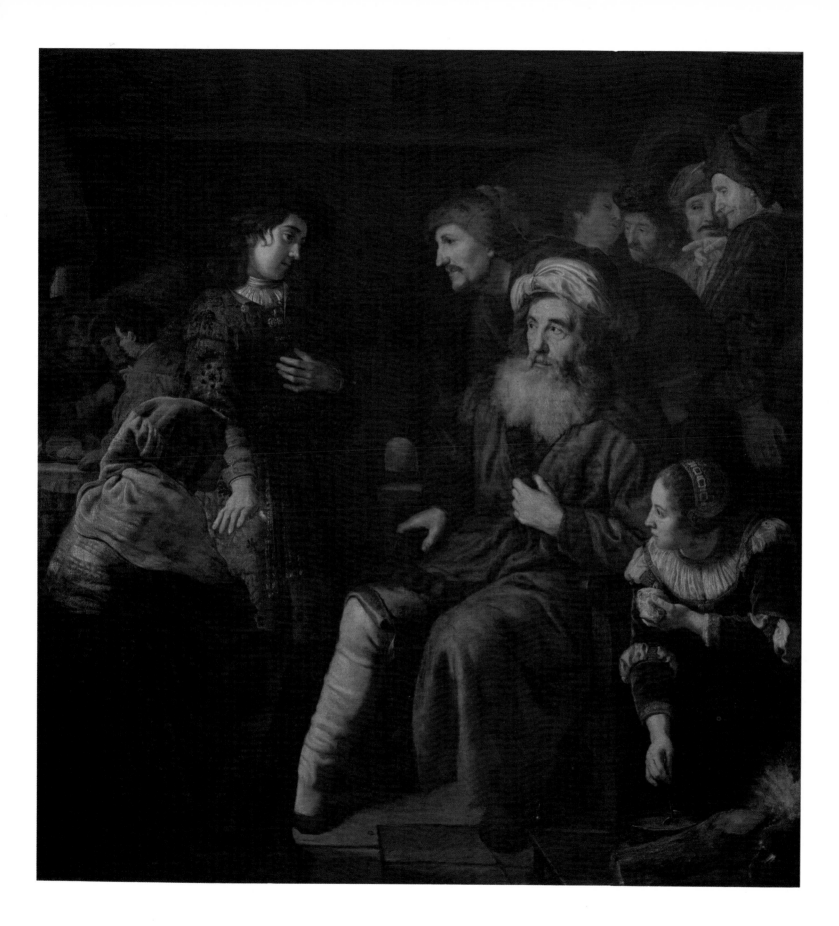

69

JAN VICTORS

The Expulsion of Hagar and Ishmael

Canvas, 143.5 × 178.7 cm
Signed and dated at the lower right: *Johanes Victors fc 1650*
Jerusalem, The Israel Museum; Inv. No. 219.79

Provenance: 1 June 1829, J.A. van Dam sale, Dordrecht, No. 142 (sold, for 700 florins, to Lamme); collection of Oskar Bondi, Vienna; 3 March 1949, Oskar Bondi sale, Kende Galleries, New York, No. 99, with illustration (sold, for $500, to E.E. Wolf); collection of Emile E. Wolf, New York; 1976, given by Emile E. Wolf to the American Friends of the Israel Museum.

Literature: Hamann 1936, pp. 501 ff., and Fig. 43; Sumowski 1959, p. 288; Sumowski 1963, p. 98, note 125; Bader 1976, p. 90, No. 40; Zafran 1977, p. 93, and Fig. 1; Miller 1982, p. 24 and Fig. 6; R. Grafman, *The Israel Museum Guide* (Jerusalem 1983), p. 66, with colour illustration; Miller 1985, pp. 70 ff., 289, No. 31, with illustration; Manuth 1987, pp. 164–66, and Fig. 117; Foucart 1988, p. 84; Sumowski 1983 ff., Vol. IV, (1989), p. 2602, No. 1745, p. 2644 with colour illustration.

Exhibitions: Waltham 1966, pp. 36 ff., No. 15 with illustration; Montreal-Toronto 1969, p. 116, No. 114 with illustration; exhibition catalogue *Dutch Religious Art of the Seventeenth Century*, ed. O. Naumann and P. Sutton (Yale University Art Gallery, New Haven, Conn., 1975), No. 35 with illustration.

Cut off by the lower edge of the picture, the life-size, three-quarter figures stand in a rural setting in front of the sharply receding façade of a house. From the half-door of the house, Sarah looks out. In a gesture of protection and benediction, Abraham holds his right hand above Ishmael's head, his strangely distracted glance staring into the distance. The dramatic content and importance of the patriarch's decision are reflected in his expression, which is marked by doubt and a conflict of conscience. The boy—viewed from the back—turns to his father, with his hand raised as if signalling his intention to speak. Hagar, already dressed for departure, wrings her hands in despair and casts a grieving glance back at Abraham, who is abandoning her and her son to an uncertain fate.

If one considers the selection of subjects for paintings and drawings made by members of Rembrandt's artistic circle, one is struck by the extraordinarily large number of scenes treating the story of Abraham's Egyptian maid Hagar, both before and after the birth of her son, Ishmael (Genesis 16:6–13, and Genesis 21:14–19). One of the reasons for this may be Rembrandt's intense preoccupation with Pieter Lastman's painting of 1612 (Fig. 81a), a group of figures from which he copied in a drawing (Fig. 81b) and which became the starting point for his numerous illustrations of the subject of the Expulsion of Hagar and Ishmael.

Jan Victors, too, frequently treated this episode. Further versions of the subject by him are to be found in, among other locations, New York (collection of R. Feigen), Cardiff (National Museum of Wales), and Leningrad (State Hermitage).[1] On account of the close-up view of its figures and the tight cropping of the scene as a whole, the Jerusalem version of 1650—in contrast to the paintings now in New York and Cardiff which date from the 1640s—places greater emphasis on spiritual expression as opposed to extensive pictorial narrative.

As Hamann observed (1936), the imposingly presented and sumptuously dressed figure of the patriarch is derived from Rembrandt's etching of the same subject, dated 1637 (Fig. 81d). A characteristic of the Jerusalem painting—the alignment of the figures parallel to the picture plane—is also to be found in a drawing in Budapest by an anonymous pupil, which follows Rembrandt's etching in reverse.[2] Closer to Victors's painting, however, is a drawing from the early 1640s, now in Washington (Fig. 69a), which Benesch incorrectly accepted as by Rembrandt.[3] Its evenly balanced, centralised composition shows the backview of the figure of Ishmael between

69a: Anonymous Rembrandt pupil, *The Dismissal of Hagar and Ishmael*. Drawing. Washington, National Gallery of Art.

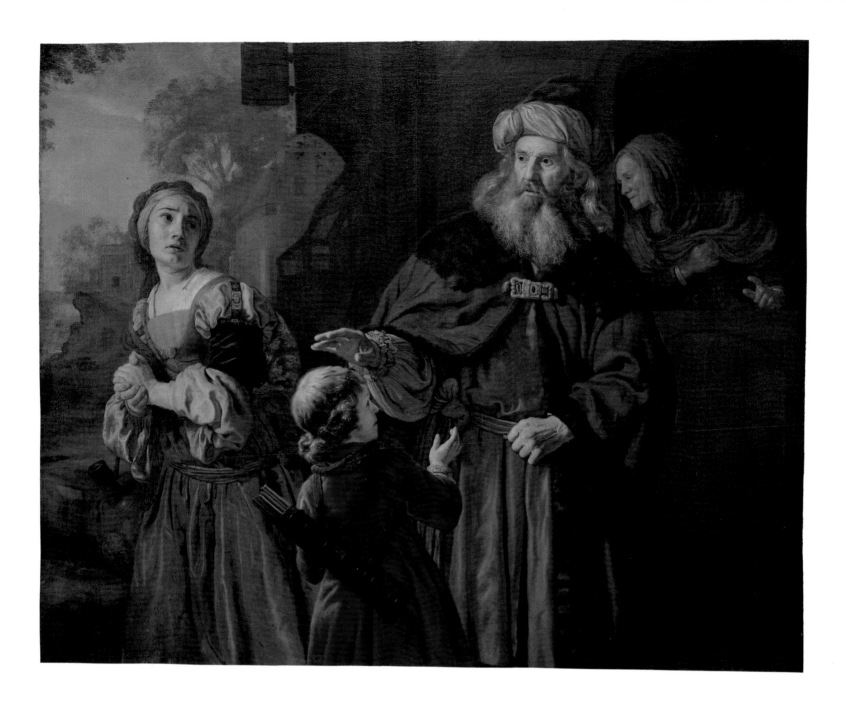

Hagar and Abraham, with all three figures cropped at the knee by the lower edge of the picture.

Hamann (1936) believed the close cropping of the picture now in Jerusalem derived from a half-figure painting of the same subject by Guercino in the Pinacoteca di Brera in Milan (Fig. 69c).[4] In making this claim, Hamann was, however, aware of its problematic nature, for Guercino's painting is securely documented to 1657, and the only known engraving, by Robert Strange, was not made until 1767.[5] While Hamann presumed 'an older, unknown Italian picture, by Guercino himself or by another artist trained in northern Italy' as a model for Victors,[6] Miller proposes that both Guercino and Victors had at their disposal an as yet unidentified print. In addition, Miller points out that Govert Flinck had already treated the subject in a similar way with a close-up illustration of the figures in his *Expulsion of Hagar and Ishmael* of 1640/42, now in Berlin (Fig. 69b).[7]

Since both the pupil's drawing in Washington and Flinck's painting demonstrate that the pictorial arrangement adopted by Victors in 1650 was by no means unusual in Rembrandt's circle from the early 1640s, the supposed influence of Guercino is even more questionable. Furthermore, in his early work, *Abraham and the three Angels*, now in Leningrad (Cat. No. 67), Victors had experimented with a caravaggesque half-figure type.

The Jerusalem painting shows Victors at the height of his ability as a colourist. The intensity of the colouring in this picture is in marked distinction to that of the scene of *Joseph recounting his Dreams*, painted only a year later, and now in Düsseldorf (Cat. No. 68). In

the Jerusalem picture the lighting transforms the overall 'earthy' effect of the finely nuanced tones of brown, green, red and ochre, and in some areas of the splendid drapery creates a shimmering effect. Varied application in the painting of the fabric increases the textural quality of the carefully characterised materials.

A comparison of the figure of Abraham with that in the Leningrad painting (Cat. No. 67), with that of Jacob from the Düsseldorf picture (see Cat. No. 68), and Isaac from the Paris *Blessing of Jacob*,[8] demonstrates Victors's repeated and characteristic use of heads with striking physiognomies, studied from life. Assessed in the context of the painter's qualitatively uneven œuvre, the approximately contemporary paintings in Jerusalem and Paris may, without doubt, be counted among his most significant achievements of the years between 1650 and 1660.

V.M.

1. On these, see Miller 1985, Nos. 30, 31; Manuth 1987, Nos. 6, 7, 8; Sumowski 1983 ff., Vol. IV (1989), Nos. 1731, 1741, 1784, in each case with illustrations.
2. Hamann 1936, p. 504, Fig. 48, presumes that the Budapest drawing is a preparatory study by Jan Victors for the Jerusalem painting.
3. National Gallery of Art, J.E. Widener Bequest; pen and brown ink, 156 × 137 mm. Benesch, Vol. III, No. 499 (about 1640/42). Benesch's attribution to Rembrandt is unconvincing. In spite of their being worked so thoroughly, the figures appear flat and incorporeal. The spatial relation between the trio and the motifs of the background is confused by the almost uniformly applied hatching strokes on the trees and the architectural elements. Hamann 1936, p. 543, Fig. 102 regarded the drawing as the work of a pupil. P. Schatborn (oral communication) has also rejected the attribution to Rembrandt.
4. Inv. No. 556; canvas, 115 × 154 cm. On this work, see the exhibition catalogue, *Il Guercino (Giovanni*

Francesco Barbieri 1591–1666), ed. D. Mahon (Bologna, Palazzo del'Archiginnasio, 1968), pp. 212–14, No. 102, with illustration.
5. Hamann 1936, p. 502, and Fig. 44.
6. Hamann 1936, p. 502.
7. Miller 1985, p. 71. On Flinck's painting, see J.W. von Moltke, *Govaert Flinck 1615–1660* (Amsterdam, 1965), pp. 24, 65, No. 2, Plate 8 (1640/42); I. Geismeier, *Staatliche Museen zu Berlin, Gemälde Galerie: Holländische und flämische Gemälde des siebzehnten Jahrhunderts im Bode-Museum* (Berlin, 1976), pp. 35 ff., with illustration; and, most recently, Sumowski 1983 ff., Vol. II, p. 1022, No. 622, p. 1054, with illustration. Hamann 1936, p. 502 and Fig. 45 has also presumed the model for Flinck's *Expulsion of Hagar* to be in Guercino's painting of this subject; but this view is to be rejected on the chronological grounds already indicated.
8. Musée du Louvre, Paris; canvas, 165 × 203 cm. On this work, see Miller 1985, No. 39; Manuth 1987, No. 17; Foucart 1988, pp. 82–86; Sumowski 1983 ff., Vol. IV (1989), No. 1746, in each case with an illustration.

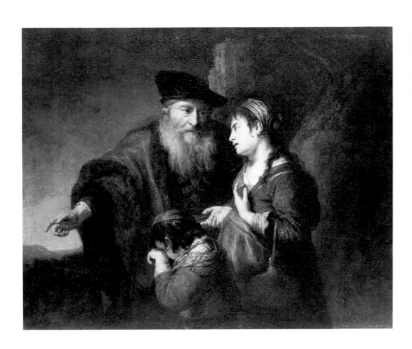

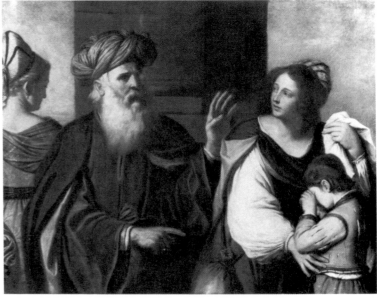

69b: Govert Flinck, *The Dismissal of Hagar and Ishmael*. Berlin, Bode-Museum.

69c: Guercino, *The Dismissal of Hagar and Ishmael*. Milan, Pinacoteca di Brera.

Gerbrand van den Eeckhout (1621–1674)

Gerbrand van den Eeckhout was baptised with the name 'Garbrand' on 22 August 1621 in the Oude Kerk in Amsterdam. He was the eighth of nine children from the first marriage of Jan Pietersz. van den Eeckhout—a goldsmith born in Harlingen in 1583—with Grietje Claesdr., a cobbler's daughter from Amsterdam. On his father's side, the painter came from a family of doopsgezinden (Mennonites). His grandfather, Pieter Lodewijcksz., had been forced to leave his home town of Brussels because of his religious convictions and—after prolonged stays in both 's-Hertogenbosch and Harlingen—had become, in 1588, a citizen of Amsterdam, where he kept a grocer's shop in the Kalverstraat. In 1593 he had his two sons, Jan (who was to become the artist's father) and Lodewijck, baptised into the Reformed Church. In 1633, two years after the death of his wife, Jan Pietersz. van den Eeckhout was married to Cornelia Willemsdr. Dedel (1594–1660), the daughter of a wealthy director of the East India Company's office in Delft. The ambitious father's second marriage brought about a rise in the family's social standing and an increase in prosperity.

Arnold Houbraken (1718) wrote that Gerbrand trained under Rembrandt, without, however, specifying the precise dates. As the earliest surviving painting by Eeckhout is dated 1641, we may assume an apprenticeship between 1635 and 1640/41. The original teacher-pupil relationship seems to have developed later into an enduring friendship. In his biography of the Amsterdam landscape painter Roelant Roghman, Houbraken describes Roghman and Eeckhout as friends of Rembrandt. Recently discovered archival material documents the existence of a friendly relationship between Roghman and Eeckhout: in his will the latter referred to Roghman as 'zijn testateurs oude bekende' ('being an old acquaintance of the testator') and bequeathed him 50 guilders. This increases the credibility of Houbraken's assertion about the friendship between each of the artists and Rembrandt. Jan Claesz. Leijdecker, Gerbrand's uncle and godfather, is among those portrayed in Rembrandt's so-called Nightwatch *of 1642.*

Gerbrand van den Eeckhout, who never married, was repeatedly appointed by official circles to advise on, and value, paintings. He had connections with Amsterdam scholars, and he is known to have exchanged verses with poets of that city. He was among the most productive and versatile of Rembrandt's pupils. His oeuvre includes paintings, drawings and etchings as well as designs for goldsmith work, ornamental engravings and book illustrations.

The great majority of Gerbrand's paintings show subjects taken from the Bible, mythology, history and episodes from Antiquity. In addition, he produced individual and group portraits, as well as landscapes. An extensive group of genre scenes, showing social amusements and music-making, as well as scenes of military life, assume a significant place in the historical development of Dutch art. The earliest of Eeckhout's history paintings testify to his interest in the work of Pieter Lastman, whose style of figure painting continued to be of importance for him. He was able to steer a path deftly between Lastman's style of narrative and the models provided by Rembrandt. Eeckhout's finest works are compelling in their choice colouring and carefully rendered surface, without, however, creating the impression of a merely routine refinement. A subdued colourfulness alternates with chiaroscuro values reminiscent of Rembrandt. Thomas Pieter Binnius is the only documented pupil of Eeckhout, although no works attributable to him have so far been identified.

Gerbrand van den Eeckhout died on 26 September 1674 in his home town of Amsterdam. At the end of his life he occupied a house in the elegant Herengracht together with the widow of his brother Jan, who had died in 1669, and whose children are mentioned in his will. To his nephew (who was also his godson and namesake) he bequeathed the proceeds from the sale of his artistic estate—consisting of drawings, prints, plaster casts and so on—as well as a gold ring with a diamond which had been owned by his father.
V.M.

70

Attributed to

GERBRAND VAN DEN EECKHOUT

The Tribute Money

Canvas, 63 × 84 cm; signed and dated, by an unknown hand, at lower left: *Rembrandt f. 1655* Bywell, Northumberland, The Viscount Allendale's Trustees.
Only exhibited in Amsterdam and London

Provenance: (?) Prince Phillipe François de Rubempré sale, Brussels, starting on 11 April 1765; J. Blackwood sale, Christie's, London, 20–21 February 1778; Robit sale, Paillet, Delaroche, Paris, 11–18 May 1801, No. 116 (sold for 8850 francs, to Lafontaine); J. Webb sale, Phillips, London, 30–31 May 1821 (sold to Raile); S. Clarke sale, Christie's, London, 8–9 May 1840, No. 31 (sold, for £630, to Woodburn, year given as 1645); 1853, Woodburn art dealers, London; W. Ellis sale, Christie's, London, 27 May 1876, No. 85 (sold to W.B. Beaumont, later Lord Allendale).

Literature: Smith 111 (year given as 1645); Bode 1883, pp. 508 ff; Bode 1897–1906, Vol. VI (1901), p. 38 403; Valentiner 1905, p. 94; Hofstede de Groot 1915, p. 73, No. 118; Weisbach 1926, pp. 458–60 and Fig. 142; Van Rijckevorsel 1932, pp. 199 ff.; Bredius 586; Benesch 1944, p. 299; Hamann 1948, p. 381 (work of a pupil); Van de Waal 1952, Vol. I, p. 217 and note 3 (Rembrandt, but according to H. Schneider and G. Falks, contribution by Eeckout); Nordenfalk 1956, pp. 81 ff. and Fig. 8; Sumowski 1957/58, p. 231 (probably by Eeckhout); Bauch 85; Bredius/Gerson 586; Gerson 276; Sumowski 1983 ff., Vol. II, p. 744, at No. 486 (work of a pupil); in all cases, except where otherwise noted, assumed to be by Rembrandt.

Exhibitions: London, 1815; London, 1899, No. 21; Yokohama, Fukuoka, Kyoto, 1986/87, No. 9.

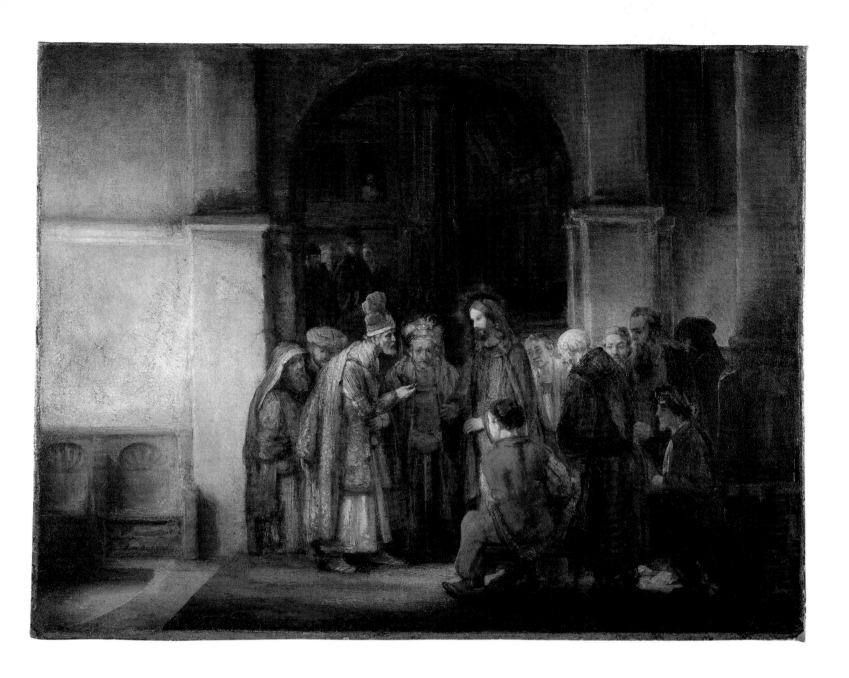

The gospels according to Matthew (22:16–21), Mark (12:13–17) and Luke (20:20–26) report, in almost identical words, on the enemies of Christ, who tried to outwit him with a trick question so as to exploit his answer as a charge against him. The group sent by the Pharisees and Herodians at first hypocritically pretend to acknowledge Christ's truthfulness. In answer to their final question as to whether payment due to the Emperor in the form of taxes ought to be made, Christ asks to be shown a coin on which he points to the image and inscription of the Roman Emperor: 'Then saith he unto them, Render therefore unto Caesar the things which are Caesar's; and unto God the things that are God's. When they had heard these words, they marvelled, and left him, and went their way' (Matthew 22:21f.).

The depicted scene clearly takes place in the precinct of the Temple. In the wall running parallel to the picture plane there is an entrance flanked by columns and topped by a rounded porch. Through this opening, we can see monumental architectural structures, blurred by distance, with people strolling about in front of them. The arch surrounds and centres the symmetrically arranged main group in the composition, which consists of a frontally viewed Pharisee, a further opponent of Christ, and Christ himself, the last two figures being placed in profile view, opposite each other. The upper torsos and heads of these figures are lightly bent towards the coin that the spokesman of the group holds in his bent right hand to show the others. In the right foreground, a group of Christ's disciples follow the event with rapt attention, keenly alert.

The two Pharisees are accompanied by two men placed diagonally behind them, but still within the span of the arch.

The Dutch poet Joost van den Vondel, in his panegyric on the official opening of Jacob van Campen's new Town Hall in Amsterdam in 1655, refers to several decorative scenes, including one of the New Testament subject of the tribute money.[1] Regrettably, he mentions neither the artist's name, nor the precise placing of this scene within the decorative scheme of the building. The present painting, therefore, has attracted speculation in a number of respects in connection with Rembrandt's part in the decorative programme for the town hall; but no convincing answers have emerged from this.[2] For this reason, the question as to if, and to what extent, a connection may be made with the works commissioned by the Amsterdam Regents for their ambitious new building, must be excluded from the following discussion.

When Wilhelm Bode discussed the painting in 1883, in his *Studien zur Geschichte der Holländischen Malerei*, in the context of his consideration of Rembrandt's artistic development, he assessed the picture as follows: 'Although somewhat negligent in the drawing and, in part, also in the characterisation of the figures, the picture nonetheless provides evidence, in it colouring, that the uniform and oppressive tonality of most pictures of this period were largely only an expression of Rembrandt's mood, and that he was thus, on occasion, also able to paint a picture with his former strength and splendour of colouring'.[3] Bode, in effect, plays down the weakness he

70a: Albrecht Dürer, *The Marriage of the Virgin.* Woodcut.

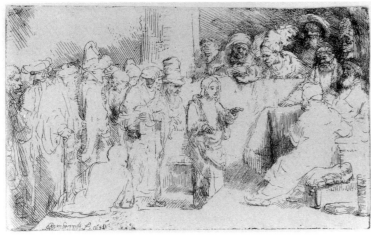

70b: Rembrandt, *The twelve-year-old Christ among the Scribes.* 1652. Etching (Bartsch 65).

70c: Gerbrand van den Eeckhout, *The Tribute Money.* 1674. Lille, Musée des Beaux-Arts.

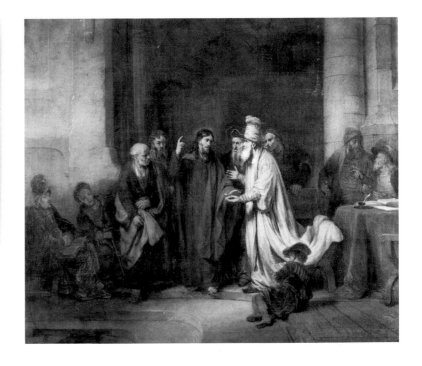

notes in both the extent of linear construction and the style of the figures, by reference to the picture's colouring. While he notes that the colourfulness harks back to earlier examples within Rembrandt's œuvre, he perceives this nonetheless—with regard to the date of the painting—as a positive exception in comparison with the works painted by the master at almost the same time, with their markedly reduced colour. By this means, Bode himself—even though this was possibly not his intention—formulated crucial arguments against the attribution of the work to Rembrandt. Hamann was the first to take these to their logical conclusion in describing the *Tribute Money* as the work of a pupil. While Bauch adheres to the attribution to Rembrandt, Gerson leaves open the question of authorship.

In many respects, the painting may be seen as a compilation from various sources of motifs and types of composition and, thus, as the work of a pupil. The central trio in front of the arch follows, in a modified form, the woodcut (Bartsch 82) with the marriage scene from Dürer's *Life of the Virgin* (Fig. 70a).[4] There are also connections with elements such as the dominating stone niche behind the figure of Christ in Rembrandt's *Supper at Emmaus* of 1648, now in the Musée du Louvre in Paris,[5] and the background of the etching of 1651/52 with *Christ Teaching* (Bartsch 67; 'La petite tombe'). Rembrandt's etching (Bartsch 65) *Christ among the Scribes* (Fig. 70b), was made in 1652. The male figure seated in the right foreground of the etching provided the model for the back-view figure dressed in red in the painting.

The planar construction of the architecture of the interior of the Temple, which consists of both immediate and distant space, serves merely as a foil for the play of light, which has here taken on a certain independence. There is no trace of the characteristic features of the Biblical stories of Rembrandt's late period, such as the atmospheric 'melting' of ambiguous space—achieved through the use of light and shadow and intended to increase the dramatic aspect of the scene—or the tendency to give individual figures a certain monumentality. The structure of the composition, the narrative style and the arrangement of space in the scene suggest, rather, an artist striving to equal works by Rembrandt from the 1640s. Particularly close in this respect is Rembrandt's *Christ with the Woman taken in Adultery* of 1644, now in London.[6]

Bode's criticism of the figures is justified. To some extent, regardless of whether Pharisees or disciples of Christ, they seem like inanimate staffage. The application of paint alternates between sketchily and summarily treated passages, and an exaggerated attention to detail; but a texturing of the surface through colour—as would be typical of Rembrandt's work—is not achieved.

There are no direct connections to scenes of the same subject by Rembrandt. The authenticity of the painting of 1629, now in the National Gallery of Canada in Ottowa, has rightly been questioned;[7] and the etching of about 1635 (Bartsch 68) with the dynamically moving figure of Christ at its centre, reveals more differences than similarities.

The picture has repeatedly been connected with Gerbrand van den Eeckhout. With regard to the architecture, the figure types, and the costumes, this would appear understandable. In numerous paintings from about 1650 Eeckhout looked increasingly to the style and treatment of space in Rembrandt's paintings of the 1640s. A superficial affinity is to be found in the comparison with Eeckhout's *Tribute Money* in the Musée de Beaux-Arts in Lille, a late work by the artist, dated 1673 (Fig. 70c).[8] Nonetheless, the similarities are limited to specific motifs, for example the figure of the Pharisee with the high hat, and the division of space through the use of a wall with an entrance placed parallel to the picture plane. It is not the painting of 1655, but rather Rembrandt's already mentioned etching (Bartsch 68) that here represents a point of reference for Eeckhout's own approach, especially as far as the figure of Christ is concerned. If one also takes into account in this comparison Eeckhout's signed and dated picture of 1658, *Christ in the Synagogue at Nazareth* (Cat. No. 71), it becomes clear why there has been disagreement concerning the attribution of the painting of 1655.

Among elements in the Dublin painting counting against an attribution of the *Tribute Money* to Eeckhout,[9] are the clear and balanced construction, the compelling arrangement and distribution of the figures in the foreground and middle-ground, and the lively and striking characterisation of the physiognomies—all broadly typical of Eeckhout's works. Eeckhout always applied colour with regard to the nature of the depicted form, and he aimed at rembrandtesque effects through emphatic layerings in the distribution of light and shade. Rembrandt's so-called 'rough' manner of applying paint was not adopted by Eeckhout. The painting in Dublin is also distinct in its painstaking treatment of the surface, as against the free manner of painting in the Allendale picture, especially in the costume of the Pharisee with the hat.

V.M.

1. See J. van den Vondel: *Inwijdinge Van't Stadthuis t'Amsterdam. Toegeigent Den E. E. Heeren Burgemeesteren en Regeerderen der zelve Stede* (Amsterdam 1655), verse 1156: 'En elders hoe men Gode en Cezar tol betaelt/Door last van't eeuwigh Wort, zoo lang in Kracht gebleven', cited in *De werken van Vondel*, ed. J.F.M. Sterck, H.W.E. Moller et al., Vol. v (Amsterdam, 1931), p. 898.
2. In particular, Van de Waal 1952. Vol. I, pp. 216 ff., has considered the subject recorded by Vondel in the context of the programme for the Amsterdam Town Hall. He assumes that the *Tribute Money* of 1655 in the Allendale collection is a form of *modello* made by Rembrandt in connection with a commissioned work eventually not carried out; on this matter, see also Nordenfalk 1956, passim. The connection established by Van der Waal between the painted architecture in the picture and the actual architecture of the Town Hall as it was built is only of a general nature and does not constitute a compelling link with the decorative programme. According to Gerson in Bredius/Gerson, No. 586, in 1919 F. Schmid-Degener already proposed a connection between the painting and Vondel's poem.
3. Bode 1883, pp. 508 ff.
4. This is especially clear if one considers the case of an anonymous pupil's drawing, now in the collection of the Dresden Kupferstich-Kabinett (from the collection of Friedrich August II), see W.R. Valentiner: *Rembrandt: des Meisters Handzeichnungen*, Vol. I (Klassiker der Kunst, Vol. XXXI), (Stuttgart/Berlin/Leipzig, n. d. [1925]), p. 419, No. 400, with illustration. The central trio of Christ and the two Pharisees is similarly oriented to the work of Dürer, but this cannot be considered as a possible drawn copy after the painting because of differences in the subsidiary figures. Valentiner (as above), p. 490, No. 400, and Sumowski 1961, p. 23, No. C79, have rightly referred to Rembrandt's *Ecce Homo* etching (Bartsch 76) in connection with the figure of the Pharisee with the coin. In the Rembrandt etching the treatment of both the movement and pose of this figure appears, in reverse, in that of the man in front of the right entrance steps who mocks Christ. This circumstance does not, however, count against the possible derivation of both figures from Dürer's woodcut. Unlike Benesch Vol. VI, C79, Sumowski (as above) does not believe the Dresden drawing to be a copy. Valentiner, 1905, p. 94 was the first to note the connection of the painting with Dürer's *Life of the Virgin*.
5. Bredius 578; Bauch 82; Gerson 218; Bredius/Gerson 578; Tümpel 69.
6. Bredius 566; Bauch 72; Gerson 208, Bredius/Gerson 566; Tümpel 63.
7. On the painting in Ottowa, see, most recently *Corpus* C7 (work of a pupil from Rembrandt's immediate circle, not earlier than 1631).
8. See Sumowski 1983 ff., Vol. 2, p. 744, No. 486, p. 849, with colour illustration.
9. Unlike the author, who is preparing a monograph, with catalogue raisonné, on the paintings of Eeckhout, Christopher Brown (verbal communication) accepts the attribution of the picture to Gerbrand van den Eeckhout.

71

GERBRAND VAN DEN EECKHOUT

Christ teaching in the Synagogue at Nazareth

Canvas, 61 × 79 cm
Signed and dated at lower right: *G.V. Eeckhout Fe. A⁰ 1658.*
Dublin, National Gallery of Ireland; Inv. No. 253

Provenance: Van Zwieten sale, The Hague, 12 April 1741, No. 139 (sold, for 200 florins to Synthoff); J.B. Horion sale, Brussels, 1 September 1788, No. 159 (sold, for 255 francs, to Fouquet); Coclers sale, Lebrun, Paris, starting on 9 February 1789, No. 87 (refers to date as 1658; sold, for 981 francs, to Marin); Marin sale, Lebrun, Paris, 22 March 1790, No. 176 (sold, for 416 francs, to Saubert); H. de Zoete sale, Christie's, London, 9 May 1885, No. 223 (sold, for £122, to the museum).

Literature: Armstrong 1890, p. 286; Roy 1972, pp. 68 ff., 219, No. 58 *Christ and the Scribes*; Nystad 1975, p. 147 and Fig. 30 *Christ in the Synagogue at Nazareth*; *National Gallery of Ireland: Illustrated Summary Catalogue of Paintings* (Dublin, 1981), p. 42 with illustration; Potterton 1982, pp. 104 ff. and Fig. 2; Sumowski 1983 ff., Vol. II, pp. 721, 733, No. 428, p. 791, with illustration; Potterton 1986, p. 43 253 and Fig. 54.

Exhibition: London, 1985, No. 26.

The painting—its signature and its date of 1658 were only revealed when cleaning was undertaken in 1981[1]—shows Christ teaching on the Sabbath in the synagogue of his home-town, Nazareth. Nystad related the subject to Luke 4:16–21,[2] 'And he came to Nazareth, where he had been brought up: and, as his custom was, he went into the synagogue on the Sabbath day, and stood up for to read. And there was delivered unto him the book of the prophet Esaias. And when he had opened the book, he found the place where it was written … And he closed the book, and he gave it again to the minister, and sat down. And the eyes of all them that were in the synagogue were fastened on him, And he began to say unto them, This day is this scripture fulfilled in your ears.'

In the painting, the seated figure of Christ points with his raised left hand to the prominently placed figure of a white-bearded scribe holding a folio volume. This indicates that the scene may be identified with the cited verses of the Luke, even though the text speaks of a server (minister) who receives the book from Christ. It is not possible to refer to an extensive iconographic tradition for the subject, and it seems to have been only very rarely treated outside the realm of Netherlandish history painting. An exception is to be found, however, in the case of a wood-cut illustration by Lieven de Witte for Willem van Branteghem's *Dat leven ons Heeren* (The Life of Our Lord), of 1537 (Fig. 71a).[3] Here, true to the Biblical text, the seated figure of Christ passes the book to a simply dressed server, who takes it from him respectfully. By comparing Eeckhout's work with the drawings and etchings of Rembrandt, Nystad was able to demonstrate the probability that Eeckhout too derived his seting for the scene in following the model of a Jewish *sjoel*—a place for study

attached to a synagogue. The wooden partition with a bench is a characteristic piece of furniture for this type of interior.[4]

Rembrandt's *Hundred Guilder Print* (Bartsch 74), as well as his etching of *Christ Teaching* (Bartsch 67, 'La petite tombe'), clearly influenced Eeckhout's composition, especially with regard to the central placing of the figure of Christ. Eeckhout's group of reading figures placed in front of the arched entrance that can be made out at the far left of the picture's background, reveals Eeckhout's knowledge of Rembrandt's *Tribute Money* etching (Bartsch 68) from the mid-1630s.[5] Meanwhile, as Sumowski has remarked,[6] the Pharisee standing in a raised position diagonally behind Christ is another Rembrandt etching (Bartsch 65) may be connected with Eeckhout's *Twelve-year-old Christ among the Scribes* (see Fig. 70b). For his treatment of space in the Dublin picture, Eeckhout took his starting point in works by Rembrandt from the 1640s. Eeckhout's own contribution, however, is to be found in the picture's colouring and in the very varied characterisation of his figures.

The painting is to be counted among the artist's most accomplished works: it shows that he offers a balanced alternation of transformed rembrandtesque compositional devices and something individual, without thereby giving the impression of routine ecclecticism.

V.M.

1. See Potterton 1982, pp. 104 ff.
2. Nystad 1975, p. 147.
3. The book, which appeared in Antwerp in Latin and Dutch, contains extensively illustrated and combined gospel texts; on this, see Ilja Veldman and Karen van Schaik, *Verbeelde boodschap: De illustraties van Lieven de Witte bij 'Dat leven ons Heeren' (1537)*, Haarlem and Brussels, 1989.
4. Nystad 1975, passim.
5. Pointed out, most recently, by Potterton 1986, p. 43.
6. Sumowski 1983 ff., Vol. II, p. 733, at No. 428.

71a: Lieven de Witte, *Christ in the Synagogue at Nazareth*. 1537. Woodcut.

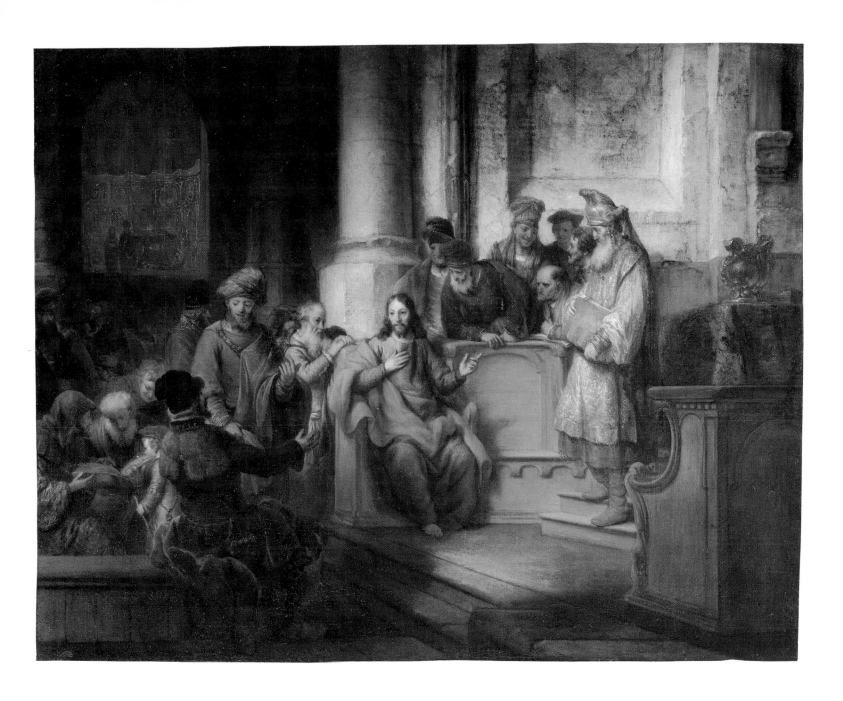

Samuel van Hoogstraten
(1627–1678)

He was born in Dordrecht on 2 August 1627. According to his own account[1] he was first a pupil of his father, Dirck van Hoogstraten, and then, after the latter's death in December 1640, of Rembrandt in Amsterdam; among his fellow-pupils in Rembrandt's studio were 'Fabritius' (Carel, not Barent), Abraham Furnerius and Constantijn van Renesse. By April 1648 he had returned to Dordrecht. In May 1651 he travelled to Vienna, where he worked for the Emperor. In 1652 he was in Rome; he was back in Vienna by the following year. He was in Dordrecht late in 1654 and remained there until he left for London, which was before September 1662. He was still in London at the time of the Great Fire in September 1666—there is an account of it in his Inleyding—*but returned to Holland shortly afterwards. He settled first in The Hague, where he joined the painters' confraternity, Pictura, in January 1668. He had finally returned to Dordrecht where he was one of the two Provosts of the Mint by 1673. In the following years he was at work on his* Inleyding tot de Hooge Schoole der Schilderkonst, *which was published in 1678. Hoogstraten, who was a poet as well as a painter, died in Dordrecht on 19 October of that year.*

He painted genre scenes, portraits, architectural fantasies and religious subjects; according to Houbraken,[2] who was his pupil, he also painted landscapes, marines, animals, flowers and still lifes. His early work is in a rembrandtesque style but he soon abandoned this. Hoogstraten mentions his great interest in illusionistic painting and he made peepshows, of which there is a fine example in the National Gallery in London.[3] In addition to Hoogstraten, Godfried Schalcken (who later went to join Dou) and Aert de Gelder (who joined Rembrandt), were among his pupils.
C.B.

72
Attributed to
SAMUEL VAN HOOGSTRATEN
Young Woman at an open Half-Door

Canvas, 102.5 × 85.1 cm
Signed, bottom centre: *Rembrandt f. 1645*
Chicago, Art Institute; Inv. no. 1894.1022

Provenance: De Gueffier Collection, Paris; his sale, A.J. Paillet, Paris, 1 March 1791, No. 67: 'une jeune Fille du pays de Frise, appuyée devant une croisée', sold in the same lot as a second painting by Rembrandt of exactly the same dimensions—36 pouces high by 30 wide—and also on canvas 'de forme ceintrée par le haut' showing 'un jeune Guerrier vu à mi-corps & de face, ajoute d'une armure; il est dans l'attitude de boucler son ceinturon'; Robit collection, Paris; his sale, A. Paillet and H. Delaroche, 11 May 1801, No. 120: 'le portrait d'une jeune paysanne de Nord-Hollande'; said to be a pendant to No. 119: 'Le portrait d'un jeune guerrier, proportion de nature. . .'[1] Bought for 3450 francs by Hibbert; collection of George Hibbert, London; his sale, Christie's, London, 13 June 1829, No. 68; collection of Nathaniel Hibbert, until at least 1857(?); collection of Prince Paul Demidoff; his sale, Florence, Palazzo San Donato, 15 March and subsequent days, 1880, No. 1114 (unsold); sold by Princess Demidoff (formerly Lise Troubetzkoi) to Martin A. Ryerson, Chicago, June 1890; Presented by Mr Ryerson to the Art Institute in 1894.

Literature: Bredius/Gerson 367; Bauch 507; Gerson 248.

Exhibitions: London 1818, No. 100; London 1844, No. 23; London, 1857, No. 87; Chicago 1890, No. 5; Chicago 1893, No. 5; New York 1909, No. 91; Detroit 1930, No. 42; Chicago 1933, No. 75; Chicago, 1934, No. 107; Amsterdam 1935, No. 12; Chicago 1935–36, No. 4; Worcester 1936, No. 4; Chicago 1942, No. 27; Philadelphia 1950–51, No. 37; New York, Toledo, Toronto 1954–55; Chicago, Minneapolis, Detroit, 1969–70, No. 8.

Engraving: By C.G. Geyser (1772–1846)

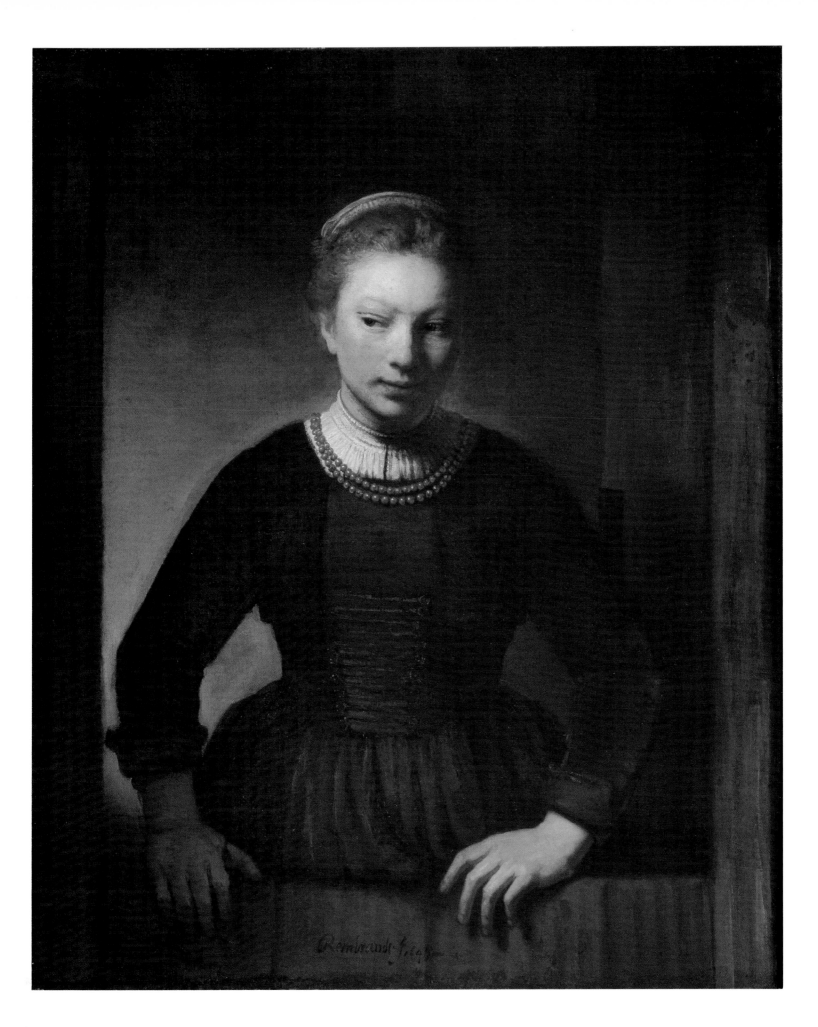

This painting has a distinguished provenance, having been in the De Gueffier, Robit and Demidoff collections in the eighteenth and nineteenth centuries. It has been much admired as an outstanding example of Rembrandt's sympathetic treatment of young female sitters and has been the subject of fanciful identifications. Emile Michel in 1893 thought her an orphan of the Municipal orphanage in Amsterdam,[2] as did Bode in his 1900 catalogue.[3] Valentiner thought that she might be Hendrickje Stoffels,[4] an idea mentioned by Bredius,[5] denied by Jakob Rosenberg[6] and raised again by De Vries.[7] Bauch, followed by Kusnetzow,[8] suggested that she might be Geertje Dircks. In fact she bears no significant resemblance to the sitters in paintings which are generally thought to show Rembrandt's mistresses (Cat. Nos. 36 and 45).

The general compositional scheme of the painting is based on Rembrandt's *Portrait of Agatha Bas* (Cat. No. 35), in which the sitter is placed within a niche, but it belongs with a group of pictures which do not fall into the category of portraiture. They include *A young Girl leaning on a Window-sill*, also dated 1645, in the Dulwich Picture Gallery (Bredius 368) (Fig. 72a), the *Young Girl at a Window* of 1651 in the Nationalmuseum, Stockholm (Bredius 377) and *A young Girl holding a Broom* in the National Gallery of Art, Washington (Bredius 378). In my view, only the first of these is certainly by Rembrandt and it is with this painting that the Chicago picture should be compared. It was on the basis of this

comparison that Gerson questioned the attribution to Rembrandt in 1968, pointing out that it is 'much stiffer and less sensitive' than the Dulwich painting. He thought that 'this might be due to the patching work of later restorers, but then again it may be the original work of a pupil (Jan Victors?), basing himself on a Rembrandt design.' Bode had, as early as 1883, commented on the poor state of preservation of the painting, describing it as a ruin because of the restoration and heavy overpainting. The painting is indeed in a relatively poor state, having suffered through overcleaning in the past and the paint layer having been flattened by harsh relining. There is substantial abrasion in the background, the flesh tones and in the dress.[9]

The Dulwich painting shows a young girl leaning her elbows on a stone sill. The elaborate arrangement of her hair and her gold necklaces suggest that she is not wearing contemporary dress but is in historical costume and that she is intended to represent a Biblical, presumably Old Testament figure. There can be no doubt, however, that the Chicago girl is wearing contemporary dress. Indeed, her dress with its short jacket and laced bodice, is a regional costume and it was presumably for this reason that she was described as Frisian in the catalogue of the De Gueffier sale and as from North Holland in that of the Robit sale. In fact, her costume is from Waterland, the area just to the north-east of Amsterdam. A closely comparable costume can be seen in a painting of about 1570 (Fig. 72b). Rembrandt's model was probably a married woman, as unmarried women in Waterland costume wore ribbons in their hair.[10] Many women from Waterland were domestic servants in Amsterdam. Geertje Dircks, who entered Rembrandt's household as a nurse for Titus after Saskia's death, was from Edam in Waterland. Rembrandt shows a woman in a related costume in two drawings.[11]

It was Josua Bruyn who first associated the name of Samuel van Hoogstraten with the Chicago painting in a review of the second volume of Sumowski's *Gemälde der Rembrandt Schuler*.[12] Sumowski had attributed to Hoogstraten a painting of a *Young Man at a half-open Door* (Cat. No. 74), formerly thought to be by Nicolaes Maes, which is in the Hermitage, on the basis of stylistic comparison with the *Self-Portrait with a Medallion on a Gold Chain* of 1645 in the collection of the Prince of Liechtenstein at Vaduz (Cat. No. 73). Sumowski had also noted that there is a preparatory drawing for the Hermitage painting in the Kupferstichkabinett, Berlin (Fig. 74a).[13] Bruyn concurred with these

72a: Rembrandt, *Girl leaning on a window-sill*. 1645. London, Dulwich Picture Gallery.

72b: Attributed to J. van Horst, *Girl from Edam*. c.1570, panel. Amsterdam, Rijksmuseum (destroyed).

attributions and then extended the argument by pointing to the Leningrad painting as the immediate compositional prototype for the Chicago picture, which he also considers to be by Hoogstraten. It is that argument which is presented in visual terms in this section of the exhibition. It is hoped that the juxtapositions will demonstrate that it is possible to move from the securely documented *Self-Portrait* of 1645 to the Leningrad *Young Man* and then to the Chicago *Young Woman* and that all display the same stylistic characteristics, permitting the attribution of the latter two to Samuel van Hoogstraten. Bruyn also introduced into the argument a drawing of a seated young woman in the Bibliothèque Nationale, Paris,[14] the tilt of whose head and position of whose upper body are similar to those of the *Young Woman* in Chicago. Following Sumowski, he considers this drawing to be by Hoogstraten and suggests that the model may be the same woman as in the Chicago canvas.

The signature is similar in its orthography to authentic signatures by Rembrandt but is placed in an unusually prominent place, when compared with, for example, the signature on the Dulwich painting, which is tucked away on the right hand side. According to a condition report made on the painting at the Art Institute 'it is consistent with the painting in terms of pigment particle size, craquelure and distressing. It also lies directly on the underlying paint surface without the presence of an interceding varnish.'[15] If, therefore, the signature was applied before the picture was varnished, it must have been done soon after its completion, perhaps with the date on the Dulwich picture in mind.

C.B.

1. This painting cannot now be identified with certainty.

2. Michel 1893, pp. 303, 561–62.

3. Bode 1900, Vol. 4, No. 301.

4. Valentiner, *Rembrandt Paintings in America*, New York, 1931, No. 90.

5. Bredius, 1st edition (1936)

6. Rosenberg 1948, Vol. 1, pp. 50–51.

7. A.B. de Vries, *Rembrandt*, Baern 1956, p. 54.

8. J. Kusnetzow, 'Neue Forschungen zu Rembrandts "Danae"', *Bildende Kunst*, 7 (1970), p. 377.

9. I am most grateful to Frank Zuccari, Head of the Conservation department at the Art Institute of Chicago, who sent me a condition report on the painting.

10. My thanks to Simon Honig Jansz., Keeper at the Nederlands Openlucht Museum, Arnhem, who kindly identified the costume.

11. Benesch 1973, Nos. 314, 315. Benesch describes the costume as from Zeeland but in fact (according to Mr Honig) it is from Waterland. Benesch dates these drawings to 1636.

12. *Oud Holland*, 101 (1987), pp. 230–31.

13. Red crayon, pen and brown ink, and brown wash, 237 × 187 mm. Inv. No. 11974. Sumowski, *Drawings*, 5, No. 1261. Bock and Rosenberg (1930, p. 211) had attributed it to Ploos van Amstel. Lugt (1931, p. 55) attributed it to Hoogstraten but thought it a copy of the Leningrad painting which at that time was attributed to Maes. Sumowski pointed out that the corrections to the drawing make it clear that it is preparatory to the painting.

14. Black and red chalk, pen and brown ink, brown wash, 205 × 157 mm. Sumowski, *Drawings*, 5, No. 1260.

15. See note 9 above. Mr Zuccari continues 'Thus if the signature were spurious it could only have been added very early in the life of the picture and would have required the prior removal of any existing varnish. In my opinion the signature is integral to the painting.'

73

SAMUEL VAN HOOGSTRATEN

Self-Portrait with a Medallion on a gold Chain

Panel, 55 × 46 cm
Signed, to the right of the sitter's shoulder,
S. v. H. / 1645
Vaduz, Collection of the Prince of Liechtenstein

Literature: Veth 1889, p. 145; Thieme-Becker,
Vol. 17, p. 464; Sumowski, *Drawings*, Vol. 5,
2472; Sumowski, *Gemälde*, Vol. 2, 851.

Copy: Braunschweig, Herzog Anton Ulrich-
Museum, Inv. No. 1022 (panel, 60 × 46 cm)[1]

Hoogstraten, conscious no doubt of the
example of Rembrandt, painted a number of
self-portraits in the years around 1644 and
1645. The earliest dated example is the *Self-
Portrait in a pearl-fringed beret and an ermine collar*
in the Bredius Museum, The Hague, which is
dated 1644.[2] In the same year is the
melancholic *Self-Portrait with Vanitas Still-life*
in Rotterdam.[3] Rembrandt's influence can
clearly be seen in the *Self-Portrait in fantastic
dress in a window* (Fig. 73a),[4] on loan to the
Dordrecht Museum from a private collection,
which is based on Rembrandt's 1640 *Self-
Portrait* (Cat. No. 32).

This composed and self-confident self-
portrait was painted in 1645, when the artist
was 18. At this time he was probably still in
Rembrandt's studio, as he is not recorded back
in his native Dordrecht until 1648. The subtle
shading, broad strokes in the hair and costume
and careful build-up of the features of the face
are similar to the Chicago *Young Woman* and it
is on such stylistic similarities that the
attribution of that painting to Hoogstraten
depend.

C.B.

1. In his Catalogue of the Dutch paintings at
Braunschweig (*Herzog Anton Ulrich-Museum,
Braunschweig. Die Hollandische Gemälde*,
Braunschweig,1983, p. 101, No. 1022), Rudiger
Klessmann has argued that the painting may be an
autograph replica.
2. Panel, 63 × 48. Signed, middle right and dated
16(.)4. Bredius Museum, The Hague (56–1946).
Sumowski, *Gemälde*, 2, No. 847.
3. Panel, 58.4 × 73.9 cm. Signed, on the edge of the
table, and dated 1644. Rotterdam, Museum Boymans-
van Beuningen. Sumowski, *Gemälde*, 2, No. 849.
4. Canvas, 98 × 80 cm. Amsterdam, Collection of
Mr W. Russell. Sumowski, *Gemälde*, 2, No. 852

73a: Samuel van Hoogstraten, *Self-Portrait in
fantastic costume at a window*. Dordrecht Museum,
on loan from Mr Willem Russell.

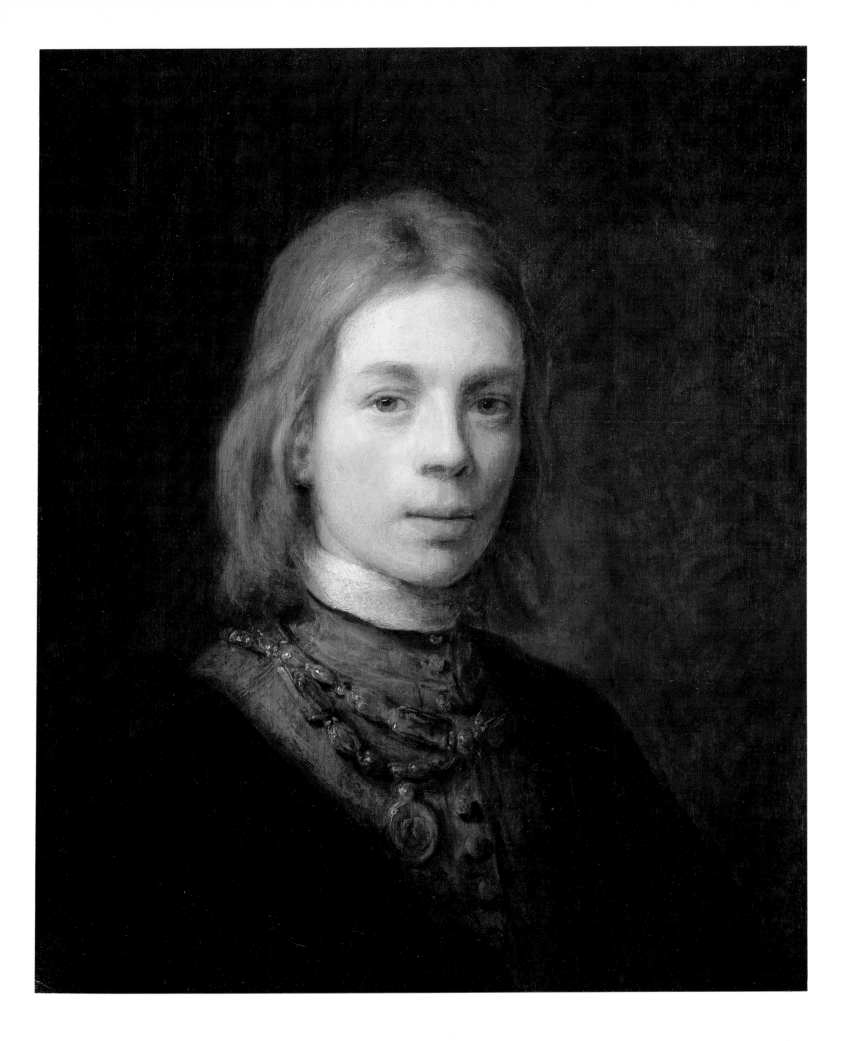

74

SAMUEL VAN HOOGSTRATEN

A young Man wearing a Hat decorated with Pearls and a gold Medallion in a Half-Door

Canvas, 42 × 36 cm
Hermitage Museum, Leningrad

Provenance: Semenoff Collection, St Petersburg (1906 Catalogue, No. 278)

Literature: Hofstede de Groot, Vol. 6, 1915, No. 111 (Maes); Hermitage Catalogue 1958, No. 2812 (Maes, in about 1652); Sumowski, *Drawings*, Vol. 5, under, No. 1261 ('might be an early work by Samuel van Hoogstraten'); Sumowski, *Gemälde*, Vol. 2, No. 856 (Samuel van Hoogstraten).

Traditionally this painting has been attributed to Nicolaes Maes. It is related, however, to a drawing (Fig. 74a) now in Berlin, which Sumowski has shown to be preparatory to this painting because it contains significant changes which appear in the painting. The drawing is in the style of Samuel van Hoogstraten rather than in that of Maes. The painting can also be seen, despite its heavy layer of old varnish, to be close in style to a painting like Hoogstraten's *Self-Portrait* of 1645 (Cat. No. 73). It stands in an intermediary position between that picture and the *Young Woman at an open Half-Door* (Cat. No. 72) which is here attributed to Hoogstraten. It is hoped that the juxtaposition of the three paintings in the exhibition will confirm these attributions. This painting probably dates from shortly after the *Self-Portrait* of 1645, that is, in the second half of the 1640s.

C.B.

74a: Samuel van Hoogstraten, *Young man in a hat, at a half-door*. Drawing.
Berlin, Kupferstichkabinett SMPK.

Carel Fabritius
(1622–1654)

Carel Fabritius was baptised on 27 February 1622 in Midden-Beemster. His father, Pieter Carelsz., worked there as a teacher, a sexton, and as 'eerste voorsanger in der kercke' (precentor in the church). Outside school hours, he carried out his schildersampt *(office as a painter). In 1620 he was granted a licence from the town council for this additional occupation. Although none of the father's works is known, his artistic activity had its consequences. Three of his sons—Carel, his younger brother Barent (1624–1673), and Johannes—became painters. They must have learnt the basics of their profession from their father. In 1641 Carel and Barent became members of the Reformed Church. In the entry relating to this event, their names are both accompanied by the term* Timmerman *(carpenter). It would seem that Carel and Barent first worked as carpenters; but it is also possible that they adopted the term* Timmerman *as a surname. In September 1641, 'Carel Pietersz. Fabricius' (faber = smith, carpeter) married Aeltge van Hasselt. Shortly after their wedding, the couple moved to Amsterdam. There, Carel joined Rembrandt's workshop. Samuel van Hoogstraten, who was also working there, was later (1678) to recall 'Onzen Fabritius, mijn medeleerling' (our Fabritius, my fellow pupil). Having received his artistic training from his father, Carel was not only taught by Rembrandt, but must also have been his collaborator and 'stylistic double'. In view of the most recent attributions of works to Carel Fabritius, it would seem that he principally carried out commissions for portraits in the name of his master. As well as these, he probably painted* tronies. *Examples of this genre are, at any rate, cited in the estate inventory of his wife, who died in April 1643. Not long afterwards, Carel was once again in Beemster, about thirty kilometres north of Amsterdam. It is probable that he remained in contact with the Rembrandt studio. From about 1645, at the latest, he was working as an independent master. Around this time he painted his earliest signed picture,* The Raising of Lazarus (Warsaw, Muzeum Narodowe), *which is comparable in style to Rembrandt's works of the 1630s. The* Portrait of Abraham de Potter (Cat. No. 76), *dated 1649 or 1648, however, reveals Carel Fabritius with a style of his own. The figure is rendered with impressive clarity and strikingly placed against a pale background—not the characteristic dark of Rembrandt. Carel Fabritius is documented as being in Delft in 1650, where he married the widow Agatha van Pruysen. In 1652 he became a member of the Guild of Saint Luke, although*

he was only able to pay the membership fee of twelve guilders in two installments. In 1653 he undertook to repay the 620 guilders that he had borrowed in 1647 from Jasper de Potter. In the meantime the sum had risen, through accumulated interest, to 728 guilders. Financial worries oppressed Carel Fabritius to a considerable degree, and for this reason he took on inferior work. For 'een groot en eenighe cleijne wapenen' (one large and several small coats of arms), he received from the city the meagre sum of 12 guilders. He did, however, receive more important commissions. Hoogstraten (1678) reports that Carel provided trompe-l'oeil room decorations, and regrets that work of this kind was not to be found in royal residences or churches. Evidence of Carel's striving for illusionistic effect is to be found in his View of Delft, with the Window Display of a Dealer in Musical Instruments, *dated 1652 and now in the National Gallery in London, a scene with optical distortions, probably intended for a peep-show with a semi-circular back wall. The painter died when the Delft powder store exploded on 12 October 1654, on which occasion a quarter of the city was destroyed.*

Carel's artistic legacy has come deown to us in a fragmentary state. Including the most recent attributions only about fourteen pictures may at present be attributed to him. It is hardly possible to reconstruct with any degree of certainty the separate stages of his development from a representative of the Rembrandt school into the independent painter of his Delft years. To a certain extent each of his works remains isolated, and yet each provides evidence of an impressive originality of viewpoint, allowing us to understand something of the influence exerted by this most important of all Rembrandt's pupils. The works produced in the year of his death, among them the celebrated Goldfinch (Mauritshuis, The Hague) *or the* Gate Watch (Staatliches Museum, Schwerin), *convey the impression—however distinct each work is in detail—of clarity of form, colour and light that illustrates an approach towards objectivity. Pieter de Hooch and Jan Vermeer were to continue working in this manner.*

J.K.

1644(?)
Canvas; 124.5 × 100.3 cm, signed: *Rembrandt. f / 1644* (the year is placed slightly below the level of the 'f'; the lettering of the signature is not typical for Rembrandt and is not by his hand).[1]
Toronto, Art Gallery of Ontario.

Provenance: collection of L.B. Coclers; L.B. Coclers salew, S.S. Roos et al., Amstgerdam, 7 August 1811, No. 64 'La naiveté et la bonne humeur sont peintes dans la physiognomie de cette personne, le coloris est d'une vérité étonnante, d'un excellent dessein, trés-délicat, qui fait un extraordinaire à Rembrandt' (re-purchased, for 2400 guilders, by Roos); collection of Cardinal Fesch; Cardinal Fesch sale, Rome, 17–18 March 1845, No. 192, as 'Portrait of the Widow of Justus Lipsius' (sold, for 341(scudi); collection of Sir G.L. Holford, Dorchester House, London; Sir G.L. Holford sale, Christie's, London, 17–18 May 1928, No. 35; collection of R.Y. Eaton, Toronto; given by R.Y. Eaton (1956) and Mrs R.Y. Eaton (1966) to the Art Gallery of Ontario, Toronto.

Literature: Bredius/Gerson 369; Bauch 506; Gerson 249; Tümpel A113; *Corpus* C114.

Exhibitions: London 1851, No. 80; London 1862, No. 41; London 1893, No. 75; London 1894, No. 65; Amsterdam 1898, No. 64; London 1899, No. 69; Paris 1921, No. 41; London 1921/22, No. 32; Toronto 1935, No. 18; Detroit 1930, No. 45; New York, Toledo and Toronto 1954/55, No. 45; Vancouver 1966.

The picture shows an old woman sitting in an armchair. She is shown life-size, the lower picture edge cropping her figure at knee level. She supports herself by resting her right arm on the arm of the chair, and holds in her left hand a lace-trimmed handkerchief—a status symbol,[2] as is the precious ring which she wears on her right hand. She is otherwise dressed entirely in plain black, against which the white of her winged bonnet, her collar, her handkerchief and her cuffs are set off sharply. The flesh-tones enliven this austere contrast: her face, reflected in the light which enters

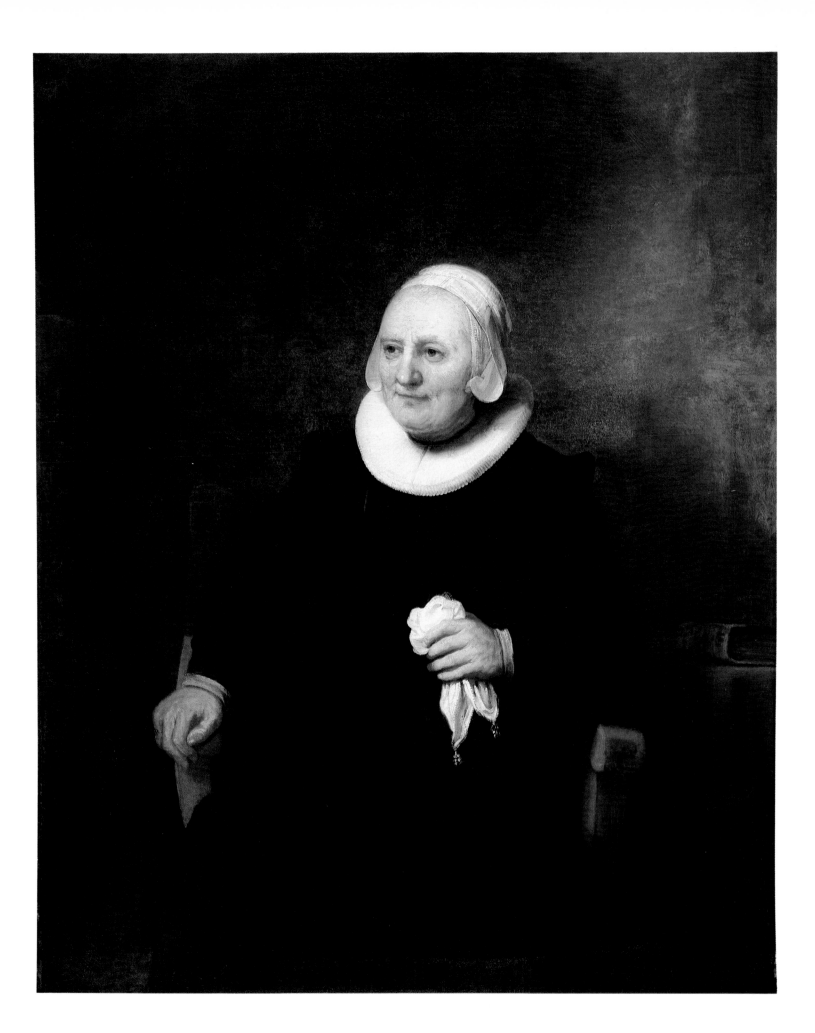

75a: Rembrandt (?), *Portrait of a Preacher* (?).
1644. Cologne, Wallraf-Richartz Museum.

75b: Rembrandt, *Portrait of the Preacher Anslo and his wife* (detail from Cat. No. 33).
Berlin, Gemäldegalerie SMPK.

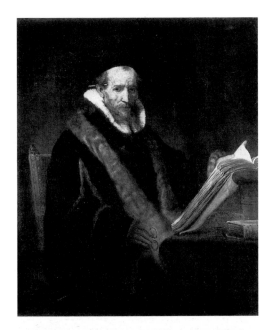

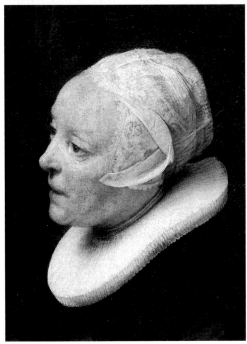

from the left, is notable for its varied colourfulness. The need for warmth is met by a richly nuanced, graduated pink, and the colouring of lips and cheeks, as well as by the addition of brown in the passages of darker tone. The brush-stroke is varied in direction, being used not only to apply colour, but also to impose structure. The image as a whole is striking. Perhaps the sitter had herself contributed to this effect, for her pose suggests self-assurance, as if she were used to such procedures. She sits upright in her chair, not looking at the book, which lies on a table to the right, but rather away from it to the opposite side of the room. The position of both hands and head underscores her movement, as does her glance that appears to fix on an object that lies outside the picture, to the viewer's left.

The woman's pose would lead one to assume the presence of a male pendant. Smith believed this to be the *Portrait of a Preacher* (?), also dated 1644, and now in Cologne (Fig. 75a).[3] Both paintings are included, though not as pendants, in the 1811 sale catalogue of the Coclers collection. At that time the picture in Cologne was regarded as a posthumous portrait of the philologist Justus Lipsius (1547–1606). Vosmaer, however, believed the sitter to be the Amsterdam pastor Jan Cornelisz. Sylvius, because of the similarity he noted with the two etched portraits of Sylvius made by Rembrandt in 1633 (Bartsch 266) and 1646 (Bartsch 280).[4] Sylvius (1564–1638) was married to Aaltje van Uylenburgh (1572–1644), an older cousin of Rembrandt's wife Saskia. Bredius has pointed out that portraits of the couple by Rembrandt are mentioned in the inventory of the estate of a grandson of the preacher.[5] This identification, however, has not been accepted. Hofstede de Groot had already expressed his doubts about identifying the sitter in the painting with the etched portraits of Sylvius. Vey and Kesting also supported this view.[6] But the belief that the male and female portraits belonged together survived for a long time. The almost identical dimensions—the Cologne portrait measures 126 × 103 cm—cannot, however, blind one to the fact that neither the composition nor style of the two works correspond. Just as the pictures hardly belong together, so, too can they hardly be taken for authentic works by Rembrandt. K. Bauch assumed that, in the case of the *Preacher* (?) in Cologne, Rembrandt designed the whole portrait, but only executed the head of the finished work.[7] From this partial removal of the work from Rembrandt's œuvre, Gerson made a positive attribution—to the school of Rembrandt.[8] G. Schwartz was the first to express doubts regarding the

authenticity of the female portrait in Toronto; and he was followed by Tümpel, who catalogued the picture as from the workshop.[9] The Rembrandt Research Project has confirmed this attribution through more extensive examination, at the same time proposing Carel Fabritius as a possible author. Carel Fabritius, who probably received his first training from his father, entered Rembrandt's studio at the end of 1641. There, he saw not only the *Nightwatch*, on which Rembrandt was working, but also the large-scale *Portrait of the Mennonite Preacher Anslo and his Wife*, which is dated 1641 (Cat. No. 33). The *Portrait of a seated Woman* is indebted to the second of these works: it adopts a modified version of the seated pose of Anslo, the motif of the handkerchief reappears and, above all, the costumes of the two women are the same. The technique is, however, decidedly different. While Rembrandt is attentive to surface qualities, savouring the dull sheen of silk with the devotion of a painter of still-lifes, this characteristic is lacking in the Toronto picture. Here, it is form itself that interests the artist, not so much its momentary qualities and atmospheric character. Of the two female faces, one is modelled in subtly blending tones (Fig. 75b), the other, on the contrary, so clearly defined as to be almost like a montage. In the area of the left cheek, spot-like forms bounce off one another. In doing so, brush-strokes reveal a surprising irreverence for the depicted forms, and a rhythm which has an unmistakable and individual stamp.

Other pictures eliminated from Rembrandt's œuvre have been attributed to Carel Fabritius. He has been shown to be the author of the picture formerly known as *Rembrandt's Self-portrait*, and now titled *Bust of Rembrandt*, in Passadena (*Corpus* C97) and of the pendant *Portraits of a Man and a Woman* in the collection of the Duke of Westminster (Figs. 75c and 75d; *Corpus* C106 and C107, respectively). The female portrait from this last-named pair establishes that the painting in Toronto belongs to this group of pictures, even though such a comparison brings together young and old. Both heads are turned in the same manner, and their outline is identical. The cheek bones of both women stand out as a feature less indicative of a true physiognomy than a stylistic tendency, which explains its frequent recurrence. The artist has clearly endeavoured to render the physiognomic features in forms as simple as they are striking; resulting in a close resemblance between the two models. The male portrait in the collection of the Duke of Westminster is comparable in its pronounced features to the painter's signed *Self-portrait* (?)

75c: Attributed to Carel Fabritius,
Portrait of a Man. Pendant to Fig. 75d.
Collection the Duke of Westminster.

75d: Attributed to Carel Fabritius,
Portrait of a Woman. Pendant to Fig. 75c.
Collection the Duke of Westminster.

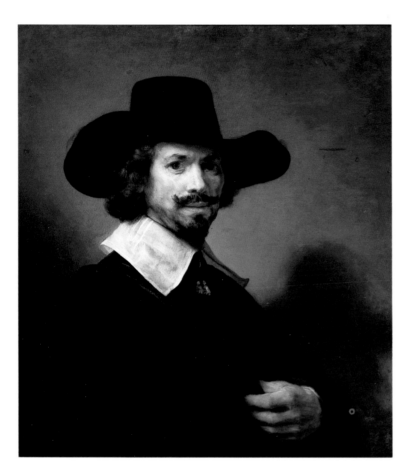

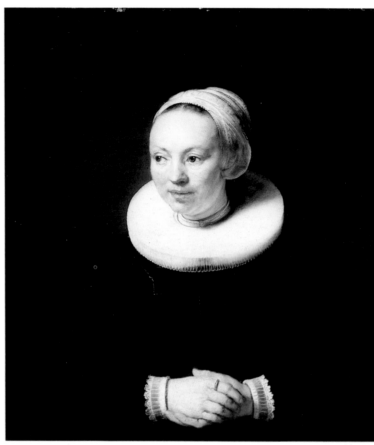

in Rotterdam,[10] which presumably anticipates the *Abraham de Potter* of 1648 or 1649 in Amsterdam (Cat. No. 76). From the start Fabritius seems to have pursued, and retained, an independent manner of portraiture. His forms, too, remained fundamentally the same, and this accounts for the link between the early works and the two later ones. In keeping with the artist's advanced stage of development, the Rotterdam *Self-portrait* (?) is treated in a painterly, free and abridged manner; but, as with the early pictures, the face is broken up into distinct areas. Individual forms conjured out of colour, light and shade seem to swim towards one another, into one another, or across one another. The brush-stroke remains relatively detached from the objects it depicts even in passages such as the eyes, which are independent of larger structures. It is here that autograph features can be detected, which are markedly individual in character and even unite individual works that have little else in common, as with the case of the *Portrait of a seated Woman with a Handkerchief* in Toronto and the *Abraham de Potter* in Amsterdam (Fig. 75f and 75e).

J.K.

1. According to E. van de Wetering et al., *Corpus*, p. 720, C114, the signature lacks homogeneity. Angular elements in the script (in the 'a', 'n' and 'f') 'are definitely untypical' for Rembrandt.
2. On the significance of the handkerchief as an attribute in portraiture, see E. de Jongh, in Exh. Cat. Haarlem, 1986, No. 15. Rembrandt frequently introduced the motif; see *Portrait of the Mennonite Preacher Anslo and his Wife* (Cat. No. 33), *Portrait of Catrina Hoogshaet* (Bredius/Gerson 391) and *Portrait of Marguerite de Geer* (Bredius/Gerson 394).
3. Smith 1836, Nos. 349 and 557. See also *Corpus* C114.
4. Vosmaer 1877, pp. 261–62, 536.
5. Bredius 237.
6. Hofstede de Groot 1893, p. 195, note 2. Vey (Kesting) 1967, pp. 87–88.
7. Bauch 392.
8. Bredius/Gerson 237, presumed to be by Gerbrant van den Eeckhout after a drawing by Rembrandt. A preparatory sketch of the portrait is to be found in Dresden (Bensch 762). According to Volker Manuth, in Berlin (oral communication), an attribution to Eeckhout would not be justified.
9. Schwartz 1984, p. 380; Tümpel A113.
10. Brown 1981, pp. 38–39, 123, No. 4; Sumowski, *Gemälde*, No. 603; Giltaij in Rotterdam, 1988, No. 7.

75e: Carel Fabritius, detail of Cat. No. 76.

75f: Attributed to Carel Fabritius, detail of Cat. No. 75.

76

CAREL FABRITIUS
Portrait of Abraham de Potter

1649(48?)
Canvas, 68.5 × 57 cm, signed, at the upper centre, *Fabritius* (scratched in the wet paint with the end of the brush) and, at the upper right, *Abraham de Potter/AE [t] 56/C. Fabritius 1640. f.* (the last figure of the year has been substantially gone over and was presumably originally '9' or '8').[1]
Amsterdam, Rijksmuseum; Inv. No. A1591.

Provenance: 25 June 1892, Earl of Dudley sale, Christie's, London, No. 6 (sold, for £204.15s., to Colnaghi art dealers, London); 1892, acquired from M.H. Colnaghi by the Rijksmuseum, Amsterdam.

Literature: Brown 1981, 2; Sumowski 682.

Exhibitions: London 1929, No. 329; Rotterdam 1935, No. 18; Amsterdam, 1935, No. 146; Amsterdam 1945, No. 114; Brussels 1946, No. 28; Amsterdam 1952, No. 38; London 1952/53, No. 227; New York, Toledo and Toronto 1954/55, No. 22; Rome 1956/57, No. 98.

The portrait is not treated on a small scale, but neither is the figure shown life size. The artist shows the sitter in half-length and turned towards the right. The simple construction of the picture as a whole compensates for the reduced scale of the figure. The black of the costume and the white of the ruff collar are evenly applied—without any notable nuances. The painting is composed of a few extended areas of colour. Only the face is rendered in greater detail; but even here the brush-strokes are not used for modelling. The natural plasticity and the continuity of the features is reduced to several luminous patches of colour next to, and above, one another which appear to be laid over the darkly shaded eyes like a mask. In places the brush-stroke takes on a certain independence. The ear is captured in a sketchily dabbed manner, and in the region of the eyes one can find isolated structures that are partly painted in with broad strokes and partly applied in spot-like fragments. These accented additions infuse life into the pictorial scheme which, however, remains abstract. The painter's aim was to accentuate, not explore the transitional and intermediate regions of the face. He seems to have proceeded analytically, first 'dismantling' a given physiognomy, then reducing the individual features to unmistakable and characteristic facial elements, before piecing together the different parts. With the suppression of all subsidiary motifs and aspects, both a sense of the presence of a living being and a feeling of the passage of time are excluded from the portrait. The features are taken at face value and, in simplistic forms, impressed upon the viewer—in luminous, almost shadowless colour set against a pale background. The conception of an image, as being based on the true appearance of the object, together with the desire to render the basic structure of that object, necessitated the move away from the hazy chiaroscuro of Rembrandt towards a lighter palette. This manner of painting was not insensitive to the psychological moment. It is, indeed, in the compelling simplicity and clarity of form, colour and light, that Carel Fabritius defines the sitter, and yet only with regard to his outer appearance.

Abraham de Potter (about 1592–1650) who, according to the information given in the inscription on the picture, is portrayed at the age of 56, was a wealthy Amnsterdam silk merchant. His wife, Sara Sauchelle, came from Emden, a town where Carel Fabritius's father had distant relatives. The two families knew each other, indeed they were quite close. In 1636, Abraham de Potter and his wife acted as godparents at the baptistm of Carel's younger brother, Johannes, in Midden-Beemster. On 1 October 1647, Carel borrowed 650 guilders from Jasper de Potter, Abraham's son. Brown's assumption that Jasper's financial support may have prompted Carel to portray his father is not entirely without foundation. Carel, nonetheless, had to repay the borrowed sum, which by 1653 had risen to 728 guilders through accumulated interest.[2]

The picture, even its pale background, was acclaimed by Sumowski, and recently also by Ziemba, as the earliest example of artistic independence in the painter's work.[3] The direct influence of Rembrandt is, in fact, no longer evident. The even distribution of light and colour covering the picture adheres to the pictorial principle characteristic of the painter's Delft period (1650–54).[4] One can no longer find any direct echo of the style of the work Fabritius produced in the years 1641–43 and shortly thereafter, when he was a pupil of Rembrandt and working for him. Stylistic features of a rather general kind—the development of the painter's most essential characteristics—link the *Portrait of Abraham de Potter* with the *Portrait of a seated Woman with a Handkerchief*, previously attributed to Rembrandt, painted in 1644 (?) and now in Toronto (Cat. No. 75). In the Rembrandt *Corpus* this picture has rightly acquired a new authenticity as the work of Carel Fabritius (*Corpus* C114).

J.K.

1. The last digit of the year must have been changed into 'o' by 1878. In that year, Jean Paul Richter saw the picture in London and was most impressed by it, as shown by the letter he wrote on 19 May 1878 to Giovanni Morelli. Richter copied down the signature and date as '*Abraham de notte AEt 56 Cfabritius 1640*' (I. and G. Richter 1960, pp. 58, 62). Wijman 1931, p. 118 undertook the correct identification of the model. On this, see Brown 1981, p. 122, No. 2.
2. Brown 1981, p. 122, No. 2; p. 146; doc. 1, p. 150, doc. 17.
3. Sumowski, p. 979; Ziemba 1990, p. 98.
4. Waagen 1854, Vol. *ii*, p. 237 admired the free painterly treatment of the picture, which he saw in the collection of Lord Ward (who later became the Earl of Dudley), concluding that Carel Fabritius had modelled his style on that of Frans Hals.

Abraham de potte[r]
Æ· 56

C. fabritius 1649

Nicolaes Maes (1634–1693)

Nicolaes Maes, the son of a silk dealer, was born in Dordrecht in January 1634. According to Houbraken, Maes learned drawing under an 'ordinary master' in his home-town, and then continued his training, probably from the end of the 1640s, with Rembrandt. He is recorded in Dordrecht again in 1653. The following year he married Adriana Brouwers, the widow of a preacher. She bore him three children, one of whom died young. Maes lived in Dordrecht for two decades. He bought a house there in 1658, and a garden outside the city in 1665. In 1674 he moved to Amsterdam, where he died in November 1693, in modest circumstances, albeit with his affairs in good order.

Nicolaes Maes is among the most outstanding of Rembrandt's pupils. His talent must have been apparent early; but little light has so far been thrown on either his development or his early work. The Expulsion of Hagar *of 1653, Maes's earliest dated work, was painted when he was 19. Alongside rembrandtesque characteristics, it already reveals a marked personal style and is an accomplished work. From shortly before this point until the later 1650s, Maes painted a number of biblical subjects and a few portraits. However, he appears to have concentrated on genre painting. The pictures dated between 1654 and 1659 shows scenes from everyday life with one or more figures, women working or lazily idling, mothers with children, and eavesdroppers curiously following amorous couples. Maes's reputation rests on these scenes, which are imbued with rembrandtesque chiaroscuro, refined human characterisation and meticulous observation of individual objects. It would seem, however, that they did not bring him sufficient financial gain, and from about 1660 he turned almost exclusively to portrait painting. 'As (according to Houbraken) he saw that young women in particular took more pleasure in white than in brown', he abandoned Rembrandt's manner and turned to the bright and colourful pictorial style of Flemish artists. He was thus better able to satisfy the desire of the Dutch bourgeoisie to be portrayed in the manner of the nobility. Maes became one of the most refined and productive painters of society portraits of the baroque era in the northern Netherlands.*

B.S.

77
Attributed to
NICOLAES MAES
The Apostle Thomas

Canvas, 120 × 90.3 cm.

The signature was carefully scratched in the wet paint, down to the level of the under-painting, at the lower left of the picture on the edge of the table. In the seventeenth or early eighteenth century, the short signature was erased, by scratching away the paint layer, and replaced by a forged Rembrandt signature. To its right is inscribed: *A1656*
Kassel, Staatliche Kunstsammlungen, Gemäldegalerie Alte Meister; Paintings Catalogue No. 246.

Provenance: collection of Lambert Hermansz. ten Kate; sale, Amsterdam, 16 June 1732, Cat. p. 76, No. 1, as Rembrandt; acquired by Prince Wilhelm of Hesse-Kassel (since 1751 Landgrave Wilhelm VIII.). Inv. No. 1749 ff., No. 297 (as a work by Rembrandt).

Literature: Bode 1883, pp. 515, 566, No. 68 (Rembrandt); Bode/de Groot, Vol. V (1901), pp. 33., 180, No. 383 (Rembrandt); Hofstede de Groot, Vol. VI (1915), p. 104, No. 182 (Rembrandt); W. Martin: 'Zur Rembrandt-Forschung', in: *Der Kunstwanderer* (1923), pp. 408–410 (copy after Rembrandt); R. Judson, in: Chicago 1969/70, pp. 45 f. 27 (ascribed to Rembrandt, close to the style of N. Maes); H. von Sonnenburg, 'Rembrandt's *Segen Jakobs*', in: *Maltechnik-Restauro* IV (1978), pp. 236–238 (N. Maes); Sumowski 1983 ff., Vol. III, pp. 1953 f., 1957, 2009, No. 1324 with further details (N. Maes; the colour illustration shows the picture as it was before 1977); Bruyn 1988, pp. 322, 331 (N. Maes).

An old man is portrayed three-quarter length and life-size. He has grey-white straggly hair and a full beard and sits deep in thought, beside a table on which there are papers, an ink-well, a book and a brass candlestick. His right arm and upper body are supported by the table, while his left rests on the arm of his chair. His head is turned slightly to the right. In his hands he hold a quill pen and an iron set-square. He wears a white shirt and a red jacket with a dark lining, the sleeves of which are left visible by his red-brown cloak trimmed with brown, yellow and white fur. The powerful light enters from the upper left and concentrates in certain areas, brightening the warm grey-brown colouring of the dark background.

The picture's condition can no longer be described as particularly good. During cleaning carried out at unknown dates in the eighteenth and nineteenth centuries the surface of the paint was, in places, considerably abraded. The dark, blank eye sockets that give the face the expression of a blind seer, are not truly representative of the original appearance of the painting. A pastel copy of the picture, made by Cornelis Troost (Fig. 77a), probably when the work was in the collection of Lambert ten Kate, shows the sitter's eyes with the pupils included, giving the impression of a distinct glance.[1] An acid attack in October 1977 caused further damage in the area of the face and where the liquid trickled down. It was only possible to reconstruct a hint of the pronounced fold between the nose and the corner of the mouth.[2]

The Kassel inventory of 1749 listed the figure, which was later called 'Portrait of an architect', as Archimedes, the philosopher and mathematician of Antiquity; yet the figure's principal attribute belongs more properly to one of the Apostles. The figure cannot, in any case, be identified with certainty as the attributes of the Apostles were ambiguous and varied in Netherlandish baroque art.[3] A set-square was given not only to Thomas but also to Judas Thaddeus and James the Less.[4] Traditionally, and according to legend, this attribute belonged to Thomas, who, during his mission to India, had been required to build a castle for a king. He had therefore been provided with the implements needed to do so, but he gave these away to the poor, promising the king a palace in heaven instead.[5] The type of old man seen here is also an indication that the figure is intended to be the Apostle Thomas.[6]

In the seventeenth century, except in the case of Peter and Paul, and the Four Evangelists, portraits of this type were only produced as part of cycles of the Twelve Apostles, to which might be added images of Christ and the Virgin. When Thomas was shown as a single figure, the preference was for scenes of the doubting Thomas placing his finger in the resurrected Christ's wound. However, no more Apostle portraits by Maes are known. One may, therefore, wonder whether the present picture belonged to a series commissioned from a number of painters. In Netherlandish painting, shared commissions of this kind were not unusual.[7] In the case of the present work, the most immediate comparison is with the figures of Apostles by Rembrandt and his collaborators, both at about the same time and also a little later. Attempts have been made to reconstruct a series from the surviving portraits but these series are incomplete.[8] Two portraits are of three-quarter figures and approximately equal in size to the *Apostle Thomas*: Rembrandt's *Apostle Bartholomew*, dated 1657, now in the Timken Art Gallery in San Diego, and the *Apostle Paul at his Desk*, from the Rembrandt circle, now in the National Gallery of Art in Washington.[9] The relation between these two pictures is, however, not yet clear. The *Paul* could be seen as a simple pendant to an *Apostle Peter*, while the figure in the *Bartholomew*, unambiguously identified through his attribute of a knife, could only function as one of a series of pictures of the Apostles. Perhaps the possible inclusion of further independent artists in a group commission, as here proposed for consideration, will encourage the emergence of further material. One cannot exclude the possibility that the Catholic Church commissioned a series of Apostles from Rembrandt and his circle. Catholic churches were often hung with paintings and were richly decorated inspite of the hidden nature of their existence. In the St Gertrudis-Chapel in Utrecht, there is a series of the Twelve Apostles by an unknown painter from the years around 1650.[10]

In 1923, when W. Martin, in an attention-provoking critical essay, displaced the *Apostle Thomas* from its pedestal and reassessed it as a weak copy after a lost original by Rembrandt,[11] the painting was still, for the general public, a favorite among the master's works. In his statement to the press[12] (who were swiftly on hand with the scoop-formula 'Rembrandt picture a fake'), Gronau, the Director of the Gemäldegalerie at Kassel pointed out that this picture had 'nonetheless (enjoyed) special favour with the general public. No other painting in this collection has prompted so many requests for copies!' However the attribution of this work had been a little uncertain for forty years, however, as

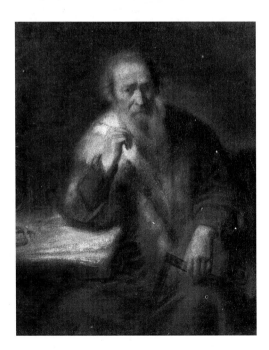

77a: Cornelis Troost, *The Apostle Thomas*, copy after N. Maes (cut down on all sides?). Pastel. Besançon, Musée des Beaux Arts.

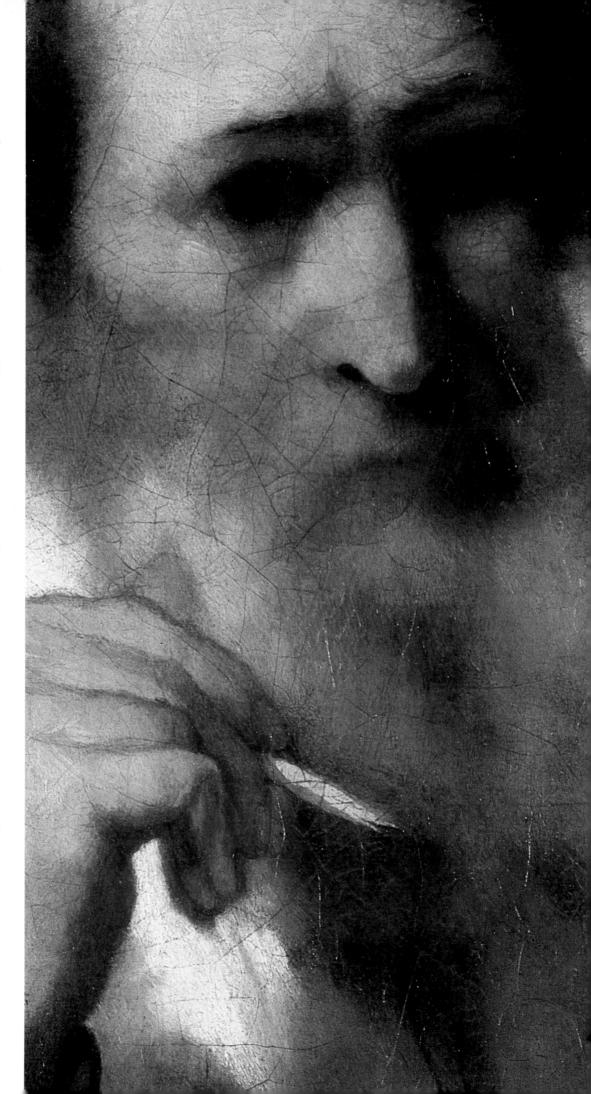

the gallery catalogues suggest.[13]

In 1883 W. Bode discovered that the signature then detectable on the painting—*Rembr. 1656*—was partly forged.[14] The signature was then removed by the Berlin restorer Hauser. Bode found the picture 'closely related to the work of Aert de Gelder', but repressed his doubts in view of its quality. In 1901 he included it in his catalogue of Rembrandt paintings, giving the already mentioned *Apostle Paul* in Washington as its pendant.[15] A. Rosenberg[16] and C. Hofstede de Groot[17] adopted Bode's argument and, in 1905 and 1915 respectively, also recorded the picture as a painting by Rembrandt. It is to Hofstede de Groot, the last advocate of the traditional attribution, that we owe the correct identification of the figure as the Apostle Thomas.

In about 1890, on the other hand, A. Bredius had attributed the picture to Nicolaes Maes.[18] Bredius was followed in 1914 by J.C. Van Dyke, who contributed his own reasoning: he felt the work could not be accepted as Rembrandt's, on account of the softness of the modelling and the excessive emphasis on both the brightly-lit hands and the paper. He also saw a connection with the portrait of *Jacob Trip* by Maes, in the Mauritshuis (see Cat. No. 79).[19] W.R. Valentiner, however, did not mention the picture in his monograph on Maes, published in 1924,[20] believing Barent Fabritius to be its author.[21] At about the same time, I.Q. van Regteren Altena thought that he detected traces of Drost's signature within the inscription of the year 1656, but this view was not published.[22] More recently, commentators have proposed further attributions, but these have either been un-, or insufficiently, justified: Titus van Rijn, Antoine Watteau (!), Karel van Savoy, and Karel van der Pluym.[23] The most favoured attribution—at least tentatively—has remained Maes[24] This attribution received further support in 1978, when H. von Sonnenburg analysed the remains of the signature after the removal of the picture's varnish,[25] and was able to establish that the layer of paint scratched away down to the under-painting, where the original artist's name would have been, only afforded space for a short name such as that of N. Maes, and that the preserved inscription of the year corresponded in its formation to the signatures on contemporary works by Maes. These observations constitute significant evidence for the attribution to Maes, but not conclusive proof, as W. Sumowski, and J. Bruyn in agreement with him, concluded.[26]

Even now, the *Apostle Thomas* has many admirers, and rightly so; the picture is among

the most compelling from the school of Rembrandt in the strict sense of that term. It is impressive as a representation of the dignity of old age and of intellectual concentration, and rich in warmly glowing colour. All the nineteenth-century commentary on the picture praises these qualities;[27] but they swiftly ceased to attract attention when the work was no longer attributed to Rembrandt. Only one of the best of Rembrandt pupils can be considered as the possible artist; and almost all of those previously considered must thus be ruled out. The isolated status of the painting means that one can not expect to find works by one of the star pupils that can be recognised as comparable at first glance. One must take into account the fact that a sound and adaptable painter would have been able to employ means of representation specific to a particular commission, and that individual works painted by him might thus stand out from the greater part of his œuvre, not only in terms of iconography, but also in terms of style.[28] Elements of continuity might then be found in the details.

Bearing in mind these considerations, it is hard not to make associations with Nicolaes Maes. Two undisputed paintings from the same period of Maes's œuvre are exhibited here with the *Apostle Thomas*. These both show a single figure in three-quarter profile or full-face. However, comparison of the three pictures draws attention to their varied states of preservation and restoration. The brightness and freshness of the *Apostle Thomas* should not blind one to the fact that this picture has suffered greater loss of substance than the two others. The *Portrait of Jacob Trip* (Cat. No. 79)

shows an old man of 84, observed from life; the *Apostle Thomas* is an idealised portrait of a historically important figure in his old age, probably painted from a model, as we may also presume was the case with the *Old Woman asleep* (Cat. No. 78). It is apparent that the artist used surprisingly varied means of expression for a citizen's portrait and for a genre painting. In the case of *Jacob Trip*, he is concerned with being objectively matter-of-fact, with an emphasis on elongated contours and broad planes to achieve a simplification of forms. On the contrary, in the case of the *Old Woman asleep*, he is concerned with rendering as great an abundance of objects as possible, and with a realistic and dazzling record of many details. There are instructive differences between the two pictures in the depiction of fur. In the *Apostle Thomas*, Maes uses precisely the same method of painting as in the genre picture, in that he introduces the fur as a soft fluff, brown, orange and yellow in tone, over dark under-painting. The fine hair, barely surviving in the Kassel picture, was executed with a smooth lifting stroke of the half-dry brush. The painter reveals outstanding ability in the observation of the hands of his models, which are marked by age and illness. In the *Apostle Thomas* and the *Old Woman asleep*, the veins stand out clearly on the backs of the hands, this effect is obtained through the use of dark shading. The result is somewhat harsher in the *Apostle Thomas*, because there the blending effect of the final layers of glaze is lacking. The fingers of the Apostle's right hand are notably bent—the sign of advanced arthritis. No comparable painter showed the same interest in this phenomenon as Maes, who recorded it in an extreme form in his *Woman fallen asleep while reading the Bible*, in Washington.[29] All three exhibited works are comparable in terms of colour, for the basic triad of red, yellow-brown and white, characteristic of Maes, is more or less strongly represented in them all. The warm flesh-tones in both the *Old Woman asleep* and in the *Apostle Thomas* contain a marked degree of yellow.

Sumowski emphasises the artistic mastery of Nicolaes Maes, who, in this hey-day of his career, was able to paint two quite different versions of the Adoration of the Shepherds—once after a Dürer print and once in the manner of Rembrandt. 'Maes shows that he . . . is capable of virtuosity in [imitating] celebrated styles'.[30] In the case of the *Apostle Thomas*, we are concerned with a subject closely associated with Rembrandt; and it is possible that Maes was commissioned to collaborate with Rembrandt on a series of Apostles. It is also worth bearing in mind that at this time

77b: Nicolaes Maes (?), *Old Woman cutting her nails*. c.1650. New York, The Metropolitan Museum of Art.

77c: Detail from Fig. 77b.

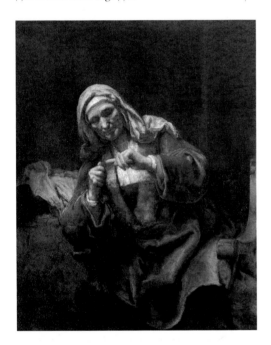

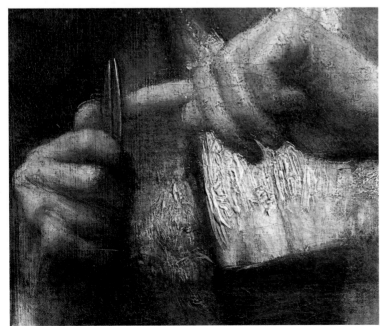

Maes was intrigued by the use of forced chiaroscuro effects.[31] Thus it is not surprising that he seems to have followed the style of Rembrandt in a way that was unique in his artistic maturity. At the age of 22, the painter appears to have consciously entered into competition with his former teacher.

One of Maes's models could have been Rembrandt's *Blessing of Jacob*, also finished in 1656, and now in the Kassel Gemäldegalerie.[32] Much in this picture might have proved appealing and challenging to Maes: the monumental image of the old man, the endlessly varied effects of the fur, the use of chiaroscuro for both strong contrast and for a more subtle tonal mixing of the visual components, and finally the luminous colouring dominated by red, yellow and white. This comparison with Rembrandt's work reveals not only Nicolaes Maes's own stylistic characteristics—in his work 'light seems to dissolve the forms rather than build them up'[33]—but also the limits of his abilities.

In 1923 J.C. van Dyke attributed another rembrandtesque painting to Nicolaes Maes; and as this work has, since then, repeatedly been cited as the closest comparison for the *Apostle Thomas*, it should not be omitted from the present discussion. The painting concerned is the *Old Woman cutting her nails*, now is the Metropolitan Museum of Art in New York (Fig. 77b).[34] The direct comparison is surpising as there is a considerable difference between the two pictures in both style and quality. The picture is New York lacks virtuoso brilliance: the brush-stroke is clumsy and tentative. There is evidence of a striving for strong chiaroscuro effects, yet this leads only to exaggerations. The expressive face, which lacks a secure structure, gives an uneven impression. The two pictures can only convincingly be seen as works by one and the same painter if one assumes that they are separated by a certain period of time. The *Old Woman cutting her nails* appears to be the proud achievement of a gifted but still unpractised beginner. The naive inconsistency between the large scale, dramatic figure, and the banal subject could be more easily explained if one imagined that the painting were the work of an artist aged about 16. Is this, then, one of Nicolaes Maes's exercises? The type of picture, and of face, anticipate the individual figures of old women from the artist's best period (Cat. No. 78).[35] A few points of contact with his earliest known paintings can be established. The flesh-tones in the early portrait of a couple, now in the Art Institute of Chicago,[36] are still applied in a rembrandtesque manner – pastose, porous and rough. In the portraits dated 1656 in San Francisco,[37] however, this characteristic has entirely disappeared. This way of painting is also to be found in the *Old Woman cutting her nails*, where it lacks any restraint (see Fig. 77c). A certain relation to this image at a more advanced level is to be detected in the old woman in an unidentified historical scene in a private collection;[38] the comparison also extends to the treatment of the drapery folds. Here the distribution of light and shadow in the face is much clearer. Should this attribution be confirmed, then the *Old Woman cutting her nails* could be regarded as standing at the very beginning of the artistic career of Nicolaes Maes.

B.S.

1. The earliest reference to this document is provided by Van Gelder 1973, p. 195. See also J.W. Niemeijer: *Cornelis Troost*, Assen 1973, Cat. No. 920 T.
2. The neutralisation of the acid and the removal of the varnish and layer of over-painting were carried out by H. von Sonnenburg in 1977/78 at the Doerner-Institut in Munich. Extensive restoration of the paint losses was carried out by Adelheid Wiesmann in 1981/82 in the Gemälderestaurierungswerkstatt of the Staatliche Kunstsammlungen in Kassel. An exhaustive report was prepared.
3. B. Knipping, *De Iconografie der Contra-Reformatie in de Nederlanden*, Vol. II, Hilversum 1940, pp. 300f.
4. As in the case of Rubens and the prints after his series of Apostles; see H. Vlieghe, *Corpus Rubenianum*, Vol. VIII, Saints: I (Brussels, 1972), No. 13, p. 36.
5. *Legenda Aurea*, concerning Saint Thomas the Apostle.
6. In the work of both Rubens and Van Dyck Thomas appears as an old man with white hair and a beard; see note 4 above, and also Glück 1931, illustration on p. 40.
7. One may cite, as an example, the series of the first twelve Roman emperors by twelve different painters in the Jagdschloss Grunwewald, Berlin.
8. See, most recently, Tümpel 1986, pp. 338–43.
9. Bredius 1935, No. 613, Tümpel 1986, Cat. No. 80, illustration on p. 341 (122.7 × 99.5 cm) and Bredius 1935, No. 612, Tümpel 1986, Cat. No. A16, illustration on p. 343 (129 × 102 cm). The slightly smaller picture in Kassel (120 × 90.3 cm) has not yet been examined with regard to the possibility of its being cut down.
10. I am grateful to Robert Schillemans, in Amsterdam, who provided this information.
11. W. Martin, Zur Rembrandt-Forschung, in: *Der Kunstwanderer*, 1923, pp. 408–10.
12. Manuscript among documents in the archives of the Gemäldegalerie in Kassel.
13. O. Eisenmann: *Katalog der Königlichen Gemäldegalerie zu Cassel*, Cassel 1888, No. 224; and G. Gronau, *Katalog der Königlichen Gemäldegalerie zu Cassel*, Berlin 19013, p. 53.
14. Bode 1883, pp. 515, 566, No. 68.
15. Bode/de Groot, Vol. V, pp. 33 ff., 180, No. 383.
16. A. Rosenberg, *Rembrandt— Des Meisters Gemälde* (Klassiker der Kunst) (2nd edition; Stuttgart/Leipzig, 19006), pp. 309, 403.
17. Hofstede de Groot, Vol. IV (1915), p. 104, No. 182.
18. Cited in: E. Michel, *Rembrandt: Sa vie, son œuvre et son temps* (Paris, 1893), p. 149, note.
19. J.C. van Dyke, *Munich, Frankfort, Cassel: Critical Notes on the Old Pinakothek, The Staedel Institute, The Cassel Royal Gallery*, New York 1914, p. 158.
20. W.R. Valentiner, *Nicolaes Maes*, Berlin/Leipzig 1924.
21. W.R. Valentiner, 'Carel and Barent Fabritius', *The Art Bulletin* XIV (1932), p. 21, note 8; and 'Willem Drost, Pupil of Rembrandt', *Art Quarterly* V (1939), p. 316.
22. Letter of 26 March 1922 to the director of the Gemäldegalerie in Kassel.
23. See the summary in Sumowski 1983 ff., Vol. III, No. 1324.
24. Weisbach 1926, p. 578; Judson 1969/70, No. 27.
25. H. von Sonnenburg: 'Rembrandts *Segen Jakobs*', *Maltechnik-Restauro*, IV (1978), pp. 236–38.
26. Sumowski 1983 ff., Vol. III, pp. 1953 ff., 1957, 2009, No. 1324, with bibliography; J. Bruyn 1988, pp. 322, 331.
27. Smith, Vol. VII (1836), p. 131, No. 370: 'Painted in a broad and admirable style'. Bode 1883, pp. 515, 566: 'Kein de Gelder, da viel zu energisch und geistvoll behandelt' (Not a work by de Gelder, as painted in too energetic and sophicated a manner); Michel 1893, op. cit. (note 18) 'Besonders frei und kraftvoll gemalt' (painted in a particularly free and powerful manner).
28. See Bruyn 1988, p. 322.
29. Sumowski 1983 ff., Vol. III, No. 1368.
30. Sumowski 1983 ff., Vol. III, p. 1953. The paintings concerned are Nos. 1317 and 1318.
31. W. Robinson: 'The Sacrifice of Isaac: an unpublished painting by Nicolaes Maes', *The Burlington Magazine* CXXVI (1984), p. 540. Emphatic contrasts of light and shade are to be found in dated paintings by Maes only between 1655 and 1658.
32. GK-No. 249. Canvas; 175.5 × 210.5 cm; Bredius 1935, No. 525; Tümpel 1986, pp. 288, 290, 293, 357, 391, Cat. 26.
33. R. Judson, exh. cat. Chicago 1969/70, pp. 45 ff., No. 27.
34. Canvas; 126 × 101.9 cm. Forged signature: *Rembrandt/1648*. Van Dyke 1923, p. 132 (an exercise by Maes); discusses the *Apostle Thomas* on p. 130; Judson 1969/70, p. 46 (*The Apostle Thomas* by Maes or by the painter of the *Womman cutting her nails*; Adams 1984, pp. 436 ff. (both pictures by Karel van der Pluym); Sumowski 1983 ff., Vol. IV, No. 1595 (*Woman cutting her nails* by Karel van der Pluym). The works Sumowski introduces as comparisons are all only attributed; the *Woman cutting her nails* has nothing in common with the few signed paintings by Van der Pluym; Bruyn 1988, p. 331 (both pictures by Maes, in the same style; the *Woman cutting her nails* goes far beyond anything that Van der Pluym was ever capable of).
35. This also observed by Bruyn 1988, p. 331.
36. Sumowski 1983 ff., Vol. III, Nos. 1386, 1387.
37. Sumowski 1983 ff., Vol. III, Nos. 1388, 1389.
38. Sumowski 1983 ff., Vol. III, No. 1314.

78

NICOLAES MAES

An old Woman asleep

Canvas, 135 × 105 cm
Brussels, Koninklijk Museum van Schone
Kunsten; Inv. No. 2983
Only exhibited in Berlin

Provenance: Léon Gauchez art dealers, Paris;
acquired by the museum in 1885.

Literature: Hofstede de Groot 1915, p. 511, No.
99; Valentiner 1924, Fig. 35; Sumowski 1983
ff., vol. III, pp. 1954, 1957, 2021, No. 1633.

Exhibition: Amsterdam 1976, No. 32.

An old woman, with spectacles held in her
right hand, has fallen asleep over a book and
her domestic task of lace-making. She has a
white shawl over her head and shoulders, a
black dress and a dark jacket with a lining of
yellow, orange and brown fur. She leans on a
table covered with a red cloth, on which a lace-
cushion, an hour-glass and a Bible are also to be
found. Further objects—writing implements, a
key, a brass candlestick and a lidded mug—
hang on the back wall or stand in a niche. The
luminosity of the colours in this well-preserved
picture is impaired by the dulling effect of a
grey-yellow varnish.

The scene is an allegory of the vice of sloth.
The hour-glass is a reminder of the approaching
end of the old woman's life; and the Bible is
open at the Book of the Prophet Amos, which
threatens sinful humanity with God's severe
punishment. The *Old Woman praying*, in the Art
Museum in Worcester, Conn., an allegory of
virtue, is the moral counterpart to this work.[2]

The picture exhibited here belongs to a
group of four paintings produced in about 1656,
each with the single figure of an old woman in
a closely cropped interior setting.[3] With their
vivid and very varied depiction of people and
objects in light and shadow, these works
constitute some of the most notable examples
of Dutch genre painting. The contemplative air
of the figures and the treatment of space are
derived from the work of Rembrandt; but in
his objective precision, Maes strikes out on a
path of his own.[4] The picture in Brussels
makes an especially good comparison with *The
Apostle Thomas* (Cat. No. 77) on account of the
very similar presentation of the backs of the
figures' hands, with their prominent veins, and
of the fluffy appearance of the fur.

B.S.

1. Exh. cat. *Tot lering en Vermaak*, Rijksmusem,
Amsterdam, 1976, No. 32.
2. Sumowski 1983 ff., Vol. III, No. 1369.
3. Sumowski 1983 ff., Vol. III, Nos. 1366–1369.
4. On the stylistic classification of Maes's genre
paintings, see W. Robinson, in: Philadelphia/Berlin/
London 1984, Nos. 65–67, and Sumowski 1983 ff.,
Vol. II, p. 1955.

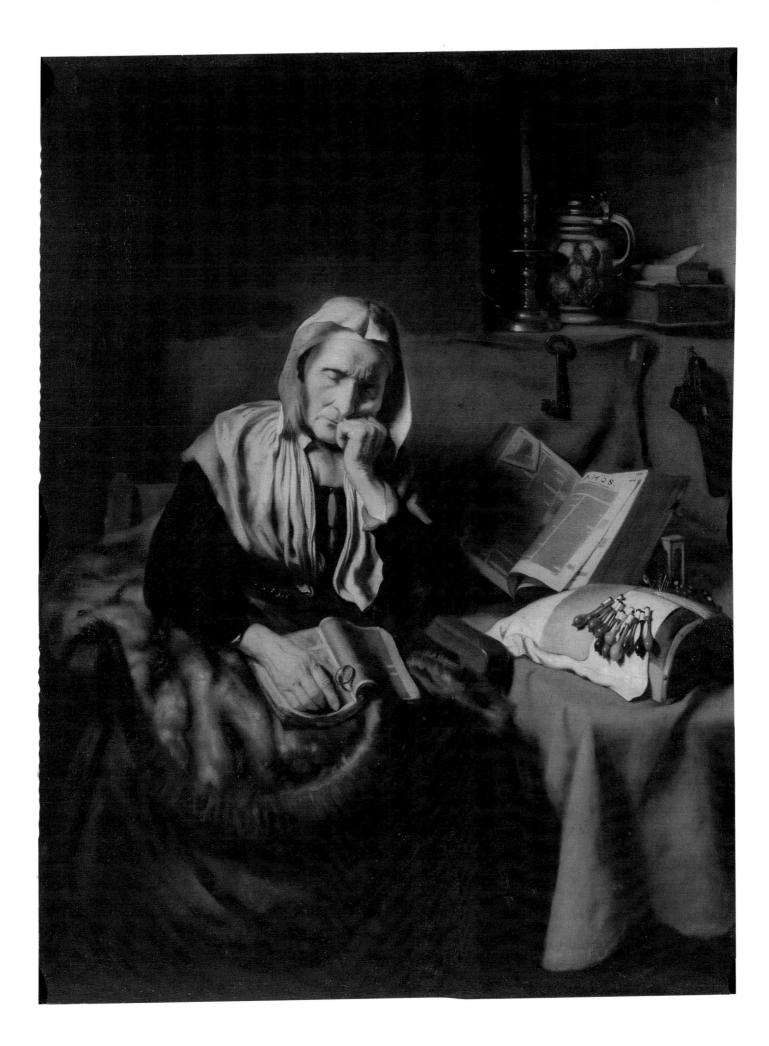

NICOLAES MAES

Portrait of Jacob Trip

Canvas, 126 × 100.5 cm
Signed at the lower left: *AE¹ 84./N. Maes./16..*
The Hague, Koninklijk Kabinet van
Schilderijen Mauritshuis; Inv. No. 90.

Provenance: 1821, transferred from the Ministry
of Shipping in The Hague to the Mauritshuis.

Literature: Hodfstede de Groot 1915, p. 581,
No. 322; C. Hofstede de Groot, 'De portretten
van het echtpaar Jacob Trip en Margaretha de
Geer door de Cuyp's, N. Maes en Rembrandt',
in: *Oud Holland* 45 (1928), p. 262 7; G. Jansen
in exh. cat. *The Impact of a Genius*, Amsterdam
and Groningen 1983; Sumowski 1983 ff., Vol.
III, at 1396.

Exhibition: Amsterdam and Groningen 1983,
No. 53.

Jacob Trip (1575–1661) was a powerful
merchant, resident in Dordrecht, who had a
share in the iron-ore and arms business of his
father-in-law, Lodewijk de Geer, a concern with
a dominant position throughout Europe. Trip
frequently had portraits made of himself and
his wife, Margaretha de Geer, possibly with a
view to providing each of his children with
them.[1] In Rembrandt's famous portrait of 1661
in the National Gallery in London, Jacob,
wearing antique costume, takes on the image of
a patriarch.[2] In the portrait by Nicolaes Maes
too,[3] which on the basis of the stated age of the
sitter must have been painted in 1659 or 1660,
the old-man appears self-confident and
dignified. Wearing a black cap and a
voluminous, fur-trimmed black cloak, he sits
upright in a massive, red-covered armchair.
The table to the right is also covered with a
red cloth. Unlike Rebrandt, Maes shows his
sitter with sober objectivity. The alert glance
hints at a not yet extinguished vitality in this
prudent and successful entrepreneur.

J.C. van Dyke compared this portrait with
the *Apostle Thomas* in Kassel (Cat. No. 77), but
regards the former as 'much weaker'.[4] In
reality, the difference between the works lies in
the means of presentation—simplified so as to
maintain clarity and formal rigour—that Maes
employed in his portraits of the 1650s. This
style is again very evident in the first dated
portraits of a couple by Maes, now in the M.H.
de Young Memorial Museum in San Francisco,[5]
which, like the *Apostle Thomas*, were painted in
1656.

B.S.

1. See *Literature*, Hofstede de Groot 1928.
2. Bredius 1937, No. 314; MacLaren 1960, pp. 328–31;
Tümpel 1986, pp. 315, 318, 319.
3. In MacLaren 1960, p. 330, note 5, four versions—
perhaps not all autograph—are listed. A more closely
cropped, more richly detailed example in the
Szépmüvészeti Muzeum in Budapest is possibly to be
regarded as the first version, despite its lack of a
signature. This opinion is held by Hofstede de Groot
1928, pp. 257, 262. Sumowski, 1983 ff., Vol. III, No.
1396, argues against it.
4. J.C. van Dyke: *Munich, Frankfort, Cassel: Critical Notes
on the Old Pinakothek, The Staedel Institute, The Cassel Royal
Gallery*, New York 1914, p. 158.
5. Sumowski 1983 ff., Vol. III, p. 1957, Nos. 1388,
1389.

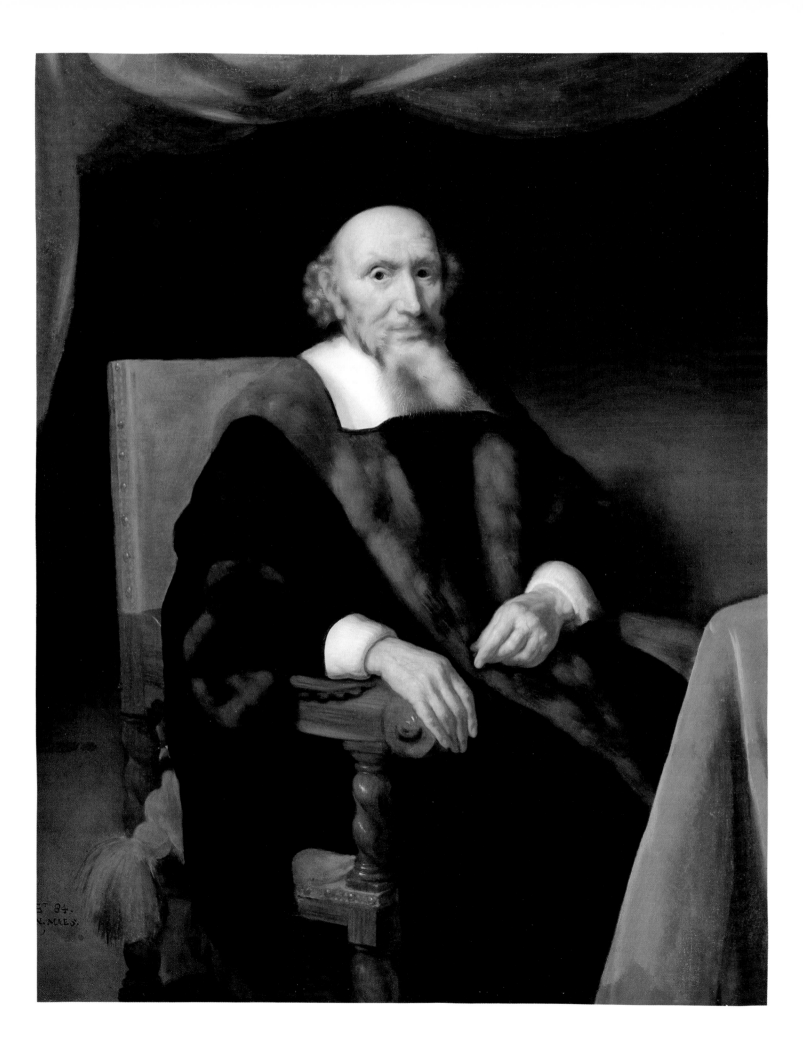

Barent Fabritius
(1624–1673)

Barent Fabritius and his brother, Carel, two years his elder, were descended, on their father's side, from a Flemish family of religious refugees. By the time of the Spanish Conquest of the Netherlands in 1584, at the latest, their grandfather, the Reformed Church preacher Carel Pietersz., had left his home town of Ghent. Barent Fabritius was baptised on 16 November 1624 at Midden-Beemster in the province of North Holland, where his father worked as a school-teacher, sexton and painter. Like his brother Carel, Barent Fabitius first learnt the trade of a carpenter. Later he took to using the Latinised form Fabritius (Latin faber = *craftsman) as a part of his name—in this too following his brother. In 1643 he signed a document in Amsterdam, but appears to have returned to Midden-Beemster after this date. In October 1647 he stayed once again in Amsterdam, the city which he also gave as his place of residence on the occasion of his marriage to Catharina Mussers (who lived in Delft) in Midden-Beemster on 18 August 1652. Connections with the city of Leiden are also documented. In 1656 Barent Fabritius completed a family portrait of the city's principal architect, Willem Leendertsz. van der Helm, a prestigious commission for Fabritius to have received. In Leiden in 1657 the artist signed a three-year rent contract for a house in the Nieuwe Steech. In May of the following year he became a member of the Leiden artists' guild, but the entry acknowledging the receipt of his guild payment on 9 October 1658 contains the additional comment: 'has moved out of the city'. Nonetheless, in 1661 he was paid for paintings commissioned by the Lutheran church in Leiden. On 20 October 1673 Barent Fabritius was buried in the Leidse Kerkhof in Amsterdam; he was survived by six children.*

Little is known of the beginnings of the painter's artistic career. On stylistic grounds he is counted among the students of Rembrandt. Contact with Rembrandt's studio in the years around 1645 to 1650 are likely, but it is possible that Barent Fabritius was not a regular student there. He produced history paintings, allegories, individual figures with allegorical meaning, genre scenes and a few portraits. Clearly evident in his early work—the earliest dated painting is from 1650—is the influence of his brother, Carel, whose encouragement remained of great significance throughout Barent's life. Accordingly, recent research has been marked by a more tentative approach towards assessing the nature and degree of Rembrandt's influence on the work of Barent Fabritius.
V.M.

80
Attributed to
BARENT FABRITIUS
Woman with a Child in Swaddling Clothes

Panel, 25 × 21.5 cm (on the left cut by about 1 cm)
Signed and dated at the lower right by a later hand: *Rembrandt/f.* 164(0)[1]
Rotterdam, Museum Boymans-van Beuningen; Inv. No. 2512

Provenance: 1685, possibly in the collection of A. Heyblom, Dordrecht (see Bredius 1910, p. 12); sale, Choiseul-Praslin, Paris, 18 February 1793, No. 43 (for 345 francs); Truchsessian Gallery sale, London, 14 May 1804, No. 359 (not sold); Truchsessian Gallery sale, Skinner, Dyke & Co., London, 27–29 March (28 March) 1806, No. 160; sale, Gamba, Paris, 17–18 December 1811, No. 27 (176 francs bid; not sold); sale, Sarrazin, Paris, 8–9 January 1816, No. 7; Lord Pourtales sale, Phillips, London, 19 May 1826, No. 24 (cited as signed and dated 1640; sold for 35 guineas to P. Rainier); P. Rainier sale, Christie's, London, 24 May 1845, No. 24 (50 guineas); 1845, collection of H. Labouchère, London; 1864, in the collection of Lord Taunton, Stoke; collection of Lord Foley, Ruske Lodge; 1873, sold to Agnew's art dealers, London; about 1920, in Frank T. Sabin art dealers, London; 1921, acquired through F. Lugt, for 75000 guilders, for D.G. Beuningen; 1958, with the collection of D.G. Beuningen, to the Museum in Rotterdam. Regarded throughout as a work by Rembrandt.

Literature: Smith 176 (Rembrandt); Bredius 1910, p. 12; Hofstede de Groot 1915, No. 302 (Rembrandt); Valentiner 1921, No. 54 (Rembrandt); Bredius 1921, p. 146 (B. Fabritius?); Hannema 1949 58 (Rembrandt); Bauch, at 374 (in the style of B. Fabritius, in connection with the Braunschweig copy after Rembrandt's *Circumcision*); Sumowski 1962, p. 17, note 11 (after the corresponding figure in the Braunschweig painting); Bredius/Gerson 1969, p. 579, at, No. 374 (circle of B. Fabritius); Rotterdam 1972, p. 63, No. 2512 (Rembrandt?); Sumowski 1983 ff, Vol. III, p. 2011, No. 1327, p. 2053 with illustration (an early work by N. Maes, about 1646/50); J. Bruyn in Rotterdam 1988, pp. 32 ff. with illustration (ascribed to B. Fabritius); Bruyn 1988, p. 328, Fig. 3, p. 329 (ascribed to B. Fabritius).

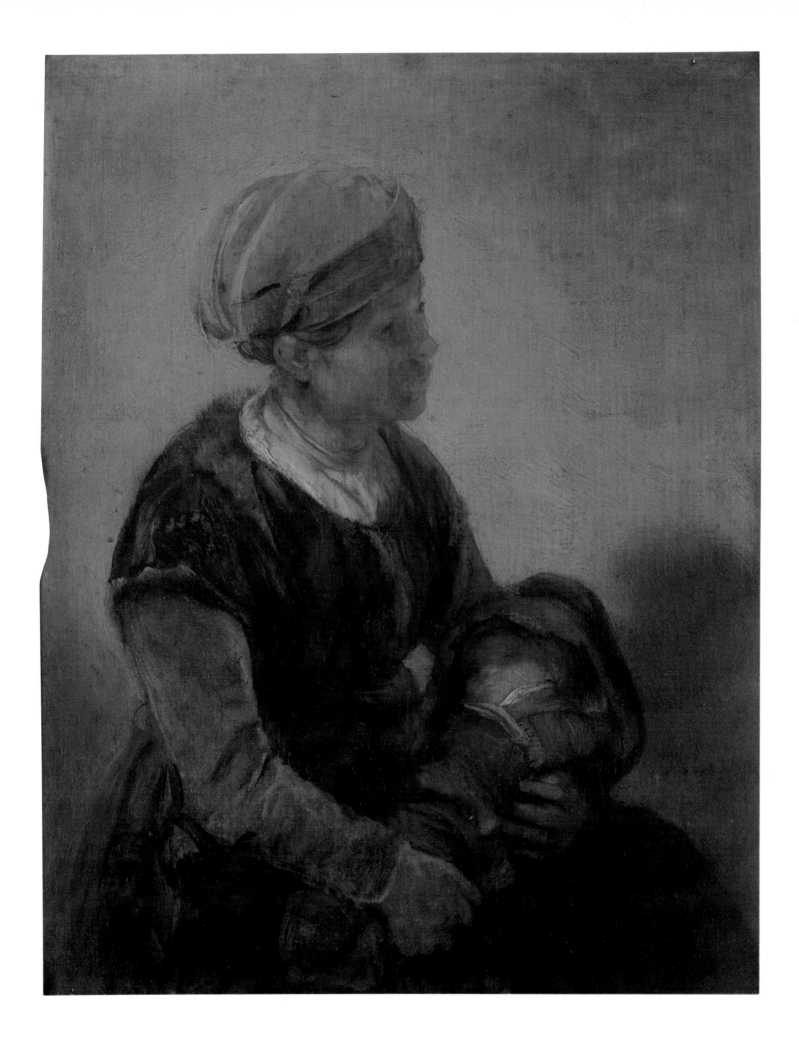

Exhibitions: London 1828, No. 85; London 1835, No. 90; Rotterdam 1949, No. 58; Paris 1952, No. 112 with illustration. Regarded throughout as a work by Rembrandt.

In front of a background steeped in a warm yellow, a seated young woman turns towards the right. She holds in her lap an infant wrapped in swaddling clothes who seems to be asleep. As is evident from the diagonal, upward direction of her gaze, the woman's interest is caught by an event occurring outside the picture.

The small-scale painting is closely related to a lost *Circumcision of Christ* by Rembrandt, now known only through a studio copy (Fig. 80a) in the Herzog Anton Ulrich-Museum in Braunschweig, and a drawing ascribed to Gerbrand van den Eeckhout in the Musée des Beaux-Arts in Brussels.[2] A study in Rembrandt's hand is now in the Staatliche Graphische Sammlung in Munich.[3] We are relatively well informed about the circumstances surrounding the evolution of the lost painting. On 29 November 1646, Frederik Hendrik, *stadhouder* of the House of Orange, ordered payment of 2,400 Carolus guilders to Rembrandt following the delivery of the two commissioned paintings of the *Birth of Christ* and *Circumcision of Christ*. The almost identical dimensions of the *Birth of Christ* preserved in Munich and the Braunschweig copy after Rembrandt's *Circumcision* show that these works can be associated with the payment.[4]

The woman and child in the lower left corner of the *Circumcision* served as model for the Rotterdam painting by Fabritius,[5] although differences can be detected in the clothing of the young woman who, unlike her counterpart in Braunschweig, does not have a dark cloak over her shoulders. Furthermore, the more emphatically rounded neckline of her bodice reveals part of her pale shift. It seems plausible to see in the Rotterdam painting a partial copy after Rembrandt's lost *Circumcision of Christ*. The slight variations between the Rotterdam and Braunschweig paintings do not contradict such a proposal, as in numerous cases studio copies reveal minor differences when compared with the master's original work, as well as a tendency to supplement or omit individual motifs.[6]

For various reasons the Rotterdam picture cannot be regarded as an autograph painting by Rembrandt. Most of his oil sketches made in preparation for planned history subjects are compositional studies executed in *grisaille* on paper as preparatory works for etchings. A feature common to all of Rembrandt's known painted sketches, is the illustration of the complete composition rather than individual figures or smaller groups; these he preferred to develop in his drawings.[7] It is also notable that almost all of Rembrandt's oil sketches were made prior to 1640. Only the direction of the woman's eyes in the Rotterdam picture points to the existence of an 'unrecorded' contextual connection; in its present form, the isolated rendering of the group of woman and child pushes the scene into the realm of genre and characterises it as a conscious adaption of a model rather than an innovative pictorial invention.

The colouring of the Rotterdam picture, untypical for Rembrandt, and its style, have led scholars to propose attributions to two of Rembrandt's pupils—Nicolaes Maes and Barent Fabritius.[8] In both cases a date of c.1646/50 is assumed. If one does not accept that the artist modelled his picture on a drawing or a painted copy of the *Circumcision*, then he must have had access to Rembrandt's studio at the time when the master was engaged on the painting he delivered in 1646. It is possible that Maes started training in Rembrandt's studio as early as 1646/48, and the fact that he would then have been only twelve years old would not have been exceptional at the time.[9] But his youth does make his authorship of the Rotterdam painting doubtful, even though the red-white-black colouring that dominates the woman's costume is indeed characteristic of many of his later works. On the other hand, this colour combination also recalls that of the *Expulsion of Hagar and Ishmael*, in San Francisco (Cat. No. 81), justifiably ascribed to Barent Fabritius, and a work that Bruyn invoked in order to renew the attribution of the Rotterdam picture to this artist.[10] Here one finds the same strongly coloured background. Both paintings are further linked by the generally fluent brushwork, which creates, for example, a positively sketchy and superficial effect in the foreground motifs of the *Expulsion* and, in the present work, in the shoulder and the skirt of the seated woman. In only a few passages of the Rotterdam picture is a pastose application of paint evident, for example in the outlines of the sleeves, in the head-scarf, on the collar and in the child's swaddling clothes. The use of rough brush-strokes around the woman's head, which partially eliminate earlier outlines, especially on the bridge of the nose and in the region of the mouth (in any case no longer clear because of later retouching) links the painting to the so-called *Self-portrait* by Barent Fabritius of 1650, now in the Städelsches Kunstinstitut in Frankfurt (Fig. 80c).[11] Here too one finds the

80a: After Rembrandt, *The Circumcision*. Braunschweig, Herzog Anton Ulrich-Museum.

background lightened in varying degrees, a feature which points to the influence of the work of Fabritius's elder brother, Carel, as is evident from works such as his portrait of Abraham de Potter of 1648/49 (Cat. No. 76). Moreover, the diffuse but decisive shadows cast by the figures in Barent Fabritius's Frankfurt *Self-portrait* and in the Rotterdam painting are comparable. Furthermore, the use of large sections of grey for the flesh-tones of the female figure in the latter is especially characteristic of Fabritius's style during the 1650s and 1660s.[12]

The Rotterdam painting appears, therefore, to be an early work by Barent Fabritius from about 1646, in which the artist digested the various artistic stimulations to which he had been exposed up to this point. For Barent Fabritius, then, the influence of Carel Fabritius may be seen as almost equal in importance to the inspiration offered by Rembrandt.

V.M.

1. The signature, not original and added by a later hand, can be read only with difficulty, and then not fully. Doubt as to the interpretation of the name as 'Rembrandt' has, until now, been expressed only by the Rembrandt Research Project (information provided by B. Haak, in a letter to the Museum of 29 January 1974: the name perhaps to be read as 'Renesse'?). The last digit of the year is also no longer clearly legible. The catalogue of the London 1826 sale throws some light on this (see the account of the painting's provenance), citing the date as 1640. I am grateful to Guido Jansen, in Rotterdam, who enabled me to study the painting.
2. On the copy in Braunschweig, see *Herzog Anton Ulrich-Museum, Braunschweig: Die holländischen Gemälde*, ed. R. Klessmann (Braunschweig, 1983), p. 172, No. 241 (with bibliography) and, most recently, Sumowski 1983 ff., Vol. I, p. 22, note 23 and p. 35 with illustration. On the drawing in Brussels, see Sumowski 1979 ff, Vol. III, p. 1528, No. 709* with illustration (as a work by Gerbrandt van den Eeckhout, about 1646). The attribution of the sheet to Eeckhout is convincing; see, however, Bruyn 1988, p. 328, and note 29 (early work by Maes). One should consider whether Eeckhout is not also to be seen as the artist of the Braunschweig copy after Rembrandt's *Circumcision*. The men behind the balustrade on the left, but also the standing High Priest, for example, are characteristic Eeckhout figures. The colouring, which is untypical of Eeckhout's work of the 1640s, is possibly taken from Rembrandt's model. Worth mentioning in this context is the fact that in the inventory of 20 January 1681 listing the estate of the deceased wife of Rembrandt's pupil Ferdinand Bol, Anna van Erkel, mention is made of, among other works, a 'besnijdenis Christi door Eeckhout' ('a Circumcision of Christ by Eeckhout'); see Blankert 1982, pp. 84 ff.
3. Pen and brush with brown ink and brown wash, with rounded upper edges, 233 × 203 mm, Benesch 581, Fig. 712.
4. On this point, see the quotation of this source in *Documents* 1979, p. 246, 1646/6. *The Birth of Christ with the Adoration of the Shepherds*, signed and dated 1646, is in the Alte Pinakothek, in Munich (Bredius 574; Bauch 79; Bredius/Gerson 574; Tümpel, 68). The painting

measures 97 × 71.3 cm, and the workshop copy in Braunschweig 98 × 73 cm. Rembrandt appears to have owned a copy of the *Circumcision*. In the inventory of his *cessio bonorum* of 1656, there is mention of, among other works, 'De besnijdenisse Christi, copije nae Rembrant' ('The Circumcision of Christ, copied after Rembrandt'); see Strauss-Van der Meulen 1979, p. 357. No. 92.
5. This connection was first recognized by Gustav Falck; see Sumowski 1983 ff., Vol. III, p. 2011, at No. 1327.
6. Thus, for example, in a *Deposition* in the Alte Pinakothek in Munich, begun in about 1636 and finished in 1639 (Bredius 560; Bauch 68; Bredius/Gerson 560; Tümpel, 57), Rembrandt includes, in the right part of the background, figures which are not to be found in the extant copies in Dresden, Staatliche Kunstsammlungen (Inv. No. 1566), Braunschweig, Herzog Anton Ulrich-Museum (Inv. No. 240), and Rotterdam, Museum Boymans-van Beuningen (Inv. No. 2513). On this, see Rotterdam 1988, p. 85, at No. 27.
7. Probably executed as painted preparation for paintings are the oil sketches of *David with the Head of Goliath before Saul* of 1627, in the Öffentliche Kunstsammlungen, Basel (see *Corpus* A9), as well as the *Deposition* in the Hunterian Museum, Glasgow (see *Corpus* A105). On the function of the oil sketches in Rembrandt's œuvre, see E. Haverkamp-Begemann, 'Purpose and Style: Oil Sketches of Rubens, Jan Breughel, Rembrandt', in *Stil und Überlieferung in der Kunst des Abendlandes*, Akten der 21. Internationalen Kongresses für Kunstgeschichte in Bonn, 1964, III (Berlin, 1967), pp. 104–13 and, most recently, Giltaij in Rotterdam/Braunschweig 1983/84, pp. 93–101.
8. The attribution to Nicolaes Maes derives from Sumowski 1983 ff., Vol. III, p. 2011, No. 1327. The Rotterdam painting was connected with Barent Fabritius by Bredius 1921, p. 146. Most recently, Bruyn has strengthened the attribution to B. Fabritius, see Rotterdam 1988, pp. 32–34, and also Bruyn 1988, p. 329.
9. See Ronald de Jager, 'Meester, leerjongen, leertijd— Een analyse van zeventiende-eeuwse Noord-Nederlandse leerlingcontracten van kunstschilders, goud- en zilversmeden', *Oud Holland*, civ (1990), pp. 69–111.
10. See Bruyn (as in note 8).
11. Canvas, 70.5 × 56 cm, signed and dated on the left, above the shoulder: *B Fabritius* ('B' and 'F' joined together) *1650*; see Pont 1985, p. 115, No. 31 and Fig. 16 and, most recently, Sumowski 1983 ff., Vol. II, p. 926, No. 598, p. 976 with colour illustration.
12. One should also mention here *The Evangelist Matthew* of 1656, in the M. Hornstein collection, Montreal, and *The Visit to the Doctor* of 1672, in the Kunsthalle, Bremen; see Sumowski 1983 ff., Vol. II, p. 922, No. 583, p. 961 with colour illustration, and p. 925, No. 597, p. 975 with colour illustration.

81

BARENT FABRITIUS

The Expulsion of Hagar and Ishmael

Canvas, 107.5 × 107.5 cm
Formerly signed at the lower left by a later
hand: *Rembrandt f.*[1]
San Francisco, M.H. de Young Memorial
Museum; Inv. No. 50.34

Provenance: (?) sale, Amsterdam (van Tetroode),
30 October 1823, No. 233 (Rembrandt, canvas,
103 × 143.5 cm); from 1824 until after 1903, in
the collection of William Basil Percy, 7th Earl
of Denbigh, Newnham Paddox, Rugby,
Warwickshire; c.1910 (?) Sulley & Co. art
dealers, London; c.1915, Colnaghi and Obach
art dealers, London; M. Knoedler & Co. art
dealers, New York; until 1950, collection of
Robert Sterling Clark, New York; 1950, given
to the Museum in San Francisco.

Literature: Bode 1897–1906, Vol. v (1901), p. 78
334 (mentions a double Rembrandt signature;
see also the heliogravure illustration in the
volume); Wurzbach 1906–1911, Vol. II (1910),
p. 402 (Rembrandt or N. Maes); Bangel 1914,
p. 355 (probably by G. van den Eeckhout);
Hofstede de Groot 1915, p. 11, No. 6
(Rembrandt?, signed at the lower left:
Rembrandt f.); Hamann 1936, p. 484, Fig. 20 (G.
van den Eeckhout, with reference to Lastman's
painting of the same subject in Hamburg);
Illustrations of Selected Works (San Francisco,
1950), p. 65 with illustration (B. Fabritius);
Pont 1958, pp. 19 ff., 103, No. 3 with
illustration (B. Fabritius; about 1650); Judson
1969, p. 60, No. 52 with illustration (B.
Fabritius); Haverkamp-Begemann 1969, p. 288
(B. Fabritius?); Sumowski 1983 ff., Vol. II,
pp. 910, 915, No. 547, p. 927 with illustration
(B. Fabritius, his earliest history painting,
about 1650, after motifs in works by Lastman
and Rembrandt).

Exhibitions: London 1824, p. 15, No. 100
(Rembrandt); *Art Treasures of the United
Kingdom. Collection at Manchester in 1857* (1857),
p. 61, No. 838 (Rembrandt); London 1903,
p. 157, No. 192 (Rembrandt); Santa Barbara
1951, No. 25 (B. Fabritius); Montreal-Toronto
1969, p. 85, No. 53 (B. Fabritius); Chicago-
Minneapolis-Detroit 1969/70, p. 60, No. 52
(B. Fabritius).

At a great age, Sarah bore Abraham a son, and
God's promise was thus fulfilled. The boy
received the name Isaac. During the celebration
marking the occasion of his weaning, Sarah
noticed that Ishmael, son of Abraham and the
Egyptian maid Hagar, looked scornfully on
Isaac, and she therefore demanded that
Abraham expel both mother and child, in order
to ensure the succession for her own son. After
initial hesitation, Abraham, following God's
commandment, gave in to Sarah's wish: 'And
Abraham rose up early in the morning, and
took bread, and a bottle of water, and gave it
unto Hagar, putting it on her shoulder, and the
child, and sent her away.' (Genesis 21:14.) No
other Old Testament subject was so frequently
treated by Rembrandt and his circle as the
Expulsion of Hagar and Ishmael. Richard
Hamann devoted an extensive study to the
complex evolution and iconography of this
subject.[2]

The painting shows the scene of parting
against the background of an Italianate
landscape. On the left, and in front of tall trees
and buildings, peasants tend to their cattle. On
the opposite side, the land opens out to form a
river valley closed off on the right by a steep
mountain slope with a stone bridge and tower-
like buildings. The manner in which the arch of
the bridge on the right and the milkmaid on
the left are cropped makes it clear that the
canvas has been reduced in size. This is
confirmed by Pieter Lastman's version of the
same subject, painted in 1612 and now in the
Kunsthalle in Hamburg (Fig. 81a).[3] In many of
its passages, Lastman's rectangular panel served
as a model for Fabritius, and thus gives an
impression of the now lost sections of his
painting. Whereas the older iconographic
tradition usually emphasised the actual act of
expulsion by showing a relief-like series of
figures all moving in the same direction,
Lastman innovatively opted for a centralised
composition of the type which was to dominate
in the course of the seventeenth century. The
arrangement of the protagonists evokes an
almost classical effect achieved through the
combination of the statuesque rendering of the
figures and their emotional solemnity. A black
chalk copy of the group of figures, made in
1635/37 (Fig. 81b),[4] reveals Rembrandt's
continuing interest in the art of his teacher, an
interest which in many cases he passed on to
his own pupils. A prime example of this is the
Expulsion of Hagar and Ishmael in San Francisco.
The background is an almost literal repetition
of the setting in the Hamburg picture.
Moreover, the figure of Abraham is also
identical in pose and costume, although the
patriarch with his dark beard seems to be

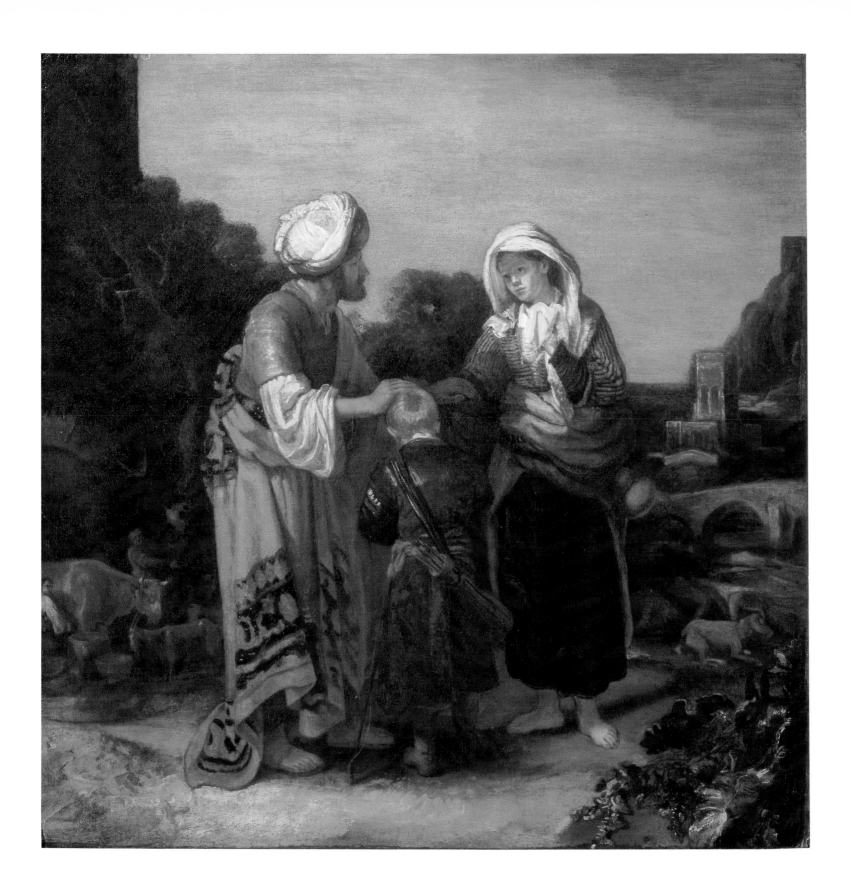

younger than his Hamburg counterpart. Turned symmetrically towards each other, Hagar and Abraham flank the small figure of Ishmael, who stands between his parents, viewed from the back and with his head slightly bowed as he receives his father's blessing. Bow and quiver point to the boy's future destiny as a great bowman and hunter (Genesis 21:20). Significant differences can also be seen in the figure of Hagar. She is more simply dressed and, instead of a headdress resembling a turban, wears a white head-scarf. By illustrating the figures as stationary and omitting all indication of body movement, all reference to the *contrapposto* motion in Lastman's painting is eliminated. This transformation is completed by the rendering of Hagar about to wipe her tears rather than gesticulating passionately.

In the first instance, it is the colouring that suggests an attribution of the painting to Barent Fabritius. Characteristic is an overall, warm tone, to which even the richly nuanced red-black-white accents in the costumes of Abraham and Hagar have been subordinated. The subdued colours are applied in a broad, soft manner and without any harsh linearity, and they link the figures with the landscape. In particular, the manner in which individual parts of the body are set against a light background—as, in the present case, with the heads and left shoulders of Abraham and Hagar—is also frequently found in works by Barent Fabritius that evolved independently of a direct model.[5] Moreover, the simple, heavy

fall of folds of drapery is comparable to those found in paintings by Fabritius from the 1650s and 1660s. The sweeping and, in comparison to Lastman's painting, strongly reduced folds of Abraham's cloak recall, among other details, Peter's cloak in the Braunschweig painting of 1653 (Fig. 81c).

As the provenance of Lastman's painting is unknown, it is difficult to establish with certainty how Fabritius could have known Lastman's model. In any case, and as Hamann has pointed out, 'there can be no question that the sole model for Fabritius was Rembrandt's drawn copy, which is cropped at least on the right, as it records either incompletely or, not at all, features of the San Francisco painting. Accordingly, it would seem that Fabritius knew either Lastman's original, or a drawn or painted copy of the Hamburg picture.[7] The somewhat varied rendering of Ishmael is obviously derived from Rembrandt's work of 1640s and 1650s. Taking his cue from his own etching (B. 30) of 1637 (Fig. 81d), in the drawings in Amsterdam and London, Rembrandt shows Ishmael with his back to the viewer and wearing a knee-length tunic and half-length boots.[8] Sumowski sees a possible inspiration for Barent Fabritius in the drawn version of the subject in the Rijksprentenkabinet in Amsterdam (Fig. 81e).[9]

Using Pieter Lastman as his point of departure while simultaneously drawing on Rembrandt, in his *Expulsion of Hagar and Ishmael* of about 1650 Barent Fabritius set about achieving a more subtle colouring and greater

81a: Pieter Lastman, *The Dismissal of Hagar and Ishmael*. 1612. Hamburg, Kunsthalle.

81b: Rembrandt, *The Dismissal of Hagar and Ishmael*. Drawing. Vienna, Albertina.

painterly effects. Here he drew his iconographic inspiration from Lastman; in his possibly earliest surviving painting, the Rotterdam *Woman with a Child in Swaddling Clothes* (Cat. No. 80), from Rembrandt. A tendency to eschew baroque pathos in favour of a calmer use of gesture, and a marked determination to master the demands of colouring, are characteristics not only of the painter's early work.

V.M.

1. The painting was once signed twice at the lower left by a later hand: *Rembrant*, and *Rembrandt f.*; both signatures can be seen in the heliogravure illustration in Bode 1897–1905, Vol. V, at No. 334. The signature in capital letters—probably nineteenth century—was removed at an unknown date. The second signature was removed when the picture was cleaned in 1950 by Suhr, who described it as 'surely not Rembrandt'; see information in a letter from Bruce F. Miller of 5 February 1981 to the museum. I am grateful to Marion C. Stewart, in San Francisco, for drawing my attention to this letter.

2. See Hamann 1936. On the choice of Old Testament subjects in the work of Rembrandt and his pupils, see Manuth 1987, pp. 44–58.

3. Panel, 49 × 71 cm, signed and dated 1612; see *Katalog der Alten Meister der Hamburger Kunsthalle*, 4th edition (Hamburg, 1956), p. 89, No. 191 with illustration; and Sumowski 1983 ff., Vol I, pp. 11, 21, note 12, and p. 25 with illustration.

4. Rembrandt's drawing (192 × 159 mm) is in the Albertina in Vienna; Benesch 447, Fig. 506. It belongs to a group of copies drawn in red and black chalk in about 1635/37 after paintings by Pieter Lastman.

5. See, among other examples, the *Satyr with Peasants* in the Wadsworth Atheneum, Hartford, Conn.; Sumowski 1983 ff., Vol. II, p. 915, No. 549, p. 929 with colour

illustration (about 1652), and the figure of the prophet in *Elijah and Zarepath's Widow*, present whereabouts unknown see Sumowski 1983 ff., Vol II, p. 918, No. 559, p. 939 with illustration (about 1660).

6. Hamann 1936, p. 485; but see Sumowski 1983 ff., Vol. II, p. 915, at No. 547, who presumes Rembrandt's drawing in Vienna to be the link.

7. In 1929 a copy of Lastman's Hamburg *Expulsion of Hagar*, cropped at left and right, was on the London art market; on this, see Müller 1929, p. 58, note 1 and p. 74, Fig. 19a.

8. These are the drawings Benesch 916 (1650/52) in the Rijksprentenkabinet in Amsterdam, and Benesch 524 (1642/43) and Benesch 962 (about 1655) in the British Museum in London. On the three sheets, see, most recently, Schatborn 1985, pp. 88 ff., at No. 40.

9. Sumowski 1983 ff., Vol. II, p. 915, under No. 547. The sheet discussed is Benesch 916, see also Note 8.

81c: Barent Fabritius, *Peter in the House of Cornelius*. 1653. Braunschweig, Herzog Anton Ulrich-Museum.

81d: Rembrandt, *The Dismissal of Hagar and Ishmael*. 1637. Etching (Bartsch 30).

81e: Rembrandt, *The Dismissal of Hagar and Ishmael*. Drawing. Amsterdam, Rijksprentenkabinet.

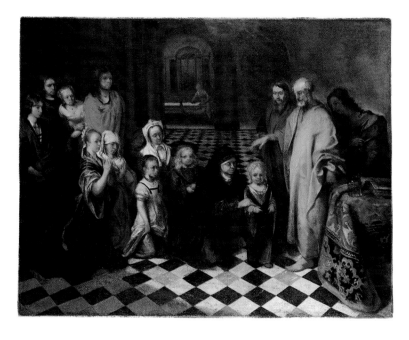

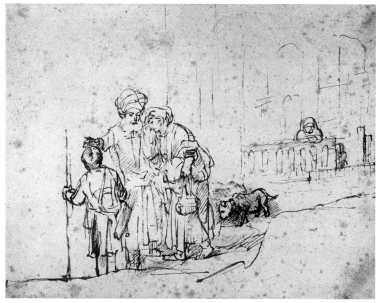

Willem Drost

There are few known dates relating to the artist's life. Neither the year of his birth nor that of his death is known; nor is there any archival information on his apprenticeship.

The art historiographer and painter Arnold Houbraken mentions Drost's training under Rembrandt, a stay in Rome with his colleague, the painter Joan van der Meer, and a friendship formed there with the painter from Munich, later active in Venice, Johan Carl Loth, called Carlotto (1632–1698). Drost followed Loth to Venice where they collaborated on a series of scenes of the Evangelists, known to be in the collection of the Venetian Giorgio Bergonzi in 1709. In 1685 Grand Duke Cosimo III de' Medici purchased a self-portrait by Drost, probably painted in Venice around 1660, and now in the Uffizi. Two signed and dated portraits of Dutch citizens 1654 and 1663 indicate the period within which Drost was in Italy. Also dated 1654 and bearing his signature is Drost's Bathseba reading David's Letter (Paris, Louvre), not only one of his masterpieces but one of the best paintings of the Rembrandt school. The last known document on the painter's life comes from Rotterdam: on 23 December 1680 he was a witness at the drawing up of an inventory of the collection of paintings belonging to a certain Joan van Spijckoort.

Drost's oeuvre includes biblical subjects, individual allegorical figures and portraits. His earliest dated work—an etched self-portrait—was made in 1652, which allows the conclusion that Drost trained under Rembrandt in the late 1640s and early 1650s. Until he left for Italy, where he adopted a style close to that of Johann Carl Loth and the Venetian tenebrosi, Rembrandt's art exerted the greatest influence on Drost. However, although these early works are conceived in a Rembrandtesque manner, Drost's attempts at a more subtle colouring are evident. The high quality of Drost's principal works show him to be a Rembrandt pupil of importance. It is thus with good reason that scholars have recently considered attributing to Willem Drost some paintings from the early 1650s which have long been regarded as by Rembrandt or his anonymous followers.

V.M.

82

Attributed to
WILLEM DROST
The Vision of Daniel

Canvas, 98.5 × 119 cm
Berlin, Gemäldegalerie Staatliche Museen Preussischer Kulturbesitz; Inv. No. 828 F

Provenance: possibly identical with the painting from the collection of Peter Anthony Matteux auctioned about 1715 in London as No. 41 C ('Rembrant—Daniel's vision of the Ram');[1] 1792, inherited by Lady Inchiquin from the collection of her uncle Sir Joshua Reynolds; Sir Joshua Reynolds sale, Christie's, London, 13–17 March 1795 (17 March), No. 81 (re-purchased for Lady Inchiquin by Wilson for 170 guineas); 22 March 1795, sold to Charles Offley, London, for 160 guineas; 31 January 1796, acquired by the London banker Joseph Berwick for 210 guineas; passed to Berwick's daughter and her husband, Sir Anthony Lechmere, The Rydd; 1883, sold to the Parisian art dealer Charles Sedelmeyer; 1883, acquired from Sedelmeyer by Wilhelm von Bode for the Gemäldegalerie in Berlin.

Literature: Hofstede de Groot 1915, Vol. VI, p. 35, No. 53 (Rembrandt); Bredius, p. 23, No. 519 (Rembrandt); Sumowski 1957/58, pp. 236 ff. and 273 and Fig. 104 (the work of a pupil—C. Fabritius?—retouched by Rembrandt); Bauch, p. 229 (Rembrandt); Bredius/Gerson 1969, pp. 600 ff. (work of a pupil); Berlin 1975 p. 354, No. 828 F (school of Rembrandt); Sumowski 1983 ff., Vol. I, pp. 13 and 39 with illustration (pupil of Rembrandt, about 1650); Bruyn 1984, pp. 148 and 153 ff. with illustration of detail, Fig. 5 (W. Drost, about 1650); Kelch 1986, pp. 13 and 15 and Fig. 5 (Drost); De Bazelaire/Starcky 1988/89, p. 64 at No. 55 (school of Rembrandt); Sumowski 1983 ff., Vol. V (1990), p. 3063, at note 16 (not by Drost).

Exhibitions: London 1883, No. 234; Philadelphia 1948, No. 98; Detroit 1948/49, p. 21; Amsterdam-Groningen 1983, No. 3 (Rembrandt and/or his workshop).

Of noble Israelite ancestry, Daniel was carried off to Babylon by Nebuchadnezzar during the Siege of Jerusalem. In Babylon, he was trained, together with other youths, for service at court. During the reigns of several Babylonian

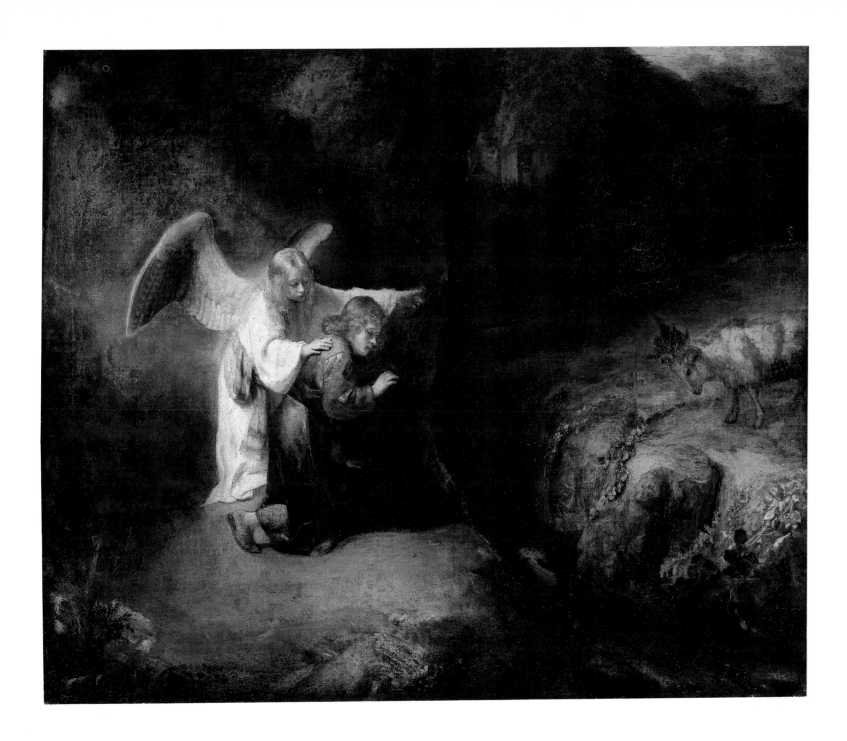

and Persian kings, he came to be regarded as an interpreter of signs and dreams as well as a wise judge and thus attained a position of prestige and influence. The eighth chapter of the Book of Daniel recounts one of the prophet's visions, and this provides the textual basis for the present composition.

On the banks of the river Ulai, near the Palace of Shushan in the province of Elam, Daniel saw how a ram with wondrous horns was thrown to the ground before being trampled on by a he-goat (Daniel 8:2–7). At God's bidding, the Archangel Gabriel interpreted this vision for Daniel: the he-goat embodied the King of Greece (Alexander the Great) and the ram symbolised the kings of the Medes and the Persians (Daniel 8:15–26).

The picture shows the moment at which the Archangel, set against the background of a wooded mountain ravine, bends tenderly over the kneeling young prophet and points with his left arm at the apparition of the ram on the opposite river bank. Daniel balances his nervously hunched-up torso by placing his left hand on a boulder, while his right hand is raised towards the ram in a gesture which expresses both astonishment and self-defence. Daniel reacts to the angel's touch with an abrupt turn of the head. The Archangel, almost child-like in appearance, bends towards Daniel without spread wings and offers protection within his wide-sleeved, open arms: 'So he came near where I stood: and when he came, I was afraid and fell upon my face: but he said unto me, Understand, O son of man: for at the time of the end shall be the vision.' (Daniel 8:17.)

After the Middle Ages, the subject of the painting was very rarely treated by artists. The iconographic tradition is seen in only a few examples of printed Bible illustrations from the late fifteenth and the sixteenth centuries. A paradigmatic comparison is with a wood-cut of the subject after a sketch by Hans Holbein the Younger from the so-called *Icones* (Fig. 82a) a series of illustrations of the Old Testament, which appeared in Lyon in 1538.[2] This wood-cut shows that the Berlin painting departs from the otherwise consistent iconographic tradition. Particularly striking in the wood-cut is the distance between the Archangel and Daniel, as well as its epic expansiveness: true to the text, the artist shows both the ram and the he-goat, the latter seen attacking from the cloud bank placed diagonally above the figures, a detail the painter eschews in favour of concentrating on the actual figures. The painted composition is primarily characterised by the contrast between the two youthful protagonists on the one hand and by the inhospitable and threatening character of the ambience on the other. Only occasionally are the predominantly amorphous forms of the landscape clearly identifiable. Neither the sparkling silhouette of the Palace of Shushan in the distance, nor the sparse vegetation creeping over the rocky river bank, succeeds in distracting the viewer's attention from the figures. Even the ram, as the reason for the meeting between Archangel and man, is granted only a minor role, and even this is only due to Gabriel's demonstrative gesture. Light is the principal means used to express the visionary mood of this scene. The softly illuminated ground around the figures and the ram is cut by the dark river bed. As a natural source of light, the cloud-covered sky at the upper right corner of the picture is ineffective. Lighting from the left lifts the two figures richly contrasted from their dark setting. The figure of Gabriel in particular seems to exude an unearthly glow, as if surrounded by a transparent veil. An ominously luminiscent aura forms around the apocalyptic ram.

Both the quality of the painting, which is difficult to assess because of its poor state of preservation,[3] and the common provenance with Rembrandt's *Susanna* of 1647 (Cat. No. 37), resulted in a general hesitancy to question the attribution of the *Vision of Daniel* to Rembrandt himself. Only with the emergence of a more sophisticated stylistic criticism, based on the extensive study of works by both Rembrandt and his school, as well as increasing recognition of the characteristic methods and techniques of both master and pupils, did doubts arise. Sumowski was the first to voice his misgivings,[4] pointing out, among other things, the implausibility of the assumption that when executing this painting Rembrandt took the exceptional step of copying the drawing of the same subject ascribed to him which is now in the Louvre in Paris (Fig. 82b).[5] Indeed, Rembrandt's paintings generally deviate considerably from his own sketches. Furthermore, Sumowski established not only variations in the quality of the finishing of the picture, but also, with the aid of x-rays, the existence of underpainting atypical for Rembrandt. Sumowski accordingly placed the painting in the category of works by pupils after drawings by the master.

While Bauch (1966) adhered to the traditional attribution to Rembrandt, for Gerson (1969) the question of authorship remained open, although he regarded both the drawing and the painting as the works of pupils. Bruyn (1984) attributed the *Vision of Daniel* to Willem Drost, who was a pupil of Rembrandt in the years around 1650. Our knowledge about Drost as a history painter is still patchy, not least because, until now, only two multi-figure biblical scenes were

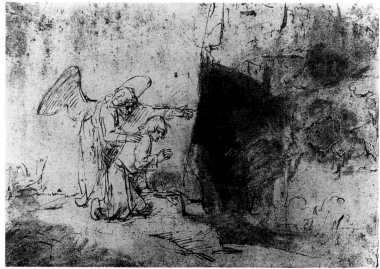

unquestionably accepted as being by him. These are the signed *Noli me tangere*, in the Gemäldegalerie in Kassel (Fig. 83c), a late work of a 'classicistic' character, most probably painted in the second half of the 1660s following Drost's return from Italy,[6] and the *Ruth and Naomi* in Oxford, which Pont accepted—despite the absence of a signature—as a work from Drost's pre-Italian period and one thus constituting the starting point for further attributions (Cat. 83).

The *Ruth and Naomi* in Oxford and the *Vision of Daniel* in Berlin have a number of characteristics in common. The concentration on the pairs of figures is striking, an aspect even more marked in the case of *Ruth and Naomi* because of its fragmentary state. The dark backgrounds of both compositions are thinly painted and very summarily treated, so increasing the impact of the figures, which stand out through being modelled with side-lighting. There are notable similarities in the sketchy execution of those parts of the body turned away from the light, for example Daniel's strongly shadowed left hand and Ruth's bent right hand. The young prophet's thigh appears too long in comparison with his calf; and the treatment of the shoulder area in the figures of both Ruth and the Angel points to some uncertainty in the anatomical structuring of the figures. The pronounced play of hands in both paintings helps to convey the spiritual mood of the scene. The heavy material of the drapery falls in wide pleats and the brightly coloured details of costumes are striking, for example Daniel's sash, or the borders of the women's robes. Altogether, the colouring is characteristic of Drost, consisting principally of brown tones with hints of green; while white, ochre and traces of red (in the angel's wings and as a soft lip colour) are also evident.

In the early 1650s Rembrandt was intensely preoccupied with history paintings depicting two figures, and he made a remarkably large number of drawings illustrating meetings between angels and men. He was apparently searching for convincing figural compositions which would capture the extraordinary character of these scenes. He experimented with ever new variations of movement and pose, such as for the *Meeting of Hagar and the Angel*, or for the *Angel consoling Christ in the Garden of Gethsemane*.[7] For the *Vision of Daniel*, Drost appears to have taken his cue from this compositional framework. Accordingly, the group of Gabriel and Daniel appears as an iconographically modified variation of one of Rembrandt's own inventions. It is possible that a group, such as that recorded in Rembrandt's

drawing with Elijah and the Angel, in Paris (Fig. 82c), may have been Drost's starting point.[8]

The Berlin *Vision of Daniel*, probably painted about 1650/52, should be taken into account when the question of further attributions to Willem Drost arises.

V.M.

1. The details regarding the provenance of the painting before 1795 are taken from the findings of Francis Broun: 'Sir Joshua's Rembrandts' (unpublished ms), 1984, p. 23 and note 1.
2. On Holbein's illustrations, see M. Kästner, *Die Icones Hans Holbeins des Jüngeren: Ein Beitrag zum graphischen Werk des Künstlers und zur Bibelillustration Ende des 15. und in der ersten Hälfte des 16. Jahrhunderts*, 2 Vols (Heidelberg, 1985); on the *Vision of Daniel*, see Vol. I, pp. 317 ff.
3. Particularly striking are the numerous thin cracks in the right half of the picture, which have formed in a semi-circular shape around the ram, but which are also present in the thinly painted background, a reddish coloured, deeper-lying layer of paint is beginning to show through. In addition there are passages where rigorous cleaning has been carried out, for example in Gabriel's drapery. The x-ray photograph shows a notable zig-zagging outline running diagonally above the figure of the angel, to the upper picture edge. I am grateful to Gerhard Pieh, Director of the Restaurierungswerkstatt of the Berlin Gemäldegalerie, and to Jan Kelch, who have helped me in my examination of the painting.
4. Sumowski 1957/58, pp. 236 ff.
5. Benesch, Vol. V, No. 901, Fig. 1113. Paris, Musée du Louvre; pen and brown ink, with wash, and white lead corrections, 165 × 243 mm. On this, see, most recently, De Bazelaire/Starcky 1988/89, p. 63, No. 55 (Rembrandt). The largely accepted attribution of the drawing to Rembrandt should be re-examined. It is possible that the two figures derive from a related group devised by Rembrandt. As a whole, the composition is unconvincing, especially as the river bed runs through the scene, dividing it contextually on the one hand, and into two unequally executed halves on the other. It is true that the sheet in Paris lacks the sequence of thick parallel hatching strokes that is characteristic of drawings securely attributable to Drost; yet Daniel's angular profile recalls the figures from a series of drawings in the Rijksprentenkabinett in Amsterdam ascribed to Drost. Of particular interest here, is the figure of Joseph, in the scene where he is shown being sold by his brothers; see Benesch C99 (copy after Rembrandt) and, most recently, P. Schatborn, 'Tekeningen van Rembrandts leerlingen', in: *Bulletin van het Rijksmuseum*, xxxiii (1981), pp. 100 ff., and Fig. 13 (Drost).
6. On this, see the commentary in Cat. 83.
7. See, among others, the drawings Benesch 898, 899 (connected to the etching *Christ in the Garden of Gethsemane*, Bartsch 75) as well as Benesch 904.
8. Paris, Fondation Custodia, collection of Frits Lugt; Benesch, Vol. V, 907 and ad 907 (c.1652).

82a: After Hans Holbein the Younger, *The Vision of Daniel*. Woodcut, from *Historiarum veteris instrumenti icones ad vivum expressae*, Lyon 1538.

82b: Rembrandt, *The Vision of Daniel*. Drawing. Paris, Musée du Louvre.

82c: Rembrandt, *Elijah and the Angel*. Drawing. Paris, Foundation Custodia (coll. F. Lugt).

83

WILLEM DROST

Ruth declares her Loyalty to Naomi

Canvas, 87 × 71 cm
Oxford, Ashmolean Museum; Inv. No. A390
Only exhibited in Berlin and Amsterdam

Provenance: Charles T.D. Crews sale, Christie's, London, 1–2 July (1 July) 1915, No. 20 (C. Fabritius; sold for £210, to Buttery); H.A. Buttery art dealers, London; F.H. Schiller sale, Sotheby's, London, 6 May 1925, No. 16 (C. Fabritius; sold for £830, to Bamford); W.R.F. Weldon, London; 1929, given by Mrs Weldon to the Museum in Oxford.

Literature: Sumowski 1957/58, pp. 232, 263 and Fig. 62 (B. Fabritius); Pont 1958, p. 129, No. b 4 (ascribed to Drost, about 1652/53); Pont 1960, pp. 205, 210, 211 and Fig. 2, pp. 218–21 (Drost); Sumowski 1961, p. 23 at C100; Oxford 1962, p. 48 152 (Drost); Sumowski 1969, pp. 375 ff. (Drost, early 1650s); Judson 1969, pp. 55 ff., No. 42, p. 150 with illustration (Drost); Schulz 1978, p. 83, note 32 (Drost ?); A. Tümpel 1978, p. 99, Fig. 21 (Drost); Sumowski 1979 ff., Vol. III, p. 1186 (Drost, about 1651); Oxford 1980, p. 32 (Drost); Sumowski 1983 ff., Vol. I, pp. 608, 611, No. 311, p. 620 with illustration (Drost, about 1651); Bruyn 1984, p. 154 (Drost, fragment); *Corpus*, Vol. III, pp. 530 ff. and Fig. 8 (Drost).

Exhibitions: London 1903, No. 139 (C. Fabritius); London 1953, No. 27 with illustration (B. Fabritius); Chicago/Minneapolis/Detroit 1969/70, pp. 55 ff., No. 42 with illustration (Drost); Oxford 1975, No. 30 (Drost).

The four chapters of the biblical Book of Ruth tell of a man called Elimelech who, because of a famine, moved with his family from Bethlehem in the land of Judah to the land of the Moabites. After his death, his two sons married Moabite women; but the sons also died after ten years. Naomi, Elimelech's widow, finally decided to return to her homeland accompanied by her daughters-in-law, Orpah and Ruth. After initial hesitation, Orpah gave in to Naomi's repeated suggestion that she return to her family house in the land of the Moabites. Ruth, however, remained loyal to her mother-in-law, trusting her fate in a foreign land to her faith in God: 'for whither thou goest, I will go: and where thou lodgest, I will lodge: thy people shall be my people, and thy God my God' (Ruth 1:16). In Bethlehem, Ruth supported both herself and Naomi by working as a gleaner in the corn-field owned by Boaz, a wealthy relative of Elimelech. After another relative had foregone his right of inheritance to the estate of Elimelech, Boaz purchased a piece of the deceased's land and, with this, the right to marry Ruth. According to the genealogical tradition of the house of David, the son born of this union, Obed, was the grandfather of the subsequently renowned king (see, among other texts, Ruth 4:22), and thus an ancestor of Christ.

The picture shows Ruth's solemn declaration to Naomi that she will follow her on the road to Bethlehem and not abandon her. This rarely treated moment was first introduced by Pieter Lastman into baroque painting.[1] The old woman dressed in yellow, overcome with emotion, turns to her daughter-in-law, who emphasises her pledge of fidelity with the solemn gesture that accompanies her declaration. Notable from the point of view of iconography is the omission of the figure of Orpah, who, in as far as one can speak of a tradition for the subject, may frequently be found as a subsidiary figure in the background, being a narrative counterpart to Ruth. However, Rembrandt had already eliminated this motif in his etching of the subject (Bartsch 120) from the earlier 1640s (Fig. 83a), for a long time mistakenly identified as a depiction of the gypsy Preciosa, a character from the work of the Spanish author Cervantes.[2]

The attribution to Willem Drost of the Oxford painting, which has clearly been cut on both sides, is convincing.[3] A rectangular preparatory drawing, now in the Kunsthalle in Bremen (Fig. 83b),[4] records the complete composition; and there can be no doubt that Drost is the author of the sheet. A comparison with the artist's *Noli me tangere* drawing in Copenhagen, which constitutes the starting

point for the signed painting in Kassel (Fig. 83c),[5] reveals not only general stylistic similarities—but also an identical rendering of characteristic sections. According to Benesch,[6] the study in Bremen cannot be a copy after a lost drawing by Rembrandt, as it lacks the typical characteristics of a copy. Nor can the sheet be considered a drawn copy after the Oxford painting on account of such differences as the placing of Naomi's arm and the folds of her robe.

A number of motifs indicate the influence of works by Rembrandt. Pont correctly pointed to the figure of Abraham in Rembrandt's etching of 1645, *The Sacrifice of Isaac* (Bartsch 43), as a model for the position of Ruth's arm.[7] Her complex and elaborately rendered head-dress finds its equivalent in the back-view figure of the standing woman with the child in the *Hundred Guilder Print* (Bartsch 74).

Physiognomic similarities abound, as is especially evident if one compares the figure of Ruth with that of the Magdalen in Drost's *Noli me tangere*, now in Kassel—convincingly dated by Sumowski to the period following Drost's return from Italy (the 1660s).[8] For the group of Christ and the Magdalen in this painting, Drost seems to have referred to the drawing (now in Copenhagen) which he had made in the early 1650s under the influence of Rembrandt's *Noli me tangere* of 1651 (Bredius/Gerson 583),[9] now in the Herzog Anton Ulrich-Museum in Braunschweig. Schmidt-Degener has drawn attention to the graceful, old-fashioned drapery folds of the robe of Rembrandt's figure of Christ which evoke associations with Gothic sculpture,[10] even

83a: Rembrandt, *Ruth and Naomi*. Etching (Bartsch 120). Amsterdam, Rijksprentenkabinet.

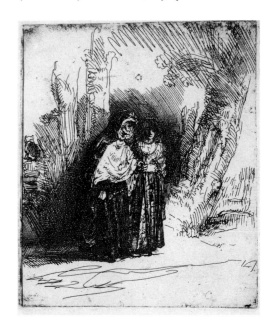

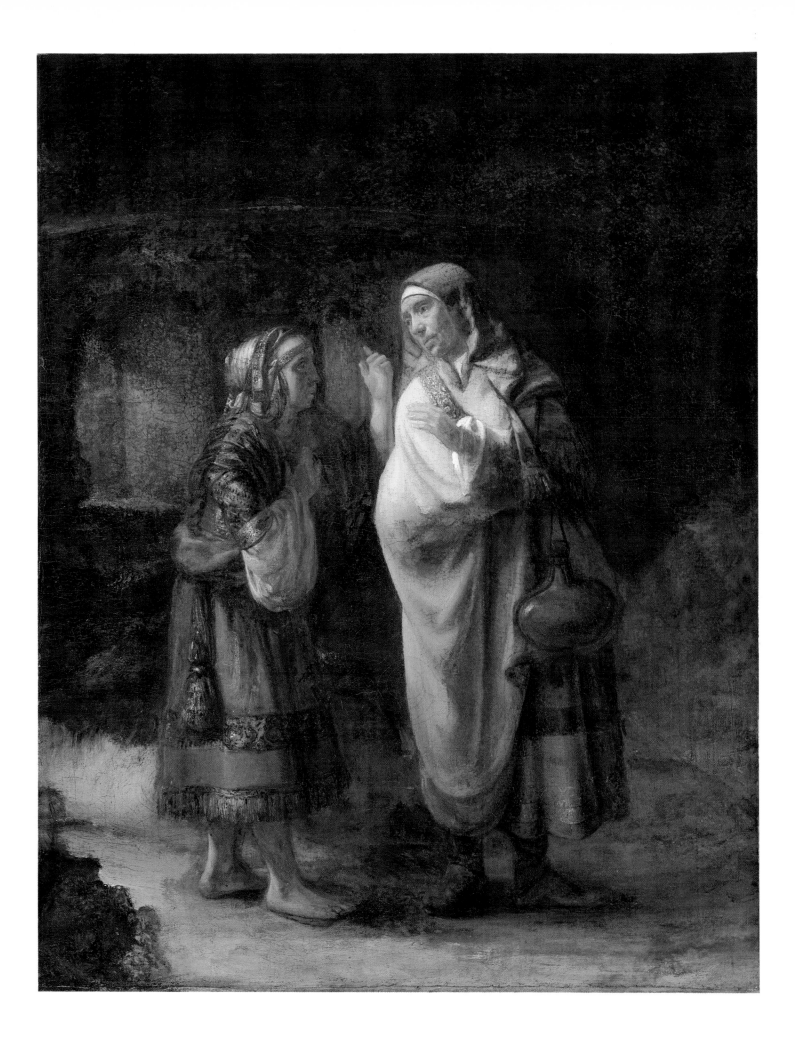

though a specific model cannot be identified. In an exhaustive study Benesch established that such a phenomenon is not unique in Rembrandt's œuvre.[11] Drost's figure of Naomi indicates that he too followed this tendency of adopting characteristics of earlier styles. This is especially clear in the draping of her cloak, which—like a pallium—is wrapped around her so as to bind her right arm close to her chest. Moreover, the position of her head and her arm, her matronly headdress and her lively expression recall figures of the Madonna from medieval scenes of the Lamentation, from which Rembrandt himself had drawn inspiration in the 1630s. Drost's Naomi follows almost literally the mourning figure of Mary in Rembrandt's study sheet of about 1635/36 (Fig. 83d).[12]

Clues for the dating of the Oxford painting are provided by deficiencies in the linear conception of the female figures, which appear somewhat wooden. The organic relationship between the draped limbs and the body as a whole is not always convincing. The position of Naomi's arm under her cloak, for example, remains as ill-defined as the meeting of Ruth's shoulder and right arm. Notwithstanding the already highly developed independence of the colouring (itself characteristic for Drost), this picture is one of the artist's early works and was probably painted about 1651/52, towards the end of his apprenticeship in Rembrandt's studio.

V.M.

1. Lastman's rectangular painting of 1614, now in the Niedersächsische Landesgalerie in Hanover, played a decisive part in the dissemination and development of the subject within the realm of Dutch history painting; on this, see A. Tümpel 1978.
2. The subject was first correctly identified in A. Jordan, 'Bemerkungen zu Rembrandts Radierungen', in *Repertorium für Kunstwissenschaft* xvi (1893), pp. 296–302, especially p. 301; on this see also Münz 1952, Vol. II, p. 115, No. 267.
3. See Pont 1960.
4. See Sumowski 1979 ff., Vol. III, p. 1186, No. 546 with illustration (also gives bibliography).
5. Drost's drawing is now in the Kongelige Kobberstiksamling in Copenhagen (Inv. No. 7049); see Sumowski 1979 ff., Vol. III, p. 1188, No. 547* with illustration (early 1650s). On the painting in the Staatliche Kunstsammlungen in Kassel (Inv. No. 261), see H. Vogel, *Katalog der Staatlichen Gemäldegalerie zu Kassel* (Kassel, 1958), p. 51, No. 261 and, most recently, Sumowski 1983 ff., Vol. I, p. 612. No. 315, p. 624 with illustration. Drost's painting was dated to the early 1650s on account of the connection with Rembrandt's *Noli me tangere* of 1651, now in Braunschweig (Bredius/Gerson 583). Sumowski recognized that the picture must have been made in the 1660s at the earliest, because of its 'preziös-klassizistischer Züge' (affected classicistic features), which Drost referred to for his drawing of the same subject in Copenhagen (see above).
6. Benesch, Vol. vi, p. 392, No. C100, Fig. 1640; see, however, the earlier argument of Sumowski 1957/58, p. 237.
7. Pont 1960, p. 210.
8. See note 5.
9. On Rembrandt's painting, see, most recently, R. Klessmann, 'Rembrandts *Noli me tangere*: mit den Augen eines Dichters gesehen', in *Niederdeutsche Beiträge zur Kunstgeschichte*, xxvii (1988), pp. 89–100.
10. F. Schmidt-Degener, 'Rembrandt imitateur de Claus Sluter et de Jean van Eyck', in *Gazette des Beaux-Arts*, xxxvi (1906), pp. 89–108, especially p. 101. Schmidt-Degener's observations, on the whole correct, are somewhat qualified by his attempt to identify specific models in the realm of late medieval sculpture and painting.
11. See O. Benesch, 'Rembrandt and the Gothic Tradition', in *Gazette des Beaux-Arts*, xxvi (1994), pp. 285–304; also reprinted in E. Benesch, ed., *Otto Benesch: Collected Writings*, Vol. I (New York, 1970), pp. 147–58.
12. Amsterdam. Rijksprentenkabinett, red chalk, and pen and brown ink, 201 × 1433 mm; inscribed at the top in Rembrandt's hand: '*een dijvoot thr[?]eesoor dat in een fijn harte bewaert wert tot troost haarer beleevende siel*' ('a special treasure that is stored in a fine heart will be a comfort to her modest soul'). Benesch Vol. I, No. 152, Fig. 156 (about 1637); Schatborn 1985, pp. 18 ff., No. 7 with illustration (late 1635 to early 1636). Rembrandt's sheet of studies may be connected with the painting of the *Entombment* of 1636/39, in the Alte Pinakothek in Munich (Bredius/Gerson 560), from the so-called Passion cycle painted for Frederik Hendrik.

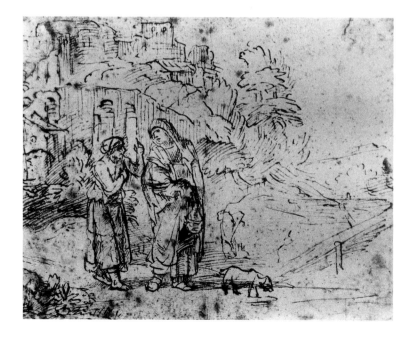

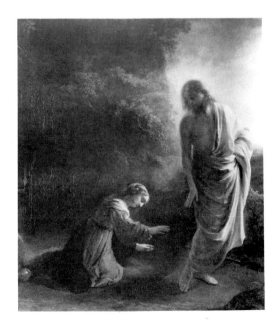

Bibliography

83b: Willem Drost, *Ruth declares her loyalty to Naomi*. Drawing. Bremen, Kunsthalle.

83c: Willem Drost, *Noli me tangere*. Kassel, Staatliche Kunstsammlungen, Gemäldegalerie Alte Meister.

83d: Rembrandt, *Sheet of studies with grieving Maries*. Drawing. Amsterdam, Rijksprentenkabinet.

Ainsworth 1982
M.W. Ainsworth et al, *Art and Autoradiography: Insights into Paintings by Rembrandt, Van Dyck, and Vermeer* (The Metropolitan Museum), New York 1982.
B.
Adam Bartsch, *Le peintre-graveur*, 21 Vols., Vienna 1802–21.
Bader 1976
A.R. Bader, Exh. Cat. *The Bible Through Dutch Eyes*, Milwaukee Art Center 1976.
Bangel 1914
R. Bangel, in: U. Thieme, F. Becker, *Allgemeines Lexikon der Bildenden Künstler*, Vol. X, Leipzig 1914.
Bartsch
Adam Bartsch, *Catalogue raisonné de toutes les estampes qui forment l'œuvre de Rembrandt, et ceux de ses principaux imitateurs, composé par Gersaint, Helle, Glomy et P. Yver*, 2 Vols., Vienna 1797.
Bastet, F.L.: see Amsterdam 1989.
Bauch 1933
K. Bauch, *Die Kunst des jungen Rembrandt*, Heidelberg 1933.
Bauch 1960
K. Bauch, *Der frühe Rembrandt und seine Zeit. Studien zur geschichtlichen Bedeutung seines Frühstils*, Berlin 1960.
Bauch 1966
K. Bauch, *Rembrandt Gemälde*, Berlin 1966.
Von Baudissin 1925
K. Graf von Baudissin, Rembrandts Berliner Susanna, *Repertorium für Kunstwissenschaft* 46 (1925), pp. 263–64.
De Bazelaire/Starcky 1988/89
M. de Bazelaire, E. Starcky, *Rembrandt et son école, dessins du Musée du Louvre*, Musée du Louvre, Cabinet des dessins 1988/89, Paris 1988.
Benesch
Otto Benesch, *The Drawings of Rembrandt. A critical and chronological Catalogue*, 6 Vols., London 1953–57.
Bergström 1966
Ingvar Bergström, Rembrandt's Double-Portrait of himself and Saskia at the Dresden Gallery, *Nederlands Kunsthistorisch Jaarboek* 17 (1966), pp. 143–69.
Blankert 1967
A. Blankert, Heraclitus en Democritus, in het bijzonder in de Nederlandse kunst van de 17de eeuw, *Nederlands Kunsthistorisch Jaarboek* 18 (1967), pp. 31–124.
Blankert 1982
Albert Blankert, *Ferdinand Bol (1616–1680)— Rembrandt's pupil*, Doornspijk 1982.
Blankert, A.: see also Washington, Detroit & Amsterdam 1980–81.
Bode 1883
W. Bode, *Studien zur Geschichte der Holländischen Malerei*, Braunschweig 1883.
Bode 1892
W. Bode, Rembrandts Predigt Johannes des Täufers in der Königlichen Gemälde-Galerie zu Berlin, *Jahrbuch der Königlich Preussischen Kunstsammlungen* 13 (1892), pp. 213–18.
Bode 1895
W. Bode, Rembrandts Bildnis des Mennoniten Anslo in der Königlichen Galerie zu Berlin, *Jahrbuch der Königlich Preussischen Kunstsammlungen* 16 (1895), pp. 3–12.
Bode 1897–1905
W. Bode, *Rembrandt. Beschreibendes Verzeichnis seiner Gemälde. Geschichte seines Lebens und seiner Kunst. Mit Mitwirkung von C. Hofstede de Groot*, 8 Vols., Paris 1897–1905; English and French editions, Paris 1897–1906.

Bode 1902/03
W. Bode, *Rembrandts Gemälde des Paulus im Nachdenken im Germanischen Museum zu Nürnberg*, *Zeitschrift für bildende Kunst* n.s. 14 (1902/03), p. 48.
Bode 1913
W. Bode, The earliest dated Painting by Rembrandt of the Year 1626, *Art in America* 1 (1913), pp. 3–7.
Bomford, D.: see London 1988–89.
Bramsen 1950
H. Bramsen, The Classicism of Rembrandt's 'Bathseba', *The Burlington Magazine* 92 (1950), pp. 128–31.
Bredius 1910
A. Bredius, Rembrandtiana, *Oud Holland* 28 (1910), pp. 1–18.
Bredius 1910a
A. Bredius, Etwas aus dem Nachlasse Ferdinand Bols, *Kunstchronik*, 21 (1910), p. 465.
Bredius 1921
A. Bredius, bespreking van: W.R. Valentiner, Rembrandt. Wiedergefundene Gemälde, *Zeitschrift für bildende Kunst* N.F. 32 (1921), pp. 146–52.
Bredius 1935
A. Bredius, *Rembrandt schilderijen*, Utrecht 1935 (German ed. Vienna 1935, English ed. London 1937).
Bredius/Gerson 1969
A. Bredius, *Rembrandt. The complete Edition of the Paintings*, revised by H. Gerson, London 1969; revised edition of A. Bredius, *Rembrandt schilderijen*, Utrecht 1935.
Brochhagen 1968
E. Brochhagen, Beobachtungen an den Passionsbildern Rembrandts in München, in *Minuscula discipulorum [...] Hans Kauffmann zum 70. Geburtstag 1966*, Berlin 1968, pp. 37–43.
Broos 1970
B.P.J. Broos, Rembrandt borrows from Altdorfer, *Simiolus* 4 (1970), pp. 100–08.
Broos 1970a
B.P.J. Broos, The 'O' of Rembrandt, *Simiolus* 4 (1970), pp. 150–84.
Broos 1972
B.P.J. Broos, "Rembrandt.verandert. En overgeschildert", *De Kroniek van het Rembrandthuis* 26 (1972), pp. 137–52.
Broos 1977
B.P.J. Broos, *Index to the formal Sources of Rembrandt's art*, Maarssen 1977.
Broos 1981
B.P.J. Broos, *Rembrandt en tekenaars uit zijn omgeving. Oude tekeningen in het bezit van de Gemeentemusea van Amsterdam, waaronder de collectie Fodor*, III, Amsterdam 1981.
Broos 1987
Ben Broos, *Meesterwerken in het Mauritshuis*, The Hague 1987.
Brown, B.L.: see Washington & Cincinnati 1988–89.
Brown, C. 1983
C. Brown, Rembrandt's "Saskia as Flora" X-rayed in *Essays in northern European Art presented to Egbert Haverkamp-Begemann on his sixtieth Birthday*, Doornspijk 1983, pp. 48–51.
Brown, C.: see London 1980; London 1988–89.
Bruyn 1959
J. Bruyn, *Rembrandt's keuze van Bijbelse onderwerpen*, Utrecht 1959 (address delivered to the Koninklijk Oudheidkundig Genootschap in Amsterdam on 11 November 1958).
Bruyn 1970
J. Bruyn, Rembrandt and the Italian Baroque, *Simiolus* 4 (1970), pp. 28–48.
Bruyn 1982
J. Bruyn, The documentary Value of early graphic Reproductions, in Bruyn et al. 1982–, Vol. 1, pp. 35–51.
Bruyn 1984
J. Bruyn, review of: Werner Sumowski, Gemälde der Rembrandt-Schüler, I (J.A. Backer—A. van Dijck), Landau/Pfalz 1983, *Oud Holland* 98 (1984), pp. 146–62.

Bruyn 1988
J. Bruyn, review of: Werner Sumowski, Gemälde der Rembrandt-Schüler, III (B. Keil—J. Ovens), Landau/Pfalz 1986, *Oud Holland* 102 (1988), pp. 322–33.
Bruyn 1990
J. Bruyn, An unknown assistant in Rembrandt's workshop in the early 1660s, *The Burlington Magazine* 132 (1990), pp. 715–18.
Bruyn et al. 1982–
J. Bruyn, B. Haak, S.H. Levie, P.J.J. van Thiel and E. van de Wetering, *A Corpus of Rembrandt Paintings*, Vol. 1–, The Hague, Boston & London 1982– (Stichting Foundation Rembrandt Research Project); the following volumes have been published to date: 1, 1625–31 (1982), 2, 1631–34 (1986) and 3, 1635–42 (1989).
Bruyn Kops, C.J. de: see Amsterdam 1984.
Busch 1971
W. Busch, Zu Rembrandts Anslo-Radierung, *Oud Holland* 86 (1971), pp. 196–99.
Carasso-Kok, M.: see Haarlem 1988.
Cetto 1959
A.M.Cetto, De Anatomische les van Dr Deyman door Rembrandt, *De Kroniek van het Rembrandthuis*, 13 (1959), pp. 57–62.
Chapman 1990
H. Perry Chapman, *Rembrandt's Self-Portraits. A Study in seventeenth-century Identity*, Princeton 1990.
Clark 1966
K. Clark, *Rembrandt and the Italian Renaissance*, New York 1966.
Collins Baker 1926
C.H. Collins Baker, Rembrandt's "Painter in his Studio", *The Burlington Magazine* 48 (1926), p. 42.
Coornhert 1586
D. Vsz. Coornhert, *Zedekunst, dat is, wellevenskunste*, n.p. 1586 (reprint, with introduction by B. Becker, Leiden 1942).
Corpus, see: Bruyn et al. 1982–.
Documents
W.L. Strauss and M. van der Meulen (with the assistance of S.A.C. Dudok van Heel and P.J.M. de Baar), *The Rembrandt Documents*, New York 1979.
Van Domselaar 1660
T. van Domselaar (ed.), *De Hollantsche Parnas, of Verscheide Gedichten*, Amsterdam 1660.
Dudok van Heel 1969
S.A.C. Dudok van Heel, Het maecenaat De Graeff en Rembrandt, *Maandblad Amstelodamum* 56 (1969), pp. 150–55.
Dudok van Heel 1980
S.A.C. Dudok van Heel, Doopsgezinden en schilderkunst in de 17de eeuw. Leerlingen, opdrachtgevers en verzamelaars van Rembrandt, *Doopsgezinde Bijdragen* N.R. 6 (1980), pp. 105–23.
Dyserinck 1904
J. Dyserinck, Eene Hebreeuwsche inscriptie op een schilderij van Rembrandt, *De Nederlandsche Spectator* 1904, pp. 160 and 350.
Van Eeghen 1956
I.H. van Eeghen, Marten Soolmans en Oopjen Coppit, *Maandblad Amstelodamum* 43 (1956), pp. 85–90.
Van Eeghen 1956a
I.H. van Eeghen, Een doodshoofd van Rembrandt bij het Amsterdamse chirurgijnsgilde?, *Oud Holland* (1956), p. 35 ff.
Van Eeghen 1957
I.H. van Eeghen, De Staalmeesters, *Jaarboek Amstelodamum* 49 (1957), pp. 65–80.
Van Eeghen 1958
I.H. van Eeghen, *Een Amsterdamse burgemeestersdochter van Rembrandt in Buckingham Palace*, Amsterdam 1958.
Van Eeghen 1958a
I.H. van Eeghen, De Staalmeesters, *Oud Holland* (1958), pp. 80 ff.
Van Eeghen 1969
I.H. van Eeghen, De restauratie van het voormalige Anslohofje, *Maandblad Amstelodamum* 56 (1969), pp. 199–205.

Van Eeghen 1969a
I.H. van Eeghen, Rembrandt en de mensenvilders, *Maandblad Amstelodamum* 56 (1969), pp. 1–11.
Van Eeghen 1971
I.H. van Eeghen, De vaandeldrager van Rembrandt, *Maandblad Amstelodamum* 58 (1971), pp. 173–81.
Van Eeghen 1985
I.H. v[an] E[eghen], De tekeningen van vader en zoon Andriessen: Agatha Bas bij Coclers, *Maandblad Amstelodamum* 72 (1985), pp. 1–3.
Eisler 1927
M. Eisler, *Der alte Rembrandt*, Vienna 1927.
Ekkart 1988
R.E.O. Ekkart, De portretten van Laurens Reael en Suzanna Moor, zogenaamd beide door Cornelis van der Voort, *Bulletin van het Rijksmuseum* 36 (1988), pp. 7–10.
Emmens 1956
J.A. Emmens, Ay Rembrant, maal Cornelis Stem, *Nederlands Kunsthistorisch Jaarboek* 7 (1956), pp. 133–65.
Emmens 1968
J. Emmens, *Rembrandt en de regels van de kunst*, Utrecht 1968.
Eyffinger, A.: see The Hague 1987.
Félibien
André Félibien, *Entretiens sur les vies et sur les ouvrages des plus excellents peintres, anciens et modernes*, Paris 1666–68, 5 Vols. The life of Rembrandt is contained in Vol. 4, published in 1684, pp.150–57.
Foucart 1982
J. Foucart, *Les Peintures de Rembrandt au Louvre*, Paris 1982.
Freise 1909
K. Freise, Bathsebabilder von Rembrandt und Lastman, *Monatshefte für Kunstwissenschaft* 2 (1909), pp. 302–13.
Frerichs 1969
L.C.J. Frerichs, De schetsbladen van Rembrandt voor het schilderij van het echtpaar Anslo, *Maandblad Amstelodamum* 56 (1969), pp. 206–11.
Froentjes 1969
W. Froentjes, Schilderde Rembrandt op goud, *Oud Holland* 84 (1969), pp. 233–37.
Galichon 1866
E. Galichon, Quelques notes à propos d'un portrait de Corneille Nicolas Anslo par Rembrandt, *Gazette des Beaux-Arts* 20 (1866), pp. 234–39.
Van Gelder, H.E. 1943
H.E. van Gelder, Marginalia bij Rembrandt I: De pendant van Maurits Huygens, *Oud Holland* 60 (1943), pp. 33–34.
Van Gelder, H.E. 1953
H.E. van Gelder, Rembrandts portretjes van M. Huygens en J. de Gheyn III, *Oud Holland* 68 (1953), p. 107.
Van Gelder, H.E. 1957
H.E. van Gelder, *Ikonografie van Constantijn Huygens en de zijnen*, The Hague 1957.
Van Gelder 1953
J.G. van Gelder, Rembrandt's vroegste ontwikkeling, *Mededelingen der Koninklijke Nederlandse Akademie van Wetenschappen* (afd. Letterkunde, n.r. 16/5), Amsterdam 1953.
Van Gelder 1963
J.G. van Gelder, Jeremia treurende over de verwoesting van Jeruzalem, *Openbaar Kunstbezit* 7 (1963), afl. 15.
Gerson 1961
H. Gerson, *Seven letters by Rembrandt*, The Hague 1961.
Gerson 1968
H. Gerson, *Rembrandt Paintings*, Amsterdam 1968.
Giltaij 1988
J. Giltaij, *De tekeningen van Rembrandt en zijn school in het Museum Boymans-van Beuningen*, Rotterdam 1988.
Gregory & Zdanowicz 1988
J. Gregory and I. Zdanowicz, *Rembrandt in the Collections of the National Gallery of Victoria*, Melbourne 1988.
Van Guldener
Hermina Tunsina van Guldener, Het Jozefverhaal bij Rembrandt en zijn school, phil. diss. (manuscript), Utrecht 1947.
Haak 1969

B. Haak, *Rembrandt. Zijn leven, zijn werk, zijn tijd*, Amsterdam 1969.
Hamann 1936
Richard Hamann, Hagars Abschied bei Rembrandt und im Rembrandt Kreis, *Marburger Jahrbuch für Kunstwissenschaft* 8–9 (1936), pp. 471–578a.
Hamann 1969
R. Hamann, *Rembrandt*, Berlin 1969.
Hannema 1949
D. Hannema, *Catalogue of the D.G. van Beuningen Collection*, Rotterdam 1949.
Hausherr 1963
R. Hausherr, 'Zur Menetekel-Inschrift auf Rembrandts Belsazarbild', *Oud Holland* 78 (1963), pp. 142–49.
Haverkamp-Begemann 1959
E. Haverkamp-Begemann, *Willem Buytewech*, Amsterdam 1959.
Haverkamp-Begemann 1969
Egbert Haverkamp-Begemann, Rembrandt und seine Schule—Zur Ausstellung in Kanada (besprking van tentoonstelling 'Rembrandt and his pupils', Montreal/Toronto 1969), *Kunstchronik* 22, (oktober 1969), pp. 281–89.
Hecht, P.: see Amsterdam 1989.
Heckscher 1958
W.S. Heckscher, *Rembrandt's Anatomy of Dr Nicolaas Tulp*, New York 1958, pp. 191–92.
Held 1961
J.S. Held, Flora, Goddess and Courtesan, in *De artibus opuscula XL: Essays in Honor of Erwin Panofsky*, New York 1961, pp. 201–08.
Held 1967
J.S. Held, Rubens' 'Het Pelsken', *Essays in the History of Art presented to Rudolf Wittkower*, Londen 1967, pp. 188–92.
Heppner 1963
A. Heppner, Moses zeigt die Gesetztafeln bei Rembrandt und Bol, *Oud Holland* 78 (1963), pp. 142–49.
Hinterding and Horsch 1989
Erik Hinterding and Femy Horsch, 'A small but choice collection': the Art Gallery of King Willem II of the Netherlands (1792–1849); A Note on Willem II's Collection of Drawings; Reconstruction of the Collection of Old Master Paintings of King Willem II, *Simiolus* 19 (1989), pp. 5–122.
Hoff 1973
U. Hoff, *European Painting and Sculpture before 1900*, National Gallery of Victoria, Melbourne 1973.
Hofstede de Groot 1899
C. Hofstede de Groot, Isaac de Jouderville, leerling van Rembrandt?, *Oud Holland* 17 (1899), pp. 228–29.
Hofstede de Groot 1915
C. Hofstede de Groot, *Beschreibendes und kritisches Verzeichnis der Werke der hervorragendsten holländischen Maler des XVII. Jahrhunderts*, Vol. 6, Esslingen a. N., Stuttgart & Paris 1915.
Hofstede de Groot 1925
C. Hofstede de Groot, Rembrandt's "Painter in his Studio", *The Burlington Magazine* 47 (1925), p. 265.
Hofstede de Groot 1925a
C. Hofstede de Groot, The Author of a so-called Rembrandt, *The Burlington Magazine* 47, 1925, pp. 75–76.
Hollstein (Holl.)
F.W.H. Hollstein, *Dutch and Flemish Etchings, Engravings and Woodcuts, c. 1450–1700*, Vols. 1–, Amsterdam 1949–.
Hoogstraten 1678
Samuel van Hoogstraten, *Inleyding tot de hooge schoole der schilderkonst: anders de zichtbaere werelt*, Rotterdam 1678.
Houbraken 1781–21
Arnold Houbraken, *De groote Schouburgh der Nederlantsche konstschilders en schilderessen*, 3 Vols., Amsterdam 1718–21.
Isarlov 1936
George Isarlov, Rembrandt et son entourage, *La Renaissance* (juli-sept. 1936), pp. 1–50.
Jantzen 1923
H. Jantzen, *Rembrandt*, Bielefeld & Leipzig 1923.

De Jongh 1969
E. de Jongh, The Spur of Wit: Rembrandt's Response to an Italian Challenge, *Delta. A Review of Arts, Life and Thought in the Netherlands* 12 (1969), pp. 49–67.
Jongh, E. de: see Amsterdam 1976; Haarlem 1986.
Judson 1969
J. Richard Judson, Paintings Catalogue, *Rembrandt After Three Hundred Years—A Exhibition of Rembrandt and his Followers*, Chicago-Minneapolis-Detroit 1969/70.
Kai Sass 1971
E. Kai Sass, *Comments on Rembrandt's Passion Paintings and Constantijn Huygens's Iconography*, Copenhagen 1971.
Kan 1971
A.H. Kan, *De jeugd van Constantijn Huygens door hemzelf beschreven*, Rotterdam 1971 (1st ed. Rotterdam 1946).
Kauffmann 1924
H. Kauffmann, Rembrandts Berliner Susanna, *Jahrbuch der Preussischen Kunstsammlungen* 45 (1924), pp. 72–80.
Kauffmann 1977
H. Kauffmann, Rembrandts "Belsazar", in *Festschrift Wolfgang Braunfels*, Tübingen 1977, pp. 167–76.
Kelch 1986
J. Kelch et al, *Bilder im Blickpunkt. Der Mann mit dem Goldhelm* (Eine Dokumentation der Gemäldegalerie in Zusammenarbeit mit dem Rathgen-Forschungslabor SMPK und dem Hahn-Meitner-Institut für Kernforschung Berlin), Berlin 1986.
Kettering 1977
Alison McNeil Kettering, Rembrandt's *Flute Player*: a unique Treatment of Pastoral, *Simiolus* 9 (1977), pp. 19–44.
Kettering 1983
Alison McNeil Kettering, *The Dutch Arcadia: pastoral Art and its Audience in the Golden Age*, Ottowa and Montclair 1983.
Kieser 1941/42
E. Kieser, Über Rembrandts Verhältnis zur Antike, *Zeitschrift für Kunstgeschichte* 10 (1941/42), pp. 129–62.
Klamt 1975
J.-C. Klamt, Ut magis luceat; eine Miszelle zu Rembrandts "Anslo", *Jahrbuch der Berliner Museen* 17 (1975), pp. 155–65.
Klein 1988
P. Klein, Hat Rembrandt auf Zuckerkistenholz gemalt? *Zuckerhistorische Beiträge aus der Alten und der Neuen Welt, Schriften aus dem Zuckermuseum Berlin* 25 (1988).
Klibansky, Panofsky and Saxl 1964
R. Klibansky, E. Panofsky and F. Saxl, *Saturn and Melancholy. Studies in the History of Natural Philosophy, Religion and Art*, London 1964.
Kunoth-Leifels 1962.
E. Kunoth-Leifels, *Über die Darstellungen der 'Bathseba im Bade' (Studien zur Geschichte des Bildthemas 4. bis 17. Jahrhundert)*, Essen 1962.
Levy-van Halm, J.: see Haarlem 1988.
Van Luttervelt 1956
R. van Luttervelt, Bij het portret van Oopje Coppit, *Maandblad Amstelodamum* 43 (1956), p. 93.
MacLaren 1960
N. MacLaren, *The Dutch School: National Gallery catalogues*, London 1960.
MacLaren/Brown 1991
N. MacLaren/C. Brown, *The Dutch School: National Gallery catalogues*, revised and enlarged by Christopher Brown, London 1991.
McGrath 1984
Elizabeth McGrath, Rubens's "Susanna and the Elders" and moralizing Inscriptions on Prints, in H. Vekeman and J. Müller Hofstede (eds.), *Wort und Bild in der niederländischen Kunst und Literatur des 16. und 17. Jahrhunderts*, Erftstadt 1984.
Van Mander 1604
K. van Mander, *Het leven der doorluchtighe Nederlandtsche en Hooghduytsche schilders*, in *Het schilder-boeck*, Haarlem 1604.
Van Mander *Wtlegghingh* 1604
K. van Mander, *Wtlegghingh op den Metamorphosis Pub. Ovidii Nasonis*, in *Het schilder-boeck*, Haarlem 1604.
Manuth 1987

Volker Manuth, Ikonografische Studien zu den Historien des Alten Testaments bei Rembrandt und seiner frühen Amsterdamer Schule. Mit einem kritischen Katalog der biblischen Gemälde des Amsterdamer Malers Jan Victors, phil. diss. (manuscript), Freie Universität Berlin 1987.
Martin 1901
W. Martin, *Het leven en werken van Gerrit Dou*, Leiden 1901.
Martin 1913
W. Martin, *Gerard Dou: Kassiker der Kunst*, Stuttgart 1913.
Meyer 1880
J. Meyer, Amtliche Berichte aus den Königlichen Kunstsammlungen, *Jahrbuch der Königlich Preussischen Kunstsammlungen* 1 (1880), pp. V–VI.
Miller 1982
D. Miller, Jan Victors: An Old Testament Subject in the Indianapolis Museum of Art, *Perceptions* 2 (1982), pp. 22–29.
Miller 1985
Debra Miller, *Jan Victors (1619–1676)*, 2 Vols, phil. diss. (manuscript), University of Delaware 1985.
Miller 1986
D. Miller, A Case of Cross-Inspiration in Rembrandt and Drost, *Jahrbuch der Berliner Museen* 28, (1986), pp. 75–82.
Von Moltke 1965
J.W. von Moltke, *Govaert Flinck*, Amsterdam 1965.
Du Mortier 1984
Bianca M. du Mortier, De handschoen in de huwelijkssymboliek van de zeventiende eeuw, *Bulletin van het Rijksmuseum* 32 (1984), pp. 189–201.
Müller 1925
C. Müller(-Hofstede), *Studien zur Geschichte des biblischen Historienbildes im XVI. und XVII. Jahrhundert in Holland*, Berlin 1925 (diss.).
Müller 1929
Cornelius Müller, Studien zu Lastman und Rembrandt, in *Jahrbuch der Preussischen Kunstsammlungen* 50 (1929), pp. 45–83.
Münz 1952
L. Münz, *Rembrandt's Etchings*, 2 Vols., London 1952.
Orlers 1641
J.J. Orlers, *Beschrijvinge der Stadt Leyden*, Leiden 1641.
Picinello 1653
F. Picinello, *Mundus symbolicus in emblematum universitate formatus*, Cologne 1695 (ed. princ. Milan 1653).
Pigler 1956
A. Pigler, *Barockthemen. Eine Auswahl von Verzeichnisse zur Ikonografie des 17. und 18. Jahrhunderts*, 2 Vols, Budapest/Berlin 1956 (2nd revised ed. Budapest 1974).
Pont 1958
D. Pont, *Barent Fabritius 1624–1673*, Utrechtse kunsthistorische studies III, Utrecht 1958.
Pont 1960
D. Pont, De compositie 'Ruth and Naomi' te Bremen en Oxford. Toe-schrijving aan Willem Drost, *Oud Holland* 75 (1960), pp. 205–21.
Potterton 1986
H. Potterton, *Dutch Seventeenth and Eighteenth Century Paintings in The National Gallery of Ireland*, Dublin 1986.
De Raaf 1912
K.H. de Raaf, Rembrandt's Christus en Maria Magdalena, *Oud Holland* 30 (1912), pp. 6–8.
Raupp 1980
H.-J. Raupp, Zur Bedeutung von Thema und Symbol für die holländische Landschaftsmalerei des 17. Jahrhunderts, *Jahrbuch der Staatlichen Kunstsammlungen in Baden-Würtemberg* 17 (1980), pp. 85–101.
Raupp 1984
Hans-Joachim Raupp, *Untersuchungen zu Künstlerbildnis und Künstlerdarstellung in den Niederlanden im 17. Jahrhundert*, Hildesheim, Zürich & New York 1984 (Studien zur Kunstgeschichte, Vol. 25).
Van Regteren Altena 1959
I.Q. van Regteren Altena, Rembrandt en Wenzel Hollar, *Kroniek van de Vriendenkring van het Rembrandthuis* 13 (1959), pp. 81–86.

Van Regteren Altena 1983
I.Q. van Regteren Altena, *Jacques de Gheyn: Three Generations*, 3 Vols., The Hague, Boston & London 1983.
Reynolds 1798
Sir Joshua Reynolds, *The Literary Works*, 1798.
Reynolds 1819
Sir Joshua Reynolds, *The Literary Works*, 1819.
Reynolds 1975
Sir Joshua Reynolds, *Discourses on Art*, ed. R. Wark, 2nd ed., New Haven and London 1975.
Van Rijckevorsel 1932
J.L.A. van Rijckevorsel, *Rembrandt en de traditie*, Rotterdam 1932.
Van Rijckevorsel 1938
J.L.A. van Rijckevorsel, Rembrandt's schilderijen voor Prins Frederik Hendrik, *Historia, Maandblad voor Geschiedenis en Kunstgeschiedenis* 4 (1938), pp. 221–26.
Roberts 1965
Keith Roberts, Rembrandt's "The Feast of Belshazzar"; a recent Acquisition by the National Gallery, London, *The Connoisseur Yearbook* 1965, pp. 65–71.
Rosenberg 1948
J. Rosenberg, *Rembrandt*, 2 Vols., Cambridge (Mass.) 1948.
Rosenberg, Slive & ter Kuile 1966
J. Rosenberg, S. Slive, E.H. ter Kuile, *Dutch Art and Architecture 1600–1800*, Harmondsworth 1966.
Roy, A.: see London 1988–89.
Royalton-Kisch 1984
M. Royalton-Kisch, Over Rembrandt en van Vliet, *De Kroniek van het Rembrandthuis* 36 (1984), pp. 3–23.
Rubens 1967
A. Rubens, *A History of Jewish Costume*, London 1967.
Russell 1977
Margarita Russell, The Iconography of Rembrandt's "Rape of Ganymede", *Simiolus* 9 (1977), pp. 5–18.
Schatborn 1973
Peter Schatborn, Olieverfschetsen van Dirck Hals, *Bulletin van het Rijksmuseum* 21 (1973), pp. 107–16.
Schatborn 1985
Peter Schatborn, *Tekeningen van Rembrandt, zijn onbekende leerlingen en navolgers* (catalogus van 'Nederlandse Tekeningen in het Rijksprentenkabinet', Rijksmuseum Amsterdam IV), The Hague 1985.
Schatborn, P.: see Amsterdam 1988–89.
Van Schendel 1956
A. van Schendel, De schimmen van de Staalmeesters, *Oud Holland* (1956), pp. 1–23.
Schmidt-Degener 1913
F. Schmidt-Degener, Portretten door Rembrandt, I. Titia van Uylenburch en François Coopal, *Onze Kunst* 24 (1913), pp. 1–11.
Schmidt-Degener 1918/19
F. Schmidt-Degener, Rembrandts Pfauenbild, *Kunstchronik und Kunstmarkt* 54 (1918/19), pp. 3–7.
Schneider 1990
Cynthia P. Schneider, *Rembrandt's Landscapes*, New Haven & London 1990.
Schulz 1978
W. Schulz, Lambert Doomer als Maler, *Oud Holland* 92 (1978), pp. 69–105.
Schwartz 1984
Gary Schwartz, *Rembrandt: zijn leven, zijn schilderijen*, Maarssen 1984.
Slive 1953
Seymour Slive, *Rembrandt and his Critics 1630–1730*, The Hague 1953.
Slive 1964
S. Slive, Rembrandt's "Self-Portrait" in a Studio, *The Burlington Magazine* 106 (1964), pp. 483–86.
Sluijter 1986
Eric Jan Sluijter, *De 'Heydensche Fabulen' in de Noordnederlandse schilderkunst circa 1590–1670. Een proeve van beschrijving en interpretatie van schilderijen met verhalende onderwerpen uit de klassieke mythologie*, Leiden 1986 (diss.).
Smith 1836
J. Smith, *A Catalogue Raisonné of the Works of the most*

eminent Dutch, Flemish and French Painters, VII, London 1836.

Smith 1982
David R. Smith, Masks of Wedlock. Seventeenth-Century Dutch marriage Portraiture, Ann Arbor 1982 (Studies in the Fine Arts: Iconography, No. 8).

Stechow 1942
W. Stechow, Rembrandt und Titian, The Art Quarterly 5 (1942), pp. 135–46.

Strauss & Van der Meulen 1979
W.L. Strauss and M. van der Meulen (with the assistance of S.A.C. Dudok van Heel and P.J.M. de Baar), The Rembrandt Documents, New York 1979.

Sumowski 1956
Werner Sumowski, Einige frühe Entlehnungen Rembrandts, Oud Holland 71 (1956), pp. 109–13.

Sumowski 1956
W. Sumowski, Eine Anmerkung zu Rembrandts Gastmahl des Belsazar, Oud Holland 71 (1956), pp. 88–96.

Sumowski 1957/58
Werner Sumowski, Nachträge zum Rembrandtjahr 1956, Wissenschaftli-che Zeitschrift der Humboldt-Universität zu Berlin, Gesellschafts- und sprachwissenschaftliche Reihe, j.g. VII, 1957/58, pp. 223–78.

Sumowski 1961
Werner Sumowski, Bemerkungen zu O. Beneschs Corpus der Rembrandt-Zeichnungen II. Bad Pyrmont 1961.

Sumowski 1962
Werner Sumowski, Gerbrand van de Eeckhout als Zeichner, Oud Holland 77 (1962), pp. 11–38.

Sumowski 1963
W. Sumowski, Zeichnungen Rembrandts und seines Kreises im Kupferstichkabinett der Veste Coburg, Jahrbuch der Coburger Landesstiftung (1963), pp. 89–106.

Sumowski 1969
Werner Sumowski, Beiträge zu Willem Drost, Pantheon 29 (1969), pp. 372–382.

Sumowski 1979 ff.
Werner Sumowski, Drawings of the Rembrandt School, New York 1979 ff. (Vols 1—9 published).

Sumowski 1983[–1990]
Werner Sumowski, Gemälde der Rembrandt-Schüler, 5 Vols., Landau 1983[–1990].

Sutton, P.C.: see Philadelphia, Berlin & London 1984; Amsterdam, Boston & Philadelphia 1987–88.

Thiel, P.J.J. van: see Amsterdam 1984.

Thieme-Becker
U. Thieme, F. Becker, Allgemeines Lexikon der bildenden Künstler, 37 Vols, Leipzig 1907–1950.

Trivas 1937
N.S. Trivas, New Light on Rembrandt's so-called 'Hendrickje' at Edinburgh, The Burlington Magazine 70 (1937), p. 252.

Tümpel 1968
C. Tümpel, Ikonographische Beiträge zu Rembrandt, I–II, Jahrbuch der Hamburger Kunstsammlungen 13 (1968), pp. 95–126; 16 (1971) pp. 20–38.

Tümpel 1969
Christian Tümpel, Studien zur Ikonographie der Historien Rembrandts. Deutung und Interpretation der Bildinhalte, Nederlands Kunsthistorisch Jaarboek 20 (1969), pp. 107–98.

Tümpel 1970
Christian Tümpel, Rembrandt legt die Bibel aus, Berlin 1970.

Tümpel 1971
Christian Tümpel, Ikonografische Beiträge zu Rembrandt. Zur Deutung und Interpretation einzelner Werke, Jahrbuch der Hamburger Kunstsammlungen 16 (1971), pp. 20–38.

Tümpel 1984
Christian Tümpel, Die Rezeption der Jüdischen Altertümer des Flavius Josephus in den holländischen Historiendarstellungen des 16. und 17. Jahrhunderts, in H. Vekeman and J. Müller Hofstede (eds.), Wort und Bild in der niederländischen Kunst und Literatur des 16. und 17. Jahrhunderts, Erftstadt 1984, pp. 173–204.

Tümpel 1986
Christian Tümpel, Rembrandt, Amsterdam 1986.

Tümpel A. 1978
Astrid Tümpel, Ruth erklärt Naomi die Treue von Pieter Lastman—Zur Genese eines typischen Barockthemas, Niederdeutsche Beiträge zur Kunstgeschichte 17, 1978, pp. 87–102.

Valentiner 1921
W.R. Valentiner, Rembrandt. Wiedergefundene Gemälde, Stuttgart 1921 (Klassiker der Kunst 27).

Valentiner 1926
W.R. Valentiner, Two early Self-Portraits by Rembrandt, Art in America 14 (1926), p. 117.

Valentiner 1933
W.R. Valentiner, Zum Werk Gerrit Willemsz. Horst's, Oud Holland 50, 1933, pp.241–49.

Valentiner 1956
W.R. Valentiner, The Rembrandt Exhibitions in Holland, The Art Quarterly 19 (1956), pp. 390–404.

Voll 1907
K. Voll, Das Opfer Abrahams von Rembrandt in Petersburg und in München, in Vergleichende Gemälde-Studien, Munich & Leipzig 1907, Vol. 1, pp. 174–79.

Vollbehr 1891
T. Vollbehr, Rembrandts Paulus im Gemache, Mitteilungen aus dem Germanischen Nationalmuseum 1891, pp. 3–7.

Voskuil 1975
J.J. Voskuil, Van onderpand tot teken. De geschiedenis van de trouwring als beeld van functieverschuiving, Volkskundig Bulletin 1 (1975), pp. 47–79.

Voss 1905
H. Voss, Rembrandt und Titian, Repertorium für Kunstwissenschaft 28 (1905), pp. 120–23.

De Vries et al. 1978
A.B. de Vries, Magdi Tóth-Ubbens and W. Froentjes, Rembrandt in the Mauritshuis, Alphen aan den Rijn 1978.

Waagen 1870
G.F. Waagen, Die Gemäldesammlung in der Kaiserlichen Eremitage zu St. Petersburg, St. Petersburg 1870 (Berlin 1864).

Van de Waal 1965
H. van de Waal, Rembrandt, Portret van zijn zoon Titus, Openbaar Kunstbezit 9 (1965), No. 9.

Van de Waal 1956
H. van de Waal, Museum 61 (1956).

Van de Waal 1956a
H. van de Waal, De Staalmeesters en hun legende, Oud Holland 1956, pp. 61–107 (Reprinted in English in H. van de Waal, Steps towards Rembrandt, Amsterdam/London 1974, pp. 247–92).

Wagenaar 1765
Jan Wagenaar, Amsterdam in zyne opkomst. . ., Vol. 2, Amsterdam 1765.

Welcker 1938
A. Welcker, Titus van Rhijn als teekenaar, Oud Holland 55 (1938), pp. 268–73.

Van de Wetering 1976–77
E. van de Wetering, Leidse schilders achter de ezels, in exhib. cat. Geschildert tot Leyden Anno 1626, Leiden (Museum De Lakenhal) 1976–77, pp. 21–31.

Van de Wetering 1983: see Amsterdam and Groningen 1983.

Van de Wetering 1986
E. van de Wetering, The Canvas Support, in Bruyn et al. 1982–, Vol. 2, pp. 15–43.

Wheelock Jr, A.: see Washington & Cincinnati 1988–89.

White 1982
C. White, The Dutch Pictures in the Collection of Her Majesty the Queen, Cambridge 1982.

White, Alexander & D'Oench 1983
C. White, D. Alexander en E. D'Oench, Rembrandt in Eighteenth Century England, Yale Center for British Art, New Haven 1983.

Wolleswinkel 1987
E.J. Wolleswinkel, De staatsie-portretten van het echtpaar Hem-Vos, De Nederlandsche Leeuw 104 (1987), Cols. 394–401.

Worp 1891
J.A. Worp, Constantijn Huygens over de schilders van zijn tijd, Oud Holland 9 (1891), pp. 106–36.

Worp 1892–99
J.A. Worp, De gedichten van Constantijn Huygens, 9 Vols., Groningen 1892–99.

Wurzbach 1906–1911
Alfred von Wurzbach, Niederländisches Künstler-Lexikon, 3 dln. en suppl., Wenen, Leipzig 1906–1911.

Zafran 1977
Eric Zafran, Jan Victors and the Bible, Israel Museum News 12, 1977, pp. 92–118.

Exhibitions

Amsterdam 1898
Rembrandt: schilderijen bijeengebracht ter gelegenheid van de inhuldiging van Hare Majesteit Koningin Wilhelmina, Amsterdam (Stedelijk Museum) 1898.

Amsterdam 1923
Jubileum-tentoonstelling van de Vereeniging Rembrandt, Amsterdam (Rijksmuseum) 1923.

Amsterdam 1932
Rembrandt tentoonstelling ter plechtige herdenking van het 300–jarig bestaan der Universiteit van Amsterdam, Amsterdam (Rijksmuseum) 1932.

Amsterdam 1933
Het stilleven, Amsterdam (Kunsthandel J. Goudstikker) 1933.

Amsterdam 1935
Rembrandt tentoonstelling ter herdenking van de plechtige opening van het Rijksmuseum op 13 juli 1885, Amsterdam (Rijksmuseum) 1935.

Amsterdam 1935
Vermeer, Amsterdam (Rijksmuseum) 1935.

Amsterdam 1945
Weerzien der meesters, Amsterdam (Rijksmuseum) 1945.

Amsterdam 1946
Aanwinsten, Amsterdam (Rijksmuseum) 1946.

Amsterdam 1952
Drie eeuwen portret in Nederland, Amsterdam (Rijksmuseum) 1952.

Amsterdam 1969
Rembrandt 1669/1969, Amsterdam (Rijksmuseum) 1969.

Amsterdam 1971
Hollandse schilderijen uit Franse musea, Amsterdam (Rijksmuseum) 1971.

Amsterdam 1976
E. de Jongh ed., Tot lering en vermaak: betekenissen van Hollandse genrevoorstellingen uit de zeventiende eeuw, Amsterdam (Rijksmuseum) 1976.

Amsterdam 1984
P.J.J. van Thiel and C.J. de Bruyn Kops, Prijst de lijst. De Hollandse schilderijlijst in de zeventiende eeuw, Amsterdam (Rijksmuseum) 1984.

Amsterdam 1988–89
Peter Schatborn, Jan Lievens 1607–1674: prenten und tekeningen, Amsterdam (Museum het Rembrandthuis) 1988–89.

Amsterdam 1989
F. L. Bastet et al, *De verzameling van mr. Carel Vosmaer (1826–1888)*, Amsterdam (Rijksprentenkabinet) 1989.
Amsterdam, Boston & Philadelphia 1987–88
Peter C. Sutton et al, *Masters of 17th-century Dutch landscape painting*, Amsterdam (Rijksmuseum), Boston (Museum of Fine Arts) & Philadelphia (Philadelphia Museum of Art) 1987–88.
Amsterdam & Groningen 1983
The Impact of a Genius. Rembrandt, his Pupils and Followers in the Seventeenth Century, Amsterdam (K. und V. Waterman), Groningen (Groninger Museum voor Stad en Lande) 1983.
Amsterdam, Paris & London 1948–49
Meesterwerken uit de Pinacotheek te München, Amsterdam, Paris & London 1948–49.
Amsterdam & Rotterdam 1956
Rembrandt tentoonstelling ter herdenking van de geboorte van Rembrandt op 15 juli 1606, Vol. 1: *Paintings*, Vol. 2: *Drawings*, Vol. 3 Etchings, Amsterdam (Rijksmuseum) und Rotterdam (Museum Boymans) 1956.
Atlanta 1985
Masterpieces of the Dutch Golden Age, Atlanta (High Museum of Art) 1985.
Basel 1948
Rembrandt-Ausstellung, Basel (Katz Galerie) 1948.
Berlin 1890
Ausstellung von Werken der niederländischen Kunst des 17. Jahrhunderts . . . im Berliner Privatbesitz, Berlin (Königliche Akademie) 1890.
Berlin 1930
Rembrandt-Ausstellung, Berlin 1930.
Bern 1949–50
Kunstwerke der Münchner Museen, Bern (Kunstmuseum) 1949–50.
Birmingham 1934
Art Treasures of the Midlands, Birmingham (Museum and Art Gallery) 1934.
Boston 1970
Masterpieces of Painting in the Metropolitan Museum of Art, Boston (Museum of Fine Arts) 1970.
Bristol 1946
(City Art Gallery) 1946.
Braunschweig 1979
Jan Lievens, ein Maler im Schatten Rembrandts, Braunschweig (Herzog Anton Ulrich-Museum) 1979.
Brussels 1946
De Hollandse schilderkunst van Jeroen Bosch tot Rembrandt, Brussels (Palais des Beaux-Arts) 1946.
Brussels 1971
Rembrandt en zijn tijd, Brussels (Paleis voor Schone Kunsten) 1971.
Cambridge, Mass. 1948
Rembrandt: Paintings and Etchings, Cambridge (Fogg Art Museum) 1948.
Chicago, Minneapolis & Detroit 1969–70
Rembrandt after three hundred years: An exhibition of Rembrandt and his followers, Chicago (The Art Institute), Minneapolis (The Minneapolis Institute of Arts) and Detroit (The Detroit Institute of Arts) 1969–70.
Delft & Antwerp 1964–65
De schilder in zijn wereld: van Jan van Eyck tot Van Gogh en Ensor, Delft (Stedelijk Museum het Prinsenhof) & Antwerp (Museum voor Schone Kunsten) 1964–65.
Düsseldorf 1886
Bilder älterer Meister, Düsseldorf (Kunsthalle) 1886.
Düsseldorf 1904
Kunsthistorische Ausstellung, Düsseldorf (Kunsthalle) 1904.
Düsseldorf 1929
Ausstellung alter Malerei aus Privatbesitz, Düsseldorf (Kunsthalle) 1929.
Edinburgh 1950
Rembrandt, Edinburgh 1950.
Essen 1986
Barock in Dresden, Essen (Villa Hügel) 1986.
The Hague 1946
Herwonnen kunstbezit: tentoonstelling van uit Duitsland teruggekeerde kunstschatten, The Hague (Mauritshuis) 1946.

The Hague 1948
Meesterwerken der Hollandse School uit de verzameling van Z. M. de Koningin van Engeland, ter gelegenheid van het 50-jarig regeringsjubileum van Koningin Wilhelmina, The Hague (Mauritshuis) 1948.
The Hague 1982
Terugzien in bewondering, The Hague (Mauritshuis) 1982.
The Hague 1987
A. Eyffinger (ed.), *Huygens herdacht. Catalogus bij de tentoonstelling in de Koninklijke Bibliotheek ter gelegenheid van de 300ste sterfdag van Constantijn Huygens*, The Hague (Koninklijke Bibliotheek) 1987.
Haarlem 1986
E. de Jongh, *Portretten van echt en trouw: huwelijk en gezin in de Nederlandse kunst van de zeventiende eeuw*, Haarlem (Frans Halsmuseum) 1986.
Haarlem 1988
M. Carasso-Kok and J. Levy-van Halm (ed.), *Schutters in Holland, kracht en zenuwen van de stad*, Haarlem (Frans Halsmuseum) 1988.
Hartford 1978
Wadsworth Atheneum Paintings. Catalogue I, The Netherlands and the German-speaking Countries, ed. E. Haverkamp-Begemann, Hartford 1978.
Indianapolis & San Diego 1958
The young Rembrandt and his times, Indianapolis (John Herron Art Museum) & San Diego (The Fine Arts Gallery of San Diego) 1958.
Kassel 1964
Rembrandt und sein Kreis, Kassel (Staatliche Kunstsammlungen) 1964.
Kleef 1965
Govaert Flinck, der Kleefsche Apelles, Kleef (Städtisches Museum Haus Koekkoek), 1965.
Leiden 1956
Rembrandt als leermeester, Leiden (Stedelijk Museum De Lakenhal), 1956.
Leiden 1976
'*Geschildert tot Leyden Anno 1626*', Leiden (Stedelijk Museum De Lakenhal) 1976.
Leningrad 1986
Meesterwerken van de Westeuropese schilderkunst uit de XVI–XIX eeuw uit de verzameling van het Museum Boymans-van Beuningen, Leningrad (Hermitage) 1986.
London (British Institution), 1815, 1819. 1821, 1822, 1824, 1826, 1827, 1828, 1835, 1839, 1848, 1852, 1860, 1865, 1866.
London (Burlington Fine Arts Club) 1900, 1905.
London (Royal Academy), 1877, 1893, 1928.
London 1878
Winter Exhibition: Works by the Old Masters and by Deceased Masters of the British School, London (Royal Academy of Arts) 1878.
London 1883
Winter Exhibition: Works by the Old Masters, London (Royal Academy of Arts) 1883.
London 1894
Dutch Exhibition, London (Guildhall) 1894.
London 1899
Winter Exhibition: Works by Rembrandt, London (Royal Academy of Arts) 1899.
London 1903
Exhibition of a Selection of Works by Early and Modern Painters of the Dutch School, Art Gallery of the Corporation of London, Guildhall, London 1903.
London 1922
Loan Exhibition of Pictures by Old Masters, London (Thos. Agnew and Sons) 1922.
London 1929
Exhibition of Dutch Art 1450–1900, London (Royal Academy of Arts) 1929.
London 1930
Commemorative Catalogue of the Exhibition of Dutch Art Held in the Galleries of the Royal Academy, London (Burlington House) 1930.
London 1938
Seventeenth Century Art in Europe, London (Royal Academy of Arts) 1938.
London 1945–46

National Art-Collections Fund Exhibition, London (National Gallery) 1945–46.
London 1947–48
Cleaned Pictures, London (National Gallery) 1947–48.
London 1948
London (Whitechapel Art Gallery) 1948.
London 1948
Pictures from the Devonshire Collection, London (Agnew's) 1948.
London 1948
Fine Paintings by Old Masters London (Leger Galleries) 1948.
London 1952–53
Dutch Pictures 1450–1750, London (Royal Academy of Arts) 1952-53.
London 1958
The Robinson Collection: Paintings from the collection of the late Sir J.B. Robinson, BT, now in the possession of the Princess Labia, London (Royal Academy) 1958.
London 1964
The Orange and the Rose. Holland and Britain in the Age of Observation 1600–1750, London (Victoria und Albert Museum) 1964.
London 1971–72
Dutch Pictures from the Royal Collection, London (The Queen's Gallery) 1971–72.
London 1976
Art in Seventeenth Century Holland, London (The National Gallery) 1976.
London 1980
Christopher Brown, *Second Sight. Titian: Portrait of a Man and Rembrandt: Self-Portrait at the Age of 34*, London (National Gallery) 1980.
London 1980
Paintings from Glasgow Art Gallery, London (Wildenstein) 1980.
London 1980
Ten Paintings by Gerard Dou, London (David Carritt Ltd) 1980.
London 1984
Rembrandt and the Passion, London (British Museum, Department of Prints and Drawings) 1984.
London 1985
Masterpieces from the National Gallery of Ireland, London (National Gallery) 1985.
London 1988–89
David Bomford, Christopher Brown and Ashok Roy, *Art in the making: Rembrandt*, London (National Gallery) 1988–89.
London 1988
Treasures from the Royal Collection, London (The Queen's Gallery) 1988.
Madrid 1985–86
El siglo de Rembrandt, Madrid (Museo del Prado) 1985–86.
Manchester 1857
Art Treasures of the United Kingdom. Collected at Manchester in 1857, Manchester (Museum of Ornamental Art) 1857.
Manchester 1929
Manchester (City Art Gallery) 1929.
Manchester 1957
Art Treasures Centenary: European Old Masters, Manchester (City Art Gallery) 1957.
Montreal & Toronto 1969
Rembrandt and his pupils: a loan exhibition of paintings commemorating the 300th anniversary of Rembrandt, Montreal (The Montreal Museum of Fine Arts) & Toronto (The Art Gallery of Toronto) 1969.
Moscow 1982
Anticnost, Moskow (Pushkin Museum) 1982.
Moscow & Leningrad 1975
100 Paintings from the Metropolitan Museum of Art, New York, Moscow (Pushkin Museum) and Leningrad (Heremitage Museum) 1975.
Moscow & Leningrad 1984
Masterpieces from the Alte Pinakothek, Munich, Moscow (Pushkin Museum) and Leningrad (Hermitage Museum) 1984.
Münster 1939

Meisterwerke holländischer und flämischer Malerei aus westfälischem Privatbesitz, Münster (Landesmuseum) 1939.
New York 1909
The Hudson-Fulton Celebration, New York (The Metropolitan Museum of Art) 1909.
New York 1942
The Art of Rembrandt, New York (The Metropolitan Museum of Art) 1942.
New York 1950
A Loan Exhibition of Rembrandt, New York (Wildenstein Gallery) 1950.
New York 1967
In the Presence of Kings, New York (The Metropolitan Museum of Art) 1967.
New York 1970
Masterpieces of Fifty Centuries, New York (The Metropolitan Museum of Art) 1970.
New York, Toledo & Toronto 1954–55
Dutch Painting: The Golden Age. An Exhibition of Dutch Pictures of the Seventeenth Century, New York (The Metropolitan Museum of Art), Toledo (The Toledo Museum of Art) & Toronto (The Art Gallery of Toronto) 1954–55.
New York, Toledo & Toronto 1954–55
Dutch Painting. The Golden Age, New York (The Metropolitan Museum of Art), Toledo (The Toledo Museum of Art), Toronto (The Art Gallery of Toronto) 1954–55.
Nice 1975
Rembrandt et la Bible, Nice (Musée National message biblique Marc Chagall) 1975.
Oberlin 1963
Youthful Works by Great Artists, Oberlin (Allen Memorial Art Museum) 1963.
Oslo 1959
Fra Rembrandt til Vermeer, Oslo (Nasjonalgalleriet) 1959.
Oxford 1975
Dutch Pictures in Oxford, Ashmolean Museum, Oxford 1975.
Oxford 1980
Summary Catalogue of Paintings in the Ashmolean Museum, Oxford 1980.
Paris 1861
Exposition de la Société des Amis de l'Enfance, Paris 1861.
Paris 1921
Exposition hollandaise, Paris 1921.
Paris 1950–51
Le paysage hollandais au XVIIe siècle, Paris 1950–51.
Paris 1951
Chefs-d'Oeuvres des Musées de Berlin, Paris 1951.
Paris 1952
Chefs d'œuvres de la collection D.G. van Beuningen, Paris (Petit Palais) 1952.
Paris 1970–71
Le siècle de Rembrandt. Tableaux hollandais des collections publiques françaises, Paris (Petit Palais) 1970–71.
Paris 1970
Choix de la collection Bentinck; en souvenir de l'ambassadeur des Pays-Bas, Paris 1970.
Paris 1986
B. Broos, *De Rembrandt à Vermeer. Les peintres hollandais au Mauritshuis de La Haye*, Paris (Grand Palais) 1986.
Philadelphia & Detroit 1948–49
Paintings from the Berlin Museums, Philadelphia (Philadelphia Museum of Art) & Detroit (The Detroit Institute of Arts) 1948–49.
Philadelphia 1950–51
Diamond Jubilee Exhibition, Philadelphia (Philadelphia Museum of Art) 1950–51.
Philadelphia, Berlin & London 1984
Peter C. Sutton, *Masters of seventeenth century Dutch genre painting*, Philadelphia (Philadelphia Museum of Art), Berlin (Gemäldegalerie SMPK) & London (Royal Academy of Arts) 1984.
Raleigh 1956
Rembrandt and his pupils, Raleigh (North Carolina Museum of Art) 1956.

Raleigh 1959
Masterpieces of Art, Raleigh (North Carolina Museum of Art) 1959.
Rome & Milan 1954
Pittura olandese del seicento, Rome (Palazzo delle Esposizione) und Milan (Palazzo Reale) 1954.
Rome 1928
Capolavori della pittura olandese, Rome 1928.
Rome 1956–57
Il seicento Europeo, Rome 1956–57.
Rotterdam 1907
Tentoonstelling van oude [Hollandse] schilderijen in Rotterdams particulier bezit, Rotterdam (Rotterdamse Kunstkring) 1907.
Rotterdam 1935
Vermeer, Rotterdam (Museum Boymans-van Beuningen) 1935.
Rotterdam 1949
Honderd jaar Museum Boymans Rotterdam. Meesterwerken uit de verzameling D.G. van Beuningen, Rotterdam 1949.
Rotterdam 1972
Museum Boymans-van Beuningen Rotterdam, Old Paintings 1400–1900, Rotterdam 1974.
Rotterdam 1988
J. Giltaij and G. Jansen, *Een gloeiend palet.—Schilderijen van Rembrandt en zijn school*, Museum Boymans-van Beuningen, Rotterdam 1988.
Rotterdam & Braunschweig 1983/84
Schilderkunst uit de eerste hand. Olieverfschetsen van Tintoretto tot Goya—Malerei aus erster Hand. Ölskizzen von Tintoretto bis Goya, Rotterdam (Museum Boymans-van Beuningen), Braunschweig, (Herzog Anton Ulrich-Museum) 1983/84.
Santa Barbara 1951
Tenth Anniversary Show. Old Master Paintings from California Museums, Santa Barbara Museum, Calif. 1951.
Sarasota 1960
Figures at a Table, Sarasota (John and Mable Ringling Museum of Art) 1960
Schaffhausen 1949
Rembrandt und seine Zeit, Schaffhausen 1949.
Shrewsbury 1951
Pictures from Shropshire Houses, Shrewsbury Art Gallery 1951.
Sofia 1985
Meesterwerken van de Nederlandse schilderkunst uit de 17e eeuw uit het Museum Boymans-van Beuningen Rotterdam, Sofia 1985.
Stockholm 1956
Rembrandt, Stockholm (Nationalmuseum) 1956.
Tel Aviv 1959
Holland's Golden Age. Paintings, Drawings, Silver of the XVIIth Century Lent by Dutch Museums and Private Collections, Tel Aviv (Helena Rubinstein Pavilion) 1959.
Tokyo & Kyoto 1968–69
The Age of Rembrandt: Dutch paintings and drawings of the 17th century, Tokyo (The National Museum of Western Art) & Kyoto (Municipal Museum) 1968–69.
Tokyo & Kyoto 1974–75
Masterworks of European Painting from the Gemäldegalerie alte Meister, Dresden, Tokyo (The National Museum of Western Art) & Kyoto (Municipal Museum) 1974–75.
Tokyo 1987
Space in European Art, Tokyo (The National Museum of Western Art) 1987.
Toronto & Montreal 1969
Rembrandt and his Pupils, Toronto (Art Gallery of Ontario) and Montreal (Museum of Fine Arts) 1969.
Venice 1990
Le Cortigiane di Venezia dal Trecento al Settecento, Venice (Casinò Municipale di Venezia) 1990.
Washington & Cincinnati 1988–89
Beverly Louise Brown and Arthur K. Wheelock, Jr., *Masterworks from Munich. Sixteenth- to eighteenth-century paintings from the Alte Pinakothek, Munich*, Washington (National Gallery of Art) and Cincinnati (Cincinnati Art Museum) 1988–89.
Washington, Chicago & Los Angeles 1982–83

Mauritshuis. Dutch Paintings of the Golden Age, Washington (National Gallery of Art), Chicago (The Art Institute of Chicago) & Los Angeles (Los Angeles County Museum) 1982–83.
Washington, Detroit & Amsterdam 1980–81
Albert Blankert e.a., *Gods, Saints and Heroes: Dutch painting in the age of Rembrandt*, Washington (National Gallery of Art), Detroit (The Detroit Institute of Arts) & Amsterdam (Rijksmuseum) 1980–81.
Washington, New York & San Francisco 1978–79
The splendor of Dresden, Washington (National Gallery of Art), New York (The Metropolitan Museum of Art) and San Francisco (California Palace of the Legion of Honor) 1978–79.
Vienna & Kassel 1955–56
Gemälde der Kasseler Galerie kehren zurück, Vienna (Kunsthistorisches Museum) and Kassel (Landesmuseum) 1955–56.
Yokohama, Fukuoka and Kyoto 1986/87
Rembrandt and the Bible, Yokohama (Sofo Museum of Art), Fukuoka (Fukuoka Art Museum) and Kyoto (National Museum of Modern Art) 1986/87.
Zürich 1953
Holländer des 17. Jahrhunderts, Zürich (Kunsthaus) 1953.

The exhibition in Amsterdam is supported by
The City of Amsterdam
Golden Tulip Barbizon Centre Hotel
Ministry of Welfare, Health and Cultural Affairs

KLM Royal Dutch Airlines is the official carrier of the Rijksmuseum, Amsterdam